SNYDER'S MEDIEVAL ART

SECOND EDITION

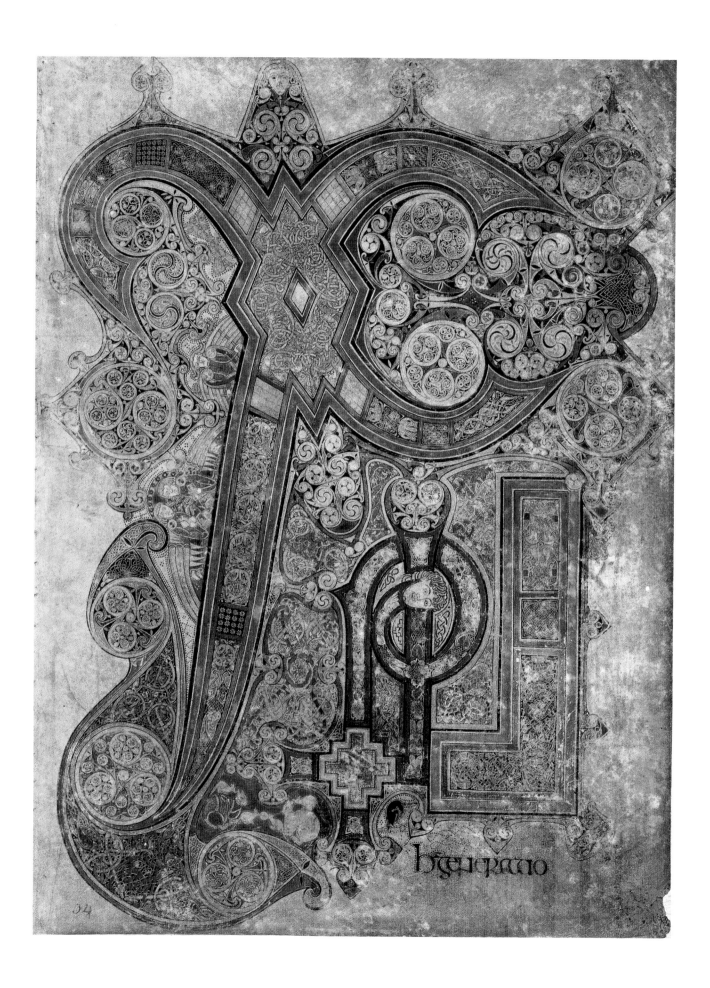

SNYDER'S MEDIEVAL ART

SECOND EDITION

Henry Luttikhuizen and Dorothy Verkerk

Prentice Hall
Upper Saddle River, NJ. 07458

This book is dedicated to Kit

Library of Congress Cataloging-in-Publication Data

Snyder, James.
 Snyder's Medieval Art / Henry Luttikhuizen, Dorothy Verkerk — 2nd ed.
 p. cm.
 Includes bibliographical references and index.
 ISBN 0-13-192970-4 (text paperback) — ISBN 0-13-193825-8 (case bound)
 1. Art, Medieval. 2. Christian art and symbolism—Medieval, 500–1500. I. Luttikhuizen,
 Henry, 1964– II. Verkerk, Dorothy, 1958– III. Title.

N5975.S58 2006
709'.02—dc22 2004060135

Editor in Chief: Sarah Touborg
Editorial Assistant: Sasha Anderson
Manufacturing Buyer: Sherry Lewis
Executive Marketing Manager: Sheryl Adams

Credits and acknowledgments borrowed from other sources and reproduced, with
permission, in this textbook appear on page 527.

Pearson Education LTD.
Pearson Education Australia PTY, Limited
Pearson Education Singapore, Pte. Ltd
Pearson Education North Asia Ltd
Pearson Education, Canada, Ltd
Pearson Educación de Mexico, S.A. de C.V.
Pearson Education–Japan
Pearson Education Malaysia, Pte. Ltd

This book was designed and produced by
Laurence King Publishing Ltd, London
www.laurenceking.co.uk

Every effort has been made to contact the copyright holders, but should there be any errors or
omissions, Laurence King Publishing Ltd would be pleased to insert the appropriate
acknowledgment in any subsequent printing of this publication.

Editor: Rada Radojicic
Picture Researcher: Emma Brown
Designer: Andrew Lindesay, Golden Cockerel Press

Front Cover: *Creation and the Virtues.* Fol. 1v. Uta Codex. Bayerische Staatsbibliothek, Munich.
Early 11th century.

10 9 8 7 6 5 4
ISBN 0-13-192970-4
Printed in The United States

CONTENTS

PREFACE AND ACKNOWLEDGMENTS
FIRST EDITION

The term "medieval" is derived from the Latin *medius* (middle) and *aevum* (age). It is generally applied to the era that lies between the demise of the Greco-Roman world and the beginnings of the Renaissance in Europe. Opinions vary as to the dates when the Medieval period begins and ends, however. For this book I have chosen the dates just prior to the reign of Constantine the Great, the first Roman emperor to sanction the Christian church (Edict of Milan, A.D. 313), to the second quarter of the fourteenth century, when Europe was devastated by the Black Death. The one unifying factor in European culture between those dates was the Christian church, and the arts that survive are for the great part those that served the church and the worshippers.

It is impossible to survey a thousand years of art in a comprehensive fashion in one volume. Nor can one hope to give a thorough analysis of architectural structure for such a vast period with changing styles. For these reasons I have focused my attention on the Christian house of worship as a theater of the arts. I am more concerned with the symbolic and aesthetic qualities of buildings and their decorations than with their external form. Remarkable continuities in the arts existed from the period of the Early Christian basilica to that of the Gothic cathedral in terms of programs of decoration and style of presentation, whether they be in the medium of mosaics, frescoes, sculptures, or stained glass. I have concentrated my discussion mostly on the church arts of Italy, Byzantium, France, and Germany.

I am indebted to many teachers, colleagues, and students for the ideas presented here. While a graduate student at Princeton I was stimulated by the fascinating seminars and lectures of Albert Mathias Friend, Jr., that dealt with Early Christian and Byzantine iconography. Earl Baldwin Smith opened my eyes to the complexities of architectural types and symbols. Professor Kurt Weitzmann introduced me to the study of narrative cycles in book illustration, a subject that has never ceased to fascinate me. To these great scholars I owe very much, although I am not sure that they would endorse some of the ideas and conclusions presented here.

My students and colleagues at Bryn Mawr are a constant source of help and inspiration. Among my colleagues I owe special thanks to Dale Kinney, Phyllis Bober, and Charles Mitchell for their conversations and ideas. Myra Uhlfelder and Gloria Ferrari Pinney helped me with problems in Latin translations. I also thank Eileen Markson, who was untiring in solving library problems at every stage in the research. Mary Campo and Jerry Lindsay were very helpful in keeping my correspondence in order.

Finally, very special thanks are due to Sheila Franklin Lieber and her excellent staff at Abrams. Without the help of my editor, Joanne Greenspun, with whom I spent long hours in consultation, this book would never have reached the press. Jennifer Bright arduously but lovingly sought out the photographs and colorplates, and Dirk Luykx, with Jean Smolar, did the handsome design and layout for the book. I would also like to express my gratitude to an astute scholar, known to me only as "reader number two," who offered a number of excellent suggestions regarding this material and the composition of the text.

James Snyder
Bryn Mawr, April 1988

PREFACE AND ACKNOWLEDGMENTS
SECOND EDITION

Published in 1989, James Snyder's *Medieval Art* has been in constant use for college teaching, a testament to its strengths as a textbook. In revising it, we gained a greater appreciation of Snyder's keen assessments of architecture, his sheer breadth of knowledge, and his astute judgment of contemporary scholarly debate. We have tried to achieve a balance between Snyder's text and our own, keeping that which is still relevant and insightful, and adding text that updates the reader on new materials and on advances in scholarship. After sixteen years it was evident that the textbook needed thorough revision since the field of art history has changed as have the expectations of students and teachers. We recognized that there was a real need for a medieval art textbook that was strong on color reproductions; hence, the decision to publish half of the illustrations in color, and to reproduce a good many of the illustrations in color that were black and white in the first edition. In revising and adding to the illustrations we were pleased to include photographs of works of art that had been restored or cleaned, thereby giving the reader the most up-to-date images. We were also particularly fortunate to acquire the 1927 Alinari photograph of the south transept of the Church of the Holy Sepulcher showing the door lintel still intact.

We made the decision to include more material from Islamic contact with the West, notably through the Crusader States, and from Celtic, and Byzantine art. We believe this will give the reader a broader understanding of the artistic exchange that shaped the art and architecture of Western Europe. Interest in the Middle Ages has never waned, so we added a short chapter on Medievalism, with the hope that this will open the door for teachers and students to examine the continuing influence of, and nostalgia for, this extraordinarily fertile period of human history.

The first edition had a decidedly Proto-Renaissance bent that reflected the lingering notion that the art and architecture of the Middles Ages, especially those periods that embraced a more Classical style, were preludes to the Italian Renaissance. In our revisions, we have tried to correct this bias by showing how the visual culture of the Middle Ages is worthy of being fully appreciated in its own right.

We have updated the bibliography carefully and thoroughly, making tough decisions about what to omit and what to add. As a general guideline, nineteenth-century German works were omitted along with works that have been superseded by more recent publications. The emphasis is on recent and revised books in English.

For their many insightful comments and suggestions, we would like to thank the following reviewers: David S. Areford, University of Massachusetts Boston; Sarah Blick, Kenyon College; A. Victor Coonin, Rhodes College; Yoshio Kusaba, California State University, Chico; Stephanie Maloney, University of Louisville.

A number of colleagues lent us their time and expertise in the revising of this textbook. We would like to thank Craig Hanson and John Yiannias for reading and commenting on chapters. Larry Silver generously offered hospitality during research, and also help with the bibliography. Jaroslav Folda graciously shared photographs and copyright information for Crusader works of art that were difficult to access. He should also be thanked for reading the Crusader chapter. Alas, we could not include more because of word length constraints, but we were delighted to include this new and exciting material. We also received the assistance of our students Rebecca Merz and Jennifer Van Etten. Jennifer was especially helpful with her insights into the painting *Riders of the Sidhe*, by John Duncan. We also want to thank our editors Sarah Touborg, Kara Hattersley-Smith, and Rada Radojicic for their patience and determination to move this project forward. Emma Brown deserves our thanks for her relentless pursuit of photographs and permissions.

This revised and colorful textbook is dedicated to our children, Arie and Gabrielle Luttikhuizen and Kees, Amelia, and William Verkerk.

Henry Luttikhuizen
Dorothy Verkerk
December 2004

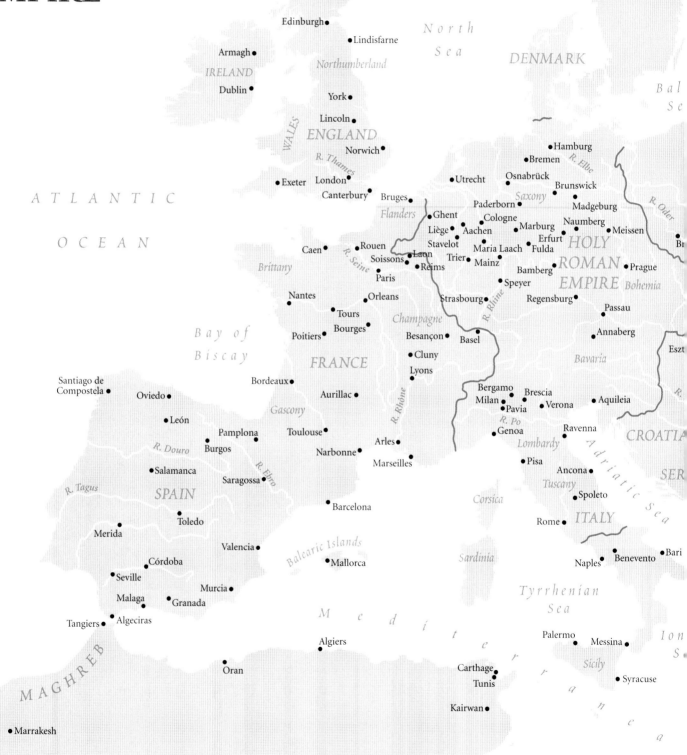

EUROPE *and the* BYZANTINE EMPIRE

Urnes
Borgund

NORWAY

SWEDEN

Orkney

Inverness
SCOTLAND
Iona
Aberdeen

Edinburgh

Lindisfarne

North
Sea

DENMARK

Bal
Se

Armagh
IRELAND

Northumberland

Dublin

York

Lincoln

WALES
ENGLAND
Norwich

R. Thames

Exeter
London
Canterbury
Bruges
Flanders
Ghent
Utrecht
Hamburg
Bremen
Osnabrück
R. Elbe
Brunswick
Madgeburg
R. Oder
Br

ATLANTIC

OCEAN

Caen
R. Seine
Rouen
Soissons
Laon
Paris
Liège
Stavelot
Reims
Trier
Mainz
Paderborn
Cologne
Aachen
Marburg
Erfurt
Maria Laach
Fulda
Naumberg
Meissen
HOLY
ROMAN
EMPIRE
Bohemia
Prague
Bamberg
Speyer
Regensburg
Passau

Brittany

Nantes
Orleans
Tours
Bourges
Poitiers

Champagne
Besançon
Basel
Strasbourg

R. Rhine

Annaberg
Eszt

Bay of
Biscay

FRANCE
Cluny
Lyons

Bavaria

R

Santiago de
Compostela
Oviedo
León
Bordeaux
Aurillac

Gascony

R. Rhône

Bergamo
Milan
Pavia
Brescia
Verona
Aquileia
CROATIA
SER

Pamplona
Burgos
R. Douro
Salamanca
Saragossa
R. Ebro
SPAIN
R. Tagus
Toledo
Merida
Córdoba
Seville
Malaga
Algeciras
Tangiers
MAGHREB

Toulouse
Narbonne
Arles
Marseilles

Barcelona

Balearic Islands

Valencia
Mallorca
Murcia
Granada

Corsica

R. Po
Genoa
Ravenna
Lombardy
Pisa
Ancona
Tuscany
Spoleto
Rome
ITALY

Adriatic Sea

Sardinia

Naples
Benevento
Bari

Mediterranean

Tyrrhenian
Sea

Palermo
Messina
Sicily
Syracuse
Ion
S

Algiers

Oran

Carthage
Tunis

Kairwan

Tripoli

Marrakesh

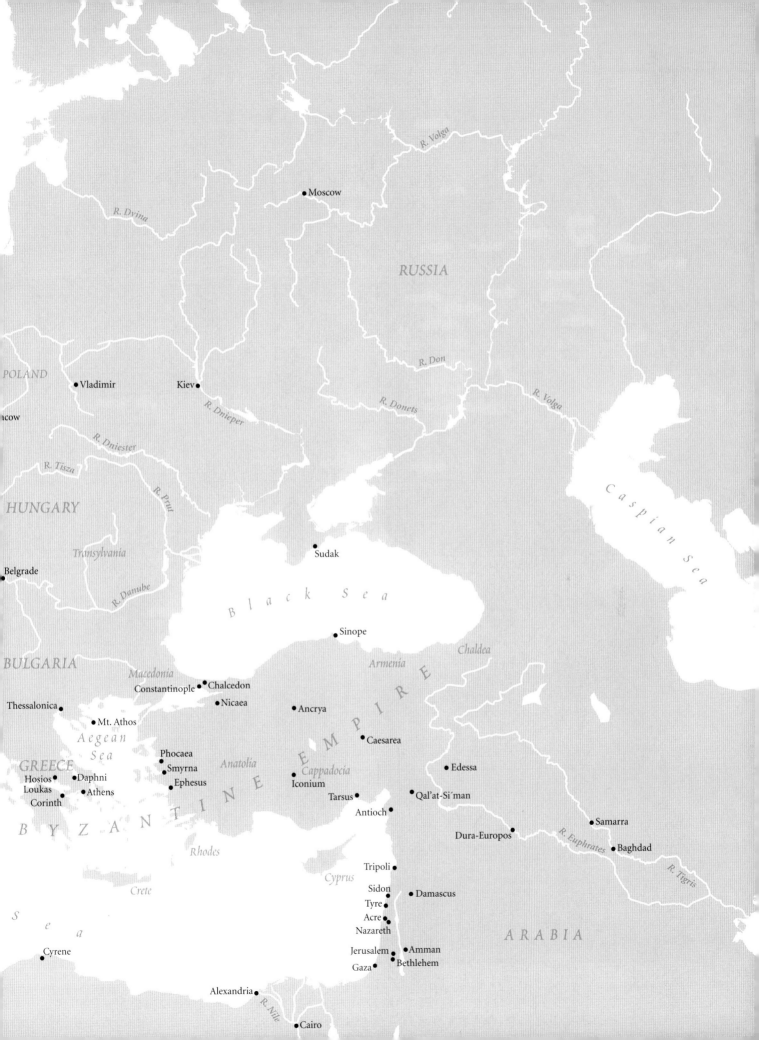

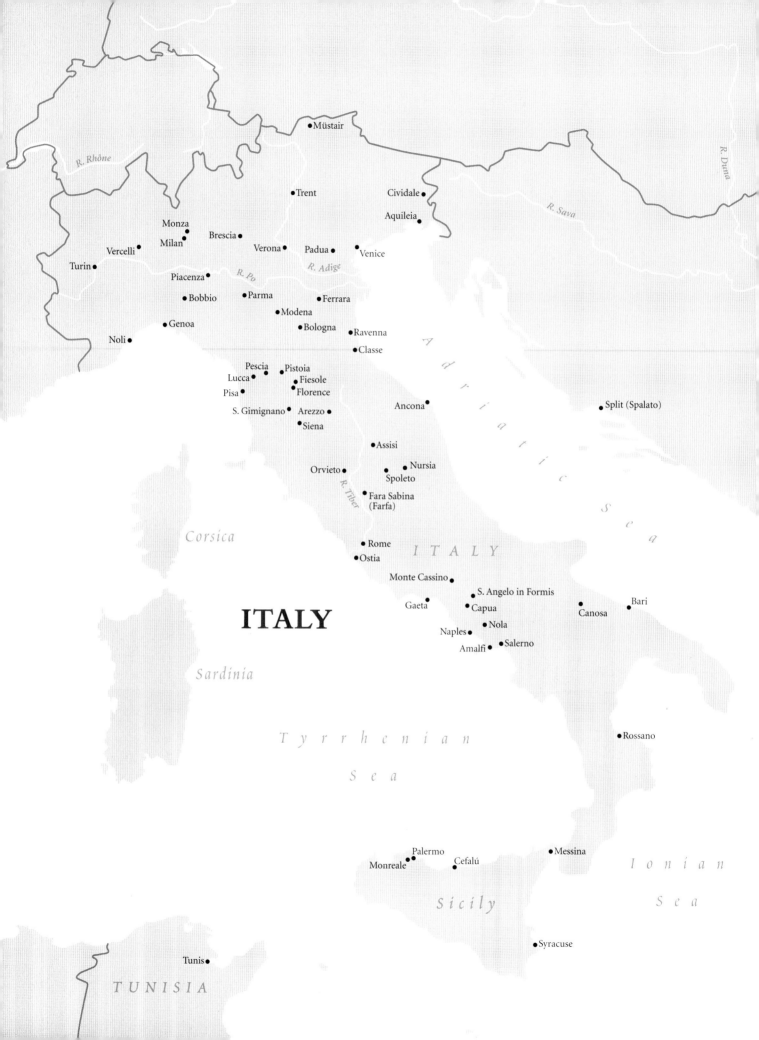

Müstair

Trent

Cividale
Aquileia

Monza
Vercelli
Milan
Brescia
Verona
Padua
Venice
Turin

R. Adige

Piacenza
R. Po

Bobbio
Parma
Ferrara

Modena

Genoa
Bologna
Ravenna

Noli
Classe

A d r i a t i c

Pescia
Pistoia
Lucca
Fiesole
Pisa
Florence

Ancona
Split (Spalato)

S. Gimignano
Arezzo
Siena

S e a

Assisi

Nursia
Orvieto
Spoleto

R. Tiber
Fara Sabina
(Farfa)

ITALY

Rome
I T A L Y

Corsica
Ostia

Monte Cassino
S. Angelo in Formis
Gaeta
Capua
Bari
Naples
Nola
Canosa
Amalfi
Salerno

Sardinia

T y r r h e n i a n

Rossano

S e a

Palermo
Messina
I o n i a n
Monreale
Cefalú

S e a

S i c i l y

Syracuse

Tunis

TUNISIA

R. Rhône

R. Sava

R. Drina

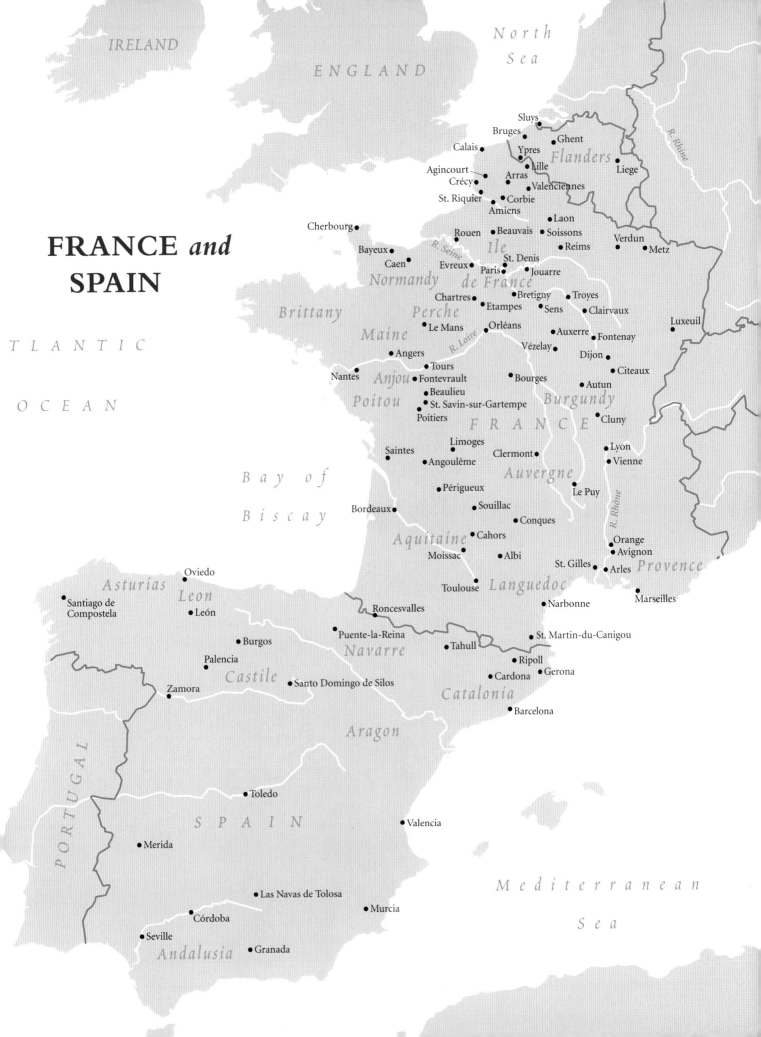

FRANCE *and* SPAIN

IRELAND

ENGLAND

North Sea

A T L A N T I C

O C E A N

B a y o f

B i s c a y

Cherbourg

Bayeux
Caen

Normandy

Brittany

Maine

Perche

Anjou

Poitou

Nantes
Angers
Tours
Fontevrault
Beaulieu
St. Savin-sur-Gartempe
Poitiers

Saintes

Bordeaux

Aquitaine

Calais
Agincourt
Crécy
St. Riquier

Sluys
Bruges
Ypres
Lille
Arras
Corbie
Amiens

Ghent

Valenciennes

Flanders

Liege

R. Rhine

Rouen
Beauvais
Soissons
Laon

Evreux
R. Seine
St. Denis
Paris
Jouarre

Verdun
Reims
Metz

Ile de France

Chartres
Etampes
Bretigny
Sens
Troyes
Clairvaux

Le Mans
Orléans
Vézelay
Auxerre
Fontenay
Dijon

R. Loire
Bourges
Autun
Citeaux

F R A N C E

Burgundy

Cluny

Limoges
Angoulême

Clermont

Auvergne

Lyon
Vienne

Périgueux

Souillac

Le Puy

Conques

Cahors

Moissac
Albi

Toulouse

St. Gilles

Languedoc

Orange
Avignon
Arles

Provence

Marseilles

Luxeuil

R. Rhône

Narbonne

Asturias
Leon

Oviedo

Santiago de
Compostela

León

Burgos
Palencia

Castile

Zamora

PORTUGAL

Roncesvalles

Puente-la-Reina

Navarre

Santo Domingo de Silos

Aragon

Tahull

St. Martin-du-Canigou

Ripoll

Cardona
Gerona

Catalonia

Barcelona

Toledo

S P A I N

Valencia

Merida

Las Navas de Tolosa

Murcia

M e d i t e r r a n e a n

S e a

Córdoba

Seville

Andalusia

Granada

THE BRITISH ISLES

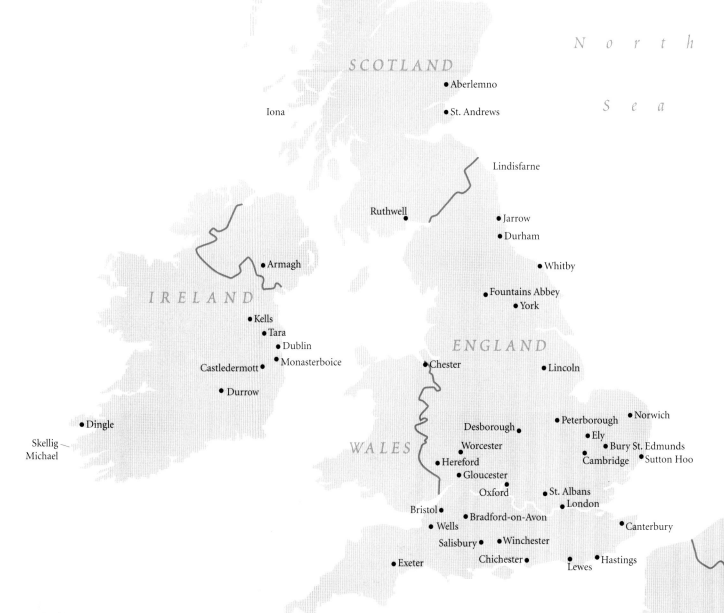

NORTH

ATLANTIC

OCEAN

North

Sea

SCOTLAND

• Aberlemno

Iona

• St. Andrews

Lindisfarne

Ruthwell

• Jarrow

• Durham

• Whitby

• Armagh

• Fountains Abbey

• York

IRELAND

ENGLAND

• Kells

• Tara

• Dublin

• Lincoln

Castledermott •

• Monasterboice

• Chester

• Durrow

• Norwich

• Peterborough

• Dingle

Desborough •

• Ely

WALES

• Worcester

• Bury St. Edmunds

Skellig

Michael

• Hereford

Cambridge •

• Sutton Hoo

• Gloucester

Oxford •

• St. Albans

Bristol •

• London

• Bradford-on-Avon

• Canterbury

• Wells

Salisbury •

• Winchester

• Exeter

Chichester •

• Hastings

Lewes

ATLANTIC

OCEAN

FRANCE

PART ONE
LATE ANTIQUITY

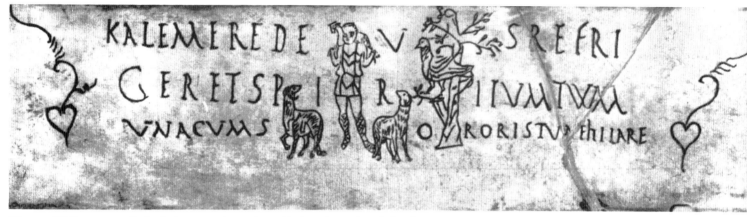

Fig. 1.1. "Kalimere, may God refresh your soul, together with that of your sister, Hilara."
Epitaph from the Roman catacombs. 4th century. Courtyard, Lateran Museum, Rome

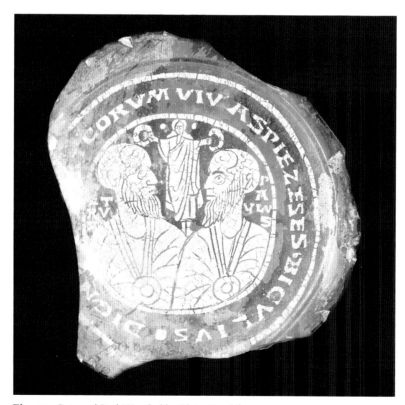

Fig. 1.2. *Peter and Paul, Wreathed by Christ.* Bowl fragment.
Find-place unknown. Diameter of base-disc 3½″, bottom 1⅛″,
bottom with base ⅛″. 4th century. British Museum, London

1

ART AND RELIGION
IN LATE ANTIQUITY

"Kalimere, may God refresh your soul, together with that of your sister, Hilara." These words are roughly incised on a stone funerary slab today embedded in the wall of the inner courtyard of the Lateran Museum in Rome (**fig. 1.1**). The simple yet poignant invocation is interrupted by four images scratched across the middle of the Latin words, breaking the continuous flow of letters into fragments that are at first difficult to put together. The central figure is that of a youthful shepherd, garbed in a short tunic and sandals, standing frontally and carrying a lamb across his shoulders. Two sheep, heraldically posed, stand below him with their heads turned upward. To the right a dove perches in an olive tree. Although the images are simple, they are difficult to interpret because the figures of sheep, a shepherd, and a dove are motifs derived from pagan visual traditions that represented the afterlife as a bucolic setting. Are Kalimere and Hilara followers of the shepherd Orpheus, or are they followers of Jesus of Nazareth, who described himself as a shepherd and his people as his sheep? Though this ambiguity can frustrate attempts at precise interpretation, it is one of the more intriguing aspects of Late Antique art, because the intermingling of the old and new is the matrix from which the tradition of western European art will evolve. Syncretism, the combination of different forms of belief or practice, is the hallmark of Late Antiquity.

Hundreds of such decorated funerary inscriptions of the third and fourth centuries were uncovered in Rome and elsewhere in the Late Antique world, and many of them depict more complex signs, symbols, or pictures than the one cited above. These images have often been found in the tomb chambers of the subterranean burial sites, the catacombs, once excavated outside the city walls but today frequently discovered buried beneath the debris and landfill of urban expansion.[1] The inscriptions found throughout the catacombs are only some of the items that were discovered there, many of them displaying silent yet poignant grief. Bone dolls, fragments of terracotta lamps, and even the more luxurious gold-glass fragments indicate that the deceased were commemorated with whatever means were available to the mourners. One beautiful example of gold glass is the fragment of a vessel with the portraits of the principal saints in Rome during Late Antiquity, Peter and Paul (**fig. 1.2**). The inclusion of the glass was no doubt meant to invoke the protection of the saints in the afterlife.

Because Christianity was founded in the eastern Mediterranean as a mystical cult that was an offshoot of Hebraic teachings in the Old Testament, it was once thought that Christians had embraced literally the second commandment: "You shall not make for yourself an idol in the form of anything in heaven above or on the earth beneath or in the waters below. You shall not bow down to them or worship them; for I, the Lord your God, am a jealous God" (Exod. 20:4–5). Discoveries in the twentieth century, however, indicate that the picture is much more complex, not only for Christians but also for Jews.

Presented to the art world in 1965, the three sculptures *Jonah Cast Up*, *Jonah Under the Gourd*, and *Jonah Praying* (**figs. 1.3–5**) radically changed views about the nature of early Christian art. These three sculptures were found in a large jar, along with a *Jonah Swallowed by a Great Fish*, a *Good*

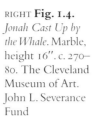

RIGHT **Fig. 1.4.** *Jonah Cast Up by the Whale.* Marble, height 16″. c. 270–80. The Cleveland Museum of Art. John L. Severance Fund

ABOVE **Fig. 1.3.** *Jonah Praying.* Asia Minor, probably Phrygia (central Turkey). Marble, 18 × 8″. c. 270–80. The Cleveland Museum of Art. John L. Severance Fund

RIGHT **Fig. 1.5.** *Jonah Under the Gourd.* Asia Minor, probably Phrygia (central Turkey). Marble, 12½ × 18 × 7″. c. 270–280. The Cleveland Museum of Art. John L. Severance Fund

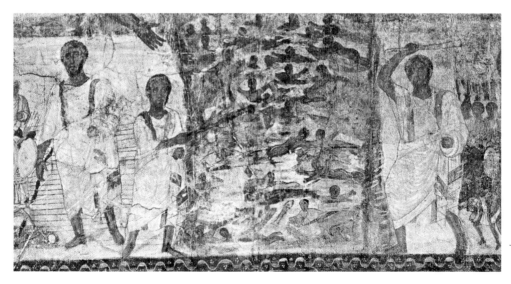

Fig. 1.6. *Moses Leads the Migration from Egypt,* Dura-Europus Synagogue. Wall painting, c. 245–56, National Museum of Damascus

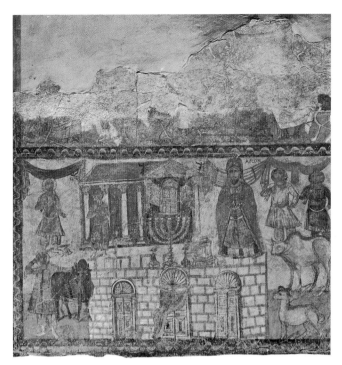

Fig. 1.7. *The Temple of Aaron*, Dura-Europus Synagogue.
Wall painting, c. 245–56, National Museum of Damascus

artisanship indicate a wealthy Christian patron who commissioned the pieces sometime around A.D. 270–80. We can envision an affluent Christian household that intended to display the sculptures in the house or garden just as their neighbors would display sculptures of their heroes or gods such as Hercules or Dionysos or Isis.

Another exciting discovery in 1920, of the Dura-Europos synagogue and its cycle of wall paintings, was highly significant for the study both of the origins of Christian art and also of Judaism and religious imagery. The synagogue, adapted from a house, was filled with three bands of fifty-eight secco wall paintings that portrayed Jewish heroes from the books of Genesis, Exodus, Samuel, Kings, Esther and Ezekiel. Dating from 245–56, these paintings are the earliest yet discovered. Scenes of salvation such as the Crossing of the Red Sea are interspersed with scenes of more liturgical significance such as Aaron and the Temple (**figs. 1.6, 1.7**). The artists who painted these spectacular stories and heroes of Jewish history relied on frontal views, the hieratic treatment of figures, and a flattened pictorial space in order to convey the meaning of the stories and figures. This is a series of narrative paintings that were previously unknown in Jewish art, indicating that an affluent Jewish community could embrace more than symbolic art such as the menorah found in Jewish funerary art in Rome; for example, the catacomb of Via Torlonia with its sketchy renditions of Jewish ritual objects that stood as symbols for Jewish history, or the Temple of Solomon, or even Jewish worship (**fig. 1.8**). Other than funerary art, the other examples of large-scale Jewish art are from synagogues, namely beautiful mosaics such as those found in the nave of the Beth Alpha

Shepherd, and six portrait busts, all sculpted in marble from the Roman Imperial quarries at Docimium in ancient Phrygia (now Central Turkey). The Docimium quarries supplied the Roman Empire with high-quality marble in the form of unfinished blocks that were used for sculpture, paving, and veneer. Clearly, the quality of the material and the

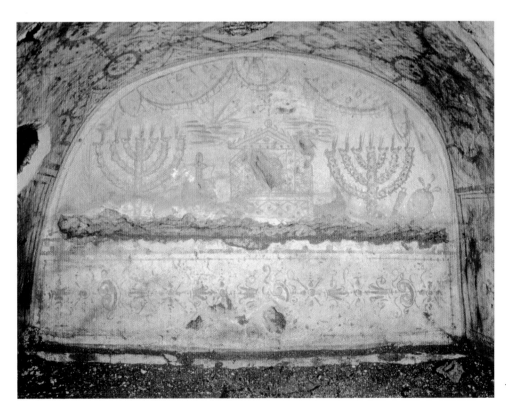

Fig. 1.8. Menorah and ritual objects, Jewish Catacomb, 3rd –4th century. Villa Torlonia

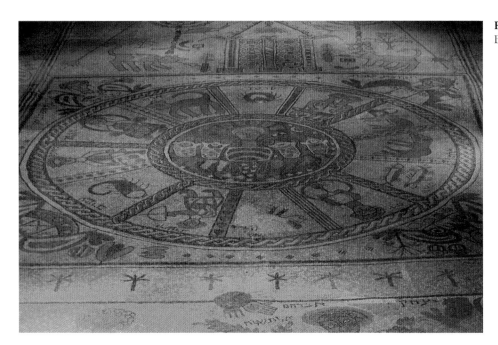

Fig. 1.9. Sacrifice of Isaac mosaic, Beth Alpha Synagogue, 6th century

synagogue (**fig. 1.9**). The motifs of ritual objects are found in the synagogues, indicating that there was a continuity between synagogue and funerary art motifs. The sixth-century Beth Alpha mosaics expand the symbolic repertoire to include scenes of the Sacrifice of Isaac. The central panel depicts a sun god driving a four-horse chariot against a background of stars and a half-moon, and surrounded by the signs of the zodiac, each with its name in Hebrew; the four corners of the square indicate the four seasons. The sun god was adapted for a Christian funerary setting in the Tomb of the Julii, where Christ is shown with rays of the sun emanating from his head, in a visual manifestation of the idea that Christ is the Risen Son of God (**fig. 1.10**). The depiction of the sun god was a motif found in pagan, Jewish and Christian works of art, demonstrating that artistic motifs could be borrowed from other religions but were re-contextualized and given specific meanings by each cong-regation. The paintings from Dura-Europos, the Roman

Fig. 1.10. *Helios* (Christ as Sun-God?). Mosaic in the vault of the tomb of the Julii, Vatican Grottoes. 3rd century

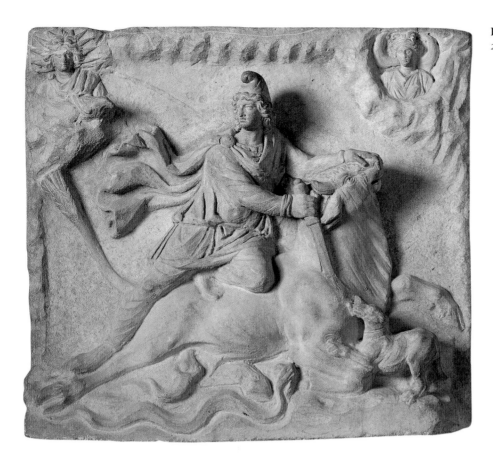

Fig. 1.11. *Mithra Slaying the Bull.* Marble. 2nd–3rd century, The Louvre, Paris

catacombs and the Beth Alpha mosaic are only three examples of a vigorous period of Jewish creativity not only in the arts but also in Jewish law and theology during Late Antiquity.

Christianity, one of a number of mystery cults that had seeped into Roman mystical faiths from the eastern Mediterranean world, was attractive because it was direct in its teachings and accessible to anyone willing to join the congregation. Mithraism, also popular at this time, shared many similar beliefs and rituals with Christianity: a period of initiation when one was a catechumen, a sacred meal of bread and wine, and baptism. Particularly popular with the Roman legionnaires, the god Mithra was born of a mother-rock by a river under a tree, coming into the world with the Phrygian cap on his head and a knife in his hand. The beautifully sculpted *Mithra Slaying the Bull* (**fig. 1.11**) depicts the moment when the god slays the bull that has brought all troubles into the world. Once slain by Mithra, the bull's body becomes the source of all vegetation and finally of the creation of humans. This eastern cult, popular throughout the Roman Empire, even though it did not allow female members, was finally suppressed in the fourth century.

Despite the abundant evidence of Christian art, there was a tension between the use of art and the admonition "You shall not make for yourself an idol." The earliest Christian authorities of the Church—Origen, Clement of Alexandria, Irenaeus, Tertullian—professed this belief, and at one of the first church synods (conventions or councils), held in Elvira in Spain about 315, a canon or rule citing the second commandment was included to establish the position of the Christian Fathers concerning imagery in churches.[2] The fact that the Church felt the need to make such rules indicates that the arts were lively and held a place in the worship and private devotional practices of Christians.

The world into which Christianity was born was one in which visual imagery served an important role as communication as well as embellishment, as messages as well as objects of admiration. A pictorial language had long existed that illustrated state and civic policies to an audience not always capable of or concerned with reading texts; a wealth of pictorial clichés, much as in modern advertising, informed everyone who walked the streets or gathered in the markets of the cities in the Roman Empire. Such communication was vital and was bound to survive. Many of the pagan signs and symbols were appropriated, often with little or no change, for Christian use.

After 313, with the transformation of the Christian church from a simple, domestic, congregational meeting of *ecclesia* to a state-sponsored spectacle performed before the public in great basilicas, the prohibitions of a few words of the Jewish commandment or the fears of the opponents of paganism were soon to give way to a Christian society that made full use of art, whether in the form of tiny decorative motifs or elaborate public displays, whether enhancing a simple

utilitarian object or adorning the walls of monumental edifices rising in abundance within and outside the walls of the city. Already in the fourth century, writers such as Prudentius and Paulinus of Nola leave ample testimonies to the proliferation of images and their use as isolated paintings marking the graves of martyrs or as elaborate mural schemes for the decoration of churches.

The second commandment was voiced against idols to be adored, but it did not condemn pictures that served as visual instruction, or reminders of biblical heroes and stories. Often cited is the pronouncement of Pope Gregory the Great, who, in a letter (c. A.D. 600) to a bishop of Marseilles, explained the point as follows: "Pictures are used in churches in order that those ignorant of letters may by merely looking at the walls read there what they are unable to read in books."[3] Paulinus of Nola implied the same function of pictures when he described their didactic role for the initiates who gathered for instruction. Later, more philosophical justifications for the use of pictures, based on the doctrine of the Incarnation—God was made man in the flesh—will be mustered by the intellectual Fathers of the Byzantine Church in reaction to the absolute policies of iconoclasm.

During the first centuries it appears that the organization of the Church was loose and varied, with volunteer administrators the overseers (later bishops) and the stewards (later deacons) looking after the business of the local congregation. The rituals, too, were fluid and not well documented, often following local patterns rather than a centralized authority.[4] It seems that the congregation (*ecclesia*) assembled at sunrise on Sunday for prayer and again at sunset for a meal (compare the Jewish Sabbath-eve meal) beginning with the breaking of bread and the blessing of wine—the essential elements of the more fully developed sacrament of the Eucharist. Prayers were offered and hymns were sung, and sometimes a special guest or member would deliver a sermon. There was no need for a special architecture for these humble needs. A house would do. Paul says "They broke bread in their homes and ate together with glad and sincere hearts" (Acts 2:46). The dining room (*triclinium*) of the typical house would suffice for the small numbers participating.

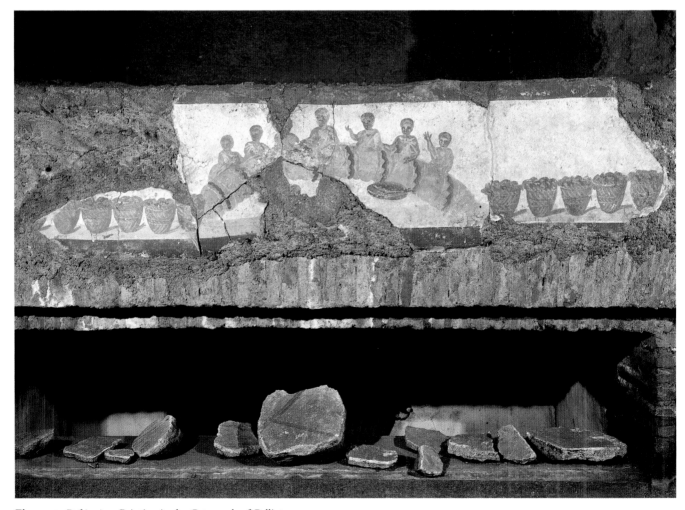

Fig. 1.12. *Refrigerium.* Painting in the Catacomb of Callixtus, Rome. 3rd century

THE CATACOMBS AND FUNERARY ARTS

Since the Christians, along with the Jews and many Romans following other religions, did not normally practice cremation, what were needed were burial grounds, and these took the form of the common open-air cemeteries or underground chambers referred to as catacombs (named after a cemetery on the Via Appia, where the Church of San Sebastiano was later built). Many of the Christian cemetery grounds were the collective properties of church organizations and were legally registered. One of the largest to be excavated, the Catacomb of Callixtus, was, in fact, under the supervision of the deacon Callixtus, a rich banker in the early third century. Roman law protected any tomb, and even during periods of severe persecution these sites "outside the walls" of the city were sanctified as inviolable and inalienable property rights.

Nineteenth-century writers of Gothic novels found in the catacombs the romantic settings for eerie tales of frightened Christians gathering in secrecy in dark and scary underground chambers to escape their persecutors, a misconception that still holds today. The catacombs, with few exceptions, were not places for secret meetings and refuge. They were not only dark, but also cramped, labyrinthine, and, with their unhealthy air, uncomfortable. Generally entered through a modest portal above ground, the subterranean passages were restricted by law as to size and position along the roads outside the city walls. The narrow galleries and chambers were excavated by *fossores*, members of a kind of guild of gravediggers, from the *tufa*, a rocky but soft stone composed of sand and volcanic ash. Although the Roman catacombs are perhaps the most well known, catacombs are also found in central and southern Italy, Sicily, Malta, North Africa, and Egypt, and always in areas where the rock is soft and tunneling easy.

Depending upon the quality of the soil, as many as six layers of galleries could be excavated underground, resulting in ground plans that resemble three-dimensional spider webs. Burial niches, or *loculi* (singular: *loculus*), carved into the gallery walls, were closed by slabs of stone with inscriptions such as that of Kalimere cited above. Larger chambers, called *cubicula* (singular: *cubiculum*), formed crypts for family burials or for the commemoration of special sites where martyrs were buried. Some larger tombs, often distinguished by arched niches called *arcosolia* (singular: *arcosolium*), had room for several burials side by side. The wealthier could afford a stone or lead sarcophagus, which was often ornamented and elaborately carved. In some of the larger *cubicula*, or in buildings erected above the catacombs, Christians gathered for special funerary meals (*agape*, or feast of love) and memorial banquets, following the practice of the pagans in honoring their dead. In the Catacomb of Callixtus, the sketchy figures of seven disciples seated behind an arced table (**fig. 1.12**),

Fig. 1.13. *Fish and Bread*. Detail of a painting in the crypt of Lucina in the Catacomb of Callixtus, Rome. 3rd century

before which seven baskets of bread are aligned, could be interpreted as a commemorative meal for the deceased person, or as the celestial banquet for the deceased found frequently in pagan art; however, the central figure breaks the bread, so the fresco could allude to the Eucharistic sacrament, as anticipated when Christ breakfasted on fish and bread with seven apostles by the Sea of Tiberias (John 21:1–14).[5]

The *Fish and Bread* (**fig. 1.13**) painted on the wall of the crypt of Lucina in the Catacomb of Callixtus was surely intended to evoke the association of the body and blood of the Savior. Very early on, the fish was a symbol of Christ, derived from the acronym of his title in Greek, "Jesus Christ, Son of God, Savior," which became *Ichthys*, or fish. According to Prosper of Aquitaine, the fish signified Christ as the food given to the disciples and to the whole world. Within the reed basket containing the bread representing the body of Christ, one can discern a transparent glass containing red wine, symbolic of the blood of the Savior.

In these diminutive and mysterious burial caverns the *fossores* and decorators worked to distinguish Christian burials from pagan tombs, especially if a martyr's grave were incorporated in a *cubiculum*. Tertullian wrote that "it is permissible to live with the pagans but not to die with them," and while most of the Christian catacomb decorations repeat the general compositions of traditional pagan tombs—murals with little more than geometric lines to divide the walls and ceilings into boxes, circles, and rectangular compartments—the pictorial motifs added frequently indicate a Christian burial. Along with the ever-present "Elysian fields", or paradise garden, often with little more than a few trees, flowers, birds, and urns, one distinguishes the Good Shepherd and his

flock (**fig. 1.14**), the favorite funerary motif derived from Psalm 22 (Vulgate Bible; Psalm 23 in King James version) (see also the parables in Luke 15:4–7 and John 10:11–16):

> The Lord is my shepherd, I shall not be in want. He makes me lie down in green pastures, he leads me beside quiet waters, he restores my soul. He guides me in paths of righteousness for his name's sake. Even though I walk through the valley of the shadow of death, I will fear no evil, for you are with me; your rod and your staff, they comfort me.

This psalm was a popular one for funerary rites and the Good Shepherd painted on the walls of the tomb was no doubt a comforting visual reminder for the mourners.[6]

The complexity of the artistic interaction between religions is brought sharply into focus by the example of the Via Latina catacomb. Discovered in 1955, it is one of the most orderly and well planned of all the Roman catacombs and a veritable treasure trove of funerary art. In Cubiculum O, Christ raises his rod to bring Lazarus, who has lain in the tomb for four days, back from the dead (**fig. 1.15**). The four days is significant because there was a belief that the spirit of the deceased lingered for three days around the corpse, so that bringing Lazarus back after four days underscored the miraculous power of Christ over death.

Just down the corridor from the Crossing of the Red Sea is Hercules Slaying the Hydra, a scene that derives from Greek mythology (**fig. 1.16**). Hercules grasps one of the nine heads of the Hydra, which has terrorized the people with its

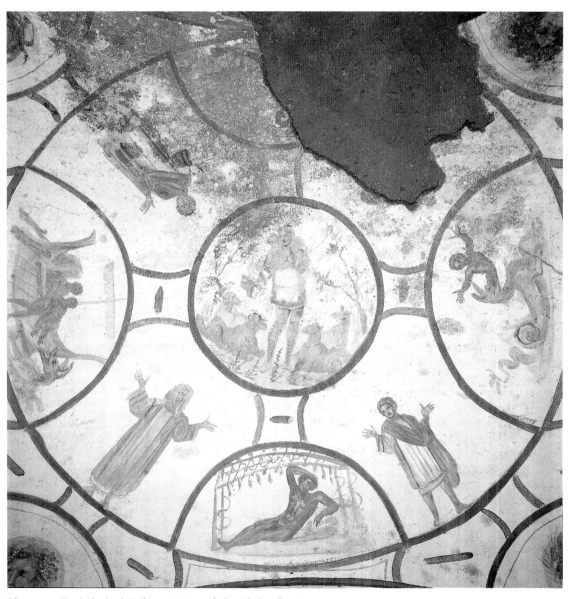

Fig. 1.14. *Good Shepherd.* Ceiling painting of a burial chamber in the Catacomb of Saints Peter and Marcellinus, Rome. 4th century

ABOVE **Fig. 1.15.** *Raising of Lazarus*. Catacomb della Via Latina, Rome. Mid 4th century

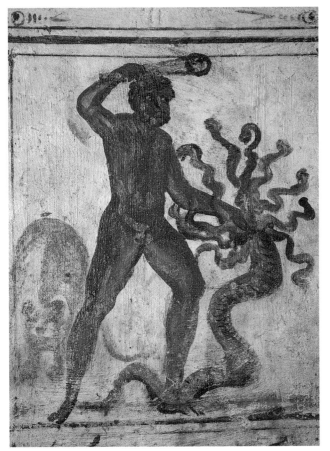

LEFT **Fig. 1.16.** *Hercules Fighting the Lernaean Hydra*. Catacomb della Via Latina, Rome, Hall N. Mid 4th century

foul, death-dealing breath, and raises his club to kill the creature. This enigmatic scene is not readily interpreted in a funerary context; yet, the inclusion of scenes from mythology and from Scripture within the Via Latina catacomb serves to underscore the fact that the Late Antique world saw a complex intermingling of old and new religions, with members of the same family no doubt adhering to different faiths.

While the decorators of the catacombs were rarely accomplished fresco painters, their quick, sketchy lines softly capture light and shadow playing across forms, and the relaxed gestures effectively repeat the normal conventions for movements and actions in pagan art. This is particularly discernible in the *orans*, or praying figures, symbols of faith for the soul of the deceased. Generally female, they stand in a frontal position and lift up their hands in the ancient attitude of prayer, imploring their god for the deliverance of the dead. As a motif of faith and hope, the *orans* with uplifted arms also personify the faith of the Church in general, and as such often serve as a symbol of *ecclesia*.

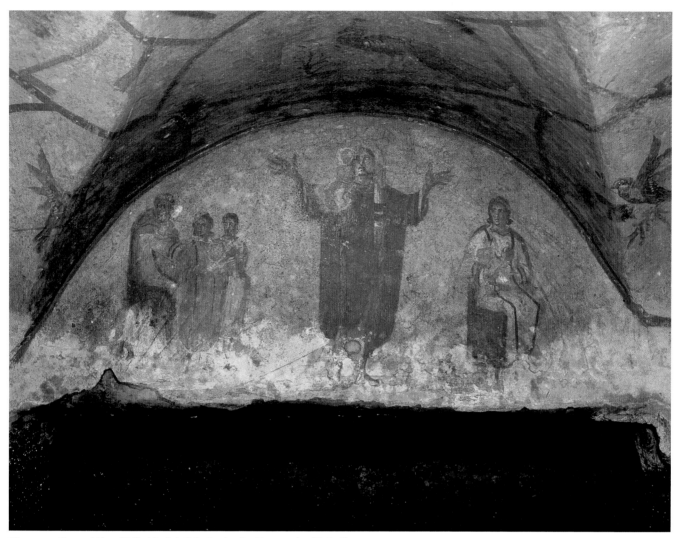

Fig. 1.17. *Donna Velata* (Veiled Lady). Painting in the Catacomb of Priscilla, Rome. 3rd century

The *Donna Velata* (Veiled Lady) in the Catacomb of Priscilla (**fig. 1.17**) is a beautiful example of the *orans* type, personifying with great expressive force the essence of prayer. The huge, deeply shadowed eyes staring upward and the enlarged hands imploring God's deliverance are dramatically brushed in, conveying a sense of urgency. The praying hands and the enlarged eyes—the windows of the soul—express it all vividly. The body itself is of no consequence; it is merely sketched in by the broad vertical strokes that quickly mark out the area of the heavy mantle. In many respects the abstraction of the body to a flat pattern and the exaggeration of the dilated eyes and the distended fingers anticipate the style associated with the Byzantine icon.

The ceiling fresco in the Catacomb of Saints Peter and Marcellinus (fig. 1.14) gathers together a number of familiar figures, offering a comprehensive message of salvation and comfort in a funerary context. The slightly domed ceiling of the chamber is marked out by a huge circle within which is inscribed, in faint lines, a giant cross that has another circle at its center and semicircular fields at the ends of each arm. The geometric layout thus presents a unified field for the pictorial motifs presented within each compartment. In the topmost circle stands the Good Shepherd with a lamb across his shoulders. In the rectangular areas between the arms of the cross, in the second zone of the decoration, appear *orans* figures, symbols of the prayers for the deceased; and in the cupped sections along the lower band adjoining the greater circle are four lively narratives or picture-stories relating the ordeal of Jonah and the sea serpent, a story from Jewish history that tells how Jonah is "reborn" after three days lying in the belly of the creature. Reading clockwise from the top, Jonah is thrown from the boat at sea and swallowed up by the sea serpent, a certain death; next, Jonah prays for deliverance while inside the belly of the sea serpent; then the creature spits up Jonah on the shore; and, finally, a refreshed Jonah sits under a gourd vine in a paradise garden, his salvation accomplished.

SARCOPHAGI

The same funerary themes and motifs are repeated across the surfaces of sculptured stone coffins, or sarcophagi. The *orans* and the Good Shepherd frequently appear as the principal motifs, sometimes placed against a decorative reference to the Eucharistic wine or vine, the blood of Christ; in the case of the sarcophagus in the Lateran Museum (**fig. 1.18**), this takes the form of putti gathering grapes. A more complicated type has extended narratives carved across the horizontal face.

A good example is the Jonah Sarcophagus in the Lateran (**fig. 1.19**), which includes many of the scenes found in the catacombs. In the lower register, from left to right, Jonah is on his mission of prophecy: first he pays for his journey with a sack of money given to a sailor; next, while at sea, the crewmen throw him overboard and the great fish, in the form of a sea serpent with a marvelous curlicue tail, gulps down the hapless Jonah; turning tail, the creature then spits forth Jonah on the shore in compliance with God's plan of salvation; and, finally, above to the right, Jonah, striking the pose of the sleeping Endymion in mythological illustrations, rests under a gourd arbor, a paradisiacal setting. In the last scene, the artist has relied on representations of a popular story from Greek mythology of a young shepherd, who was loved by Selene (the moon). In one version of this legend, he asked Zeus for immortality and perpetual youth; always contrary, Zeus consented on the condition that Endymion remained eternally asleep.

In an irregular band above the Jonah story, other salvation motifs are added as pictorial footnotes to the main theme. To the left is one of Christ's first miracles, the Raising of Lazarus, who was resurrected through his sisters' faith and prayers; next, Moses strikes the rock to nourish the thirsting Israelites in the desert; and finally, Peter escapes from prison (this scene is uncertain). Scattered about the reclining Jonah are three more random footnotes. At his feet, along the shore, appears a tiny box floating in the water with a figure, like a jack-in-the-box, releasing a dove: the story of Noah and the Ark. Above Jonah's head stands the Good Shepherd guarding

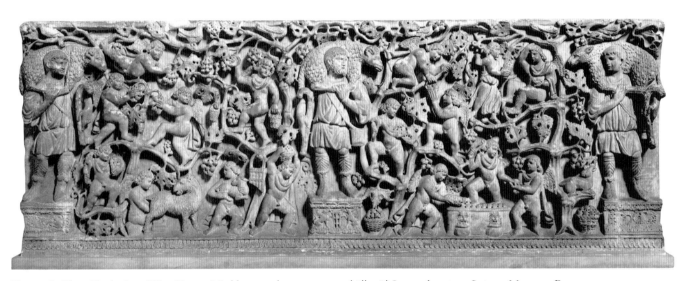

Fig. 1.18. *Three Shepherds and Vine Harvest.* Marble sarcophagus, approx. 3′ 6″ × 8′. Late 3rd century. Lateran Museum, Rome

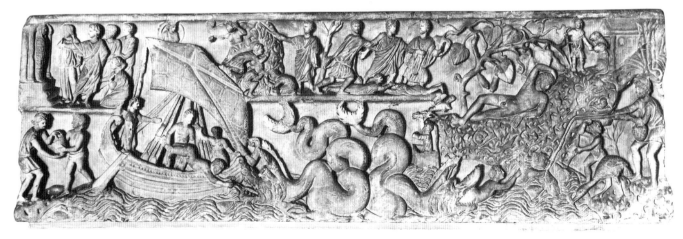

Fig. 1.19. *The Story of Jonah* (Jonah Sarcophagus). Marble sarcophagus, approx. 2′ × 7′. Late 3rd century. Lateran Museum, Rome

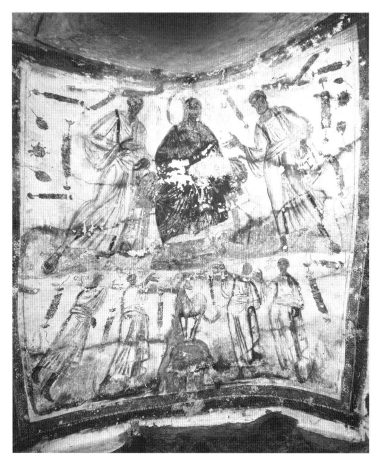

Fig. 1.20. *Christ Enthroned Between Saints Peter and Paul*. Wall painting in the Catacomb of Saints Peter and Marcellinus, Rome. 4th century

his flocks before a tiny building; and, finally, on the far right edge of the sarcophagus, a rustic fisherman casts forth his line, the familiar image of Christ as the fisher of souls.

The narratives are presented with the dynamic rhythm and intensity characteristic of the repetitious prayers familiar in early litanies. In fact, the pace of these carvings brings to mind the rapid evocation of images found in some of the earliest prayers of the Church, where examples of salvation are cited from the Old and New Testaments. One such litany for the dying and the dead reads: "Receive, O Lord, thy servant into the place of salvation . . . Deliver, O Lord, his soul as thou didst deliver Noah from the deluge . . . as thou didst deliver Jonah from the belly of the whale." [7]

Much speculation has focused on the question of the models used for the pictorial sequences that are repeated, more or less regularly, in both frescoes and sarcophagi reliefs. The story of Jonah, for instance, is found in nearly the same sequence with identical pictures on sarcophagi and in paintings, with only minor variations. A practical answer would be that the decorators had access to standardized workshop models from which they culled their motifs, working much like modern advertising artists who assemble pattern books of ready models to copy. The Jonah

sarcophagus, for example, is a superb example of how artists achieved the aims of their patrons using a standard visual vocabulary common in the Late Antique world. Endymion is the model for Jonah, the context of the surrounding scenes giving the viewer, who would know the story of Jonah, the correct identification.

Many of the frescoes and sarcophagi dating from later in the fourth century present more ambitious and orderly compositions, suggesting that more monumental models were accessible, very likely those that were devised for the walls of the new basilicas built under the sponsorship of Constantine and his successors. Such is certainly the case with a painting in the "Crypt of the Saints" in the Catacomb of Saints Peter and Marcellinus (**fig. 1.20**). Here are not the anonymous personifications of faith and Christ in the guise of the *orans* and Good Shepherd but actual portraits, with Christ, dressed in regal robes, enthroned between two standing figures, one with a short-cropped gray beard, the other with a long beard, who are identified as Peter and Paul. The orderly composition, with the lower band displaying Christ a second time in the guise of the Lamb of God (Rev. 4), has a grandeur of conception that no doubt owes much to the apse decorations in the great basilicas of Rome, perhaps Saint Peter's, which it probably copies.

A similar sophistication can be noted in the splendid sarcophagus in Sant'Ambrogio in Milan (**fig. 1.21**). All four faces are carved with well-articulated figures of the apostles seated or standing in rows about Christ. On the front, Christ is enthroned as a teacher, much as in the catacomb painting just discussed; on the back, he stands atop a mound, raising his right arm above Paul as if making a proclamation, while with his left hand he unravels a scroll that falls into the hands of Peter. Five apostles on either side gesture toward Christ. They stand before architectural facades that project regularly behind them resembling a series of portals. Below the groundline is a narrow frieze of tiny sheep symmetrically placed about a central lamb on a mound. They form the symbolic counterparts of the apostles and Christ above them, another feature of many apse compositions.

Interestingly, the pose of Christ proclaiming and delivering a scroll, the Law, to Peter resembles a familiar pagan formula for the representation of the imperial *traditio legis*, or transference of the law, found in many Roman relief sculptures. On the sarcophagus in Sant'Ambrogio, the theme is more specifically the Christian counterpart the Lord Gives the Law, which formed the central motif in representations of the Mission of the Apostles well known in later monuments. Not only are the compositions of these last two examples impressive in their monumentality, but the general stylistic treatment is accomplished. The wealth of the patron was no

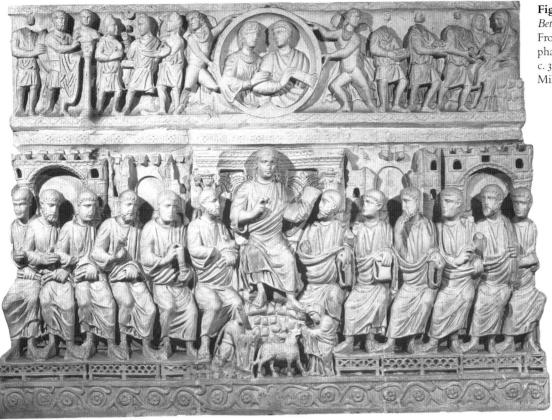

Fig. 1.21. *Christ Enthroned Between the Twelve Apostles.* Front of a marble sarcophagus, approx. 3′ 9″ × 7′ 6″. c. 380. Sant' Ambrogio, Milan

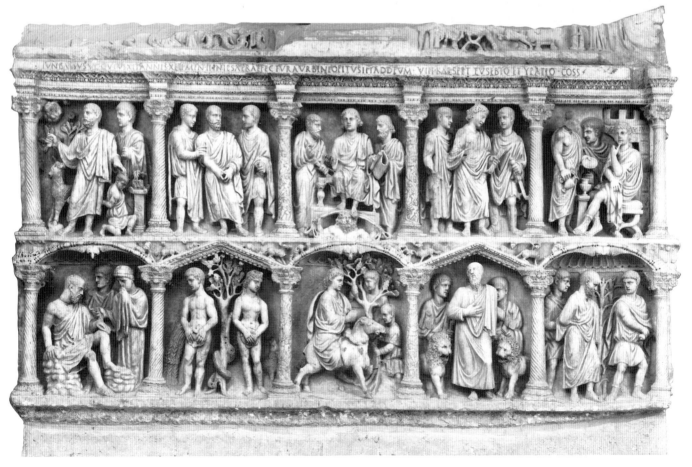

Fig. 1.22. Sarcophagus of Junius Bassus. Marble, approx. 3′ 10½″ × 8′. 359. Grottoes of Saint Peter, Vatican City

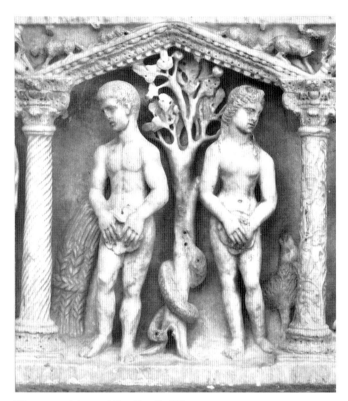

Fig. 1.23. *Adam and Eve.* Detail of Fig. 1.22

doubt the key factor in determining the quality of this monument, the richer members of society obviously able to employ the more gifted artists.

The splendid Sarcophagus of Junius Bassus (**figs. 1.22, 1.23**) can be dated to 359 according to an inscription on the lid, when Bassus, prefect and former consul of Rome, was baptized on his deathbed. Perhaps Bassus's hesitation in converting to Christianity was simply a judicious concession to Roman state religion, which was still followed by the majority of the city officials. Constantine had done the same.

Whatever the facts are, the themes presented on the sarcophagus are Christian. In two registers, four Old Testament stories are juxtaposed with scenes from the New on either side of a portrayal of Christ on the central axis. Above, Christ appears enthroned as the youthful Lord of the Heavens, with his feet resting on a personification of Caelus (the heavens, depicted as Jupiter holding a veil over his head). Peter and Paul stand beside Christ. Below, he is mounted on a donkey in the Entry into Jerusalem. Both are related to the imperial theme of *adventus*, or the coming and reception of an emperor before the people, and thus are appropriate for a patron with close ties to the state. The four Old Testament scenes are funerary subjects in that they are related to aspects of salvation and funerary liturgies: the Sacrifice of Isaac (top left); Job's Wife Sitis Offering him Bread, and the Fall of Adam and Eve (both lower left); and Daniel in the Lions' Den (second from the right in the lower register). The unusual

selection of New Testament and events has been interpreted as a response to typological themes. These include scenes of the arrests of Peter and Paul and, expanded across two zones, the arrested Christ before Pilate.

The elegant carving of the architectural details, with their elaborate shafts, capitals, and entablatures, bespeaks an artist familiar with the finest Classical idioms. Tiny figures of lambs enacting the stories of the Three Hebrews in the fiery Furnace, Moses Striking the Rock, the Multiplication of the Loaves and Fishes, and the Baptism of Christ fill the spandrels of the lower arches and gables like symbolic footnotes. The youthful Christ in the upper register appears Apollonic; the bearded heads of Abraham, Daniel, Job, Peter, and Paul are all noble Roman types. Adam and Eve are presented as diminutive Classical nudes posed on either side of the Tree of Knowledge.

THE FIRST CHURCHES

There is little surviving evidence of Christian art above ground before the Peace of the Church in A.D. 313, since much of it was either destroyed or was domestic in nature. It is known that the first churches or meeting places were simply the homes of the faithful, with certain rooms adapted and outfitted for the basic needs of the services. Such house-churches are recorded as *tituli* (singular: *titulus*), churches named after the owners of the property, and they presumably displayed a plaque designating them as legal places for worship. Twenty-five are recorded in Rome in the early fourth century, some of which retained their *titulus*, or title, when basilicas were later built over them. It is also known that tenement apartments were often converted, but most of those excavated were more elaborate town houses or villas.

The house-church needed only a hall large enough for a small assembly and a meal. The *triclinium,* or dining room, would usually be appropriate. Other rooms to the sides served the postulants (new candidates) and the catechumens (converts yet to receive baptism) when Mass was held for the members only. Essentially, then, the house-church was a simple domestic structure, a small community center at most, and the only special area needed would be that of the baptistery, which, of course, meant a font and access to water.

Such simple domestic quarters serving the needs of the Christians throughout the Roman world were ubiquitous, as attested by the remains of a house-church in the remote frontier town of Dura-Europos on the Euphrates in Syria. Dura-Europos, a Roman garrison town, is indicative of the complexities of the Late Antique world. After a siege in 256–57 the city was abandoned, leaving behind a Jewish synagogue, a Christian house-church, a temple to Mithra, and temples to other gods worshipped by the inhabitants, all seemingly in harmony, borrowing and adapting shared visual traditions.

2

CONSTANTINE AND THE ARTS

In March, A.D. 313, four months after the defeat of Maxentius at the Milvian Bridge in Rome, Constantine, the new Caesar of the West Roman Empire, issued the following decree in Milan: "We decided that of the things that are of profit to all mankind, the worship of God ought rightly to be our first and chiefest care, and that it was right that Christians and all others should have freedom to follow the kind of religion they favoured; so that the God who dwells in heaven might be propitious to us and to all under our rule." Constantine, son of an earlier caesar, Constantius, had claimed his title over Maxentius, one of the tetrarchs invested by Diocletian to rule the vast Roman world.

According to his early biographers, Constantine won the decisive battle over the larger army of Maxentius through the miraculous intervention of the Christian God, who appeared to him in the skies on the eve of the battle in the form of a monogram and cross, or *Chi Rho* (the Greek XP, an abbreviation of *Christus*). From the heavens thundered the prophecy: "*in hoc signo vinces*" (in this sign, conquer). Placing the Christian symbol on his military standard, Constantine did indeed conquer the West, and by 325 he had also subdued and executed his rival Licinius, the last of the tetrarchs, to claim the East Roman Empire as his domain too. Constantine was now the sole and absolute inheritor of the imperial titles of caesar and augustus.

The nature of Constantine's relationships with the Christians has been an issue of considerable controversy.[1] Until he was baptized on his deathbed in 337, he remained a catechumen, perhaps out of a desire to be open to all religions, including the pagan affiliations of the majority of

the Roman senate—the Edict of Milan of 313 had specifically stated that "all others" would be tolerated. On the other hand, other prominent Christians also choose to delay baptism until the ends of their lives, though the Church would eventually frown on this practice. Whatever the state of his inner spiritual life, Constantine showed remarkable acumen in his patronage of the arts to further his political aims.

Constantine's Arch in Rome, the largest imperial arch to survive, is a three-vaulted structure with an assembly of sculptures from various periods (**figs. 2.1, 2.2**).[1] The giant round reliefs above the two side arches are *spolia* (sculpture or architectural fragments plundered from earlier imperial monuments), as are the huge rectangular plaques in the attic. The tondi on the north face, for example, are from the period of Emperor Hadrian (A.D. 117–38) and depict a Boar Hunt; a Sacrifice to Apollo; a Lion Hunt; and a Sacrifice to Hercules. In each of the scenes, Hadrian's face was rechiseled with the features of Constantine. The smaller friezes directly above the side arches and the winged victories carved in the spandrels are products of Constantine's workshop. The frieze on the west side of the north face depicts a distribution of money to the people, a familiar subject in Roman historical relief sculpture. The arch combines the older Classical style of Hadrian's reign with the human figures carved in the Classical pose for the human figure, with one leg bent and the other, supporting the weight of the body, straight; typically, one arm is up while the other is down. The artists were also careful to give the illusion of a three-dimensional space for the figures to occupy. The contemporary frieze employs a different style in which the large crowd of figures is lined up

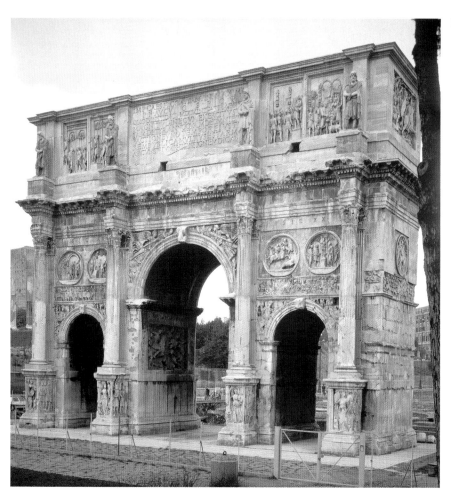

Fig. 2.1. Arch of Constantine, Rome. 312–15

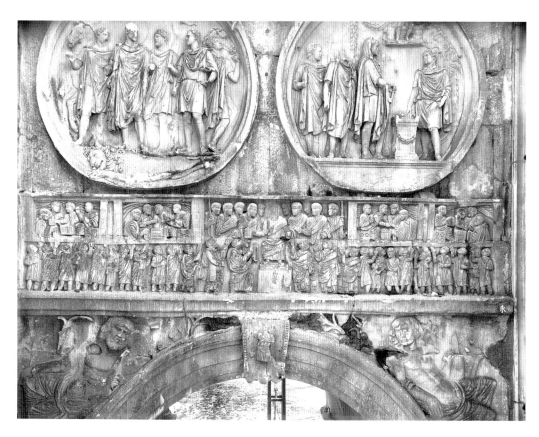

Fig. 2.2. *Constantine Distributing Favors.* Detail of fig. 2.1. 312–15; medallions 117–38

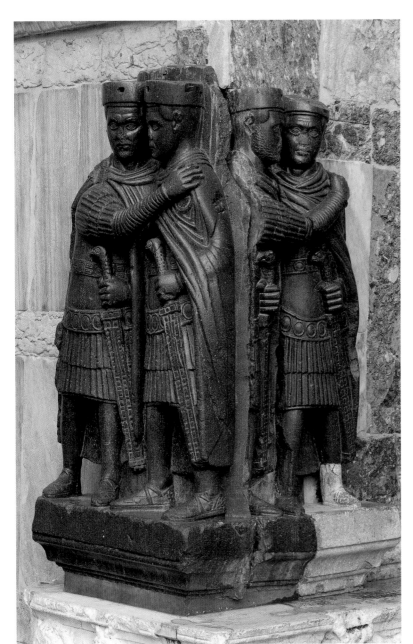

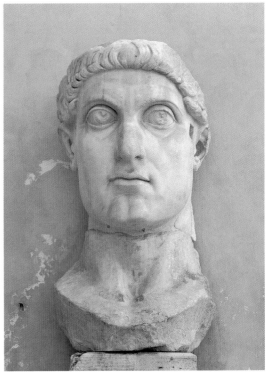

Fig. 2.3. *The Tetrarchs.* Porphyry, height 4′ 3″. c. 305. Exterior corner of San Marco, Venice

Fig. 2.4. Colossal head of Constantine. Height 8′ 6″. 313. Palazzo dei Conservatori, Rome

in neat, uniform rows. The entire focus of the composition and the figures is on the all-important central figure of the emperor; alas, the effect today is lessened since his head is now missing. Although the arch commemorates the Battle of the Milvian Bridge, there is no reference to the legend of the *Chi Rho*, indicating that this is a political monument that drew upon older traditions and combined them to create a pastiche that acclaimed the new emperor of a united empire.

The less classical style of Constantine's workshops was not new, but could also be found in the earlier, porphyry sculpture of the four tetrarchs (**fig. 2.3**). Carved from the hard, imperial purple stone, the sculpture represents the western emperor and caesar, and the eastern emperor and caesar. The stylistic choices clearly enhance the message that

is to be conveyed, one of absolute solidarity. The face of each ruler is identical: individual features are suppressed and replaced by a uniform portrait of a unified political structure. The representation of the body found in Hadrian's sculptures on Constantine's Arch has been rejected for a representation of power through the garb and gestures of the figures. Four large hands grip swords while the arms are enlarged in order to grasp the shoulders of the compatriots in a gesture of solidarity. Through the representation of the figures, gestures, and faces, the message is clear and successfully communicated.

Similar changes in style can be found in his other public monuments. The colossal head of Constantine, a fragment of a huge statue that once towered over the public in a niche of the Basilica of Maxentius and Constantine in the Forum,

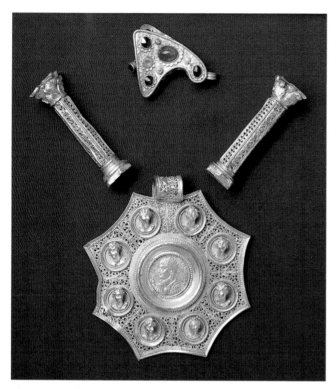

Fig. 2.5. Pendant with a double solidus of Constantine I. Gold sheet, 4th century. The Cleveland Museum of Art

displays many of the same features: a stiff, hieratic style with a rigid frontality; a fixed, staring upward gaze in the huge eyes carved out with deep craters for pupils; the reduction of the facial features to harsh conventions raised or submerged in the polished mask-like face of smooth planes (**fig. 2.4**).

The abstractions in the portrait of Constantine indeed convey a sense of spiritual gravity and the overpowering presence of authority. The great eyes, the windows of the soul, are features befitting an inspired leader with a new and lofty conception of his calling by some divine being. The emphasis on the large eyes is similar to the *orans* figure of *Dona Velata* in the catacombs, indicating that this motif, like many others, was a widely shared visual vocabulary found in the Late Antique world, whether it was a monumental political statement or a humble prayer.

All was not brute power in the way Constantine's portrait was used for political propaganda; more subtle means were employed for more intimate contexts. The Cleveland Pendant consists of a gold coin bearing the profile of Constantine surrounded by eight busts of men and women whose identity is undetermined, though they may represent figures from Roman mythology (**fig. 2.5**). The features of Constantine are more refined and less stylized, probably closer to his actual physiognomy, even if slightly idealized. Of the highest quality gold work, this type of pendant would be given as political gifts to imperial family members or close supporters. Constantine's patronage of the arts was an effective tool to further his political aims.

THE BASILICA

The building that Constantine raised as the new house of worship for the Christians is called the *basilica*. The old type of meeting place, the home that was altered for worship, was much too small and unpretentious to provide the necessities of Christian worship under Constantine, although a number of the so-called *tituli* churches continued to serve communities in various parts of the city. The basilica was a generic building type that served numerous functions in the Roman world as a gathering place for law courts, business transactions, stock and money exchanges, audience halls for civic affairs, and so forth. Essentially it was a large longitudinal hall with raised platforms, or tribunes, to accommodate its functions. The advantage of this type of structure is that it could be easily adapted to the needs of the patron or the community in terms of its size and the cost of the materials. There was no *one* basilical form, and surely the building that Constantine's builders fashioned for Christian worship must be considered one of the most innovative of Late Antique architectural forms.[2]

The stricter organization of the Christian community under Constantine made a distinct physical separation of the clergy and congregation necessary. One end of the basilica was enlarged and marked off as the tribune or sanctuary for the clergy and the altar. For the gathering of the faithful, the main body of the longitudinal hall was divided into a nave (the central aisle) and side aisles. The entrance was placed at the end opposite the altar, and an atrium or open court was set before the porch (narthex) for the gathering and instruction of the postulants and catechumens. Timber roofs with flat ceilings covered the main hall, and windows in the nave above the level of the side aisles opened the interior for light. This upper zone of the nave is called the clerestory.

One result of this division of the basilica was the emphasis on longitudinal space, which was exactly the type of space needed for the processions used in the liturgy. With the entrance at one end, the sanctuary culminating in the form of a semicircular apse at the other, and a long hallway in between, the experience of the Christian basilica was one of movement in time along a marked axis to the altar. Furthermore, it was totally an experience of interior space for the faithful. The exteriors were simple, barn-like structures of brick that formed an opaque box to enclose the space. Only the entryways were monumentalized and decorated with mosaics or paintings.

In light of these early building types, the original Basilica of Saint Peter (**figs. 2.6, 2.7**) must be seen as something of a fortuitous compromise and innovation. Sometime around 324, Constantine donated the burial grounds on the Vatican Hill to the church as a site for the erection of a major basilica commemorating the tomb of Saint Peter there. The oldest *memoria* built over Peter's remains experienced an increasing number of pilgrims visiting the site—and no doubt the demands for burial grounds there as well—so it was only

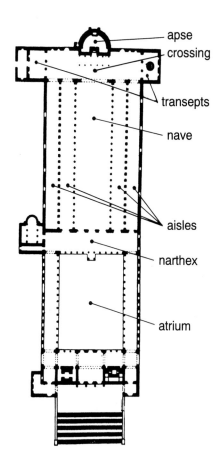

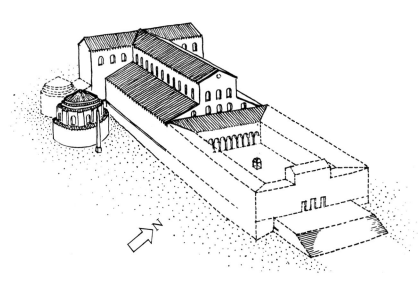

LEFT **Fig. 2.6.** Saint Peter's, Rome. Plan.
c. 324–40

ABOVE **Fig. 2.7.** Isometric reconstruction of Saint
Peter's, Rome (after Krautheimer). c. 400

BELOW **Fig. 2.8.** Reconstruction of the *memoria*
of Saint Peter in the sanctuary of Saint Peter's,
Rome (after Toynbee). c. 324–37

fitting that one of the major churches in Rome should be erected on this spot (**fig. 2.8**).[3] In order to achieve this it was necessary for Constantine's builders to level the area about the tomb by building up foundations on the south side of the sloping hill and sinking the ground level on the north and west sides. The topography of the site also forced the builders to situate the apse toward the west, rather than the more typical oriental, or eastern focus. As in most building campaigns, the sanctuary with the altar and, in this case, the *memoria* of Saint Peter, was raised first and presumably completed before the death of Constantine in A.D. 337. This sanctuary, however, was enlarged in an unusual manner, very likely to accommodate the hundreds of pilgrims who gathered about the *memoria* daily. The space before the apse was spanned by a huge hall extending far beyond the side walls of the aisles, forming great projecting transept arms. The nave was probably finished after A.D. 350 with its double aisles of twenty-two columns that were *spolia* from ancient buildings. At some later date, about A.D. 390, a vast atrium was added before the facade.

The cross-transept and the apse were marked off from the nave dramatically by a huge archway, later referred to as the triumphal arch, which carried an appropriate inscription: "Since under Thy leadership the Empire rose once again triumphant to the stars, Constantine the victor has founded this hall church [*aula*] in Thine honor," a reference to the victory over Maxentius under the sign of Christ. The *memoria*

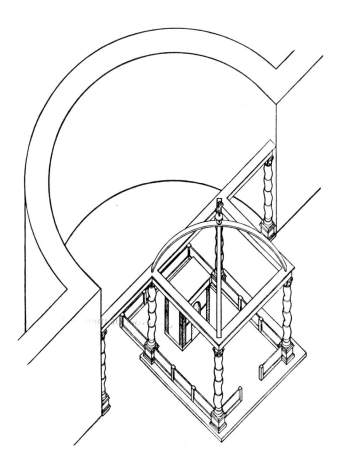

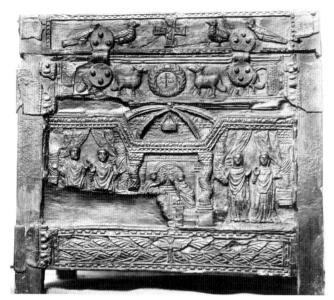

Fig. 2.9. Shrine of Saint Peter. Ivory casket from Pola, 5⅝ × 7⅝″. c. 400. Museo Civico, Rome

Petri was elaborated with a baldacchino, or canopy, supported by four twisted columns of porphyry carved with vine tendrils that were imported from Constantinople. Two more porphyry columns supported an extension of the architrave of the baldacchino across the opening of the apse, which, when hung with curtains, would be concealed from public view. An unusual carving on an ivory reliquary box from Pola in Istria (**fig. 2.9**) is believed to be an accurate representation of the Constantinian *memoria* and its columns, with the faithful making an offering while male and female members of the church stand as *orans* before the side screens. The broad nave, once paved with a carpet of stone tombs, served as a funerary basilica. Unlike earlier funerary basilicas, in Old Saint Peter's the tomb of the saint was thus incorporated directly into the church, forming a combination of martyrium-funeral hall, a unique solution in its time. The transept and the occidental positioning of the apse were innovative features of Old Saint Peter's. Later, this unique plan, hallowed by its associations with the "prince" of the apostles, was accepted as a standard form.

As noted above, the architecture of the Early Christian basilica was foremost one of interior space, and while the generic models of the structure may be quite easy to trace in Roman architecture, the interior is an Early Christian invention and one that, according to early descriptions, was constructed of "heavenly type in symbolic fashion." This is a vague statement, but it has often been argued that the basilica can, in fact, be seen as a reflection on earth of the New Jerusalem in heaven.[4]

For the most part, the early fourth-century structures were erected over or near the graves of the martyrs, the Roman equivalents of the holy sites in Jerusalem; in a desire to rest in eternal life near these "special dead," wealthy patrons would often erect their tombs adjacent to the large funerary basilicas. The most famous mausoleum was built for Constantine's

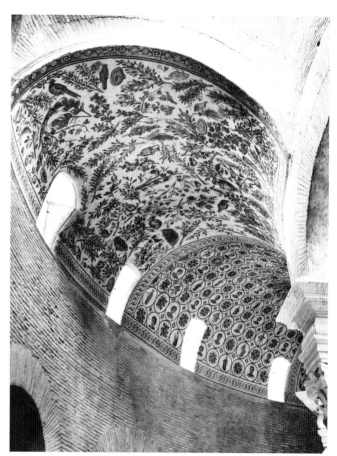

Fig. 2.10. Santa Costanza, Rome. Portion of vault mosaics. c. 350

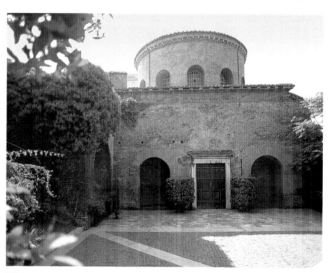

Fig. 2.11. Santa Costanza, Rome. Exterior

Fig. 2.12. Santa Costanza, Rome. Plan

Fig. 2.13. *Peacocks, Grapevines and Fruit.* Detail of ceiling mosaics, Santa Constanza, Rome. Mid 4th century

Fig. 2.14. *Jonah and the Whale.* Detail of floor mosaic in the Basilica of Aquileia (Venetia). 314–20

daughter Constantia (d. 354) (**figs. 2.10–13**). The building is circular in plan with the interior subdivided into two concentric rings by a circle of twenty-four double columns. The mausoleum uses a circular plan typical of traditional imperial mausolea. The beautiful mosaics in the ambulatory vault are but a remnant of what originally was commissioned for the tomb. Originally there were twelve sections of mosaic, symmetrically divided into panels with six types of ornamentation that included vine scrolls with vintaging putti, lozenges, octagons, foliage with birds, and even what is thought to be portrait busts of Constantia and her husband. The mosaics are an outstanding example of the interrelationship between floor mosaics and their adaptation to ceilings.

Floor mosaics survive in appreciable numbers. Especially intact are those of the Basilica of Aquileia, in northern Italy, ascribed to Bishop Theodore (314–20), where amid the numerous geometric divisions of the pavements displaying conventional bucolic motifs one finds the Good Shepherd, the story of Jonah and the Sea Serpent, and a type of winged Victory standing between a basket of bread and a chalice of wine, motifs common in the catacombs (**fig. 2.14**). Domestic mosaics, such as those found in the home of the wealthy landowner Julius, could also convey the ideals of a secular life (**fig. 2.15**). Set out in three registers, the mosaic displays a picture of a great country estate, watched over by its master and mistress, while seasons unfurl and the estate's abundance pours in. The adaptability of standard scenes between secular and religious images can be seen by comparing the depiction of how Lord Julius rides into his estate and the image of Christ's entry into Jerusalem found in the *Sarcophagus of Junius Bassus* (fig. 1.22); both of these depictions are based on an imperial *adventus*.

An examination of commissions by wealthy patrons that were smaller and more private than public works such as Old Saint Peter's reveals a similar trend to that found in funerary art: old traditions were deemed valid and adapted for Christian use. In other words, one could embrace the new Christian God, but still remain steeped in the education and values of the Classical world. The most famous piece of the Esquiline Treasure that was found in Rome in 1793 is a large rectangular bridal casket with an inscription identifying it as the property of Projecta, wife of Secundus (**figs. 2.16, 2.17**). The inscription is a Christian one, but it is combined with pagan pictorial motifs such as the Toilet of Venus, nereids, tritons and sea-monsters. Caskets such as this are thought to be bridal gifts. Many of the Roman senatorial class did not embrace Christianity, but retained their venerable customs and commissioned works of art that reflected this way of life. The quality, subject matter and style of the Priestess of Bacchus diptych demonstrates that fourth-century Rome was not an entirely Christian city (**fig. 2.18**). The Symmachus family, which commissioned the piece, retained its traditionalist religious beliefs in the old Roman gods, though even these would be suppressed by the end of the fourth century.

Fig. 2.15. Floor mosaic, House of Dominus Iulius, Carthage. Late 4th century. Bardo Museum, Tunis

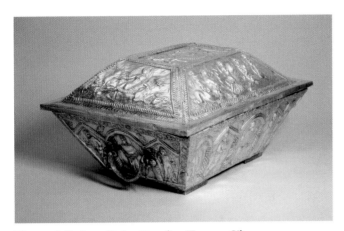

Fig. 2.16. Projecta Casket, Esquiline Treasure. Silver gilt, 21½ × 11″. c. 380. British Museum, London

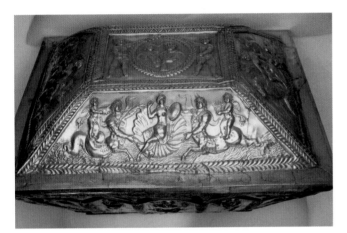

Fig. 2.17. Projecta Casket (lid).

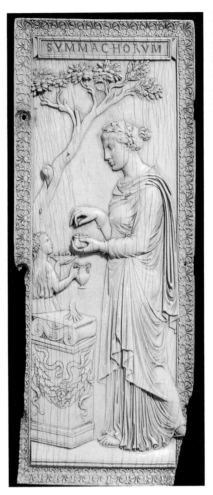

Fig. 2.18. *Priestess of Bacchus,* from the Symmachus Diptych. Ivory, 11½ × 4½″, c. 400. Victoria and Albert Museum, London

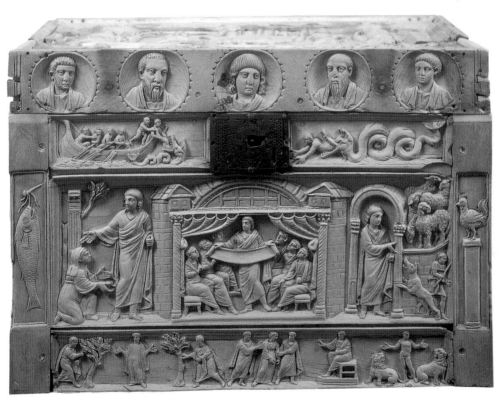

Fig. 2.19. Scenes of the Old and New Testaments. Ivory casket, 8¾ × 12⅞ × 9½″. North Italian (?). c. 360–70. Museo Civico Cristiano, Brescia

In many of the small, portable religious objects that are enriched with ivory, gold, or wooden plaques and encrusted with precious gems and enamels—the so-called sumptuary arts—one often finds the pictorial modes side-by-side with a more iconic representation serving as the centerpiece about which narrative cycles or sign-symbols are clustered. A fine example is the reliquary casket preserved today in the Museo Civico Cristiano in Brescia, Italy, dated about 360–70 and assigned by most authorities to a North Italian workshop (**fig. 2.19**).[5] The four sides are formed of ivory plaques with upper and lower horizontal strips framing a broader central panel. The lid is composed of two plaques and a rim with roundel bust-portraits of Christ and the apostles; the four corner posts have vertical strips of ivory that carry single salvation or Passion signs (a fish, rooster, column, cross, and so on). The larger central plaques on the faces illustrate episodes from the ministry of Christ, while the narrower bands display diminutive Old Testament narratives and sign-symbols of salvation, including representations of Susanna and the Elders, Daniel in the Lions' Den, Jonah and the Sea Serpent (on the front), and stories of Moses, Jacob, David, and others (along the sides and back). The casket bears traditional scenes such as the story of Jonah, but it also introduces new stories that indicate a growing and expanding repertoire of Christian subject matter.

CONSTANTINOPLE

Constantine the Great overcame his last formidable rival, Licinius, at the battle of Chrysopolis in 324, and with that victory claimed the entire Roman Empire, East and West, as his domain. The emperor rarely resided in Rome for long periods, and partly to bolster his eastern and northern frontiers, partly to avoid the politics of the senatorial families in Rome, he decided to establish a "New Rome," a new capital, in the East. For the site he selected the old Greek town of Byzantium, so named after the original colonizer in the seventh century B.C., Byzas of Megara.

Located on the attractive and defensible peninsula called the Golden Horn, Byzantium had served as an independent port for Rome until it sided with the rival of Septimius Severus, one Pescennius Niger. After a three-year campaign (A.D. 193–6), Byzantium fell to the army of Septimius Severus and was razed. Constantine, realizing its strategic position, soon rebuilt the city, adding a huge complex with baths and a hippodrome, and Byzantium once more prospered. It was officially renamed Constantinople on May 11, 330.

Constantine's plans for the "New Rome" were ambitious. Following the model of Rome, distinctive promontories were marked out in the terrain as the "seven hills"; the city was partitioned into fourteen regions; and an impressive palace, palace church, senate house, circuses, and other civic and ecclesiastical buildings were erected to enhance it as an imperial capital. Eusebius, in his *Life of Constantine*, described the building program in considerable detail. Aside from the huge palace complex and the churches that Constantine founded, Eusebius tells us that he also "filled the city which bore his name everywhere with bronze statues of the most exquisite workmanship" that had been removed from various cities and sanctuaries in the Empire, including Rome.[6]

Very little survives of the fourth-century city, and we must make the most of the literary accounts in assessing its grandeur. Eusebius describes the great palace, but unfortunately the foundations presently visible are those of later rebuildings and extensions of the massive complex of rooms and ceremonial corridors.[7] We are told of the magnificent palace church of Hagia Sophia, completed in 360, which was razed during the Nika riots of 532 and rebuilt by Justinian (to be discussed in Part Two).

Constantine also founded the Church of the Holy Apostles, the Apostoleion, in the form of a huge Greek cross (arms of equal length) with a wide court. The church had a conical roof over the crossing of the arms, marble revetment on the walls, and costly furnishings. Nothing remains of the Apostoleion. It, too, was rebuilt by Justinian in 536, remodeled again in the Middle Byzantine period, later converted into a mosque by the Turks, and subsequently destroyed. The Apostoleion was an impressive addition to the repertory of Christian church types, as we shall see.[8] The central plan with a dome was to become the basic formal core of many later Byzantine churches and *martyria*. With the services held in the very center of the cross structure, with the arms serving the congregation, changes in the liturgy and processional ceremonies were necessitated. Furthermore, it seems that the Apostoleion was more than a church for congregational services. It served also as a martyrium-mausoleum for the relics of the apostles and for Constantine himself, who was sometimes called the "thirteenth apostle."

All that remains of the great city are its foundations and ramparts of the massive defensive walls that encircled it, some metalwork, coins, and fragments of mosaics and sculptures. One of the sculptures, a marble base for the obelisk that served as a marker in the hippodrome (c. A.D. 390), carved with portraits of Theodosius and his court, deserves special attention (**fig. 2.20**).

Even in its weathered condition, the Theodosian base is an impressive monument. The emperor and his court are portrayed presiding over the games in the hippodrome on one face, and receiving the offerings of conquered barbarians on the other. The hieratic treatment of the figures and suppression of space bring to mind the abstract friezes on the Arch of Constantine. Aligned in rigid, frontal positions, Theodosius—the central and tallest figure—and his two sons, Honorius and Arcadius, stand within the *kathisma*, or royal box, flanked by members of the imperial family, magistrates, soldiers, and bodyguards. Below them, in a second shallow plane, are two rows of citizens watching the entertainers—the tiny figures in the lowest zone—perform at the chariot race.

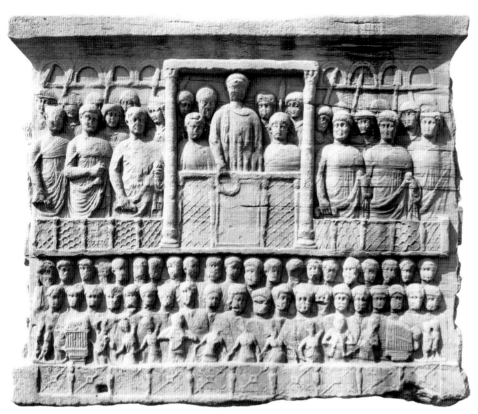

Fig. 2.20. *Theodosius and Court Presiding at the Hippodrome.* Base of the Obelisk of Theodosius, Constantinople. Marble. Height of obelisk base 7′ 10″. c. 390

The severe denial of space, the shallow carving with simple, closed contours, the unusual inverted perspective and hieratic scale (with the lower figures smaller), and the suppression of movement among all but the tiny musicians and dancers mark an even further departure from the canons of style typical of Late Antiquity.

JERUSALEM

During Constantine's reign, the most hallowed *martyria* for pilgrimages were built on the very sites where the divinity of Christ had been revealed in his life and passion. Tradition has it that the empress dowager Helena, Constantine's pious mother, made an extensive pilgrimage to Palestine about 326 and had memorials and churches erected over these holy places. Near the most sacred sites of the Crucifixion (Golgotha) and the Entombment (Holy Sepulcher) she had excavated the ground where the very wood of the True Cross was found. She also ordered structures to be built commemorating the place of Christ's Ascension (Mount of Olives), the ground where he taught the disciples at Mambre, and the grotto of his birth in Bethlehem.[9]

From scant remains and the descriptions of Eusebius, the buildings erected on Golgotha at this early date can be recovered in part. Just outside the walls, the rocky grotto that served as the tomb donated by Joseph of Arimathea for Christ's burial was fashioned into a small conical structure with twelve exterior columns in a circle supporting a domical baldachino, the Holy Sepulcher.[10] The ground about the tomb was leveled and surrounded by a paved court, open to the sky, semicircular at the west end. In the southeastern corner of the court the rock of Golgotha was isolated and cut into the form of a giant cube marking the site of the Crucifixion, and to the east of the court, adjoining the main street, a large basilica "more beautiful than any on earth," according to Eusebius, was erected over the place where the relics of the True Cross were discovered by Helena (**fig. 2.21**).

The basilica—also called the martyrium in early times—was begun in 326 and consecrated in 336 by an assembly of bishops (fig. 2.21). Because of its cramped location, the building was somewhat short and wide in proportions and was preceded on the street side by a colonnaded propylaeum (a covered entranceway) and a squat, open atrium.[11] The wide nave was separated from the double side aisles by great columns. A pitched roof covered the aisles, eliminating the clerestory area for windows in the nave, and a coffered ceiling under the simple gabled roof extended across the entire width of the basilica. According to Eusebius, the richness of the ceiling coffers, the gilded capitals, and the stone revetment on the walls contributed to an overwhelming effect on the congregation. At the western end, a quasi-domed apse was encircled by twelve columns, the number of the apostles. About the middle of the fourth century a domed rotunda was built over the tomb shrine to accommodate the countless pilgrims who visited the sacred site. This structure was known as the Anastasis Rotunda (from the Greek for resurrection).

Saint Jerome relates the journey of Paula to Jerusalem and Bethlehem in the fourth century—typical of many

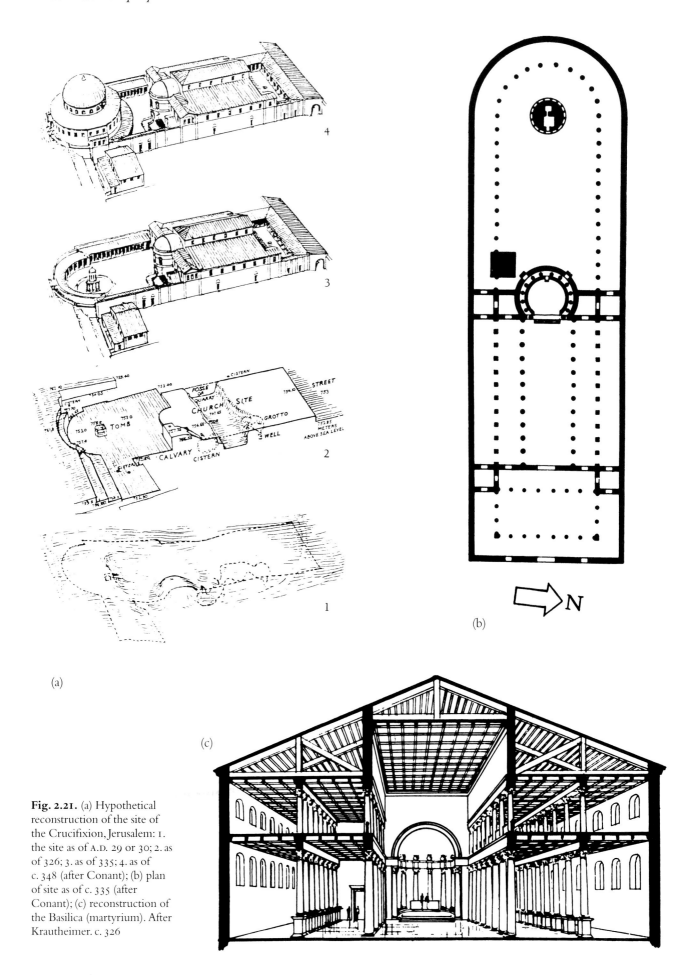

Fig. 2.21. (a) Hypothetical reconstruction of the site of the Crucifixion, Jerusalem: 1. the site as of A.D. 29 or 30; 2. as of 326; 3. as of 335; 4. as of c. 348 (after Conant); (b) plan of site as of c. 335 (after Conant); (c) reconstruction of the Basilica (martyrium). After Krautheimer. c. 326

Fig. 2.22. Isometric reconstruction of the Church of the Nativity, Bethlehem (after Krautheimer). c. 333

the Magi adoring God, the star that shone above, the Mother who was a Virgin, the revered foster-father Joseph and the shepherds who came in the night to see the Word which had come to pass" (Jerome, *Letters*, 108, 8–10).[12] Paula's vision may have been inspired, in fact, by pictures at the site depicting the birth of Christ. According to Saint Jerome, the birthplace of Jesus continued to be identified with a cave to the east of the town, below a sacred grove associated with the cult of Adonis. At the time of Constantine, this pagan cult was suppressed and the first Church of the Nativity was constructed on the site, incorporating the cave.

The Constantinian basilica at Bethlehem—rebuilt by Justinian—displayed unusual architectural elements (**fig. 2.22**). A broad colonnaded atrium, open to the sky, led into a squarish nave with double aisles. In place of the apse, however, there was a curious octagonal construction with a wide circular opening in the floor that gave a view into the grotto below. Some believe the octagon was covered by a pyramidal roof with an aperture for sunlight.

The atrium and nave of Constantine's basilica were retained in the rebuilding of Justinian in the sixth century, but the curious octagon was replaced by a chancel in the form of a trefoil. The grotto was elaborated and made accessible for the pilgrims, and both the facade and the apse of the grotto were decorated with mosaics. It is possible that the Early Christian representations of the Ascension and the Adoration of the Magi, such as that on the six-century Monza pilgrimage

pilgrimages—and how "casting herself down before the Cross [the memorial erected on Golgotha] she prayed as though she saw the Lord hanging there. When she entered the Tomb in the Anastasis [another name for the Holy Sepulcher] she kissed the stone which the angel had rolled away from the entrance and with the ardor of true faith touched with her mouth the place where Our Lord had lain."

Entering the grotto in Bethlehem, "she swore—as I myself have heard—that with the eyes of faith she beheld the Child, wrapped in swaddling clothes and lying in the manger,

Fig. 2.23. *Adoration of the Magi.* Pilgrim's flask from Palestine. Silver, diam. 5⅞″. Late 6th or early 7th century. Cathedral Treasury, Monza

Fig. 2.24. *Ascension.* Pilgrim's flask from Palestine. Reverse of Fig. 2.23

phial (**figs. 2.23, 2.24**), may reflect the monumental mosaic decorations of churches in Palestine.[13] The establishment of Bethlehem as a place of pilgrimage also encouraged the development of local craft industries producing religious souvenirs of variable artistic merit. Although dating from the sixth century, the Sancta Sanctorum pilgrim's box is thought to be the type of souvenir a pilgrim such as Paula would have brought back from her travels (**fig. 2.25**).

The decoration of the grotto would most likely have been a Nativity (remains of a much later restoration still exist), and it is highly possible that at this time the bathing of Christ made its first appearance in Nativity scenes. The seventh-century pilgrim Arculphus (and others after the rebuilding) remarked on a new feature at the site incorporated into Justinian's church: the spot where the star shone down and from which a well sprung forth, the place where the Child was first bathed. Thus it appears that features of the sites in the Holy Land provided many details for the iconography of illustrations for those wonders in Early Byzantine art.

Fig. 2.25. Scenes from the Life of Christ. Painted box for pilgrims' mementos of the Holy Land. Wood, 9⅞ × 7⅛″. Late 6th century. Museo Sacro Cristiano, Rome

3

THE FIFTH AND SIXTH CENTURIES

When Constantine moved his capital to Constantinople in A.D. 330, he left behind a Rome whose landscape within the city walls was never really Christianized, since the senatorial class dominated the city itself. The Constantinian building projects were on private family land and the large projects, such as Old Saint Peter's, were physically marginalized on the edges of the city or outside its walls. This would slowly change in the ensuing decades as Christianity began to gain an ever-increasing power among the ruling class. By the mid-fourth century, as the Roman patricians become Christianized, the Late Antique world develops into an even more complex mix of Christianity and pagan religions, especially among the intellectual class.[1]

The Berlin Pyxis, for example, demonstrates the persistent intermingling of the classical and the Christian in both iconography and style (**fig. 3.1**). On one of the finest of many ivory pyxides to survive, Christ is shown as a Roman philosopher, or teacher. He is seated on a throne holding a codex and raising His hand in a gesture of teaching and instruction. His short curly hair and beardless face mark him as a member of the intellectual class. Flanking him are Peter and Paul, who also hold codices and raise their hands in oratorical gestures. The humble, youthful shepherd in a short tunic has been replaced by a teacher who imparts his wisdom and philosophy to his disciples much like the philosophers of the Roman world. Pyxides such as this may have functioned as containers for the Eucharist, though other functions cannot be ruled out with any certainty; the form of the ivory box is based on a classical type embraced by the upper class. The same theme, with slight variations, can also be found in a monumental

format in the apse mosaic in the Chapel of Sant'Aquilino in San Lorenzo Maggiore in Milan (**fig. 3.2**). Here too, Christ, depicted as a young beardless teacher, raises his hand in a gesture of teaching while his disciples stand on either side of him. Slight differences, however, show that the Christ as Teacher iconography was still fluid. In the apse mosaic, he is shown with a cruciform halo, which would later become standard. In his left hand he holds a scroll, taken from a leather case at his feet, that symbolizes the teachings of Scripture. This type derives from pictures of pagan symposia, common in Hellenistic art, where learned friends are seated about their mentor. In Christian terms, the philosopher theme could easily be seen as a type for the Sermon on the Mount (Matt. 5) and, as such, was widespread in Italy by the fifth century.

At the end of the fourth century, Theodosius I (379–95) made Orthodox Christianity no longer simply a legal religion, but the only approved religion of the state. The result transformed Rome from a pagan city ringed by Christian funerary basilicas to a city dotted with Christian churches and Christian processions that wound their way through the streets.

The fifth century witnessed unprecedented church building. After the devastating sack of Rome by Alaric in A.D. 410, the papacy took control of Rome because the secular center had moved from Milan to Ravenna. Building projects, no longer under imperial control, become the prerogative and responsibility of the papacy. Now large churches penetrate the interior of the city, their size and conspicuous presence altering the skyline and challenging their classical setting.

It was also during the first half of the fifth century that the great Church councils were held. At the Council of

Fig. 3.1. Berlin Ivory Pyxis. Ivory, h 4½, diam. 5½″. Museum für Spätantike und Byzantische Kunst/Staatliche zu Museen Berlin. 5th century

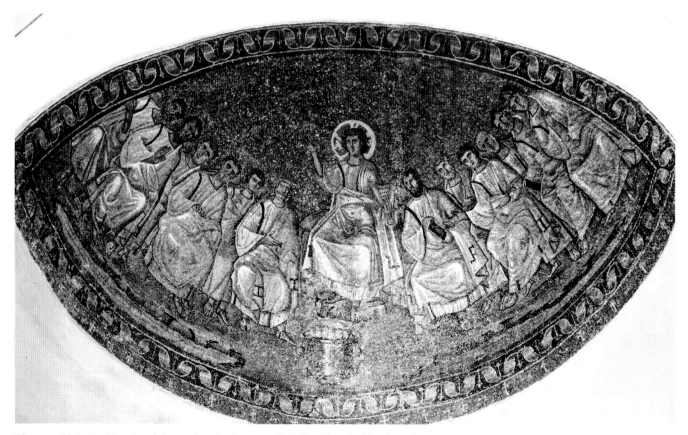

Fig. 3.2. *Christ Teaching, Seated Among Apostles.* Apse mosaic in the Chapel of Sant'Aquilino, San Lorenzo Maggiore, Milan. c. 400

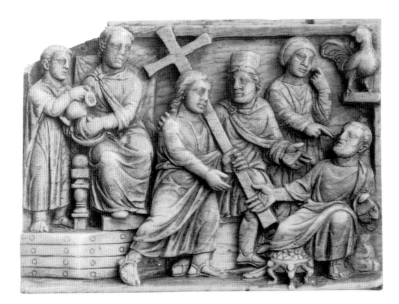

Fig. 3.3. *Pilate Washing His Hands; Christ Carrying the Cross.* Plaque on an ivory casket, 3 × 3⅞″. c. 420. British Museum, London

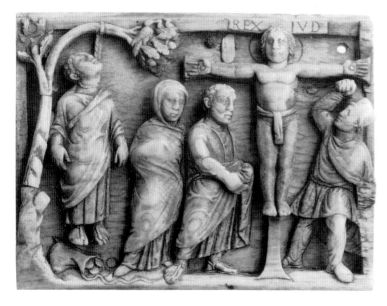

Fig. 3.4. *Death of Judas; Crucifixion.* Plaque on an ivory casket. 3 × 3⅞″. c. 420. British Museum, London

Ephesus in 431, Mary was officially entitled *Theotokos*, the "bearer of God," and not merely the mother of a human child. The final definitions of the Incarnation (the two natures of Christ) and the exalted role of Mary *Theotokos* were established at the Council of Chalcedon in 451 and were in part the inspiration of Pope Leo, whose *Tome* of 449 on these matters was instrumental in formulating the orthodox position. And so religious art took on a new role, that of illustrating the expanding the dogma and doctrine of the Catholic faith. A new mode of pictorial expression arose in the West, one that can be termed catechetical as well as narrative and symbolic, one in which the expanded mural decorations were not merely embellishments for the new church but also instructions for those who could read their messages.

The ivory plaques depicting scenes from Christ's Passion, for example, clearly demonstrate the power of images to convey a didactic message (**figs. 3.3, 3.4**). These plaques brilliantly condense the narrative into a seamless whole, in a manner not dissimilar to that used on sarcophagi. On the left, Pontius Pilate, seated on a throne on a raised platform, washes his hands in water poured by a male servant. In the center, Christ confidently strides forward with the cross, accompanied by a Roman soldier who seems to usher Christ out with a gesture of his hand. To the right, Peter leans backwards from the cross and stretches out his hand toward Christ. Behind Peter, a woman points an accusing finger at him, while on a ledge above is a rooster that signifies the fulfillment of Christ's prophecy to Peter: "before the cock crow, thou shalt deny me thrice" (Matthew 26:34). In the next plaque, the weight of Judas' body bends the bough of the tree, while below thirty pieces of silver, the money Judas was paid for the betrayal of his friend, spill out of a sack. In sharp contrast to Judas, whose body is shown slumped, Christ, wearing a loincloth, is stretched across the arms of the cross with seemingly little

difficulty. His figure conveys his triumph over betrayals and suffering. Below him, Longinus the Centurion bends and twists his body to view the crucified figure, while Mary and John the Beloved stand in mute grief. The expanded narrative includes one of the first representations of the Crucifixion to survive from Late Antiquity. The expressive gestures and expansive postures indicate that this artist is using the human figure to tell the story of a double betrayal in a vigorously visual manner. These plaques are two of four, which, though now separated, must originally have been mounted on the four sides of a small square casket. The function of this ivory box is not known, but it could have been either for private,

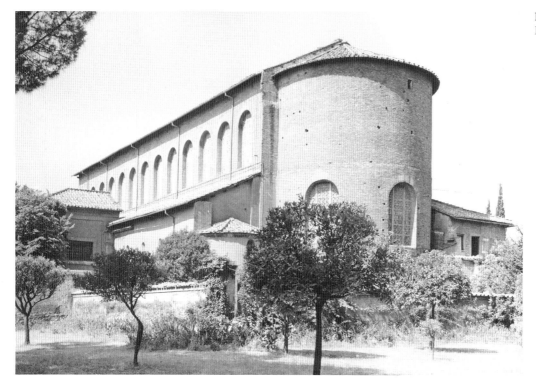

Fig. 3.5. Santa Sabina, Rome. Exterior of apse. 422–32

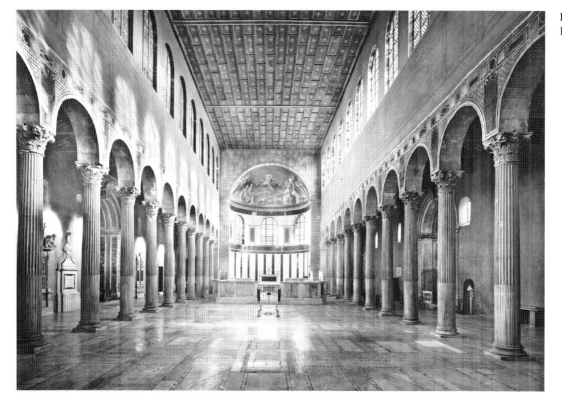

Fig. 3.6. Santa Sabina, Rome. Nave

personal use or for an ecclesiastical purpose. The didactic nature of this ivory is also found in the images on the walls and apses of the newly erected churches.

Although the exteriors of these early churches would remain austere and lacking in architectural embellishments, the interiors would receive lavish treatment, as would the doorways marking the threshold between the profane world and the sacred world.

The finest surviving example of what has been called the "standard" Early Christian basilica is the *titulus* church of Santa Sabina, high on the Aventine Hill in what was then a fashionable quarter of Rome (**figs. 3.5, 3.6**).[2] According to an inscription inside the narthex, the basilica was founded by Pope Celestine I (422–32). This type of so-called standard basilica emerged in the fifth century and was admirably suited to serve the function of a parish church. The ground plan is simpler, with three clearly marked spatial units, an atrium, nave, and apse, but with no complex additions such as transverse transepts. The interior is one of regularity and discipline, the lightness and vigor created by the tall rounded windows of the clerestory, which repeat the rhythm of the nave arcade. The nave arcade consists of an uninterrupted line of *spolia* columns that have carefully cut square bases. Great care was used, since these square bases match each other flawlessly. The deeply carved Corinthian capitals carry an arcaded architrave of colored marble. Over the columns are panels displaying a chalice, paten, and cross. On the seventh and eighth spandrel from the apse, the motif changes to a chalice and a crown of thorns, perhaps a symbolic marker for

liturgical uses. The long nave directs one's focus irresistibly down toward the altar, which is placed before a simple apse with three windows.

Of approximately the same date are the famous wooden panels of the doors of Santa Sabina in Rome (**fig. 3.7**), probably commissioned by Pope Celestine I. Eight large and ten small cypress panels survive from a larger ensemble, though the exact arrangement of the panels can no longer be determined since the panels were rearranged twice. The Crucifixion panel is one of the most enigmatic; the Crucifixion was rarely represented in Late Antiquity and this representation is unlike any other. Christ and the two thieves stand in the posture of *orans* against an architectural form that resembles a basilica. This curious iconography is a reminder that Christian iconography was still fluid and innovative even in the fifth century. Although few have survived, carved doors were no novelty. Ambrose's church in Milan had an earlier set of wooden doors that unfortunately are too fragmentary for our discussion. These early examples of story telling on doors became the models for a lasting tradition in Medieval and Renaissance church arts.

The classical flavor found in Santa Sabina is even more apparent in the interior of Santa Maria Maggiore (the major church of Mary) on the Esquiline Hill (**figs. 3.8, 3.9**). The plan shows a single-aisled nave with slightly projecting transepts (the latter may be the work of rebuilding about 1290), with side aisles flanking the nave. The proportions are especially pleasing since the nave is twice the width of the side aisles. The nave arcade is composed of exquisite Ionic

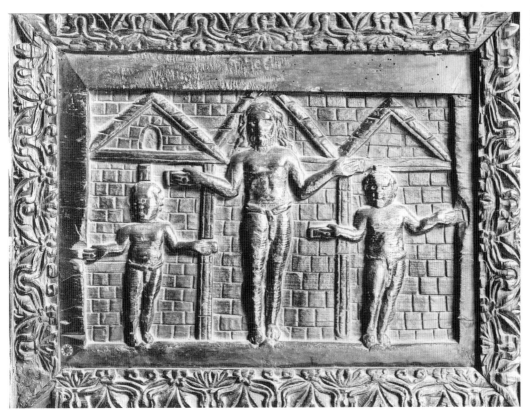

Fig. 3.7. *Crucifixion*, a panel from the doors of Santa Sabina, Rome. Cypress wood, smaller panels 11 × 15¾″. 422–32

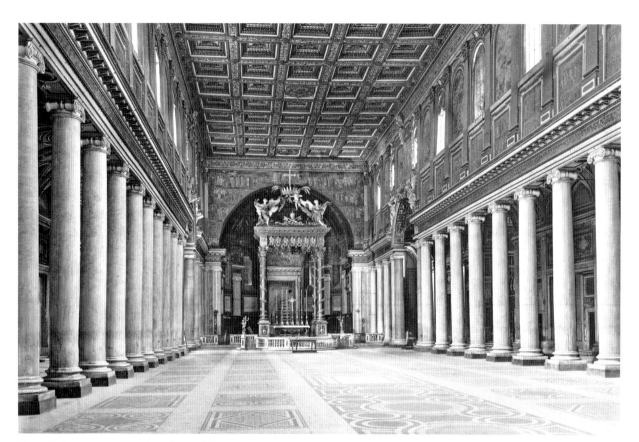

Fig. 3.8. Santa Maria Maggiore, Rome. Nave. c. 432–40

Fig. 3.9. Mosaics on the triumphal arch of Santa Maria Maggiore, Rome. c. 432–40

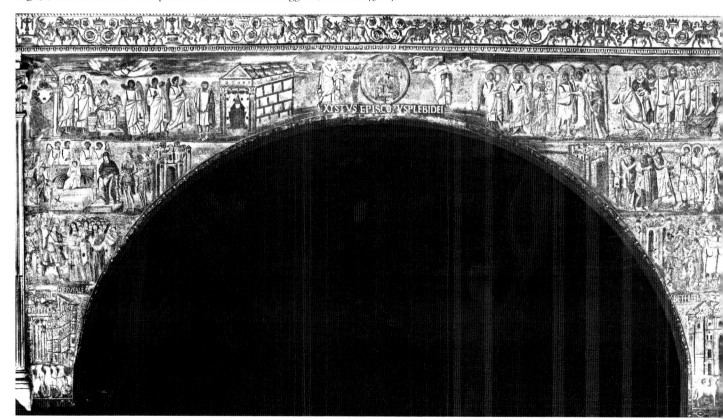

columns that carry a straight entablature. The original exterior is obscured beneath additions and renovations of much later periods.

It was about this time, in the early fifth century, that new schemes for decorating the great basilicas in Rome must have incorporated vast picture cycles much like those described by Paulinus of Nola. In his annual poems to Saint Felix, Paulinus describes the events from the Old Testaments that were painted on the walls of his church. The heroic deeds and mighty stories of God's salvation were meant to inspire Paulinus to act like Abraham and Moses in his daily life. In response to Alaric's sack of Rome, the Church Father Augustine (d. 430), in writing his monumental *De civitate Dei*, or *The City of God*, put down in comprehensive form the Christian philosophy of history and the meaning of *ecclesia*.[3] The extensive narrative cycles painted on the walls of the basilicas closely parallel Augustine's divisions of time and his interpretations of them, which were meant to give meaning to historical events from the time of the Patriarchs to the present. Unfortunately, little survives in painting, but in mosaics the extant panels in Santa Maria Maggiore give a small glimpse into the riches of narrative painting in church interiors.

The original fifth-century mosaics that lined the walls and covered the arch before the apse remain rare and beautiful survivors of Late Antique art. A series of rectangular mosaic panels along the nave walls at clerestory level depicts Old Testament scenes in two registers. Surviving only in part after various restorations and mutilations, the panels illustrate episodes from the lives of the patriarchs, including Abraham and Jacob (along the south wall) and Moses and Joshua (on the north).

The Parting of Lot and Abraham (**fig. 3.10**) is a good example of how the artists of the fifth century both continued and expanded the stylistic flexibility found in the statue of the tetrarchs and in ivory plaques in order to convey a story (figs. 2.3, 3.3, 3.4) and its accompanying moral, in a visually more compelling manner. Through the use of exaggerated gestures and postures, the story is clearly written in the figures of the composition. Abraham and Lot found that they could no longer live comfortably together in the country with their large families, retainers, and flocks. Lot, on the right, agrees to take his family to the city, while Abraham, on the left, will remain in the country. Although both Abraham and Lot wear white classical robes and stand in the formulaic pose inherited from the classical period, the artist has greatly distorted Lot's right arm and hand. Was the artist simply incompetent, or have the arm and hand been enlarged and emphasized in order to make the point that Lot has chosen the city toward which he points? Space has also been used to tell the story. In the center of the composition, there is an empty V-shaped space that emphasizes the impending physical separation between the two men; their flocks and herders are placed below so that they do not obscure the two men, but instead remind the viewer that this is the cause of the separation. Although Abraham's son Isaac is not yet born, he is shown as

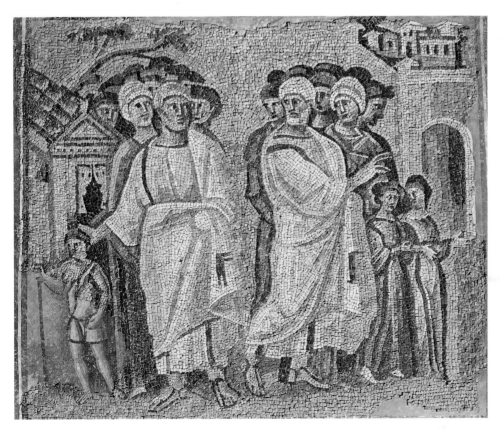

Fig. 3.10. *The Parting of Lot and Abraham*, Santa Maria Maggiore (mosaic)

a smaller figure, as are Lot's daughters. Placed as they are before a symbolic tent and city, they are reminders that God's covenant will be fulfilled in the country through Isaac, while God's wrath will be incurred by the wicked cities of Sodom and Gomorrah, where Lot and his family will come to sorrow.

The mosaics on the arch are reminiscent of the Arch of Constantine in that the architectural structure mimics the form of the Roman military arch and also conveys a powerful message of the triumph of the Church (fig. 3.9). Dedicated to the Virgin Mary, the mosaics on the triumphal arch depict episodes of the Infancy cycle, though with decidedly imperial overtones. In the topmost register are the Annunciation and Presentation, while in the second register are portrayed the Birth of Christ and the Adoration of the Magi, the three kings from the east. The diminutive figure of Christ is regally seated in a lavishly jeweled throne as the angels and the Virgin surround him as royal courtiers to receive the gifts from the Magi. Below is the story of the Massacre of the Innocents and the Flight into Egypt. In the center of the arch are the four symbols of the Evangelists: Luke as the winged ox, Matthew as the winged man, Mark as the winged lion, and John as the eagle. A reference to the second coming of Christ is made in the representation of the prepared throne, or *etimasia*. The empty throne can be linked to ancient council ceremonies, where similar empty thrones were displayed with the insignia

of the imperial office to signify the divine presence of the king. This tradition was taken over by the church at the Council of Ephesus, where an empty throne, or *cathedra*, was set up with the scriptures opened across it to summon the invisible presence of Christ as the divine judge presiding over the council. Thus the unusual mosaics in Santa Maria Maggiore demonstrate the double appearance of Christ: first in His earthly birth and secondly in His anticipated return at the end of time.

The apse mosaics at the churches of Santa Pudenziana and Saints Cosmas and Damianus are reminders of the versatility of apse decoration in this early period, when experimentation was more usual than standardization. The mosaic in Santa Pudenziana, dating from about A.D. 400, has been partially obscured by later rebuildings and restorations (**fig. 3.11**). Enthroned between the apostles, led by Peter and Paul, the bearded Christ stares out while making the familiar gesture of teaching or proclamation. In the colorful skies above are busts of the four creatures from the Book of Revelation that became symbols of the Evangelists. Here Christ is shown as an older man, with long dark hair and a full beard, rather than as the young shepherd or the teacher. Hence this older Christ is envisioned as the one on the "throne set in heaven" from the Apocalypse (Rev. 4). Two veiled female figures, heavily restored, stand behind Peter and

Fig. 3.11. *Christ in Majesty.* Apse mosaic in Santa Pudenziana, Rome. c. 400

Fig. 3.12. *Christ Acclaimed by Saints Peter and Paul with Saints Cosmas and Damianus, Saint Theodorus Tiro and Pope Felix IV.*
Apse mosaic in Saints Cosmas and Damianus, Rome. c. 526–30

Paul and offer wreaths, symbols of martyrdom. They are the personifications of the church of the Gentiles, behind Paul, and the temple of the Jews, behind Peter. The complex cityscape in the distance is without precedent. In the midst of the city, directly behind Christ, rises a hill surmounted by a tall cross bedecked with gems. The mosaic cross is meant to reproduce a famous cross erected on Mount Golgotha in Jerusalem in the fourth century. The apse refers to Christ's sacrifice, but also looks toward the end of time.

The end of time theme and the reference to martyrdom are also found in the apse of Saints Cosmas and Damianus (**fig. 3.12**). Again, Christ is depicted as an older, bearded figure holding a scroll and gesturing to the right, his figure hovering on heavenly clouds. Paul, shown with his black hair in a "widow's peak," presents one of the Arab twin brothers, Cosmas and Damianus, physicians who had been martyred for their faith. Behind them stands Pope Felix, who was the founder of the church. To the right, Peter, sporting his

standard white cap of hair, presents the other twin brother, while Saint Theodorus Tiro, a soldier martyr, stands in the wings. Pope Felix carries a small model of the church, while the other saints carry wreaths, a reference to their martyrdom. Small tufts of vegetation are signifiers that the event takes place in Paradise. The apse reiterates the theme of Christ returning on clouds at the end of time, but places the emphasis on the gathering of the saints to their eternal reward. The inclusion of Pope Felix honors him as founder of the church and also gives a local accent to this universal theme.

In the Late Antique world, the emphasis on an apse decorated with elaborate mosaics would have evoked the idea of an entry into a radiant heaven. Pagan representations of paradise provided Christians with a number of familiar motifs. The stretched tent or canopy of the cosmos that appears in pagan vaults and domes of heaven found a place in the very summit of the apse, and the fields of Elysium, its verdant meadows accentuated by bright flowers, served as a stage for

the figures. Exotic pagan riverscapes with putti fishing would be taken over by Christians to represent the refreshing waters of paradise that flow beneath the throne in heaven.

The intimate relationships between the imagery of the apse and that of the liturgy performed at the altar were conspicuous. The divine service in heaven above reflected the Mass below. Hence, the architectural decoration served as a giant stage set for the liturgical drama. Numerous legends testify to the belief that the portrait of Christ in the apse was miraculously conceived. According to one legend, the face of the Savior appeared in the apse of the Lateran basilica during the consecration services before Bishop Sylvester, the Emperor Constantine, and the startled congregation.

ILLUMINATED BOOKS

"All Scripture . . . is profitable to teach, to reprove, to correct, to instruct in justice, that the man of God may be perfect" (2 Tim. 3:16). Like many religions such as Judaism and Islam, Christianity is a book religion that is based on the Word as transmitted in the scriptures through the inspiration of the Holy Ghost: "They have God for author." For the Christians the canonical or accepted books of scripture were the Old and New Testaments. Taken together, the Testaments constitute a comprehensive encyclopedia of history, revelation, and instruction ranging from the shadowy beginnings of man created in God's image in Genesis through the long chronicles of the Jews and the brief life of Christ.

The Bible (*biblos* means book in Greek) also contains texts that can be described as ordinances of law and manuals of instruction (Leviticus, Deuteronomy), poetry (Psalms), proverbs, prophecies, and philosophical discourses (Job). But history is foremost, and like many ancient epics, the Bible was illustrated at an early time with pictures comprising lengthy narrative cycles. As we have seen, the more hieratic images of godhead, such as those described in the visions of Ezekiel, Isaiah, and in the Book of Revelation, were given iconic picture form as well, especially in sacred settings such as the basilica apse, but pictures in the narrative mode—repeated images that tell a story in cartoon fashion to be read with the text—were just as significant for the development and transmission of Christian art.[4]

Book illustration had developed through a number of stages before it was inherited by the Christians. The simplest form was a tiny picture inserted into the column of the text of a papyrus scroll at the appropriate place. With the introduction of the codex, the paginated book form, the illustration was often enhanced as a work of art by the addition of a frame to isolate it from the text. These framed miniatures could, in turn, be elaborated by squeezing two or more episodes—iconographic units—into each frame. A further elaboration was to extract the picture from the text and place it alone in the form of a large frontispiece or full-page illustration, where it assumed an independent existence from the

script and, sometimes, an independent meaning from the text as well.

One of the finest examples of an illustrated Classical text is the Codex Vergilius Vaticanus, usually called the Vatican Vergil and dated no earlier than the fourth century, although it is generally thought to be an accurate copy of a much earlier illustrated edition (**fig. 3.13**).[5] The codex contains a number of framed miniatures illustrating passages of the *Aeneid* and the *Georgics*—it has been estimated that the original contained more than 245 painted scenes. Well-proportioned, lively figures, fully modeled in delicate, painterly shades, are casually placed in elaborate interiors with sophisticated perspectives or in landscapes with grottoes, seas, and cities. These scenes are illusionistically rendered with the atmospheric tonalities of Homer's "rosy-fingered dawn" (a frequently repeated cliché), with green-brown grounds fading away into a blue sky along a fuzzy horizon of pink or lilac. The artist, steeped in the stylistic traditions of Roman wall painting, has treated the folio as a window into a bucolic setting.

A famous set of illustrations for the Herbal of Dioscurides (*De Materia Medica*) in the National Library in Vienna, dated A.D. 512, seems to have been of special Byzantine patronage (the princess Juliana Anicia is portrayed in one miniature) and was very likely produced in the Eastern capital (**figs. 3.14–3.16**). Indeed, the portrait of Dioscurides welcoming

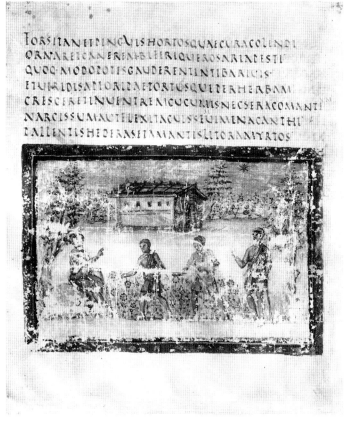

Fig. 3.13. *Instructions for Gardening* (The Old Gardener of Corycus). Illustration to Virgil's *Georgics* in the Codex Vergilius Vaticanus (fol. 7v). 8⅝ × 7¾″. Early 5th century. Vatican Library, Rome (MS lat. 3225, fol. 7v)

the personification of Discovery carrying a mandrake root is executed with the sophistication of an Antique author portrait. Soft modeling appears in the toga, and the rugged facial features of the elderly doctor are vividly captured in flecks of light and dark. Such seated portraits were very common in Greek and Roman cities, usually in sculptured form, where they could enhance architectural settings such as gymnasia, libraries, and other civic buildings. It was very likely from such public statuary that the portraits of the Evangelists so familiar in Gospel books were derived.[6] More unusual is the inclusion of a portrait of the artist, also inspired by the personification of Discovery, who draws the mandrake root on his easel. The accurate botanical drawings, such as the one of violets (fig. 3.15), form one of the chief delights of the manuscript.

The earliest illustrations found in Biblical books date roughly from the same time—late fifth and sixth centuries—and the miniatures retain the same Antique illusionism and vivid color of their secular counterparts. It should be noted that the earliest are not complete Bibles. Not only was the Old Testament too vast, but there were serious questions as to just which books were authentic and canonical, so what we find are sets of illustrations corresponding roughly to the major divisions of the Bible. Genesis was very popular as the introductory text and often appears alone throughout the Middle Ages. The stories of Moses and the Law—Exodus, Leviticus, Numbers, Deuteronomy—together with Genesis formed an independent unit called the Pentateuch, or first Five Books; another set comprised the first eight, the

Fig. 3.14. *Portrait of the Author and the Discovery of the Mandrake Root.* Miniature in *De Materia Medica* of Dioscurides. 15 × 13″. 512. Österreichische Nationalbibliothek, Vienna (Cod. med. gr. I, fol. 4)

Fig. 3.15. *Violets.* Miniature from *De Materia Medica*, (fol. 148)

Fig. 3.16. *De Materia Medica*, artist drawing the Mandrake Root, (fol. 5)

ABOVE **Fig. 3.17.** *The Story of Jacob.* Miniature in the Vienna Genesis. 13¼ × 9⅞″. 6th century. Österreichische National-bibliothek, Vienna (Cod. theol. gr. 31, fol. 12v)

ABOVE RIGHT **Fig. 3.18.** *Potiphar's Wife.* Miniature in the Vienna Genesis, (fol. 31r)

RIGHT **Fig. 3.19.** *The Story of Adam and Eve.* Miniature in the Ashburnham Pentateuch. 14½ × 12⅜″. Late 6th century. Bibliothèque Nationale, Paris (MS nouv. acq. lat. 2334, fol. 6)

Octateuch, and was particularly popular in Byzantium; while such parts as Kings, Psalms, Prophets, and Job were usually treated as independent volumes.

Two well-known manuscripts for Christian usage attest to the popularity of Genesis for illustration at an early date. The more complete and better preserved is the so-called Vienna Genesis, a deluxe picture Bible with an abbreviated Greek text written in silver on parchment stained purple. Purple is the color of royalty, and this suggests that the manuscript was commissioned by an imperial patron, perhaps in Constantinople, although the provenance and date are much debated.[7]

In many miniatures, the figures are simply aligned in rows along a groundline, but in one, the curious story of Jacob's encounter with his brother Esau (Gen. 32:22–30), the episodes are presented consecutively from left to right in the upper register (**fig. 3.17**). Jacob leads his two wives, maid-servants, and eleven sons toward the ford at Jabbok, which they pass over—to enter the register of illustrations below—

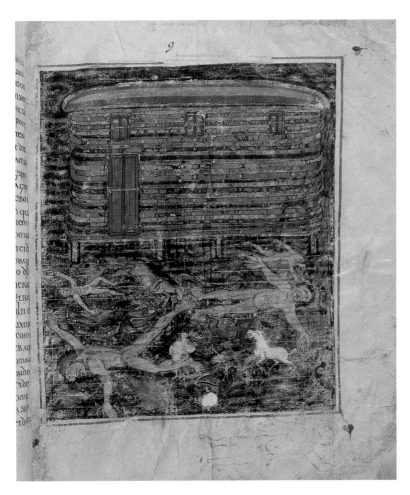

Fig. 3.20. *Deluge.* Miniature in the Ashburnham Pentateuch, (fol. 9r)

along the curving bridge foreshortened to connect the upper with the lower level. Jacob is again repeated with the "man who wrestled with him till morning," and finally his meeting with Esau is illustrated on the same ground in the lower left.

The scene of Joseph accosted by Potiphar's wife is placed in a Roman architectural setting (**fig. 3.18**). Joseph, not wanting to have sexual relations with the woman, flees through the door in his efforts to escape her unwanted attentions. To the left and below are included domestic scenes of spinning and childcare. The illustrations cohabitate with lines of text, blurring the delineation between text and image that was found in the Vatican Vergil.

The Greek text of the Vienna Genesis manuscript suggests that the scriptoria that first produced these illustrated books are to be located in some Greek-speaking center, perhaps Constantinople. Common sense would further lead one to assume that the miniatures were painted there, too, but the issues of provenance remain thorny problems for scholars.

The Ashburnham Pentateuch, named after the British Lord Ashburnham who owned the manuscript at one time, has a liveliness and complexity not found in contemporary manuscripts (**figs. 3.19, 3.20**).[8] Many pages have tiny, agile figures scattered within undulating registers, which are given vivid and colorful backgrounds of blue, green, red, yellow, and brown. These provide settings for contoured hills, jagged cliffs, exotic

towered structures, and primitive huts and sheds. The drawing of the fauna is based on keen observation, and a spirited animation is conveyed in the sprightly movements of the horses, sheep, and cattle. The figures are well proportioned and articulated with an energy and intensity not found in Greek manuscripts. Their costumes, whether the simple garb of the peasant farmers in the story of Cain and Abel or the more exotic regalia of the higher classes, are rendered in exact detail. Plants and trees are vividly differentiated—note especially the date palm, the field of wheat, and the furrowed pasture.

Thought to have been created in Italy, the Ashburnham Pentateuch was probably used as a teaching book where the illustrations helped the reader to interpret the text, especially passages of scripture with difficult messages such as the story of the giants who walked the earth. Born from a mating of the "sons of god" and the "daughters of man," the Nephilim were monstrous giants that brought about the Deluge by their wicked deeds. Here, the ark is portrayed as a woven and riveted basket that has been tightly sealed. In the waters below, the evil Nephilim and their evil human counterparts are drowned in agony for their misdeeds. Interestingly, the gender of all the giants, humans, and animals is male.

The earliest illustrated New Testament books—the Gospels according to Matthew, Mark, Luke, and John—display an even greater diversity. It should be noted that the other New

Fig. 3.21. *Parable of the Wise and Foolish Virgins.* Miniature in the Rossano Gospels (fol. 2v). 12⅛ × 10¼″. Second half of the 6th century. Museo dell' Arcivescovado, Rossano

Fig. 3.22. *Trial of Christ Before Pilate.* Miniature in the Rossano Gospels (fol. 8v)

Testament texts—Acts, the Letters, and Revelation—were conceived as independent books apart from the Gospels. Generally, the Gospels are introduced individually with an author portrait of the Evangelist, either seated or standing, placed within or before an architectural frame.

A sixth-century Gospels with illustrations is painted on purple-stained parchment and written in Greek, indicating some aristocratic patron in the East Christian capitals, possibly Constantinople (**figs. 3.21, 3.22**). The Rossano Gospels has selections from all four Evangelists and is arranged for the liturgical year.[9] The narrative illustrations appear in an unusual fashion on pages before the Gospels, with liturgical readings for Passion week. The iconographic units are painted above the abbreviated texts on scroll-tablets held by prophets. Thus the idea of the Old Testament prophecies underlying the mysteries in the life of Christ, a parallelism so familiar in later Medieval art, appears here in a striking manner. Among the lively narratives, a number—the Raising of Lazarus, the Entry into Jerusalem, the Last Supper—are represented according to iconographic formulae that occur in much later cycles, indicating that these narratives had become standardized. Other stories are elaborately expanded beyond the account given in the Gospel text. In the illustration of the Five Wise and the Five Foolish Virgins (fig. 3.21), a parable on the Last Judgment in Matthew, the artist elaborated the details in a most interesting fashion, indicating that he was following other sources. The virgins are aligned in a row: the five wise carrying flaming torches are dressed in white chitons signifying their purity; the five foolish, grouped outside the golden gate of the marriage chamber, are clad in vari-colored mantles indicating their tainted personalities. The bridegroom's chamber, moreover, is a verdant orchard recalling the Garden of Eden, with four rivers flowing from a mound: the beatific vision of heaven as the reward for the wise at the Last Judgment. More striking is the portrayal of the bridegroom as Christ with a cruciform halo and dressed in a golden mantle. His gesture is emphatic, as he bars the foolish from his bridal garden, and the strained intensity suggested by the lines in the downcast eyes of the rejected virgins imparts an element of expressionism to the parade of charming young women. The illustration makes clear what the text does not; the bridegroom is Christ who gathers his faithful to the eternal garden.

An unusual illustration in the Rossano Gospels is a full-page miniature. The scene depicts Christ brought before Pilate by the high priests Annas and

Fig. 3.23. *Sarcophagus of Junius Bassus.* Marble, approx. 3′ 10½″ × 8′. 359. Grottoes of Saint Peter, Vatican City

Caiaphas. The miniature shows the enthroned Pilate in a semicircular setting above Christ and his tormentors. In the Trial of Christ, a monumentality is achieved through the symmetrical placement of the figures about the frontal figure of Pilate on the central axis. To the sides, the Jews, who cry out "Crucify him, crucify him," are tightly gathered and cramped together to fit the circular boundary of the upper zone. Below are the accused. To the left, Christ, dressed in gold, is flanked by court officials. To the right, a writhing Barabbas, naked to the waist and with his hands tied behind him, is presented like a dangerous criminal by two guards.

How unlike the sketchy, quick-paced narratives this hieratic representation seems. The accoutrements of the tribune chamber are carefully added, with the high-backed, cushioned throne of judgment for Pilate complete with flanking standards bearing portraits of the emperors; the table is spread with writing instruments on a cloth with two more imperial portraits embroidered upon it; a clerk-scribe stands to the right taking notes on a wax tablet. All of this offers a strikingly realistic portrayal of an actual Roman court of justice, with Pilate radiating authority. Pilate gestures to the accusers as he seemingly questions them, "Why, what evil has he done?"

Because of the elaboration and monumentality of the trial miniature, so different from the other narrative versions,

such as that on the Sarcophagus of Junius Bassus (**fig. 3.23**), it is generally believed that some special source inspired the artist. André Grabar suggests that it was derived from an illustrated law book, perhaps a copy of the Code of Justinian. William Loerke offers a more imaginative solution. He argues that the miniature is a copy of a mural once decorating the *domus Pilati*, the praetorium in Jerusalem where the trial was believed to have taken place and which was an important pilgrimage site by the fourth century.[10]

The provenance and dates of the manuscripts so far discussed are matters of fierce debate, but there are no such problems with one of the most remarkable illustrated New Testament codices, the Rabbula Gospels, written by the monk Rabbula in the monastery of Saint John of Zagba, Mesopotamia, and dated A.D. 586.

The first pages—nineteen in all—are handsome canon tables (**fig. 3.24**). These constitute a harmony or concordance of the Gospel texts as devised by Eusebius for Constantine. Eusebius drew up ten basic lists or canons, the first containing episodes (indicated by the number of the passage in the text) common to all four Gospels; the second canon included those passages repeated in the first three, and so on.[11] The canon tables are in the form of painted arcades, with the equivalent passages relating the life of Christ cited within each inter-columniation marked in parallel: Matthew, Mark, Luke, and

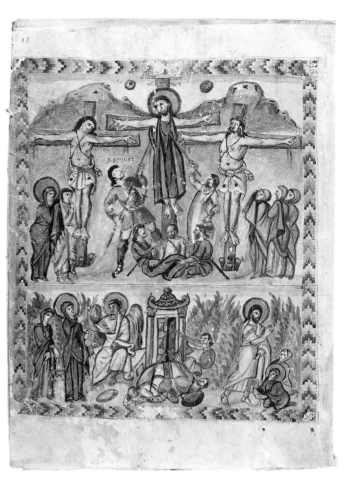

Fig. 3.24. *Canon Table.* Miniature in the Rabbula Gospels. 13 × 10½″. Completed at Zagba, Mesopotamia, c. 586. Biblioteca Laurentiana, Florence (MS Plut. I, 56, fol. 9v)

Fig. 3.25. *Crucifixion.* Miniature in the Rabbula Gospels, (fol. 13)

John. The borders of many of the canons are enhanced with small vignettes illustrating in an abridged fashion the major events in the life of Christ or portraits of the Evangelists, seated or standing. A spontaneity and directness can be perceived, as if the tiny pictures were meant to be colorful footnotes for the passages cited.

Large, full-page miniatures inserted in the text are astonishingly sophisticated, although similar in execution to the Codex Rossanensis (figs. 3.21, 3.22). These include a remarkable Crucifixion, a hieratic Ascension, a statuesque Madonna standing on a pedestal, and a courtly Dedication picture with Christ enthroned between two bishops and two monks. The *Crucifixion* (**fig. 3.25**) is one of the earliest fully "historiated" types, in which many of the narrative details described in the Gospels are illustrated, including the eclipsed sun, the two thieves hanging on crosses beside Christ, the soldiers casting lots for Christ's robe, the lance bearer named Longinus, the man lifting the sponge soaked in vinegar to Christ's lips, and the three women who witnessed the tragedy along with the Virgin and John and Evangelist.

Below this magnificent Crucifixion is a horizontal band with two more scenes: in the first, two Marys (including the

Virgin) visit the empty tomb guarded by an angel, and in the second, a *Noli me tangere*, the resurrected Christ warns the Magdalene (and curiously his mother) not to touch him. Mary's presence in these latter scenes is not mentioned in the Gospels and surely indicates a more complex iconographic source. One unusual detail stands out even more: in the Crucifixion, Christ is not covered by the traditional loincloth but wears instead a long purple tunic or robe with two golden *clavi* or bands, a garment known as a royal *colobium*. Thus the double composition has a grandeur and complexity that go far beyond the requirements of simple narration. Indeed, its striking symmetry and integrated design bespeak a monumental prototype.

The *Ascension*, also composed in two zones, is even more monumental in conception (**fig. 3.26**). In the opening lines of the Book of Acts, the apostles are given their commission to be witnesses of Christ in the uttermost corners of the world, "And when he had said these things, while they looked on, he was raised up: and a cloud received him out of their sight. And while they were beholding him going up into heaven, behold two men stood by them in white garments. Who also said: Ye men of Galilee, why stand you

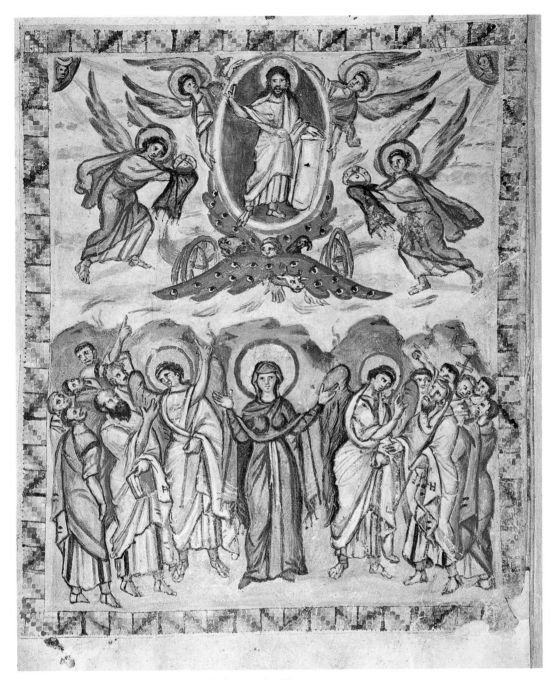

Fig. 3.26. *Ascension.* Miniature in the Rabbula Gospels, (fol. 13v)

looking up to heaven? This Jesus who is taken from you into heaven, shall so come, as you have seen him going into heaven" (Acts 1:9–11).

It is obvious that the miniature is no direct illustration for this short text. More than a cloud receives him: a huge aureole surrounds the ascending Christ. Below this glory, a curious chariot with fiery wheels, scarlet wings filled with eyes, the heads of four creatures (lion, ox, eagle, and man), and a mysterious Hand of God appear directly over the head of a standing female *orans* figure. The inspiration for this impressive *Maiestas Domini* is not that of John's Revelation, as we found in Roman mosaics, but rather the prophecy of Ezekiel (1:3–28), where

the seer experienced the vision of the "likeness of the glory of the Lord" in the midst of winged tetramorphs and flaming wheels from whence thundered the voice of God. That the image of God (theophany) is here based on the vision of Ezekiel and not that of John the Evangelist should come as no surprise when we remember that the Book of Revelation was considered spurious at an early date by the Eastern Churches, while the prophecies of the Old Testament, especially those of Ezekiel and Isaiah, were authoritative.[12]

Such a picture certainly merits a place in the apse of an Eastern church, and there are good reasons to believe that it copies a famous mosaic or fresco in a major Palestinian shrine

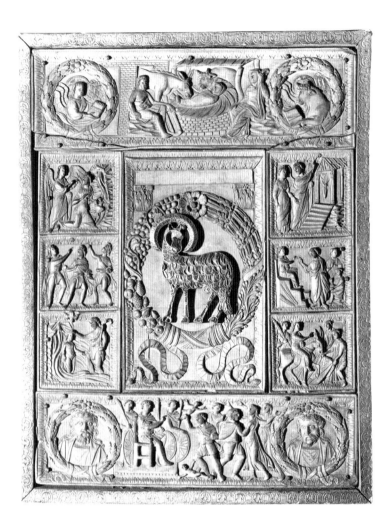

Fig. 3.27. Scenes from the apocryphal Infancy cycle and the Life of Christ. Ivory book cover, 14¾ × 11⅛″. North Italian (?). Late 5th century. Cathedral Treasury, Milan

large central fields are decorated with applied symbols of Christ in silver *cloisonné*. The left, illustrated here, is adorned with a lamb—Christ as the sacrificial victim—while the right has a cross—Christ as victor. In the four corners are bust portraits of the Evangelists, in strict frontal poses, and their symbols: the angel and the ox, above, the heads of Matthew and Luke, below. The upper plaque displays a curious Nativity with Joseph, dressed as a shepherd or workman, holding a carpenter's saw, seated opposite Mary before a flimsy shed in which we see a crib, the Child, the ox and the ass.

Each side plaque is decorated with three framed scenes to be read from top right to left and down: the Virgin in the temple, with an angel pointing upward at the miraculous star; the Annunciation, curiously placed in a landscape where Mary, attired as a princess, fetches water from a stream; the three Magi following the star; the twelve-year-old Jesus before the doctors in the temple; the Baptism of Christ (which usually initiates the ministry cycle); and the Entry into Jerusalem (the beginning of the Passion events). In the lower plaque a dramatic Massacre of the Innocents is enacted before Herod with the soldiers literally smashing the babes to the ground before their wailing mothers. Scenes illustrating the miracles of Christ dominate the iconography of the back cover (not illustrated here).

The unusual iconography of the Infancy scenes can be traced to an independent textual source—the apocryphal gospels—that was popular in North Italy and elsewhere. By Apocrypha are meant the books of the Bible that were not accepted as true or canonical by the early Church Fathers. Usually attributed to some famous author, these legendary testimonies, dating roughly to between the first and third centuries, colorfully filled in the sparse Gospel accounts of the childhood of Christ and the life of Mary and had a lasting influence.[14] Especially popular was the Syriac Protoevangelion of James (and the later Latin version of it, the Gospels of Pseudo-Matthew), which contains stories of the Virgin and the angel in the temple, the Annunciation at the well, and the Magi following the star that are not found in the canonical Gospel accounts.

(perhaps the Eleona, where the Ascension took place).[13] More than a site or liturgical commemoration, however, the picture also serves a catechetical role in demonstrating one of the basic mysteries in the personality of Christ as defined in the great Church councils held in Ephesus in 431 and Chalcedon in 451: the doctrine of the Incarnation and the two natures of Christ, human and divine. This lesson is underscored when we focus on the lower zone of the Ascension, where the prominent figure below the Hand of God, the *orans*, is surely the Virgin Mary. She is not mentioned in Acts, nor is she normally associated directly with the *Maiestas Domini* at so early a date.

Many of the manuscripts discussed above are in fragmentary condition and without their original book covers. From depictions of Gospel Books in mosaics, it can be deduced that these luxury manuscripts were probably covered in bindings that were embellished with jewels or covered in plaques of precious materials such as silver or ivory. One such cover survives in the so-called Milan "five-part" diptych (**fig. 3.27**). Each side is made up of five ivory plaques. The

The handful of illuminated books to survive from Late Antiquity show a remarkable variety in the style, format and quality of the illustrations. Some are interspersed throughout the text, some are gathered at the front of the book. Some are filled with detailed narrative scenes, while others show more iconic representations. The variety is also a reminder that our knowledge of illuminated books is very incomplete because none of them resemble one another very closely, indicating that the book arts were in an evolutionary stage that saw great experimentation.

ART AND ARCHITECTURE IN THE EASTERN MEDITERRANEAN

Considerable evidence survives for the fifth-century churches built in Syria, and one in particular, Qal'at Si'man, east of Antioch, remains in great part intact in ruinous splendor (**figs. 3.28–31**).[15] The giant *martyrium*, built about A.D. 470 around the venerated column of Saint Simeon Stylites (on which the hermit spent the last thirty years of his life in meditation), is in the form of a huge cross (260 by 295 feet). The column, of which the base still survives, stood in the very center of the cross within an octagonal precinct that was either open or covered by a timber dome. Each of the four arms forms a full basilica; that on the east terminates in a trebled apse. The other arms with their narthexes (on the southern and western arms) resemble giant transepts with aisles.

The sense of grandeur and monumentality of Qal'at Si'man is still striking from the exterior. The great tripartite facades resemble triumphal arches with engaged columns and piers crowned by elegant Corinthian capitals and leaf friezes. Hybrid classical stringcourses decorate many of the architectural members. One distinctive Syrian variation is the continuous profile that runs over the windows in the clerestory of the facade and over those of the apses on the east. Attached structures included a monastery, a tomb, a baptistery, and a hospice; at the foot of the hill were built several inns for pilgrims, four monasteries, and the basilical church. It is important to note that Qal'at Si'man was essentially a pilgrimage center, with a caravansary of sorts, that included chambers for pilgrims and monks, incorporated into the complex.

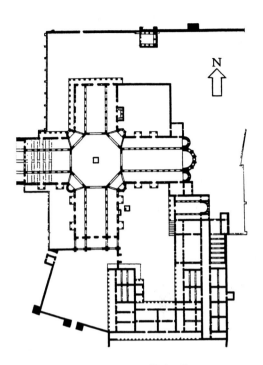

Fig. 3.28. Martyrium of Saint Simeon Stylites, Qal'at Si'man, Syria. Plan (after Krautheimer). c. 470–90

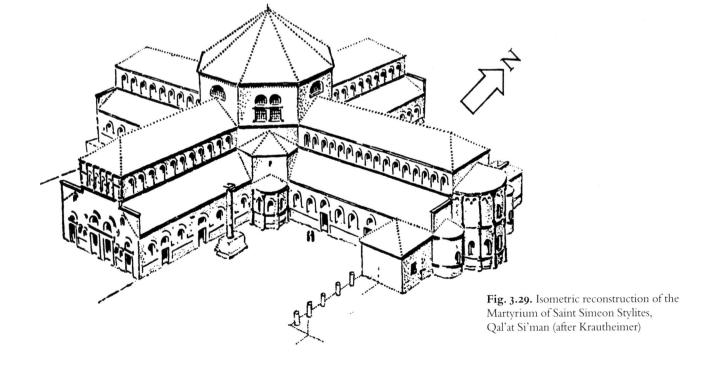

Fig. 3.29. Isometric reconstruction of the Martyrium of Saint Simeon Stylites, Qal'at Si'man (after Krautheimer)

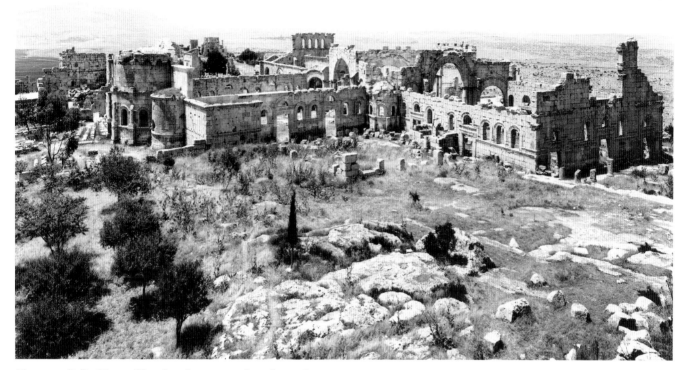

Fig. 3.30. Qal'at Si'man. Church and monastery from the northeast

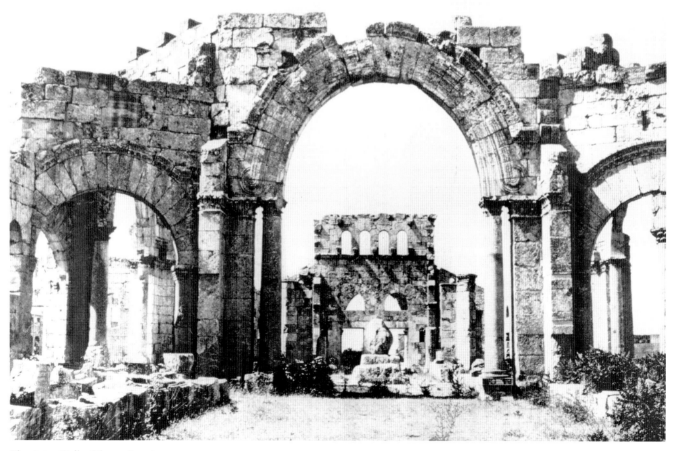

Fig. 3.31. Qal'at Si'man. Interior

Although in the case of Saint Menas the pilgrimage site does not survive, an intriguing icon of the saint with Christ does. Martyred under Diocletian in about 295, Saint Menas, like Simon Stylites, became one of the most popular saints in Coptic, or Christian, Egypt (**fig. 3.32**). Fearlessly professing his faith, he was led before the local ruler, found guilty, put to torture, and finally beheaded. According to legend, his body was brought to Egypt and enshrined where many came to seek miraculous cures. The fame of the miracles that his relics performed spread far and wide and thousands of pilgrims came to the grave in the desert of Mareotis, between Alexandria and the valley of Natron. The small icon carefully shows that Saint Menas has the favor of Christ, who wraps his arm around the saint in a gesture of unity. Christ is distinguished from Saint Menas by his cruciform halo and the bejeweled Gospel he carries; the dark hair and features of Christ also play a counterpoint to the white hair and lighter robes. Christ stands taller than the saint to underscore his divine status and gazes upward and to the right while the saint looks directly into the viewer's eyes. The message is subtly made through visual means: the gesture of unity and the direct gaze indicates that Christ favors Saint Menas and through the saint, by extension, the Coptic Christians.

One of the most precious and rare survivors of the textile medium is the Icon of the Virgin, now in the Cleveland Museum of Art (**fig. 3.33**). Set within an architectural

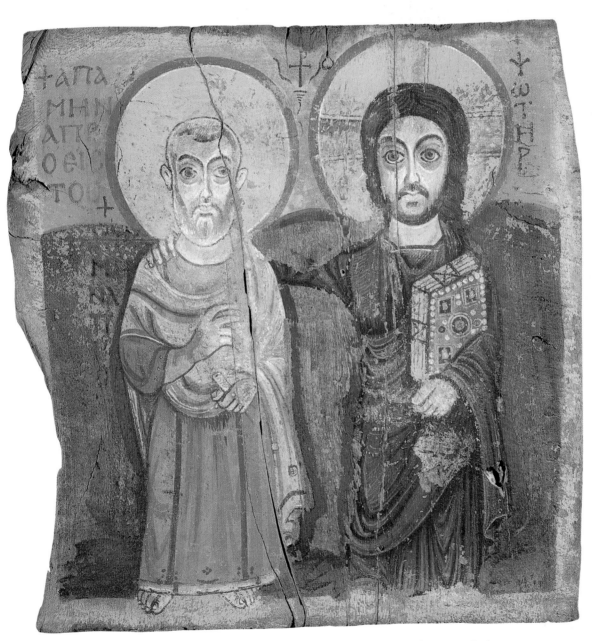

Fig. 3.32. *Christ and Menas.* Coptic. Tempera on panel, 22½ × 22½″. 6th–7th century. The Louvre, Paris

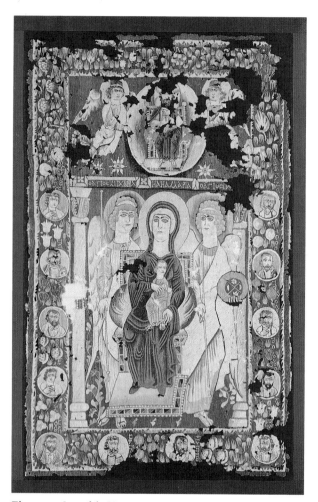

Fig. 3.33. *Icon of the Virgin.* Egypt, Byzantine period. Slit and dove tailed-tapestry weave; wool. 70 × 43″. 6th century. The Cleveland Museum of Art

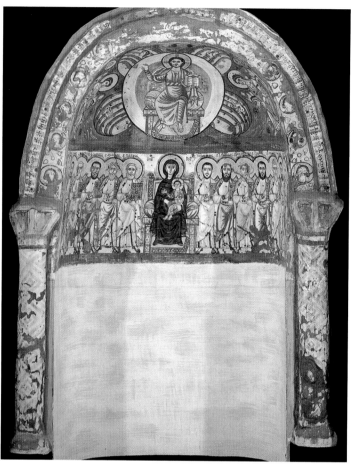

Fig. 3.34. *Ascension.* Apse painting from the Monastery of Apollo at Bawit, Egypt. Coptic. 6th century. Coptic Museum, Cairo

setting, the Greek inscription on the lintel identifies the figures: the Holy Michael, the Holy Mary, the Holy Gabriel. Interestingly, the Christ Child is not named. The border is decorated with fruits and flowers and, in the lower part, with medallions containing the busts of apostles whose names are inscribed nearby in Greek and are translated as: Andrew, Matthew, Paul the Apostle, Luke, James, Phillip, Mark, Thomas, John, Matthias, Peter, and Bartholomew. Unlike the Saint Menas icon, this image shows Christ as a diminutive figure on his mother's lap, a wise little man seated on the throne of Wisdom, his mother.

A more commanding presence is the apse painting from the Monastery of Apollo at Bawit, Egypt (**fig. 3.34**). The upper part of the apse depicts Christ in Majesty blessing and holding an open book displaying the text of the Trisagion, which is the Greek expression "thrice holy," derived from the Eastern Christian liturgy. He is flanked by the four apocalyptic beasts, symbols of the four Evangelists, from Ezekiel's vision, with personifications of the sun and moon and arch-

angels. Below Christ are the Virgin and Child with the Apostles, each holding a jeweled Gospel book. As on the Saint Menas icon, Christ is shown with darker features, yet the paintings share many of the standard features seen in other depictions of Christ enthroned. He displays the cruciform halo, holds a codex, and raises his right arm in benediction. The reference to the liturgy gives a local accent to the painting.

The fifth and sixth centuries are characterized by the experimentation that can be found in architecture, painting, and sculpture. Drawing upon the rich visual traditions of the fourth century, Christians borrowed and adapted many motifs from the secular world; in doing so, they created the foundation for hundreds of years of Christian iconography that expressed the faith, teachings, and hopes of the Church. Some of the inventions, such as the Giants Drowning in the Waters of the Deluge in the Ashburnham Pentateuch, would not survive; others, such as Christ in Majesty, would become a standard icon of Christian art.

PART TWO

THE BYZANTINE EMPIRE

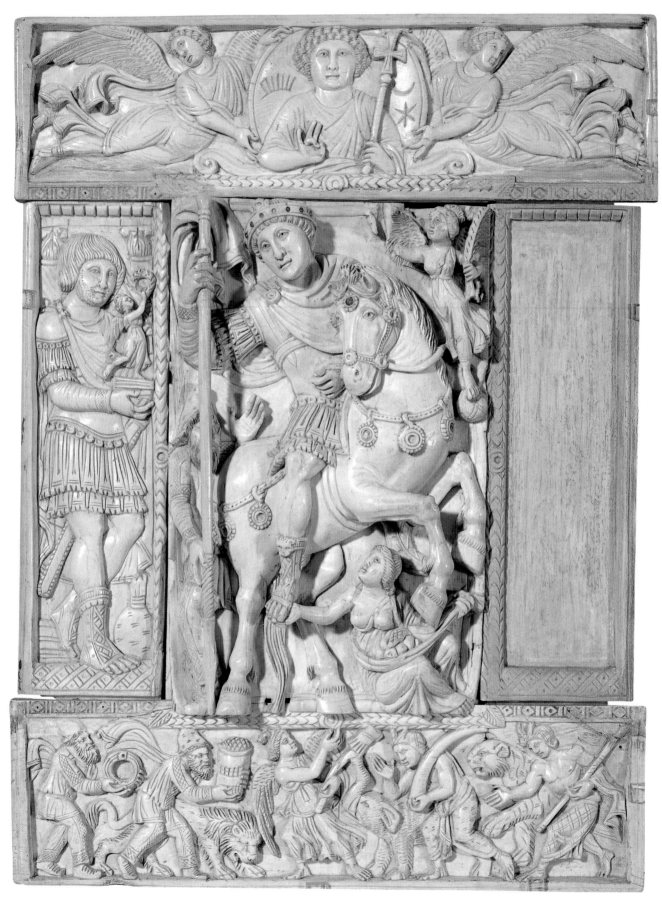

Fig. 4.1. *Justinian (?) as Defender of the Faith* (The Barberini Diptych). Leaf of an imperial ivory plaque, 14¼ × 11″. Mid-6th century. The Louvre, Paris

4

BYZANTINE ART BEFORE ICONOCLASM

THE BYZANTINE EAST

Constantinople, the "New Rome" consecrated by Constantine in A.D. 330, was devastated by civil riots in 532. Two opposing factions in the city, the Greens and the Blues, not only massacred each other, they also destroyed nearly half of the imperial city as well. The imperial palace, the Constantinian cathedral of Hagia Sophia, and the *martyrium*, the Holy Apostles (Apostoleion), as well as other religious structures, were razed. Justinian, emperor from 527 to 565, put down the revolt, and the restoration of the city and its famed churches commenced immediately. The new buildings erected by Justinian represent some of the most original and ingenious architectural accomplishments in Byzantine history.

Justinian was a shrewd administrator and a devout defender of the orthodoxy in Constantinople.[1] Convinced of his divine calling as leader of Church and State, the coregent of Christ on earth, Justinian instituted a policy that combined temporal and religious spheres into one, whereby the emperor ruled with absolute authority as a sacred monarch, a policy known as caesaropapism (emperor-pope). With his powerful military state sanctioned by the Church, Justinian sent out his armies to reconquer all Christian lands lost to invading barbarians and Persians on the fringes of the empire.

An ivory plaque, known as the Barberini Diptych (**fig. 4.1**), is believed by some to be a portrait of Justinian as defender of the faith, and while this identification is not certain, the elegant piece clearly displays Justinian's policies.[2] In the center, the triumphant leader, wearing a crown and posed in a lively manner on a rearing steed, plants his lance in the ground before a startled barbarian. Seated at the right is a goddess (Gaea or Terra) representing Earth. A tiny winged personification of Victory flies in at the top right. In the narrow plaque to the left, a military officer offers the emperor another trophy of triumph (the missing panel on the right presumably featured a second such figure). Below, in the horizontal plaque, appear the agitated figures of the conquered heathen and barbarians bearing gifts of tribute and accompanied by exotic animals that distinguish their territories, the lion and elephant of Africa, and the tiger of Asia. Another winged personification stands amid them and gestures upward to the conquering emperor.

Justinian secured the territories bordering the Mediterranean Sea. His armies drove the Goths out of Italy; they forced the Vandals to surrender North Africa and they pushed Persian invaders into the hinterlands of Asia Minor. The topmost panel of the Barberini Diptych illustrates the divine authority that appointed the emperor his special regent on earth. Two angels support an *imago clipeata* (circular portrait) of Christ blessing the leader. In 554, after reclaiming the Mediterranean Sea as part of the Roman Empire, Justinian issued a decree announcing, "We believe that the first and greatest blessing for all mankind is the confession of the Christian faith . . . to the end that it may be universally established . . . we have deemed it our sacred duty to admonish any offenders."

A complex bureaucracy administered Justinian's new empire efficiently, and the old code of Roman law, which had become encumbered and inefficient since the time of the Caesars, was studied and rewritten by capable scholars at

court in a new form, a body of civil law (*corpus jurus civilis*) known as the Justinianic Code that provided a model for legal systems throughout Europe. But it is Justinian's grandiose building programs that concern us. No less impressive than his institutions in administration and victorious military campaigns were the highly original structures that his architects created for the Christian church in Constantinople. Indeed, Church and state were both glorified and fused in his most astonishing undertaking, the rebuilding of the imperial cathedral, Hagia Sophia.[3]

HAGIA SOPHIA

Hagia Sophia dominates the landscape of Constantinople much as the great Parthenon does the skyline of the Acropolis (**fig. 4.2**). From the exterior it resembles a giant mass of interlocking geometric blocks rising rhythmically to a huge domed apex. But, unlike ancient Greek temples, this House of God overwhelms the viewer. There is no sense of human scale to mediate our confrontation with the huge building, and, furthermore, an even more awesome experience awaits us when we enter the structure.

The building of Hagia Sophia commenced immediately after the riots of 532 were quelled, and the final consecration took place only five years later, on December 27, 537. It seems clear that Justinian had in mind a grandiose project for his palace church from the start. Hagia Sophia was to be a monument to the glory of Church and state that would surpass all earlier churches, including the former basilica on the site, and was to outdo in grandeur even the famed Temple of Solomon, the Old Testament archetype of all Christian temples.

To accomplish this, Justinian appointed two learned scientists, *mechanopoioi*, to design and supervise the building. Anthemius of Tralles was an expert in geometry who specialized in theories of statics and kinetics. Isidorus of Miletus taught physics at the universities of Alexandria and Constantinople and was the author of commentaries on vaulting techniques. They were not builders but theoretical scientists, and this is unusual, considering the building practices of the time. The project was an extremely costly one. Thousands of workmen were brought in from all parts of the empire to labor in the brickyards; marble revetments and capitals were shipped in from workshops in the nearby Proconnesian islands, and marble columns were appropriated from Rome, Ephesus, and other Greek sites.

In plan, Hagia Sophia is a huge squarish rectangle (230 by 250 feet) augmented by two narthexes and a broad atrium (only a few foundations remain today) on the west, and a

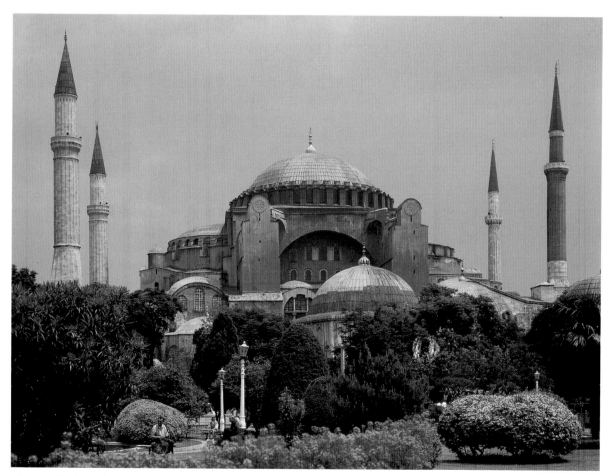

Fig. 4.2. Hagia Sophia, Constantinople. Exterior from the southwest. 532–37

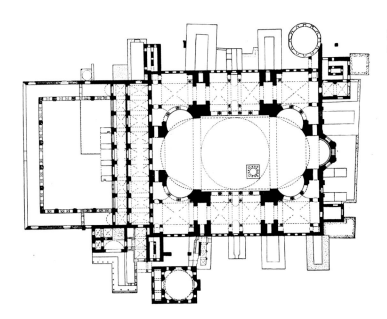

Fig. 4.3. Hagia Sophia, Constantinople. Plan (after Schneider)

single projecting apse on the east (**fig. 4.3**). Aside from this rudimentary alignment of parts, however, it little resembles the basilicas of earlier times. The nave, in fact, is totally dominated by the soaring dome over its center, a dramatic feature that interrupts the longitudinal flow of space commonly experienced in Christian basilicas (**fig. 4.4**). The directional focus toward the altar with its closed, tunnel-like projection of space is overwhelmed by the vast openness of spaces that rise and swel out and upward to the summit of the lofty dome (165 feet) in the very center of the building. Hagia Sophia has been described as a fusion of a hall basilica and a centralized double-shell structure.

Four giant piers, forming a square in the center approximately one hundred feet on each side, are joined by sweeping arches to create the base for the giant dome. The transition from a square plan to a circular base for the dome is accomplished by pendentives, great curved triangular sections built into the corners that rise from the arches of the square, upon which the dome rests (**fig. 4.5**). To the east and west the space descends from the central axis in scooped-out hollows formed by semidomes of exedrae, which, in turn, enclose the smaller half-domes of the diagonally placed conchs on the corners. This sequence of spherical spaces culminates in the apse on the east, and a vaulted passageway abutting the inner narthex on the west.

The north and south flanks are screen walls penetrated by arcades that open into the side aisles (three vaulted bays on each side). Galleries and a high clerestory with two rows of windows fill the arched shape of the upper walls. Any sense of solid wall on the north and south sides is thus lessened by the various openings—the nave arcade, the galleries, the windows in the clerestory—which are rhythmically articulated in units of 3–5–7 throughout. The lofty dome, penetrated by forty arched windows along its base, seems not to rest solidly on the pendentives but to hover above an aureole of lights, as if it were suspended from heaven (**fig. 4.6**). Even the giant piers

seem to dissolve into the fabric of the aisles, which in turn are amorphous and difficult to clarify spatially when viewed from the center of the nave.

How does one describe the dynamics of such an astonishing construction? Many theories have been proposed to explain the complex system of buttressing in Hagia Sophia. It has been suggested that the rippling semidomes on the east and west and the solid exterior piers on the north and south form the buttressing that holds up the dome. It has been argued that the central core of Hagia Sophia is raised like a giant, freestanding baldachino, and that the lateral spatial units, including the aisles, the narthexes, the galleries, conchs, and apse, are essentially unconcerned with the structure of the inner core and stand as independent architectural units. And yet there is no sense of an additive assembly of parts when standing in the nave. The whole seems indivisible and organic, leading one slowly through space from the summit downward in a centripetal fashion, giving the impression of being enclosed in an immense floating canopy of the heavens.

The enigma of Hagia Sophia can be partially answered by the building techniques employed. The weighty stone and concrete vaults and domes raised by the Romans over their giant structures would have required an entirely different disposition of foundations and walls. By the sixth century it was common practice to construct lighter vaults and domes with thin bricks embedded in mortar, thus reducing the problems of thrust and support considerably, and this type of construction was employed by Justinian's builders. The walls, vaults, and domes of Hagia Sophia were constructed of thin bricks forming a skin held up by four piers of sturdy ashlar construction. This allowed for greater flexibility in shaping the spaces to be enclosed. A variety of interlocking volumes expand outward from the inner shell—exedrae, conchs, and apse—resulting in a daring interplay of interior spaces.

To add radiance to the interior, colorful materials lined the walls and vaults. Porphyry and marble slabs—white, green,

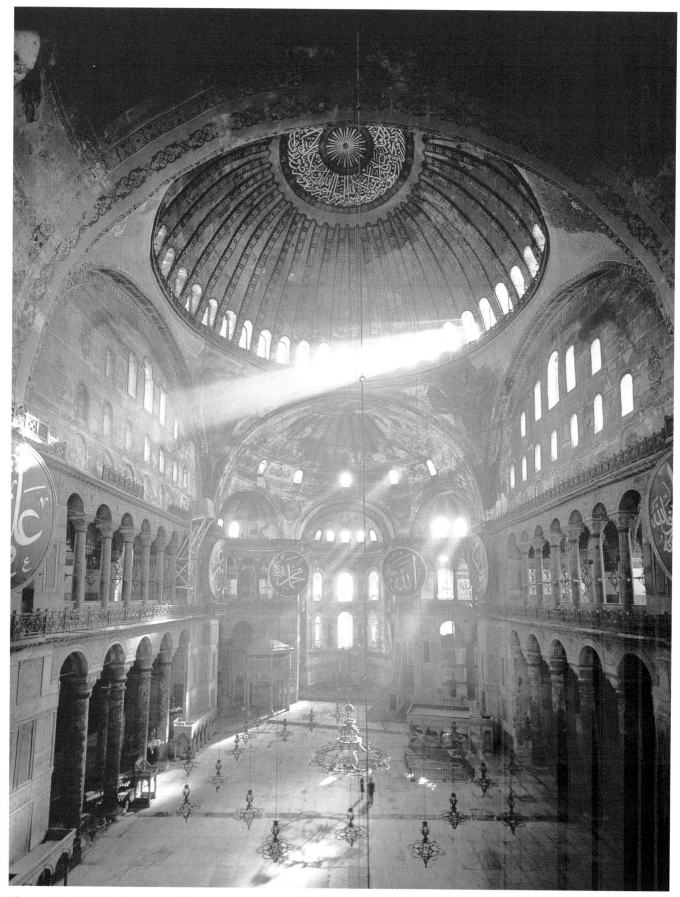

Fig. 4.4. Hagia Sophia, Constantinople. Interior toward the east

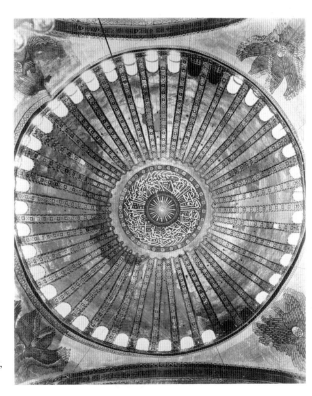

Fig. 4.5. Methods of supporting a dome: (a) *Pendentive.* The curved triangular section in the corner of a square bay that supports the dome. (b) *Squinch.* The half-conical niche built into the corner of a square bay, transforming it into an octagon suitable for supporting a dome

Fig. 4.6. Hagia Sophia, Constantinople. Interior, view into the dome. Height of dome 184′

yellow, and blue—served as revetments for the walls. The great dome was enriched with gold mosaics, and the windows were filled with colored glass. A new type of capital was employed that radically transformed the appearance of the architectural supports. The sculptural character of Classical capitals was discarded for one of patterned surfaces with deeply undercut acanthus leaves sprouting lacy tendrils that impose an organic quality on the simple blocky shape and spill over into the architraves as colorful friezes. Thus one enters an exotic, brightly colored world culminating high above with the splendor of a golden heaven. With the myriad shafts of light pouring through the windows at the base of the dome, an incredible sense of mystery is evoked. Hagia Sophia becomes a heaven under the heavens. It is not difficult to accept the report that Justinian, at the dedication of Hagia Sophia on December 27, 537, exclaimed, "Solomon, I have surpassed thee."

More than the quest for grandeur and celestial symbolism shaped Justinian's palace church, however. The complex liturgies of the Eastern church necessitated more clearly marked stations for the clergy, the emperor, and the laity.[4] Two impressive processions marked the opening of the services and, after the dismissal of the catechumens, the beginning of the Mass of the faithful: the Lesser Entrance and the Great Entrance. In the first, the Lesser Entrance, the celebrant (bishop or patriarch) and members of the clergy assembled in the narthex, where the emperor awaited them. The procession then moved through the royal door into the inner narthex and down the nave, passed the ambo or pulpit in the center, and finally along the *solea* (a path with low walls in the middle of the nave) to the door of the sanctuary. The emperor walked beside the celebrant into the sanctuary and presented his gift of gold, usually a paten or chalice, and then retreated to a special loge in the south aisle. The patriarch took his place high on the semicircular steps that formed the *synthronon*, or benches in the apse.

After readings from the scriptures by the deacon in the ambo and a sermon (homily) by the patriarch on the meaning of the words, the catechumens were dismissed. The Great Entrance (the Entrance of the Mysteries) followed, with a solemn procession led by the deacon, who brought the Eucharistic bread and wine to the altar from a small building outside the church. The clergy first received communion, then the faithful, who gathered before the sanctuary (men and women were apparently segregated during the service, the women in the north aisle and gallery, the men in the south). The emperor left his "royal box" and entered the sanctuary to receive communion directly from the patriarch. In later Byzantine rites, the Great Entrance was restricted to the interior of the church itself, which necessitated the addition of a special side chapel, the *prothesis*, on the north side of the apse, where the Eucharistic elements were prepared and stored. A second chamber, the *diaconicon*, on the south side, was used for vesting the bishop. Thus the typical Middle Byzantine church featured the familiar tripartite plan at the eastern end. At Hagia Sophia, however, a single apse projected from the sanctuary.

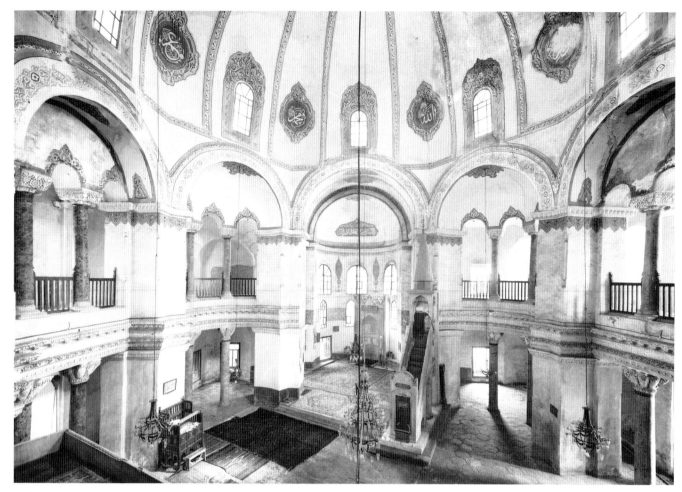

Fig. 4.7. Saints Sergios and Bakchos, Constantinople, c 525. Interior

JUSTINIAN'S CHURCHES IN CONSTANTINOPLE

Justinian's building campaigns extended from the desert lands in the Near East to northern Italy, but it was primarily in his capital, Constantinople, that innovations in architecture are to be found. His historian, Procopius, describes more than thirty churches in Constantinople (*The Buildings*), and of these, four seem to be related to Hagia Sophia in that they were domed and centrally planned. The famed Apostoleion was rebuilt in 536. The Greek-cross plan of the Constantinian structure was retained, with domes raised over the center and over the four arms of the cross, establishing a handsome building type that was frequently copied (compare San Marco in Venice, figs. 6.5–7).

Saints Sergios and Bakchos (**figs. 4.7, 4.8**), built in 525 alongside an earlier basilical church in the private residential area where Justinian lived before he was named Caesar, has been considered to be an experimental and miniature version of Hagia Sophia.[5] It features a double-shell plan with a dome, an octagonal core, and an ambulatory and galleries within a slightly irregular square. Very likely it was built as a private

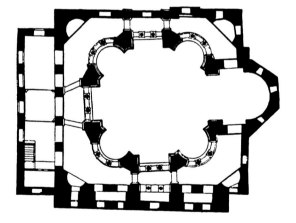

Fig. 4.8. Saints Sergios and Bakchos, Constantinople. Plan (after Dehio/Bezold).

palace church alongside a congregational basilica since the dedicatory inscription names Justinian and Theodora as founders. The construction is like that of Hagia Sophia, with vaults and dome built of light, thin bricks embedded in mortar. The capitals, too, are similar to those in Hagia Sophia.

THE FIGURATIVE ARTS

Were there figurative mosaics in Justinian's churches in Constantinople as there were in Rome? A ninth-century mosaic of the *Virgin and Child Enthroned* (**fig. 4.9**) was uncovered in the apse of Hagia Sophia with an inscription stating that "the images which the imposters [the iconoclasts of the eighth century] had cast down here, pious emperors have again set up."[6] The inference is that the post-iconoclastic mosaic replaced a pre-iconoclastic Virgin and Child. Other evidence of pre-iconoclastic figurative decoration is found in a room of the patriarchal palace adjoining the church, where medallion portraits of saints appear (their faces replaced by crosses and their names erased) and in a mosaic of the

Presentation of Christ in the Temple discovered in a walled-up area of the Mosque of Kalenderhane, originally a pre-iconoclastic church in Constantinople.[7] The latter, although only a fragment, displays stylistic affinities with mosaics in Thessaloniki dating from the seventh century. The possibility of figurative mosaics in Constantinopolitan churches of Justinian's reign should not be ruled out.

Indeed, under Justinian II (685–95), the cult of images reached an apogee. Under the authority of the Quinisext Council called by Justinian II at Constantinople in 692, many of the arguments in favor of representations of the Divine were articulated. One of the arguments, for example, stated: "Now, in order that perfection be represented before the eyes

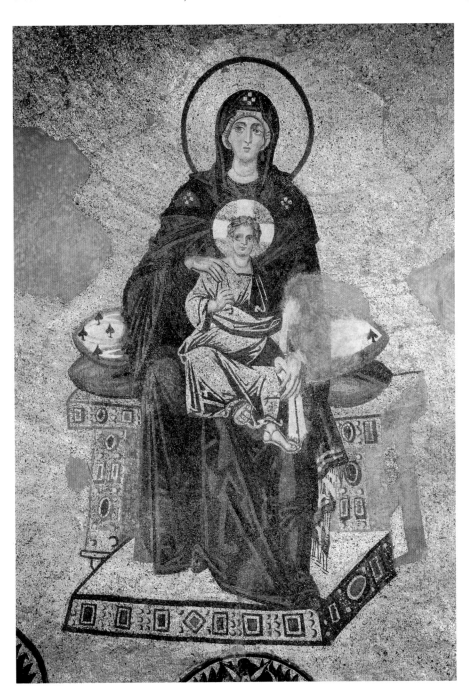

Fig. 4.9. *Virgin and Child Enthroned.* Apse mosaic in Hagia Sophia, Constantinople. Before 867

ABOVE **Fig. 4.10.** *Christ.* Gold coin of Justinian II (obverse), diam.¾″. Constantinople. 692–95. Byzantine Visual Resources, © 1987, Dumbarton Oaks, Washington, DC

RIGHT **Fig. 4.11.** *Portrait of Ariadne.* Ivory panel of an imperial diptych, 14⅜ × 5⅜″. Early 6th century. Museo Nazionale, Florence

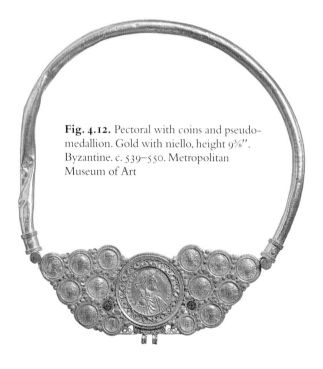

Fig. 4.12. Pectoral with coins and pseudo-medallion. Gold with niello, height 9⅜″. Byzantine. c. 539–550. Metropolitan Museum of Art

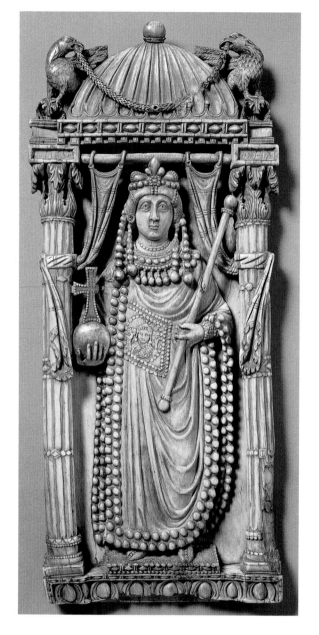

of all people, even in paintings, we ordain that from now on Christ our God . . . be set up, even in images according to His human character, instead of the ancient Lamb." Justinian II even had the likeness of Christ the Pantocrator (world ruler) stamped on his gold coins (**fig. 4.10**); this coin perhaps reflects the famous icon of Christ that was displayed on the Chalke Gate that led into the imperial palace in Constantinople. The representation of Christ is now similar to representations of the god Zeus, with a distant and forbidding countenance. The introduction of the Christ-Pantocrator on the gold coin meant that the imperial portrait had to take a secondary place on the reverse of the solidi.

That Constantinople was a major center for figurative arts is indeed demonstrated by the wealth of sumptuary arts, both secular and religious, that survive in the form of ivories and metalwork with portraits and narratives. Ivory was a precious medium highly valued for its fine grain that allowed for exquisite and minute detail in carving. A number of ivories with figurative designs served as covers for state and church documents in the form of diptychs.[8] Of similar high quality is the *Portrait of Ariadne* (**fig. 4.11**), an empress who died in 515. Here the abstraction is so advanced that Ariadne appears as a cult image, placed within an ornate baldacchino. She holds a scepter and an orb surmounted by a cross, and her body is richly adorned by beads, jewels, and other details of her precious imperial regalia.

An actual example of Byzantine jewelry is found in an imposing neck ring that may have been made for an aristocrat or general associated with the Byzantine court (**fig. 4.12**). The large central medallion, formed from two gold sheets

worked in repoussé, depicts an unidentified emperor on the front and a personification of a city, probably Constantinople, on the back. Gold coins were often worked into elaborate jeweled settings that displayed the likenesses of emperors and personifications.

Portraits are also found on the ivory diptychs that were made to commemorate the appointment of the consul of the year, a practice documented by the ivories from 406 to 539 (**fig. 4.13**). On such occasions, the consul presided in a special box in the hippodrome, where games were held in his honor (and at his expense). Anastasius, consul in 517, appears twice in hieratic isolation on a huge throne adorned with many attributes of his office. On the right-hand side, the arena below the throne is a diminutive arc crammed with heads of spectators and tiny, agitated performers battling lions. The surface is loaded with symbolic paraphernalia, including heraldic lions, personifications of victory, and imperial scepters. The consul's face is an oval mask with huge, staring eyes, and his elaborate costume is a rich pattern of rosettes and diamond-shaped ornaments. The consul is obviously not a portrait likeness of his physiognomy, but rather an emblem of his short-lived office.

A different style, a mode that seems astonishingly Classical when compared to the abstraction of the consular diptychs, also appears in many ivories. An ivory plaque, the largest surviving Byzantine example, portrays the Archangel Michael holding a staff in his left hand and a large orb in his right, surmounted by a jeweled cross (**fig. 4.14**). The size of the panel is so great that it exceeded the width of the tusk from which it was carved, resulting in angled corners on the left-hand side. The carving has a liveliness about it even though the placement of the winged angel in the elaborately carved porch is somewhat ambiguous. Michael's face is youthful and fleshy; his stance is casual; and his well-proportioned body is draped with softly falling folds of the tunic and pallium. A Hellenic radiance and grace distinguish this ivory figure from that of Anastasius, and the carefully modeled drapery, the delicately engraved lines of the hair and wings, and the well-defined facial features suggest that the carver was a court artist of the highest caliber. The Greek inscription at the top may be translated as: "Receive the suppliant before you, despite his sinfulness." The accompanying panel, now lost, may have depicted an imperial patron for whom the inscription petitions God's mercy.

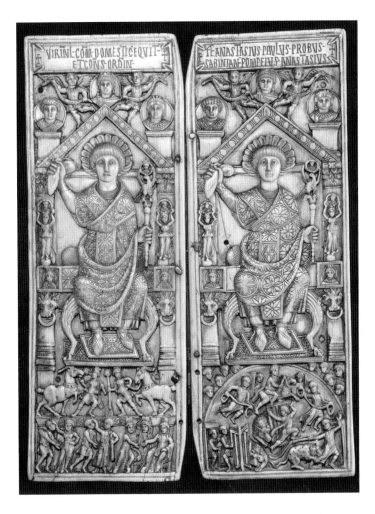

LEFT **Fig. 4.13.** *The Consul Anastasius.* Ivory diptych, each 14⅛ × 5⅛". 517. Bibliothèque Nationale, Paris

RIGHT **Fig. 4.14.** *Archangel Michael.* Right panel of an ivory diptych, 16⅞ × 5⅝". Early 6th century. British Museum, London

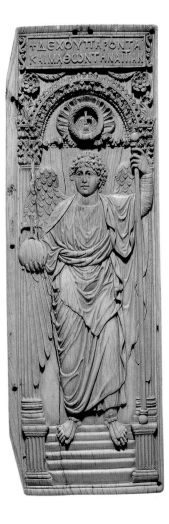

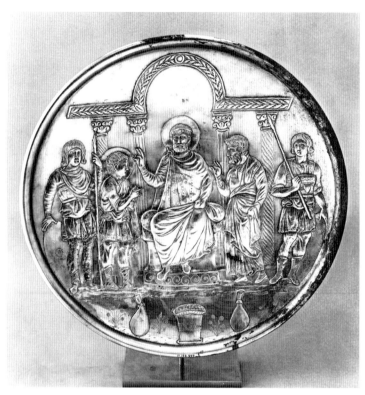

Fig. 4.15. *David Before the Enthroned Saul.* Silver plate from Cyprus, diam. 10⅓″. 610–41. Metropolitan Museum of Art, New York. Gift of J. Pierpont Morgan

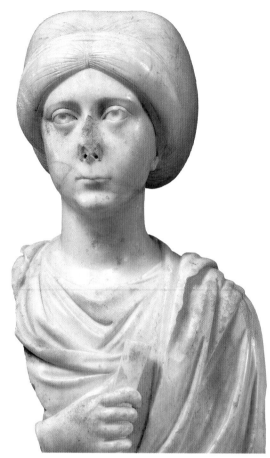

Fig. 4.17. Bust of a Lady of Rank. Probably from Constantinople. Marble, height 20⅞″. Byzantine. Late 5th–early 6th century. Metropolitan Museum of Art, New York

Fig. 4.16. Book covers from Sion Treasury. Front and Back. Gilded silver, 14½ × 11¾″; 14¾ × 10¾″. 6th century. Dumbarton Oaks, Washington DC

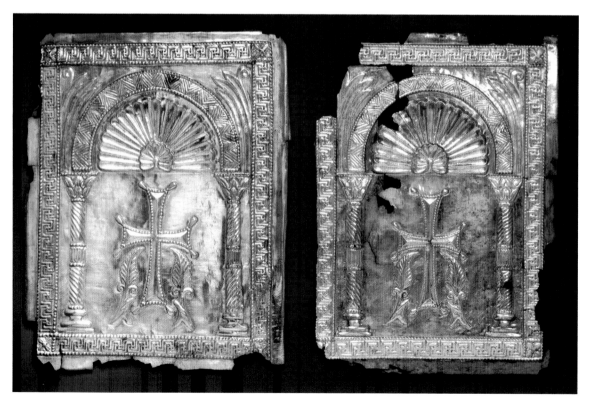

A ceremonial presentation such as that of the young *David Before the Enthroned Saul* (**fig. 4.15**) recalls that found in the Rossano Gospels. King Saul is enthroned, raising his right hand in a speaking gesture toward David. The arch surrounding Saul isolates his figure from David and the other courtiers. The figure on the right of a spear-bearer is in the Classical tradition that finds its origins in the art of the ancient Greeks. Only the haloes behind the heads of Saul and David indicate that the scene unfolding is Christian in content.

The David plate is but one of many silver patens that have been found in hoards. Silver goods represented two things: gifts that were lavished on the churches, and a type of gift that, in a time of crisis, could be used to save the community. One especially rich treasure hoard was found in Kumluca, Turkey, near the Monastery of Sion (**fig. 4.16**). The Sion Treasure contained over fifty objects of silver, ranging in value and artistic merit. Objects like the pair of silver-gilt book covers from the hoard are only a small indication of the wealth of objects that once adorned churches. Some of the church furniture in the treasure was stamped by officials from Constantinople, indicating that objects like the book covers were roughed out in the city, stamped for their quality of silver by an official, and then sent out for finishing and inscriptions that were specified by the patron. Due to the richness of the church hoards, patrons often gave the silver objects to their local church.

A personal glimpse into the world of Byzantine patronage can be found in the superbly carved portrait bust of a lady of rank, which presents a meditative woman with a compelling gaze (**fig. 4.17**). She holds a scroll, the symbol of an educated person; her long fingers draw attention to the scroll in her hand, indicating her pride in being recognized as among the educated elite in an era that prized learning for both men and women.

THESSALONIKI

Situated on the northeast coast of Greece, Thessaloniki was an important Aegean port and urban center in Hellenistic times. A Christian church was founded there in the first century, but after the emperor Galerius redeveloped the city in the early fourth century, building a hippodrome, a vast palace complex that included a huge circular mausoleum, and a triumphal arch, Christians were severely persecuted (c. 303–11). During the course of the fifth century, after Christianity had been restored as a state religion, Thessaloniki assumed an important role as a provincial capital, the seat of the prefect of Illyricum. At this time, too, the bishop of Thessaloniki served as head of

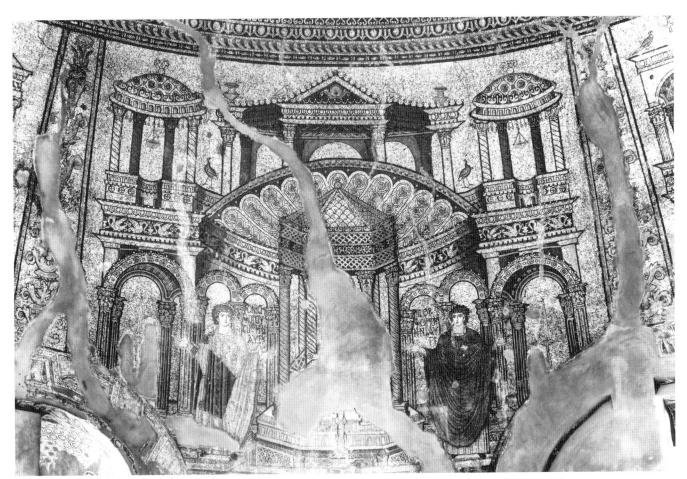

Fig. 4.18. *Saint Onesiphoros and Saint Porphyrios.* Mosaic frieze in dome in Hagios Georgios, Thessaloniki. 5th century

the churches in that area of the Balkans, but it is important to note that he was subject to the patriarchy of Rome, not Constantinople, until 732, when the Isaurian emperor Leo III annexed all bishoprics of Illyria to the patriarch of Constantinople. In the late sixth century, Thessaloniki was gravely endangered by roving tribes of Slavs and Avars. A plague devastated the city in 586, and these misfortunes created a spiritual atmosphere that was instrumental in the rise of the cult of saints, particularly that of Saint Demetrios, a third-century martyr.

Among the numerous churches built in Thessaloniki during the fifth century, two remain with substantial mosaic decorations intact. The rotunda that was to serve as the mausoleum or throne room of Galerius was converted into a church now known as Hagios Georgios (**fig. 4.18**), dating from about 450.[9] To the imposing domical structure were added chancel and apse with an ambulatory and a towered narthex that opened to the triumphal arch and palace of Galerius just beyond. The mosaic decoration that filled the huge dome, nearly one hundred feet in diameter, was unprecedented in Christian churches of the period. The lowest zone, which forms a sort of wainscoting or drum for the heavens above, is better preserved. It is divided into eight sections, with magnificent mosaics of fantastic architectural sets resembling great palace facades or theater fronts (*scenae frons*) with intricate niches, exedrae, aedicules, canopies, and towers serving as symbols of heavenly mansions. The gold light of the background shines through the giant elevations, imparting eerie qualities of weightlessness and transparency to them. Before each facade stand two or three tall saints posed

frontally as *orans*. Inscriptions identify them and record the dates of their martyrdom. While flat, frontal, and weightless, the martyrs are delicately stylized with fine lines to give faint patterns to their costumes, and their faces are slightly modeled. They seem to be idealized types of handsome young men.

Equally impressive but on a much smaller scale is the apse mosaic in a small chapel, known today as Hosios David, attached to the monastery of Latmos in Thessaloniki (**fig. 4.19**).[10] Here, in another variation of the *Maiestas Domini* theme, a youthful Savior appears enthroned on a rainbow within a radiant aureole. The partial figures of four winged creatures—the angel, lion, ox, and eagle (symbols of the four Evangelists, Matthew, Mark, Luke, and John, respectively)— issue from the bright glory, and below the feet of Christ rises a mound with the four rivers of paradise. An inscription on the scroll held by Christ informs us, "I am the spring of living water."

In the rocky terrain to either side appear two figures. One, to the right, sits comfortably holding the Gospels open on his lap as he gazes across the curvature of the apse to the apparition of Christ. Although traditionally identified as Habakkuk the prophet, this witness must be Saint John the Evangelist, whose text (Rev. 4) describes the vision. The other figure, turning away and standing in a cringing posture to the left, has been identified as Ezekiel, the prophet who had a similar vision of the *Maiestas Domini*, except that the animal guardians were tetramorphs (four-headed creatures) as they were represented in the *Ascension* miniature of the Rabbula Gospels (fig. 3.26). The mosaic seems to proclaim that the vision of godhead described by the Old Testament prophets,

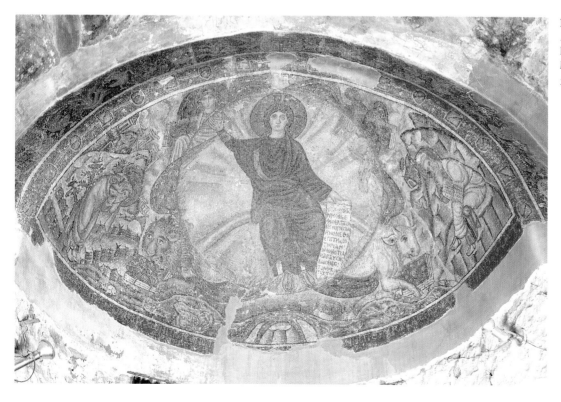

Fig. 4.19. *Maiestas Domini.* Apse mosaic in Hosios David, Latmos Monastery, Thessaloniki. 5th century

on which the Byzantine church relied, was the very same as that experienced by the New Testament Evangelist John, the favored source for the Latin church. The former hides his eyes from the glory; the latter views it contemplatively.

A third church in Thessaloniki, Hagios Demetrios, presents us with mosaics of a very different style and content in the form of *ex-voto* portraits of patron saints protecting the donors, who vowed to make donations to the church in times of need.[11] During the course of the sixth century, Thessaloniki suffered a number of disastrous setbacks, and it was the intercession of Saint Demetrios that saved the city, according to local legend.

The life of Demetrios is difficult to reconstruct, but it is generally believed that he was a member of a senatorial family and an officer in the army who was martyred by Galerius because of his Christian faith. During the troublesome years of the sixth century, with the Slavs and Avars pressing near the city walls of Thessaloniki by land and sea, Demetrios was adopted as protector of the city, and, according to a seventh-century text, *The Miracles of Saint Demetrios*, his popularity promoted an enthusiastic cult-following among the citizens. This, in turn, spurred on a new type of personalized devotion that had been gradually developing in the Byzantine world. A subtle transformation of the imagery in the church resulted, one in which the role of the picture was not to educate the worshipper but to offer him a direct confrontation with mysterious powers of protection and healing embodied in the image of the saint.

One of the better preserved mosaics in the now restored church of Hagios Demetrios portrays Demetrios embracing Bishop Johannes (left) and a city governor, Leontius (right) (**fig. 4.20**). All three men stand rigidly frontal, and below them an inscription records the mosaic as a donation: "You see the donors of the glorious house on either side of the martyr Demetrios, who turned aside the barbarous wave of barbarian fleets and was the city's salvation." On another face

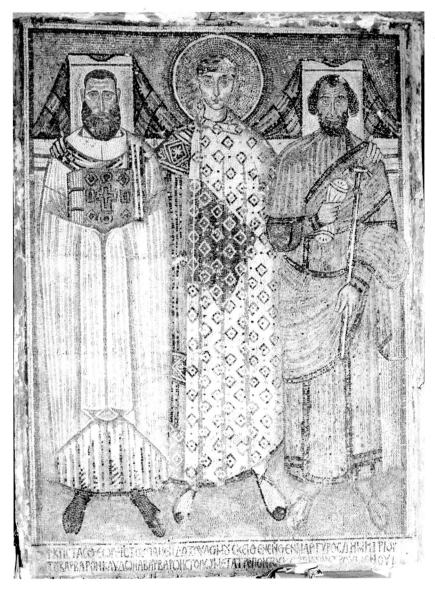

Fig. 4.20. *Saint Demetrios with Bishop Johannes and Prefect Leontius.* Mosaic on chancel pier in Hagios Demetrios, Thessaloniki. c. 650

of the chancel pier appears a companion saint (Bakchos?) standing between two boys who were presumably the sons of a donor placed in the protective custody of the martyr through eternity (**fig. 4.21**). The advanced abstraction in these images reminds us of the development of the hieratic portraits of saints in the apses of Roman basilicas. The tall proportions, the reduction of the bodies to flat carpets of surface patterns, the rigid frontality, and the imposing presence of these large figures, who fill the borders completely with little indication of a spatial setting, induce a mysterious response on the part of the worshipper.

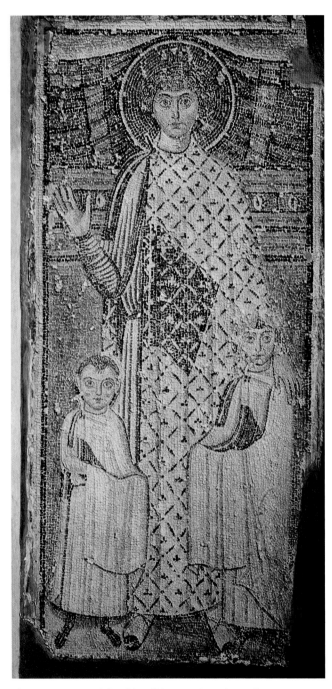

Fig. 4.21. *Saint Bakchos (?) and Two Boys.* Mosaic on the chancel pier in Hagios Demetrios, Thessaloniki. c. 650

How does one account for the startling abstractions in the portrait of the saint? Surely there is something more than inherent stylistic developments involved here, something that has created a new meaning for the image of man that these icons embody. In the writings of a sixth-century theologian, the so-called Pseudo-Dionysius the Areopagite, we can find an interpretation of the relationships between nature, man, and god that provides us with a partial answer. In his treatises *The Ecclesiastical Hierarchy, The Celestial Hierarchy*, and *Mystical Theology*, all matter and being are described as forming a ladder of essences that reaches from the most mundane and earthly through the animals, man, and angels of various categories, culminating in the pure spirit and essence of God. This image of the hierarchy of matter and spirit is basic to mystics of all ages and is ultimately derived from Plato's analogy of the cave.

The pure spiritual light of godhead shines forth at the top of the ladder of being, while lifeless, inert matter lies in darkness at the bottom. Man appears at the midpoint in this chain of being, a spirit imprisoned in an earthly body. But a saint is different. He is more spiritual in form, and to render the likeness of a saint, the artist must search for an image higher on the ladder of being than his human form provides. In his treatise *Mystical Theology*, the Pseudo-Dionysius writes: "This is my prayer . . . in the earnest exercise of mystical contemplation, abandon all sensation and all intellectual activities, all that is sensed and intelligible . . . thus you will unknowingly be elevated, as far as possible, to the unity of that beyond being and knowledge. By the irrepressible and absolving ecstasies of yourself and of all, absolving from all, and going away from all, you will be purely raised up to the rays of the divine darkness beyond being."[12]

The mosaic portrait can be interpreted in an analogous manner. The artist is to discard the physical and sensuous appearance of the saint. He is to reject the illusionistic devices of natural lighting, perspective, and modeling of the saint as an object in space by refining all fleshy matter until the saint becomes a transparent, weightless shell, until the body is distilled into a pure form to contemplate. The stillness and transparency of the portrait will then induce a quiet, hypnotic trance in the beholder.

The Pseudo-Dionysius does not discuss art, but we know that his mysticism was steeped in the writings of the pagan philosopher Plotinus (A.D. 205–70) and his school of thinking, known as Neoplatonism, a philosophy derived from the writings of Plato. In the *Enneads*, Plotinus provides us with an aesthetic basis for the arts in this mystical world of hierarchies.[13] The artist is not to create copies of natural objects, but to seek to portray the higher images: "How are you to see the virtuous soul and know its beauty? Withdraw into yourself and look alone . . . act as does the creator of a statue that is to be made beautiful: he cuts away here, he smoothes there, he makes this line lighter, this other purer, until a lovely face has grown upon his work . . . [You must]

bring light to all that is overcast . . . until there shall shine out on you from it the godlike splendor of virtue, until you see perfect goodness . . . in the stainless shrine" (*Enneads* I. 6.9).

Not only should the artist strive for an abstraction of matter and light, but also of space. Distance dims colors and blurs details. The artist should reject spatial illusionism and depict the object close at hand and in its fullest dimensions. Forms should not overlap or conceal one another, and their colors must be pure and bright, not shaded or diminished as forms seen in natural space and natural light. The eye should see pure color: "The eye, a thing of light, seeks light and colors which are the modes of light, and dismisses all that is below the colors and hidden by them as belonging to the order of darkness, which is the order of matter" (II. 4.5).

Plotinus further informs us that beauty of color is enhanced through symmetry of parts: "In visible things, as indeed in all else, the beautiful thing is essentially symmetrical, patterned" (I. 6.1). Finally, Plotinus writes that the viewer must participate intimately with the image and not merely observe it as a work of art indifferently. He should strive to identify with the image and go up the ladder of essence with it and participate in its world. The mosaic portrait of Demetrios engages viewers directly and stares hypnotically at them. Be silent, be still, lift yourself out of your body through the image: When you perceive this image, when you find yourself attuned to "that only veritable Light which is not measured by space, not narrowed to any circumscribed form nor again diffused . . . when you perceive that you have grown to this . . . you need a guide no longer" (I. 6.9).

Thus Plotinus provides us with four stylistic means for establishing the aesthetics of the Byzantine icon portrait. First, bring the object close to the viewer so that he may contemplate it unobstructed and fully; second, employ pure color to portray pure form, one that is not subjected to the breakdown of forms seen in the natural light of this lower world; third, order the pattern of pure color and the transparency of light into a symmetrical composition to assure its stability and permanence; and, finally, place the image in a frontal position so that it regards the viewer directly, inviting him to participate in its goodness and purity. The icon portrait, in contrast to those of Late Antiquity (or the Renaissance of the fifteenth century), displays an imposing frontality and regards us directly. We shall return to some of these ideas in the next chapter.

MOUNT SINAI

A different kind of abstraction appears in the apse mosaic that Justinian had placed in the church in the Monastery of Saint Catherine on Mount Sinai (**fig. 4.22**).[14] As with many churches in the distant provinces, Justinian's building program was primarily focused on providing fortifications to secure them. To the Monastery of Saint Catherine he added massive walls and installed housing for a garrison of soldiers to protect the isolated monastery from desert nomads. The church itself, dedicated to the Virgin, according to Procopius, was of local provincial construction, and to enrich the basilica Justinian sent artisans from Constantinople or some other Byzantine

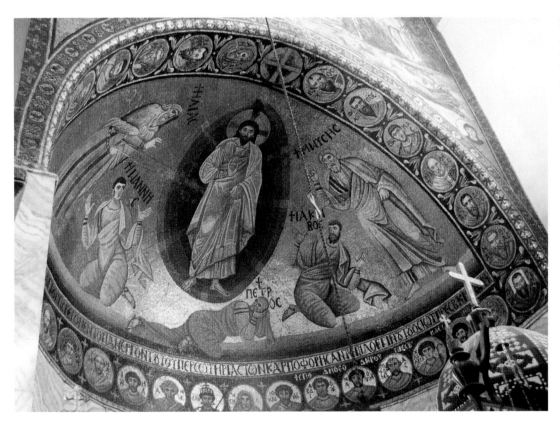

Fig. 4.22. *Transfiguration.* Apse mosaic in the church of the Monastery of Saint Catherine, Mount Sinai. c. 550–65

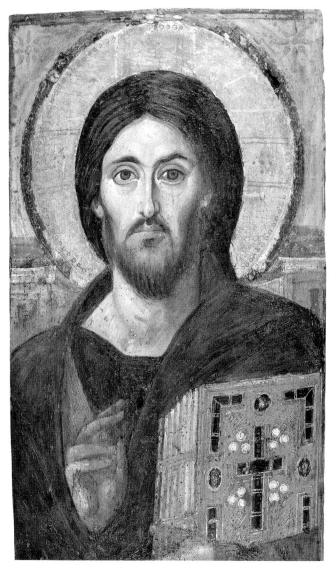

Fig. 4.23. *Christ.* Tempera and gold on panel, 34 × 17⅞″.
c. 700. Monastery of Saint Catherine, Mount Sinai

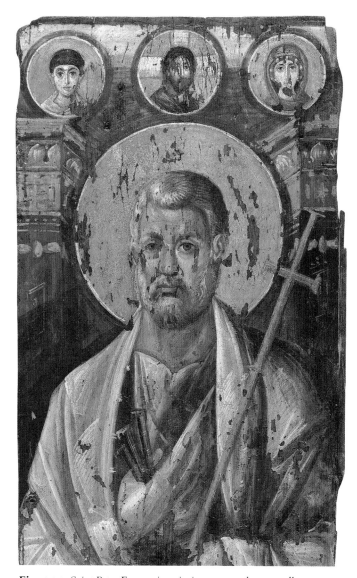

Fig. 4.24. *Saint Peter.* Encaustic painting on panel, 34 × 21″.
Early 7th century. Monastery of Saint Catherine, Mount Sinai

center (Gaza?) to provide it with a sumptuous apse mosaic. The theme of the Transfiguration had special meaning for Mount Sinai since it was on this very site that Moses received the tablets of the Law from the Lord—where divinity was revealed to him.

In some respects, the general design of the mosaic brings to mind the slightly earlier presentation in the apse of Saints Cosmas and Damianus in Rome. The corporality of all the figures is vigorously presented. Indeed, the bodies of the gesticulating apostles, who "fell on their face" before the vision of the divine Christ, are given considerable bulk through modeling. The full-bodied Christ fills the blue mandorla, and the attending Moses and Elias (Elijah) are tall, pillar-like forms with a weighty presence. Yet abstractions are clearly evident in the setting and general arrangement of the figures. Where, one might ask, is the "high mountain apart," an important aspect of the iconography? The background is

solid gold, with only thin bands of green and yellow at the base to serve as a vague ground for the figures.

Among the other treasures of the monastery on Mount Sinai are hundreds of icons painted on panels, dating from the sixth through the nineteenth century. Icons were mostly painted on a wooden panel prepared with a thin layer of plaster, or on material stretched over the panel, or even directly on to the bare wood. The surface was then coated with a layer of paint on which the outline of the composition was incised with a sharp tool. Successive layers of paint were then applied, starting with the background color, then the swathes of drapery, and lastly the flesh tones of the face and hands. The pigments were typically made using natural materials, usually earth colors, which were combined with a binding agent of egg, though the encaustic technique of using melted wax as the vehicle for the pigments was employed in some early icons of the sixth and seventh centuries.

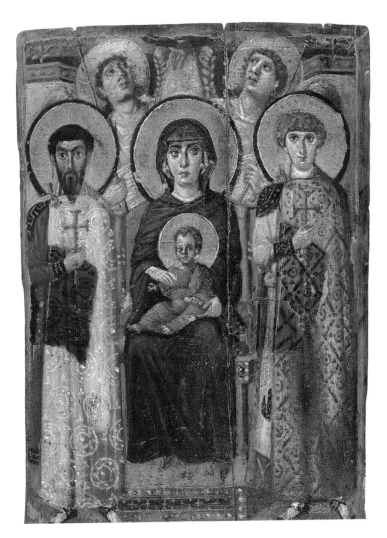

Fig. 4.25. *Virgin and Child Enthroned with Angels and Saints.* Encaustic painting on panel, 27 × 19⅜″. Early 7th century. Monastery of Saint Catherine, Mount Sinai

One of the earliest icons to survive, the image of Christ combines the Classical tradition with an image of Christ Pantocrator (**fig. 4.23**). Like the Justinian II coin, this icon may be a copy of the mosaic icon of Christ that decorated the Chalke Gate in Constantinople. A sense of three dimensions created by olive green brushstrokes gives the illusion that a light source from the right throws into shadow the left side of Christ's neck. The enlarged, slightly asymmetrical eyes suggest an idealized interior spirituality, filled with wisdom and serenity beyond human understanding. The icon portrays the ideal type of Christ with the great gold halo framing his features. The exedra behind the figure and the progressively deepening shades of blue in the sky are remnants of Classical means of framing the figure and of creating the illusion of spatial depth.

Saint Peter is placed before a similar architectural background (**fig. 4.24**). The icon's large format (36½ inches by 21 inches) allows for the addition of three busts in roundels in the upper part. A bust of Christ occupies the central roundel, with the Virgin on the right and a youthful figure, probably Saint John, on the left, thus creating a type of *Deësis* that became institutionalized in Byzantine art. The dignified figure of Saint Peter shares similarities of composition, modeling and a correspondingly impressionistic use of color with the bust of Christ, although the roundels show a more linear treatment of drapery. The features of Saint Peter are also marked by asymmetry, employing a facial type that had become standardized in the fifth and sixth centuries.

The final icon from Mount Sinai shares similar traits to the Coptic textile icon of the Virgin and Child with Saints (**fig. 4.25**). In this wooden panel, the Virgin and Child are also enthroned and flanked by Saints George and Theodore, while behind them two angels strain their necks to look toward the heavens. Less classicizing in style, the artist created a regular and balanced composition in the march of the three halos across the wooden surface. The Virgin's is accented by the halo of the Christ Child seated on her lap. The various gazes of the figures convey an important message. The angels look toward the heavens to indicate the rewards of the Christian life. The Virgin and Child look beyond the viewer; the Virgin in sorrow for the events that will take her son from her, and the Child in anticipation of his sacrifice. The saints, however, look directly to the viewer, since they are the conduits to approach the divine and attain heaven.

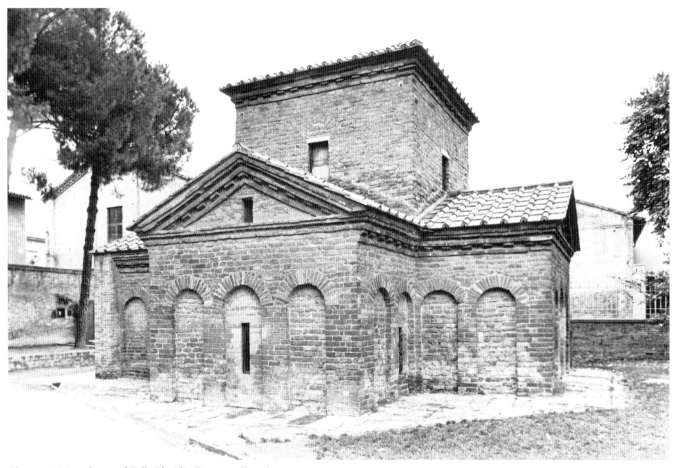

Fig. 4.26. Mausoleum of Galla Placidia, Ravenna. Exterior. c. 425–50

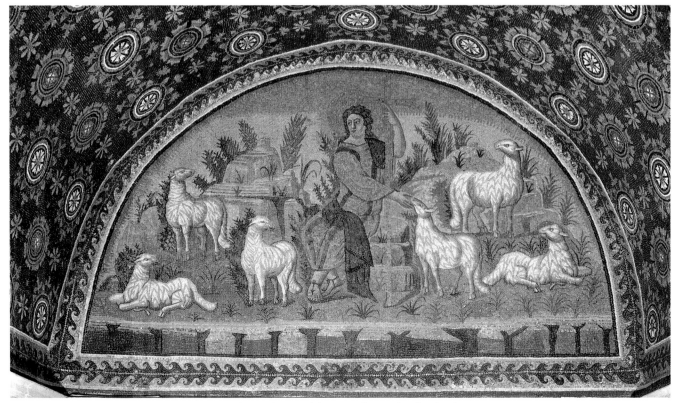

Fig. 4.27. *The Good Shepherd.* Lunette mosaic in the north arm of the Mausoleum of Galla Placidia

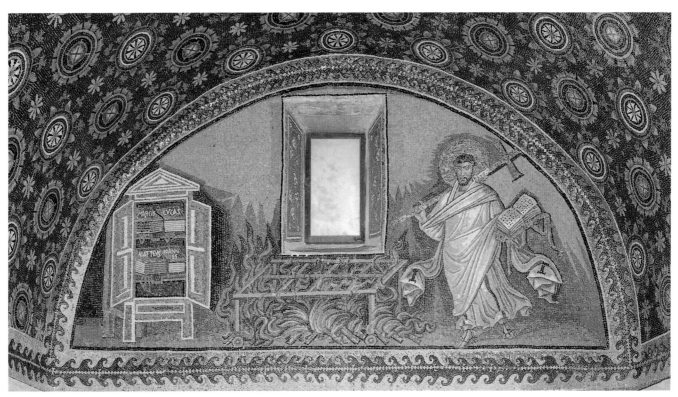

Fig. 4.28. *Saint Lawrence*. Lunette mosaic in the south arm of the mausoleum of Galla Placidia, Ravenna

RAVENNA

Situated in an inlet on the Adriatic coast below Venice, Ravenna has, from earliest times, impressed visitors as a strange and exotic city. In the fifth century, Gaius Apollinaris Sidonius described Ravenna as "a marsh where all the conditions of life are reversed, where walls fall and waters stand; where towers float and ships stand still; where invalids walk and their doctors take to bed . . . where merchants shoulder arms and soldiers haggle like hucksters, where eunuchs study the arts of war and barbarian mercenaries study literature."[15]

In A.D. 402, Honorius, the son of Theodosius the Great, moved the capital of the western empire from Milan to Ravenna. Following his death in 423, his sister, Galla Placidia (424–50), the benefactor of Pope Sixtus III in Rome, initiated an ambitious building program in Ravenna centered about the palace church of Santa Croce that included a mausoleum (and chapel dedicated to Saint Lawrence) that stands intact today (**figs. 4.26–28**).[16] The mausoleum is laid out on a Greek cross plan with barrel vaults over the arms and a central dome on pendentives. The exterior design with blind arcades framing the windows and the masonry with thick bricks and narrow mortar joints point to Milanese workmanship, as is to be expected. The decoration of the interior, on the other hand, is surprising in its lavishness, giving a glimpse into the richness of Byzantine mosaic decoration.

The floor of the small building has been raised some five feet since the fifth century, and the intimacy one feels in being so close to the mosaics in the vaults and dome is deceptive. The mausoleum is a glistening box, with blue and gold mosaics covering the entire interior above the walls (which are sheathed in marble), including the lunettes that terminate the arms. The vaults on the north-south axis are decorated with splendorous golden stars shining out from a rich, deep-blue background; those on the east-west axis have elegant golden tendrils set against the blue. A golden cross and busts of the Apocalyptic symbols appear in the deep blue of the dome, while four pairs of apostles, flanking alabaster windows, decorate the upper walls of the central bay. The lunettes in the arms display scenes that carry us back to the repertoire of Early Christian funerary arts with two (east and west) decorated with stags, standing amid rich overgrowths of tendrils, drinking from the life-giving waters of paradise. The lunette over the entrance in the north arm has the Good Shepherd tending his flocks; that in the south presents a curious representation of Saint Lawrence, his grill aflame, and an open bookcase at the left displaying the four Gospels.

The Good Shepherd, however, is not to be confused with the ordinary bucolic figures found in the catacombs. He is garbed in brilliant gold and purple and holds a tall golden scepter, a reminder that the humble shepherd of the catacombs has become a young prince of the imperial family.

The so-called Orthodox Baptistery (San Giovanni in Fonte) in Ravenna was built at the end of the fourth century in the form of a high octagonal structure with four shallow

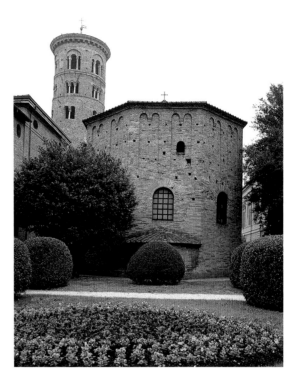

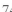

ABOVE LEFT **Fig. 4.29.** Orthodox Baptistery, Ravenna. Interior. 450–60

ABOVE **Fig. 4.30.** Orthodox Baptistery, Ravenna. Exterior

LEFT **Fig. 4.31.** Orthodox Baptistery, Ravenna. View into the dome

niches (**figs. 4.29–31**). The octagonal shape of the building is derived from imperial mausolea, such as Diocletian's Mausoleum in Split. In Christian thinking, the number eight was associated with the Resurrection, thus the baptistery combines the concepts of death and rebirth. This is particularly fitting since Christians believed that one died to the world in the waters of baptism and was reborn into the Church. One's physical death was not to be mourned because it was merely a moving on to the promises of heaven. In fact, saint's days were celebrated on the day of their death, not their physical birth.

After Ravenna was elevated to an imperial residence, a remarkable transformation took place in the remodeling of the interior by Bishop Neon, sometime between 450 and 460.[17] The timber roof was replaced with a light dome constructed of hollow tubular tiles set in concrete, and the entire superstructure was lavishly lined with mosaics and stucco niches. One is immediately aware that this is a baptistery. The font is huge, and the summit of the dome is brightened by a scene of the Baptism of Christ set against a golden background.

The mosaics of the Orthodox Baptistery rise in concentric bands with a combination of solid architectural foundations, serving as a base for the heavens above, and figures of saints placed in a terrestrial landscape. There are major differences in the conception of figures in space, however. The lower zone is partitioned into eight divisions with alternating representations of altar tables carrying Gospels and jeweled thrones resembling the "prepared thrones" for Christ's Second Coming that are found in Early Christian Rome. Elaborate candelabra grow from the lower pendentives into this band, further marking the eight divisions.

Instead of portraying frontal saints before the architectural base, as at Hagios Georgios (fig. 4.18), the Ravennate mosaicist lifted the figures into the upper register and placed them on a shallow landscape stage set against a blue background. The twelve apostles are depicted as figures moving in

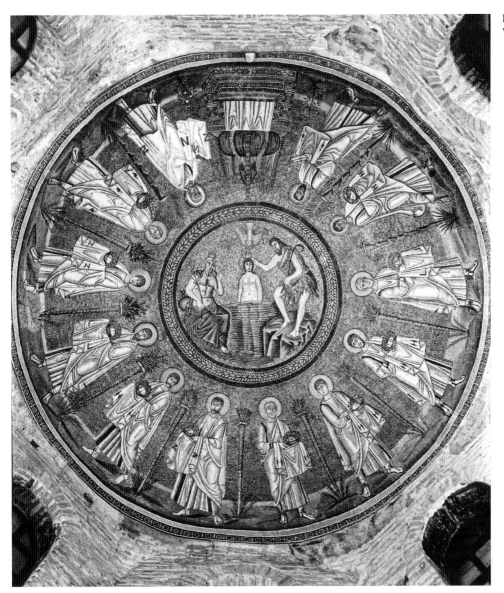

Fig. 4.32. Arian Baptistery, Ravenna. View into the dome. c. 500

procession about the dome. They are isolated by the alternating colors of their mantles, white and gold, and more emphatically by the floral candelabra that rise between them. The disjunction between the eight spokes of floral divisions in the lower zone and the twelve in the upper disturbs any sense of spatial continuity or illusionism, however.

A further change of style can be seen in the procession of apostles in the dome of the Arian Baptistery (**fig. 4.32**), dating from about 500, built by the Ostrogothic king Theodoric. Unlike Orthodox Christians, Arians do not believe in the Trinity. To their understanding, Christ and God the Father do not share a single essence or nature. In the Arian Baptistery, the figures, flattened and frozen in their poses, are mechanically aligned against a stark golden background. The colorful and complicated pattern of the decorations in the Orthodox Baptistery is reduced to a simple repetition of white silhouettes separated by palm trees against the expanse of gold. The lower register with altars and thrones is eliminated. This heightened abstraction has been attributed to the tastes of the new patrons, the Arian Ostrogoths, but the matter is more complex.

The disintegration of the Roman Empire in the West during the later fifth century is difficult to assess. Theodoric the Great (454–526), king of the Ostrogoths (eastern Goths), is the principal actor in Ravenna's part of this drama. Taken as a hostage in his youth, Theodoric was educated in Constantinople. At the age of eighteen, he was sent back to rule over his people in the area north of the Black Sea. The Byzantine emperor Zeno next sent Theodoric and his restless tribes on a campaign to quell barbarian encroachments on the frontiers. Between 487 and 493, Theodoric led hordes of Ostrogoths into northern Italy to drive out the usurper Odoacer. Odoacer capitulated at Ravenna in 493, and Theodoric set up his newly won empire there.

Some historians have seen Theodoric's short-lived reign as a blessing for the West, and in terms of economic recovery, religious tolerance, and cultural revival in Italy, this is true. In some respects, Theodoric acted as a vice-regent of East Rome, Byzantium, but it is clear that he wanted to establish the autonomy of his western empire. Aside from the dangers posed by his political ambitions, Theodoric's rule had a serious flaw in the eyes of the empire. He was an Arian Christian, and while Theodoric himself was very tolerant of the beliefs of others, he could never reconcile his Arian faith with the orthodoxy of the Roman and Byzantine Churches, and he established his own Arian Churches in Ravenna.

Theodoric's Mausoleum is a curious mixture that reflects this king's background and life (**fig. 4.33**). The centrally planned structure consciously emulates and adapts Classical forms of imperial, domed, rotunda mausolea. An enormous single slab of stone, weighing 300 tons, provided the shallow dome; this monolithic stone was imported from Istria. Around its circumference are twelve rectangular loops inscribed with the names of the apostles (**fig. 4.34**). These

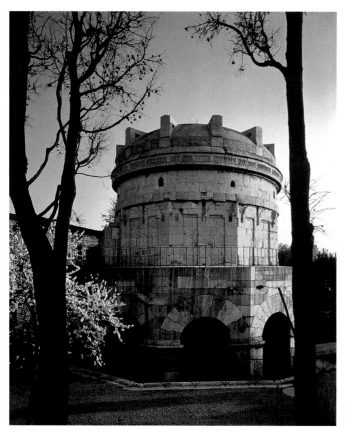

Fig. 4.34. Mausoleum of Theodoric, Ravenna. Exterior

Fig. 4.33. Mausoleum of Theodoric, Ravenna. c. 526

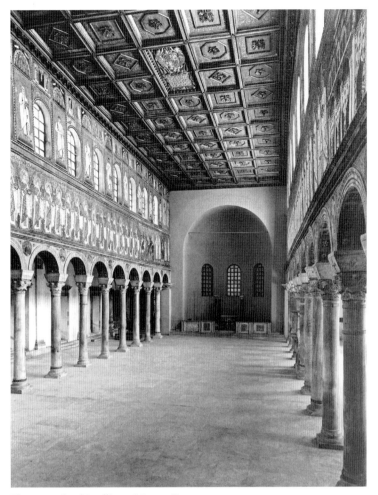

Fig. 4.35. Sant'Apollinare Nuovo, Ravenna.
View of nave toward the east. c. 500

with blind arcades. In contrast to the brick used elsewhere in Ravenna, huge blocks of ashlar without mortar were used in a stone construction conforming to Roman practice. A two-story structure, the lower floor served as a funerary chapel, while the upper housed the sarcophagus, which was a porphyry bath.

The palace church of Theodoric in Ravenna was originally dedicated to "Our Lord Jesus Christ" (rededicated to Saint Martin after the Byzantine occupation in 539, and then to Saint Apollinaris in the ninth century). Presently known as Sant' Apollinare Nuovo, it is one of the most memorable monuments in Ravenna.[18] The structure is a simple basilica in plan and elevation without projecting transept arms, and the building techniques conform to Milanese practices.

The entire elevation of the nave above the arcade is filled with rows of figures seen against golden backgrounds (**fig. 4.35**). As in Christian basilicas in Rome, these decorations are arranged in three horizontal zones, but the selection of themes in each departs considerably from the norm and reflects Theodoric's Arian interests. The walls between the windows in the clerestory form a portrait gallery of white-robed authorities of the Old and New Testaments, thirty-two in all, who stand in frontal positions. They hold either books (apostles) or scrolls (prophets and patriarchs). This follows the program of Roman basilicas, but in the blank zone between the clerestory and the nave arcade, where biblical narratives usually appear, a stunning procession of male and female martyrs, slightly taller than the figures in the clerestory, moves from the entrance toward the altar on either side. On the left, twenty-two female martyrs, elegantly attired, proceed rhythmically from diminutive representations of the port of Classe to the enthroned Virgin and Child (with the three Magi) near the altar (**fig. 4.36**).

projections may have served as handles to lift the block. The ornamental frieze around the dome is composed of stylized round-headed pincers, a design that repeats standard Ostrogothic jewelry. The lower floor is a decagon that serves as a foundation for the circular upper floor, which is articulated

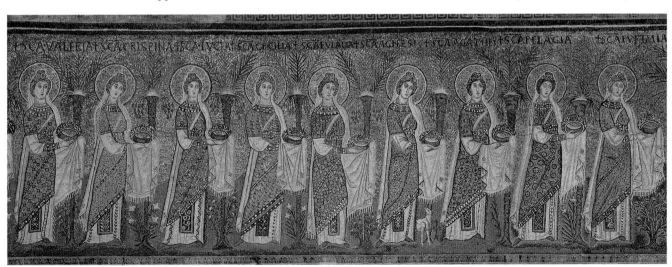

Fig. 4.36. *Procession of Virgin Martyrs*. Mosaics on the north wall of the nave of Sant'Apollinare Nuovo, Ravenna. c. 500. Detail

On the right, twenty-five male martyrs in white march slowly from the *palatium* (palace) of Theodoric to Christ enthroned between angels opposite the Virgin (**figs. 4.37, 4.38**). Curiously, the narrative scenes—all New Testament stories—are lifted to a narrow band between the clerestory and the ceiling, where they alternate with decorative panels of shell canopies that serve as frames for the apostles and prophets below.

When the Byzantines took Ravenna from the Ostrogoths in the middle of the sixth century, remodelings were carried out in order to convert Theodoric's "Arian" mosaic programs to ones acceptable to the Orthodox Church. To what extent this meant replacing large expanses of the earlier mosaics is a matter of some debate. The figures of Theodoric and his court that formerly appeared in the portals of his *palatium* (outlines of some figures are still visible) were surely expunged by the Byzantines, but would it have been necessary for them to replace the two processions of martyrs? It has been argued that the present rows of saints are Byzantine and should date from about A.D. 550–60. The leader of the male martyrs, Saint Martin (who was not in fact a martyr but a popular warrior against the Arians in northern Europe), is clearly a replacement made for the rededication of the church to him.

But are these handsome figures Byzantine in style? They are very like the apostles in the Arian Baptistery, and if one compares them to figures in mosaics in Byzantine churches in the East, a number of significant stylistic differences are apparent. To be sure, they show a similar state of abstraction with their bodies reduced to weightless patterns of color, but these martyrs are not icons in the strict sense of the term. They are not individualized, nor are they placed in rigid frontal poses. Only the inscriptions give them identities (Agnes, however, is accompanied by a lamb), and they simply form a melodic sequence of anonymous saints that fill the House of the Lord as they bear their gifts, crowns of martyrdom, to Christ at the altar.

The beautiful abstraction of these weightless saints floating against a brilliant gold background of the heavens can best be studied in the female martyrs. They are all sisters of one family with nearly identical facial features and coiffures. Only subtle variations are introduced to establish a cadence in their movement. Every third or fourth figure slightly tilts her head; the right hands are alternately veiled and free; the linings of the crowns they carry change from red to green to red. Even the rudimentary paradise landscape partakes of this subtle rhythm. The palm fronds form a pattern of green-blue-

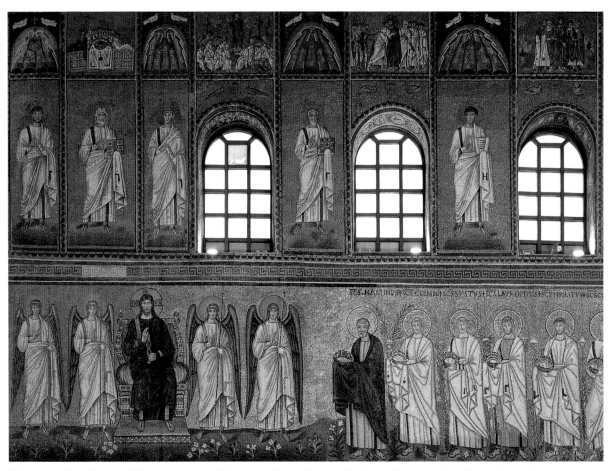

Fig. 4.37. *Christ Enthroned Between Angels and Procession of Saints* (below); *Prophets and Apostles; Gospel scenes* (above). Mosaics on the east end of the south wall of the nave of Sant'Apollinare Nuovo. c. 500 (alterations c. 550–60)

green, then one of blue-green-blue; below, white lilies alternate with red roses.

The New Testament narratives in the topmost register alternate with conchs (**fig. 4.39**).[19] Those on the left illustrate thirteen individual episodes from the ministry of Christ; those on the right, thirteen scenes from the Passion. The treatment of the figures and space in the narratives is similar to that of the saints and prophets below. There is little movement or drama in the stories. Only slight variations appear in the poses and postures. The compositions are simple designs often displaying a symmetrical grouping of the figures, forming simple color shapes. The draperies, with their bold outlines, are set against gold backgrounds, a style that can only be characterized as Ravennate, neither Roman nor Byzantine on the whole.

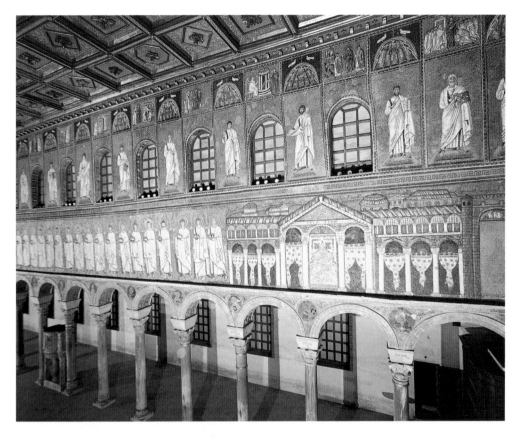

Fig. 4.38. *Theodoric's Palace.* Mosaic on west end of the south wall of the nave of Sant'Apollinare Nuovo. c. 500 (alterations c. 550–60)

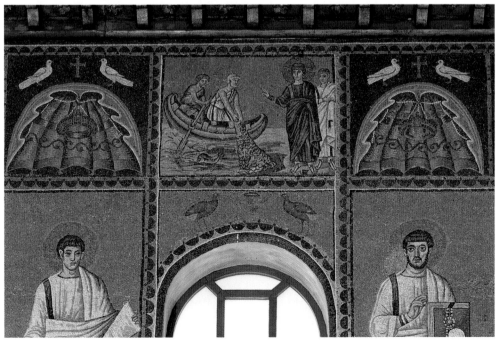

Fig. 4.39. *Calling of Peter.* Mosaic in upper register of the north wall of the nave of Sant'Apollinare Nuovo. c. 500

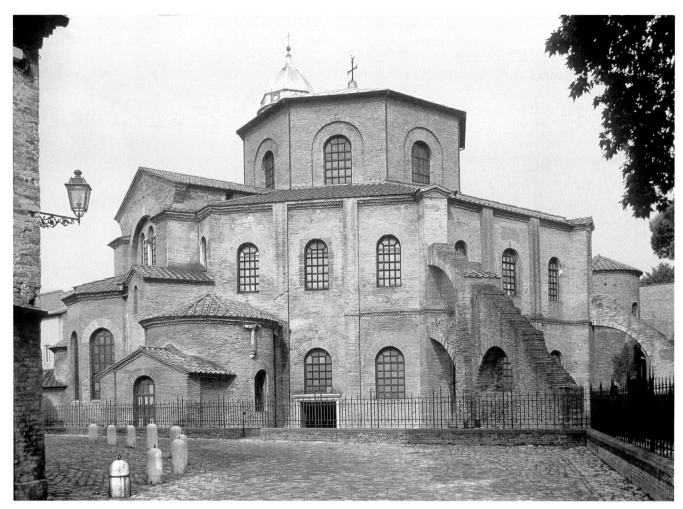

Fig. 4.40. San Vitale, Ravenna. Exterior. Completed 546–48

San Vitale (**figs. 4.40–47**) was founded by Bishop Ecclesius in the last years of Theodoric's reign (d. 526).[20] The construction was delayed, however, and the monograms on the capitals of the ground floor indicate that the building was constructed during the tenure of Bishop Victor (538–45). Furthermore, mosaics in the sanctuary state that the sumptuous decorations there were completed about 546–48, when Maximianus was archbishop and Ravenna was the exarchate of the Byzantine world under Justinian. The ground plan is closely related to that of Saints Sergios and Bakchos in Constantinople (c. 525–35), and column shafts and capitals were imported from the marble workshops of the capital in the Proconnesian islands. Like its Constantinopolitan model, San Vitale is raised on an octagonal, double-shell plan with ambulatory, galleries, and semicircular niches on the sides. The apse projects from a square chancel (**fig. 4.41**).

Local craftsmen were employed, and the building techniques are those of northern Italy. The dome is constructed of hollow tubes inserted into each other and set in mortar (compare the Orthodox Baptistery). Other features that

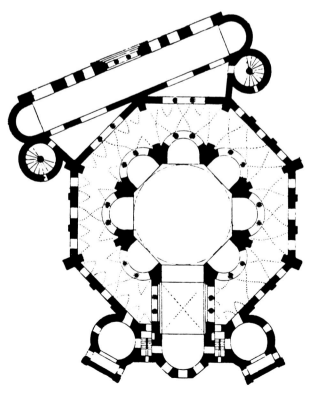

Fig. 4.41. San Vitale, Ravenna. Plan (after Dehio/Bezold)

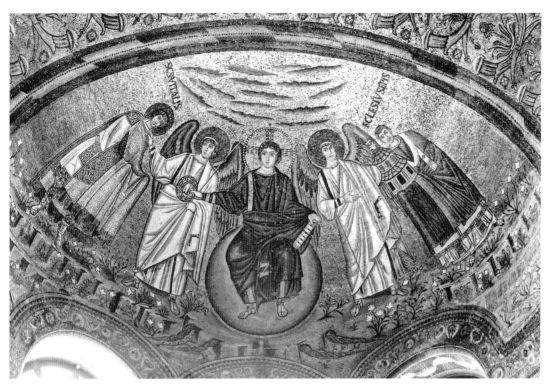

Fig. 4.42. San Vitale, Ravenna. View into apse. Completed c. 546–48

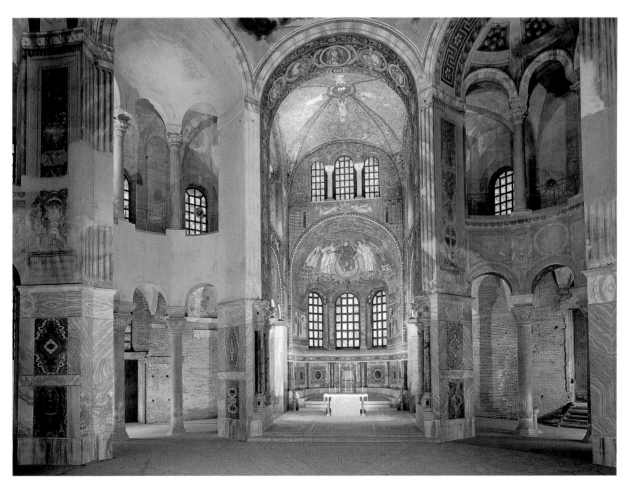

Fig. 4.43. San Vitale, Ravenna. Interior

suggest indigenous building practices are the clarity of the polygonal units when viewed from the exterior, and the rather lofty proportions of the interior, with large windows in the ambulatory, galleries, and dome, creating an aureole of bright light about the central core. A long, shallow narthex, terminating in towers, is set off axis on a side of the octagon and serves as the entrance.

While the interior of San Vitale is light and airy, the chancel and apse form a closed inner sanctum glowing with colorful mosaics. The lower walls are reveted with marble, and above the elegant columns and basket capitals, mosaics like huge luminous tapestries cover the walls and vaults. In the summit of the chancel vault the *agnus Dei*, the sacrificial Lamb of God, appears as the leitmotif for the Eucharistic program of the mosaics below. In the lunette on the south side of the chancel appears a representation of the sacrifices of Abel and Melchizedek on either side of a huge altar on which hosts and a chalice are displayed. Abel offers a lamb to the Hand of God, the bloody sacrifice of the Old Testament, while Melchizedek extends a host. As in the nave mosaic in Santa Maria Maggiore, Melchizedek is the type for the New Testament priest who gives the bloodless offering in the Mass.

In the left spandrel, Moses appears twice, tending his flocks and removing his sandals before the burning bush, while on the far right stands Isaiah, the prophet of the Incarnation. These themes are elaborated in the lunette on the north side of the chancel, with Abraham offering the meal to the three men seated beneath the oak at Mambre (**fig. 4.44**), and to the right, the Sacrifice of Isaac. In the right spandrel, Moses appears receiving the Law (in the form of a scroll) from the Hand of God, and to the far left the prophet Jeremiah stands with an open scroll.

Above the lunettes, flanking the openings in the galleries on either side, are portraits of the Evangelists. They are seated in rocky landscapes with their books open before them, and above, in a stepped, cliff-like setting, stand their respective symbols, taken from the imagery in the Book of Revelation. The typological concepts involved here—the Old Testament anticipating the New, and the depictions of the Evangelists with their beasts set in a landscape—are Latin, not Byzantine, in origin, but the placement of these scenes within architectural spaces brings to mind the cyclical disposition of later Byzantine mosaic programs.

The mosaics in the chancel thus present clearly defined narratives, with landscape settings under cloudy skies, and the pervasive tonality, a rich green, suggestive of a terrestrial rather than a celestial setting. While the figures move gracefully in these scenes, there is an emphasis on strong linear silhouettes with little modeling in the drapery. The landscapes, too, are pressed out with flora scattered about to fill the shallow ground, and the furnishings—the banquet table and the altars—are rendered in inverse perspective and tilted upward.

If one compares the scene of Abraham's banquet to the same episode in Santa Maria Maggiore, the advanced stage of abstraction in the Ravennate mosaic is immediately evident. The early fifth-century representation retains much of the illusionism of Antique painting, with three-dimensional figures placed clearly in space about a table in an atmospheric landscape. At San Vitale the illusionistic qualities are diminished. The table before the three men who visit Abraham is not only tipsy but unfolds precariously. The men's feet seem to project arbitrarily, the braces of the table legs are askew, and the bench for the visitors apparently has no legs. The shading of the oak of Mambre, for instance, is reduced to a series of peppermint stripes; the rolling hills beyond are transformed into lacy patterns of overlapping scallops; the clouds display herringbone striations; and the floral motifs are simply pinned to a groundline. Thus a curious compromise between the illusionistic qualities of earlier narration and the more iconic tendencies toward flat patterns is encountered in the chancel mosaics of San Vitale.

The warm green world of the Old Testament in the chancel is suddenly transformed into one of a radiant golden heaven in the apse. In the semidome, the youthful Christ is enthroned on a giant globe that hovers above a mound with the four rivers of paradise nourishing a strip of landscape dotted with scattered flowers. With his left hand he holds the seven-sealed scroll on his knee, while with his right he offers a crown of martyrdom to the Ravennate saint, Vitalis, standing on the far left. To the right stands Bishop Ecclesius, the builder of the chapel, offering Christ a diminutive model of his church. The background is solid gold with only a few colored strips of clouds floating in the summit.

The most famous mosaics in San Vitale are the two court portraits that appear on the walls of the apse directly beneath the enthroned Christ. Justinian did not attend the ceremonial dedication of the chapel, but he is portrayed there as the principal actor in the drama of the Great Entrance, offering a costly paten to the church (**fig. 4.45**). He is attended by the archbishop Maximianus, the only participant identified by an inscription, the banker Julianus Argentarius (who financed the building), standing just behind them, and the general, Belisarius, to Justinian's right.

The individualized features of these four figures indicate that they are true portraits based on likenesses available to the mosaicist. Justinian is blessed with a halo and wears a bejeweled crown and a royal robe to distinguish him as the regent of Christ on earth. The characterization of Justinian is vivid and brings to mind the description of the emperor found in the *Secret History* of Procopius (a historian of the period): "In person he was . . . rather moderate in stature; not thin, just slightly plump. His face was round and not uncomely and even after two days fasting his complexion would remain ruddy."[21]

Maximianus, the notorious archbishop hated by the citizenry, is portrayed as lean, fanatic, and grim. With a few tesserae of orange, the artist imparts a nervous quiver to his lower lip. His eyes seem to twitch. Julianus Argentarius, who

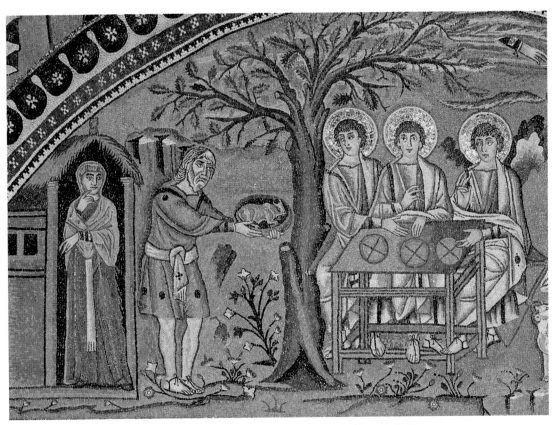

Fig. 4.44. *The Feast of Abraham.* Mosaic on the north side of the chancel of San Vitale, Ravenna

Fig. 4.45. *Justinian and his Retinue.* Mosaic in the apse of San Vitale, Ravenna

served as Justinian's promoter in Ravenna, appears as a stout, fatheaded strong man with a double chin and scraggly hair. Belisarius, Justinian's able commander, is the blandest personality of the foursome. For the rest, types, not true portraits, are presented. To Justinian's right stand youthful members of the army representing the power of the state; to his left, two deacons accompany Maximianus, the authority of the Church. Their features are somewhat emaciated and drawn.

Although the mosaic displays obvious hieratic characteristics in the symmetry, frontality, stiffness of pose, co-planar organization, and lavish use of gold for the background, the designer underscores the preeminence of Justinian and Maximianus by placing them centrally and having them overlap the other attendants slightly. Their feet also ride atop the others in what seems at first to be a spaceless void framed by pillars and a roof. The bodies are flat, vertical blankets marked by the emphatic vertical lines of the drapery. The emperor stares out relentlessly at the spectator in the fashion of the portraits in Thessaloniki, and no doubt some such iconic elevation of Justinian's person was intended here. He is

portrayed as a saintly emperor eternally present at the celebration of the Mass in San Vitale.

Directly opposite Justinian is the colorful portrait of Theodora with her retinue (**fig. 4.46**). They have gathered in an outdoor annex (the atrium?) that has a fountain and a curtained doorway. The harsh, hieratic qualities are somewhat relaxed, with the elegantly clad empress placed off center and slightly back in the composition, before an elaborate niche or exedra. She offers a chalice as her donation to the church. The representation of the three Magi embroidered on the hem of her robe makes the act of offertory explicit. The stunning patrician lady standing next to Theodora is probably Antonia, wife of Belisarius and close friend of the empress.

Theodora was known for her ravishing beauty as well as her ruthless manner and haughty disposition. Framed in a huge, towering tiara studded with emeralds, pearls, diamonds, and sapphires, Theodora peers out amid a fireworks of riches. Procopius tells us that "Theodora was fair of face and of a graceful, though small, person; her complexion was moderately colorful, if somewhat pale; and her eyes were dazzling and vivacious."[22] Here she seems aged—she died the year after this

Fig. 4.46. *Theodora and her Court.* Mosaic in the apse of San Vitale, Ravenna

Fig. 4.47. San Vitale, Ravenna. View of south wall of the chancel, with *Abel and Melchizedek* in the lunette, *Moses* and *Isaiah* in the spandrels, portraits of Evangelists in the gallery, and the Lamb of God in the vault

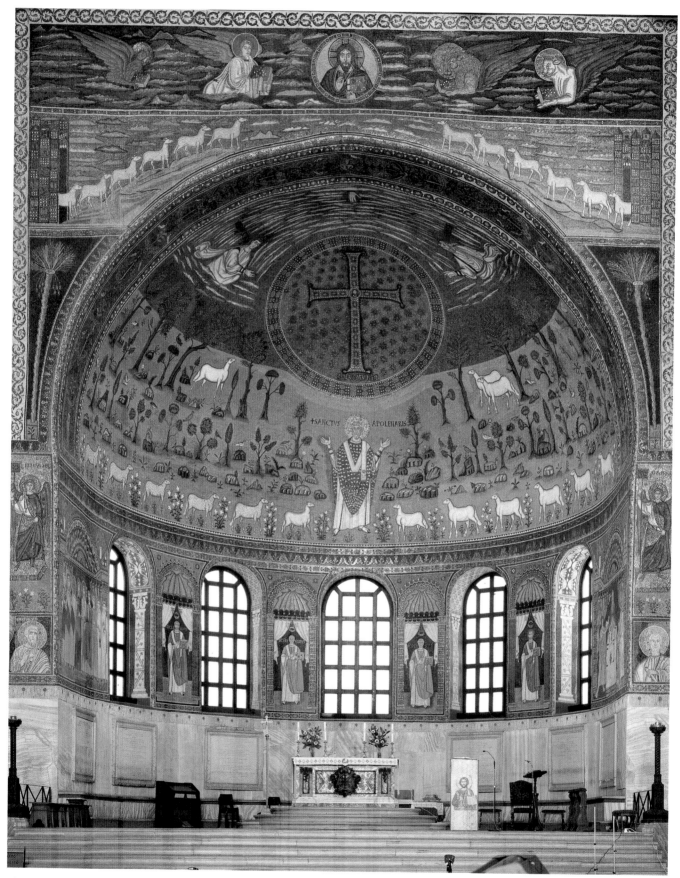

Fig. 4.48. *Transfiguration.* Apse mosaic in Sant'Apollinare in Classe, Ravenna. c. 549

portrait was made—but still the elegant and proud queen who, according to one biographer, burst into Justinian's chamber as he was packing to flee the city during the Nika riots of 532 and shouted, "If you wish to flee, flee. Yonder is the sea; there are the ships. As for me, I stay . . . May I never put off this purple or outlive the day when men cease to call me queen."[23]

In 549, Maximianus consecrated Sant'Apollinare in Classe (Ravenna's port town), an exceptionally beautiful basilical church founded under the Ostrogothic rulers. The relics of Saint Apollinaris, the first bishop of Ravenna, martyred during the reign of Vespasian, were enshrined there, and he figures prominently in the mosaic in the conch of the apse (**fig. 4.48**).[24] The mosaic dates to only a few years after those in San Vitale, but a surprising modification in style and content is evident. For one thing, the broad landscape setting is now abstracted to the point where it forms a flat green backdrop with no indications of spatial illusionism. All details are isolated and treated as individual motifs—plants, sheep, and rocks—lined up in rows symmetrically about the central axis. Even more astonishing is the abstraction of the subject matter. Two overlapping themes are presented, one in iconic, the other in symbolic form.

The central figure is Saint Apollinaris. Dressed in bishop's vestments and posed as an *orans*, he reflects the priest who stands behind the altar directly below the mosaic. The apotheosis of the bishop-saint is thus analogous to later Roman apse representations such as that in the Church of Sant'Agnese, where the patron saint looms above the altar in a similar fashion. The sheep to the sides refer to the role of the bishop as the protector of the flock.

Above Apollinaris appears a huge aureole of blue, studded with stars and containing a great gemmed cross with a tiny bust portrait of Christ at its center. The Hand of God issues from clouds in the summit of the apse, and to the sides appear half-length portraits of Moses and Elias. Directly below the aureole, to the right and left, are three lambs attending the vision. One of the main theophanies of Christ—when his divinity was revealed on earth—was the Transfiguration: "And after six days Jesus taketh unto him Peter and James, and John his brother, and bringeth them up into a high mountain apart: And he was transfigured before them. And his face did shine as the sun: and his garments became white as snow. And behold there appeared to them Moses and Elias talking with him. And Peter answering, said to Jesus: Lord, it is good for us to be here: if thou wilt, let us make here three tabernacles, one for thee, one for Moses, and one for Elias. And as he was yet speaking, behold a bright cloud overshadowed them. And lo, a voice out of the cloud, saying: This is my beloved Son, in whom I am well pleased: hear ye him. And the disciples hearing, fell upon their face, and were very much afraid. And Jesus came and touched them: and said to them, Arise, and fear not. And they lifting up their eyes saw no one but only Jesus" (Matt. 17:1–8).

It is interesting to note that the major figures in the theophany—the transfigured Christ, the voice of God, and the three apostles—appear as symbols, while the two Old Testament figures in the vision, Moses and Elias, are presented as humans. This deliberate restriction of New Testament figures to symbolic forms is, in some respects, a conscious return to aniconic (symbolic rather than figural) representation in art.

Ravenna is the repository of the most extensive mosaics from the sixth century, but it can also claim a prominent place in relief sculpture. The most impressive monument of ivory carving of the sixth century is the large episcopal chair or cathedra of Maximianus, archbishop of Ravenna from 546 to 556 (**figs. 4.49–51**).[25] The body of the throne is completely covered with large ivory plaques fitted to a structural

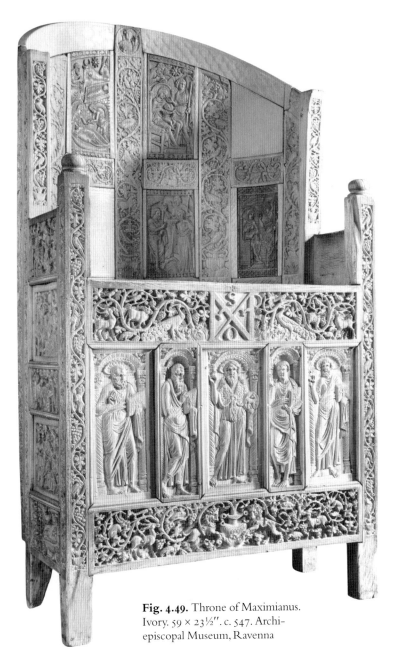

Fig. 4.49. Throne of Maximianus. Ivory. 59 × 23½″. c. 547. Archiepiscopal Museum, Ravenna

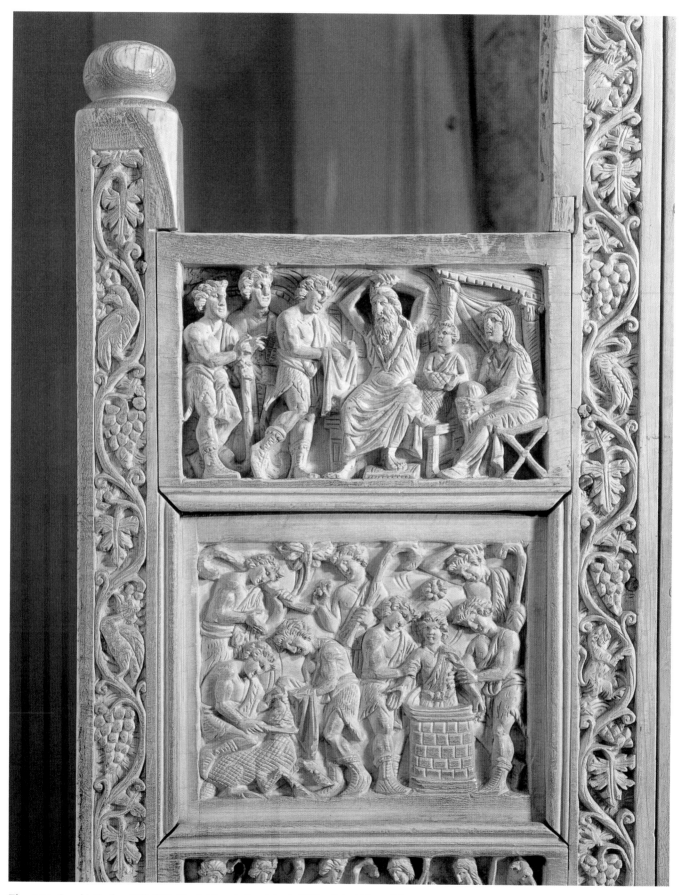

Fig. 4.50. *Joseph's Brethren Tell of His Death* (above); *Joseph in the Well and the Killing of the Kid* (below). Detail of Fig. 4.49

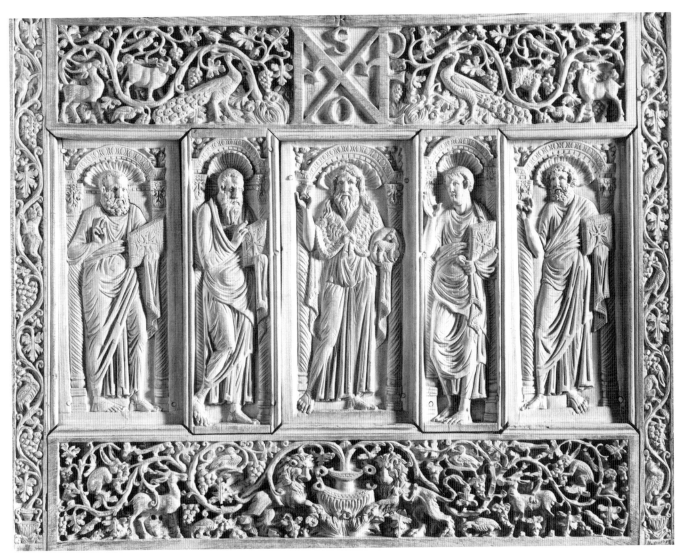

Fig. 4.51. *Four Evangelists and John the Baptist*. Detail of Fig. 4.49

armature of wood. The legs and posts are lined with ivory strips with intricate vine scrolls peopled by tiny animals and birds. Across the front are five vertical panels portraying John the Baptist flanked by standing figures of the four Evangelists squeezed into arched niches, their alert and expressive heads cupped within conches forming haloes. Their stances are subtly varied, with ripples of movement being created by the shifting of their weight, the raising of arms, the large whorls of drapery spinning across their torsos, and the richly textured patterns of the arched niches that hold them to the surface.

The sides of the throne are bedecked with rectangular panels, alternating in size, that relate the story of Joseph in Egypt. In these narratives a surprisingly rich, flickering texture predominates, too. In the episode where Joseph is put into the well by his brothers (Gen. 37:23–35), the carver adds a star, a tree, and another shepherd wherever space is left over within the frame. The nervous shepherds, vigorously modeled, move and turn with a brisk energy that adds more vibrancy to the surface pattern.

The vertical reliefs on the back of the throne are of special interest to the iconographer, for here one of the most complete presentations of the Infancy cycle based on the Protoevangelion of James precedes the narratives of Christ's ministry. These include representations of the suspicion of Joseph, Mary submitting to the test of the bitter waters, Joseph reassured of Mary's purity in a dream, and the birth of Jesus with the midwife Salome testing the virginity of the mother. The harsh resonance of the design vibrates with the jarring juxtaposition of the coarse-grained fabric of the bedding, the angular brickwork of the high crib, and the large rosette boldly placed between the heads of the ox and ass.

The craftsmen who carved the ivory panels on the throne were talented artisans, and the expressive and rhythmic style they display bespeaks a major center of production, very likely Constantinople.

Fig. 4.52. Pulpit, Bishop Agnellus. 6th century. Ravenna Cathedral

The ambo of Archbishop Agnellus (556–69) hints at the variety of relief sculpture to be found in Ravenna (**fig. 4.52**). In contrast to the energy and vibrancy of the throne, the ambo is serene and stately to the eye. One of several impressive sixth-century ambos, the panels on the stairs and faces of the ambo are decorated with six rows of animal reliefs: lambs, peacocks, deer, doves, ducks, and fish. These are no doubt visual reminders of homilies and liturgical readings such as Psalm 42, "As the deer pants for streams of water, so my soul pants for you, O God."

Although Ravenna would be abandoned as an imperial city, this meant that it was not subject to rebuilding projects, allowing the preservation of many of its buildings, mosaics, and carvings to give an indication of the richness of early Byzantine art not only in Italy, but also throughout the empire.

5

MIDDLE AND LATE BYZANTINE ART

The production and veneration of icons developed rapidly during the course of the sixth century.[1] In Byzantium, icons, like relics, were treated as trustworthy representations of the divine. In addition, icons were much more accessible than relics as objects of devotion. Prescribed rituals were followed for their veneration, including *proskynesis* (prostrating oneself before the image) and the placing of candles about the base of the icon.

Some icons were thought to be *acheiropoietai*, images not made by human hands. In some cases they were impressions miraculously left on cloth or stone that came in contact with the holy person.[2] Other legends inform us that Saint Luke was the first artist to paint a portrait of the Virgin from life, and that it was the prototype for later icons of Mary holding her child. It is no wonder, then, that the goal of the icon painter was to duplicate the prototype as faithfully as possible. To do otherwise would dilute the true image. Hence copies of copies result throughout Byzantine history.

ICONOCLASM

An abundance of evidence shows that worshippers believed in the miraculous qualities of the icon, that it could protect or heal in times of need. Indeed, it could serve as a *palladium*, an image that provided security for a whole community when placed above the city gate (so named after the ancient statue of Pallas Athena on which the safety of Troy depended). For some, the veneration of a painted portrait could erase the distinction between a likeness and an idol to be worshipped, and it was this issue that was constantly raised by those churchmen who opposed the use of icons in churches in general. According to these critics, image veneration violated the "spirituality" of worship, the belief that the divine presence of Christ could only be evoked in the mystery of the Liturgy. The second commandment given to Moses (Exod. 20:4), prohibiting the use of graven images, was also often cited. Icons too closely resembled pagan idols, and their veneration, it was feared, transformed worship into idolatry.

With few exceptions, icons, unlike relics, are produced by human hands. Consequently, iconoclasts argued icons do not deserve veneration, for they are not defined by physical contact with the divine, as are relics, but by the artist's touch.

The defenders of icons (iconodules, iconophiles) continued to repeat the old argument that pictures served a didactic role as visual aids for the illiterate: "An image is, after all, a reminder; it is to the illiterate what a book is to the literate, and what the word is to hearing, the image is to sight" (John of Damascus, *Oratio 1*).[3]

Another apology contended that the icon, as an image of its prototype, while not partaking of its true substance, did provide a channel by which the faithful could demonstrate their love and honor for the one depicted.[4] According to the Book of Genesis, "God created man to his own image" (1:27). It follows, therefore, that God could be envisioned as a human form, or, to put it another way, the image of man was a reflection of the deity. Thus the painter of the icon was partaking in the divine act of creation, although he reproduced only the reflection.

The Incarnation of Christ underscored the point. Mary was the vehicle by which the divine was given human form,

rgued by Theodore the Studite (A.D. 759–826), ndeed, can the Son of God be acknowledged to have ι man like us—he who was deigned to be called our brother—if he cannot, like us, be depicted?" Much earlier, at the Quinisext Council called by Justinian II at Constantinople in 692, many of these arguments had already been mustered: "Now, in order that perfection be represented before the eyes of all people, even in paintings, we ordain that from now on Christ our God . . . be set up, even in images according to His human character, instead of the ancient Lamb."[5] For the iconophiles, the rejection of iconic likeness seemed dangerously close to denying Christ's humanity and the visibility of his suffering.

Imperial opposition to the cult of images in the form of an imperial policy called iconoclasm (image-breaking) flared up when Leo III assumed rule in 717. Leo III had grown up in Isauria in southeastern Anatolia, near the Arab frontiers, and some scholars believe that exposure to Islamic prohibitions against the use of sacred representation played a role in his mistrust of icons. During the reign of Leo's son, Constantine V (741–75), iconoclastic policies were most stringently enforced, and icons were destroyed, mosaics torn from churches, and monks and others who supported the cult of images persecuted.

The first edict against the veneration of icons was apparently issued as early as 726, although it is not known to what extent the Church authorities accepted it. At the so-called Iconoclastic Council held in 754 at Hiereia, all figurative imagery of Christ in churches was banned: "The divine nature is completely uncircumscribable and cannot be depicted or represented by artists in any medium whatsoever."[6]

There are other reasons why Leo III and his son may have vehemently opposed the veneration of icons. Justinian II had proclaimed on his coins that Christ was *Rex Regnantium*, the King of Kings. By thus raising the authority of the Church over the state, the fine balance of caesaropapism so vital to the absolute authority of the Byzantine monarch was upset. The military emperors, beginning with Leo III, wished to reset the balance, so to speak, by proclaiming their authority over the Church and the monasteries. Iconoclasm was a means of sapping the wealth and popularity of the monasteries, which drew thousands of pilgrims to their icons and shrines.

The persecution of monks who defended the veneration of icons was also part of the campaign of Constantine V, especially between 762 and 768. Icons were no longer produced in Constantinople, and those on display were destroyed. Mosaic icons of Christ, Mary, and the saints were torn out and replaced with ornamental decorations or crosses, the one symbol that was allowed by the iconoclasts. The famed icon of Christ on the Chalke Gate leading into the imperial palace was removed and replaced by a cross, and it seems that the apse mosaic in Hagia Sophia was removed.

The son of Constantine V, Leo IV (775–80), continued the iconoclastic policies in the face of growing opposition on the part of the monastic communities. When he died in 780, Empress Irene discontinued the prohibition, and there was a lull in iconoclastic policies.

At the seventh Ecumenical Council, held in Nicaea in 787, the veneration of icons was restored, and the icon of Christ on the Chalke Gate was returned to its site. The restoration, however, was short-lived, for in 813 Emperor Leo V reinstated iconoclastic policies. The icon on the Chalke Gate was again removed and, following the new prohibition of art, some monastic craftsmen fled to western Christian lands, especially Italy. A series of military disasters in Crete, Sicily, and Amorion (in central Turkey) sapped the power and prestige of the emperors at home.

The patriarch John the Grammarian led a second wave of iconoclasm, claiming that icons are incapable of showing what is praiseworthy in one's character, since they offer little or no knowledge of what they represent. On their own, icons cannot explain anything about God and the saints. For this, he believed, words are necessary. Images can only get in the way by distracting the pious from proper representations, which are provided solely by verbal descriptions.[7]

In response, iconophiles, led by Photios, argued the benefits of icons. Through likeness, sacred images granted beholders with opportunities to form mental pictures of Christ and the saints. Icons made impressions in the hearts and minds of those who viewed them. Visual images could provide excellent role models to imitate by directing the gaze of pious observers towards what is true and good. Consequently, there is no reason to deny their use in veneration. Figurative representations, like words, were capable of showing paths of saintly virtue.

THE TRIUMPH OF ORTHODOXY

The iconodule empress Theodora was instrumental in the final restoration of the veneration of icons in Constantinople on March 11, 843. This date is still known as the "Feast of the Orthodoxy." The icon of Christ on the Chalke Gate was again restored.[8] Theodora's pious act initiated the second golden age of Byzantine art. Among the important restorations was the image of the Virgin enthroned in the apse of Hagia Sophia, which was accompanied by an inscription reading: "The images which the imposters had cast down here, pious emperors have again set up." In a homily delivered in Hagia Sophia on March 29, 867, the patriarch Photios addressed the mosaic of the Virgin and Child in the following words:

> Christ came to us in the flesh, and was borne in the arms of His Mother. This is seen and confirmed and proclaimed in pictures . . . Does a man hate the teaching by means of pictures? Then how could he

not have previously rejected and hated the message of the Gospels? Just as speech is transmitted by hearing, so a form through sight is imprinted upon the tablets of the soul, giving to those whose apprehension is not soiled by wicked doctrines [iconoclasm] a representation of knowledge concordant with piety . . . It is the spectators rather than the hearers who are drawn to emulation. The Virgin is holding the Creator in her arms as an infant. Who is there who would not marvel, more from the sight of it than from the report . . . ? For surely, having somehow through the outpouring and effluence of the optical rays touched and encompassed the object, it too sends the essence of the thing seen on to the mind, letting it be conveyed from there to the memory . . . Has the mind seen? Has it grasped? Has it visualized? Then it has effortlessly transmitted the forms to the memory.[9]

The end of iconoclasm was announced publicly by the installation of the icon of Christ on the Chalke Gate of the imperial palace in 843, and henceforth there would be no ban on icons in the Orthodox Church. A fourteenth-century icon (**fig. 5.1**) marks the occasion. In the center the *Virgin Hodegetria*, a miraculous image that was believed to have been painted by Saint Luke, can be seen. The *Virgin Hodegetria* has been copied numerous times and has become a familiar iconographic type. In these images, the Virgin can appear enthroned, standing, or in half-length, but she always holds the infant Christ to the side on her left arm while "guiding" or

Fig. 5.1. *Icon of the Triumph of the Orthodoxy*. Tempera and gold on panel, 15⅜ × 12¼″. Second half of 14th century. British Museum, London

"pointing the way to Salvation" (the Child) with her right hand. The Child is characterized as a miniature philosopher, holding a scroll in his left hand and raising his right in benediction or proclamation. On the left, Theodora and her three-year-old son Michael III venerate the *Hodegetria* icon. The patriarch and his entourage appear on the right. In the register below, iconophiles carry icons in celebration, including a martyred nun, Saint Theodosia of Constantinople, at the far left. She was killed trying to protect the holy image on the Chalke Gate from iconoclasts. Here she holds that sacred image for all to see.[10]

The restoration of churches and religious images proceeded as an official policy under the Macedonian emperors who succeeded Theodora (regent from 843–56) and her son Michael III (842–67). Basil I the Macedonian (867–86) is generally credited with initiating a renaissance of Byzantine art and architecture, and under him and his successors, Leo VI (886–912) and Constantine VII Porphyrogenitus (912–59), the prestige and culture of the East Roman Empire reached its zenith.

Soon after the reinstatement of Orthodoxy, the Khludov Psalter challenged readers to recognize the impious folly of iconoclasm. Psalm 51 (**fig. 5.2**) rebukes those who choose earthly treasures over heavenly ones. To the left, Saint Peter stands on top of the humiliated sorcerer Simon Magus (Acts 8:14–25), who drops a bucket of coins. Directly below this biblical scene and in a parallel configuration, the upright iconophile patriarch Nikephoros, holding an icon of Christ in his hand, crushes the wild-haired iconoclast John the Grammarian, who is surrounded by coins. The point of the juxtaposition of these pairs is far from subtle. John the Grammarian, like Simon Magus, it is suggested, failed to recognize the spiritual truth because he relied on wealth and power rather than God. In addition, the spilled coins might also refer to Judas, further suggesting that John the Grammarian betrayed Christ.

Another page from the Khludov Psalter illustrating Psalm 68 (**fig. 5.3**) links iconoclasm to the tormenting of Christ on the cross. The text implores God for salvation from persecutors. To the right, Christ is given vinegar to quench his thirst (Mark 15:36; Luke 24:36). Echoing this scene from below, John the Grammarian and a bishop, both labeled with inscriptions, deface an image of Christ with a cleaning agent—vinegar. Attacks on Christ's body are openly compared with assaults on his image, implying that iconoclasm is hurtful to God and mocks the Incarnation.[11]

Through trade, military conquests, and shrewd diplomacy, Byzantine influence spread throughout the western Mediterranean and as far north as the Baltic Sea and White Sea. The Italian republics—Pisa, Genoa, and especially Venice—turned more and more to Constantinople for models in statecraft and the arts. The Muslim caliphs of Córdoba in

Fig. 5.2. Simon Magus and Patriarch Nikephoros. Illustration from the Khludov Psalter, 7¾ × 6″. c. 850–75. State Historical Museum Moscow (GIM 86795 or Khlud. 129-d, fol. 51v)

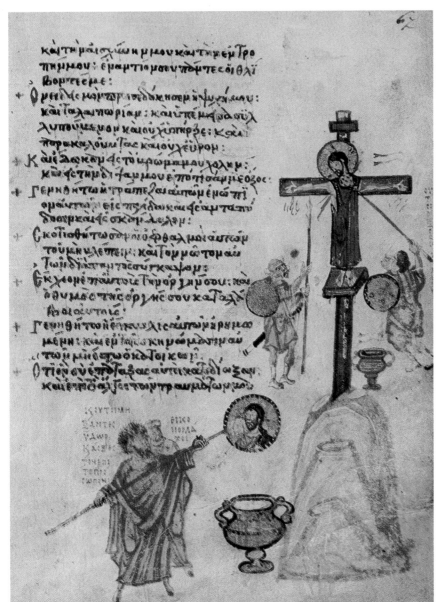

877–86), refused to recognize the Roman See as anything more than the bishopric of Rome. The final schism between Rome and Constantinople occurred in 1054, when the pope and the Byzantine patriarch excommunicated one another.[12] By the end of the eleventh century, the Byzantine emperor and the patriarch of Constantinople, who, in Byzantine eyes, were the temporal and spiritual leaders of the world, now believed that the bishop of Rome had separated himself from the rest of the Church.

Some idea of the luxurious conditions that surrounded the emperor and patriarch can be gleaned from reports of court ceremonies (recorded in the *Book of Ceremonies* by Constantine VII Porphyrogenitus),[13] and other descriptions of the great imperial palace complex. It covered acres of sloping land from the hills behind Hagia Sophia to the southern coast of the peninsula. Few remains of the palace exist today, but sources inform us that the complex was a vast maze of telescoped palace chambers that featured a grand entranceway, broad courts, reception rooms, audience halls, chapels, and throne rooms added one to the other. The various ceremonial units were connected by colonnaded corridors, and the whole area was enhanced with ponds, gardens, and grottoes.

The tenth-century complex was thus a magnified Hellenistic palace. The main stateroom, the Magnaura, was a vast reception hall where the emperor sat at one end on the "Throne of Solomon," flanked by bronze lions and gilded birds in a gilded tree. The animals were automata, or mechanized creatures, and upon the visitor's entry, the lions roared and flapped their tails, the birds chirped, and the emperor, dressed in exotic costume, was raised on high like a living icon by a mechanical contrivance.

Within the sprawling complex of ceremonial halls and rooms, Basil I built a palace church, the Nea, or "The New," situated on a terrace. The Nea, completed in 880, no longer survives, but descriptions give us some idea as to its plan and

Spain held the Byzantine emperor and his capital in highest esteem and employed Byzantine mosaic workers to decorate their palaces and mosques. Nor were the northern Europeans untouched. The Saxon emperor Otto I petitioned for a Byzantine princess, Theophano, as wife for his son, Otto II.

That the level of scholarly activity increased during the dynasty of the Macedonians was due, in part, to the reopening of the Academy in Constantinople (closed during the reign of the iconoclasts). Efficient and progressive curricula were instituted to train the civic and diplomatic personnel, and much education was based on reading of the Greek classics in ancient philosophy, drama, poetry, mathematics, and the sciences. Indeed, the role of the educational program deeply affected developments in the arts, especially book illustration.

Constantinople asserted its ecclesiastical authority, too. Photios, the powerful patriarch of Constantinople (858–67,

construction. In plan, it was based on one of the most popular and innovative variations of the central church in Middle Byzantine architecture, the cross-in-square with five domes (quincunx). The Greek cross-in-square plan divides the church into nine square and rectangular bays. The central bay, the largest square, is domed; the smaller, square corner bays are usually domed or groin-vaulted, while the four arms of the cross are rectangular with barrel vaults. An apse and two lateral chambers, the *prothesis* and *diaconicon*, are built into the east end of the square, while a narthex and an atrium are added to the west. Often porticoes were built into the flanks of the structure. In the Nea, the narthex extended from the west front along the north and south sides, forming a U-shaped addition that virtually enclosed the cross-in-square. The Nea did not rival Hagia Sophia in size. Its spaces were concentrated and compressed, resulting in a pronounced steepness in elevation. The interior was richly decorated with marbles and mosaics, the latter displaying scenes of the life of Christ with the *Pantocrator* and angels filling the central dome.

The hallowed Apostoleion, the Greek cross-plan church with five domes built by Constantine the Great, was renovated and redecorated by Basil and his successors. It, too, was subsequently destroyed, and we must rely again on descriptions of the tenth and twelfth centuries by Constantinus Rhodius and Nikolaos Mesarites for a reconstruction of the church and its decoration.[14] The large central dome displayed the bust of Christ *Pantocrator* in the summit with the Virgin and apostles standing below, while the mosaics in the other domes and walls in the arms of the cross presented a sophisticated scheme of subjects from the life of Christ, including the Transfiguration, the Anastasis (the Harrowing into Hell), the Ascension, and Pentecost.

While it would be hazardous to reconstruct the iconography of these pictures in detail, Mesarites's description indicates that the mosaic program in the Church of the Holy Apostles was carefully conceived and, in many ways, served as a superb model for the decorations in monastic churches, such as Hosios Loukas and the Church of the Dormition at Daphne, where the major ecclesiastical festivals (feasts) of the life of Christ rotate above the heads of the worshippers, culminating in the awesome *Pantocrator* in the summit of the central dome. Perhaps the learned patriarch Photios was the mind behind this new program of church decoration.

MOSAICS AND IVORIES

Mosaics were gradually restored and added in Hagia Sophia. The evidence of pre-iconoclastic figurative decoration is indeed slim, but remains of several mosaics added by the Macedonian and later emperors have come to light in the cleaning of areas hidden by whitewash painted over the walls and vaults after the Turkish occupation in 1453.[15] The summit of the dome was decorated with a Christ *Pantocrator*, and huge winged cherubim filled the pendentives below. The upper walls of the nave served as a portrait gallery with saints and prophets, standing in rigid frontal poses, filling the walls between the windows.

Hagia Sophia was too vast to lend itself to an intricate iconographic program such as that in the Church of the Holy Apostles. Most of the Middle Byzantine mosaics recovered are individual panels located in the peripheral areas such as the galleries, narthex, and vestibules leading into the church. They are of a type known as *ex-votos*, pictures that commemorate a vow or donation of a member of the imperial family in recognition of divine favors bestowed. The earliest, dating to the end of the ninth century, appears in the lunette over the "imperial door," or main entrance in the narthex, and probably depicts Leo VI (886–912) receiving the investiture of Divine Wisdom (Hagia Sophia) in the form of Christ (**fig. 5.4**).

Leo prostrates himself (*proskynesis*) before Christ, who sits on a lyre-backed throne, to either side of which appear medallions with busts of the Virgin and the Archangel Gabriel. In a homily composed by Leo VI for the feast of the Annunciation, the relationships between Christ as Holy Wisdom and the emperor as vice-regent on earth are elucidated, perhaps accounting for the additions of the Virgin and the angel of the Annunciation.[16] However, there may be another reason for commissioning this mosaic and for choosing this particular location in the church to place it. Leo may have commissioned the work as an act of penance. According to church rule, one could marry only twice. Leo VI violated this standard by secretively marrying for the fourth time in hope of producing a male heir. As punishment, the emperor was barred from entering the sanctuary. Nonetheless, Leo was able to father a son and his marriage was ultimately recognized by the Church. Yet the mosaic does not identify Leo with an inscription, allowing the possibility that the lunette may refer to the relationship between Christ and imperial authority.

Leo's son, Constantine VII Porphyrogenitus ("born in the purple"), succeeded him. A precious ivory (**fig. 5.5**) marks Constantine's coronation. As the King of Kings, Christ takes priority and is elevated on a footstool above the new emperor. Constantine stands to his right to receive God's blessing, an indication of the emperor's orthodoxy and God-given authority. Christ places a pearled crown on the emperor's head. In response, Constantine opens his arms and bows in humble submission.

An icon depicting King Abgar of Edessa (**fig. 5.6**) reinforces the emperor's intimacy with the divine and his promotion of sacred imagery. According to tradition, Abgar, suffering from a disease, summoned a messenger and sent him to Palestine in hopes of receiving a cure. The king told the man to either return with greatest of miracle-workers or, at least, bring back a picture of him. Unable to reach Christ, the messenger climbed a tree and began to draw his appearance on a piece of cloth. Witnessing this, Christ approached the

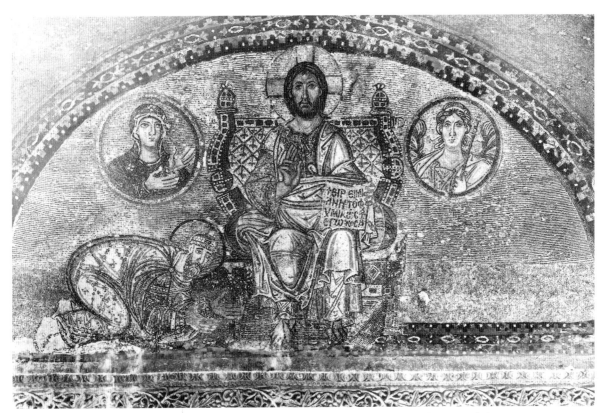

Fig. 5.4. *Leo VI Making Proskynesis Before the Enthroned Christ.* Mosaic in the lunette over the imperial doorway in Hagia Sophia, Constantinople. c. 900

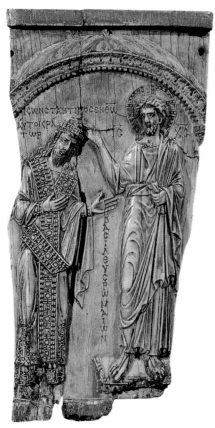

Fig. 5.5. *Christ Crowning the Emperor Constantine VII.* Ivory. 7⅜ × 3¾″. c. 945. State Pushkin Museum, Moscow

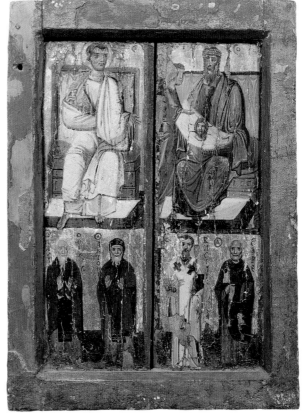

Fig. 5.6. *Abgar of Edessa.* Tempera and gold on panel. 10th century. Monastery of Saint Catherine, Mount Sinai

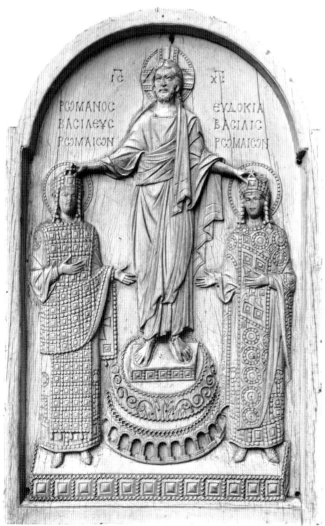

Fig. 5.7. *Coronation of Emperor Romanos II and Eudocia by Christ.* Ivory relief, 9½ × 5⅞″. 945–49. Cabinet des Médailles, Paris

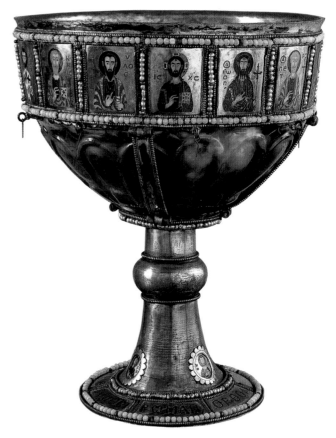

Fig. 5.8. Chalice of Emperor Romanos II. Sardonyx, enamels, and pearls, 8⅞ × 5½″. 959–63. San Marco Treasury, Venice

man. He took the linen handkerchief (*mandylion*) and applied it to his face. Miraculously, his image became superimposed, creating a true image of himself. The messenger returned to Edessa with the *mandylion* and Abgar's health was restored. In the upper right quadrant of the icon, Abgar wears a pearled crown and closely resembles Constantine VII, who had the sacred relic of the *mandylion* in his collection. The story of the *mandylion* and its representation in numerous icons effectively reinforces the veneration of icons, for it reveals that Christ himself sanctioned their use.[17]

The coronation ivory of Emperor Romanos II and Eudocia by Christ (**fig. 5.7**) also reaffirms the intersection of imperial authority with Christian faith. Although the composition of the image is symmetrically balanced and static, its figures appear quite graceful. The elongated proportions of the thin figures and the delicate carving of their sumptuous regalia, suggest a noble elegance.

In this regard, Romanos's luxurious chalice (**fig. 5.8**) is also noteworthy. The red color of the costly sardonyx cup is

ideal for a regal vessel holding Eucharistic wine. Fifteen enameled icons framed with pearls, including one of Christ Blessing, surround the chalice's rim, reinforcing the nexus between the veneration of icons and participation in the sacrament as opportunities to experience the presence of the divine.[18]

In the late tenth century, the lunette over the door of the south vestibule at Hagia Sophia was decorated with a mosaic presenting the enthroned Virgin as protector of the church and city between standing figures of Constantine I, on her left, and Justinian I, on her right (**fig. 5.9**). As an *ex-voto*, this mosaic functions quite differently, however, since it commemorates the memory of the long-deceased benefactors of the church, one of whom, Constantine, had been canonized. Constantine offers the Virgin a model of the city he had founded in her honor, Constantinople, while Justinian presents a diminutive representation of the Church of Hagia Sophia, which he rebuilt in 532. Hence this mosaic honors the meritorious donations of the two principal emperors in the history of the site.

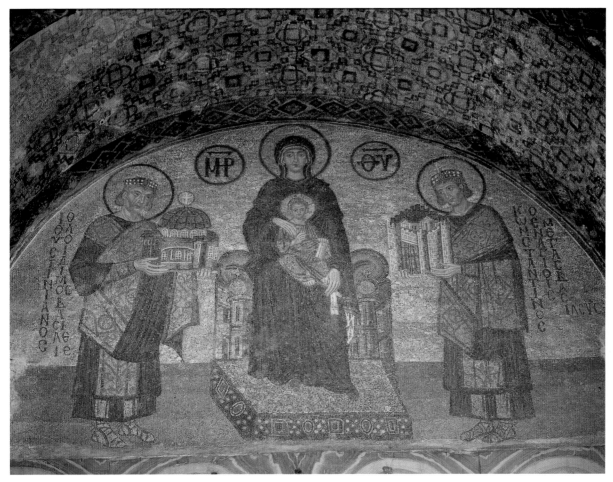

Fig. 5.9. *Virgin and Child Enthroned Between Emperors Constantine I and Justinian I.* Mosaic in tympanum over the door leading into the narthex from the south vestibule in Hagia Sophia, Constantinople. Late 10th century

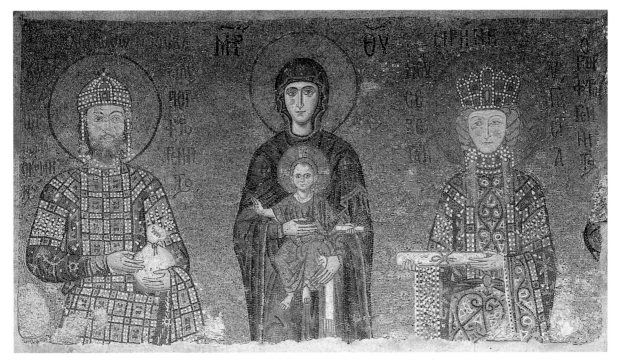

Fig. 5.10. *Virgin and Child between Emperor John II Comnenus and Empress Irene.* Mosaic in the south gallery of Hagia Sophia, Constantinople. Early 12th century

Some changes in style are evident. More colors are employed in the variety of tesserae laid in, giving the lunette a much brighter tonality than that over the imperial door in the narthex, and the lines that model the draperies are delicate, although the silhouettes remain closed and the bodies flattened. The emphasis is on the imperial regalia, the bejeweled stole (*loros*), crown (*stemma*), and scarlet boots. The refinements in technique can be seen particularly in the heads. While they are not based on authentic portraits of the emperors (they closely resemble one another), the diverse colors of the cubes, including touches of orange, and the gray-green lines that model the contours of the cheeks and jaw, impart a saintly demeanor to their gaunt features.[19]

In the so-called imperial box, reserved for members of the royal family, at the east end of the southern gallery, more *ex-votos* have been uncovered. That of the Virgin and Child standing between the emperor John II Comnenus (1118–43) and the empress Irene is particularly instructive for the study of stylistic development, with further refinements in the use of rich colors and a more meticulous application of the fine tesserae (**fig. 5.10**). A sense of weightless serenity resides in these imperial figures, whose bodies are lost behind the flat expanse of their stunning regalia. Irene was the daughter of a saint, King Ladislaus of Hungary, and the delicate treatment of lines and colors in her pale face seems enchanting.

In contrast, the figure of the Virgin is more three-dimensional. Her deep-blue mantle is subtly modeled with darker shades of tesserae, and her ideal beauty is established with the final crystallization of a number of conventions for her face: the *Theotokos* has a long, oval face with large, almond-shaped eyes, a small pinched mouth, a long arced nose, and dark shading along the contours of her right cheek and upper eye sockets.

The *ex-voto* of John II Comnenus typifies a number of Byzantine court portraits. A static, iconic presentation results, with the symmetrical placement of frontal figures offering donations to an elevated holy person. In the mosaic, John II gives a bag of silver and Irene extends a roll of parchment. Such ceremonials were ritualized and obligatory at the imperial court.[20]

Subtle grace and a taste for the classical can also be seen in contemporary works of a smaller scale. The Harbaville Triptych (**fig. 5.11**), less than twelve inches tall, was made for personal devotion. Named after its nineteenth-century collector, the triptych initially served as a precious ivory portable object for veneration. The work's statuette saints are arranged in two rows. When opened, the *Deësis* (Christ Enthroned between the Virgin Mary and Saint John the Baptist) surrounded by saints is revealed, suggesting the appearance of a heavenly court. The *Deësis* is often associated with prayers of intercession in anticipation of the Last Judgment. The style and iconography of this eleventh-century ivory likely derive from similar objects produced by the imperial workshop of Constantine VII, a hundred years previously.[21]

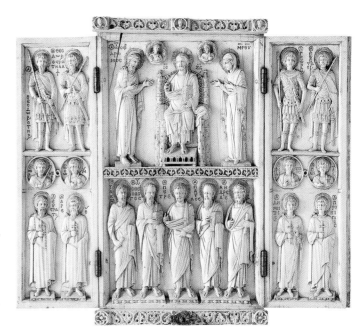

Fig. 5.11. Harbaville Triptych (front). Ivory, open 11 × 19″. Mid 11th century. The Louvre, Paris

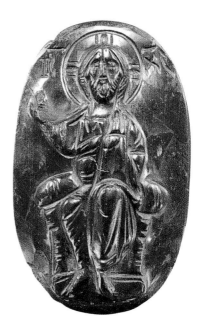

Fig. 5.12. Cameo with Christ Enthroned. Bloodstone, 1¼ × 1⅛″. Second half of 11th century. The State Hermitage, Saint Petersburg, Russian Federation

A bloodstone cameo of Christ Enthroned (**fig. 5.12**) is ambiguous in function. It could have been worn as jewelry or been inserted into a reliquary box or gospel cover. Cut from a dark stone with red veins, a material readily associated with the gift of sacrificial blood, the cameo shows the seated Christ offering his blessing.[22] As Anthony Cuttler has recently suggested, rubbing the surface of the stone may have intensified feelings concerning the proximity of the divine.[23]

THE IMPERIAL SCRIPTORIA

In contrast to the gradual crystallization of iconic features in mosaic figurative compositions, a very different style developed in the narrative illustrations in books produced in Constantinople during the course of the ninth, tenth, and eleventh centuries. Not only was the livelier narrative mode of Early Christian miniatures revived, but surprising enrichments were frequently added in the form of sumptuous Antique frames or backgrounds, and Classical personifications. These classicizing tendencies are so predominate that the period has sometimes been called the Macedonian Renaissance,[24] but the term "Renaissance" should be applied cautiously. As we have seen, the continuity of the Hellenistic heritage can be traced from early times in Christian art, and we are frequently faced with the question of survival or revival of ancient styles in various periods. In addition, with some exceptions, these classicizing features are found only in book illustration and related narrative arts.

That there was a conscious return to ancient models can hardly be questioned, however. With the reopening of the Constantinopolitan Academy following iconoclasm, a renewed interest in ancient Greek texts occurred. Not only the more practical works on engineering, science, medicine, horticulture, and mathematics, but the literary masterpieces of the past in philosophy, drama, poetry, and mythology were also resurrected. The texts were copied and edited by the scribes of the court scriptoria, and often illustrations were repeated as well. In fact, this wave of humanism, if so it can be called, preserved many ancient texts, including the works of Euripides, Sophocles, and others, providing Europe with the basic body of Classical writings that are still studied today.[25]

The eloquence and refined style of the classics rubbed off on the theologians as well. It seems clear that the learned patriarch Photios neither feared nor ignored the ancients. In his *Myriobiblion*, Photios commented on the contents of his own library, and Classical texts are almost as numerous as Christian writings. Among others, Photios had a copy of the *Bibliotheke*, a popular mythological handbook attributed to Apollodorus, an Athenian of the second century B.C. These interests in the classics were shared by the enlightened Macedonian emperors. The scholar-emperor Constantine VII Porphyrogenitus wrote encyclopedic treatises on early Greek texts dealing with military tactics, agriculture, and medicine. According to his biographers, Constantine VII even practiced painting and designing enamels in the court workshops.

One of the earliest products is an illustrated book of the Homilies of Gregory of Nazianzus made for Basil I about 880. A variety of miniatures appears for the sermons, and among them a large, full-page painting of the vision of Ezekiel in the Valley of the Dry Bones (Ezek. 37:1–14) is one of the most stunning (**fig. 5.13**). Within a lavish golden frame appear three figures in a colorful landscape. In the lower right a youthful angel leads Ezekiel through a valley filled with bones and skulls, and in the upper right the prophet appears a second time receiving the command from the Lord to prophesy the resurrection.

The most eye-catching aspect of the miniature is the filmy landscape painted in fluid, impressionistic strokes against a blue and pink sky. The highlights on the ridges of the basalt rocks and the craggy mountain peaks are carefully brushed in, and the effects of atmospheric perspective are captured in the subtle tonal gradations. The figures are relaxed and graceful, and soft highlights of white are applied to the draperies, the hands, and facial features. The well-proportioned Ezekiel seems more a pensive philosopher than a starved prophet.

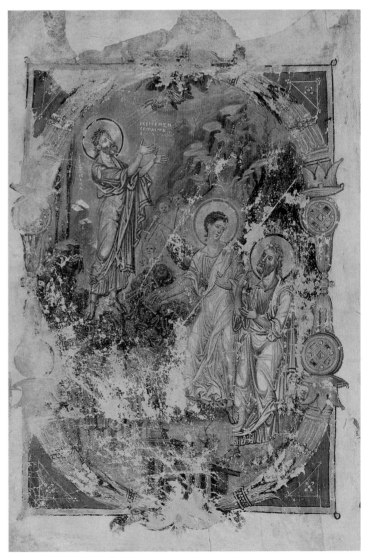

Fig. 5.13. *Ezekiel in the Valley of the Dry Bones.* Illustration in the Homilies of Gregory of Nazianzus. 16 × 11⅜″. c. 880. Bibliothèque Nationale, Paris (MS gr. 510, fol. 438v)

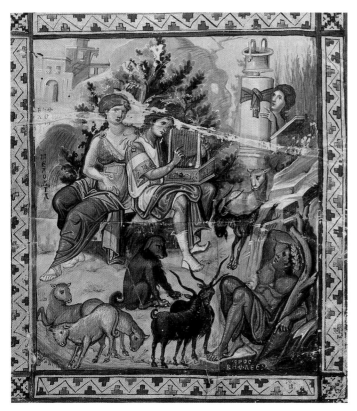

Fig. 5.14. *David Composing the Psalms.* Illustration in the Paris Psalter. 14 × 10¼″. c. 950. Bibliothèque Nationale, Paris (MS gr. 139, fol. 1v)

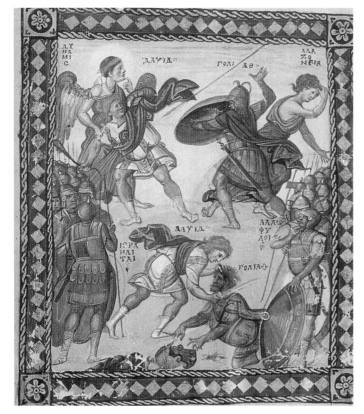

Fig. 5.15. *David Combats Goliath.* Illustration in the Paris Psalter. Bibliothèque Nationale, Paris (fol. 4v)

The classicism in the vision of Ezekiel is primarily a matter of style, but in another court manuscript, the Paris Psalter, dating in the early tenth century, the revival of Antique forms and motifs is so apparent that the miniatures appear as elaborate composites made up from various sources. The introductory miniature, *David Composing the Psalms* (**fig. 5.14**), is an excellent example of a "courtly" production.[26] The full-bodied figures and the rich colors remind one more of a mural painting than something designed for the confines of a book. In the center is the shepherd seated among his flocks, a bucolic motif that perhaps owes its inspiration to Hellenistic representations of Orpheus playing to the animals in a landscape. Here it functions as an author portrait, since David was considered to be the composer of the Psalms.

Eight full-page miniatures with episodes from his life introduce the Psalms. In the center of the picture, David plays the harp. A draped female, personifying musical inspiration and identified as Melodia, sits in a relaxed posture next to him. In the top right, behind a column, a nymph, perhaps Echo, listens intently as David's song fills the air in the woodland clearing. More surprising is the figure reclining in the fashion of an ancient river or mountain god in the lower right. Labeled "Bethlehem," he personifies the site where David spent his youth, the village itself appearing in the top left background.

Like the miniature of Ezekiel, that of David is striking in the illusionistic effects achieved by the rich colors and fluid brushwork. The figures are idealized types who do not move or gesture dramatically but are embodiments of the ancient Greek idea of beauty in repose. Classical, too, is the centripetal design of the compositional elements about David. Abandoned are the iconic features of symmetry, hieratic scale, and rigid frontality. The painting remains, however, a blatant pastiche of motifs.

In another image, David combats Goliath (**fig. 5.15**). The artist of the Paris Psalter, however, has added a female personification, Dynamis, spurring the young shepherd into battle, while another, Alazoneia (boaster), flees behind Goliath. The illumination conflates two narrative scenes. Below the contest, David decapitates the defeated giant.

A unique document of the Macedonian period is the Joshua Roll, with the story of Joshua's military campaigns illustrated in a continuous frieze in a scroll format (**fig. 5.16**).[27] With very few exceptions, the scroll had ceased to be used as a book since the second century. Its appearance here underscores the idea of a conscious revival of Antique forms, and it may be significant that one of the more familiar pictorial scrolls in Antiquity was the sculptured triumphal column that commemorated military victories. With its abridged text, limited to the

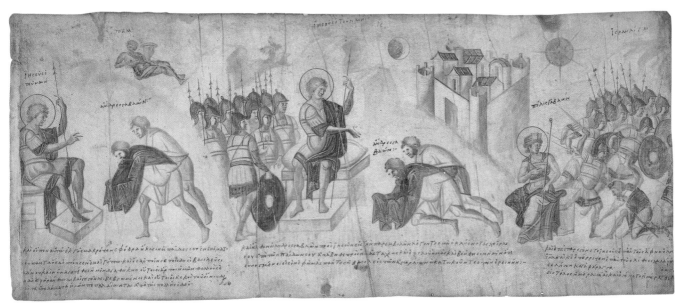

Fig. 5.16. *Joshua and the Emissaries from Gibeon.* Illustration in the Joshua Roll. Height of scroll 12¾″. 10th century. Vatican Library, Rome (Cod. Palat. grec. 431, sheet 12)

chapters in the Book of Joshua in the Old Testament devoted to military feats, the Joshua Roll could hardly function as a service manual for the church. Very likely it was specially made up for some contemporary military hero, an imperial commander of the Byzantine armies, a "New Joshua," to commemorate his victories.

Fifteen sheets of parchment are joined to form the scroll. The artist employed a drawing technique with faint tints of red, yellow, blue, and brown washed in, since gold and thick tempera would have cracked when rolled up. The section illustrated here presents the story of Joshua and the emissaries from Gibeon in three distinct narrative episodes (Josh. 9:6–15; 10:6; and 10:10–11). In the first, two messengers approach Joshua at his camp in Gilgal (note the personification on the hill beyond) announcing, "We are come from a far country, desiring to make peace with you." In the second scene, two more emissaries from Gibeon report to Joshua that the Amorites have besieged their city and it will surely fall if his mighty army does not save it; finally, to the far right, one can see how the armies of Joshua "slew them the Amorites with great slaughter in Gibeon."

In cartoon fashion, the three episodes are illustrated one after the other, but rather than resorting to line frames to separate the scenes, the artist created the illusion of a continuous panorama of action by linking them with landscape motifs, especially the sloping hill, and by inserting personifications of sites and cities. To the right, the battle before the walled city of Gibeon is introduced by the *Tyche* (a personification of a city), who wears a crown in the form of a city gate. The artist used a similar Classical model for this seated figure, as did the painter of Melodia in the Paris Psalter.

The appropriation of Classical motifs can also be found in portraits of the Evangelists in Byzantine Gospel books. In

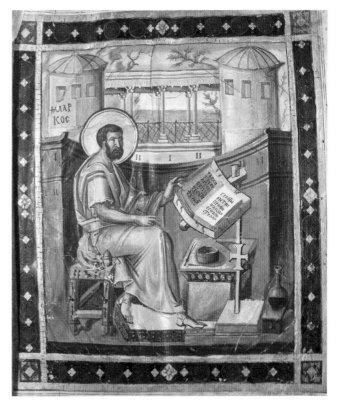

Fig. 5.17. *Saint Mark.* Illustration in the Stauronikita Gospels. 10th century. Stauronikita Library, Mount Athos (Cod. 43, fol. 11)

the handsome Gospels in the Monastery of Stauronikita at Mount Athos, another product of a Constantinopolitan atelier of the tenth century, the conventional Early Christian Evangelist portrait has been elaborated by adding motifs from ancient portraits of philosophers and dramatists (**fig. 5.17**). Mark's meditative and relaxed pose, even his costume and

bearded head, are derived from some such Classical figure.[28] In contrast to the tradition in the West of placing the Evangelist in a landscape with the appropriate Apocalyptic symbol (a lion for Saint Mark), derived from John's Revelation and Jerome's commentaries, the Macedonian painter places Mark in a niche before the proscenium wall of a Hellenistic theater or library, much as sculptures of literary giants in the ancient world would have been displayed before the public as monumental author portraits.

During the course of the eleventh and twelfth centuries, a number of new directions in Byzantine painting at the imperial court emerged. The illusionism that characterized Macedonian productions gives way to a highly refined iconic style where more hieratic features are restored along with the abstract gold backgrounds. In addition, there is a return to the diminutive "column-picture" format; and, finally, colorful borders and headings of delicate abstract ornamentation are more and more incorporated into the miniatures, reminding one of the luxurious embellishments in Islamic illuminated manuscripts.

An example of the first tendency is found in the Menologion of Basil II in the Vatican Library, dating between 976 and 1025 (**fig. 5.18**). A *menologion* is a general service book for each day of the year, with readings of some notable event such as a martyrdom, an episode from the life of Christ, and so forth, appropriate for the day. In the Vatican manuscript, only the readings and illustrations for September through February are preserved, but more than 430 miniatures appear. Eight different artists signed the paintings, an unusual practice in Byzantine art, and therefore it is not surprising that a variety of styles are present.

The miniature portraying Saint Michael is typical of many of those that present a single saint standing before a simple architectural or landscape setting with a rich gold background. The Archangel Michael is tall and slender and stands in a proud frontal position as he vanquishes little blue and green demons (the fallen angels) placed symmetrically about him. His blue and gold costume is drawn in hard, straight lines with sharp angular pockets. Sprays of gold model the blue mantle as if pure light were shining through the saint's body. The setting is simplified: hills of green and blue rise symmetrically as compositional props, with little indication of atmospheric illusionism or naturalism.

A highly imaginative artist of the twelfth century painted the sumptuous miniatures illustrating the Homilies on the Virgin, written by a monk, Jacobus Kokkinobaphos (**fig. 5.19**). Bright colors, especially blues, reds, and golds, verge on the garish in many miniatures, but the execution is meticulous and elegant throughout. Many of the pictures display original compositions to illustrate the mystical content of the monk's sermons, but even in those that present more conventional narratives, such as the Ascension illustrated here, the elaborations of the frames and backgrounds are startling. In the lower center of the painting, we find a composition as old as that in the Rabbula Gospels (fig. 3.26), with Mary standing amid the apostles witnessing the ascending Christ. The frame dominates the miniature. An architectural facade rises in three well-marked zones to form a structure with five domes. In a lunette at the base of the central dome, a diminutive representation of Pentecost appears.

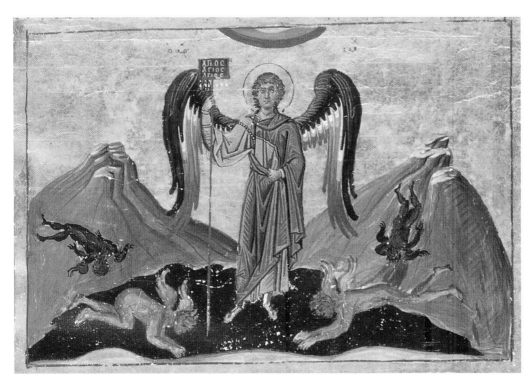

Fig. 5.18. *Archangel Michael.* Illustration in the Menologion of Basil II. 10 × 14½″. c. 1000. Vatican Library, Rome (MS grec. 1613, p. 168)

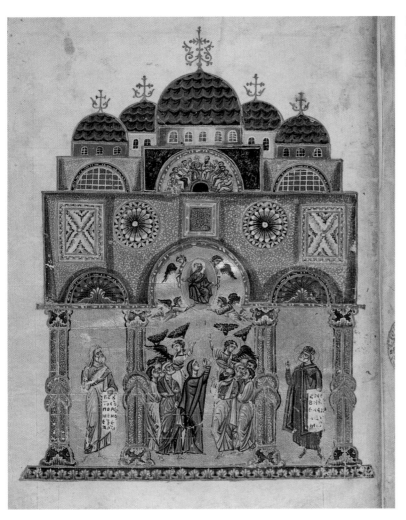

Fig. 5.19. *Ascension*. Illustration in the Homilies on the Virgin by Jacobus Kokkinobaphos. 9⅝ × 6⅝″. 12th century. Bibliothèque Nationale, Paris (MS gr. 1208, fol. 3v)

THE MONASTERY CHURCH

Monasticism in Byzantium served as an organization for the pious who wished to live in retirement from the mundane affairs of the world, but it was also an influential authority in the balance of power between the Church and state in the empire. The spokesmen for the Orthodox Church were traditionally drawn from the ranks of the monastery, and, indeed, metropolitan and parish churches were subordinated to the monastic system. Byzantine monasticism, following the Rule of Saint Basil (c. 330–79), was loosely organized around individual communities of monks.

Because the monastic congregations in the Middle Byzantine period were relatively small—frequently fewer than twelve monks—their churches were small, and yet, during the period, it was the monastic church, not the great metropolitan cathedral, that established the norm for religious architecture: the Greek cross-in-square plan with a dome over the crossing. The four arms of the cross (connecting the inner core to the outer walls) and the bays in the corners of the square were vaulted. The apse was usually augmented with flanking chapels, the *prothesis* and the *diaconicon*, and the side facing west was fronted by a vaulted narthex. In addition, the

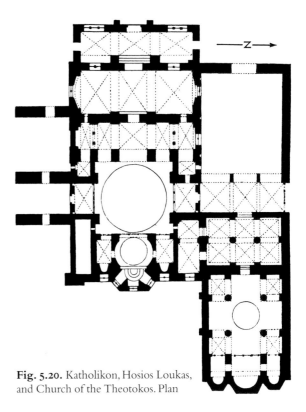

Fig. 5.20. Katholikon, Hosios Loukas, and Church of the Theotokos. Plan

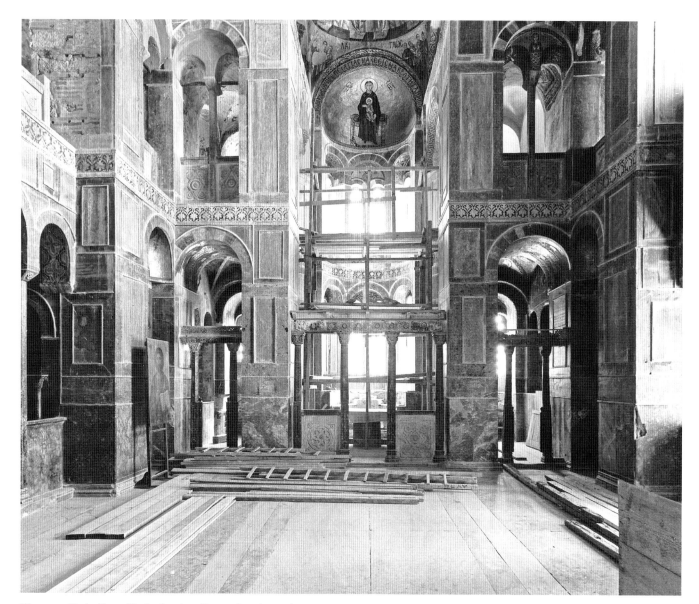

Fig. 5.21. Katholikon, Hosios Loukas, Greece. Interior. 11th century

ancillary spaces were concentrated around the central dome, which was lifted high.

Looking into the *naos* (nave) of the Katholikon of Hosios Loukas in Greece (Phocis), one can sense the clarity and nobility of this compacted dome and cube construction, yet, due to the small scale, a comforting intimacy is effected by the concentration of spaces about the beholder standing in the very center of the church (**figs. 5.20–22**).[29] The unity of parts here—the great circular dome rising from the center of the Greek cross, which, in turn, is encased in a cube—creates a perfect image of the cosmos to which the church was compared in contemporary descriptions (*ekphraseis*), a point to which we shall return.

Hosios Loukas is more complicated in elevation than most Byzantine churches of the period, however. A secondary dome rises before the apse, and the *naos* has high, open

galleries that accentuate the vertical lift of the central bay. Furthermore, the dome rests not on a square bay but on one that is transformed into an octagon by *squinches* (half-conical niches built into the four corners of the bay). From these eight segments pendentives rise to form the circular base for the dome. The exterior is also elaborated with richly textured courses of stone and brickwork.

The Middle Byzantine cross-in-square churches have sometimes been considered little more than modifications of the huge cross-domed structures of earlier architecture, but this view ignores the dynamic inventiveness born of the restraints imposed by such simple plans. For one thing, Hosios Loukas is an intricate skeletal structure of interlocking spatial units and not merely a massive hollowed-out cube. Due to the complex interplay of the nine-bay plan with open galleries and double and triple windows that pierce the west

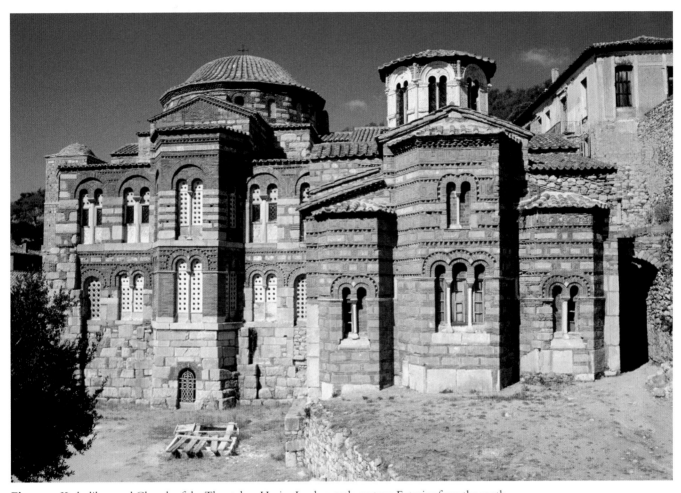

Fig. 5.22. Katholikon and Church of the Theotokos, Hosios Loukas. 11th century. Exterior from the south

wall and the four corners, the experience of space is unusual in the magnetism that draws us to the center of the church. We are invited to turn and explore its intricacies and nuances of changing illumination in the various stereometric parts. The darker shadows of the marble revetment lining the walls and piers, the bright glitter of the mosaic pictures that fill the vaults and dome above, seem to revolve about us.

The church at Daphni in Greece (near Eleusis) is one of the most famous Middle Byzantine churches due to the extensive remains of the mosaic decorations there (**figs. 5.23–28**). Built about 1080, Daphni, like Hosios Loukas an imperial foundation, is simpler in elevation. The galleries are omitted so that the high dome rests directly on the tall piers of the *naos*. A comforting balance of dome and cube thus replaces the complex interpenetrations of space that we experience in Hosios Loukas. Because of this concentration, the mosaics in the central bay seem more dominating and crucial to our experience of the church and its meaning as a house of worship.

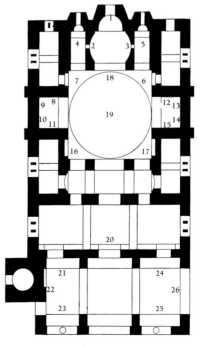

Fig. 5.23. Church of the Dormition, Daphni. Plan with mosaics indicated (after Demus and Diez).

1. Madonna with Child
2. Michael
3. Gabriel
4. John the Baptist
5. Nikolaos
6. Birth of Christ
7. Annunciation
8. Birth of Mary
9. Crucifixion
10. Entry into Jerusalem
11. Lazarus
12. The Three Magi
13. Resurrection
14. Thomas
15. Presentation
16. Transfiguation
17. Baptism of Christ
18. The Sixteen Prophets
19. Pantocrator
20. Dormition
21. Last Supper
22. Washing of the Feet
23. Judas Betrayal
24. Presentation of the Virgin
25. Prayer of Joachim and Anna
26. Benediction of a Priest

Otto Demus, in his fine book on Byzantine mosaic decoration, has likened the Middle Byzantine church to an "icon in space," and while such a characterization may seem extreme, the symbolic meaning he finds in the domed cross-in-square structures certainly enriches our responses to them.[30] For Demus, the meaning of the church is threefold. Citing various *ekphraseis* and interpretations (in particular the *Historia mystagogica* attributed to Germanus, patriarch of Constantinople between 715 and 730), Demus describes the church as an image of the cosmos with the dome symbolizing the heavens, the squinches and vaults representing the paradise of the Holy Lands, and the piers and walls constituting the terrestrial world. The mosaics clarify this interpretation. The higher the painting, the more sacred is the image, an idea analogous to the Neoplatonic ladder of being which, as we have seen, served as the aesthetic basis for the icon in general.

The architecture is divided into discrete zones to accommodate the imagery of this Neoplatonic universe. The summit of the central dome is the exclusive domain of the *Pantocrator*; the mosaics lining the curved surfaces below—the squinches and vaults—present the major events in the life of

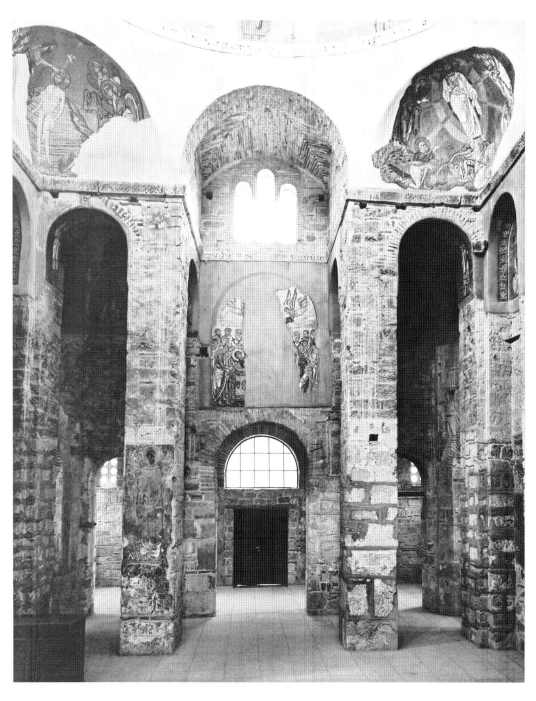

Fig. 5.24. Church of the Dormition, Daphni. c. 1080–1100. Interior facing west

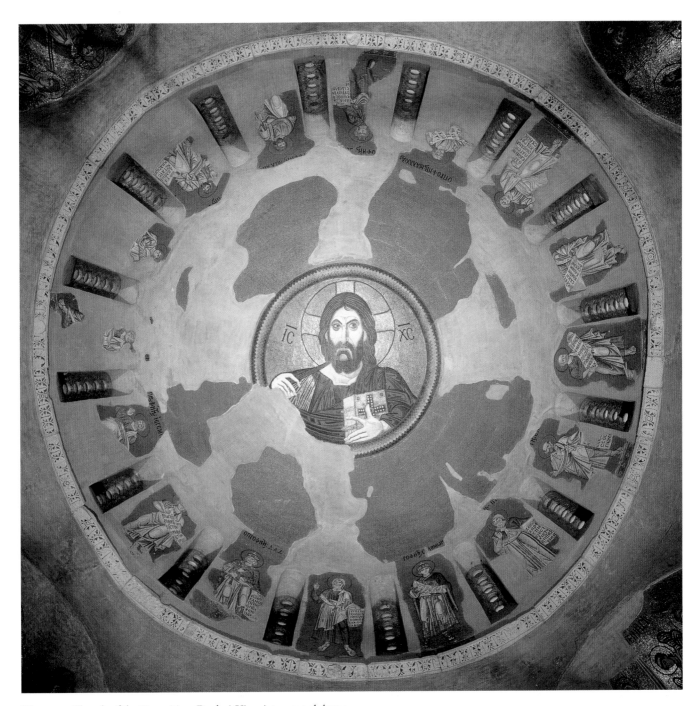

Fig. 5.25. Church of the Dormition, Daphni. View into central dome

Christ on earth; and the rank and file of the saints on the lower walls and piers commemorate those among us who have attained sainthood. Standing below, the worshipper occupies the lowest rung in this hierarchy.

At Daphni, the *Pantocrator* (**fig. 5.25**) is presented as a huge bust portrait within an oculus or medallion. His facial features are those of the pre-iconoclastic icon of Christ discussed earlier (fig. 4.23), but this ruler is stern if not menacing, and in his rigid left hand he carries a heavy book, signifying the Word of God.

The mosaics in the squinches next engage the beholder's eyes. Turning clockwise from the northeast corner, we see the Annunciation, the Nativity, the Baptism of Christ, and the Transfiguration. Other narratives that make up the Christo-logical cycle are placed on the walls of the cross-arms, north and south, and they complete the series of the *Dodekaeorta*, or Twelve Feasts of the Byzantine calendar (the major festivals of the life of Christ celebrated during the year). The mosaics in the squinches are not narratives in the traditional sense, how-ever. They are like staged performances of actual events, with

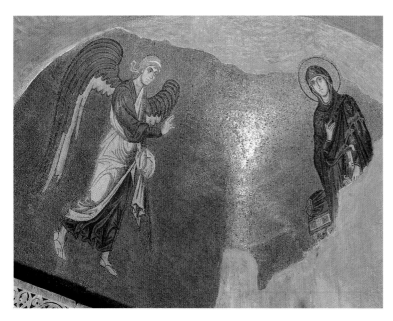

Fig. 5.26. *Annunciation.* Mosaic in southeastern squinch in the Church of the Dormition, Daphni

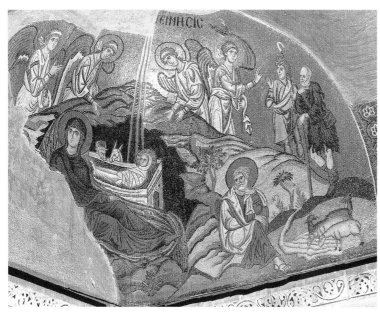

Fig. 5.27. *Nativity.* Mosaic in the northeastern squinch in the Church of the Dormition, Daphni

real actors performing in the space before the beholder. In the *Annunciation* (**fig. 5.26**), Mary and Gabriel hover as bright forms projecting from the abstract gold background of the niche as if standing in the real space of the *naos*. By virtue of the deep curvature of the squinch, they confront each other directly; Mary stands in a frontal position, but at the same time she faces Gabriel across the way much as she looks down at the worshipper.

In a like manner, the curvature of the squinch provides a three-dimensional stage for the *Nativity* (**fig. 5.27**). The dark grotto where the Child lies is in the deepest part of the niche, and the concave landscape moves out and around it. Mary reclines to the left, her body turned to a near frontal position as she regards the viewer, while Joseph, pondering the mystery of the Incarnation, sits off to the right and glances across the space at the Virgin. The star shines down from the

summit of the squinch, its rays descending along the curved surface of the grotto, and the angels above appear to be grouped in a semicircle about the crib. The gold background is highly effective in sealing off any illusion of representational space, and this abstraction imparts a timeless ambience to the stories. The mosaics present a never-ending cycle of the feasts of the year, not as history but as true mysteries.[31]

The *Crucifixion* at Daphni is one of the finest examples of an "iconic" Calvary picture ever created (**fig. 5.28**). It appears on the east wall of the northern cross-arm and is difficult to see from the center of the *naos*. Perhaps the Crucifixion was relegated to this secondary position because a representation of the body of Christ on a vertical cross would not lend itself easily to a curved surface. Here we find an amazing blend of the iconic and the narrative requirements of the story. The setting is reduced to a simple ground-

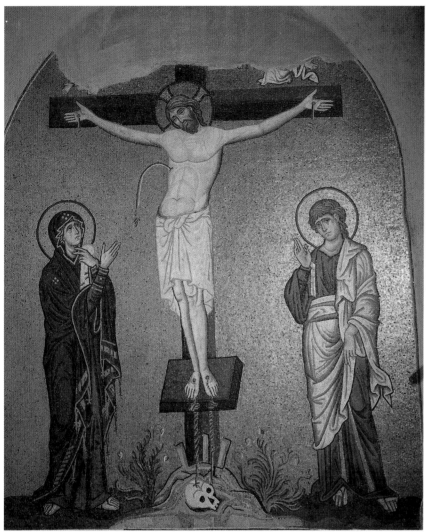

Fig. 5.28. *Crucifixion.* Mosaic on east wall of north arm in the Church of the Dormition, Daphni

House of the Lord. These appear as full-standing or bust portraits posed frontally and standing upright with respect to the floor of the *naos*. As true icons, they represent the faithful who attained sainthood and thus are elevated above the common worshipper. Finally, in the areas outside the *naos*, such as the narthexes and lateral chambers abutting the outer walls, various programs could be devised.

Everywhere rich gold and silver objects greet the eyes, augmenting the splendor of the glowing mosaics overhead. The *iconostasis*, a screen wall of wood or stone separating the *naos* from the sanctuary on the east, was added later and today functions as the main place for the display of icons. The high *iconostasis*, which was a late medieval innovation, usually consisted of three tiers. At eye level, the first of these was the carrier of larger, hieratic icons of *proskynesis*. With oil lamps and candles burning before him, the worshipper approached, knelt, and embraced the icon while offering prayers. Generally the focus of the *proskynesis* icons was on a group of three, featuring Christ between the Virgin and Saint John the Baptist, a triptych known as the *Deësis*. The two side figures served as intercessors for the faithful when Christ appears at his Second Coming to judge humanity.

The second row of icons featured an assortment of smaller portraits of standing saints, and above them appeared scenic icons with representations of the twelve feasts of the church year commemorating the major events in the life of Christ. There were many variations, and the icons were of various media. If the *iconostasis* had a door, the Annunciation (the introduction to the mysteries of the Incarnation) would be painted on it, and frequently a large Crucifixion was displayed above. Icons of the Virgin figured prominently on the *iconostasis*, as indeed they did almost anywhere that devotions were held. These appear in various media ranging from paintings on wood to costly *cloisonné* enamels and miniature mosaics.

line with a mound and the skull of Adam. The background is solid gold, and the numerous figures usually presented under the cross are eliminated. Only the two major mourners, the Virgin and John the Evangelist, are placed symmetrically about Christ. They are not reduced to flat carpets, however, but appear as well-modeled bodies covered by articulated draperies. The frontal corpus sags a bit off axis, and Christ's eyes close as his head falls to his shoulder. The Classical qualities of the figures and the symmetrical balance create an image wherein a truly spiritual ideal of human beauty is attained. A timeless Crucifixion is presented to us, a death that was ordained for man's salvation, and the Virgin and Saint John seem to accept that fact quietly without displaying the pangs and contortions of the despair they suffered.

The conch of the apse, the most sacred area in the Latin basilica, was the second most sanctified place in the hierarchy of the Byzantine program, and it is here that icons of the Virgin, standing or enthroned, were presented. The lowest zone, the walls and piers, received no scenic mosaics. Over fifty single figures are arrayed at Daphni, forming choirs of saints—apostles, martyrs, prophets, bishops—who fill the

FRESCO PAINTING

From the seventh to the tenth century, the Byzantine emperor and Abbasid caliph ruled Cyprus jointly. In the summer of 965, however, Byzantine troops took over the entire Mediterranean island. By the twelfth century, Cyprus was a convenient place for imperial armies to gather supplies on the way to the Crusades in the Holy Lands. Numerous small churches were constructed around this time. Their interior walls were frequently covered with fresco paintings, a cost-effective substitute for mosaics.

The monastic church of Panagia Phorbiotissa (Asinou) is filled with sacred iconography. On the interior wall, an extra-biblical event (**fig. 5.29**), the Dormition of the Virgin (*Koimesis*), is shown. Behind the elongated reclining body of Mary stands Christ receiving the soul of his mother, framed by grieving apostles and angels. For Orthodox Christians, the *Koimesis* provided a memorable antithesis to scenes of Christ's Infancy. Mary offered a sanctuary for divinity in her womb and she continued to care for Christ while he remained a vulnerable child. To compensate for her charity, Christ now protects her soul. The location of this fresco is opposite of the apse, where the Virgin is typically shown holding the Christ child, enhancing its rhetorical appeal. The red and gold veil worn by Mary is a local invention, drawing attention to area commerce. Cyprus was, after all, known as a great producer of fine scarlet and gold thread.[32]

Fresco painting was also a favorite medium for church decoration in the Balkans. In the twelfth-century Church of Saint Panteleimon at Nerezi (near Skopje, Macedonia), which was donated by the emperor's nephew, breathtaking paintings

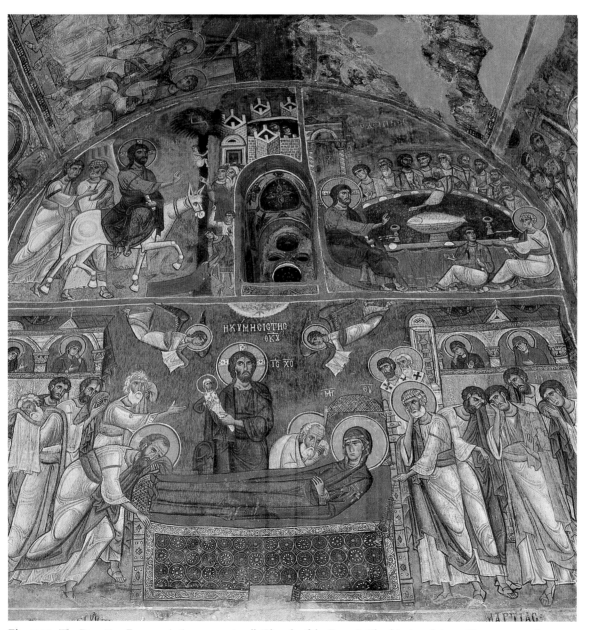

Fig. 5.29. *The Dormition.* Fresco painting on west wall, Church of the Panagia Phorbiotissa, Asinou, Cyprus. 1105–6

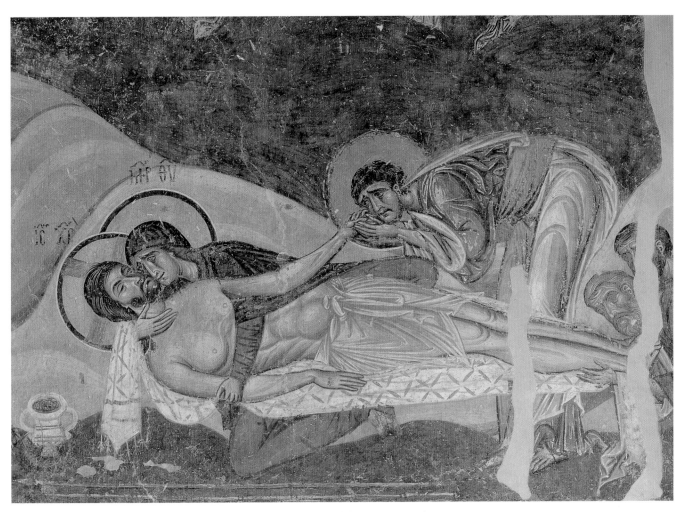

Fig. 5.30. *Lamentation.* Fresco painting. North wall of the katholikon of the monastery of
St. Panteleimon, Nerezi, near Skopje, Macedonia. 1164

blanket the walls. Many of the paintings are intensely dramatic and emotionally charged. In the extra-biblical tale of the Lamentation (**fig. 5.30**), those who love the crucified Christ mourn his loss prior to the Entombment. The elongated proportions of the figures and the exaggeration of line accentuate the broken body of Christ and helps pious observers pay heed to the pathetic qualities of the scene. Viewers are encouraged to imitate the Virgin Mary and Saint John, who shed copious tears at the sight of the dead Christ.[33]

The painting shows the deep sorrow of mourners against a barren landscape in an effort to enliven religious devotion. Throughout the middle Byzantine period, numerous homilies and hymns were composed detailing the Virgin's anguish and grief after the Crucifixion. In addition, on the Saturday morning between Good Friday and Easter Sunday, the days commemorating Christ's death and resurrection, a special liturgical lament, the *Epitaphios Threnos*, was established. The Nerezi fresco complements homilies and hymns addressing the Virgin's sorrow. Akin to these verbal laments, the painting juxtaposes Christ's death with his birth. The dead corpse of her adult son lies across the Virgin's lap, recalling scenes of Christ's infancy. Furthermore, analogous to icons of the Virgin Eleousa, Mary presses her cheek against the face of her child, drawing greater attention to her compassion and suffering (compare the Virgin of Vladimir on pages 116–17). By emphasizing the antithesis between Christ's birth and death, the painting evokes a heartfelt response from pious beholders, calling them to experience the emotional depths of Christ's sacrificial death more intensely.

PANEL PAINTING

In the twelfth century, new iconographical subjects were added to the repertoire of icon painting. The popular seventh-century devotional text, John Klimax's *The Heavenly Ladder*, which was often copied with illuminations, now appeared on a painted panel (**fig. 5.31**). This icon does not represent a particular narrative or holy figure. Instead, it shows the path for spiritual perfection. In the lower right, a group of monks stops to pray before embarking on their journey. The ladder, placed on a diagonal, includes thirty rungs corresponding to the chapters in Klimax's book and to the number of years that Christ remained hidden in preparation for his mission. Virtuous monks ascend toward heaven, where Christ

and angels are waiting to welcome them. The first in line is the author Klimax, who is approaching the highest rung. Directly behind him is the archbishop Antonios, who likely donated the painting. Unfortunately, the spiritual climb is filled with danger. Some impious monks fall to the temptations of vice. Subsequently, they are taken prisoner by demons and cast into the depths of hell.[34]

Another innovation appears in the Saint Nicholas panel (**fig. 5.32**). This picture combines a conventional half-length portrait of the saint and surrounds it with the story of his life on the margins. Although this *vita icon* or narrative icon is relatively large, the small scenes demand close inspection.[35]

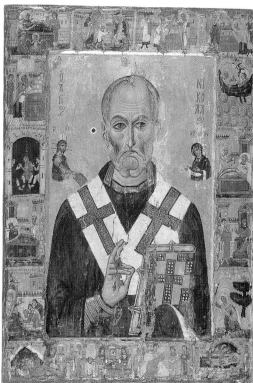

Fig. 5.32. *Icon of Saint Nicholas.* Tempera and gold on panel. 32¼ × 22⅜″. c. 1200. Monastery of Saint Catherine, Mount Sinai

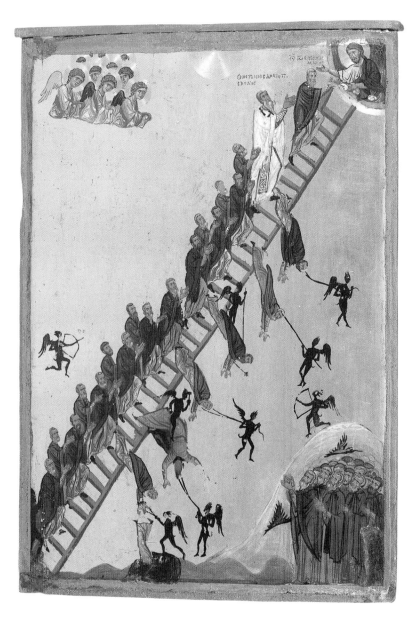

Fig. 5.31. *The Heavenly Ladder.* Tempera and gold on panel. 16 × 11½″. Late 12th century. Monastery of Saint Catherine, Mount Sinai

ARMENIA

During the Middle Ages, Armenia was divided into numerous small principalities. Christianity had been introduced to the region in the early fourth century. On the island of Aght'amer in Lake Van (in modern Turkey), the ruler of the Armenian kingdom of Vaspurakan, Gagik I, built the Church of the Holy Cross (**fig. 5.33, 5.34**) adjacent to his palace. According to legend, the king brought together artisans from throughout the world to construct the building. The church is designed in a Greek cross with a central dome. However, its exterior walls, unlike those of Byzantine churches, are decorated with stone relief sculpture. Figures of angels and saints can be seen from any direction. Carved grapevine and animal motifs also appear, suggesting the heavenly treasures of the kingdom to come.

In a scene reminiscent of Byzantine art, Gagik is depicted donating a miniature copy of his palace church to Christ. The Vaspurakan king is dressed, however, in a Muslim robe, one that may have been given to him by the Abbasid caliph of Baghdad. Surprisingly, in an apparent violation of decorum, Gagik is represented as taller than Christ and is clothed in a much more elaborate costume. Nonetheless, following tradition, Gagik is positioned on Christ's right, where he receives God's blessing.[36]

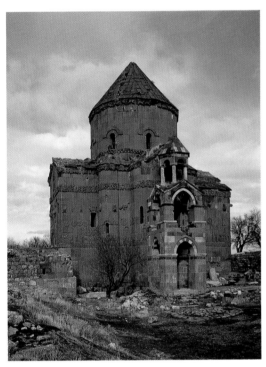

Fig. 5.33. Westwork, Church of the Holy Cross, Aght'amer Armenia (present day Turkey). 915–21

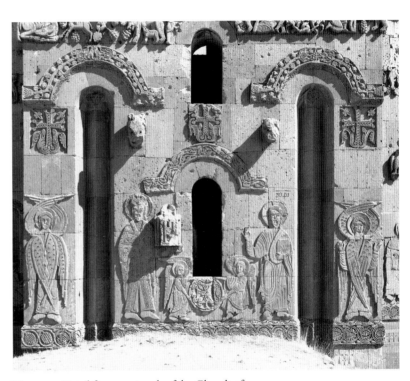

Fig. 5.34. Detail from westwork of the Church of the Holy Cross

RUSSIA

Late in the tenth century, Vladimir, the Prince of Kievan Rus (from which the name Russia derives), converted to Christianity and agreed to establish an alliance with the Byzantine emperor Basil II. To strengthen the deal, Vladimir married the emperor's sister Anna, who was less than excited about the arrangement, but complied.

Vladimir's son and heir, Yaroslav, supervised the construction of a new church, Santa Sophia (Sviata Sofiia) in the capital city of Kiev (today in Ukraine). Artisans and materials from Constantinople were imported and employed in the project. Built in cross-in-square design and covered with expensive mosaics, Santa Sophia closely resembles a Byzan-

tine church. The style and iconography of the *Pantocrator* mosaic (**fig. 5.35**) closely adheres to Byzantine conventions and is located in the central dome. In the apse mosaic (**fig. 5.36**), the *Theotokos* stands alone in the *orans* position against a gold background. Below her, Christ offers communion to the apostles. He is depicted twice, offering the host on the left and wine on the right.[37]

In the twelfth century, the Church of Saint Dmitri (**fig. 5.37**) was built in the city of Vladimir. Although the limestone building follows the Byzantine plan of cross-in-square, the extensive use of figurative relief sculpture on its exterior walls and elevated drum seem to be informed by other sources.[38]

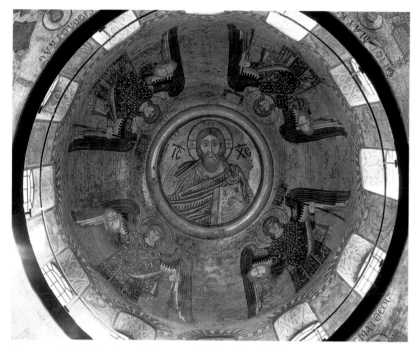

Fig. 5.35. *Christ Pantokrator.* Dome mosaic, Santa Sophia, Kiev. c. 1037

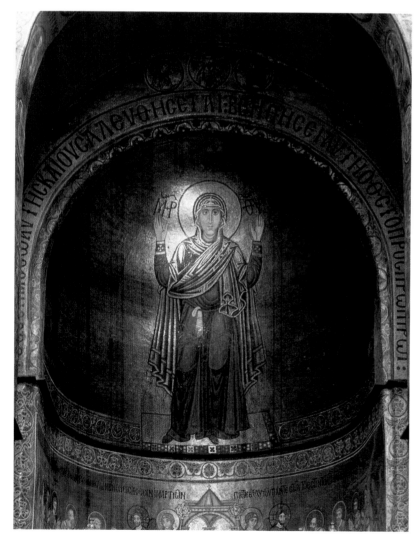

Like Byzantine churches, Russian churches were filled with icons. Arguably the most famous icon in Russia, the *Virgin of Vladimir* (**fig. 5.38**), was not produced there; it was a gift from the Byzantine court and painted in Constantinople. In Russia, it served as a *palladium* against enemy forces. Although the icon was originally placed in Kiev around 1135, it subsequently moved as the center of power shifted—first to Vladimir (1155) and then to Moscow (1480), where it was used to protect the city from Mongol invasion.

The Vladimir Madonna is a fine example of the *Virgin Eleousa* type. Rather than focus on the Virgin as a guide who points to Christ (*Virgin Hodegetria*), the image concentrates on her compassion. Like the Nezeri Lamentation fresco (fig. 5.30), the Virgin of Vladimir calls for empathy. Mother and Child press their cheeks against one another in tenderness. The sweet sadness on Mary's face, however, suggests that she has foreknowledge of Christ's future suffering and sacrificial death.[39]

Nearly three hundred years later, the artist-monk Andrey Rublyov painted a large icon of the Old Testament Trinity (**fig. 5.39**) for his monastery outside of Moscow. Although the painting is severely damaged, having loss much of its original color, it is a remarkable composition. The artist has effectively abbreviated a scene of the Hospitality of Abraham (Genesis 18:1–15). Abraham and Sarah have been eliminated; only three nearly identical messenger angels, prefiguring the Holy Trinity, remain. The ideal geometry and harmonious arrangement of the elongated angels encircling the table not only communicate a sense of tranquility and grace, they also reinforce the theological theme of the icon, the Holy Trinity as a three-in-one.[40]

Fig. 5.36. Apse mosaic, Santa Sophia, Kiev

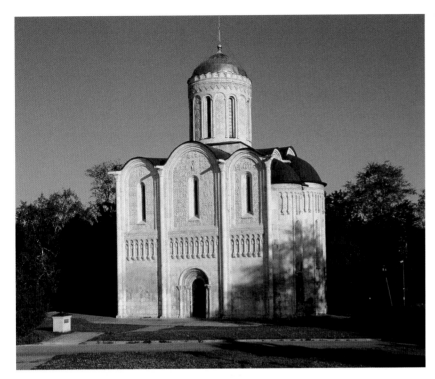

Fig. 5.37. St. Dmitri, Vladimir (exterior).
c. 1194–97

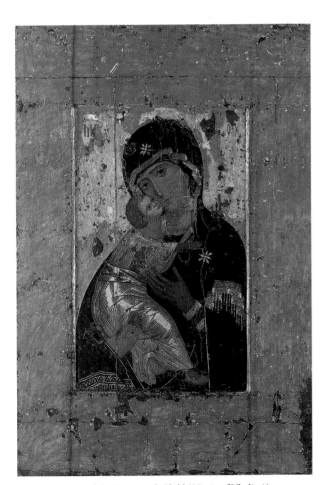

Fig. 5.38. *Icon of the Virgin and Child (Virgin of Vladimir).*
Tempera and gold on panel, 44¾ × 26¾″. Constantinople.
c. 1131 with numerous later restorations. Tretyakov Gallery,
Moscow

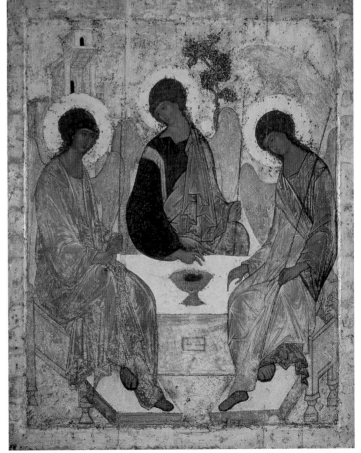

Fig. 5.39. Andrey Rublyov. *Old Testament Trinity (Three Angels Visiting
Abraham).* Tempera and gold on panel, 55½ × 44½″. 1420s. Tretyakov
Gallery, Moscow

LATE BYZANTINE ART

In April 1204, Latin Crusaders sacked the city of Constantinople and shipped much of their acquired loot, including precious relics and liturgical items, back to Western Europe. The crusaders continued to occupy the city until 1261, after a number of defeats. When the Byzantine emperor Michael VIII Palaiologos triumphantly returned to Constantinople, he walked behind the *Virgin Hodegetria* (now lost). This act marked the city's continual dedication to the *Theotokos* as well as the desire for future protection.

A huge mosaic of the *Deësis* (**fig. 5.40**), placed in the south gallery of Hagia Sophia, may have been commissioned to commemorate the retaking of the city. Despite its gigantic scale (approximately eighteen by twenty feet), the mosaic is rendered in meticulous detail. The figures are highly naturalistic. The Virgin Mary and Saint John the Baptist turn their heads towards Christ, seeming to plead for mercy on the viewer's behalf.

An icon of the Archangel Gabriel (**fig. 5.41**) also appears quite naturalistic. Despite the extensive use of gold in the veil and wings, the figure seems to be three-dimensional. The features of Gabriel, who is shown carrying a messenger's walking staff, are delicately modeled. The slight turning of the angel's head suggests refined grace as it invites an empathetic response.[41]

Between 1316 and 1321, Theodore Metochites, chief administrator of the imperial treasury, donated a new funerary chapel (*parekklesion*) for the monastic church of Our Savior in Chora (Turkish name Kariye Camii) in Constantinople. For the chapel's apse, he commissioned a remarkable fresco of the Anastasis, or the Harrowing into Hell (**fig. 5.42**). In the center, the resurrected Christ, surrounded by a white almond-shaped glory cloud (mandorla), bursts from the gates of the abyss. Victorious over death and the devil, he lifts the Old Testament saints Adam and Eve out of their tombs. With

Fig. 5.40. *Deësis.* Mosaic in the south gallery of Hagia Sophia, Constantinople. c. 1260

scenes of the Final Judgment in the ceiling vaults above, the Anastasis fresco offers an eschatological iconography proper for a burial chapel, for it prefigures Christ's Second Coming and proclaims ultimate triumph over death.[42]

On the 31 May, 1453, Ottoman Turks entered Constantinople and renamed the city Istanbul. Hagia Sophia and Our Savior in Chora were converted into mosques and the Byzantine Empire, the Second Rome, came to an end.

Fig. 5.41. *Icon of the Archangel Gabriel.* Tempera and gold on panel. 41⅜ × 29½″. 13th century. Monastery of Saint Catherine, Mount Sinai

Fig. 5.42. *Anastasis* (The Harrowing into Hell). Fresco in the apse of the funerary chapel of Christ in Chora (Kariye Camii), Constantinople. 1316–21

6

BYZANTINE ART AND ITALY

Greek inscriptions on seventh-century frescoes testify to the presence of Byzantine artisans or advisors in the Church of Santa Maria Antiqua in the Roman Forum.[1] This Italian church must have housed an incredible collection of Byzantine art before its devastation by an earthquake in 847. Although difficult to study in its present condition, the church has numerous picture cycles and portraits that can still be discerned. These images display a variety of styles ranging from the more sophisticated Byzantine figures to stockier types painted boldly with labored modeling techniques, such as that of the angel of the Annunciation (**fig. 6.1**).

Twelve miles north of Milan, the small Church of Santa Maria di Castelseprio is built in the fashion of other seventh-century churches in Lombardy, but the apse and choir are decorated with a double frieze of frescoes of astonishing beauty and freshness (**fig. 6.2**).[2] Hardly larger than miniatures, the paintings illustrate the Infancy of Christ according to Apocryphal sources. Executed with a startling spontaneity, the wispy figures move agilely in sketchy landscapes and architectural settings. Dynamic highlighting is achieved with quick, sure strokes, and the delicate hues, although considerably faded, still retain something of the fleeting blond tonalities of their original state.

How does one account for the appearance of such accomplished art in this remote village, and what is the style, anyway? The frescoes have been variously dated from the sixth century through the tenth (a graffito of 938–45 gives us a *terminus ante quem*), and because of the Greek inscriptions, they have been considered to be creations of an itinerant

Byzantine artist. It has also been argued that they are works of a Western painter following Byzantine models and, as such, represent the initial impulse for the development of the Carolingian style found in such manuscripts as the Utrecht Psalter (figs. 8.21, 8.22) and therefore should be dated to the eighth century. Along totally different lines, the Castelseprio frescoes have also been described as related to manuscripts of the so-called Macedonian period, discussed earlier, requiring a date in the ninth or tenth century. The problem has yet to be resolved, but most authorities today date the paintings to around 700 and consider them Byzantine.

VENICE

Aside from the sixth- and seventh-century mosaics in Ravenna, important remains of Byzantine art can be found in other North Italian centers, and foremost among these is Venice. The famed lagoon city had grown from a Byzantine settlement on the island of Rialto in the seventh century into one of the most powerful city-states in the Mediterranean by the ninth. To show its preeminence as an ecclesiastical center as well as a commercial port, Venice constructed an imperial church of distinction, an apostle's shrine, as hallowed as those of Rome, Milan, or Constantinople. Rome, of course, had abundant relics, including the bodily remains of Peter and Paul. Venice could claim no apostle, but, according to tradition, the evangelist Mark, patriarch of Upper Adria and founder of the apostolic Sees of Grado and Aquileia nearby, had preached there. As the protectors of Grado, the Venetians took it upon themselves to "rescue" the remains of Saint Mark

Fig. 6.1. *Angel of the Annunciation.* Fresco in Santa Maria Antiqua, Rome. c. 700

Fig. 6.2. *Presentation in the Temple.* Fresco in the apse of Santa Maria di Castelseprio. c. 700

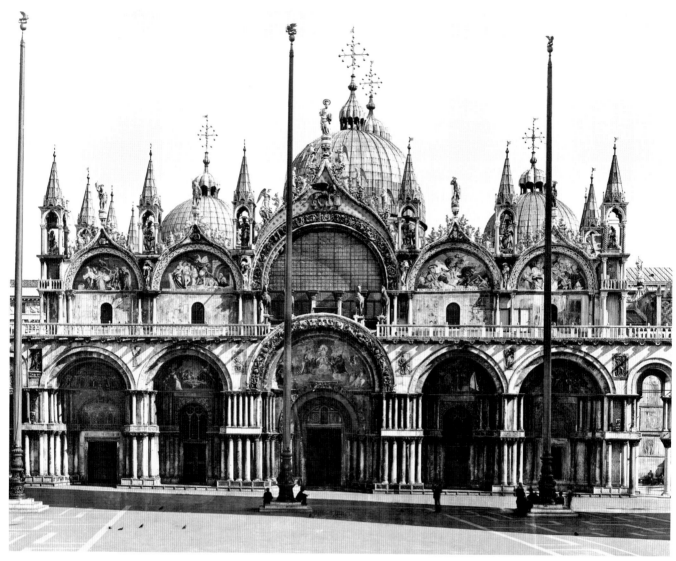

Fig. 6.3. San Marco, Venice. Exterior. Begun 1063

from his martyrium in Alexandria, then under Muslim control, and this they did in 829.

A noble shrine was needed for their newly acquired patron saint, and they erected the first church of San Marco with a cruciform ground plan.[3] It burned in 976 and was quickly rebuilt. This second San Marco was, in turn, pulled down in the eleventh century, and upon its foundations the present church was raised (**figs. 6.3–7**). Begun in 1063, the five-domed church was consecrated in 1073, and by the turn of the century the interior walls were lined with marble. An ambitious program of decoration in mosaic was planned under Doge Domenico Contarini about 1100, but the work dragged on for two centuries. Today the mosaics of San Marco present the student with a fascinating ensemble of pictures as far as chronology and iconography are concerned. They remain the most impressive Byzantine decorations in Western Europe. The exterior of San Marco is an exotic combination of Byzantine, Islamic, and Gothic features

added gradually over centuries (**fig. 6.3**). The columns lining the five portals are spoils brought back from Constantinople in 1204, during the Fourth Crusade, and the large relief plaques that are set into the walls of the west and north facades were carved by Venetian artisans copying Byzantine and North Italian Romanesque sculptures. The lanterns crowning the outer shells of the domes display the ribbed, bulbous contours of Islamic types. French Gothic gables and tabernacles were added above the portals in the fifteenth century, and seventeenth-century mosaics replace early decorations on the upper walls of the facade. Finally, there are the famous bronze horses of the Hellenistic age prancing over the central doorway (copies of these are placed there today), another reminder of the rich booty taken from Constantinople.

An extensive cycle of scenes from the Life of Christ covers the arches and vaults of the galleries in the arms of the cross. For the most part, these works echo Comnenian

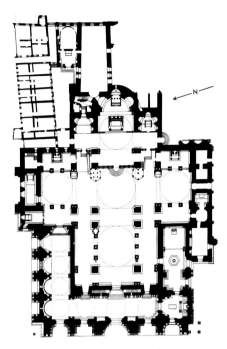

Fig. 6.4. San Marco, Venice. Plan

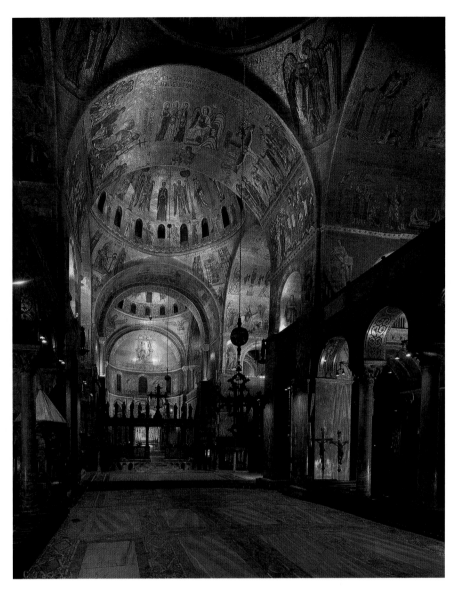

Fig. 6.5. San Marco, Venice. Interior. 12th–13th century

mosaics. Certain manneristic devices are displayed in the draperies (for example, the coils and swirls about the pivotal points of the body) and in figure groupings located within complex compositions.

The decorations of the five main domes and the vaults of the galleries in the arms of the cross were added during the course of the later twelfth century in accordance with a plan loosely related to the cosmic schemes found in Middle Byzantine churches. The dome with the *Pantocrator* is in the east, near the apse and altar, and includes the figures of the *orans* Virgin and prophets between the windows of the base of the dome. The central dome features an impressive Ascension (a theme closely related to that of the *Pantocrator*)[4] that follows Byzantine iconography except for the addition of person- ifications of the Virtues placed between the windows, which is a Western touch (**fig. 6.6**).

Early in the thirteenth century a U-shaped narthex was added to the church. In the western and northern passages of

the narthex are six domed bays lavishly decorated in mosaics with scenes from Genesis. The first of these, near the main entrance, depicts the first days of creation (**fig. 6.7**). The narratives are arranged in three concentric circles of boxed compositions, starting in the center.

The Pala d'Oro (**figs. 6.8–10**) in San Marco is one of the richest ensembles of Byzantine enamel work that survives, and while the present makeup of the "golden altarpiece" dates from the fourteenth century, the general composition reflects a type of Byzantine *iconostasis* in its assembly of miniature icons of *cloisonné* enamels in a luxurious golden frame.[5] The original pala for San Marco was ordered from Constantinople by Doge Pietro I Orseolo (976–78) and apparently consisted of golden plaques nailed on wood. About 1105 a new pala was ordered or received from Constantinople by Doge Ordelaffo Falier (1102–8) that was to serve as an antependium (a screen) for the high altar. Whether or not this was an imperial gift on the part of the

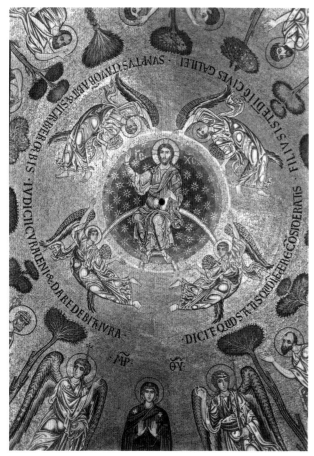

Fig. 6.6. View into the central dome with the mosaic of the Ascension, San Marco, Venice. 12th century

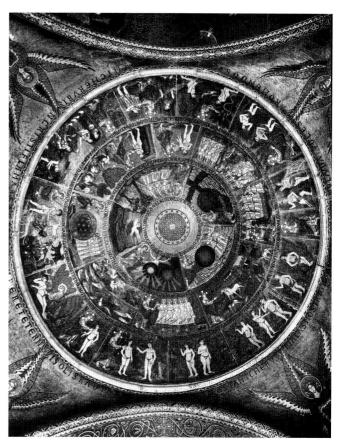

Fig. 6.7. Scenes from Genesis in the first dome of the narthex, San Marco, Venice. 13th century

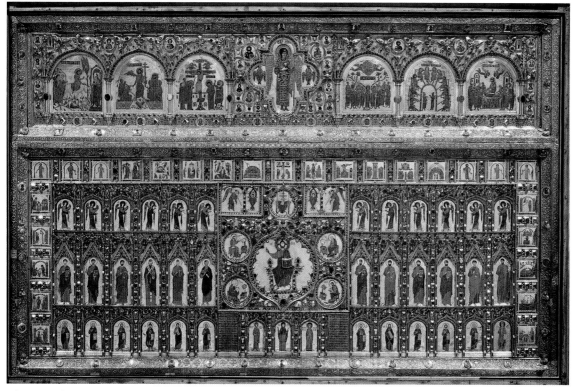

Fig. 6.8. Pala d'Oro. Gold, gems, silver gilt, and enamels, approx. 7′ × 11′9″. c. 1105, 1209, reassembled in the 14th century. San Marco, Venice

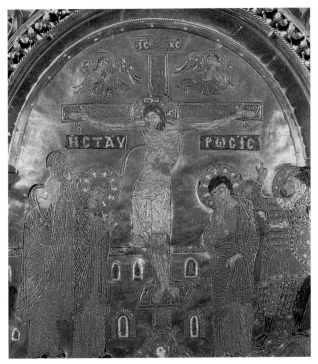

Fig. 6.9. *Crucifixion.* Silver gilt and enameled plaque on the Pala d'Oro. 12th century. Detail of Fig. 6.8

Fig. 6.10. *Maiestas Domini.* Silver gilt and enameled plaque in the center of the Pala d'Oro. Height of central figure, approx. 17″. Detail of Fig. 6.8

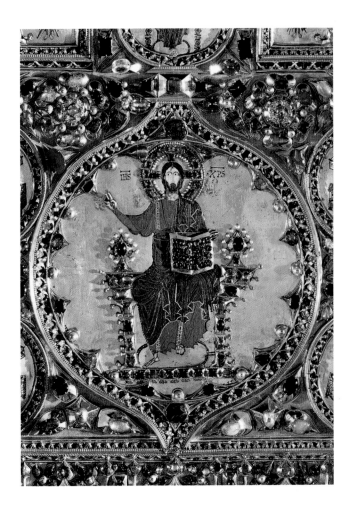

Byzantine emperor Alexius I and the empress Irene is a controversial issue, but portraits of the two (along with one of Doge Falier) appear among the enamels.

Among the sumptuary arts, that of *cloisonné* enamel leads the way in preciousness. The matrix of the enamel is powdered glass or gems heated to a molten state and then poured into a cavity, where it fuses to the gold or silver surface. In the *cloisonné* technique (from the French "partition"), the cavities or cells are carefully welded and partitioned with tiny strips of metal that form the golden lines of the finished design. The molten enamel is then poured into the appropriate cellular divisions and allowed to set. Later, the finished enamel is polished. The result is something between a stained-glass design and a mosaic, but on a miniature scale. Enameled objects were usually enriched with frames or borders of encrusted jewels or cameos. Mounted alone they could beautify a chalice, a tiara, or vestments.

The second pala was altered in 1209, when booty from the Fourth Crusade brought the rich sumptuary arts of Constantinople to Venice. An even more impressive shrine was then designed. To the central plaque, which featured a *Pantocrator,* were added a tier of enamel feast icons taken from an *iconostasis* in Constantinople. Other enamels of Venetian workmanship were also added, including the four Evangelists,

the life of Saint Mark, and the life of the Virgin, which are of inferior quality. The whole was reconstituted again under Doge Andrea Dandolo in 1342–45, when Byzantine enamels of various dates, from the tenth through the twelfth century, were added to the gold, pearl, and gemmed setting. In spite of its makeshift history, the Pala d'Oro remains one of the most impressive deposits of this fine Byzantine art, and it had influence on later Italian painted polyptychs.

SICILY

Sicily, the largest island in the Mediterranean, became a territory of the Byzantine Empire during the Early Middle Ages, until the gradual occupation of the island by Muslim invaders in the middle of the ninth century. In 1060, Roger of Normandy, brother of Robert Guiscard, led his troops from Calabria across the straits of Messina into Sicily, and by 1091 the island was occupied by Normans. The conqueror's nephew, Roger II d'Hauteville, was crowned king of Sicily, Apulia, and Calabria in 1130 and, from his capital at Palermo, proclaimed the Norman empire of the "Two Sicilys" the equal of that of the Western emperor, Lothair, and the Byzantine basileus, Manuel.

There is no question as to which of the two Roman empires Roger most wanted to emulate in building his

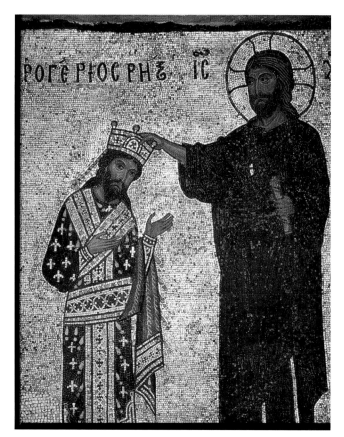

Fig. 6.11. *Christ Crowning King Roger II of Sicily.* Dedicatory mosaic in the Martorana, Palermo. c. 1148

domain. His portraits on coins and seals are based on those of the Byzantine emperors; he petitioned Manuel for a Byzantine princess to be his wife; and he fashioned the culture of his court on the model of the Byzantine state. His ambitions were so bold that after the Second Crusade in 1147, Roger planned an invasion of the city on the Bosphorus and the ousting of the Comnenian basileus. While the political dreams of Roger were never realized, the enrichment of his kingdom in Sicily along Byzantine lines is quite another story.

The dedicatory mosaic in a domed church, the Martorana, built by Roger II for one of the Greek communities in Palermo, served as a political manifesto for the Normans (**fig. 6.11**). Roger II, garbed in Byzantine court costume, stands tall and slightly bends his head to receive the crown (the Byzantine *stemma*) from Christ directly. Furthermore, his claim to be the one chosen by Christ to govern the Roman world is underscored by his actual identification with Christ. Roger's facial features are nearly identical to those of the Savior; his long hair, thin face, mustache and mouth make him the earthly counterpart of Christ. The mosaic portrait visualizes the bold proclamation of an anonymous Norman political tract of 1100, *Rex Messiah est,* the "King is the Messiah."[6]

The syncretic character of Roger's world is displayed in the magnificent palace chapel, the Cappella Palatina, erected

between the palace residence and the administrative offices in Palermo between 1132 and 1140 (**figs. 6.12–17**).[7] The structure, built in two distinct stages, combines a Latin basilica and a Greek cross-in-square *naos* with a dome. The mosaic decoration on the walls and dome is Comnenian in style, executed in part by artisans called in from Constantinople, but the iconographic program is a combination of the Byzantine image of the cosmos (in the sanctuary and transepts) and a Latin pictorial chronicle of the history of *ecclesia* from the Old Testament to the New (in the nave). The wooden ceiling of the nave, finally, is an exotic work of hanging honeycombs of interlocking cells created by Islamic craftsmen brought in from Fatimid Egypt.

The Greek-cross sanctuary built into the transept is domed and carries a lavish mosaic scheme based on the programs of Middle Byzantine churches such as Daphni. In the summit of the dome is the bust of the *Pantocrator* (**fig. 6.13**). Angels and archangels stand in a circle directly below. In the stepped squinches are the four Evangelists, and on the walls between them are prophets. The scenes of the life of Christ are then placed on the walls of the transepts and on the arches and vaults that connect them to the apses and piers of the central bay. Medallion portraits of warrior saints line the soffits of the arches, while the lower register of the end walls of the transepts, north and south, display full-length portraits

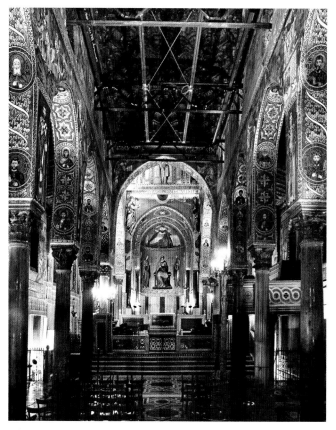

Fig. 6.12. Cappella Palatina, Palermo. Interior toward altar. Mid-12th century

Fig. 6.13. Cappella Palatina. View into the dome with the *Pantocrator.* 1143

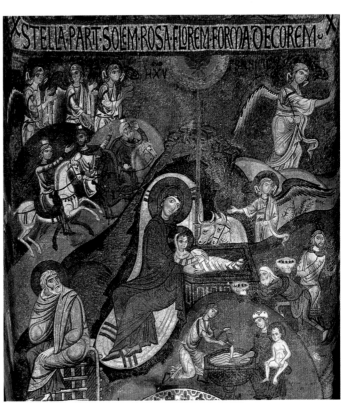

Fig. 6.14. *Nativity.* Mosaic on the wall above the apse of the south aisle in the Cappella Palatina, Palermo. Mid-12th century

of the Church Fathers and other saints, much as in a Byzantine *naos.* An inscription dates the mosaic in the dome to 1143, and the other pictures in the sanctuary were added shortly thereafter (the extensive restorations in the Cappella Palatina make it difficult to determine the chronology precisely). The basilical nave and aisles were decorated with mosaics by local artisans, trained by Greeks, during the reign of Roger's son, William I (1154–66), and grandson, William II (1166–89).

In the *Nativity* (**fig. 6.14**) one can recognize the essential features of Middle Byzantine style (compare fig. 5.27). One departure from the austere presentation at Daphni is the more discursive nature of the narrative. The designer has included extra details, such as the diminutive figures of the Magi traveling in the upper left and, a second time, adoring the Child in the middle right. Hieratic scale is exaggerated, too, and the conventions employed for drapery are mechanically rendered and disconnected. Unlike the Daphni mosaics that are carefully composed in pockets or cells of well-defined architectural spaces, those of the Cappella Palatina flow across the corners of the wall divisions and, as in the *Nativity,* invade the zone of the mosaics on the adjacent walls. The figures are treated as flat silhouettes that float against the stylized landscape with heavy, scalloped contours.

The inscriptions in the sanctuary are in Greek, those in the nave are in Latin, and the subject matter shifts from the Byzantine model to one more familiar in the Latin West. The nave mosaics could be the work of local craftsmen, trained and supervised by Greek masters, but it is impossible to tell for certain. Byzantine artisans could just as well have completed

them. Numerous restorations have also added to the difficulty.

The program of the mosaics in the Cappella Palatina is more than a mechanical juxtaposition of Byzantine and Latin iconographies, however. A distinctive Norman character appears in the arrangement of the scenes in the sanctuary. In fact, the "feast" cycle is out of balance, with the three tiers of mosaics on the south wall of the transept predominating. The original "royal box," or balcony for the king, was located on the north transept wall (later moved to the west end of the nave), directly opposite the mosaics on the south wall.[8] This axial deviation, north and south, explains the unusual emphasis on the themes displayed to the emperor during the services, for they allude to imperial *adventus* and reception ceremonies wherein the *christomimesis* (identification with Christ) of Roger II, much as in his portrait in the Martorana, is emphatically proclaimed.

In the top register, opposite the throne, the *Flight into Egypt,* a rare scene in the feast cycle, appears as the *adventus* of the young Christ before the city gates of Egypt, personified by a standing female. The largest mosaic, the *Entry into Jerusalem* in the lowest tier, is the example *par excellence* of the triumphal *adventus* of Christ before the two-towered gate of Jerusalem (**fig. 6.15**). Thus two *adventus* ceremonies, in Christ's infancy and in his triumph at the beginning of the Passion sequence, confront the king and allude to his royal reception in foreign lands. What better reminder of Roger's role as a triumphant basileus could be placed before his eyes? The divine authority of the Normans is thus proclaimed in the Cappella Palatina.

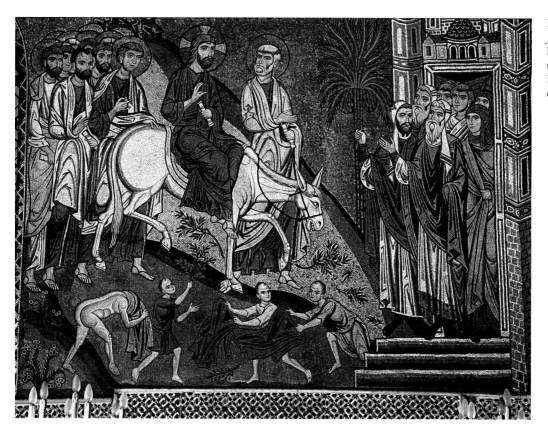

Fig. 6.15. *Entry into Jerusalem.* Mosaic on the lower wall of the south transept in the Cappella Palatina, Palermo. Mid-12th century

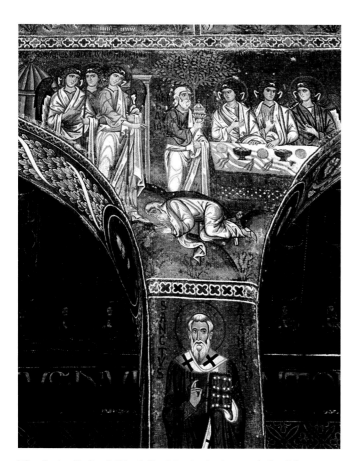

Fig. 6.16. *Abraham's Hospitality.* Mosaics in the spandrels of the nave arcade of the Cappella Palatina. Second half of the 12th century

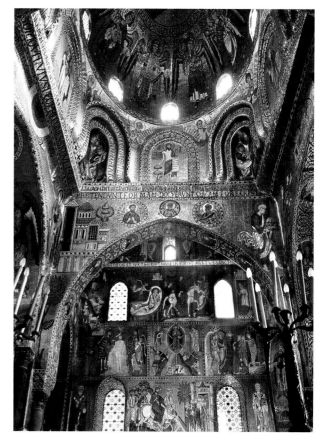

Fig. 6.17. Cappella Palatina. View into south transept

Another example of the Comnenian style in Sicily appears in the apse mosaic in the cathedral of Cefalù (**fig. 6.18**), which Roger II founded in 1131 as a royal burial church (his body was later moved to Palermo Cathedral).[9] The Cathedral of Cefalù is basically an Italian Romanesque basilica with a wooden roof, transepts, and a partly vaulted presbytery. In the main apse appears the majestic Christ *Pantocrator* with the Virgin *orans* and Archangels below and the twelve apostles lined frontally in the lowest zone. Since there is no dome in Cefalù, the decoration, completed by 1148, is an abridgment of the mosaic schemes for the *naos* in Middle Byzantine churches.

The Greek artists who executed the mosaics graduated the height of the figures to compensate for their distance from the beholder. The Virgin and Archangels thus are taller than the apostles below them, and in the conch of the apse the bust of Christ looms out as some super icon, completely dominating the sanctuary, with his right arm sweeping outward as if to embrace the worshipper. The open book on his left announces, in Greek and Latin, "I am the Light of the world," and the delicately curved lines of the tesserae in his face, especially those in his eye sockets and cheekbones, describe the drawn features of a truly ascetic leader. Less corporeal and imposing than the world ruler who stares

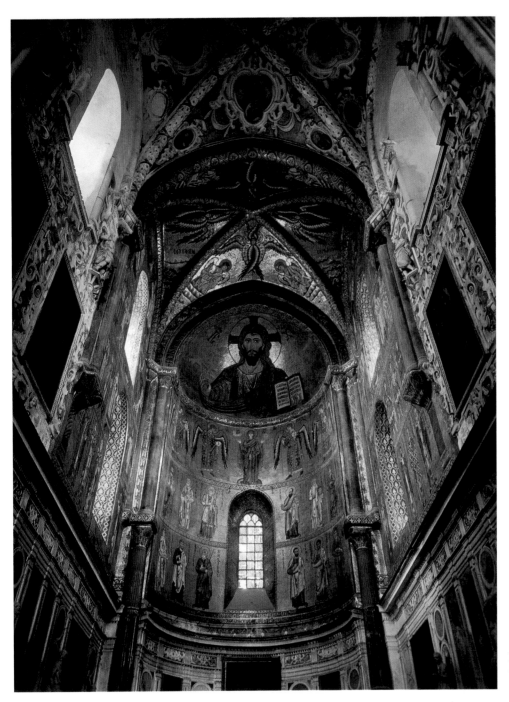

Fig. 6.18. *Pantocrator.* Mosaic in the apse of the Cathedral of Cefalù. c. 1148

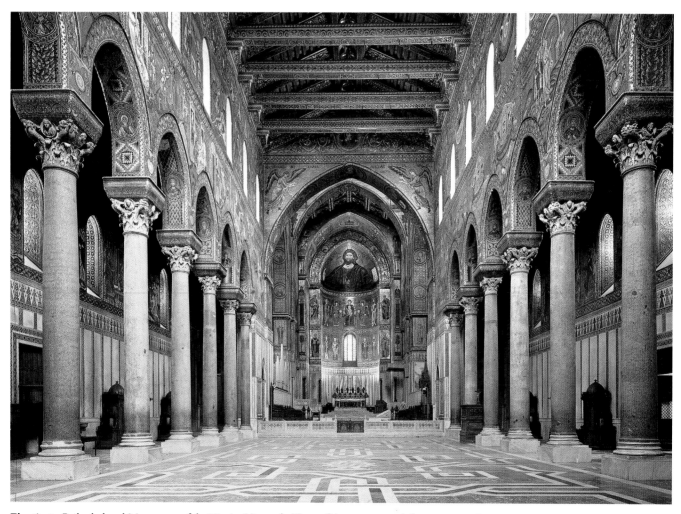

Fig. 6.19. Cathedral and Monastery of the Virgin, Monreale. View of the nave toward the east. 1174–83

down angrily from the dome at Daphni, the Christ of Cefalù seems more compassionate, and his gaze is more comforting.

In the "royal park" of Roger II, high on a hill overlooking Palermo, his grandson, William II, founded the Cathedral and Monastery of the Virgin, known as Monreale, in 1174 (**figs. 6.19–22**).[10] Built directly over the site of Hagia Kyriaka, the cathedral center for the Greek community during the Muslim occupation, the new cathedral was sanctioned to rule over the See of Palermo and the clergy of Palermo Cathedral in the city below. The latter strongly opposed the authority of the Norman rulers. Monreale was granted complete independence by a papal bull of 1176, and its abbot, a Cluniac monk, was appointed archbishop of Palermo, answerable only to the king and the pope.

The huge basilica was built and decorated rapidly, enabling William II to exert the authority of his new church as a *fait accompli* before his death. Following the example of Cefalù, the central figure in the sanctuary is the *Pantocrator* in the conch of the apse above the Virgin between Archangels and, in a lower register, the apostles (**fig. 6.20**). In keeping with Benedictine traditions, the conchs of the two side apses

received mosaic icons of Saints Peter and Paul with legends of their lives below on the walls. The square marking the crossing, lifted high with a lantern, and the sidewalls of the transept arms were decorated with a vast cycle of Christological scenes with no particular emphasis given to the major feast events as in a Byzantine church. History, not liturgy, dictated the subject matter, and extensive narratives completely dominate the scheme. Episodes from the ministry of Christ line the walls of the aisles of the nave, and in two registers, much as in the Cappella Palatina, events of the Old Testament unfold above the nave arcade from the days of Creation to the story of Jacob. Originally there were more pictures of the infancy and life of Mary in the narthex.

In spite of the vast wall spaces covered, the mosaics of Monreale display a homogeneous style. They constitute, in fact, the largest expanse of Comnenian mosaic work to survive and, dating some decades later than those of the Cappella Palatina, they are significant examples of the developments in later Byzantine art.[11] The emphasis on line over volume is accentuated by complex turnings of the drapery, often resulting in swirls and eddies about the hips,

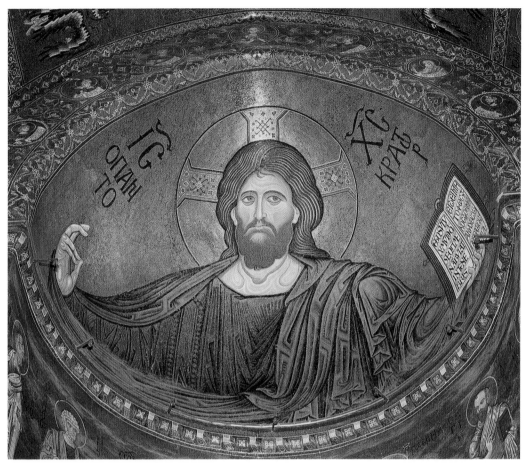

Fig. 6.20. *Pantocrator.* Apse mosaic in the Cathedral of Monreale. c. 1183

Fig. 6.21. *Christ in the Garden of Gethsemane.* Mosaic in the transept of the Cathedral of Monreale. c. 1183

Fig. 6.22. Cathedral of Monreale. View of cloister

knees, and other pivotal parts of the body and in arbitrary zigzag linear contours in the garments that flutter free from the body. All features of the anatomy are defined by lines, not modeling, and gestures and facial expressions are dramatically emphasized. Individual figures and, in some cases, entire compositions thus display a dynamic quality, characteristic of manneristic traits in later Byzantine art (**fig. 6.21**).

In keeping with Norman traditions, an imposing two-towered facade also signaled the king's authority, and a splendid cloister with sculptured capitals, some of which were executed by French artisans, adjoined the church (**fig. 6.22**). Much of the present structure was completed by 1183, and in the following decade an intense campaign for decorating the church was carried out. New teams of Greek mosaicists were brought in, and it is surprising how they adapted their techniques of decoration to the immense basilica without domes, and how they accommodated the standard Byzantine program to Western interests.

Fig. 7.1. Soissons Cernunnos. 51″. 1st century B.C.–1st century A.D. Musée Saint Rémi, Reims

7

NORTHERN TRADITIONS AND SYNTHESIS

PRECURSORS

A favorite passage in the Venerable Bede's *Ecclesiastical History of the English People*, written in the early eighth century, relates a touching parable employed by one of the chieftains of Edwin the Saxon, king of Northumbria, when considering his own conversion from paganism to Christianity:

> This is how the present life of man on earth, King, appears to me in comparison with that time which is unknown to us. You are sitting feasting with your ealdormen and thegns in winter time; the fire is burning on the hearth in the middle of the hall and all inside is warm, while outside the wintry storms of rain and snow are raging; and a sparrow flies swiftly through the hall . . . For the few moments it is inside, the storm and wintry tempest cannot touch it, but after the briefest moment of calm, it flits from your sight, out of the wintry storm and into it again. So this life of man appears but for a moment; what follows or indeed what went before, we know not at all. If this new doctrine brings us more certain information, it seems right that we should accept it.[1]

The chieftain's sparrow metaphor for the fleeting quality of a person's time on this earth and the willingness to accept new religious beliefs to explain this life are characteristic of Northern peoples who had adapted and adjusted their world views to new influences. This is particularly evident in the art from Continental Europe, where the Roman Empire had made substantial inroads into the indigenous cultures of Germanic and Celtic peoples. A synthesis, or layering, of religious beliefs makes itself evident in the art these people produced. The Soissons Cernunnos is a case in point (**fig. 7.1**). A stone relief sculpture, it depicts the Celtic god Cernunnos in his traditional iconography: crossed legs, antler horns, and a torc around his neck. He holds a bag from which coins, or grain, spill out toward two stags. As Lord of the Animals, his powers are extended through the energy of such animals as snakes or stags. Yet Cernunnos is seated within an architectural structure that includes a pediment and classical columns, architectural motifs derived from Roman sources. Flanking the Celtic god are the Roman gods Mercury and Apollo, who stand in the Classical, formulaic pose of a weight bearing leg and a resting leg that mimics the Hadrianic figures on the Arch of Constantine (figs. 2.1, 2.2). The patron of this relief sculpture probably venerated all three gods, melding the powers and religious beliefs of both cultures and thereby creating something new.

A word of caution about the term "Celtic," which has so captured the modern imagination, should be inserted here. The term Celtic is traditionally used by scholars as a linguistic guideline and defines those peoples who spoke a Celtic language (P-celtic or Q-celtic). The people who spoke these languages originated from the area around the Black Sea and gradually spread throughout Europe, organizing themselves into tribes such as the Parisii, or the Iceni. Other than a loose linguistic connection and the transmission of an artistic vocabulary, there is little else to group them into a single entity called "Celtic."

Fig. 7.2. Bouray God. Bronze. 15¾″, 1st century B.C.–
1st century A.D., Saint-Germain-en-Laye (Gaul). Musée des
Antiquités Nationales, Paris

The torc, which was a pan-European symbol of a Celt, was a neck ring with great power and status. The Great Snettisham Torc was found in 1950 (**fig. 7.3**). The torc is one of the best examples of the great skill and tremendous care that was lavished on this type of jewelry. It is made from just over a kilogram of gold mixed with silver and shaped into sixty-four threads. Eight threads at a time were twisted together to make eight separate ropes of metal. These were then twisted around each other to make the final torc. The terminals of the torc were cast from molds and welded on. The terminals are decorated with spirals and cross-hatchings that are typical of local design. The torc was much more than jewelry; stories about torcs convey their important stature in military and religious contexts. Warriors and Christian saints wore torcs to enhance their power.

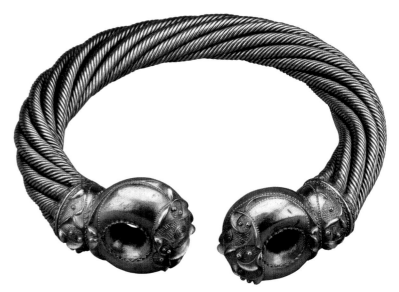

Fig. 7.3. Snettisham Torque. Gold, diam. 7¾″.
c. 1st century B.C., British Museum, London

The Bouray God is a more subtle example of how synthesis manifested itself in works of art (**fig. 7.2**). Traditionally, Celtic tribes did not embrace the human-form centered art of the Greeks and Romans, though they had contact with Greek cultures since 800 B.C. through trade and raiding. The hollow-bronze casting technique and the portrayal of a youthful man are imports; though the torc, the blunt hairstyle, and the deer hooves are decidedly Celtic traditions. The artist has chosen not to include arms on the youthful god, a choice that would have been foreign to a Roman artist. The transition from human torso to deer hooves is accomplished quite seamlessly, a material manifestation of shape-shifting. The line between the animal and human world was considered transparent; indeed, later Irish and Welsh tales are peppered with stories of men and women who are transformed into stags.

One Roman warrior, T. Manlius Torquatus, earned his name after having taken a torc from a fallen warrior. By stealing the torc, Torquatus in essence captured the warrior's strength and conferred it onto himself. Ritual deposits suggest torcs were used as offerings to the gods. The richness of material in torcs such as the Snettisham Torc suggests they were signifiers of royalty, though the Iceni tribe of that area cannot be firmly linked to this example. Gerald of Wales writes of a torc associated with Saint Cynog: "The local inhabitants consider this to be a most potent relic, and no one would dare to break a promise which he had made when it was held in front of him. On the torque there is the mark of a mighty blow, as if someone had hit it with an iron hammer. A certain man, or so they say, tried to break the collar, for the sake of the gold. He was punished by God, for he immediately lost the sight of both eyes. To his life's end he lingered on in darkness."[2]

The cross-hatching motif, also called basket-weave, found on the Snettisham Torc is also found on the elegant back surface of a bronze mirror from Desborough (Northants), a work of the first century A.D. (**fig. 7.4**). Pelta (crescent-shaped) and trumpet motifs were incised or engraved on the surface, and enamel inlays or niello (a

when hardened, formed a permanent part of the metal article. In some northern cultures, the lines were controlled and contained within strict geometric divisions of circles, triangles, rectangles, or repeated angular designs for the inlay. Such objects made handsome pins and brooches. The *Eagle Fibula* (**fig. 7.5**) is a product of the Gothic tribes in Spain about A.D. 500.

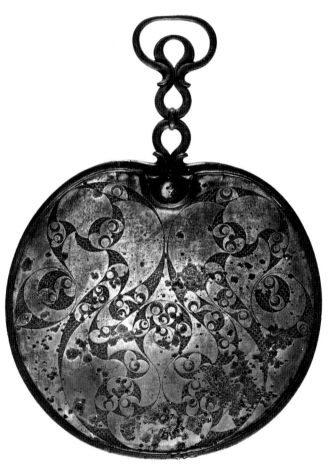

Fig. 7.4. Bronze mirror. Celtic (Desborough). Bronze and niello, length 8¾″. 1st century. British Museum, London

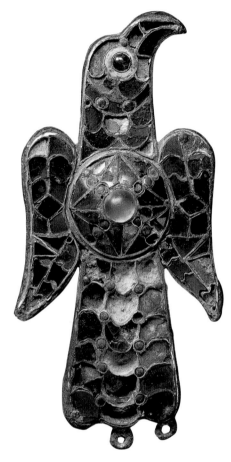

Fig. 7.5. *Eagle Fibula.* Visigothic Spain. Gilt, bronze, and gems, height 5⅝″. 6th century. Walters Art Gallery, Baltimore

sulphorous metallic substance) filled the grooves. The slightly asymmetrical composition enhances the fleeting movement of the design and the optical effect of the shifting foreground and background is typical of Celtic art. When viewing the mirror back, it is difficult to determine if the polished smooth surface is the background to the basket-weave motifs, or if the basket-weave is the background to the smooth surfaces. Tightly controlled use of a compass was no doubt employed to create these shifting effects.

Germanic tribes also made tremendous contributions to the pool of northern European art, not only in technique but also in the artistic motifs that would be absorbed into what is termed Early Medieval. Deeply rooted in their esthetic was the appreciation for sparkling gems and translucent enamel inlay in such objects. The *cloisonné* technique that was employed involved filling a metallic cavity, usually partitioned with threads of gold, with molten glass and semiprecious stones which,

THE COMING OF CHRISTIANITY

The migrations of various ethnic groups followed circuitous routes across Europe. The Visigoths settled in southern France and then in Spain; the Ostrogoths, under Theodoric, occupied northern Italy, followed later by the Lombards. By the fifth century, these tribes were largely Christians of the Arian faith. More indigenous groups, such as the Celtic speaking tribes and the Angles and Saxons, settled in the northern territories of France, Germany, and Scandinavia and then moved westward to Ireland and England in waves. The Franks and the Burgundians in turn rose to power with the Frankish kings, establishing what today is known as the Merovingian dynasty of Christian rulers. Their defeat of the Muslim army at Tours in 732 was a momentous date in history for the European world and a prelude to the rise of the powerful Carolingian empire established by Charlemagne, himself a Frankish ruler.

The Christianization of these various peoples was sporadic and often accomplished through the conversion of the king or queen, whose subjects in turn became Christianized. In Ireland, for example, Saint Patrick and other bishop saints began their proselytizing in the early fifth century, but it was not until the sixth century that Christianity took a firm hold. Even then, remnants of old beliefs were accommodated by the new religion; holy sites and sacred springs would be incorporated into the fabric of churches and monasteries, for example. In turn, Ireland sent missionaries to the Continent to establish monasteries and cement the power of Christianity. Once again, old traditions were adapted for the needs of patrons whose religion may have changed from the old gods, but whose culture remained firmly rooted in the past. It is this pattern of adoption, adaptation, and invention that makes the Early Medieval period so fascinating.

INSULAR ART

Ireland was never conquered by the Roman Empire, though it certainly had contacts through trade and travel. Saint Patrick himself was the son of a minor Roman noble. As a boy, he was captured by Irish raiders who brought him to Ireland as a sheep herder. Nevertheless, Ireland would develop its own style of liturgy, art, and architecture that showed less Roman influence than did the cultures in England and the Continent. When the monasteries were firmly established in the sixth century, Ireland became a center of learning and the arts for all of Western Europe.

In the year 431, Pope Celestine I ordained Palladius as bishop to "the Irish believing in Christ." This event marks the earliest documentation of Christianity in Ireland. Monasticism had become firmly rooted in Ireland by the sixth and seventh centuries and monasteries became important social, political, and religious centers, no doubt due to the fact that large urban centers were not part of the Irish landscape. Irish monks built monastic communities that are characterized by a clustering of buildings rather than the building of large structures to house the community. Examples include the stone cells perched on the cliff overlooking the sea at Skellig Michael (**fig. 7.6**). Located on one of two small islands off the coast of western Ireland, the monastery was founded sometime prior to A.D. 800. Originally, six small bee-hive huts were built, though one has since collapsed. They were built in the dry stack method, their exteriors being circular while their interiors are roughly square, with shelves built into the

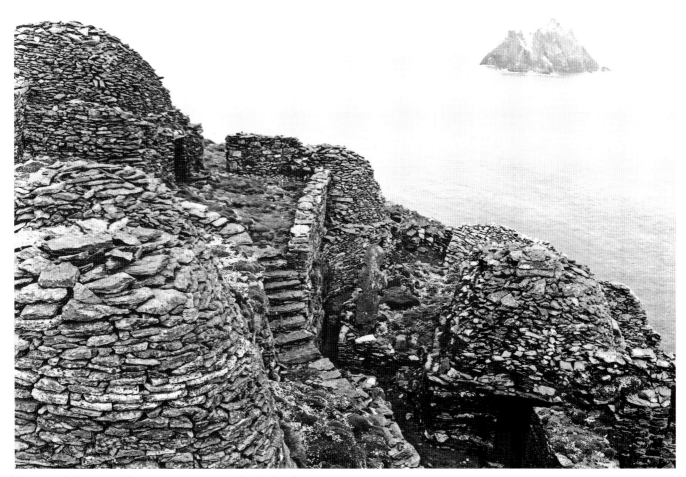

Fig. 7.6. Skellig Michael. Monastery remains, Ireland. 6th–9th century

Fig. 7.7. Carpet Page. Book of Durrow. 9⅝ × 6⅛″. Trinity College Library, Dublin (TCD MS 57, fol 3v), c. 660–80

Fig. 7.8. *Symbol of Saint Matthew.* Illustration in the Book of Durrow (fol. 21v)

walls for storage. The huts would have been used for storage and for shelter from the harsh winds. The monks eked out an existence via the two fresh water wells, the abundant fishing, the keeping of small livestock, and the small areas on the island suitable for growing modest crops. Skellig Michael was abandoned in the twelfth century when climate changes forced the monks from the island.

According to tradition, the See of Armagh was established in the center of the island about 550 as the successor to the authority of Saint Patrick, but nothing remains of the buildings there. Later, the saintly Columba founded communities at Derry, Durrow, and Swords, and on the island of Iona to the north; and in 635 the coastal island of Lindisfarne in Northumbria was settled by Saint Aidan. Already by the end of the sixth century, Saint Columbanus, "desirous to live as a stranger and pilgrim for the Lord's sake," spread the Irish missions to the continent, to the lands of the heathen Burgundians and Franks and into the wilderness of North Italy (Luxeuil, Saint Gall, Bobbio).

One of the earliest Irish Gospel books with illuminations is the Book of Durrow (Codex Durmachensis), today in the Library of Trinity College in Dublin (**figs. 7.7, 7.8**). Presumably produced in the ancient scriptorium of the monastery at Durrow in Ireland sometime around 660–80 (Lindisfarne and Iona have also been suggested), the text, according to a later colophon, was written by none other than the hallowed Saint Columba (d. 597): "I implore your benedictine, holy priest Patrick, that whosoever holds this little book in his hands remembers Columba the scribe who has written this Gospel book in the space of twelve days by the grace of God."[3]

This colophon is probably a pious forgery since these earliest illuminations seem to be created in a fully developed style. Executed in four colors—yellow, red, and green within brown-black outlines—on parchment of suede-like texture that is especially receptive to ink and color, the illuminations in the Book of Durrow consist of allover "carpet" designs, symbols of the Evangelists, and large initials for the beginnings of the Gospels. Some "carpet pages" have swirling spirals and trumpets of the Celtic type, one has a magnificent cross that seems to be based on oriental Christian motifs, while others seem more like sectioned metal plates filled with interlaced patterns like those on the Sutton Hoo belt buckle.[4] The belt buckle from Lagore Crannock provides another example of how closely metalwork and manuscript illumination were allied (**fig. 7.9**). Many of the same motifs that adorn the buckle can be found in the Book of Durrow. This suggests that the lavish adornment of jewelry to add status to the wearer has now been transferred to a book of the Bible. The status of the

Fig. 7.9. Lagore Crannock belt buckle. Detail. Bronze, 6¼″. 8th century. National Museum of Ireland, Dublin

Fig. 7.10. *Symbol of Saint Mark.* Illustration in the Gospels of Saint Willibrord (Echternach Gospels). 12¾ × 10⅜″. c. 690. Bibliothèque Nationale, Paris (MS lat. 9389, fol. 75v)

sacred scripture demanded that it receive elaborate adornment, an attitude not found in early illuminated manuscripts from the Mediterranean and the East.

Each Gospel has a carpet page paired with another displaying the symbol of the Evangelist (the carpet page of Matthew is missing). The symbol for Matthew, the first Gospel, is a man, but aside from the carefully drawn circular head, the doll-like body, lacking even arms, resembles more a metallic buckle adorned with inlays of colored glass. Vestiges of two feet, both pointing to the right of the frontal body, testify to the illuminator's lack of interest in Classical symmetry, even in such a rigid, conventionalized representation. Isolated against the white ground of the parchment, Matthew's symbol thus appears as a piece of Irish metalwork affixed to the page.

Dating to slightly later, about 690, the striking symbol of Saint Mark, the rampant lion labeled *imago leonis*, in the Gospels of Saint Willibrord (also known as the Echternach Gospels), is one of the masterpieces of early Irish art (**fig. 7.10**). This book, according to most authorities, was the very Gospel presented to Saint Willibrord for his long journey to convert the heathen in the Low Countries and Frisia, since its provenance can be traced to Echternach in Luxembourg, a monastery he founded.[5] The free, flamboyant form of the heraldic beast sweeps diagonally across the page in a prancing leap, placed like a giant jeweled pin against a fragile network of thin rectilinear lines of red and violet that form an elegant abstract pattern.

Some specialists have argued that both the Book of Durrow and the Gospels of Saint Willibrord were executed

not in Ireland but in the Irish colony established on the island of Lindisfarne in Northumbria, southeast of the Scottish coast.[6] Lindisfarne was founded by Aidan of Iona about 635 and played a key role in the exchange between the Irish and the Roman Catholic Church after the Synod of 663 at nearby Whitby. The vicissitudes of history, however, do not diminish the Irish character of the arts produced at Lindisfarne.

The masterpiece of Northumbrian art is the Lindisfarne Gospels, usually dated before 698 on the basis of the colorful colophon in the manuscript written by the priest Aldred in the early tenth century: "Eadfrith, bishop of the church of Lindisfarne [698–721], first wrote this book for God and Saint Cuthbert and all the saints in general who are on the island."[7] Much larger than the Book of Durrow, the Lindisfarne Gospels repeat the general pattern of illuminations with the addition of elaborate canon tables. The Evangelist pages are expanded to include full portraits of the authors that are clearly dependent on Mediterranean models. In general, the Lindisfarne decorations strike one as being majestic in the architectonic ordering and elegance displayed in the treatment of traditional Irish ornamental motifs. Yet within the delicate and restrained compositions there flow a myriad of Celtic motifs with exceedingly fine lines of well-balanced turnings and delicate colors of gold, dark red, pale blue, green, mauve, yellow, purple, and pink.

In the carpet page with a cross (**fig. 7.11**), countless dog-headed serpents and long-beaked birds with *cloisonné* wings performing acrobatics are fantastically elongated, their forms lost in the maze of knots and loops forming floating S and inverted C patterns of interlace. But an orderly division and symmetry govern the entire page, imposing a kind of frozen pattern and muted rhythm upon the usually wilder exuberance of Irish ornamentation.

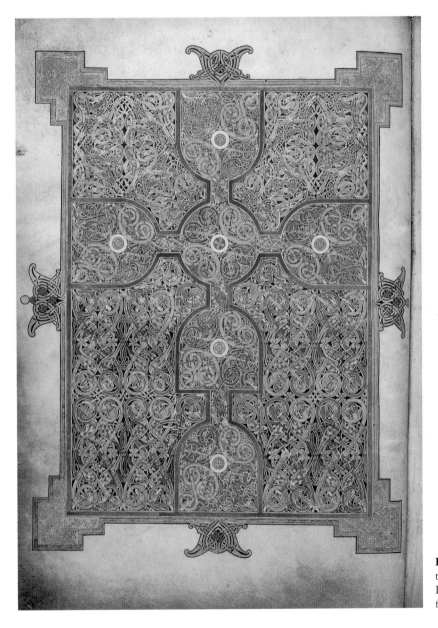

Fig. 7.11. Carpet page with a cross. Illustration in the Lindisfarne Gospels. 13½ × 9¾″. c. 710–25. British Library, London (MS Cotton Nero D. 4, fol. 26v)

Fig. 7.12. *Saint Matthew.* Illustration in the Lindisfarne Gospels. British Library, London (fol. 25v)

Fig. 7.13. *Ezra Restoring the Bible.* Illustration in the Codex Amiatinus. 20 × 13½″. Before 716. Biblioteca Medicea Laurenziana, Florence (Cod. Amiat. I, fol. 5r)

The portrait of Saint Matthew (**fig. 7.12**) comes as a complete surprise within the folios, since here we see a naturally proportioned elder comfortably seated on a cushioned bench writing in his book. The background is not painted, but a realistic curtain rod is drawn across the top right corner from which hangs a heavy, undulating drape, partially concealing a second bearded figure who acts as a witness to the miracle of Saint Matthew receiving the divinely inspired words of his gospel. Above Matthew appears the bust of his symbol, a winged man identified as *imago hominis*, who blows a tapering trumpet. Curiously, Matthew's name, in the top center, is introduced with the Greek *O Agios* (saint). How does one account for this unusual miniature? No doubt the artist had before him an early model that preserved the illusionism and modeling of Late Antique author portraits. The carefully drawn red arcs that describe the folds of the green mantle, the misunderstood rendering of perspective in the bench and unhinged footrest, the spatial implications of the curtain rod, and the fractional figures of the symbol and

the extra male witness—both intended to overlap in space—are nowhere to be found in earlier Irish illuminations.

Bede wrote of the numerous books, some illustrated, that Benedict Biscop brought to England from Rome, ultimately to be kept in Northumbria. It has long been believed that the miniatures in the famous Codex Amiatinus, written in Northumbria about 750—its text is of paramount importance to students of the Vulgate—copy those in books procured by the Benedictine reformer. The miniature of *Ezra Restoring the Bible* in the Codex Amiatinus (**fig. 7.13**) appears to be another version of the same model that served the Lindisfarne artist for Matthew, although here the artist has opted to follow more closely the classical style, perhaps to please the person for whom the book was intended.[8] Lawrence Nees has argued, quite convincingly, that the Codex Amiatinus was made at Monkwearmouth-Jarrow and was intended as a presentation gift in Rome. The inclusion of the Christ in Majesty miniature supports his hypothesis (**fig. 7.14**) since it closely follows the established tradition of

Fig. 7.14. *Christ in Majesty*. Illustration in Codex Amiatinus, (Cod. Amiat.1, fol 796v)

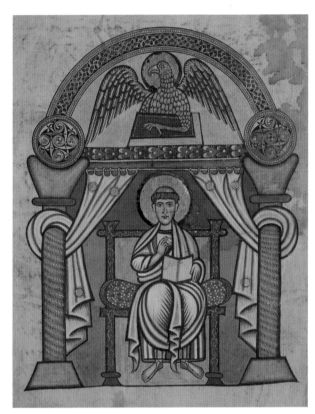

Fig. 7.15. *Saint John*. Illustration in the Canterbury Codex Aureus. 15½ × 12½″. c. 750. Royal Library, Stockholm (MS A. 135, fol. 150v)

apse mosaic in Rome. A bearded Christ holds a codex and raises his hand in a gesture of speaking. Surrounding him are the symbols of the four Evangelists, four standing figures that are either Old Testament prophets or the four Evangelists, and two angels who act as his heavenly courtiers.

The introduction of the Mediterranean style into Insular art was by no means limited to Northumbria, however. In Canterbury, the creative copying of Italian models was even more evident by the eighth century. It will be remembered that Saint Augustine of Canterbury, a Benedictine, was sent to Kent by Pope Gregory to reform the English Church. The Benedictines were the major monastic order in Italy, and they enforced their strict rule as it was formulated by the founder of the order, Saint Benedict.

The illuminated manuscripts brought to Canterbury by the earlier Roman missions stimulated the production of illustrations in a more Classical flavor. A good example is the portrait of Saint John in the Canterbury Codex Aureus, today in Stockholm, dated to about 750 (**fig. 7.15**), which clearly reflects compositions like that of Saint Luke in the Gospels of Saint Augustine, which was discussed earlier.[9] The vivid face of the youthful Evangelist staring out at the reader, the bold lines that describe the sharply contoured folds of his mantle, and the rotundity of the grained column shafts forming the frame that supports the colorful lunette with the symbolic beast—all point to an Italian source. Only the Celtic spirals and trumpets above the heavy capitals betray the ancestry of the miniaturist. With this new style in mind, we now turn to the most outstanding Irish manuscript that survives, the incomparable Book of Kells.

"The great Gospel of Columkille [the Book of Kells], the chief relic of the western world" (*Annals of Ulster*, 1003) is a vast and sumptuous production with elaborate initials and numerous full-page miniatures of holy personages, narratives of the life of Christ (Arrest of Christ, Temptations), carpet pages, and exuberant canon tables. Fortunately, it survived the devastating Viking raids that left Iona Island in ruins in 804–7, when, as some believe, it was carried off unfinished by the

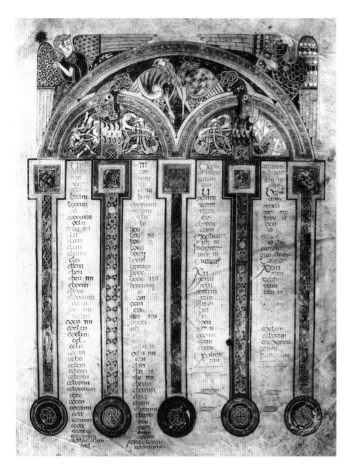

Fig. 7.16. *Canon Table* (Canons VI, VII, and VIII). Illustration in the Book of Kells. 13 × 9½″. Late 8th–9th century. Trinity College Library, Dublin (MS 58, A.1.6, fol. 5)

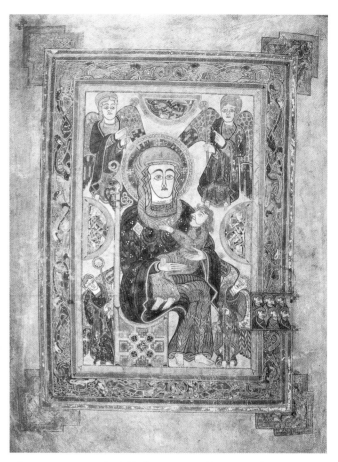

Fig. 7.17. *Virgin and Child.* Illustration in the Book of Kells (fol. 7v)

monks to Kells in County Meath in Ireland.[10] The unprecedented wealth of the manuscript's decorations indicates that it had some commemorative role as a showpiece for the Columban monks and their artists over a number of years.

The elaborate canon tables (**fig. 7.16**) that incorporate Evangelist symbols and other unusual animal motifs within their colorful spandrels seem to be influenced by a continental manuscript, very likely a courtly Carolingian Gospel book. Other pages suggest diverse Mediterranean models.[11] One striking example of such foreign intrusions is the Virgin and Child enthroned among four angels (**fig. 7.17**), an image that is placed, appropriately, opposite the first list of chapters (*breves causae*) beginning with the words *Nativitas Domini* (the Birth of the Lord). The throne and the lower torso of the Virgin are rendered in profile, with delicate black lines tracing the folds of the violet tunic that covers her legs. Mary is dressed in a Byzantine costume and assumes a pose not unlike that of the familiar *Hodegetria* (she who shows the way) type seen in Byzantine art, suggesting that the hieratic Virgin and Child may reflect a liturgical icon.

While such icons were common in Byzantine and Coptic chapels of the sixth and seventh centuries, it is likely that the direct inspiration for the Book of Kells artist was a painting brought north from Italy by Benedict Biscop, perhaps one like that recorded in his trip of 678: *imaginem beatae Dei genetricis semperque virginis Mariae* (similitude of the blessed Mother of God and ever virgin Mary).[12] At the lower right, near the Madonna's knees, the interlace border is cut by a small box in which the heads of six bearded monks (?) appear. Perhaps they are meant to represent the ancestors of Christ, since genealogy and kinship were vitally important to these communities.

Epitomizing the Irish ornamental style is the incredible *Chi Rho* page (**fig. 7.18**) that faces the beginning of Matthew's genealogy. Here the name of Christ appears for the first time in the Bible (*Christi autem generatio*) and is magically transformed into a huge sweeping *Chi* (X) that engulfs the illumination with its gaping jaws and descending tendril tail, overwhelming the smaller *Rho* (P) and the word *generatio* in the lower right corner. Indeed, to agree with Giraldus Cambrensis, the shimmering mass of ornamental motifs growing and subdividing across the unframed page is so fine and minute that it is truly difficult to believe that it is a design fashioned by human hands and not the beautiful spidery fabric of some delicate tapestry woven by angels.

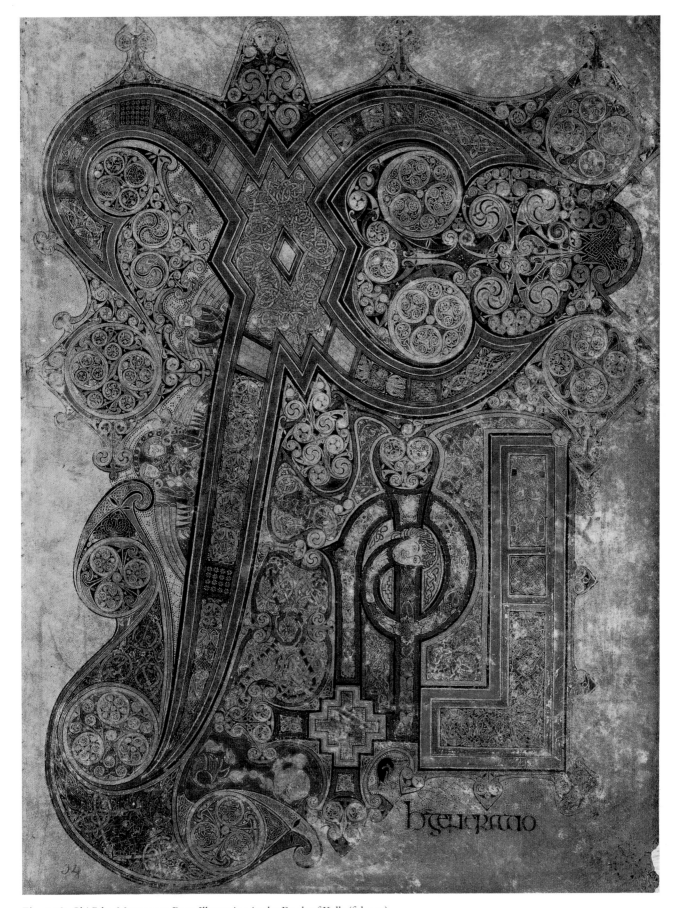

Fig. 7.18. Chi Rho Monogram Page. Illustration in the Book of Kells (fol. 34v)

The powers of concentration required for such infinitesimal execution must have hypnotized the miniaturist. In such a state of total artistic involvement, the hand, it would seem, could be led by mystical forces beyond the reasonable constraints of craft, and in producing such labyrinthine microscopic worlds, the very act of tracing the tiny lines would take on some superreality for the artist. Some scholars have suggested that the fusion of animal and letter in the name *Christus*, with the great living cross form of the *Chi*, is a veiled allusion to the Incarnation of the Word as well as to the supreme sacrifice of Christ on the cross.[13]

Curiously, human heads can be discerned here and there. Three angels appear along the descender (vertical section of the letter) of the *Chi*, a monk's head emerges from the end of the *Rho*, and surprisingly lifelike animals appear elsewhere. Two cats are crouched behind mice tugging at a round wafer, a black otter catches a fish directly below the *Rho*, and two moths are pinioned in the upper extension of the *Chi*. The fish captured by the otter (compare the legends of Irish monks miraculously treated to fish each day by an otter) has been interpreted as a symbol of Christ, while the wafer taken by the mice has been likened to the host of Communion in the Mass. Since the cats, mice, and otter are creatures of the earth and the moths belong to the air, these mysterious animals have been further interpreted as symbols of Christ's resurrection. But these are only marginal associations at best—if, indeed, we accept such interpretations—that are lost amid the grandiose fireworks of forms. It is the astonishing growth of these beautiful motifs that commands attention.[14]

The fascination and appreciation with continual change and transmutation—a magical metamorphosis—brings to mind the unruly imagination that characterizes early Irish poetry, where animals turn inside out, seas change into clouds, streams suddenly stop and begin again, where Saint Finan can boast: "A hawk to-day, a boar yesterday, Wonderful instability! Though to-day I am among bird-flocks; I know what will come of it: I shall still be in another shape."[15] And one is reminded of a fascinating riddle of the Medieval Irish:

> [Who am I?] An enemy ended my life, deprived me of my physical strength: then he dipped me in water and drew me out again, and put me in the sun, where I soon shed all my hair. After that, the knife's sharp edge bit into me and all my blemishes were scraped away; fingers folded me and the bird's feather often moved over my brown surface, sprinkling meaningful marks; it swallowed more wooddye and again travelled over me leaving black tracks. Then a man bound me, he stretched skin over me and adorned me with gold; thus I am enriched by the wondrous work of smiths, wound about with shining metal." Answer: "I am a Gospel book, illuminated and written on prepared vellum leaves and bound in a fine golden cover![16]

Typical of much Irish metalwork is the Crucifixion plaque from Rinnagan (**fig. 7.19**), which very likely served as an adornment for a book cover. Even in treating such a familiar theme as Christ on the cross, however, the craftsman's distaste for realistic representation is striking. Many of the necessary narrative elements are present, but from the rendering of the flat torso of Christ on the stunted cross to the odd figures added symmetrically above and below the arms, the intent was to emulate a piece of abstract jewelry.

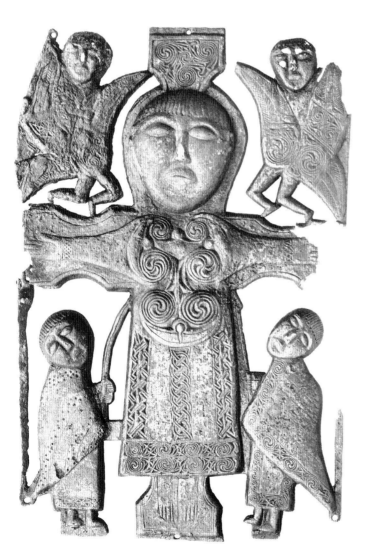

Fig. 7.19. *Crucifixion from Rinnagan.* Bronze, height 8¼". 8th century. National Museum of Ireland, Dublin

Fig. 7.20. *Tara Brooch.* Gilt, bronze, amber, and enamel, 9 × 3⅝″. c. 700. National Museum of Ireland, Dublin

Fig. 7.21. *Tara Brooch* (reverse)

The cross-fertilization between illuminated manuscripts and metalwork has resulted in a dazzling legacy of the metalworker's craft in Ireland, which spawned a variety of new techniques and materials. The most famous of these is the Tara Brooch, which retains the pseudo-penannular (semi-closed) form in the arrangement of its ornaments, but the gap in the ring is now closed because the broad "terminals" are used for elaborate ornament. The silver Tara Brooch, with its magnificent filigree, cast, gilded and overlaid ornaments, gem-set enamels and amber, is considered the pinnacle of craft of jewelmaking in Ireland (**figs. 7.20, 7.21**). The front of the brooch is filled with filigree, interlaced animals, and plain interlace ornament, while cast animals and birds designs cover the reverse.

The slightly later Ardagh Brooch (**fig. 7.22**), an annular brooch, which means the ring is completely closed, is composed of gold, silver, and glass. The chip-carving technique, introduced in the eighth century, created faceted surfaces that caught the light and sparkled. The brooches were meant as status symbols that spoke of the wearer's wealth and resources.

Insular sculpture on a grander scale is well represented by the great monolithic stone crosses that marked the countryside.

Fig. 7.22. *Ardagh Brooch.* Silver, gilt, glass. 13″ long. 8th century. National Museum of Ireland, Dublin

The earlier Irish stone crosses display the familiar Celtic abstractions, but in some of the later ones another spirit emerges. The high crosses represent the largest body of freestanding sculpture between the Roman Empire and the Italian city-states of the Renaissance. Although the dates of the crosses are controversial and difficult to pinpoint, scholars generally agree that they date from the late eighth century to the twelfth century, with the ninth and tenth centuries as the most productive period. Wooden crosses, though none survive, were probably the precursors of these stone crosses.

Early textual references to crosses do not always differentiate between wood and stone. Made from local stone, the surviving early medieval crosses are generally grouped into two categories: those with narrative scenes, and those with abstract ornament. Some crosses, such as the cross at Castle-dermott, have both ornamental and narrative panels (**figs. 7.23, 7.24**). The crosses today look very different from their original appearances. Weathering has taken a toll on the surfaces of the soft sandstone, from which many of the stones are carved. Also, recent scholarship suggests that the crosses would have been painted to highlight the figures and ornament.

Although highly conjectural, the colors would no doubt resemble those found in metalwork and manuscripts: yellow, green, blues, and dark reds. The narrative panels include Old and New Testament scenes as well as scenes from the lives of saints. The saints could be local, such as Saint Ciarán, or pan-European, such as Saint Anthony. Many of the scenes are difficult to decipher, either due to the weathering of the stone, or to our lack of iconographical tools to identify the highly abbreviated narrative.

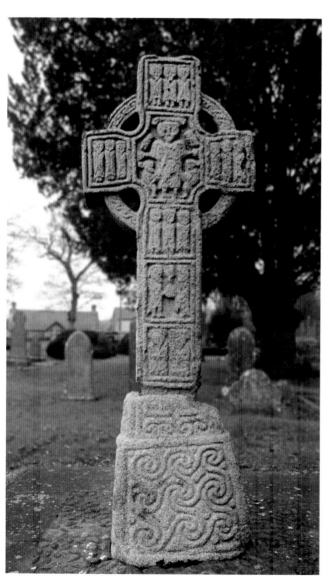

Fig. 7.23. South Cross of Castledermott. Granite, height 10′. After 812. County Kildare, Ireland

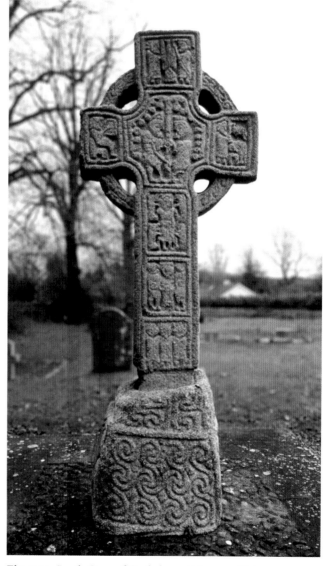

Fig. 7.24. South Cross of Castledermott (reverse side)

The high crosses served a variety of functions. They were typically located within a monastery, and often marked the boundaries of monastic lands, or important crossroads. Other crosses served devotional or penitential functions. Still others commemorated a miraculous event, the dedication of a church, or a sacred spot associated with a saint. Inscriptions, when discernible, ask that prayers be said for the patron. The magnificent cross at Monasterboice is named Muirdach's Cross due to the inscription (**figs. 7.25, 7.26**). No doubt a monastery could possess a number of crosses, both wooden and stone, that served a variety of purposes.

While Ireland boasts the largest arrays of early medieval stone crosses, Scotland produced an impressive number of controversial and fascinating cross slabs. Growing out of a sec-

ular iconography that is little understood, a cross slab at Aberlemno is one of the finest examples to survive that combines secular and Christian motifs (**figs. 7.27, 7.28**). On the front of the slab is a wheeled cross set against a backdrop of swirling, fantastic beasts. The cross itself is ornamented with a rich texture of spirals, diaper patterns and rosettes of interlace. The reverse is carved with an elaborate hunt scene and Pictish symbols. The so-called "Picts" were the inhabitants of northern and eastern Scotland who derived their name from the Romans who described them as the painted ones (Picti). The symbols are limited in number and are often carved in different combinations. Here the Z-rod, an enigmatic symbol, is imposed on a form resembling a tuning fork and placed adjacent to an apparent depiction of a round mirror with two

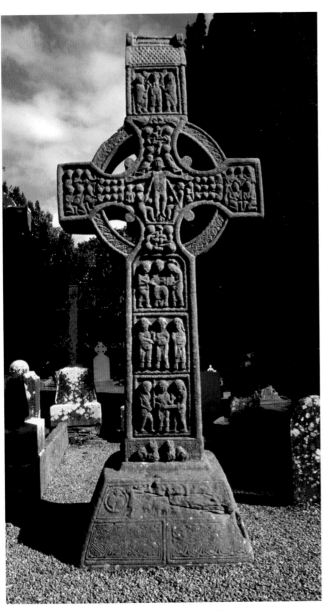

Fig. 7.25. Muirdach Cross. Carved stone, height 18′. c. 900. Monasterboice, County Louth, Ireland

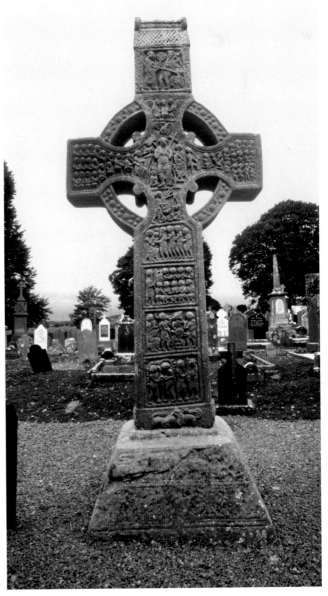

Fig. 7.26. Muirdach Cross (reverse side).

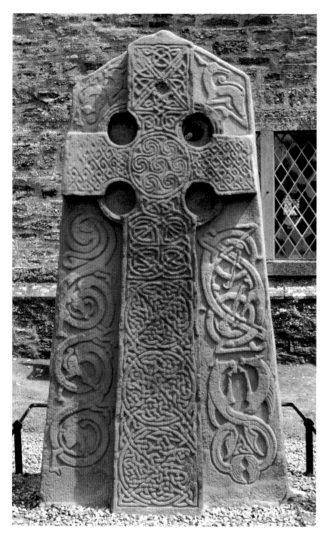

Fig. 7.27. Aberlemno cross slab, Pictish, height 7½'.
8th century. Scotland

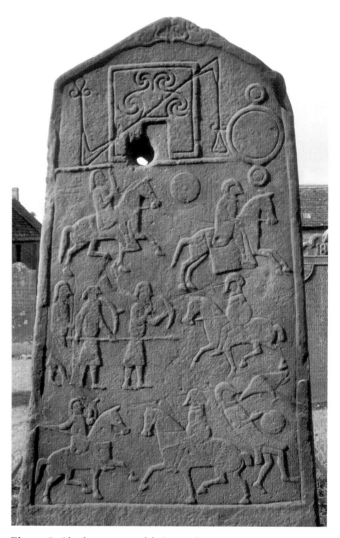

Fig. 7.28. Aberlemno cross slab (reverse)

handles. Scholars have not been able to decipher the exact meaning of the symbols. Suggestions range from boundary markers, funerary monuments, tribal insignia, and even records of marriage alliances. Whatever their meaning or function, the Aberlemno cross slab stands in mute testimony to the patrons willingness to combine the older traditions with the new.

THE ANGLO-SAXONS

By the sixth century, the Saxons in England had been semi-Christianized by the missionaries sent to England by the Roman Church. The most famous is Augustine of Canterbury, who was sent by Gregory the Great in 597. Bede tells us that the Northumbrian Benedict Biscop, founder of Saint Peter's at Wearmouth and Saint Paul's at Jarrow, had been to Rome and returned with every kind of manuscript, including one of the earliest authorized versions of Saint Jerome's Vulgate Bible.

Biscop's new texts made it possible to introduce both the Roman liturgy in chanting, singing, and other parts of the service, as well as the manner of administering the Church affairs according to Roman practice. He also brought paintings "which he might encompass about the whole church . . . shewing the agreement of the Old and New Testaments, most cunningly ordered: for example, a picture of Isaac carrying the wood on which he was to be slain, was joined to one of the Lord carrying the cross on which He likewise was to suffer"— a *dittochaeon* (parallelism) of sorts.[17] Moreover, from Gaul Biscop brought back "masons to build him a church of stone *after the Roman fashion* which he always loved." Rome, as the repository of the relics of Saints Peter and Paul, would be a powerful influence, attracting to its shrines pilgrims who would in turn bring Roman building and artistic traditions home to be adapted to local needs and customs.

Anglo-Saxon England, particularly in the region of Kent, is well known for the riches of its jewelry, with master craftsmen producing fine gold and silver metalworking. A good

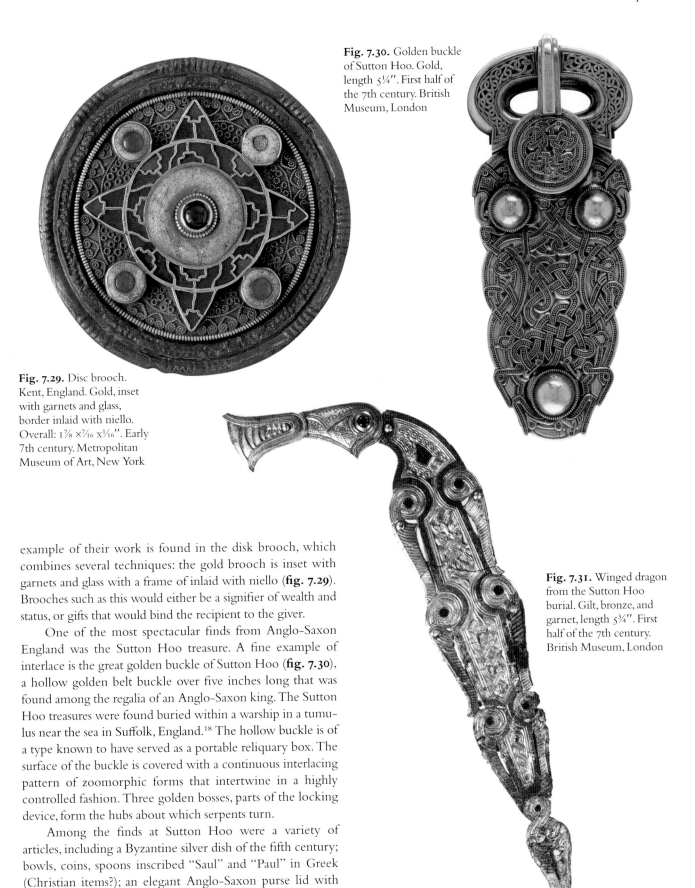

Fig. 7.30. Golden buckle of Sutton Hoo. Gold, length 5¼″. First half of the 7th century. British Museum, London

Fig. 7.29. Disc brooch. Kent, England. Gold, inset with garnets and glass, border inlaid with niello. Overall: 1⅞ ×⁷⁄₁₆ x¹⁄₁₆″. Early 7th century. Metropolitan Museum of Art, New York

Fig. 7.31. Winged dragon from the Sutton Hoo burial. Gilt, bronze, and garnet, length 5¾″. First half of the 7th century. British Museum, London

example of their work is found in the disk brooch, which combines several techniques: the gold brooch is inset with garnets and glass with a frame of inlaid with niello (**fig. 7.29**). Brooches such as this would either be a signifier of wealth and status, or gifts that would bind the recipient to the giver.

One of the most spectacular finds from Anglo-Saxon England was the Sutton Hoo treasure. A fine example of interlace is the great golden buckle of Sutton Hoo (**fig. 7.30**), a hollow golden belt buckle over five inches long that was found among the regalia of an Anglo-Saxon king. The Sutton Hoo treasures were found buried within a warship in a tumulus near the sea in Suffolk, England.[18] The hollow buckle is of a type known to have served as a portable reliquary box. The surface of the buckle is covered with a continuous interlacing pattern of zoomorphic forms that intertwine in a highly controlled fashion. Three golden bosses, parts of the locking device, form the hubs about which serpents turn.

Among the finds at Sutton Hoo were a variety of articles, including a Byzantine silver dish of the fifth century; bowls, coins, spoons inscribed "Saul" and "Paul" in Greek (Christian items?); an elegant Anglo-Saxon purse lid with garnet inlays; and ornaments from a great shield, among them a splendid gilt bronze winged dragon with a sharply tapering body (**fig. 7.31**). Such strange creatures are much like those

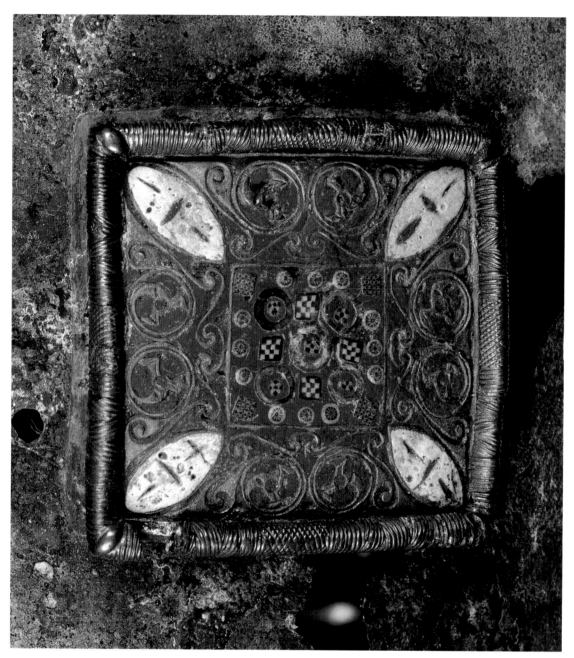

Fig. 7.32. Escutcheon from the hanging bowl, Sutton Hoo ship burial. 5th or 6th century. British Museum, London

described in early Irish poetry: monsters encountered in seafaring tales, strange dragons and demons that lurk on islands as weary voyagers seek out the happy lands (paradise) hidden far out in the western ocean. In the *Voyage of Maelduin*, a wild beast as indescribable as these interlaced ribbon creatures suddenly menaces the travelers:

> They came then to another island and a wall of stone around it. And when they came near, a great beast leaped up and went racing about the island, and it seemed to Maelduin to be going quicker

than the wind. And it went then to the high part of the island, and it did the straightening-of-the-body feat, that is, its head below, its feet above . . . it turned in its skin, the flesh and the bones going around but the skin outside without moving. And at another time the skin outside would turn like a mill, and the flesh and the bones not stirring.[19]

An escutcheon from a hanging bowl introduces yet another technique that would become popular (**fig. 7.32**). The *millefiori* (thousand flowers) technique involves assemb-

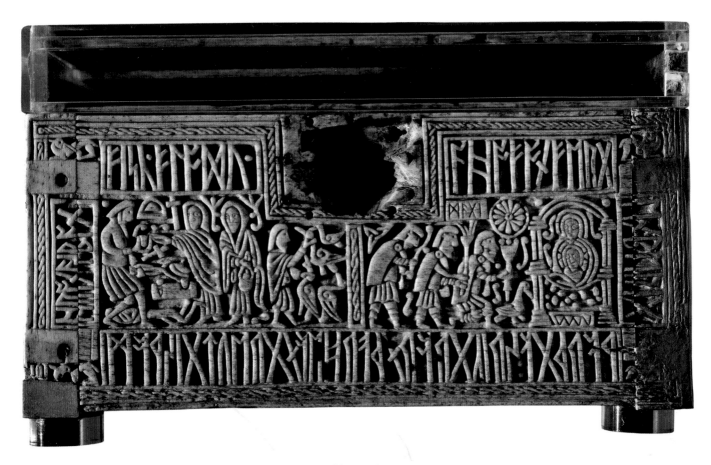

Fig. 7.33. Franks Casket, Weyland the Smith and the Adoration of the Magi. Whale bone, 9 × 4¼″. First half of the 8th century. British Museum, London

ling colored glass rods, fusing them together, stretching the strands to make them smaller, and then slicing the strands horizontally. The result can be seen in the center of the escutcheon with the rosette and checkerboard patterns. Surrounding the central panel are the S-curves and peltas found in the La Tène art of the Continent. The bowl to which this was attached were hung from chains and was used either to hold water for hand-washing, or to hold something stronger for drinking during the feasting that was so popular among northern tribes.

Ship burials, where a ship is set afire and adrift in the sea, are recorded in the Anglo-Saxon poem *Beowulf*. The identification of the king associated with the burial is still uncertain, though two candidates are favored in modern scholarship: Raedwald (590–625/6), who was overlord of the English kingdoms between 616, and his death; or Sigebert, a co-regent, who died fighting Penda of Mercia in 637. If it is either Raedwald, a convert to Christianity who abandoned his faith, or Sigebert, a devout Christian, it would explain the intermingling of secular and Christian objects in the burial. As demonstrated above, a sharp differentiation between

Christianity and other religions would have been foreign to these peoples since indigenous traditions were readily grafted on new religious beliefs.

The so-called Franks Casket is decorated with scenes from different sources. On the face of the casket, for example, a scene from the Germanic tale of Weyland the Smith is depicted alongside that of the Adoration of the Magi, who are identified in runes as the "maegi" (**fig. 7.33**). Other scenes on the back and sides have been identified as a depiction of the legendary twins Romulus and Remus, who founded Rome, and the capture of Jerusalem in A.D. 70 by the Roman emperor Titus. Still other scenes have not been identified because the tales have either been lost or a visual tradition of illustrating them was not established. The most prominent inscription is a riddle, written in Old English, about the casket itself. It can be translated as "The fish beat up the seas on to the mountainous cliff; the King of terror became sad when he swam onto the shingle." The answer is "whale's bone," which tells us that the casket was made from the bone of a beached whale. The event of a beached whale, astonishing in any age, was such that it was immortalized in this casket.

THE LOMBARDS AND ROMANS

The first notable barbarian occupation of Italy was that of the Ostrogoths in 487 under Theodoric the Great, a king who followed the Arian faith and built a splendid capital at Ravenna, employing builders and craftsmen from Rome and perhaps from Byzantium. The arts of Ostrogothic Ravenna displayed not a weakening of the Antique style, but a subtle shift toward a more hieratic and iconic mode of representation. The Lombards, a Teutonic tribe also committed to the Arian faith, invaded Italy in 568 and settled in the valley of the Po River (roughly the area today known as Lombardy), establishing their capital at Pavia, south of Milan. They left

behind a rich tradition of stone relief carving that rivals the sarcophagi of Late Antiquity.

The stone Altar Frontal of Duke Ratchis (**fig. 7.34**) was donated to the Church of Saint John in Cividale, the seat of his dukedom of Friuli (north of Trieste) between 731 and 744.[20] The side panels have stylized representations of the Visitation and the Adoration of the Magi, while the front has a more monumental relief of the *Maiestas Domini*, with a beardless Christ enthroned between seraphim in a mandorla circumscribed with leaf patterns and carried by four angels. The iconography of the Christ in Majesty conforms to the

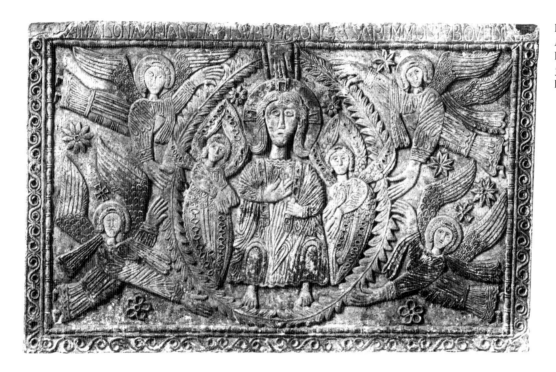

Fig. 7.34. *Maiestas Domini.* Altar Frontal of Duke Ratchis. Marble, approx. 3′ × 5′. 731–44. Museo del Duomo, Cividale

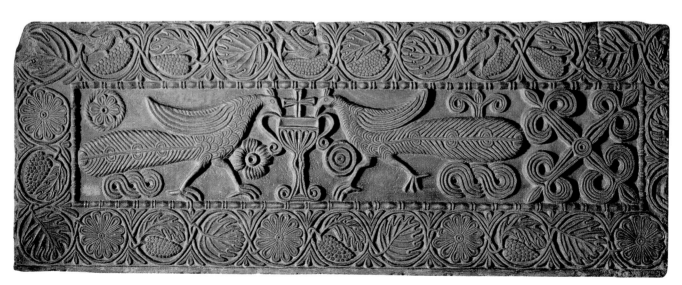

Fig. 7.35. Relief from the sarcophagus of Abbess Theodata, from the Monastery of Santa Maria della Pusterola, Pavia. c. 735. Museo Civico, Pavia

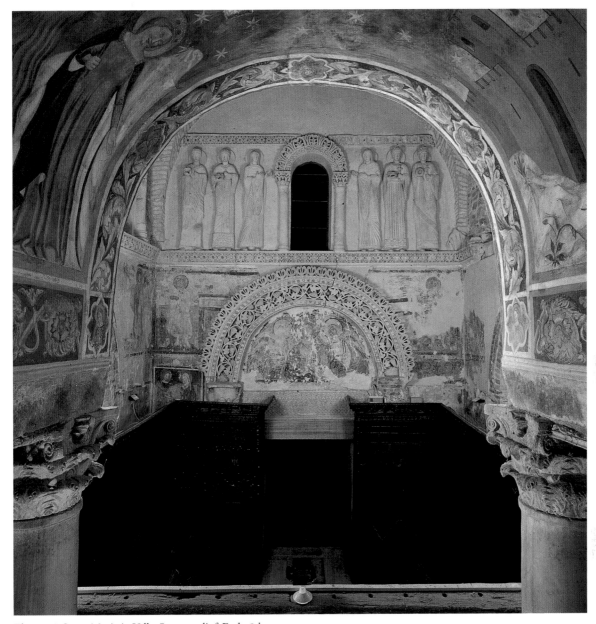

Fig. 7.36. Santa Maria in Valle. Stucco relief. Early 8th century.
Cividale del Friuli, Udine

type established in the fifth century, and the simple compositional devices of hieratic scale, symmetry, and frontality (the bodies of the angels are carved in profile) comply with the traditional iconic mode of the theme.

The sarcophagus of Abbess Theodata, from the monastery of Santa Maria della Pusterola, Pavia, is a fine example of Lombard relief carving (**fig. 7.35**). Although the peacocks drinking from a chalice surmounted by a cross give the impression of symmetry, the artist has moved them slightly to the left in order to give room to the crossed, stylized lilies on the right. A rich pattern of vegetation interspersed with rosettes surrounds the central panel, creating an evenly textured design across the surface of the carving.

A unique survivor of Lombard building and sculpture is Tempietto Longobardo (or Santa Maria della Valle) at Cividale. Two stories high, a single room is sectioned off with a screen across the east end to make a sanctuary. Above the entrance, which is decorated in abstract motifs based on grape vines and rosettes, are six life-size female saints flanking a central arched niche (**fig. 7.36**). Although it is known that Lombard artists were masters of stucco, the fragility of the medium has resulted in few survivors such as these figures. Four of the figures are crowned and carry wreaths, while the two closest to the niche are more plainly garbed. The figures are posed in various stances, with the beautifully incised lines of their drapery creating a dignified effect. Except for the

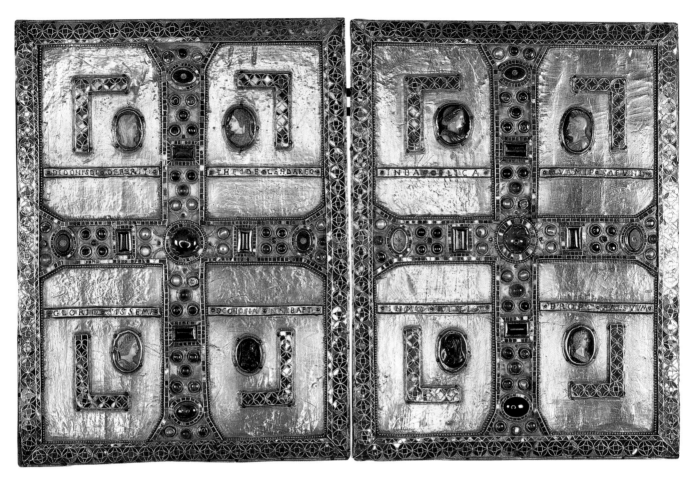

Fig. 7.37. Book covers of Gospels of Theodelinda. Gold, gemstones, pearls, antique cameos, and *cloisonné*. Each panel 10½ × 6¾″. Late 6th or early 7th century. Monza

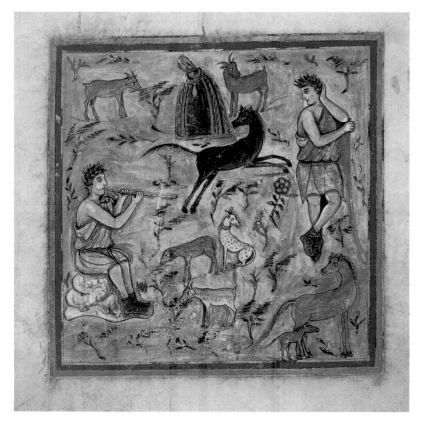

Fig. 7.38. *Shepherds Tending Their Flocks.* Illustration in the Roman Vergil. 8½ × 8¾″. 6th century (?). Vatican Library, Rome (Cod. lat. 3867, fol. 44v)

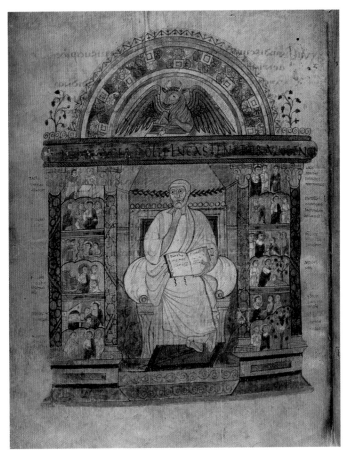

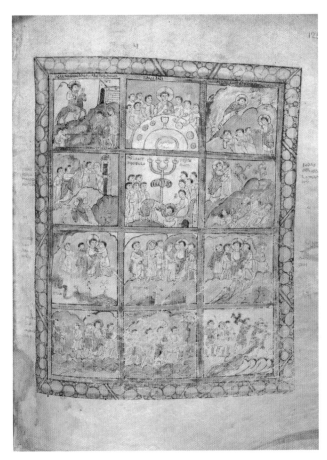

Fig. 7.39. *Saint Luke.* Illustration in the Corpus Christi Gospels (Gospels of Saint Augustine). 9⅝ × 7⅛″. 6th century. Corpus Christi College Library, Cambridge (Corpus MS 286, fol. 129v)

Fig. 7.40. *New Testament Scenes.* Corpus Christi Gospels (fol. 125r)

figures' elongation, the female saints and the vine scrolls are based on Early Christian models such as the female saints found in Sant'Apollinare Nuovo in Ravenna.

The splendid gold and jeweled book covers associated with Queen Theodelinda may have been made in Rome and given as a gift to the Lombard ruler (**fig. 7.37**). She was a champion of Orthodox Christianity, rather than the Arian Christianity followed by most of her people. The covers include Roman cameos, but they are combined with garnets in *cloisonné*, a technique associated with northern peoples. The cross, comprised of uncut gems and pearls, dominates both the front and back covers. The combination of techniques and materials makes identification of the artist difficult, but demonstrates that sharply drawn lines between Roman and Lombard are unnecessary.

Although Rome in the sixth and seventh century has traditionally been viewed as a wasteland of famine, war, and pestilence, recent scholarship has begun to paint a very different picture of a Rome that was besieged, but where the arts and culture did, in fact, endure.

One of the earliest illuminated manuscripts from Rome

is the so-called Roman Vergil. The scene of the *Shepherds Tending Their Flocks* (**fig. 7.38**) is in the tradition of the shepherds below the Parting of Lot and Abraham, in Santa Maria Maggiore. The artist has no intention of creating a three-dimensional landscape, but rather portrays the joys of the bucolic life. A horse gallops across the middle of the page, while one shepherd plays his pipes and the other casually rests his arm on his staff. Rather than creating a "window" on the flat pages of the vellum, the artist has conformed to the new esthetic of conveying a mood.

The Corpus Christi Gospels in Cambridge were allegedly brought to England by Saint Augustine of Canterbury in the late sixth century, though there is no concrete evidence to confirm this notion.[21] The text has been identified as sixth-century Italian, and the miniatures are generally considered to be of the same date. The elaborate frame that forms an alcove for Luke (**fig. 7.39**) retains aspects of perspective behind the author. The scenes that fill the boxes in the intercolumniations on either side are simplified and abridged, relying on the northern viewer's knowledge of the biblical stories to identify the scenes (**fig. 7.40**).

THE MEROVINGIANS

...e Merovingians were a dynasty of Frankish kings, descended, according to tradition, from Merovech, chief of the Salian Franks, whose grandson was the founder of the Frankish monarchy. After his marriage (493) to a Christian princess, Clotilda, he had his children baptized, but he himself was not immediately converted. Like Constantine, he is said to have invoked the Christian God before a battle with the Alemanni in the late 490s. He was victorious over them and two years later converted, having been persuaded by Clotilda and Saint Remigius, bishop of Reims, who baptized him, along with 3,000 supporters.

Like the Lombards and the Anglo-Saxons, the Franks were masters of metalworking, especially the art of *cloisonné*. A magnificent pair of bird-shaped brooches is a fine example of their craft (**fig. 7.41**). Comprised of *cloisonné* cells inset with copious amounts of garnets, and accented with glass and pearl, the cells are backed with patterned foil. Frankish ladies were known to wear a number of these types of brooches, with the bird motif being particularly popular.

Frankish metalworkers turned their considerable skill to creating Christian works of art in their favored medium. The Cumberland Medallion with the bust of Christ is a complex blending of a Late Antique type with a Frankish penchant for abstraction (**fig. 7.42**). The type of Christ enthroned and holding a book was by now a familiar one. Here, however, the artist has transformed Christ's hands into a swirling linear pattern that is echoed in the creatures that flank him. His hair and his halo have been blended, with only the cruciform markers indicating his status as Christ. Above him, the Alpha and the Omega refer to the beginning and ending of time. The brilliance of the *cloisonné* enamel would have caught the light, creating a flash of color and pattern.

When Clovis and his Franks were converted to Christianity, they adopted more than a set of religious beliefs, they also adopted the book as well. Christianity's bedrock is Scripture, so

Fig. 7.41. Pair of bird-shaped brooches. Gold, garnets with patterned foil backings, glass, covered with *cloisonné*. Overall: 1³⁄₁₆ × 1 ×¼″. Northern France. 6th century, c. 550–600. Metropolitan Museum of Art, New York

Fig. 7.42. Medallion with the bust of Christ (Cumberland Medallion) from the Guelph Treasure, Wessaraum, Germany. *Cloisonné* enamel on gold and copper, height 2″. Late 8th century. The Cleveland Museum of Art

Fig. 7.43. Page with a Cross. Illustration in the Gelasian Sacramentary. Merovingian. 10¼ × 6⅞″. Mid-8th century. Vatican, Bib. Apostolica, Rome (MS. Reg. lat. 316, fol. 132)

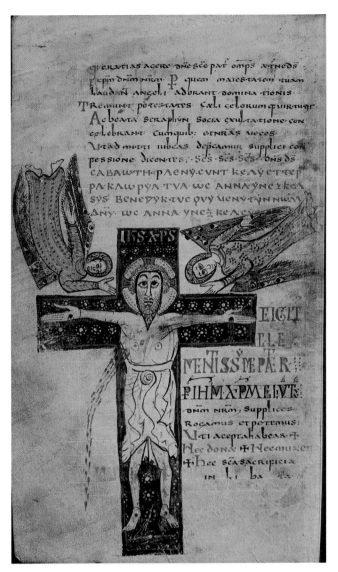

Fig. 7.44. *Crucifixion.* Illustration in the Gellone Sacramentary. 10¼ × 6½″. c. 790. Bibliothèque Nationale, Paris (MS lat. 12048, fol. 143v)

the newly converted Franks would create a demand for the codex, which was the vehicle for Bible readings and liturgical prayers. What is most interesting is the way the book was transformed in the hands of Frankish scribes and artists.

The motifs and patterns found in the *cloisonné* enamels were easily, and beautifully, transferred to the pages of a codex. The Gelasian Sacramentary, erroneously named after Pope Gelasius, reveals a curious mixture of Late Antique and Frankish motifs (**fig. 7.43**). The architectural structure of the arch has been transformed into a framing device for the lavishly decorated cross. Traditional motifs such as the Alpha and the Omega, stags, eagles, and the *agnus Dei* (Lamb of God) are combined with rosettes and pearls with colors derived from enamels: yellows, reds, and greens. The eagles that dangle from the Alpha and the Omega are close cousins

of the bird-shaped brooches. Just as the brooches added luster and status to the Frankish cloaks, the eagles adorn the cross-page contained in the sacramentary (which contained the prayers of the celebrant for the Mass).

The Gellone Sacramentary incorporates the Crucifixion into the very words of the celebrant at the mass: the Te Igitur, which are the words that open the prayers of the Eucharist (**fig. 7.44**). The T of the word Te has become the cross on which Christ is sacrificed. The artist-scribe has created a marvelous "play on words" with the Te Igitur by combining the Crucifixion with the words spoken over the bread and wine of the Eucharist, the reenactment of Christ's sacrifice. The wine and the bread were the embodiment of the blood flowing from Christ's side and the flesh nailed to the cross. In the hands of the Frankish artist, the Word has become flesh.

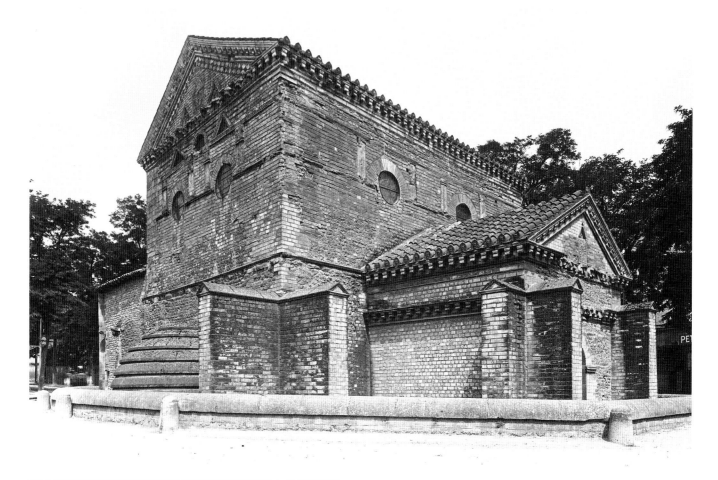

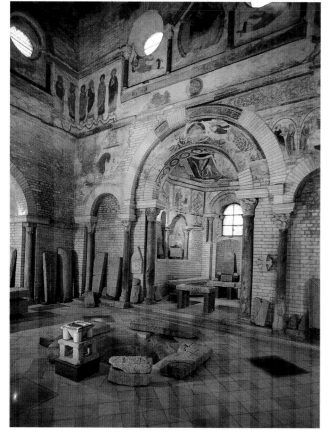

ABOVE **Fig. 7.45.** Baptistery of Saint John, Poitiers, France. Exterior from the west. 7th century

LEFT **Fig. 7.46.** Baptistery of Saint Jean, Poitiers. Interior. Mid 4th–7th century

Gregory of Tours (573–93), in his *History of the Franks*, lavishly praised a number of basilicas in his homeland, including the imposing Church of Saint Martin at Tours,[22] but scant remains of any churches earlier than the seventh century survive. One reason for this is that building in stone is a Roman tradition while the people they conquered built in timber, which does not last. One small structure survives, however, and shows a remarkable pastiche of the old and the new. The Baptistery of Saint John in Poitiers (**figs. 7.45, 7.46**) was originally a fourth-century Gallo-Roman structure. Under the Merovingian Bishop Ansoald (674–96), extensive renovation was started that incorporated some of the older features and added new ones. The original octagonal *piscina* was retained as well as the entrance porch. Three apses were added, resulting in a unique transverse-oriented plan. Saint John's is built from reused stones and bricks and decorated with Classical capitals, cornices, and embedded pilasters and pediments resembling simulated embroideries in stone. The walls were further enriched with patterns of terracotta inlays.

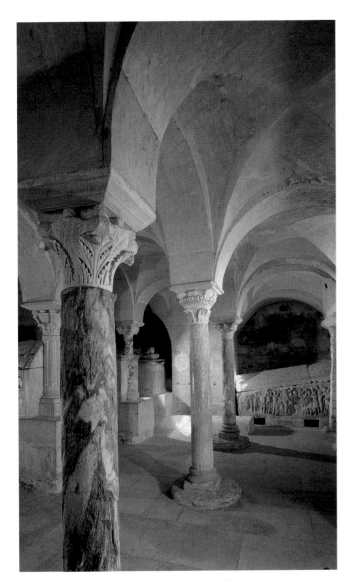

Fig. 7.47. Crypt of Saint Paul, Benedictine Abbey of Notre Dame at Jouarre, France. c. 634

Another rare, and therefore precious, survivor of Frankish architecture is the Crypt of Saint Paul in the funerary church of Saints Martin and Paul in the double monastery of Notre-Dame at Jouarre (**fig. 7.47**), founded about 630 by Ado, ex-treasurer of King Dagobert I. The crypt was situated under the raised apse of the church, almost at the same floor level as the nave. Although much altered due to later renovations, the groin vaults were supported by columns that were taken from local Roman buildings. The capitals are seventh century and were imported from workshops in the Pyrenees. The capitals are loosely modeled after Classical types, but show a remarkable difference in pattern, indicating that they were not meant to be an ensemble. The crypt was intended to house the tombs of the early abbesses and abbots of the monastery. The sarcophagi of Saint Theodochilde, Saint Aguilberte, and Saint Agilbert still survive there and show a remarkable disparity in style and taste.

THE VISIGOTHS

The Visigoths were a Germanic people who originated around the Baltic Sea. Pressure from the east forced them west, where they moved into Italy. The most famous Visigoth is Alaric, who sacked Rome in 410, inspiring Saint Augustine to write *The City of God* to explain this how this event could befall the city of Saints Peter and Paul. In order to counter Visigothic power, the Roman emperor offered them the role of allies in the region of Aquitaine. They held Toulouse until 508 when Clovis, the Frank, drove them out, and they then settled in Spain and Portugal. The Visigoths were converted in the fourth century to Arian Christianity, rendering them heretics in the eyes of the Roman Church.

The close contact with Italy created a Visigothic art and architecture that adapted many of the Italian art and architecture traditions. Dated to between 649 and 672, the crown of Recceswinth (**fig. 7.48**), a king of the Visigoths who had settled in Spain, served a commemorative purpose as a votive crown to hang over an altar or a tomb. This elegant object typifies Visigothic refined jewelry. Its large uncut gems and inlaid letters dangle from golden threads spelling out the king's

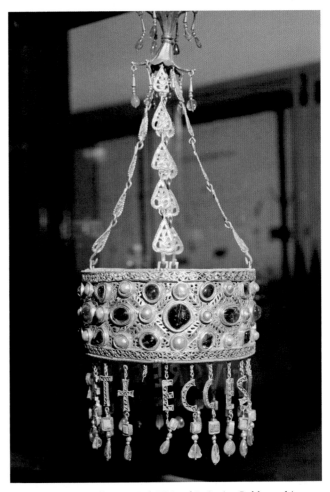

Fig. 7.48. *Crown of Recceswinth.* Visigothic Spain. Gold, sapphires, and pearls, diam. 8½″. 7th century. Museo Arqueológico, Madrid

name. The use of votive crowns is well documented in the mosaics of Ravenna, which show them hung above the altars.

Recceswinth also built a small church dedicated to Saint John the Baptist on a Roman site after he had been cured of an illness by the waters found there (**figs. 7.49, 7.50**). A small church, it is constructed with ashlar masonry, carefully cut stones put together without mortar, of a very high quality, indicating that the local workshops had learned Roman building techniques. The original church consisted of a three-aisled basilica with three separate square apses. The arches are horseshoe shaped, a distinctive type of Visigothic architecture. As in many other early Spanish churches, the apses were barrel vaulted. Though modest, the decorative chip-carving around the apse and in the capitals is some of the earliest

interior church sculpture to survive. The church is typical of early Spanish churches in its tendency to separate the interior spaces, the result being an intimate and enclosed interior.

The church of Santa María at Quintanilla de las Viñas near Burgos, now a partial ruin, retains the sanctuary and the transept (**fig. 7.51**). On the exterior of the eastern apse is carved a beautiful stringcourse filled with vine scrolls and rosettes. Additional carving is found on the arch that surrounds the transept arch. Here the vine scrolls are filled with grape clusters and birds, motifs that are highly reminiscent of the mosaics in the vaults of the Mausoleum of Santa Costanza in Rome.

San Pedro de la Nave boasts some of the earliest historiated capitals to survive (**figs. 7.52**). The Sacrifice of Isaac on

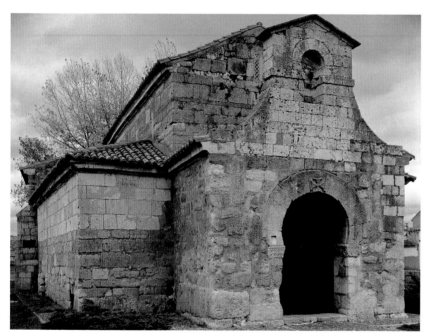

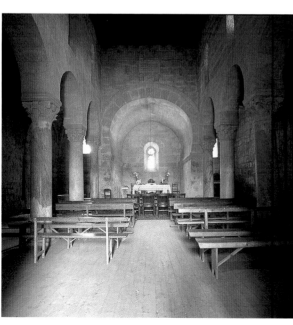

LEFT **Fig. 7.49.** San Juan de Baños. Cerrato, Spain. 7th century

BELOW LEFT **Fig. 7.50.** San Juan de Baños. Interior

BELOW **Fig. 7.51.** Santa María at Quintanilla de las Viñas (Burgos), apse entrance

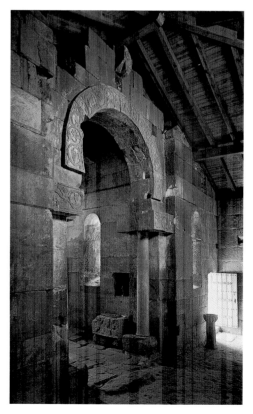

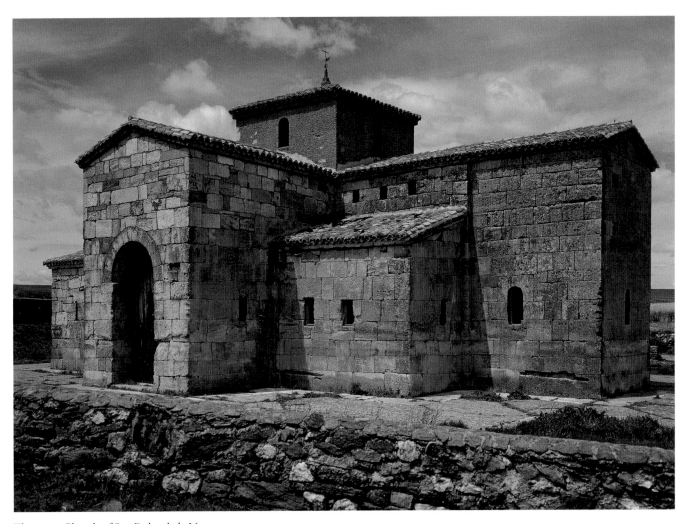

Fig. 7.52. Church of San Pedro de la Nave, Zamora, Spain. 8th century

one column capital tells the Old Testament story of how Abraham was willing, at God's command, to sacrifice his son (**fig. 7.53**). At the last moment, a ram was offered in his stead. Its appearance on the capital was no doubt a typological reminder of Christ's sacrifice, which is reenacted in the Eucharist. A simple three-aisled basilica, San Pedro de la Nave, has the unusual feature of a transept that divides a truncated nave from the sanctuary and the square-ended apse. The light of three windows illuminates the apse, inscribed by its horseshoe opening. The results is a choir in deep shadow with light streaming in from the apse. The alternation of dark and light spaces created an atmosphere ideal for the intricacies of the Spanish liturgy.

The employment of barrel vaulting, though on a small scale, and the use of relief sculpture to enliven the interior and exterior spaces of these small Visigothic churches anticipates the explosion of stone carving that is the hallmark of Romanesque churches.

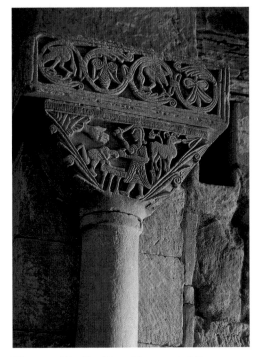

Fig. 7.53. The Sacrifice of Isaac capital. San Pedro de la Nave

8
CAROLINGIAN ART
AND ARCHITECTURE

On December 25, 800, while attending the third Christmas Mass in the Basilica of Saint Peter in Rome, the king of the Franks, Charlemagne, kneeling before the Tomb of the Apostle in the apse, was approached by Pope Leo III. When Charlemagne rose, the pope placed a crown on his head, and an auspicious acclamation was chanted by the congregation about them: "To Charles, the most pious Augustus, crowned by God, the great and peace-giving Emperor, life and victory!" Much controversy obscures the actual events that took place—Einhard, Charlemagne's biographer, states that the king was unaware of the pope's plan and would have avoided the ceremony had he known—but the fact remains that a chieftain of Frankish origin and speech from across the Alps was officially crowned emperor of the Romans, an act that was to have a lasting tradition in the history of the Holy Roman Empire and an honor that gave new dignity to Northern rulers and affirmed close Church-state unity henceforth in the Latin West. Furthermore, it was a reconstitution of the ancient Christian empire of Constantine, one based on the forged "Donation of Constantine," a document allegedly issued by the first Christian emperor submitting his crown and authority to the Roman church.[1]

The papacy had petitioned the Frankish rulers once before. In 754, Pope Stephen II had personally crowned Pepin, Charlemagne's father, "king of the Franks" in a ceremony at Saint Denis outside Paris, but the grandiose affirmation in 800 of the alliance was truly a pivotal point in history. Charlemagne would adopt imperial Roman coin types for his coin; however, this should not be understand as a "renaissance" of classical culture, but as an appropriation of certain aspects of Roman imperial culture that would be compatible with the Christian imperative of the Holy Roman Emperor.

With the death of his brother Carloman in 771, Charlemagne had inherited all of Francia (a territory that included France, western Germany, and the Netherlands), and it seems clear that he first set about to reorganize the administration of his domain, formerly identified with the "mayor's palace," into a far-reaching organization of states. The court was at first itinerant, with the king and his family, together with councilors and aides, moving from one capital to another frequently. Now a system of vassalage was adopted with counts or companions of the court controlling defined territories or counties. The clergy, always powerful in the government in the North, were incorporated as the court clergy.

Admittedly, the Carolingian administration was loosely organized, and the domain lacked a central capital until Aachen was established in 794, but it is apparent from numerous sources that Charlemagne had in mind a reforming and standardizing of the liturgy, which would be based on the Roman liturgy. The "academy" that Charlemagne established at his court was very likely an informal circle of learned clerics and scholars who gathered about him from time to time. The monastic schools spread the new education throughout the North, creating an atmosphere conducive for learning.

PALACES

Even before Charlemagne was crowned emperor, he began to create an elaborate palace complex for himself. Extensive excavations and studies of the site have been carried out and published in five volumes (1965–68), and, furthermore, the major building, the palace chapel, survives nearly intact, although it is somewhat smothered under later additions. Dedicated to the Virgin, the chapel was nearly complete by 798 (**figs. 8.1, 8.2**). Originally, the chapel was part of a large complex of palace structures. From its huge courtyard—over 650 feet broad—a long gallery led to the royal hall, the *aula regia*, where official state business would be conducted.

This handsome structure was the emperor's private chapel, and its spiritual models were the palace churches in Rome (the Lateran—Einhard referred to the Aachen edifice as "Charlemagne's Lateran") and in Constantinople. Much speculation has been devoted to its actual physical model or models in both plan and elevation, but it is apparent that the *cappella palatina* of Charlemagne owes much to the palace church of Justinian in Ravenna, San Vitale (figs. 4.39–4.42), a building that Charlemagne knew well from his trips to Italy. Einhard reports that *spolia* from Rome and Ravenna, mostly marble columns and panels, were incorporated into the new structure.

The ground plan features a central octagon supporting a dome, a projecting apse, and an impressive two-towered entrance. Charlemagne employed a Frankish builder, Odo of Metz, and Einhard was the general supervisor of the entire complex. Thus the imprint of the North is not lacking, especially in its solid walls and the beautiful metalwork railings. San Vitale is light and airy with its brick construction; the *cappella palatina* at Aachen is more geometrically logical. The attached entrance way is tall but compact, with a deep exedra carved from its plain front and a giant "window of appearance" (an opening where the emperor could view the atrium and be visible to the people there) penetrating its second level. Two cylindrical towers squeeze in the portal, symbolizing its function as a fortress as well as an imperial foundation.

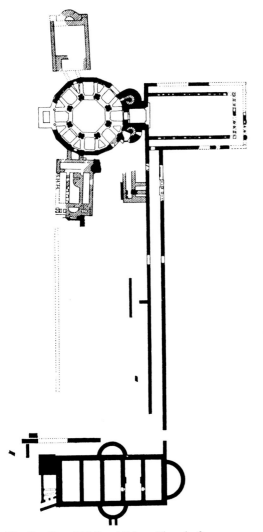

Fig. 8.1. Royal Hall and Palace Chapel of Charlemagne, Aachen. Plan of the 9th-century complex (after Conant)

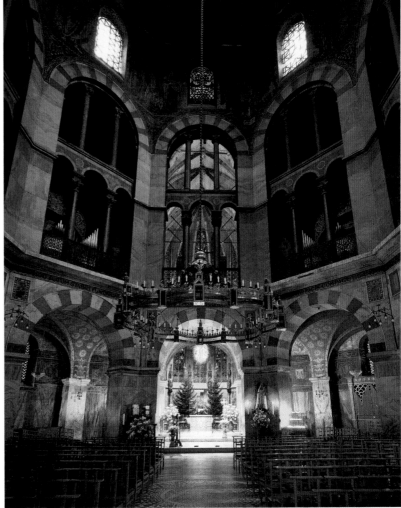

Fig. 8.2. Palace Chapel of Charlemagne, Aachen

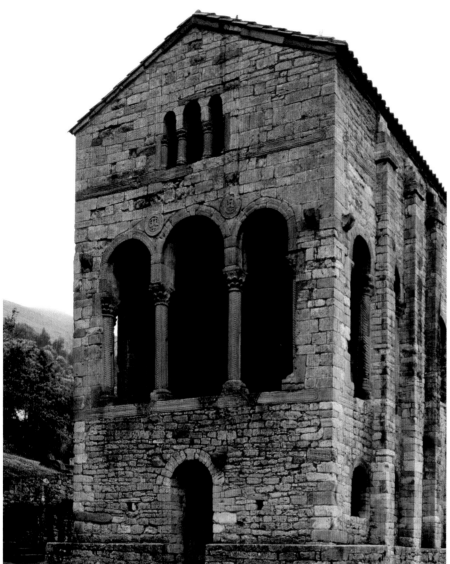

Fig. 8.3. Santa María Naranco, Oviedo. Exterior. Before 848

crowned, stepped before the upper altar dedicated to Christ and placed there a golden crown just like the one he wore. And according to a panegyric addressed to Charlemagne (*De sancto Karolo*), dating from a later period, this identification was still remembered: "Oh King, triumphator of the world, Co-ruler with Jesus Christ. Intercede for us, Our Holy Father Charlemagne."[2] In 814, Charlemagne was interred in his beautiful chapel.

Charlemagne was not the only Early Medieval ruler who desired to create an impressive palace complex that would add to his prestige and give a home to his court. Ramiro I (842–50) built a palace complex in Naranco, near Oviedo (**fig. 8.3**). Although like Aachen little remains of the complex, chroniclers describe it as having palaces, baths, dining halls, and churches. Only what is presumed to have been the palace hall has survived. The main block of the building is divided into three compartments, the central one covered by a heavy tunnel vault with transverse arches. The vaults of the crypt level allow the upper story to be lighter and twice as tall. The upper story has porches on either end; the three-arched opening elegantly repeats the smaller arches below. The vaulting system is quite daring, and the fine ashlar masonry of the walls indicates Ramiro had skilled builders at his disposal. Large buttresses articulate the exterior walls of the palace hall, creating an even and symmetrical rhythm across the surface. The palace hall was later converted to a church dedicated to the Virgin Mary.

On the second level, directly behind the window above the entrance, is a broad platform on which sits the marble throne of Charlemagne, serving as his royal loge with a view down to the altar dedicated to Mary in the apse. Directly opposite Charlemagne's throne and above the altar of Mary was a second altar (on the first level of the galleries) dedicated to the Savior, and this in itself is significant. The Lateran, too, was originally dedicated to the Savior. The throne of the emperor thus mirrored the altar-throne of Christ; Charlemagne, chosen by God, was the co-regent of Christ on earth, and at Aachen their dual presence is emphatically stated.

Across the octagonal space that separates the domain of the secular ruler—the two-towered facade—and that of the divine—the sanctuary—the powers of church and state interpenetrate and reflect one another. According to a ninth-century description of the coronations of Charlemagne's son Louis the Pious, the emperor, dressed in royal robes and

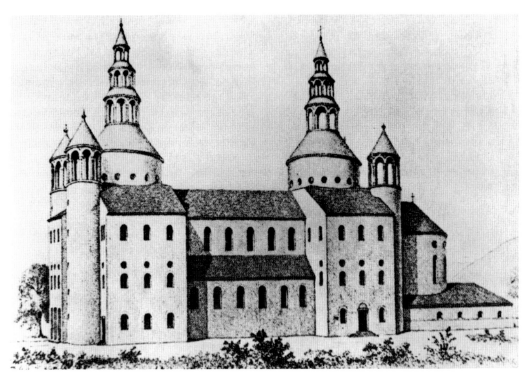

BASILICAS

One unusual but consistent feature of the major Carolingian basilicas was the independent structure that emphatically marked the western or entrance end of the church, an independent "westwork" (*Westwerk* in German). The westwork could function variously as a station in the processional liturgy, an imperial loggia, a chancellery (for voting in church councils), a martyrium, or as an imperial burial site. The westwork in Carolingian churches is the beginning of the emphasis on the western entrance of the basilica plan.

The illustrious Abbot Angilbert built an entire holy city at Centula, with a complex of three churches and other monastic buildings forming the core of a sprawling community of seven villages, symbolic of the seven stations of the cross (**figs. 8.4, 8.5**). Abbot Angilbert had strong connections to the Carolingian court through Charlemagne's daughter, with whom he had a child. It was through these close family ties that the emperor could expand his sphere of influence. Charlemagne provided materials, craftsmen, and funds for the monastery, and arranged for bases, columns, and moldings to be transported from Rome. The large monastic complex could accommodate three hundred monks and one hundred novices. The number three runs as an important theme throughout the planning and dedication of the monastery. Dedicated to the Trinity, the monastery also enjoyed the triple patronage of Christ the Savior, the Virgin, and Saint Riquier, an abbot and preacher who became a hermit; when he died in 645, his relics were placed in the church. The plan boasts three churches dedicated and named for the Savior, the Virgin and Apostles, and Saint Benedict, the founder of the Benedictine Order. The plan features an unusual triangular cloister, which

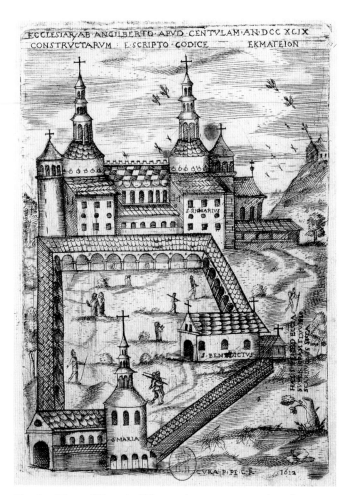

Fig. 8.5. View of Centula Abbey. 17th-century engraving after an 11th-century manuscript illumination. Bibliothèque Nationale, Paris

connects the three churches. A basilica in plan, the main church features two axial towers that dominate the profile, while the crossing tower reached a height of 180 feet. The base of the westwork was a vaulted outer vestibule, where Abbot Angilbert was buried. The inner vestibule, which served as a narthex, contained a font and an altar. Above these two vestibules was a chapel dedicated to the Savior. Immediately east of the crossing a sanctuary bay contained an altar to Saint Peter and behind that the tombs of Saint Riquier and his two companions. A raised, semi-circular apse contained the altar to Saint Riquier. This apse was marked off by six marble columns brought from Rome, with small reliquaries placed on the beam.

A number of variations on the basic plan were possible, and only gradually have the remains of westwork churches been identified and classified into regional types. One fine example, Corvey in Westphalia (**figs. 8.6–8.8**) remains surprisingly intact. While upper stories have been added to the facade, the handsome westwork still displays much of the strength and austerity of these early imperial churches, with its plain volumetric masses and clearly stated elements: the central plan (the central cupola has been submerged in the later renovations), the projecting main portal with twin

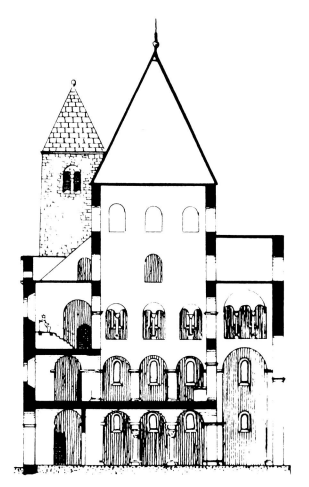

Fig. 8.6. Abbey Church, Corvey (Westphalia). Cross section of the westwork (after Fuchs)

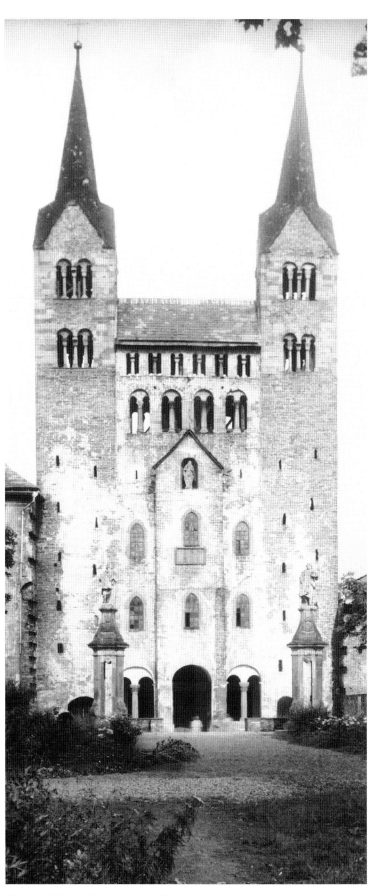

Fig. 8.7. Abbey Church, Corvey. Facade. 873–85 with later additions

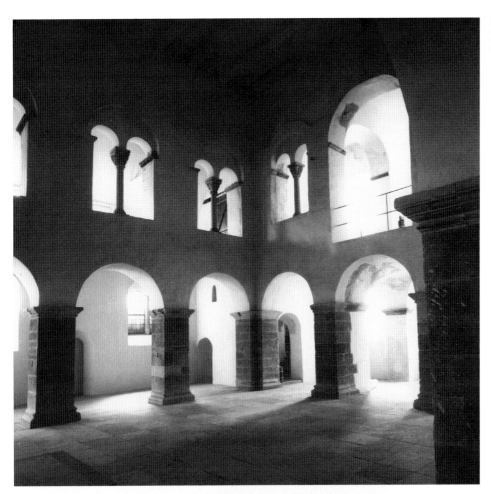

Fig. 8.8. Abbey Church, Corvey. Interior with view into western tribune. 873–85

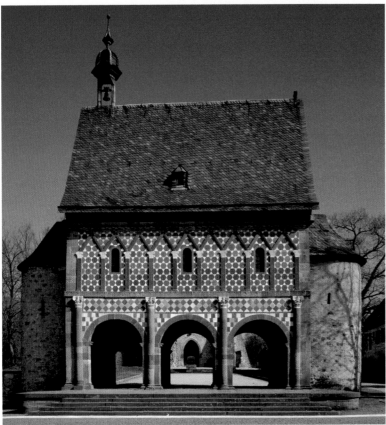

Fig. 8.9. Torhalle of Lorsch. c. 800

towers, the window or windows of appearance at the level of the upper gallery.[3] The interior of the westwork, sometimes referred to as a tribune, is also marked by the large opening for the imperial throne in the western gallery, offering an open view into the nave and sanctuary.

The famous Torhalle of Lorsch (**fig. 8.9**), originally standing within the atrium of the towered basilica there, was erected as an independent station for imperial ceremonials. Modeled loosely on the Arch of Constantine in Rome, the Torhalle (porch or gateway) served as a kind of waiting room during the visit of the emperor. The colorful masonry patterns on the exterior, which seem to be concessions to Northern taste, were inspired by a type of Roman construction (*opus reticulatum*), and remains of fresco decoration in the interior of the upper chamber also have ancient antecedents. The two towers fused to the end walls of the gateway underscore its imperial role, paralleling that of the westwork.

In an article published in 1942, Richard Krautheimer demonstrated that many of the basilical plans of Carolingian churches were patterned on the layout of Saint Peter's in

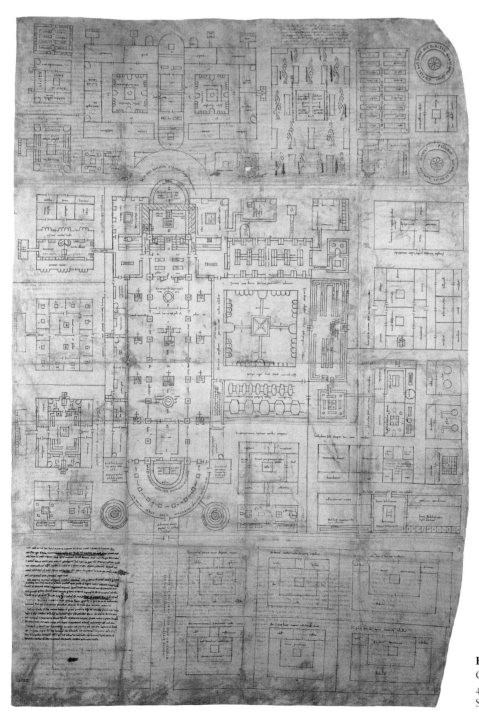

Fig. 8.10. Plan of an ideal monastery. Original in red ink on parchment, 28 × 44⅛". c. 820. Stiftsbibliothek, Saint Gall, Switzerland. (Cod. Sang. 1092)

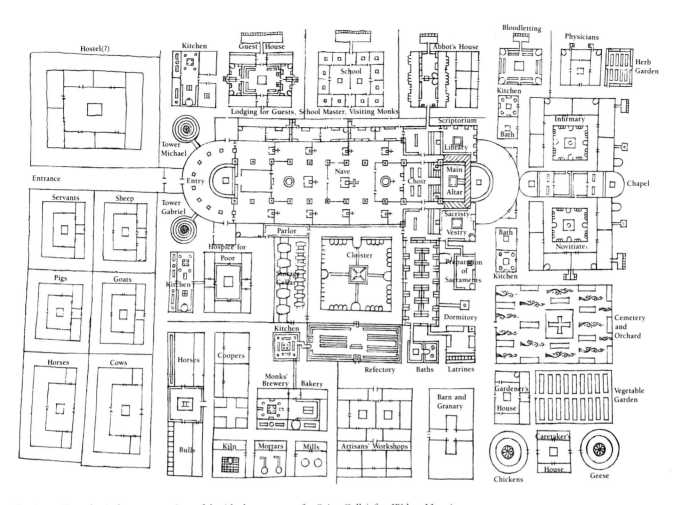

Fig. 8.11. Hypothetical reconstruction of the ideal monastery for Saint Gall (after Walter Horn)

Rome.[4] The Carolingian basilica, according to the most recent excavations, revived the T-shaped ground plan of Old Saint Peter's; the portals of the new construction added by Charlemagne thus would have transformed the church into a westwork structure, an appropriate building for conducting Christian services in the company of imperial visitors.

While an accurate reconstruction of the monastery of Centula is not possible, a complete ground plan for a Benedictine community of the ninth century survives on five sheets of vellum preserved in the abbey library of Saint Gall (Switzerland), here also reproduced in a redrawing for clarity (**figs. 8.10, 8.11**). The plan was sent by Abbot Haito of Reichenau, a leading ecclesiastical figure at the Carolingian court, to Abbot Gozbert of Saint Gall (816–36) with the accompanying note: "I have sent you, Gozbert, my dearest son, this modest example of the disposition of a monastery, that you may dwell upon it in spirit. We drew it through the love of God out of fraternal affection, for you to study only."[5]

The Saint Gall plan is laid out according to a simple grid system with axes roughly marking off four major areas about the huge church in the center. Numerous buildings are named, including the most menial sheds, the rooms for guests,

the hospital for the infirm, the quarters for the monks, and the wine cellar. Even the trees in the orchard are designated. Four basic quarters about the church are clearly marked. First is the closed monastic core—the monastery within the monastery, so to speak—adjoining the cloister on the south side of the church. This area is the sacred *claustrum*, or enclosure, reserved for the monks, who pursue their devotions there uninterrupted by outside distractions.

Opposite this sacred core, on the north side of the church, is the residence for the imperial guests and the abbot's house. Here, too, are the schools, the library, the scriptorium, and the larger kitchen. To the south, beyond the monks' refectory and kitchen, is the area for the lay workmen, the craftsmen, their kilns, mills, stables, brewery, and bakery. The final arm, to the east beyond the apse of the church, is lined with rooms for the monastic physician, the infirmary, the chapel for the sick, and a cloister. In the southeastern corner is the area for the cemetery and the orchard along with the gardener's house. Saint Gall's monastery was thus envisioned as a self-sufficient city of its own, closed to the outside world and yet accommodated to receive pilgrims and royal guests, as was the Benedictine practice.

MURAL PAINTING AND MOSAICS

Evidence of monumental mural decoration in Carolingian times is scant. The poet Ermoldus Nigellus describes extensive fresco cycles in a church at Charlemagne's residence in Ingelheim on the Rhine, with Old Testament scenes painted on one wall of the nave and New Testament episodes on the other. In the nearby palace quarters, in the *aula regia*, secular histories provided a profane testament with stories taken from the fifth-century *History Against the Pagans* by Paulus Orosius and legends of more contemporary "fathers, who were already closer to the faith," including Constantine, Theodosius, Charles Martel, Pepin, and Charlemagne conquering the Saxons. Nothing remains of the buildings or paintings at Ingelheim.[6]

Theodulf, another famous court poet, was bishop of Orléans and abbot of Saint-Benoît-sur-Loire (Fleury). He built a comfortable villa retreat between his two benefices at Germigny-des-Prés on the Loire, and the walls formed a kind of gallery of special secular paintings, including those of the seven liberal arts, the four seasons, and a *mappa mundi*, or map of the world. The villa of Theodulf has vanished, but a small oratory erected nearby still stands (**fig. 8.12**). The curious central structure has been poorly restored, but apparently a domed tower covered the crossing with four smaller cupolas at the corners. Apses projected on all four sides, the eastern or main end being trebled.

The lavish decorations in mosaic and stucco on the interior survive only in fragments, except for the surprising mosaic that fills the main apse (**fig. 8.13**).[7] An inscription along the lower border informs us to "Heed the holy oracle and the cherubim, consider the splendor of the Ark of God, and so doing, address your prayers to the master of thunder and join with them the name of Theodulf." In the center, against a golden background, rests the Ark of the Covenant as

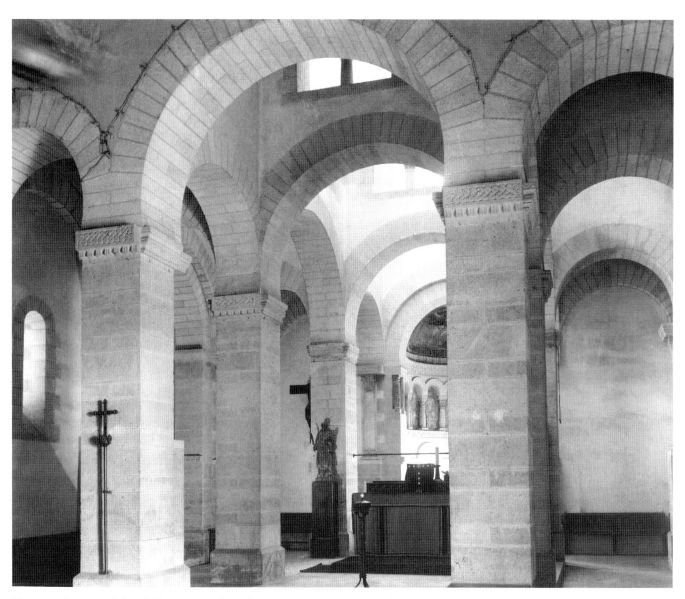

Fig. 8.12. Oratory of Theodulf, Germigny-des-Prés, France. Interior. Consecrated 806

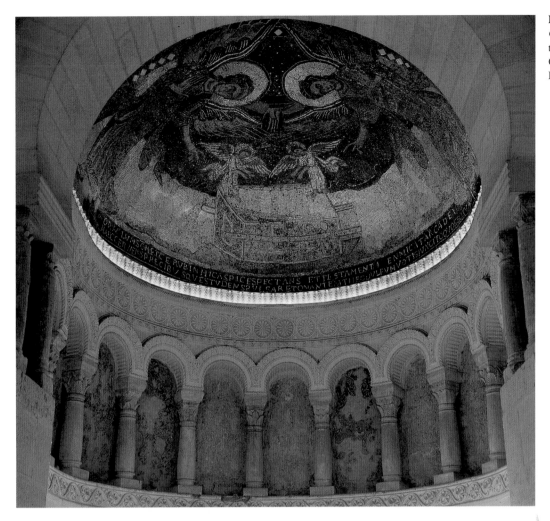

Fig. 8.13. *Ark of the Covenant.* Apse mosaic in the Oratory of Theodulf. Germigny-des-Prés, France. Early 9th century

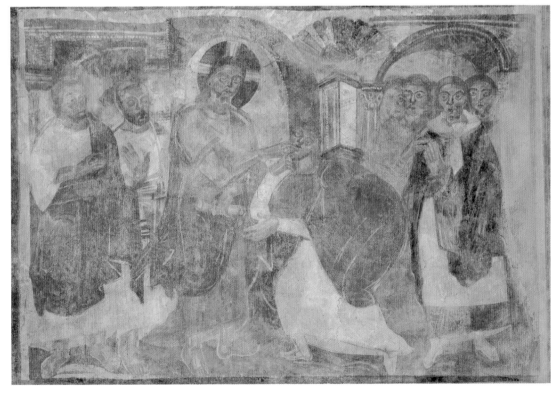

Fig. 8.14. *Christ Healing the Blind Man.* Wall painting from the Church of Saint John, Müstair, Switzerland. c. 800

described in the first Book of Kings (8:4). Two tiny angels in gold hover above the Ark, while two larger ones dressed in purple, their wing tips touching, stand to the sides. These creatures are meant to represent the cherubic and seraphic guardians of the Ark.

The style of the heads of the two larger angels is Byzantine, but the craftsmanship does not warrant an attribution to Eastern artists, and, furthermore, such a representation is unprecedented in Byzantine church decoration. The tabernacle with the Ark of the Covenant does appear in early Jewish art and in early Spanish Bibles, and the fact that Theodulf was a Spaniard may account for the unusual iconography here. This same Theodulf was very likely the composer of the *Libri Carolini*, a Carolingian aniconic treatise, and so an even more engaging solution presents itself. In keeping with the prohibition of representing godhead in portrait form, the Jewish Ark of the Covenant, as a substitution for the likeness of Christ the Lord, would serve as a powerful evocation of divine presence above the altar.

Extensive remains of mural painting were recently uncovered in the Church of Saint John at Müstair (**figs. 8.14, 8.15**) in eastern Switzerland.[8] The paintings in the nave are in registers, with scenes from the Infancy and Ministry of Christ. A Last Judgment covered the west wall behind the entrance, while the north apse presented a *Dominus legem dat* (Christ Giving the Law to Peter) with the enthroned Christ handing the keys to Saint Peter and a book to Paul. Over painting has obscured much of the figure style at Müstair, but the iconography appears to be similar to that of the cycles in Early Christian basilicas. That such programs of decoration were models for the Carolingians is also suggested by the early description of paintings in the ninth-century abbey of Saint-Faron at Meaux: "In the vault of the apse appears a figure painted on a star-spangled ground, the figure of Christ the Lord. Following each other on the walls are Bible stories, fine windows and pictures of the Fathers and the Popes."[9]

Considering the paucity of architectural remains, it is not surprising that Carolingian mural decorations are rare and fragmentary. That extensive picture cycles originating in Early Christian Rome became available to the Northern artists is, however, clearly demonstrated by the rich variety of subjects that appear in Carolingian illuminated manuscripts.

Fig. 8.15. The Church of Saint John, Müstair, Switzerland. c. 800. View into the apse

BOOK ILLUSTRATION

Carolingian book illustration presents an exciting history. Charlemagne's personal ties with the papacy were initiated nearly twenty years before the momentous coronation of 800, when in 781 he escorted his son Pepin to Rome to be baptized by Pope Hadrian. He returned to Francia with many gifts, including books. One of the earliest Carolingian court manuscripts with illuminations, the Godescalc Gospels (**fig. 8.16**), commemorates this significant journey, and the full-page miniatures that adorn its pages are startling. The text, which is actually that of a lectionary with selections of the Gospels, signed by the monk Godescalc, is dedicated to Charlemagne and his wife Hildegarde (d. 783) and contains references to the baptism of Pepin in Rome.

At the beginning of the manuscript, a handsome frontispiece for the vigils of Christmas presents an unusual *fons vitae*, or fountain of life, with a font covered by a conical dome resting on a huge, arched entablature carried by eight columns. A large cross surmounts the ensemble. The fountain is placed within a garden enlivened by plants and various fauna. Peacocks are perched on the roof, and other colorful birds are scattered about the font. A grazing hart appears in the lower right. The symbolism of the large font is clear: it refers to Pepin's baptism in 781. The Lateran Baptistery was of such a form in the fourth century and, in fact, golden statues of harts were placed about the columns, illustrating the lines of Psalm 41 in the Vulgate Bible (42 in the King James): "As the hart panteth after the fountains of waters; so my soul panteth after thee, O God." The ornate border is elaborated with various metal-colored sections joined by variegated shafts. And how bright the colors are! Shining blues, radiant oranges, and dark wines accented with touches of gold give the miniature a sparkling richness.

Fig. 8.16. *Fountain of Life.* Illustration in the Gospels (Lectionary) of Godescalc . 12⅝ × 8¼". 781–83. Bibliothèque Nationale, Paris (MS nouv. acq. lat. 1203, fol. 3v)

Fig. 8.17. *Christ Enthroned.*
Illustration in the Gospels
(Lectionary) of Godescalc (fol. 3r)

The portraits of the four Evangelists and their beasts are similarly transformed into radiant color patterns, and perhaps the most instructive miniature to study is the portrait of *Christ Enthroned* (**fig. 8.17**). The garden and the architectural backdrop are comprised of rich bands of metallic blue and wine sprinkled with floral motifs. Christ is draped in a deep purple tunic and a wine-colored mantle, and the black lines that are vigorously traced across his knees and along the drapery folds. Depicted as a youthful, beardless teacher, the Godescalc Christ is a Carolingian version of the Late Antique Christ as a philosopher type.

The Soissons Gospels is a superb example of the Evangelist as Author portrait (**fig. 8.18**). Bright oranges and light blues replace the deeper, metallic hues of the earlier miniatures. The rudimentary architectural backgrounds are now articulated behind elaborate frames, the body of Saint John the Evangelist is actually modeled with white strokes in his pinkish mantle, and the throne is tilted in space. The artist has thought in terms of four separate planes of representation and not one unified expanse. The outer border of gold with simulated gems forms the initial plane and seems to project from the surface like a metal strip. The shallow setting for the

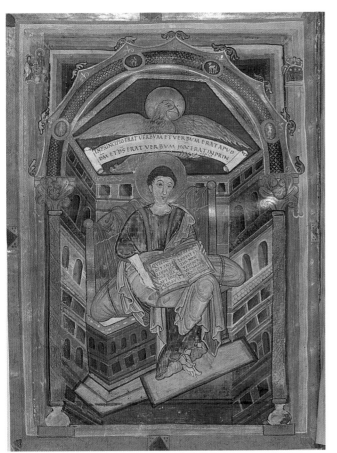

Fig. 8.18. *Saint John the Evangelist.* Illustration in the Gospel Book of Saint-Médard de Soissons. 14 × 10½". Early 9th century. Bibliothèque Nationale, Paris (MS lat. 8850, fol. 180v)

enframing arch comes next with its elaborate cusps. Painted cameos in blue and red are affixed to the intrados, while silver letters—the Alpha and Omega—hang on chains from the abaci of the capitals. The figure of Saint John is the final and foremost plane. In the frames are two small vignettes of the Wedding at Cana on the left and the Last Supper on the right, the first and last provision of wine in Christ's ministry. The symbol of John, the eagle, presents an open scroll on which is written the opening to the Gospel of John.

The manuscripts typically associated with the so-called Palace School are overtly classical in style. These are grouped about the famous Coronation Gospels in Vienna (also called the Schatzkammer Gospels) that, according to legend, were found on Charlemagne's knees when Otto III opened his tomb in the Palatine Chapel at Aachen in the year 1000 (**fig. 8.19**). The purple-stained parchment and the silver text point to a special royal function for the precious manuscript. No decorative beasts interrupt the serene portrayal; no

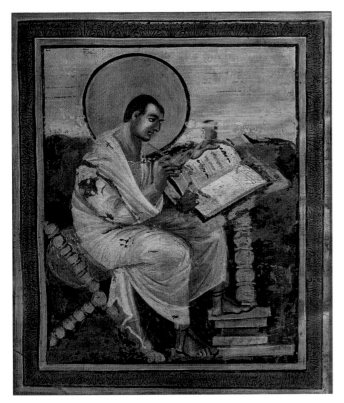

Fig. 8.19. *Saint Matthew.* Illustration in the Coronation (Schatzkammer) Gospels. 12¾ × 10". Early 9th century. Schatzkammer, Kunsthistorisches Museum, Vienna (fol. 15r)

Fig. 8.20. *Saint Mark.* Illustration in the Gospel Book of Ebbo. 10¼ × 8¾". 816–35. Bibliothèque Municipale, Épernay (MS I, fol. 60v)

complex arches or simulated gems appear as in the Soissons Gospels. The power of the portrait is derived from the monumentality of the figure and the large halo. Matthew brings to mind the author portraits of ancient Pompeii or that of Dioscurides in early Byzantine art (fig. 3.14).

A very distinctive group of illustrated manuscripts forms the Reims School—usually located at the monastery of nearby Hautvillers—since one of the chief manuscripts, the Ebbo Gospels, contains dedicatory verses in praise of Abbot Ebbo, archbishop of Reims from 816 to 835. Ebbo had been the court librarian at Aachen until he was elevated to his new position by Louis the Pious, and the Evangelist portraits in his Gospels echo the more illusionistic types of the Palace School, copies of which he presumably brought with him to Reims in 816. *Saint Mark* (**fig. 8.20**) closely conforms to his counterpart in the Aachen Gospels, with the author draped in a bulky mantle and seated frontally in a sketchy landscape. But amazing transformations of both style and iconography are immediately apparent in the Reims miniature. Mark turns his head abruptly upward toward the tiny lion unrolling a scroll in the top right. This is no simple author portrait; it is a type known as the "inspired Evangelist." Mark responds dramatically to the vision of the lion as if experiencing a mystical revelation.

This heightened animation conveying the psychological state of excitement is new, but it is an idea that soon passed into the repertory of the Northern artists. And how is this excitement so vividly expressed? Notable are the distortions of the facial features—the heavily arched eyebrows, the large staring eyes, the pointed lashes—and the nervous twitch in the fingers and torso. Even more expressive are the racing lines that replace the modeling in color. To be sure, the arms and legs are highlighted and darkened illusionistically, but the opaque qualities of the paint are dissolved and energized by swirling lines, like whirlpools spinning about the arms and legs. Gold flecks in the hair electrify Saint Mark's features, and the illusionistic landscape background is transformed into a surging waterfall of cascading lines.

These qualities are even more captivating in the masterpiece of the Reims School—the Utrecht Psalter—illustrated entirely with pen drawings (**figs. 8.21, 8.22**). It is believed that the impressive Psalter was made between 816 and 834 at the Benedictine abbey of Hautvillers (Altumvillare) in the diocese of Reims, then held by Archbishop Ebbo. The largest numbers of its illustrations are not allusive but literal and direct. They depict objects, figures, and actions just as they are described in the words of the psalmist. Furthermore, for many psalms the lines of the song are illustrated one after the other in a continuous fashion and then sprinkled over a broad panoramic landscape above or below the text. The illustrations thus become something like tableaux of pictorial riddles or charades, a form of play and instruction that the reader must decipher, an approach that was always popular in the North. A familiar example, Psalm 22 (Vulgate Bible; Psalm 23

in King James version), the "Lord is my shepherd," demonstrates this point.

"The Lord is my shepherd": He maketh me to lie down in green pastures" (the psalmist reclines among his flocks in a bucolic setting); "He leadeth me beside still waters" (a stream flows beneath the figure); "Lo, even though I walk through the valley of the shadow of death" (below, to the right, is a shallow pit with writhing demons hurling arrows); "Thy rod and thy staff, they comfort me" (behind the shepherd another figure holds a rod and a small vial); "Thou anointest my head with oil, my cup runneth over" (the chalice held in the psalmist's hand spills over its lip); "Thou preparest a table before me" (to the left a small table with food stands before the psalmist); "Surely goodness and mercy shall follow me all the days of my life; and I shall dwell in the house of the Lord forever" (in the upper left is a small basilica with an altar before which tiny figures kneel).

The composers of the tiny vignettes often exhibit a remarkable inventiveness. For Psalm 43 (44), which is a lament for the afflictions of Israel, cast out, oppressed, humbled, abused, and disgraced, the panoramic landscape features a broad city under siege with details of the text such as "Thou hast made us like sheep for slaughter" illustrated by a number of slain sheep heaped before the city gate (fig. 6.4). For the last verses of the Psalm, "Arise, why sleepest thou, O Lord," the illustrator added the figure of Christ comfortably reclining within a mandorla upon a canopied bed. Earlier, in Psalm 11 (12), "For the oppression of the poor, for the sighing of the needy, now will I arise, said the Lord," the miniaturist actually depicts the figure of Christ rising up and stepping forth from the confines of his aureole. Below, for "the wicked walk round about," the figure is shown holding onto a turnstile or forming a circle, which reminds one of Saint Augustine's commentary on this Psalm: "The ungodly walk in a circle which revolves as a wheel."

Thus the Utrecht Psalter is, in many ways, a glorious pastiche, but one should not deny the artists their keen sense of humor and inventiveness. In many instances, the scattered vignettes have pointed theological meanings, but often they seem more like clever pastimes, like pictorial riddles, for the artists and for those who will peruse these pages.

Alcuin, Charlemagne's brilliant court scholar and theologian, retired to the venerable Monastery of Saint Martin at Tours in 796. There he edited single-volume Bibles (called pandects) for Charlemagne, and worked to establish an authentic Vulgate text, an issue of much concern in the North.[10] The pandects attributed to Alcuin are not of the highest quality, however, nor are they illustrated; but succeeding abbots at Tours, perhaps inspired by the impressive illustrated codices of the Palace and Reims schools, established a tradition of producing giant illustrated Bibles of astonishing beauty.

The famous Moûtier-Grandval Bible in the British Library, one of the earliest of these, was produced under Abbot Adalbard (834–43) and contains four full-page frontispieces

Fig. 8.21. *Psalm 22 (23).* Illustration in the Utrecht Psalter. 9⅞ × 13″. 816–35. University Library, Utrecht (MS script. eccl. 484, fol. 13r)

Fig. 8.22. *Psalm 43 (44).* Illustration in the Utrecht Psalter (fol. 25r)

Fig. 8.23. *Scenes from Genesis (1:27–4:1).* Illustration in the Moûtier-Grandval Bible. 20 × 14¾″. c. 840. British Library, London (MS Add. 10546, fol. 5v)

Fig. 8.24. *Scenes from the Book of Revelation.* Illustration in the Moûtier-Grandval Bible (fol. 449v)

for the basic divisions of the Old and New Testaments: one folio for Genesis has registers illustrating the story of the creation of Adam and Eve and their fall (**fig. 8.23**); the frontispiece for Exodus has two enlarged narratives, one over the other, depicting Moses receiving the Law on Mount Sinai and Moses preaching to the Israelites; a full-page *Maiestas Domini* illustrates the beginning of the New Testament; and a final page is devoted to a pair of enigmatic scenes for the last book of the Bible, Revelation (**fig. 8.24**).[11]

It seems clear that the scriptorium at Tours had numerous illustrated models to draw upon. The most distinctive feature of this cycle is the depiction of the creator in the form of Christ *logos* (he lacks the cross-nimbed halo, however). Surprisingly, the more painterly qualities of the early style are also retained. Some attempt is made to model the nude bodies of Adam and Eve, and the heavily draped Christ, repeated like an exclamation mark between the scenes, stands in a continuous landscape ground with zones of deep blue, red-pink, and light blue indicating the atmospheric haze.

The frontispiece for the last book of the Bible, Revelation, is exceptional and difficult to interpret. In the upper half appears the Great Book of Seven Seals on a throne that initiates

John's visions in the Apocalypse (5:2–6) with the Lamb (Christ) opening one of the seals. Opposite the Lamb is the "lion of the tribe of Judah" that "prevailed to open the book," but did not. In the corners are the four symbols of the Evangelists, the "four living creatures" in the midst of the throne.

Below is a curious representation of an elderly man enthroned and lifting a veil above his head with outstretched arms. The four "living creatures" appear to assist in the unveiling. This enigmatic elder has been variously identified, but he is most likely Moses, who veiled his face after his encounter with the Lord on Mount Sinai, as recorded in Exodus. It has been noted that the image of Moses here may rely on words of the prophet Isaiah (40:22): "He stretched out the skies like a curtain," and that the figure is based on pagan representations of the sky god who carries the canopy of the heavens over his head. The meaning here is clearly that of unveiling, however, and to find an appropriate textual source we turn to the letters of Saint Paul (2 Cor. 3:12–18): "It is not for us to do as Moses did: He put a veil over his face to keep the Israelites from gazing on that fading splendor, until it was gone Only in Christ is the old covenant abrogated and because there is no veil over the face, we all reflect as in a

mirror the splendor of the Lord." Indeed it has been convincingly argued that the "widow's peak" and dark hair are a visual reference to Saint Paul who is shown in just this manner in early Christian representations.

The two curious images in the Apocalypse frontispiece thus form a diptych of sorts, a kind of harmony of the Old and New Testament visions of the Lord: the Lord veiled by Moses in Exodus is the same whose vision John experienced in Revelation. Just such a parallelism can be found in Early Christian writers, especially in the commentaries on the Apocalypse by Victorinus of Pettau (third century). Such a reading would also provide an interpretation for the frontispieces for Exodus and the Gospels in the Moûtier-Grandval Bible, where Moses receives the law on Mount Sinai and the New Law is revealed in the *Maiestas Domini*.

Illustrated frontispieces for the books in a large Bible executed for Count Vivian, lay abbot of Tours from 844 to 851, today in the Bibliothèque Nationale in Paris, are very closely related to those in the Moûtier-Grandval manuscript, and no doubt they copy the same model with minor variations. However, three new pictures together with an elaborate dedication page are added to the earlier foursome. A portrait of David and his musicians serves as a frontispiece

for the Book of Psalms; the story of Saint Paul's conversion introduces the Book of Acts; and an unusual narrative illustrating the translation of the Bible by Saint Jerome precedes Jerome's prefaces to the Bible (**fig. 8.25**). The story of Jerome's Vulgate translation would, of course, have special meaning at Tours, where the quest for an accurate Latin text was promoted by Alcuin.

The *Maiestas Domini* page for the Gospels (**fig. 8.26**) is based on the type in the Moûtier-Grandval Bible, but it is much elaborated. Here the One in heaven is surrounded by a figure-eight-shaped aureole, a form that divides the divine and human components of his body: his head and shoulders in the upper heaven, his torso below, with his feet resting on the earth that serves as a footstool (compare Isaiah 66:1). He holds a tiny wafer-like orb—the *mundus*—in his right hand, the book in his left. The four creatures are placed within the confines of the tetragon, and the prophets appear in the four circles that mark its corners. Outside the tetragon, in the four corners, the miniaturist has added full-bodied portraits of the Evangelists in the traditional poses found in Carolingian Gospel books. The harmony of the Old and New Testament witnesses, the prophets and the Evangelists, dominates this image of Christ in Majesty.

Fig. 8.25. *Story of Saint Jerome's Translation of the Bible.* Illustration in the Vivian Bible (First Bible of Charles the Bald). 19½ × 13⅝". c. 845. Bibliothèque Nationale, Paris (MS lat. 1, fol. 3v)

Fig. 8.26. *Maiestas Domini.* Illustration in the Vivian Bible (fol. 329v)

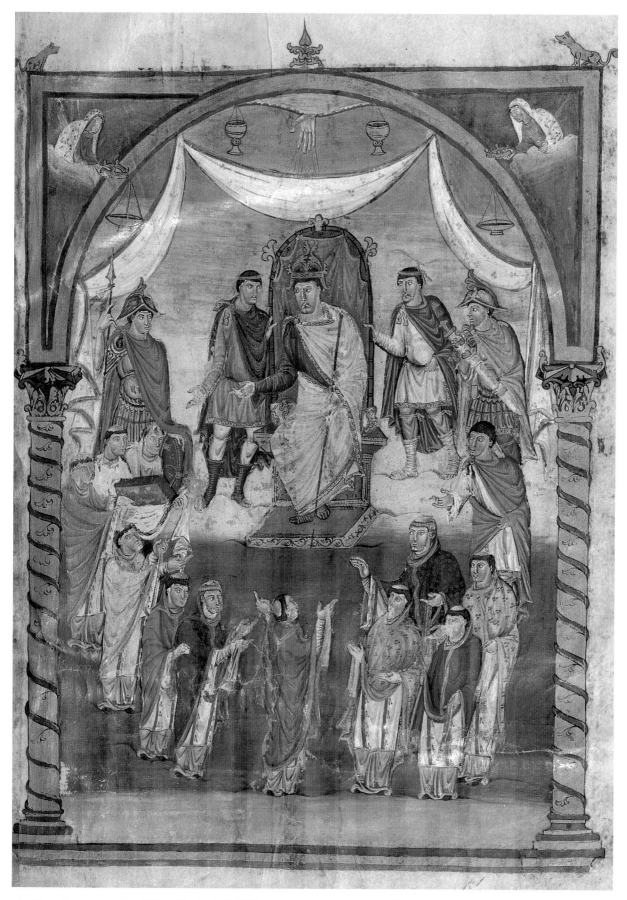

Fig. 8.27. *Presentation of the Bible to Charles the Bald.* Illustration in the Vivian Bible (fol. 423r)

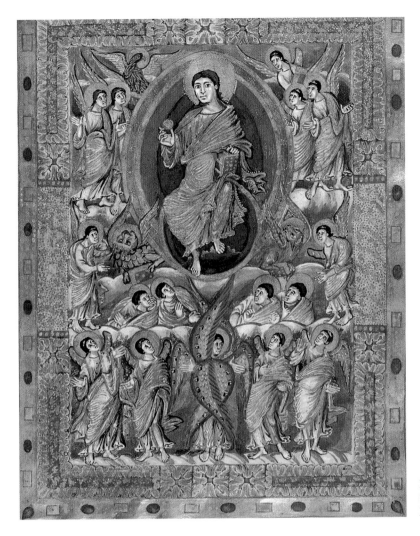

quiho die r na die
per un genitu tuu

Fig. 8.29. *Initial D with the Three Marys at the Tomb.* Illustration in the Drogo Sacramentary. 10½ × 8¼″. c. 850. Bibliothèque Nationale, Paris (MS lat. 9428, fol. 58r)

Fig. 8.28. *Maiestas Domini.* Illustration in the Sacramentary of Metz (fol. 5v). 10½ × 7¾″. c. 870. Bibliothèque Nationale, Paris (MS lat. 1141, fol. 5v)

The dedication page portraying the emperor Charles the Bald is inserted near the end of the Bible (**fig. 8.27**). Enthroned in the center of the upper zone and somewhat larger than the others is Charles the Bald flanked by two princes and two bodyguards dressed in armor. The Hand of God issues from the summit of the arch to bless the event. Below, in a loose semicircle, are arrayed various monks, three of whom present the Bible to the emperor. Verses accompanying the miniature name the emperor as Charles the Bald and the abbot as Vivian (d. 851), who has sometimes been identified as the figure with his back turned, in the lower center of the circle of monks. This is not likely. Vivian was a lay abbot, and he should be identified as the sole prince among the ecclesiastics standing to the far right introducing them.

The Christ in Majesty theme takes a different approach in the sumptuous Sacramentary of Metz (**fig. 8.28**).[12] An elaborate *Maiestas Domini* before the preface of the Canon of the Mass depicts Christ seated within an aureole and adored by a throng of angel types seldom seen together in a single representation. According to one authority, A. M. Friend, Jr., the elaboration of angels in the Metz sacramentary is due to

the influence of a new source book for angel lore. It is recorded that a Latin translation of the influential, ecclesiastical and celestial hierarchies of Pseudo-Dionysius the Areopagite was available in the library of Saint Denis by 858. Since it is also known that the venerable abbey church was patronized by Charles the Bald in his later years—he became a lay abbot in 876—Friend believes that the workshops that produced the Metz sacramentary and closely related works rich in angel types should be located at Saint Denis.[13]

The historiated initial wherein narrative scenes are incorporated into the floral decoration of the letter is found in the Drogo Sacramentary (**fig. 8.29**), presumably produced in the court scriptorium of the archbishop Drogo of Metz. The initial D[eus] for the opening of Easter Mass is typical of the insertions of narratives into the elegant golden tendrils, bars, and trellises of the initial. Below is the familiar scene of the Three Marys at the Tomb, and along the curving bar of the D two more tiny episodes are hidden amid the twining flora, Christ Appearing to Mary Magdalene, and Christ's Appearing to His Mother following the resurrection. We have seen how animals invade the initials of Merovingian and

Irish manuscripts, but this interest in marginal narration is more complex. The harmonious integration of picture and decoration such as we find in the Drogo Sacramentary anticipates by a full century the sculptured historiated capitals that are so characteristic of the Romanesque period.

Not all Carolingian illustrated manuscripts were as luxurious or sumptuous as the court productions. A number of them served monasteries—herbals, astronomical treatises, calendars, chronicles, commentaries—and had less ambitious illuminations, frequently little more than line drawings. One important example is the Trier Apocalypse (**fig. 8.30**), produced in northern France in the late ninth century.[14] This manuscript, like another very closely related to it in Cambrai, has eighty-six full-page miniatures for the text of Revelation. Such extensive cycles of illustrations are not uncommon and were responsible for the transmission of much iconography to later ages.

OTHER CRAFTS

Carolingian workshops were not exclusively devoted to manuscript illumination. Bronze-casting, ivory and crystal carving, and metalwork were traditional crafts in the North, and often the spirit of antiquarianism pervades these arts as well. A frequently cited example is the small bronze statuette identified as Charles the Bald (**fig. 8.31**) that obviously copies some Antique equestrian portrait (one source suggested is the bronze *Portrait of Marcus Aurelius* in Rome, considered to be one of Constantine in the Middle Ages). It should be remembered that Charlemagne had carted such a statue of Theodoric, his spiritual ancestor, from Ravenna to Aachen, presumably to be set up in the courtyard of his palace.

Of great significance are the numerous ivory carvings that were executed in ateliers attached to the scriptoria and that served as covers for the richly illuminated manuscripts. Because of the close association with the scriptoria, it is

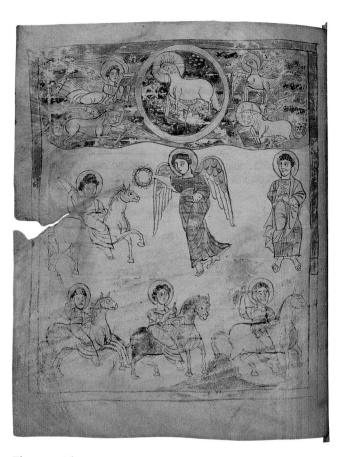

Fig. 8.30. *The Four Horsemen of the Apocalypse.* Illustration in the Trier Apocalypse. 10⅜ × 8½″. End of 9th century. Stadtsbibliothek, Trier (MS 31, fol. 19v)

Fig. 8.31. *Equestrian Portrait of a Carolingian Emperor* (usually identified as Charles the Bald). Bronze, height 9½″. 9th century. The Louvre, Paris

Fig. 8.32. *Virgin and Child with Zacharias and John the Baptist*. Book cover of the Lorsch Gospels (back). Ivory, 14⅞ × 10¾″. c. 810. Victoria and Albert Museum, London

assumed that many of the ivory carvers were guided by miniaturists, if not illuminators themselves.[15] The cover for the Lorsch Gospels (**fig. 8.32**), dating from about 810, has long been attributed to a workshop that also produced manuscripts. The stately and impressive book cover takes as its inspiration five-part diptychs from Late Antiquity such as the Barberini Diptych (fig. 4.1).

The ivory book cover of Christ Trampling the Beast also takes the five-part diptych for its format, though the panels are not separate pieces (**fig. 8.33**). Christ is shown as a beardless youth, though in this case he is a warrior, not a philosopher or teacher. The scenes surrounding Christ are of his life and miracles, from the top left and working clockwise: the prophet Isaiah who foretells Christ's birth; the Annunciation;

Fig. 8.33. Carolingian ivory cover of a Gospel Lectionary. Produced probably by an artist associated with the court of Charlemagne. c. 800. Bodleian Library, Oxford

Fig. 8.34. *Situla* (holy water bucket), decorated with scenes from the Passion and Resurrection of Christ (above) and the Infancy of Christ (below). Ivory, copper alloy, gilt mounts, and inlays. Height 8½″. From the Church of Saints Peter and Paul at Kranenburg. c. 860–80. Metropolitan Museum of Art, New York

the Nativity; the Adoration of the Magi; the Massacre of the Innocents; Christ's Baptism; the Wedding at Cana; the Storm on the Sea of Galilee; the Raising of Jairus' Daughter; the Casting out of Demons; the Healing of the Paralytic; and the Healing of the Hemophiliac. The emphasis is on the power of Christ to heal, to control nature, and to cast out evil.

The interest in extensive narrative scenes during the Carolingian period is also evident on the *situla*, or holy water bucket, which was probably made in Reims around 860–80 (**fig. 8.34**). These small buckets were used during processions to sprinkle holy water on the faithful. The face of the *situla* has been divided by bands of ornament to frame the scenes. The lower register is dedicated to scenes of his birth and early life: the Annunciation, the Visitation of Elizabeth to the Virgin, the Nativity, the Dream of Joseph, and the Baptism of

Christ. The upper register is given over to his Passion: the Betrayal, the Flagellation, the Last Supper, the Ascension, the Three Women at the Empty Tomb, and the Crucifixion. This particular example is the earliest of four surviving water buckets, which makes it a rare example of ivory carving.

A number of Carolingian ivories display a more dynamic style, with tiny figures bending and swaying in rhythmic friezes that resemble illustrations in the Utrecht Psalter. These ivories, called the Liuthard group (after a scribe), have been located at Reims, although other Frankish centers have been proposed. The inner cover of the Pericopes of Henry II, dating from about 870 (**fig. 8.35**), is a good example of these ivories. The representation of the Crucifixion is typical of the passion for narrative detail found in many of these works.[16] The elaborate outer border with Byzantine *cloisonné* enamels

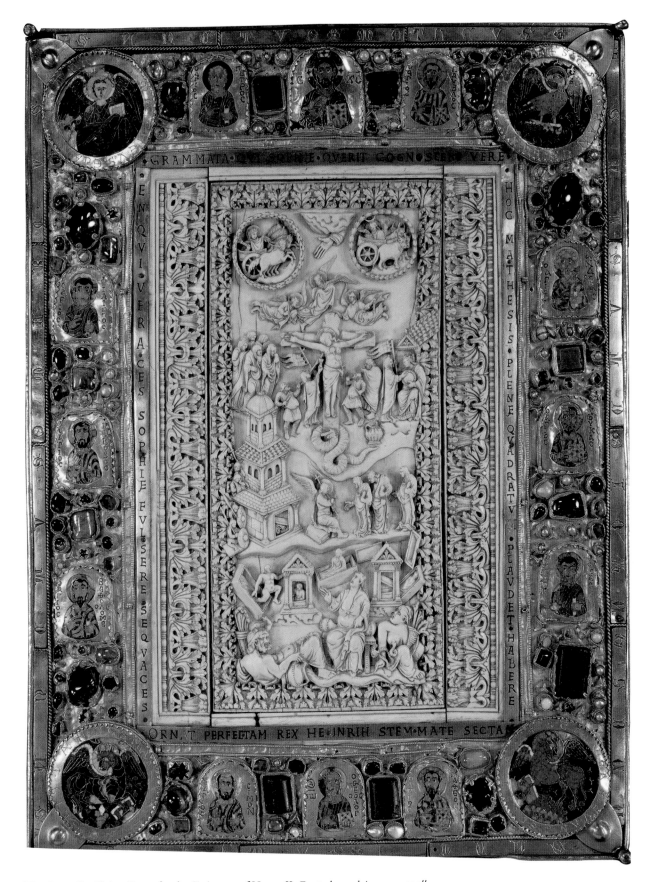

Fig. 8.35. *Crucifixion.* Cover for the Pericopes of Henry II. Central panel: ivory, 11 × 5″;
frame: Byzantine enamels, gold, pearls, and gems, height 17⅝″. c. 870 (ivory); c. 1014
(frame). Staatsbibliothek, Munich (Cod. lat. 4452)

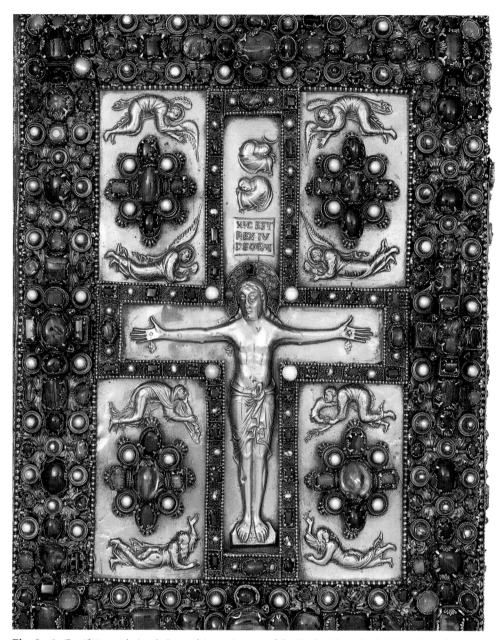

Fig. 8.36. *Crucifixion with Angels.* Second (upper) cover of the Lindau Gospels. Gold, pearls, and gems, 13⅜ × 10⅜″. c. 870–80. Pierpont Morgan Library, New York (MS 1)

and gems has been dated to around 1014, as an addition made when the Ottonian emperor Henry II presented the reset cover to the Cathedral of Bamberg.

This same dynamic style characterizes some of the goldsmiths' work of the ninth century. Because of their splendid richness and certain iconographic peculiarities, the finest of these have been assigned to the imperial workshop of Charles the Bald, perhaps to be located at Saint Denis, as mentioned above. The Crucified Christ in gold *repoussé* in the gem-studded second (upper) cover of the Lindau Gospels in the Pierpont Morgan Library (**fig. 8.36**) is one of the finest examples of such delicate gold work. The high settings of the cabochon gems would have not only adorned the most

precious words within the book, but they would also have protected the delicate gold figure of Christ on the cross; a kind of spiritual and physical protection of the Word. The front cover dates from the late ninth century and was probably made at Saint Gall in Switzerland. The back cover of the manuscript is about a century earlier (c. 760–90 and probably from Salzburg) and displays all the characteristics of Insular and Merovingian art: animal interlace, enamel work, and pearls (**fig. 8.37**). In the four corners are the Evangelists and their symbols, which are shown in a classicizing style similar to the Coronation Gospels. The covers are highly characteristic of the Carolingian period where a great variety of styles are embraced and mixed with a high degree of comfort.

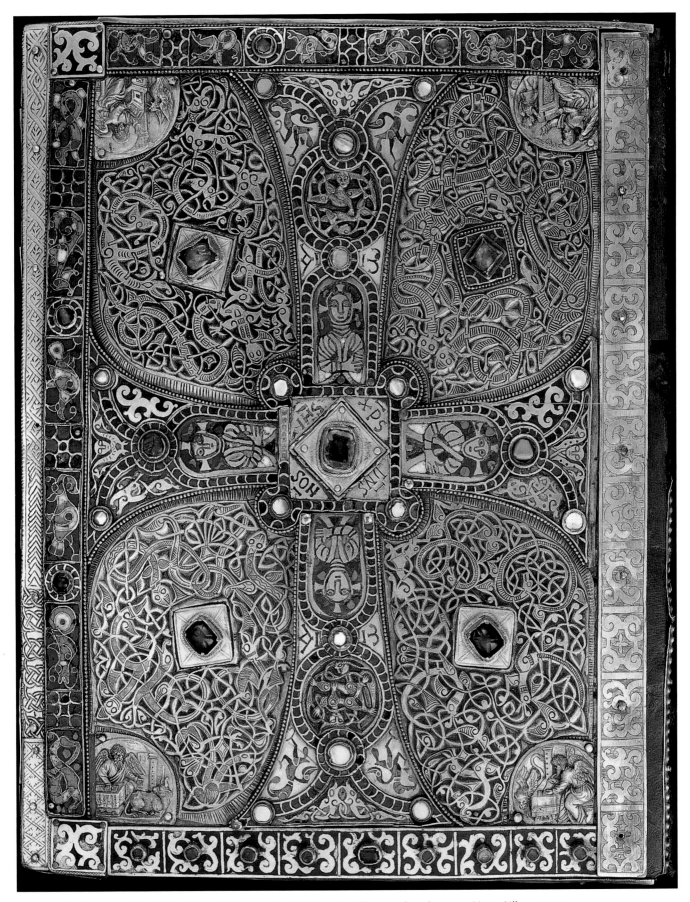

Fig. 8.37. Book cover of the Lindau Gospels (lower or back). Silver gilt with enamels and gems, 13⅜ × 10⅜″. c. 760–90

Fig. 8.38. *Enger Reliquary*. Gold and embossed silver on oak, with cloisonné pearl, and gemstone inlays. 2¼ × 5½ × 2″. Early 9th century. Staatliche Museen, Berlin

Fig. 8.39. Susanna Crystal. Northeastern France or central Rhineland. 4¼″. c. 869. British Museum, London

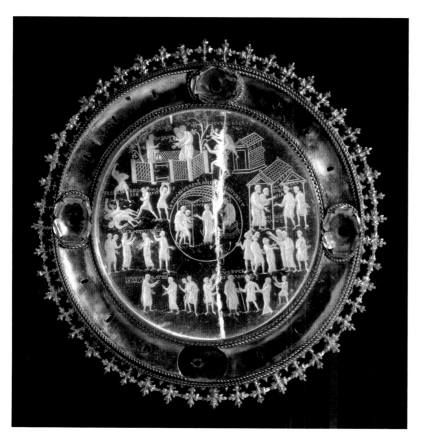

Fig. 8.40. Wolvinius. Front of the Altar of Saint Ambrose. Gold with enamel and gems.
2′ 9½″ × 7′ 2⅝″. 824–59. Sant'Ambrogio, Milan

If the words that told of Christ's life and ministry were so sacred that they should be embellished with miniatures and covered with gold and jewels, then the bones and relics of the Church's saints were also worthy to be enshrined in a similar manner. The "burse" reliquary was a type that the Merovingians favored, but its finest example is the Enger Reliquary from about 800 (**fig. 8.38**). In a burse reliquary, the wooden core is covered with gold or silver sheeting that is set with precious stones, or sometimes antique gemstones, or *cloisonné* glass and enamel on gold. Like other burse reliquaries, figurative decoration is minimal or nonexistent.

The Soissons Gospels referred to the art of gem carving in the figures painted to look like carved crystals on the arch above Saint John. The art was revived during the Carolingian period and many fine examples survive. One of the largest is the Susanna Crystal, commissioned by King Lothair II of Lotharingia (855–69), illustrating the story of Susanna and the Elders (**fig. 8.39**). According to the Apocryphal Book of Susanna, a young and beautiful girl is approached by two elders who seek her sexual favors. When she refuses them, they accuse her of loose behavior and she is condemned to death. In answer to her prayers, Daniel is sent to question the two elders. His questioning reveals that they cannot agree on the tree where Susanna allegedly committed her sins. Their punishment is death. The meaning of the crystal for King Lothair II has several interpretations, but the central themes

are the call for good government and warnings about the abuses that happen under bad government.

The great golden Altar of Saint Ambrose in Milan (**fig. 8.40**), is one of the most ambitious artworks to survive from the early reign of Charles the Bald.[17] The patron, Angilbert II, archbishop of Milan from 824 to 859, and the court artist Wolvinius are portrayed in medallions on the back, paying homage to Saint Ambrose. The elaborate front of the altar has the appearance of a fixed triptych with the Majestic Christ in the center.

The two sides are divided into six fields, each with representations of events in the life of Christ in gold *repoussé*. A number of these are clearly related to Byzantine feast pictures—note especially the Transfiguration and the post-Passion episodes—but the thin, agitated figures, with their dramatic gestures and intense stares, are very much in the style of the Reims School illumination. The fact remains, however, that the Altar of Saint Ambrose was executed for a Milanese patron and very likely executed by Italian craftsmen headed by Wolvinius.

A similar preoccupation can be seen in Rome, too. Under the pontificates of Hadrian (772–95), Leo III (795–816), and Paschal I (817–24), a resurgence of building on a grand scale took place as part of the attempts by the papacy to repair and restore Rome's ancient glory and prestige. The fervent artistic activity in Rome reflected the renewed confidence and

Fig. 8.41. *Christ in Majesty with Saints and Donor.* Apse mosaic in the Church of Santa Prassede, Rome. 817–24

optimism of the Roman Church. It must be remembered, however, that colonies of Byzantine monks and craftsmen had migrated to Rome and south Italy during the period of iconoclasm, and their presence is to be reckoned with in any study of ninth-century art in Rome.

Leo's successor, Paschal I, took a more personal interest in the restoration of Early Christian Rome. He not only built and restored a number of churches, he also commissioned some of the finest mural decorations for their walls, among them Santa Cecilia, Santa Maria in Dominica, and Santa Prassede. This last church has often been cited as the finest monument of the ninth century in Rome. Built by Paschal to replace a religious center that had grown up in the vicinity of Santa Maria Maggiore, Santa Prassede became a major receptacle for the new relics transferred from the catacombs.[18]

For the building itself, Paschal turned directly to Saint Peter's and its T-shaped plan, just as the builders in the North had done. Indeed, Santa Prassede is a miniature copy of Saint Peter's. A triumphal arch marks the juncture of the nave and the sanctuary (**fig. 8.41**).

Precedents for the decoration of the triumphal arch and apse were many in Early Christian Rome. At Santa Prassede, the outer arch presents a transformation of this Apocalyptic

imagery into the Adoration of the Multitude of Saints in heaven (Rev. 19)—an All Saints' picture—which no doubt reflects the policy of the restoration of relics that Paschal pursued, especially in regard to this church. Within the sprawling city walls of the New Jerusalem stands Christ surrounded by the Virgin, John the Baptist, and the apostles. In a verdant meadowland outside are assembled the rank and file of saints venerated at Santa Prassede.

On the inner arch that frames the apse, the representation of the Adoration of the Lamb by the twenty-four elders finds its place much as it appears in the apse of Saints Cosmas and Damianus (fig. 3.12). The apse, sheathed in glowing marble revetment, is decorated with a resplendent mosaic that repeats the apse composition of Saints Cosmas and Damianus, with a tall Christ floating in the clouds of a deep blue heaven. To either side, Peter and Paul stand on a floral carpet and present Praxedis, her sister Pudentiana (in place of Cosmas and Damianus), the brother, and the founder Pope Paschal (with a square nimbus to indicate that he alone is among the living). With Santa Prassede we come full circle and return to the golden age of Christian Rome, and this renewed pride and concerted effort to aggrandize Rome's position was the impetus for a far-reaching program of the papacy that was to be more fully realized in the twelfth century.

9

DIFFUSION AND DIVERSITY

ANGLO-SAXON ART

During the course of the ninth century, the great monasteries of England fell prey to the invading Danes, and if one can take King Alfred (871–99) as the spokesman for this difficult period, learning and the arts suffered. On the other hand, Asser, Alfred's biographer, states that the king commissioned many beautiful objects in gold and silver. During Alfred's reign the Danes were contained, and in time cultural exchange with the continent was renewed. By the middle of the tenth century, the reclaimed monasteries were reformed under strict Benedictine rule, particularly under Dunstan, archbishop of Canterbury (960–88), and Ethelwold, bishop of Winchester (963–84). Under Ethelwold, direct contacts were made with the monastery of Fleury in France, which was itself reformed by the Cluniac abbot Odo (927–44).

Anglo-Saxon art of the tenth and eleventh centuries has been the subject of intense study, and the complexities and varieties of its forms and styles are gradually being sorted out.[1] One of the difficulties is the willingness of Anglo-Saxon artists to borrow and adapt from a variety of sources, emulating their model closely in some cases, but only loosely in others.

The Alfred Jewel is a case in point (**fig. 9.1**) since it clearly continues the traditions of metalworking, but borrows from a variety of sources in iconography and technique. The small jewel was found near Athelney, Somerset, a place associated with King Alfred. The inscription on the jewel reads AELFRED MEC HEHT GEWYRCAN (Alfred had me made), suggesting strongly that this was commissioned by the king. It has an openwork gold frame that encases a rock crystal that covers a *cloisonné* figure of Christ. Carrying two scepters, he is a type of Christ borrowed from Irish art, resembling the figure on the Muirdach cross (figs. 7.25, 7.26). The golden animal head has a small aperture at the tip that was probably used to hold a pointer, since it is believed the Alfred Jewel was a bookmarker, perhaps for the manuscripts Alfred commissioned to bring about a reform in literacy.

Although manuscripts created during the reign of King Alfred show little decoration, the foundations were laid for a renewed interest in illuminated manuscripts in the tenth century.

One of the finest Anglo-Saxon manuscripts to survive is the Benedictional of Saint Ethelwold, dated to between 971 and 984 and produced at Winchester.[2] The dedication poem in the manuscript states that "a bishop, the great Ethelwold, whom the Lord had made patron of Winchester, ordered a certain monk subject to write this present book . . . He commanded also to be made in this book many frames well adorned and filled with various figures decorated with numerous beautiful colors and with gold."

A benedictional, a special book made up for the use of the bishop, contains the solemn blessings given during the Mass in preparation for Communion.

Fig. 9.1. The Alfred Jewel. Gold, filigree, *cloisonné*, enamel, and rock crystal. 871–99. 2½" long. Ashmolean Museum, Oxford

Fig. 9.2. *Baptism of Christ.* Illustration in the Benedictional of Saint Ethelwold. 11½ × 8½″. 971–84. British Library, London (MS Add. 49598, fol. 25r)

Quia tues dī meus &fortitu
do mea . quare me reppu
listi . &quare tristis incedo .
dum affligit me inimicus ;

intabernaculum tuum ;
Introibo adaltare dī ad
dm quiletificat iuuentu
tem meam

Spera indeum quio confite
bor illi . salutare uultus
mei & dī meus

Fig. 9.3. *Illustration to Psalm 43 (44).* Anglo-Saxon Psalter. 12⅜ × 15″. Early 11th century. British Library, London (MS Harley 603, fol. 25)

Although some miniatures are missing, it seems that each major feast was accompanied by two full-page pictures appropriate to the blessing. For the feast of the Epiphany (6 January), for instance, the *Baptism of Christ* (**fig. 9.2**) is paired with the *Adoration of the Magi*. Especially striking are the broad frames that form elaborate trellises over which the leaves of the "Winchester acanthus," as they are called, clamber and intertwine, spiraling out from giant golden bosses that punctuate the corners and the centers of the borders. The figures overlap and merge with the lush growth around the page. In the *Baptism*, the Jordan, issuing from a river-god's urn, swells upward to cover Christ's loins and then tapers off in undulating waves about the wading Baptist and the angel to flow naturally into the border of flowers. The bright colors are laid on in lines, not areas, and the overall effect is not too unlike that of the vibrant portraits in the Ebbo Gospels (fig. 8.20) of the Reims School.

Sometime around the year 970, the masterpiece of the Reims School, the Utrecht Psalter, was brought to the scriptorium of Christ Church in Canterbury where, during a span of 150 years, it served as the inspiration for at least three creative copies. In the earliest of these copies, the Psalter in the British Library (**fig. 9.3**), dated to the early eleventh century, the facility of the English artists in duplicating the model is astonishing. If one did not notice the Anglo-Saxon script of the text, the illustrations could be mistaken for those in the Utrecht Psalter. The drawings are carried out in colored inks instead of the monochrome of the Reims

Psalter, and there is a slight tendency toward a more patterned and precise treatment of the fleeting figures scattered about the illusionistic landscapes. The lines are shorter, points of spears are sharper, and faint arabesques emerge in details of the landscape. The Harley 603 Psalter is clear testimony to the overwhelming impact of the dynamic linearism of the Reims School in early English art.

The second variant, the Eadwine Psalter in Trinity College Library at Cambridge (**figs. 9.4, 9.5**), dates to about 1150 and includes a portrait of a scribe. Now a border is added to contain the restless movement and subordinate the agile figures to the fixed framework of a boxed composition. The city walls and the hillocks are schematized into surface patterns that divide the horizontal field into three distinct bands. A groundline anchors the horsemen and sheep along the lower border; the canopied bed of Christ hangs from the crenelations of the upper frame; and the apostles sit along scalloped contours of the flattened terrain. Even the sketchy quality of the tiny figures gives way to sharper linear conventions and bold outlines.

The conflict between freedom of movement and constrictions of the frame and field, so basic to the Romanesque style, is resolved in the Gothic version of about 1200 (**fig. 9.6**), today in Paris. The artist has retained the basic iconography, but "updated" it with the inclusion of contemporary military costume. This rare opportunity to study the drastic transformations of a model through two centuries is very revealing.

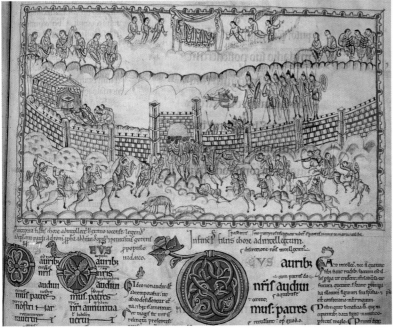

Fig. 9.4. *Illustration to Psalm 43 (44).* Miniature from the Eadwine Psalter. 4 × 7¼". c. 1150. Trinity College Library, Cambridge (MS R.17.1, fol. 76)

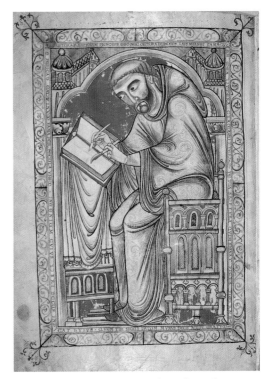

Fig. 9.5. *The Scribe.* Miniature from the Eadwine Psalter (fol. 283v)

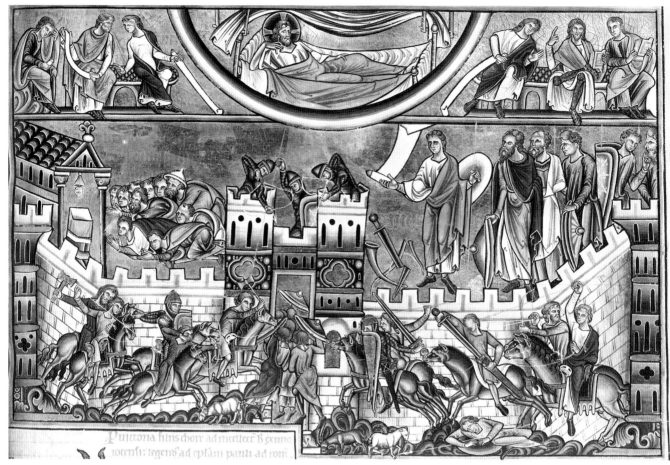

Fig. 9.6. *Illustration to Psalm 43 (44).* Miniature in the Canterbury Psalter. 11⅝″ wide. c. 1200. Bibliothèque Nationale, Paris (MS lat. 8846, fol. 57r)

The linear style of the Utrecht Psalter was the impetus for an important body of Anglo-Saxon art of the tenth and eleventh centuries. One of the most impressive examples is the Crucifixion in the so-called Ramsey Psalter that has been dated to the last quarter of the tenth century and attributed to the Winchester scriptorium (**fig. 9.7**). The delicate rendering of an iconic Christ on the cross between Mary and John the Evangelist superbly displays the sensitivity of the English artist. The long, graceful outlines of Christ's limbs and torso contrast with exciting contrapuntal accents of vibrating calligraphic motifs that mark the border of his loincloth. The irregularly hooked outline of Mary's mantle, rendered as if a magnetic force were attracting the frets like metallic filings, adds a frenzied touch to her body, which dramatically tapers from broad shoulders to tiny feet. The artist conveys the sense of her shower of tears by having the Virgin fervently embrace the jagged ends of her mantle as if she were sobbing over a dead child.

The anticipation of the Romanesque style in England is announced in a harsher manner in the Arundel Psalter, made, according to its calendar, for the New Minster in Winchester, dated to about 1050–60. The *Crucifixion* (**fig. 9.8**) presents a more static and hieratic image, with the

energies of the lines quelled beneath heavy bars painted as contour lines for the draperies and silhouettes. The figures loom larger by virtue of their material weight; the lines of the drapery are hardened into regular metallic ridges. The all-over effect is that of an engraved design for an enamel plaque rather than of the calligraphic gymnastics of pen drawing. These, too, are Romanesque traits, and the significance of the stronger stylization of the Arundel *Crucifixion* is that it gives evidence of the natural evolution of an English Romanesque art without the direct intervention of the Continental styles that are sometimes claimed to have been introduced only after the conquest of William of Normandy in 1066.

The Utrecht Psalter style is further developed in a number of later manuscripts with diminutive outline drawings. Attributed to the scriptorium at Winchester, the drawings in the New Minster Prayer Book, dating from about 1023–35, display a pronounced expressionism in the sharp outlines of the fluttering folds, the enlargement of hands, the twisting of the bodies, and the delicate heads that seem to poke outward from narrow shoulders.

The *Quinity* (Five) (**fig. 9.9**) is a particularly engaging drawing. Within a circular aureole above the cramped figures

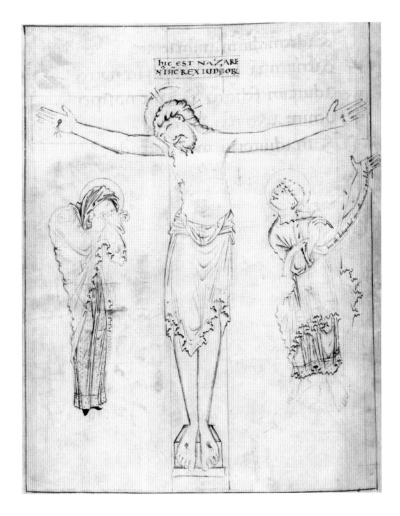

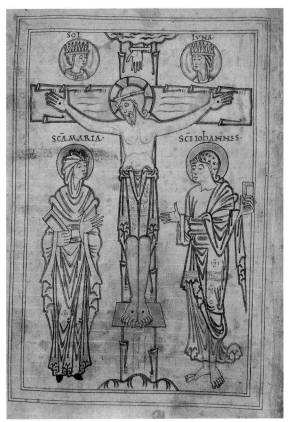

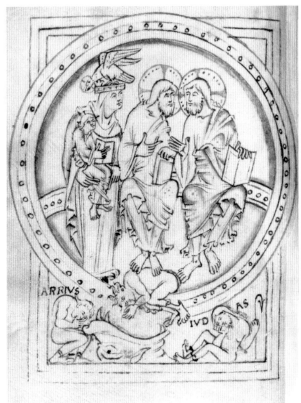

ABOVE **Fig. 9.7.** *Crucifixion*. Illustration in the
Ramsey Psalter. 13⅛ × 9⅞″. c. 990. British Library,
London (MS Harley 2904, fol. 3v)

ABOVE RIGHT **Fig. 9.8.** *Crucifixion*. Illustration in the
Arundel Psalter. 12 × 7½″. c. 1050–60. British Library,
London (MS Arundel 60, fol. 12v)

RIGHT **Fig. 9.9.** *Quinity*. Illustration in the New
Minster Prayer Book. 5 × 3⅝″. c. 1023–35. British
Library, London (MS Cotton Titus D.xxvii, fol. 75)

of earthly despair, Arrus (Arius) and Judas—two archetypal traitors to the Church—the Quinity, in the form of four human figures and the Dove, is aligned on a rainbow. The two enthroned figures—God the Father and Christ the Son—are bearded and have cross-nimbed haloes, while Mary, holding the Christ Child and serving as a perch for the Dove, stands at the left. Hence, a "quinity" is actually presented. How does one account for this unusual iconography?[3] Always a difficult theology to express visually, this illustration is an unusual experiment to portray One God in Three Persons.

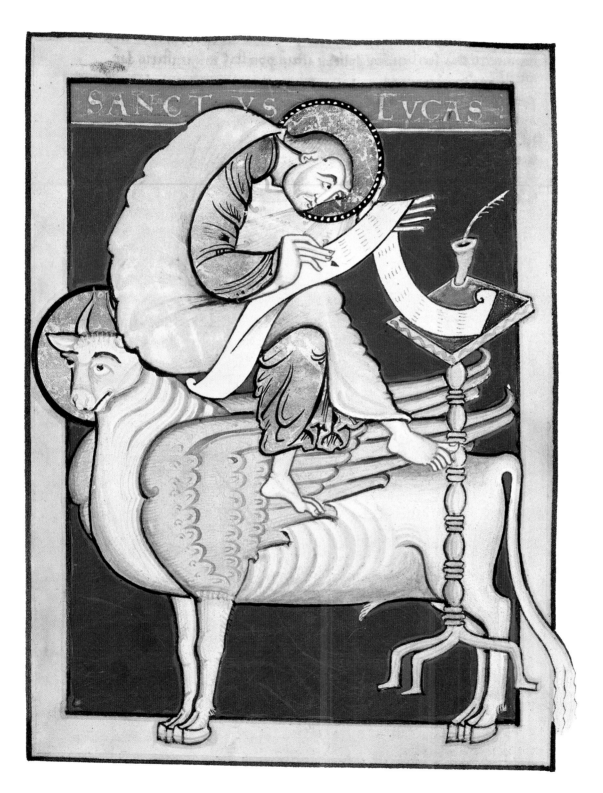

Fig. 9.10. *Saint Luke.* Pierpont Morgan Gospels. 11 × 6¾″. c. 1120. Pierpont Morgan Library, New York (M777, fol. 37v)

ANGLO-NORMAN ART

The Battle of Hastings in 1066 may have meant the political domination of the Anglo-Saxons by the Normans, and it did seem to have a chilling effect on manuscript production, but the resumption of the art of illuminated books shows that the melding of Anglo-Saxon with Norman artistic traditions launched an impressive new chapter in manuscript illumination.

The Pierpont Morgan Gospels demonstrate the Anglo-Norman penchant to create a new iconography by drawing from disparate sources (**fig. 9.10**). The frontispiece to Luke is a very unusual portrayal of the Gospel writer: the figure of Luke is seated on his large winged ox, which stands with a bland, yet knowing, look on its face. Luke is hunched over in a manner found in Carolingian gospel books such as the Ebbo Gospels. The large ox, the symbol of Luke, is not, however, found in Carolingian works, but in Insular manuscripts, such as the Book of Durrow, which feature large symbols. The equestrian Gospel writer is difficult to trace, but he may have been derived from texts that describe the personifications of air, fire, earth, and water riding on an eagle, a lion, a centaur, and a griffin.

At St Albans, manuscript illumination had an impressive revival. The Albani Psalter (**fig. 9.11**), executed about 1120–30, with forty full-page narratives ranging from Genesis to Pentecost in subject matter and numerous "inhabited" initials, as they are called, displays stunning designs and abstractions that no doubt owe something to Ottonian models.[4] The symmetrical composition and the colored background of the Fall of Adam and Eve are hallmarks of the extensive cycle of pictures.

At Bury St Edmunds the revival of illumination also occurred on a large scale and there is evidence that there was artistic exchange between Bury St Edmunds and St Albans. The *Life and Miracles of Saint Edmund* is stylistically so similar to the Albani Psalter that it has been suggested that the Albani artist, known as the Alexis Master, may have had a hand in the creation of this manuscript (**fig. 9.12**). The *Life* includes thirty-two miniatures that show the martyrdom and miracles of Saint Edmund, an East Anglian king who was killed by the Danes in 869 and whose relics were housed at the Bury monastery. The macabre scene depicts the story of eight thieves who had entered into the church to rob the shrine of Saint Edmund. The saint, displeased to be so rudely treated,

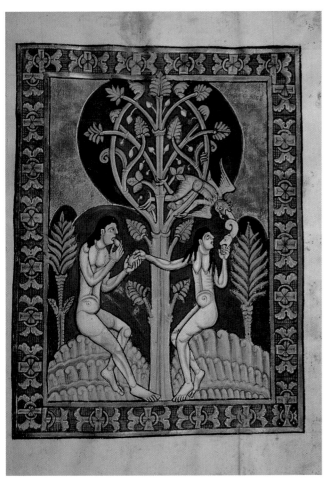

Fig. 9.11. *Fall of Adam and Eve.* Illustration in the Albani Psalter. 10⅞ × 7¼″. After 1120. Library of Saint Godehard, Hildesheim (fol. 9r)

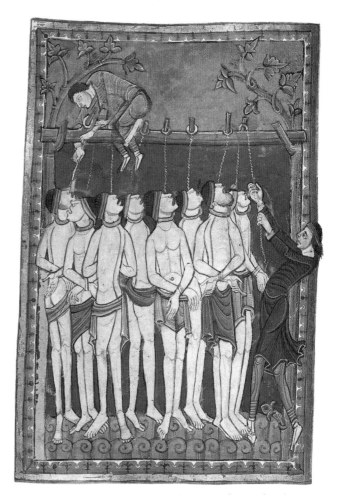

Fig. 9.12. *Hanging of Eight Thieves.* Illustration from *Life and Miracles of Saint Edmund.* 10¾ × 7¼″. c. 1130. Pierpont Morgan Library, New York (M736, fol. 19v)

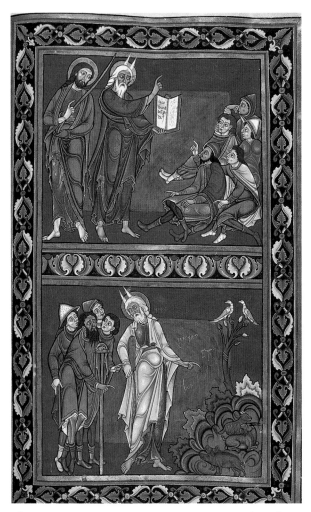

Fig. 9.13. Frontispiece to Deuteronomy. Bury St Edmunds Bible. 20¼ × 13¾″. Corpus Christi College, Cambridge (MS 2, fol. 94r)

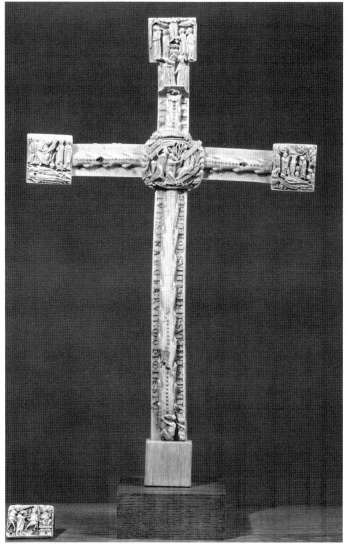

Fig. 9.14. Altar Cross from Bury St Edmunds (front). Walrus ivory, height 22¾″. c. 1140. The Cloisters Collection, Metropolitan Museum of Art, New York

intervened by causing the thieves to lose the power of movement until the morning, when they were discovered and then hanged for their transgression. The moral of the story and the illustration is that Bury St Edmunds was protected by a local saint with great powers and woe to those who would despoil the monastery.

In the giant Bible of Bury St Edmunds (**figs. 9.13**), dating to about 1130–40, the handsome miniatures display a compromise between the freer abstractions of Northern art and the conventions of Byzantium, especially in the drapery patterns. Saint Anselm, the abbot, came from Santa Saba in Rome, and very likely he brought examples of the huge ceremonial Bibles, so popular in Italy at the time, to serve as models in his scriptorium.[5] The Christ in Majesty is highly traditional in its presentation, though the four symbols have been given a greater prominence than is found in Carolingian

works. The frontispiece to Deuteronomy is a more creative composition, with the tall figures of Aaron and Moses standing in front of a group of Israelites who look remarkably like Englishmen of the twelfth century. While Moses instructs them on the food prohibitions, the "students" are depicted with either rapt attention, bored indifference, or dreamy distraction, figures that are in strong contrast to the elongated and elegant Moses and Aaron.

The illuminator of the Bury Bible was a secular craftsman named Hugo, who is also listed in the documents of the abbey as a sculptor and metalworker. The elegant altar cross, attributed to the workshop at Bury Saint Edmunds, is an exquisite example of the finest in English ivory carving.[6] The front of the cross (**fig. 9.14**) is fashioned as a Tree of Life to which the body of Christ was affixed (perhaps the fragment now in the Kunstindustrimuseet in Oslo). Square

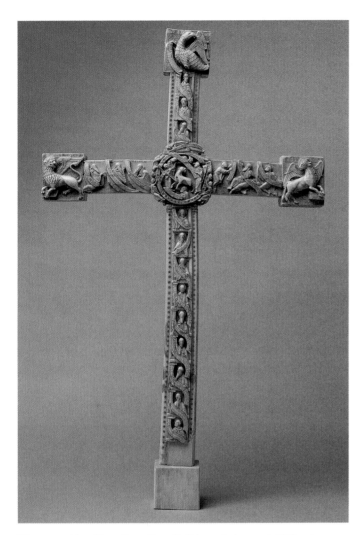

Fig. 9.15. Altar Cross from Bury St Edmunds (reverse). Walrus ivory, height 22¾″. c. 1140. The Metropolitan Museum of Art, New York. Purchase, 1963, Cloisters Fund

THE OTTONIANS

The empire of Charlemagne, once divided among his heirs, gradually weakened and shrank into small principalities with little central authority or power. And as in much of Western Europe, the waves of invading forces from the fringes of the Christian world—the Vikings, the Magyars, the Slavs—redirected the energies of the cultural programs that Charlemagne had so magnificently initiated. The farflung monastic centers had defensive walls, not oratories, to build; the scribes had few costly models on hand to inspire them. Large parts of Europe turned their energies to defense and the arts suffered during this period of conflict.

Then in the early years of the tenth century, in the eastern territories across the Rhine, in Saxony, there emerged a powerful family of rulers—the Ottos—who had the means and determination to establish a kingdom and maintain channels of communication between east and west, north and south. An impressive victory for Otto I, The Great (936–73), was won over the Hungarians on his eastern frontiers in 953. The dream of Charlemagne was revived, and in 962, in Rome, Otto was crowned Augustus and Emperor of the Latin Christendom, henceforth known in history as the Holy Roman Empire. The imperial lineage now linked Otto to Charlemagne and Constantine the Great, and the impact of this symbolic genealogy was to have lasting significance throughout Europe until very recent times.

The Ottonians looked to the Carolingians for much of their artistic inspiration, and while they frequently resided in Rome, the Rhine and the Meuse (Maas) river valleys became their chief avenues of communication, and their immediate models were those about them in the North, Aachen in particular. It was also during this period that the first reverberations of the reform movements of the Cluniac Order in France were felt across Europe, heralding the reestablishment of the powers of the monastic world in the delicate balance of Church-state power in the North.

The revival of Carolingian art was by no means a slavish and empty aping of the past.[7] In architecture, Carolingian westwork churches were taken as models for imperial presence in the ecclesiastical communities, but their outward forms were refashioned to make them imposing and majestic. The finest architectural remains are to be found just south of Magdeburg at Gernrode, where the Church of Saint Cyriakus was founded by the margrave Gero (960–5) to serve as a royal convent (**figs. 9.16–18**).[8] The Ottonian structure is intact and well preserved, except that the apse built into the flat entrance wall is believed to be a later, twelfth-century, addition.

In plan, Gernrode displays a simple nave with side aisles, a square chancel and apse raised over a crypt, slightly projecting transept arms, and a westwork with a high tribune flanked by two round towers. The exterior is plain but impressive in the clarity of its cubic and cylindrical massing of elements, and the divisions of the elevation on the exterior are subtly marked by changes in pilaster strips on the towers and blind

plaques at the ends of the arms carry tiny representations of the Deposition (right), the Marys at the Tomb (left), and the Ascension of Christ (top). The missing piece at the bottom presumably illustrated the Harrowing into Hell, since diminutive figures of Adam and Eve appear at the base. A central medallion carried by angels displays the story of Moses and the Brazen Serpent, an Old Testament prefiguration of the Crucifixion.

On the reverse (**fig. 9.15**), the Sacrificial Lamb, whose side is pierced by a personification of *Synagoga*, appears in the central medallion, while symbols of the Evangelists appear in the square plaques on the arms and top. Replacing the Tree of Life are busts of prophets holding scrolls. The complex iconography has yet to be explained adequately. Whatever the case, it is the exquisite technique of carving on such a small scale that truly impresses.

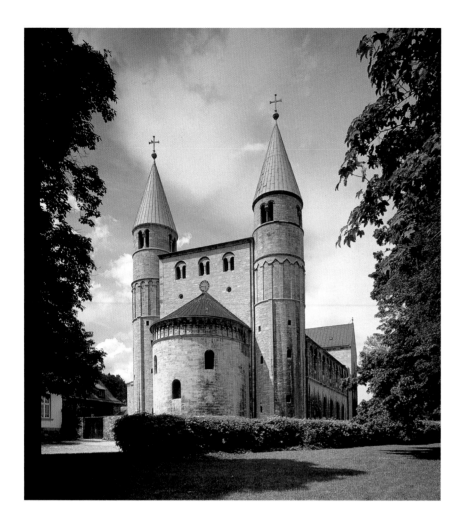

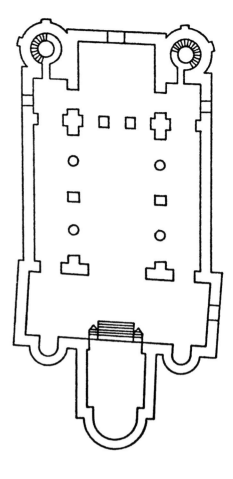

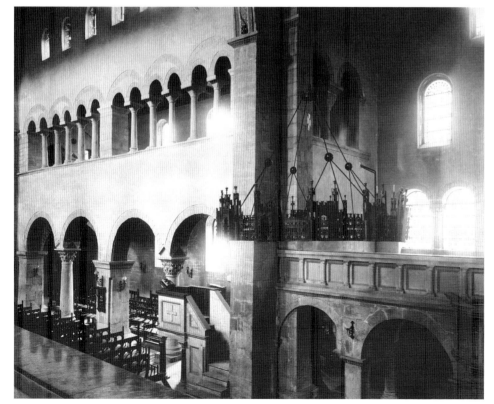

ABOVE LEFT **Fig. 9.16.** Saint Cyriakus,
Gernrode. Exterior from east.
Founded 961

ABOVE **Fig. 9.17.** Saint Cyriakus. Plan
(after Lehmann)

LEFT **Fig. 9.18.** Saint Cyriakus.
Interior from southeast

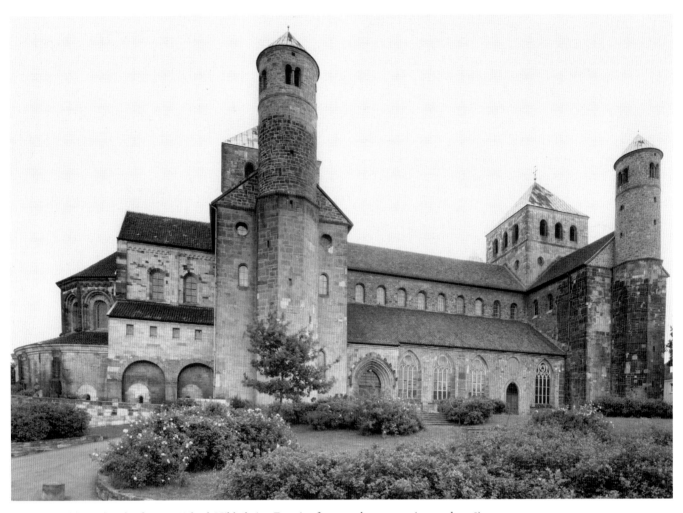

Fig. 9.19. Abbey Church of Saint Michael, Hildesheim. Exterior from south. 1010–33 (restored 1958)

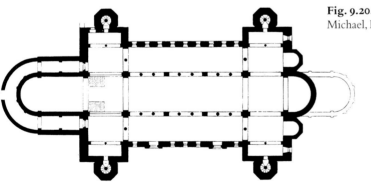

Fig. 9.20. Abbey Church of Saint Michael, Hildesheim. Plan

arcades over the nave windows. The interior is equally imposing in its austerity, with the nave divided into two large bays by great rectangular piers carrying arches that rest midway on columns between them. A new feature appears in the gallery of six arches over each bay above the triforium, which is an arcaded gallery between the nave arcade and the clerestory. The nave is covered by a timber roof.

The simple volumes of Gernrode were elaborated into a complex assembly of stereometric forms in the great Church of Saint Michael in Hildesheim, begun about 1000 by the learned court bishop Bernward (**figs. 9.19, 9.20**). As though a major chord had been struck on an organ, the building rises majestically, with the crossing establishing the proportions throughout. It is doubled in the transept arms and trebled in the nave. In the elevation, the height is approximately twice the width. Thus the simple beauty of the square, doubled and trebled, with apses and towers anchoring the extremities, presents a tightly knit assembly of austere volumes on the exterior.

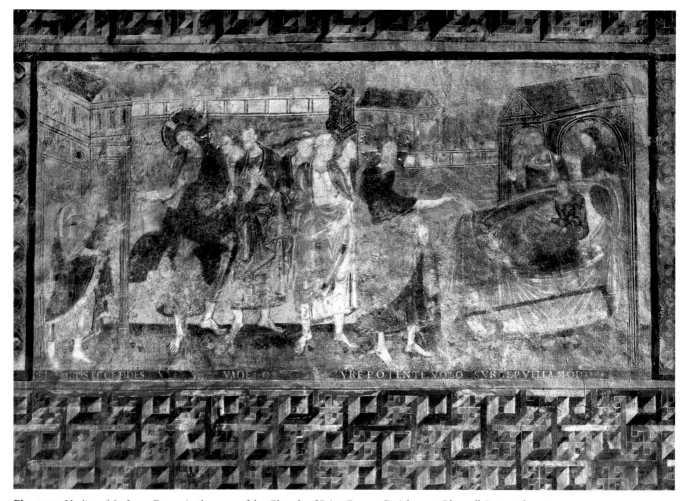

Fig. 9.21. *Healing of the Leper.* Fresco in the nave of the Church of Saint George, Reichenau-Oberzell. Late 10th century

The plan of Saint Michael's features a more complex elevation in the transepts, with galleries in the arms called "angelic choirs." The nave, with three square bays and the so-called "Saxon" alternation of pier and columns, is more severe. No doubt along the high expanse above the nave arcade colorful murals depicting biblical stories were painted originally, much as mosaics lined the naves in Early Christian basilicas. Few remains of such fresco decoration survive in Saxony, but the paintings in the nave of the Church of Saint George at Reichenau-Oberzell on Lake Constance (**fig. 9.21**), dated to the late tenth century, have frequently been cited as examples of this Ottonian art, particularly in the more animated style of thin figures swaying and gesticulating against a plain background.

Bernward of Hildesheim, the builder of Saint Michael's, is a remarkable figure in Ottonian history.[9] Born of a noble Saxon family, he was educated in the best cathedral schools (Heidelberg and Mainz) and traveled extensively through France and Italy. In 987, he was elected chaplain at the imperial court and appointed tutor of the young Otto III by the empress-regent Theophano, the Byzantine widow of Otto II (d. 983). Indeed, it may be that some of the grandiose ideas of young Otto III may have derived from the teachings of the powerful ecclesiastic.

But Bernward had more interests than the political to occupy his energies, and, according to his biographer, Thangmar of Heidelberg, he excelled in the arts and crafts, frequenting the workshops of his artisans. The huge bronze doors cast for Saint Michael's at Bernward's behest about 1015 (**figs. 9.22, 9.23**) are his most impressive commission.[10] As tutor to Otto III, Bernward had spent time at the royal palace in the neighborhood of Santa Sabina in Rome, where he would have seen the famed wooden doors, and it was perhaps there that the inspiration for such multifigured narratives for doorways came to him. The great doors were cast in two solid valves, an incredible feat of foundry work, an art in which the casters of the Rhine and Meuse valleys had always excelled. The huge monolithic casts stand some sixteen and a half feet high, and each valve is divided into eight registers with narratives in each field.

The left door has scenes from Genesis reading from top to bottom, beginning with the shaping of Adam in the first days of creation and concluding with the murder of Abel by Cain. Scenes from the life of Christ are ordered from bottom

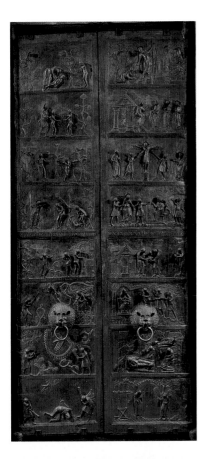

Fig. 9.22. Scenes from Genesis (left) and the Life of Christ (right). Doors of Bishop Bernward. Bronze, height 16′ 6″. 1015. Cathedral, Hildesheim (originally made for Abbey Church of Saint Michael)

BELOW **Fig. 9.23.** *Adam and Eve Passing the Blame Before God.* Detail of fig. 9.22

to top on the right valve, from the Annunciation to the Resurrection. It would seem that some type of parallelism was meant to be presented here that harmonized Old and New Testament events, and indeed some such reading seems appropriate in the pairing of scenes such as the Fall of Adam and Eve with the Crucifixion in the third row, and the lively story of the Admonition to Adam and Eve with the Judgment of Christ before Pilate.

Ottonian narrative style as presented in the bronze reliefs displays a distinctively dramatic style. The figure of the Christ *Logos* leans with his accusing finger across a large blank space at the figures of Adam and Eve, who indicate their shame by awkwardly clutching their fig leaves to their bodies. They too point aggressively in an attempt to pass the blame. The empty space emphasizes visually the distance between the human and the divine, while the tree separates the man and the woman. The *cire perdu*, or lost-wax, method of casting the delicate figures allowed the artists to vary the height of the relief so that background details—plants and trees—are little more than engraved floral designs, while the animated figures gradually project from the feet upward until their heads appear in three dimensions.

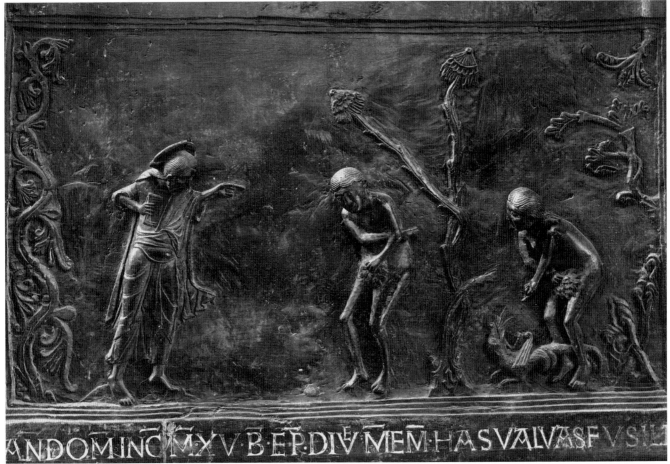

Abbess Matilda (974–1011) may also have been inspired by a Roman monument when she commissioned the seven-branched candlestick for the Convent of the Holy Trinity in Essen (**fig. 9.24**). The monumental candlestick closely emulates the representation of the Temple of Solomon menorah depicted on the Arch of Titus. The granddaughter of Otto I, Matilda was one of several prominent female patrons who enriched the treasuries of Ottonian convents.

Bernward's scriptorium at Hildesheim excelled in manuscript illumination, as did a number of court and monastic scriptoria throughout the Ottonian kingdom. Unlike the monastic workshops in England, however, the Ottonian illuminations were mainly produced in royal foundations, and there has been much controversy over the location of these ateliers. Formerly it was assumed that the Benedictine Abbey at Reichenau on Lake Constance, famed for its liturgical codices, was the major center for the illuminators, but this has been seriously challenged.[11] It is now believed that the main center for the illustration of elegant manuscripts, mostly destined for royal patrons, was the old Carolingian capital of Trier (Trèves) on the Moselle. Other major centers were Echternach and Cologne.

Indicative of the problems of provenance are the illuminations in the splendid Gospel book known as the Codex Egberti, named for its owner, Archbishop Egbert, who was the imperial chaplain to Otto II at Trier. The frontispiece,

depicting the archbishop between two diminutive monks named Keraldus and Heribertus, establishes the ownership at Trier, while the monks who present the book to Egbert are identified as being from Augia, the old Latin name of Reichenau. In any case, the style of the miniatures—portraits of the Evangelists, fifty New Testament scenes, several illuminated initials—introduces the distinctive Ottonian mode for the first time. The Gospel book includes a selection of stories—all New Testament—that seem to have been of special interest to the Ottonian scriptoria, where basic service books, not Bibles, were produced (it will be recalled that the narratives in Carolingian Bibles were predominantly Old Testament).

Furthermore, the iconography of the New Testament scenes in the Codex Egberti points to new sources, namely Byzantine models, for the illuminators, and it comes as no surprise that direct links with the East were now openly negotiated. There is much evidence for the importation of Byzantine ivories, enamels, silks, and manuscripts at this time; indeed, it seems certain that Eastern craftsmen were sometimes employed in the court ateliers.[12]

The fifty New Testament illustrations in the Codex Egberti range from the Infancy through the Passion of Christ, and the compositions of many of the miniatures suggest a certain indecision on the part of the painters in following their models. The *Annunciation* (**fig. 9.25**) is a good example. Framed within the text by a simple band decorated with gold lozenges (an Early Christian convention), the two figures, Gabriel and Mary, are placed irregularly to the left on a bumpy groundline as bright silhouettes seen against an abstract background. The figures are described in heavy outlines with long arcs and straight lines, and with little shading to indicate the modeling of the body. The artist places the figures against a backdrop of simple color that does not detract from the theatrical gestures of the Angel Gabriel and the Virgin. Qualities of immediacy and vividness achieved through intense colors and sharp lines are traits that are uniquely Ottonian and mark the temperament of a talented artist responding to the vigorous tenor of his time and place.

Fig. 9.24. Essen Candlestick. Bronze. c. 1000. Essen Cathedral

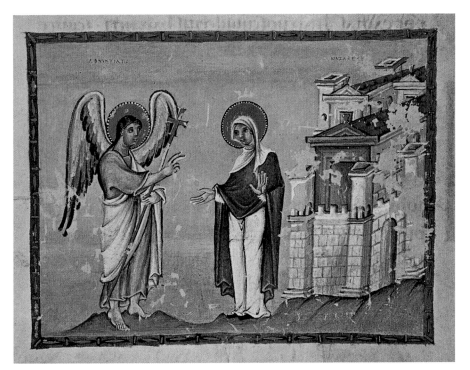

Fig. 9.25. *Annunciation.* Illustration in the Codex Egberti. 9⅜ × 7½″. 977–93. Stadtbibliothek, Trier (Cod. 24, fol. 9r)

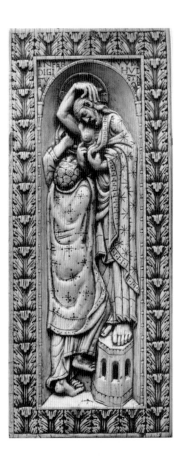

Fig. 9.26. *Doubting Thomas.* Ivory plaque, 9⅝ × 4″. Early 11th century. Staatliche Museen, Berlin

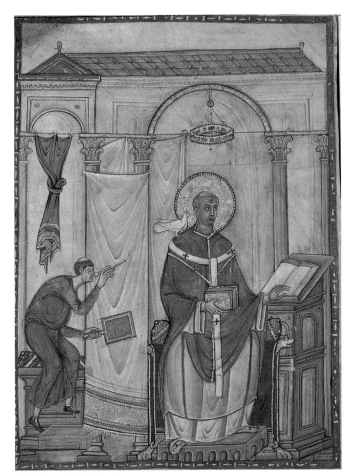

Fig. 9.27. *Gregory the Great Composing a Text.* Illustration in the Registrum Gregorii, c. 983–87. Trier, Stadtbibliothek (MS 171/1626)

Another use of emphatic gesture can also be seen in the Doubting Thomas, though here the space is contracted for narrative effect (**fig. 9.26**). Thomas cannot believe that his friend and teacher has come back from the dead, so he must touch his wounds to confirm that this person is indeed his Lord. The figures are tightly packed between the decorative frame, forcing Thomas to step on to the pedestal on which Christ stands. The viewer can only see the top of Thomas' head as he peers intently into his friend's wound. In an exaggerated gesture with an emphasis on his large hand, Christ holds himself exposed to the probing gaze of his disciple while he in turn looks into Thomas' eyes. The tightly packed composition and the dramatic gestures eloquently portray the intense emotions of the moment.

An entirely different approach is taken by the artist of the scene *Gregory the Great Composing a Text*, a page from the *Registrum Gregorii*, a collection of Pope Gregory the Great's letters commissioned by Archbishop Egbert (**fig. 9.27**). The artist's name is unknown, but modern scholars refer to him as the Gregory Master. Pope Gregory is seated in front of a lectern holding a book in his right hand, while his left hand lies still upon the blank pages of an open codex. On his shoulder, a dove whispers the words into his ear. As was common practice, the pope does not write the words himself, but the secretary takes dictation on his wooden tablet with a stylus. The legend states that the secretary was curious why Pope Gregory had paused in his dictation. Peeking through a

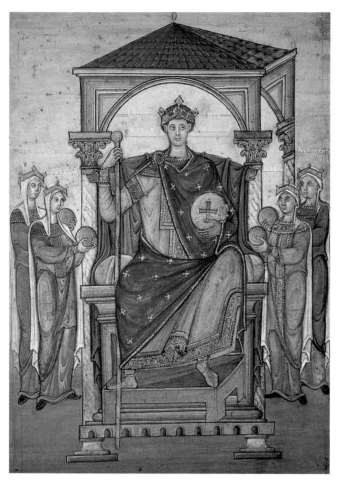

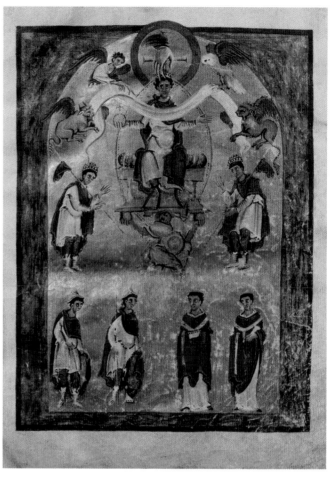

Fig. 9.28. *Otto II Surrounded by the Personified Provinces.* Detached leaf from the *Registrum Gregorii.* c. 983. Musée Condé, Chantilly (MS 14)

Fig. 9.29. *Otto III Enthroned amid Church and State.* Illustration in the Aachen Gospels of Liuthar. 10⅞ × 8½". c. 1000. Cathedral Treasury, Aachen (fol. 16r)

hole in the curtain, he is surprised to see the Dove of the Holy Spirit guiding the pope's thoughts and words. The Gregory Master is not so concerned about providing a visually plausible space and figures that are on an equal scale; rather, he is telling the viewer about the importance of the visionary scene that they witness. Pope Gregory is given a larger stature than the lowly secretary, a large halo that frames his head, and an architectural space that separates him. The arch and the votive crown above him reiterate the emphasis on this special person.

The Gregory Master is also responsible for the portrait of Otto II surrounded by personifications of the four provinces (**fig. 9.28**). Here too the artist has used an architectural frame to separate and distinguish the emperor from mere mortals. The enthroned emperor holds a large scepter and an orb of the world inscribed with a cross. The posture, the throne, the architectural setting, and accoutrements give Otto II an almost Christ-like appearance.

The crystallization of the Ottonian style into an art of greater abstraction can be studied in two Gospel books made for Otto III. The dedication page of the Aachen Gospels

(**fig. 9.29**) presents the youthful Otto enthroned on high within a mandorla representing the heavens; his throne is supported by a straining atlantid (Earth or Tellus in the form of Atlas supporting the world); he is flanked by two emperors wearing identical crowns (the other Ottos?); and the four symbols of the Evangelists fly about his head carrying a long scarf or scroll-like cloth that breaks across his shoulders. From a circle above, the Hand of God places a crown, against a cross, on the head of Otto III.

The emperor, dressed in the same regalia as the two in obeisance beside him, opens his arms to receive the divine favors bestowed upon him. "May God invest your heart with this book, Otto Augustus," reads an inscription on the opposite page, commanding the ruler to establish his empire on the wisdom of the Gospels. With the four creatures about his head—the four Gospels—and the Hand of God above, the inference that he is invested heart and soul is clearly marked by the scroll that bisects his body. As Ernst Kantorowicz has suggested,[13] this may illustrate the idea of the king's two bodies: his heart and soul (shoulders and head) signify his divine investiture, while his torso, here resting on Tellus or the

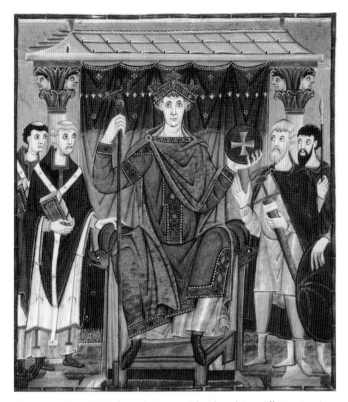

Fig. 9.30. *Otto III Enthroned Between Church and State.* Illustration in the Gospels of Otto III. 13 × 9⅜″. c. 1000. Staatsbibliothek, Munich (Clm. 4453, fol. 24r)

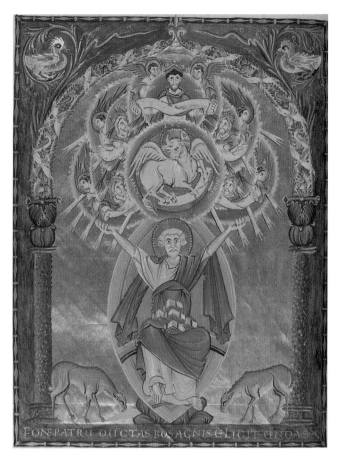

Fig. 9.31. *Saint Luke.* Illustration in the Gospels of Otto III (fol. 139v)

Earth, represents his earthly role as a secular ruler. Below Otto, in the terrestrial world, are two soldiers and two clerics representing the unity of state and Church in his domain.

The second Gospel Book of Otto III (**fig. 9.30**) is also dated about 1000, but exhibits an alternative kind of Ottonian abstraction of space, scale, and frontality. Otto, the "boy wonder," looms large in the center of the page enthroned before a temple that represents a palace. All details of his regalia are enlarged and emphasized, including the eagle on the scepter in his right hand, the lion heads on the imperial throne, and the huge gemmed crown. A rich border adorns his purple mantle. To his right, in smaller scale, stand the representatives of the Church holding Gospel books, attending him alertly as they touch his throne; to his left are the soldiers of state with sword and shield, making gestures of acclamation. Compared to the Carolingian portrait of Charles the Bald (fig. 8.25), the image of Otto is one of commanding authority, an icon of a divinely appointed monarch, a powerful statement of Church and state united in the awesome Augustus.

Another good comparison with this imperial portrait is the mosaic panel of Justinian and his retinue at Ravenna (fig. 4.43), where the glaring statement of caesaropapism was

superbly fashioned. As the son of a Byzantine princess and capable student of Bernward, Otto III would have approved of the caesaropapism associated with Justinian. Crowned successor to Charlemagne at Aachen in 983, Otto later received the crown of the Church from the pope in 996. Otto thus was divinely appointed, and our miniaturist pays him a splendid tribute in this portrait in his own Gospel book.

"Divinely inspired" is also a fitting characterization of the Evangelist portraits in Otto's Gospels (**fig. 9.31**).[14] The astonishing representation of the seated Evangelist writing his text is here transformed into an image of mystical revelation with the writer lifted into the heavens. Luke, identifiable by the ox directly above his head, is transfixed and stares out frighteningly as if lost in a hypnotic trance. He has been inspired by the prophets, whose heads emerge from the fiery wheels that turn about them.

The intense colors and the jagged circles of light make Luke's vision spin like an exploding fireworks display. The palette is dissonant, as so often in Ottonian miniatures. Cool blues are placed against greens and purples, but it is the thrusting lines and swirling edges that bring vitality to the image. Perhaps there is even something mystical in the overlapping of revolving circles of light, caught up in and reverberating with

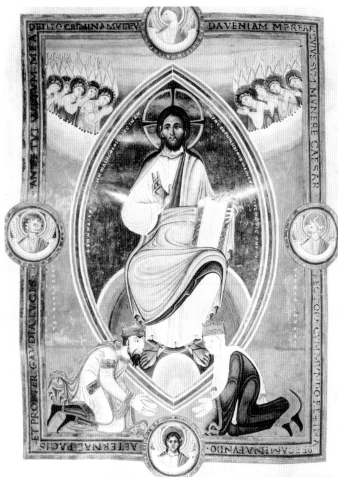

Fig. 9.32. *Conrad II and Queen Gisela Before the Maiestas Domini.* Illustration in the Codex Aureus of Speyer Cathedral. 19⅝ × 13¾″. 1043–46. Library, Escorial (Cod. Vitr. 17, fol. 2v)

Fig. 9.33. *Scenes of the Infancy of Christ.* Illustration in the Codex Aureus of Echternach. 17¼ × 12⅜″. 1053–56. Germanisches Nationalmuseum, Nuremberg (MS 156142, p. 19)

the harmonies of the spheres, just as the Gospels resound sonorously with the prophecies of the Old Testament.

The attraction of Byzantine art manifests itself in a curious way in certain manuscripts produced in Echternach (or Trier?) for Henry III, the Holy Roman emperor from 1039–56, that mark the end of our period. In the sumptuous Codex Aureus dated 1043–46 that was presented to Speyer Cathedral by Henry III, the dedicatory frontispiece displays the parents of the emperor, Conrad II and Gisela, kneeling before a great *Maiestas Domini* (**fig. 9.32**). Here the vigor of Ottonian line has been quelled somewhat, and the faces of Christ and the angel in the lower medallion have been added by a Greek artist at the court, as can be seen in their distinctive Byzantine features when compared to the other heads on the page.

In another manuscript, the large Codex Aureus of Echternach, dating 1053–56, a full-page frontispiece is painted in imitation of a Byzantine silk pattern and serves appropriately as a carpet page for the beginning of Matthew's text, recalling the use of geometric decorations in Irish manuscripts of the seventh and eighth centuries. The numerous miniatures illustrating the Gospels are organized in registers much in the fashion of those in the Tours Bibles. The story of the Incarnation (**fig. 9.33**), associated with the genealogy of Matthew, is presented with stories of the Annunciation, Visitation, Nativity, and Adoration of the Magi, the first two scenes being related only in Luke's Gospel. Obviously, the pictures here depend on a set that constituted the Infancy cycle independent of the Gospel text.

The Cologne school of manuscript illumination produced the Hitda Gospels that were commissioned by the Abbess Hitda for the Convent of Saint Walburga (**fig. 9.34**). The Storm on the Sea of Galilee is told with impressive visual force. Christ and his apostles are on a boat when a ferocious storm begins to rage. Afraid for their lives, they are amazed that Christ sleeps peacefully through the tumultuous wind and rain. The artist turns the boat into a large beast that plunges through the waters while the winds tear at the sails. The apostles huddle in fear, looking anxiously toward the skies, while the calm face of the sleeping Christ rests against the crook of his arm. As in the ivory carving of the Doubting Thomas, the artists of the Ottonian period were capable of capturing the most intense moment of a biblical narrative and infusing it with power and life.

Fig. 9.34 *Christ and Boat*. Illustration in the Hitda Gospels. 11⅜ × 5⅝″. Early 11th century. Hessisches Landes-und Hochschulbibliothek, Darmstadt (MS 1640, fol. 117r)

Fig. 9.35 *Creation and the Virtues*. Illustration in the Uta Codex. Early 11th century. Bayerische Staatsbibliothek, Munich (Cod. lat. 13601)

Ottonian artists also excelled at creating pages that represented abstract theological beliefs. The Uta Codex opens with a composition created out of the most basic of geometric shapes: the circle, the square, and the triangle (**fig. 9.35**).[15] The central circle contains the Hand of God rising from the arc of the heavens and enframed by a triangle surrounded by a circle, another attempt to describe the unity of the Trinity in visual terms. The four virtues anchor the scene in the four corners. From top right and clockwise are the personifications of Justice, Temperance, Fortitude, and Prudence. Around them are inscriptions that extol the benefits of the Divine Virtues that are everlasting and unchanging. The inscription around the Hand of God states: "God, encompassing all time by his everlasting will, has from eternity hallowed all things, which he created by his hand." Thus, the Hand of God is the author of creation and the source of all virtues.

Monumental sculptures in the round are also found in the Ottonian repertoire.[16] The controversies over icons and imagery had not yet subsided, and large, fully modeled statues of Christ, the Virgin, or saints on an altar, serving an iconic presence, are the first tentative experiments. The cult of relics, which enjoyed a renewed popularity in the North, needed beautiful showcases for these objects of veneration. The first sculptures in the round, often incorporating a reliquary cavity, come surprisingly close, in fact, to fetish images. The *Virgin of Essen* (**fig. 9.36**), standing about two and a half feet high, is very appealing with her huge paste eyes staring out from the glistening orb of her golden head. Made of gold plate affixed to a wooden core and enriched with filigree, gems, and enamels that accent the stark planes of the mantle, the statue has a remote appearance. The *Virgin of Essen* was probably given to the cathedral there by Abbess Matilda, sometime around 973–82.

The cult of relics inspired one of the more interesting types of sculpture, the body-part reliquary. The relic itself was considered even more precious than the gold, silver, and jewels that encased it; it was also through relics that a patron or an institution could establish a greater prestige. The Reliquary of Saint Andrew was commissioned by Egbert of Trier to house the sandal of Saint Andrew, the brother of the great apostle Peter (**fig. 9.37**). The foot stands on a golden base that is decorated on one of the short ends with a coin from the time of Justinian that is surrounded by a sixth-

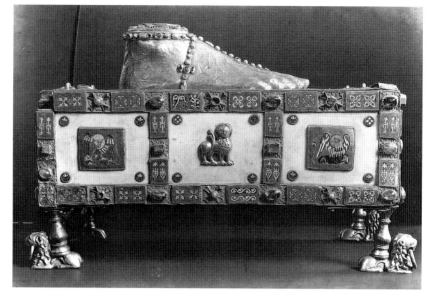

Fig. 9.37. Reliquary of
Saint Andrew. Gold, ivory,
cloisonné enamel, pearls and
jewels, inscription in niello.
c. 980s. Cathedral Treasury,
Trier

Fig. 9.36. *Virgin of Essen.* Gold
over wood, enamel, filigree, and
gems, height 29½″. 973–82.
Cathedral Treasury, Essen

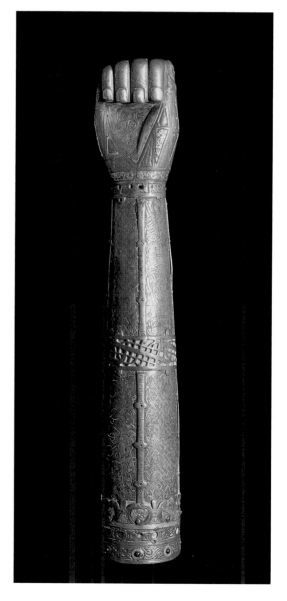

Fig. 9.38. Saint Lachtin's Arm
Reliquary. Bronze, silver, niello, gold,
copper, and glass. 15″ long. First quarter
of the 12th century. National Museum
of Ireland, Dublin

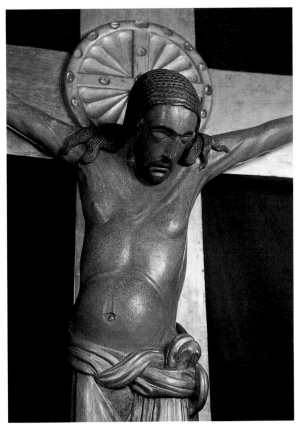

Fig. 9.39. *Gero Crucifix* (detail). Painted wood, height 6′ 2″. c. 970. Cologne Cathedral

Fig. 9.40. *Werden Crucifix*. Bronze, height 3′ 8″. c. 1070. Abbey Church, Werden (formerly in the Abbey of Helmstedt)

century Merovingian brooch. The appropriation of earlier works of art for reliquaries was a common practice that may have been intended to suggest a greater lineage and authenticity for the relic than it in fact should have enjoyed. Although it was once thought that body-part reliquaries corresponded to the part of the saint's body, such as the arm reliquary of Saint Lachtin (**fig. 9.38**), it has been shown that this is not necessarily the case. Arm reliquaries, for example, would be used by bishops to extend their power. By holding them in their hands, the arm of the bishop combined with the "arm" of the saint to bring greater power.

The earliest known example of such monumental sculpture in wood, the *Gero Crucifix* (**fig. 9.39**), was commissioned by Gero, archbishop of Cologne, for his cathedral about 970. The impressive figure is over six feet high. A cavity in the back of the head received the host. The heavy weight of the dead body is conveyed by the grooves of stretched and sagging skin in the shoulders and chest, while the stomach is swollen and bulges outward. Christ's face is superbly modeled to elicit a lonely, withdrawn somberness. The lips are contorted and

twisted down at the corners above the cup of the chin, while deep craters form the eerie sockets for the closed lids of the eyes capped by harshly contoured brows. The *Gero Crucifix* is a striking image of human suffering and death, is the work of a superior sculptor who appears far ahead of his time.

The crucifix was a popular object in early German sculpture, although most were of small scale and cast in bronze. Many are impossible to date, but one is distinguished by its huge scale and extreme refinement in casting technique—the *Werden Crucifix* (**fig. 9.40**). The tall, lean form of Christ is made up of five cast pieces flawlessly assembled into a streamlined image of quiet pathos. The narrow planes are smoother and the contours sharper than those of the crucifixes in wood. The conventions for the body parts—note especially the eye sockets and the beard—are pronounced and very stylized, but the elegant abstraction of the torso into geometric planes resembling a polished breastplate, together with the slight inclination of the head and neck, suggest a timeless characterization of the dignity of Christ even in death.

SCANDINAVIANS

Although the term Viking is often used for peoples from Scandinavia, the word means sea-raider or pirate, and it is not appropriate for the farmers and traders who made up much of the population. The conversion of the Scandanavians took place over a two-hundred-year period, starting in the late tenth century. United under his father, the kingdom of Denmark was introduced to Christianity by Harold Bluetooth (c. 945–85) who was converted in 960. In Norway, King Harald Fairhair united the various parts of Norway into a coherent whole around 900. Although King Olav I Tryggvason introduced Christianity at the end of the tenth century, it was his son Olav II Tryggvason who was able to complete the conversion in the beginning of the eleventh century. After his death in a battle, he became the patron saint of Norway. The old gods were eventually replaced, but the visual traditions continued in the service of the Church.

The Oseberg grave, one of the richest finds in Scandinavia, is situated on the west coast of the Oslo Fjord, near Tønsberg.[17] The Oseberg ship burial rivaled the discovery of the Sutton Hoo find. Archeological excavations in 1904 uncovered a ship that had been constructed as a wooden burial chamber containing the bodies of two women and a wide range of grave goods, including transport, animals, food and domestic utensils. Although the precious metalwork that was likely included in the burial appears to have already been plundered, the site preserved a wide variety of carved wooden furniture, including some magnificently carved posts with animal heads. The burial took place around the year 850 and represents an example of pre-Christian art.

One of the finest of the carved wooden posts depicts a fantastic creature (**fig. 9.41**) whose open mouth seems to roar. The surface of the head has been divided into compartments in a manner similar to *cloisonné* work. Each of the various

Fig. 9.41. Animal headpost, Oseberg Ship Burial. Wood. c. 825. Height 5′. Viking Ship Museum, Oslo

compartments receives a different pattern: the cheeks display an elaborate interlace, the snout a checkerboard pattern, and the eyebrows are patterned in bold lozenges. The three patterns work together to reinforce the shape of the animal's head and complement each other by their contrast. Although the carver has treated the head as a surface to receive ornament, it is done so skillfully that the viewer is convinced of the power and strength of this animal. The function or purpose of these carved posts is not known, but it is clear in this early example that wood carving and appreciation of ornament were well established and was likely associated with power.

The idea of the snarling beast remained a dominant theme even after the advent of Christianity in the region. This theme can be found on the eleventh-century carved portal and wall planks that have been incorporated into the twelfth-century church at Urnes in Norway (**fig. 9.42**).[18]

The arch of the door portal is carved with dragons that seem to resemble large deer hounds. The hips are emphasized by a spiral curl and the large eyes are almond shaped. Snakes writhe up and bite the beasts, creating an even and continually curving pattern that avoids a static symmetry. The *stavkirke* (stave church) at Urnes is among the twenty-eight remaining stave churches in Norway. The church was built during the second half of the 1100s and is one of the oldest and best preserved. The church was built during the second half of the twelfth century and served as a private chapel of a wealthy and high-born Norwegian family.

The *stavkirke* at Borlund, dedicated to Saint Andrew, is one of the finest examples to survive (**fig. 9.43**). Although the earliest wooden churches were built in the eleventh century, when Christianity was established, most of the churches, approximately one thousand in number, were erected in the twelfth century, though few survive. Tarred timbers and stone

Fig. 9.42. Carved portal and wall reliefs. Stave Church at Urnes. 12th century. Norway

Fig. 9.43. Stave Church at Borgund. 12th century. Norway

foundations enabled some of the wooden structures to survive. The stone foundation of the Borgund church supports four large horizontal beams. Four large beams, or staves, rise from the four corners of the foundation and are anchored by four beams at the upper ends of the staves, making a large square boxlike frame for the church. Timbers extend outward from this frame and are supported by upright beams, creating an open nave and aisles on all four sides of the central space. The steeply gabled roof, which creates the impression of an additive approach, gives a unique profile to the church. The outer walls are created by a series of upright planks. The posts of the *stavkirke* are topped by grotesque animal and dragon heads.

PART FOUR

MEDIEVAL ART AND ISLAM

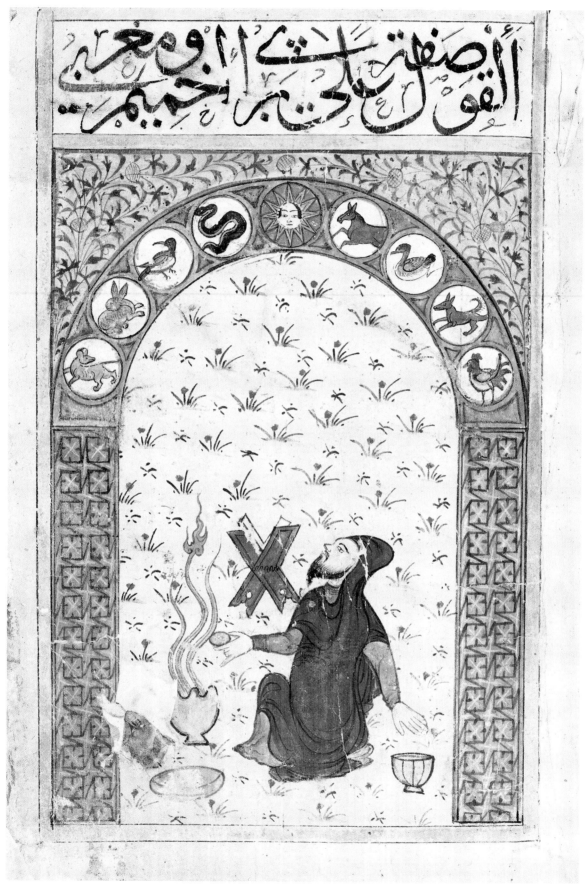

Fig. 10.1. *Miniature of an Occult Ritual.* Illumination from the Kitab al-Bulhan. 9½ × 6¼″. 1399. Bodleian Library, Oxford (MS Bodl. Or. 133, fol. 29r)

10

ISLAM IN THE MIDDLE EAST

"All praise is due to Allah, the Originator of the heavens and the earth, the Maker of the angels, messengers flying on wings, two, and three, and four; He increases in creation what He pleases; surely Allah has power over all things" (Qur'an 35.1).

It was an angel who brought Allah's divine words to a humble, forty-year-old man, who would become for Islam the last Prophet and Messenger in a long line of prophets that included Abraham, Moses, and Jesus. The last revelation to humanity is codified in the Qur'an, the literal word of Allah revealed to Muhammad over a period of twenty-two years. In its most succinct form, the *shahā datan* (two statements) sums up Muslim belief: "There is no god but God; Muhammad is the messenger of God."

Born about 570 in the city of Mecca, Muhammad died on 8 June, 632. The first years of his teaching were tentative because he was hesitant to share his revelations with people outside his intimate circle; however, he soon overcame this reluctance and began preaching to members of his tribe and then publicly in the city. The strong emphasis on social equality under the eyes of Allah would be a powerful message that would unite Arab tribes, paving the way for future Arab empire building.

With its roots in Judaism and Christianity, Islam would draw from a rich heritage of Roman, Christian, Jewish, and Persian art and architecture. Like Christianity, Islam made use of earlier architectural types that suited its style of worship and an art that could be adapted to express its beliefs. Although it was produced in Baghdad at the close of the fourteenth century, this miniature of an occult ritual demonstrates the interest in other cultures and the historical, and even mysterious past (**fig. 10.1**).[1] Inserted into a tract on astrology, divination, and prognostication is the depiction of a Christian hermit performing an undetermined rite that includes the burning of incense and the offering of a wafer, both rituals found in the Christian liturgy, albeit in a different form. Behind him is a "saw-horse" lectern, of the type to hold the Qur'an. An arch with images of animals and birds surrounds the figure and is supposed to represent the Egyptian Temple of Akhmim, which was the center of the cult of the ithyphallic god Min. Foliage, like that found on so many mosques, adorns the spandrels of the arch. The artist has created a highly interpretive rendition of a Christian hermit and of an Egyptian temple, couched in Islamic terms.

In the earliest arts and architecture of Islam, the builders, mosaicists, and stone carvers would also begin a style that, blending various cultural artistic vocabularies, created a uniquely Islamic vernacular. In 638, the Muslim Caliph Umar, aided by the Jews in Palestine, captured the city of Jerusalem from the Persians, just six years after the death of the Prophet Muhammad. On a rock called by the Jewish residents the Temple Mount, Caliph Umar built a small mosque to commemorate the sacred site. The rock had previously been the site of two Jewish temples (Solomon's and Herod the Great's), until the Roman emperor Titus destroyed Herod's temple in A.D. 70. Jews and Christians believed the site was the place where Abraham was asked to sacrifice his son Isaac. Muslims added to this the belief that it was the site where Muhammad experienced his Night Journey. "Glory to (Allah) Who did take His Servant for a

Journey by night from the Sacred Mosque to the Farthest Mosque, whose precincts We did bless, in order that We might show him some of Our Signs: for He is the One Who heareth and seeth (all things)" (Qur'an 17:1). The story of Muhammad's Night Journey begins with the Angel Gabriel, who had been bringing to the Prophet the revelation of the Qur'an, placing Muhammad on a winged mule and flying with him to Jerusalem. Upon his arrival, Muhammad met with many prophets including Abraham, Moses, and Jesus, who asked him to lead them in prayer. After a meal, Muhammad was lifted up through the seven realms of heaven, where he met heroes and prophets from Jewish Scripture until he at last entered paradise to speak with God, who encouraged him in prayer. On his return journey through the heavens, Muhammad and Moses established that five was the correct number of daily prayers. The story establishes the authority of the Second Pillar of Islam, which is to pray five times a day.

UMAYYAD DYNASTY

The first modest mosque on the site was overshadowed by the Church of the Holy Sepulcher, which was the most prominent building in Jerusalem. The caliphs of the Umayyad Dynasty (661–750) would choose to use architecture, as had Roman emperors and Christian popes, as a means of establishing their stature and imprinting their ideals on the cityscapes. The Umayyads were the first caliphs to rule who were not close relatives of Muhammad, but they were from the holy city of Mecca, so it was crucial to consolidate their position in a grand gesture. Although the earliest Islamic architecture, such as the mosque at Basra, has been lost, the Dome of the Rock is a superb statement of political and religious ambition.[2]

The prominence of the rocky outcrop assured that the new structure, renamed the al-Haram al-Sharif (the Noble Sanctuary), would dominate the skyline of Jerusalem, which it still does today. The Caliph Abd al-Malik built a magnificent new structure that was no doubt intended to rival the Church of the Holy Sepulcher, whose dimensions closely resemble the new Dome of the Rock (**figs. 10.2–10.4**). A domed, octagonal building, the Dome of the Rock draws upon Roman imperial mausolea and Byzantine martyria. The diameter of the tall dome is about 66 feet across, while it rises about 82 feet in height. Wide double ambulatories, about 39 feet in width, divide and organize the interior space around the central feature: the foundation rock. The inner colonnade consists of sixteen rounded arches carried on round columns

Fig. 10.2. Dome of the Rock, Jerusalem. Exterior. Completed 691

Fig. 10.3. Dome of the Rock, Jerusalem. Interior

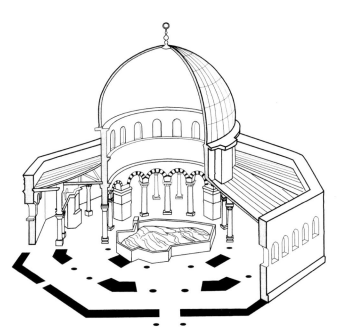

Fig. 10.4. Dome of the Rock, Jerusalem. Plan

punctuated by four square piers. In the outer colonnade the rhythm is changed to a squared pier interspersed by two columns.

Although the structure of the building is Byzantine, the massive scale of mosaic decoration both on the interior and the exterior was unprecedented. Consisting of inscriptions written in Arabic, the decoration "speaks" to the faithful, exhorting them to pray and to reject the false teachings of Christianity, such as the Trinity, which Muslims believed denied that there was one God. Although many of the original mosaics do survive, the exterior mosaics were removed and replaced with the distinctive blue glazed tiles that make the building so distinctive. The surviving mosaics are without human or animal forms, indicating the early aversion to depicting religious narrative scenes in religious buildings; though scattered examples from earlier mosques indicate that the earliest Muslims did not feel this aversion as strongly as the Umayyads. The Dome of the Rock establishes at an early point the relationship between architectural structure and mosaic decoration. Rather than merely enhancing the

architectural forms of the building, the mosaic program begins to dominate, relegating the role of walls and dome to surfaces for ornamentation.

The Dome of the Rock was not intended for Friday's prayers, but was a pilgrimage site for the faithful. The intention was to establish Jerusalem as the primary place of Muslim pilgrimage to rival the city of Medina. The Dome of the Rock is not typical of Islamic religious architecture because it is an early type that draws upon Byzantine architectural traditions before a more distinctive type of Islamic architecture had been established. The political ambitions of Abd al-Malik were made clear when an inscription proudly announced his patronage; however, a later Abbasid caliph would erase Abd al-

Malik's name and insert his own, thereby appropriating the inherent glories of the Dome of the Rock.

The Great Mosque at Damascus is a true mosque in that it was built to gather the faithful to prayer and does not commemorate a sacred historical event.[3] In plan and conception, the mosque establishes a tradition of Islamic religious architecture (**fig. 10.5**). The large and impressive Great Mosque of Damascus was built between 706–15 by the caliph al-Walid I, the son of Abd al-Malik, who purchased the entire site from the local Christian community. On the site was the church of Saint John the Baptist that was situated within the walls of what had been the Temple of Jupiter Damascenus. Before the Roman temple, the site had been occupied by the Temple of Haddad, the ancient Ammonite storm god. According to legend, the head of John the Baptist is enshrined between the columns of the prayer-hall.

After destroying all the interior walls, the rectangular area created by the standing Roman walls of the temple was divided along its length into a massive open courtyard, with a prayer-hall along its southern side (**fig. 10.6**). The prayer hall is divided into three aisles by colonnades, which form a hypostyle hall with the taller columns raising the roof to allow for a clerestory. The mihrab, which is a replacement for the original, is placed at the end of the "transept," which is created by six large piers in the center of the prayer-hall. A mihrab is a niche that is placed on the qibla wall, typically in the center of the wall. The prayer-hall runs on an east-west

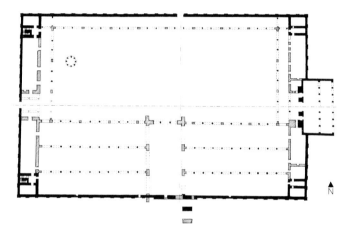

ABOVE LEFT **Fig. 10.5.** Great Mosque of Damascus (Umayyad Mosque), Syria. Plan

LEFT **Fig. 10.6.** Great Mosque of Damascus (Umayyad Mosque). Courtyard. 706–15

axis, like a Christian basilica; however, the qibla wall means that the people at prayer face at right angles through the columns. The mosque has three minarets, or towers, to call the faithful to prayer, though the third one may not be original to the mosque. The southern minarets are definitely from the original construction and are built on the foundations of Roman towers. The walls were covered in glass mosaics by Byzantine artisans and materials that had been supplied by the Byzantine emperor. With Eastern artisans and materials, one would expect Byzantine models; however, this is not the case. The courtyard mosaics seem based on Roman models depicting cityscapes and bucolic scenes much like the paintings in Pompeii. Perhaps these types were chosen for their lack of human or animal inhabitants. Various interpretations have been offered for the meaning of the mosaics. One argument is that these are portraits of the city of Damascus, others have thought they proclaim the peace and prosperity of the cities under Umayyad rule, while another interpretation is that they represent paradise. Al-Walid, who like his father was one of the greatest Umayyad patrons, had set out to embellish and enrich the city of Damascus in order to raise its status as an Islamic city that could rival Jerusalem or Medina.

Under the Umayyads, great palaces were also constructed on a scale that rivaled the great county estates of the Romans. The palaces would have served several purposes. They were the centers of great agricultural enterprises that brought wealth to the dynasty. They also served as a rural contact point between Arabic neighbors and as a place where trading could easily take place. Most importantly, they served as places of retreat from the pressures of the city with its heat and crowds. These palatial residences would have consisted of a complex of buildings that included living quarters, service quarters, a small mosque for prayer, and a bath. Many of the baths pre-date the palaces and they are perhaps one of the reasons a particular site was chosen.

Modern-day Jordan boasts the most numerous and earliest examples of these secular complexes. The largest and one of the most beautiful of the Umayyad palaces is Qasr al-Mshatta, near the city of Amman (**figs. 10.7–10.9**).[4] Although it was never finished, it was ambitious in the scope of the complex, which includes a throne room, an audience hall, a small mosque, and living quarters. A little over 472 feet in length, the thick perimeter wall was dotted with twenty-one semi-circular towers and four round towers at each corner. The towers were not intended for defensive purposes since four were used as latrines and the others are solid. They were probably meant to impress the visitors to the palace, as they do even today. Divided into three sections with a north-south axis, only the center section was partially completed. The entire plan is organized around units of three. In the center section, the northern third was intended for public uses, with the throne room created in a centrally planned space, preceded by a long hall, and punctuated with three apses to the north, east, and west.

Fig. 10.7. Mshatta palace, Jordan. Plan

Fig. 10.8. Mshatta Palace, Jordan. Facade. c. 740–50

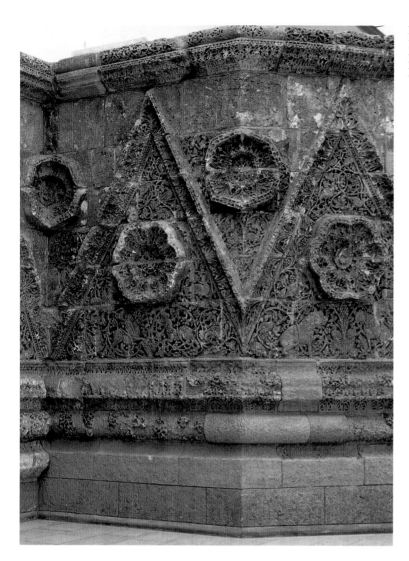

Fig. 10.9. Detail of frieze, Mshatta Palace, Jordan. 743–44. Preussischer Kulturbesitz, Museum für Islamische Kunst, Berlin

The southern third of the central section was intended for the living quarters, and for a diminutive mosque situated along the southern wall. The walls of the mosque were ornamented on all four sides with intricate and beautiful stone carvings, similar to those that could be found throughout the parts of the complex that were completed. True to the Umayyad aversion to figural decoration on religious structures, the qibla wall is decorated solely with vegetation, while the other three walls depict some animals weaving their way through the foliage.

ABBASID DYNASTY

On January 25, 750, the Umayyad dynasty was defeated in the Battle of the Zab by a new dynasty, the Abbasid. The battle took place along the River Zab in what is now Iraq. The Abbasid were proud to claim a closer link to Muhammad since they were descended from the Prophet's uncle, al-Abas, from whom they derived their dynastic name. The Abbasid caliphs were from Baghdad, which soon became their focus of artistic and architectural patronage. This is significant, since the move to the east lessened the contact between Islam and Roman traditions and, therefore, Roman Classical models.

Al-Mutawakkil, upon succeeding to the Abbasid caliphate, began construction on what would be, at the time, the largest mosque in the world, the Great Mosque of Samarra, in what is now Iraq (**figs. 10.10, 10.11**). Begun in the mid-ninth century, the mosque covered almost nine and a half acres. A total of forty-four semi-circular towers including four corner ones were located evenly around the outer brick wall, which had sixteen gates to accommodate the large numbers of worshippers. The outer wall had twenty-four windows along the southern wall, which is also where the mihrab was located. The interior walls and roof are now gone, but originally a forest of columns would have supported the roof and arranged the interior space. The interior columns would have raised the central part of the roof; for that reason this type is called a hypostyle-hall mosque. A short distance away from the north wall is the stunning Minaret al-Malwiya, which rises some 180 feet in height. Although circular, it is based

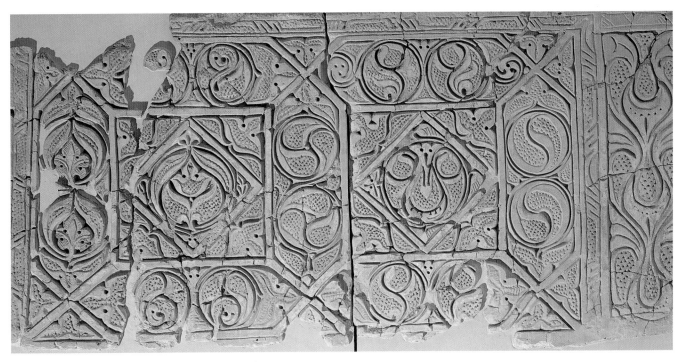

Fig. 10.10. Stucco wall panels from Samarra, Iraq. 9th century.
Museum für Islamische Kunst, Berlin

upon Mesopotamian ziggurats that used ramps to wind up the
height of the structure. At Samarra, the adaptation of eastern
architectural models is more explicit than in Jerusalem and
Damascus.

Islamic caliphs had learned that large and lavish
patronage of the arts and architecture could be a means not
only of raising the religious significance of their cities, but also
of raising their own political profile.

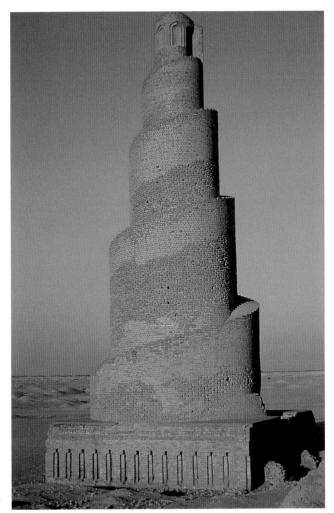

Fig. 10.11. Great Mosque of al-Mutawakkil,
Samarra, Iraq. Second half of the ninth century

11

CRUSADER ART AND ARCHITECTURE

On 27 November, 1095, Pope Urban II stood before a vast crowd at the Council of Clermont and urged all to take up arms and free the Holy Land from the Seljuk Turks, who had wrested control of the region from the Byzantine emperor. The call to arms was met with unparalleled enthusiasm as soldiers bearing the distinctive equal-armed cross on their tunics traveled far from everything familiar to the land that had fired their imagination. The destination was Jerusalem and they arrived there in 1099, filled with righteous excitement for what they perceived as their God-given mission. It was a moment in history that would have profound repercussions for the Middle East and Europe, as well as for the history of art and architecture.

During the eleventh century, pilgrimages to Jerusalem and other holy sites had become increasingly popular, and at the same time commercial enterprises flourished, both opening up Europe to larger influences. Concurrently, the Byzantine emperor Alexius I Comnenus was pressured by the Seljuk Turks on his borders, so he turned to western Europe for aid, specifically to the pope in Rome. Over a two-year period, a diverse and often zealous band of armies left Constantinople and entered Palestine. They captured the city of Antioch in 1098; Jerusalem fell on 15 July, 1099. The Muslim and Jewish residents were slaughtered. Over the course of the next decades, the Crusaders would establish control of a narrow strip of land that would become the Crusader states: the Latin Kingdom of Jerusalem, the Principality of Antioch, and the Counties of Tripoli and Edessa. All of these would be controlled by rulers who often had competing ambitions, a fact that would eventually weaken Crusader control.

The Crusaders came from all parts of Europe, bringing with them their own artistic traditions that would meld with the artistic traditions so firmly established in the Holy Land. The earliest patrons were Frankish or Italian clergy and merchants, but once the Crusades were launched, succeeding generations established residency, becoming natives of Palestine. And though artists from the East and the West came to find work with their Crusader patrons, local artists, masons, and artisans would also be employed to build and decorate the churches that marked holy sites, and to create portable works of art such as jewelry, icons, books, coins, and seals. Despite nearly two hundred years of conflict and final defeat, the Crusaders are remarkable for creating a distinctive and even flourishing art and architecture that is an astonishing layering of various artistic traditions, and that expressed both their religious and their secular views.

THE CHURCH OF
THE HOLY SEPULCHER

Lying at the very navel of the Christian world was the Church of the Holy Sepulcher, the site of Christ's burial and resurrection. A *mappa mundi,* made in England shortly after 1262, provides a glimpse into the religious cosmography of the western European medieval view of the world (**fig. 11.1**).[1] Included in a book of Psalms, the map is oriented: the top of the map is the east, where Jesus Christ stands against a celestial backdrop, flanked by two angels who swing censers. At the very center of this medieval world is Jerusalem, around which are all the known oceans and the continents. On the edges of

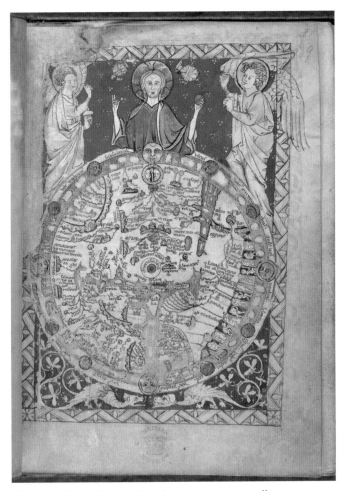

Fig. 11.1. Map of the world. Psalter manuscript, 6 × 4″. c. 1260. British Library, London (MS 28681, fol. 9r)

traditions (**figs. 11.2–11.4**).[2] The Crusader builders made every effort to retain the Anastasis Rotunda because of its venerable status as part of Constantine's original church. Attached to the rotunda was a two-story basilica with a gallery on the upper floor. The nave arcade is comprised of slightly pointed arches; the transept and the choir sported quadripartite ribbed vaults of the type found in Burgundian buildings. The crossing of the transept and nave was domed. Spanish and southern French elements can be detected in the portals of the south transept, which was the main entrance to the church. The south entrance was conceived as a two-story double portal with a rich program of decoration, both figural and non-figural. The non-figural, but richly sculpted, ornament surrounds the portals, creating a rich texture of pattern and emphasizing the shape of the arches. The interior of the church was lavishly decorated in wall and floor mosaics as well as frescoes. Although much is lost, a depiction of the Anastasis (The Harrowing of Hell), when Christ, after his death, liberated the Old Testament saints from hell, was moved from the Rotunda to the eastern apse of the new Crusader church. The church was dedicated on 15 July, 1149, fifty years after the Crusaders arrived at the gates of Jerusalem. It would survive the recapture of Jerusalem in 1187, but over the years it has suffered much abuse from pillaging, a fire in 1808, and poor restoration.

this world are shown the monstrous races, indicating that the farther from the center of the world one is, the more animal one becomes. The map is filled with textual and pictorial references to biblical stories such as the Ark of Noah and the Barns of Joseph. Geography and history are firmly aligned with sacred Scripture.

Constantine's fourth-century Church of the Holy Sepulcher was not spared when Jerusalem fell to the Persians in 614; it, along with many other churches, was pillaged and sacked. Although the church underwent restorations and survived Arab occupation, it was almost completely destroyed in 1009 by the Abbasid caliph al-Hakim. Nonetheless, the exterior walls of the Anastasis Rotunda remained standing. The Rotunda, consequently, was incorporated into the Byzantine reconstruction and much-reduced version of the church by 1040. When the Crusaders arrived in Jerusalem, the site of Christ's burial had required restoration, renovation, and expansion. Work began in 1143 under the patronage of King Baldwin III and his mother Queen Melisende, who co-ruled with her son until 1152.

The Church of the Holy Sepulcher is an amalgam of the old and the new, as well as a blending of various architectural

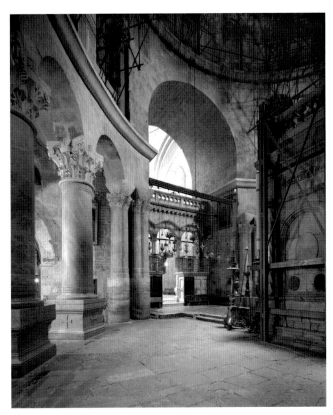

Fig. 11.2. Church of the Holy Sepulcher, Jerusalem. Interior. Dedicated in 1149

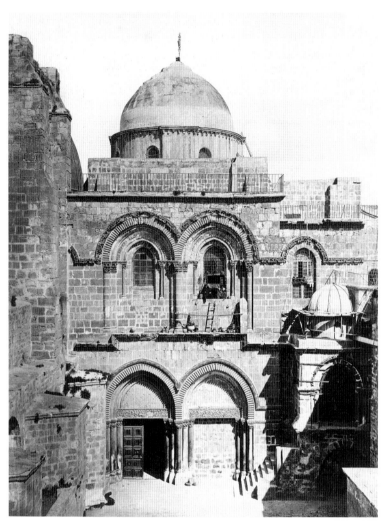

Fig. 11.3. Church of the Holy
Sepulcher, Jerusalem. Exterior

Fig. 11.4. Church of the Holy
Sepulcher, Jerusalem. Plan

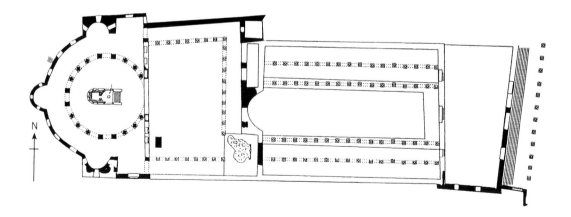

NAZARETH

North of Jerusalem, and also a site of pilgrimage, was the town of Nazareth, the boyhood home of Jesus. To commemorate the place where it was believed the Angel Gabriel told the young Virgin Mary that she was to conceive and bear a child, a church was begun shortly after 1170 when an earthquake destroyed an earlier shrine dedicated to the Annunciation. Built under the patronage of Archbishop Letard II, the church at Nazareth was less lavish than that of the Holy Sepulcher, though an impressive set of carved column capitals have survived the destruction of the church in 1263. In the 1950s, over seventy-five pieces of architectural sculpture were discovered, among them a capital depicting Saint Peter and Tabitha from the shrine grotto of the Annunciation (**fig. 11.5**). The story demonstrates the power of Saint Peter as a miracle worker after Christ's Ascension. Visiting friends in Joppa (Jaffa), Peter was called to the deathbed of a woman named Tabitha, who was famous for her good works and for clothing the poor. As Saint Peter prays at her bedside, the dead woman comes to life with his command, "Tabitha, get up" (Acts 9:40).

The sculptor has carved the scene in a vigorous and dynamic manner. Peter grasps the outstretched hand of the woman, who is rising from her bed by pushing up on her right elbow. Swirling drapery engulfs the figures, yet the structure of the human form beneath the drapery is not lost, but rather gives an animation to the composition. The capitals from the shrine grotto depicted the miracles of the apostles, many of which would have held a great relevancy because they took place in the cities and towns of the Holy Land.

BOOK ARTS

Queen Melisende, the mother and co-ruler of King Baldwin III of Jerusalem, established a rich heritage of artistic patronage, not only in architecture, but also in manuscript illumination. William of Tyre, a medieval chronicler of the Crusades, specifically mentions that Melisende was interested in the book arts. Alas, very little survives of these books; however, the Psalter of Queen Melisende gives a glimpse of the high quality and ambition of books associated with the queen (**fig. 11.6**).[5] The Psalter was intended as a personal

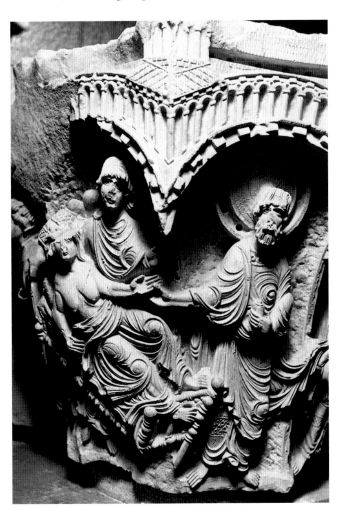

Fig. 11.5. *Saint Peter and Tabitha.* Stone capital from the aedicule of the Annunciation. Church of the Annunciation, Nazareth. After 1170

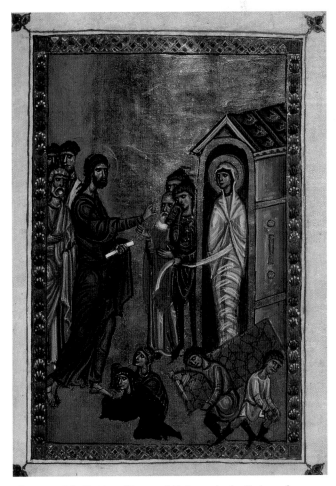

Fig. 11.6. *The Raising of Lazarus.* Miniature in the Psalter of Queen Melisende. 6 × 4″. c. 1135. British Museum, London (MS Egerton 1139, fol. 5r)

Fig. 11.7. Arsenal Bible, 11 × 8″. 1250–54. Paris, Bibliothèque de l'Arsenal (MS 5211, fol. 307r)

Fig. 11.8. Acre Triptych. Tempera and gold on panel. c. 1260. Monastery of Saint Catherine, Mount Sinai

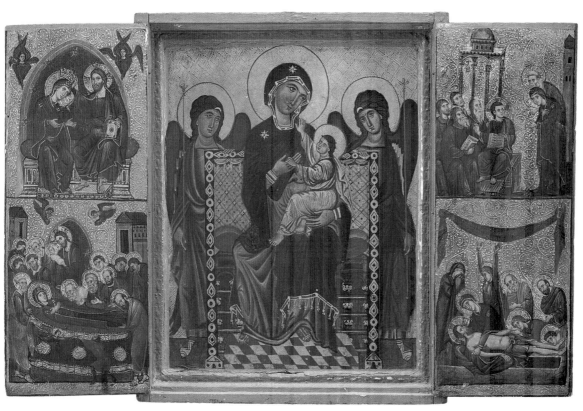

book for the queen; the Psalms were read on a daily basis for prayer, and meditation. The luxurious manuscript contains twenty-four full-page New Testament scenes, gathered at the front of the codex. In one of the frontispieces the Latin inscription *Basilius me fecit* (Basilius made me) indicates that the artist of these folios was from western Europe; however, the style of the illumination is Byzantine. Signs of the zodiac included in the calendar pages were painted by another artist in a Romanesque style, while the historiated initials were painted by yet another hand that combines Islamic, Italian, and even English motifs. A fourth artist painted the portraits of saints at the end of the Psalter in a style that once again is a combination of Byzantine and Romanesque styles. The evidence of four painters working in a variety of idioms indicates that the scriptorium in Jerusalem was a melting pot of artists who, drawing on different training and traditions, were studying and borrowing from each other.

Unlike the sculptor of the resurrection scene in Nazareth, the Melisende artist has remained true to established traditions for how to depict the Raising of Lazarus. The shrouded figure of Lazarus stands erect in the gabled tomb on the right, while Christ strides forward with his right arm raised in a gesture of miraculous power. On the other hand, the artist has made reference to contemporary persons and places. Behind the figure of the youth who holds his fist to his nose to cover the stench of decay stands the figure of a man dressed in contemporary ecclesiastical robes. The scene must have had special significance for Queen Melisende, since the story of Lazarus took place in Bethany, where the queen established a convent for her sister Yvetta at the Tomb of Lazarus, which was a popular pilgrimage site. Under the patronage of King Baldwin III and Queen Melisende, the art of the Latin Kingdom of Jerusalem would reach its zenith. The mid-twelfth century was a time of relative stability that allowed patrons and artists alike to focus their wealth and resources on the arts. The period would be short lived, however, for the Crusaders lost Jerusalem on 2 October, 1187, to the army of Salah al-Din.

Shocked by the loss of Jerusalem, the West launched a massive third Crusade under the control of Emperor Frederick Barbarossa. His death by drowning in 1190 brought a halt to the crusade and the city of Jerusalem remained in the hands of Salah al-Din. In 1191, King Richard I of England, known as the Lionhearted, brought his army to the East and captured the Byzantine province of Cyprus. Richard's forces linked up with the armies of Phillip II Augustus of France, and the two kings laid siege to the city of Acre and took it in July 1191. A harbor town, Acre is on the Syrian coast, with Mount Carmel to the south and the mountains of Galilee to the east. Unable to successfully retake Jerusalem, Richard negotiated a five-year truce with Salah al-Din that would allow Christians to visit the holy sites despite their being under Muslim control.

In 1248, the French king, Louis IX, launched the seventh crusade in an effort to take Egypt; it was not successful, so he retreated to Acre. With the arrival of King Louis, who took up residence in the city, the production of art and the building, or repair, of castles and city walls took a marked upswing. Under his patronage, the thirteenth century saw a renewal of the arts, particularly the art of illuminated manuscripts. King Louis perhaps commissioned, or is at least linked to, the impressive and very handsome Arsenal Bible, which set a new standard of artistic quality for illuminated books in the Crusader states (**fig. 11.7**).[4]

Produced in the scriptorium of Acre, the Arsenal Bible is the most lavish illuminated manuscript created in the Crusader states. The selected twenty books of the Old Testament are each given an elaborate frontispiece and an accompanying decorated initial that opens the books. Written in Old French and with an abbreviated text, the style and iconography show a combination of Eastern and Western traits. The miniatures show a reliance on the Moralized Bibles, where every text passage is explained by its own commentary, and every illustration has a second, explanatory, moralizing illustration from France, an influence probably brought by the Franciscan William of Rubrouck, who was an envoy of Louis and part of a concerted Franciscan missionary effort. On the other hand, the style of the miniatures shows distinctly Byzantine influence. The emphasis on kingly iconography strengthens the argument that the Bible should be closely associated with the royal court. Although it is an interesting exercise to parse the style and iconography of the Arsenal Bible, it should be seen as a fusion that is distinctly a product of the scriptorium of Acre.

The beautiful Acre Triptych is an important example of the varied artistic backgrounds of the Crusader artists (**fig. 11.8**). The central panel depicts the enthroned Virgin and Child flanked by angels, a standard type found in the East and the West. The left wing portrays the Dormition, or death, of the Virgin and the Coronation of the Virgin, while the right panel depicts the Lamentation of Christ and the Finding of Christ Teaching in the Temple. The product of a cooperative collaboration among at least three artists, the triptych reveals Italian and French influences as well as an understanding of Byzantine techniques.

Secular art became an important aspect of Crusader production after 1250, reflecting parallel developments in Western Europe exemplified by the Englishman Matthew Paris. The *Histoire Universelle* (**fig. 11.9**), possibly executed in 1285 as a gift for the Latin King Henry II of Lusignan (1285–91), has illustrations in a Franco-Byzantine style, with a frontispiece miniature showing clear knowledge and imitation of Islamic decoration. The purpose of these universal histories was to link contemporary events to those of the Old Testament, an effort to show the continuing blessing of God's people and his covenant with them.

History texts were especially popular in the Crusader states, the most popular of all being the *History of Outremer* by William of Tyre, which was translated from Latin into Old

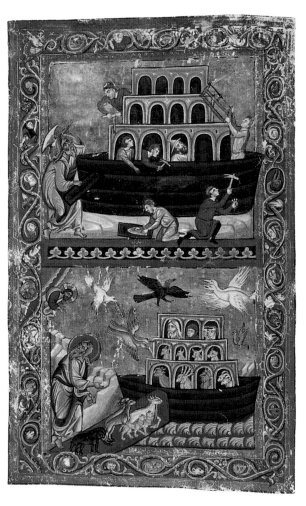

Fig. 11.9. London *Histoire Universelle*. c. 1285. British Library, London (MS 15268, fol 7v)

Fig. 11.10. William of Tyre, *History of Outremer*. 1281–91. Bibliothèque Nationale, Paris (MS fr. 1404)

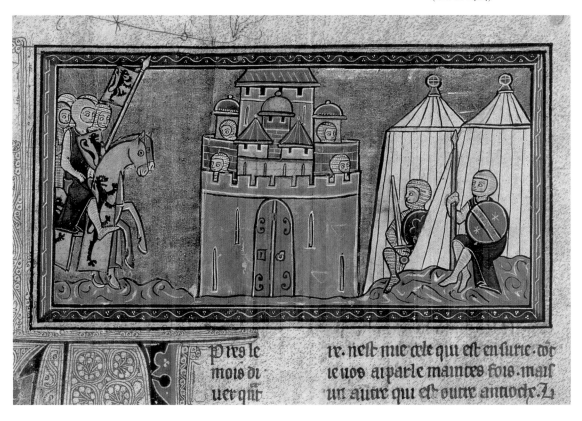

French. Histories of the Crusades, with their heroic tales of daring feats against the infidel, must have been particularly appealing, despite the realities of the situation. The climax of Crusader miniature painting in the late thirteenth century was reached when a French artist, recently arrived, painted at least three codices of the *History of Outremer*. One manuscript shows that this artist completed work begun in an Italo-Byzantine style (**fig. 11.10**). Although it follows a French Gothic format and program, his work gradually absorbed various aspects of his Crusader surroundings. Acre, the site of such great artistic endeavor, was the last Crusader city to fall to the Muslim forces in 1291, effectively ending any real Crusader control in the Holy Land.

KRAK DES CHEVALIERS

The stone castle of Krak des Chevaliers, one of the best-preserved Crusader castles, occupies a dominant hilltop, near two Roman roads and overlooking a fertile valley (**fig. 11.11**).[5] The site, due to its militarily strategic topography, was apparently used for defensive purposes as early as the thirteenth century B.C. By the eleventh century A.D., a small Arabic castle occupied this site until it fell to a crusading force in 1110. The castle was given to the order of the Knights Hospitaller in 1142, and it became their chief stronghold in 1188. The Hospitallers began as an order dedicated to the care and protection of pilgrims to the Holy Land. They established a hospice situated to the south of the Holy Sepulcher in Jerusalem that was under the protection of Saint John the Baptist. During the recapture of the city, the hospice became an important sanctuary for Christian pilgrims. Although it is not known when the order first adopted a military function, it gained control and possession of Krak des Chevaliers between 1142 and 1144, along with other strategic castles in the County of Tripoli. The strength of the castle and the advantageous site were no doubt key factors when Salah al-Din decided not to embark on a siege of Krak.

The Crusader castle occupies a little over six acres, the result of building and renovation over a period of time. The earliest surviving Crusader building probably dates from after 1142, when the central block was constructed. At the end of the twelfth century, the central block was surrounded by a massive outer wall, the result being a concentric plan that would be highly influential for its defensive utility.

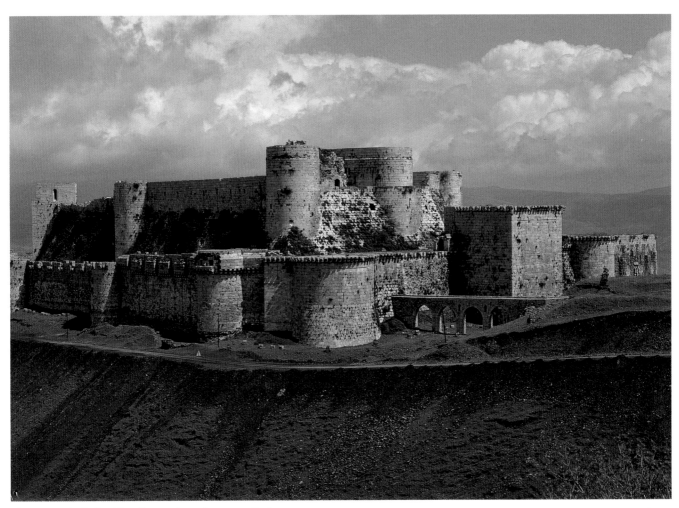

Fig. 11.11. Krak des Chevaliers. 12th–13th century. Syria

Krak boasts great physical strength due to its vast stone walls and the excellent quality of the masonry construction. Features included the main entrance on the east side, which had a gatehouse, a drawbridge, and a long ramped and vaulted passage leading into the castle. The passage makes sharp turns that would have made entering with a large force virtually impossible.

Due to the topography of the site, the central block is roughly triangular in shape. After emerging from the main gate passageway, any invading army would be confronted by a courtyard on two levels, surrounded by round defensive towers. The lower level of the courtyard was reserved for the main public buildings: the great hall, the kitchens, and the chapel. The upper courtyard linked the ring of defensive walls and the towers, where the garrison was housed. Because of the threat of sieges, and the very real potential for starvation, the central block was outfitted with extensive areas for storage and cisterns for water, enough to withstand a lengthy siege.

The castle and the Knights Hospitaller fell in 1271 to the Baybar armies. As the story goes, it was not through the fault of the castle's defenses, but through the use of trickery, when a forged letter, purportedly from their superiors, instructed the castle's defenders to surrender.

12

ISLAMIC SPAIN

CÓRDOBA

In the year 711, Berber armies from northwest Africa invaded Spain, landing on the rock of Gibraltar which they named Jebel Tariq, or Tariq's Mount, after their Arab general, Tariq ibn Ziyad. Within a year, the Berbers conquered the Visigothic capital city of Toledo and most of the Iberian Peninsula. Although many of them returned home to Africa with booty and slaves, others stayed and settled in the region they named al-Andalus, now known as Andalusia.[1]

Radical changes in the Middle East, however, would make even a greater impact on Medieval Spain. Although the Umayyad dynasty ruled the Muslim world from the city of Damascus in Syria, the fate of this family would deeply alter Iberia. One evening, in an apparent gesture of good will, the leader of the Abbasids, rivals of the Umayyads, invited the royal family to dine with them and form a truce after the Abbasid victory at the Battle of the Zab. At the banquet, however, the deceived Umayyads were massacred. With these assassinations, the Abbasids were able to seize control of the Muslim world in 750.

Only one member of the Umayyad dynasty, Abd al-Rahman I, the leader's grandson, was able to escape. Aided by political allies, al-Rahman fled across northern Africa with the Abbasids close on his heels. Al-Rahman's journey ended in al-Andalus, where he was able to find sanctuary from the Abbasids. Soon after his arrival, al-Rahman consolidated the region and made Córdoba the capital of his emirate (756–88).

In Córdoba, Christians and Jews were able to continue their religious practices so long as they paid their taxes to the Muslim leadership. As fellow "people of the Book," Christians and Jews were protected from persecution in Islamic Spain.

Although Christians in Córdoba were able to continue worshipping in public, they were not allowed to build new churches nor were they permitted to repair or renovate existing ones. Between 784–86, al-Rahman I built a mosque on the site of a previous church. Like the Great Mosque of Damascus, the mosque in Córdoba (**fig. 12.1**) was built in a hypostyle plan with alternating dark red bricks and pale white stones in the voussoirs of its horseshoe arches. Yet nostalgia for Syria does not in itself offer an adequate explanation for the mosque's visual appearance.

The prayer hall's Corinthian columns, appropriated from earlier Roman and Visigothic buildings, were relatively short. To elevate the ceiling of the mosque, al-Rahman's architects designed a two-tiered arcade with Corinthian columns on the bottom. The idea for this may have been derived from studying a Roman aqueduct at nearby Mérida. This ingenious solution not only increased the height of the interior, it also helped produce the illusion of greater spatial depth. Although the Umayyads did not introduce the horseshoe arch to Spain (there are Roman and Visigothic precedents), they definitely popularized its use, including hundreds of horseshoe arches in the Great Mosque alone.

Córdoba's mosque would undergo four renovations in its history.[2] Initially, the mosque established by al-Rahman I included a square hypostyle hall (a room filled with numerous rows of columns), likely divided into eleven aisles, with approximately one hundred and twenty columns. The central nave was slightly wider than the other aisles, accentuating the axial symmetry of the plan leading to the mihrab (prayer niche). The first change occurred in the first half of the ninth

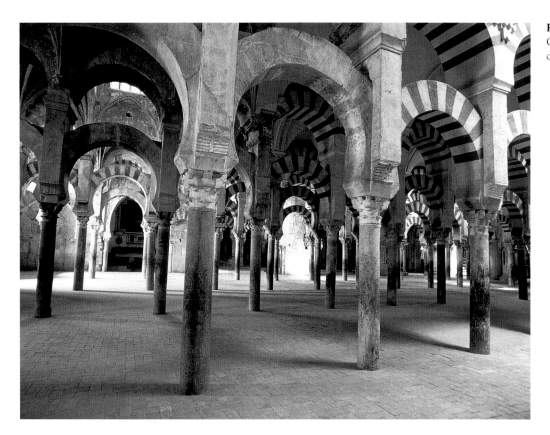

Fig. 12.1. Great Mosque, Córdoba. 785–86. View of double tiered arches

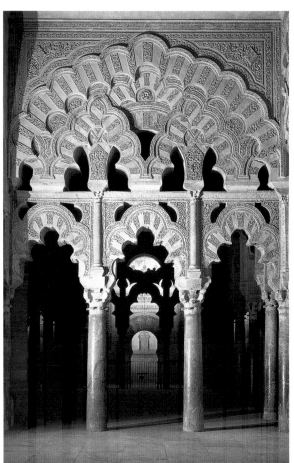

Fig. 12.2. *Maqsura* screens, Great Mosque, 965. Córdoba

century, when Abd al-Rahman II (822–52) increased the mosque's width by two aisles and its length by eight bays. The additional columns in this remodeling were not taken from other buildings, but were constructed by masons to imitate the appearance of the original.

The second alteration, however, was more dramatic and highlights the transformation of the Umayyad emirate into a caliphate. At Friday prayers on the 16 January, 929, Abd al-Rahman III (912–61) declared himself *khalifa* or caliph, successor to the Prophet Muhammad, a lofty title implying that he was the sole representative of Muhammad on earth. Claiming the status by hereditary right, al-Rahman III formally rejected the authority of the Abbasid caliph in Baghdad. Although the self-appointed caliph of Córdoba aspired to be like his ancestral namesake, al-Rahman III was barely Syrian. The son of a Muslim emir and a Christian concubine, al-Rahman III had light skin, blue eyes, and red hair, which he is said to have dyed black to give himself a more Arabic appearance; the caliph was thoroughly Iberian. Baghdad was unlikely to have felt threatened by the words of a man marginalized at the edge of the known world. However, al-Rahman's statement counteracted the Fatimids, a Shi'ite dynasty that claimed to have descended from Muhammad's daughter Fatima and currently ruled northern Africa from Algeria to Egypt. The Fatimids had set up their own caliphate in 910, nearly twenty years earlier. In addition, al-Rahman's decree may have helped to diminish the power of regional lords and hence centralized his authority within al-Andalus.

When the caliph's son and successor, al-Hakam II (961–76), remodeled the Great Mosque of Cordoba, not only did he extend the hall's length by twelve bays, he also re-designed the *maqsura* and the mihrab (**fig. 12.2**), the area directly in front of the prayer niche reserved for the caliph and his royal entourage (**figs. 12.3, 12.4**). The *maqsura* incl-udes three domed bays covered, like the dome of the mihrab, with precious mosaics of gold and lapis lazuli, and decorated with abstract geometric patterns, vegetal forms, and sacred

inscriptions from the Qur'an. The calligraphy is rendered in Kufic script, an angular writing style popular in the Middle East. The artists who completed the work, however, most likely came from the Byzantine Empire. Córdoba and Constantinople shared diplomatic and trade relations, as well as a mutual lack of admiration for the Abbasids.

The columns separating the *maqsura* from the rest of the prayer hall support do not have horseshoe arches, but elab-orate polylobed arches intricately carved with floral patterns.

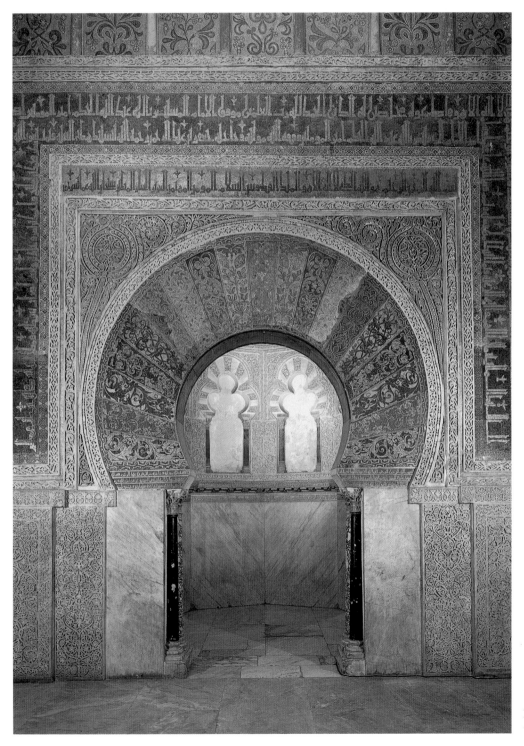

Fig. 12.3. Great Mosque, Córdoba. 965. Mihrab entrance

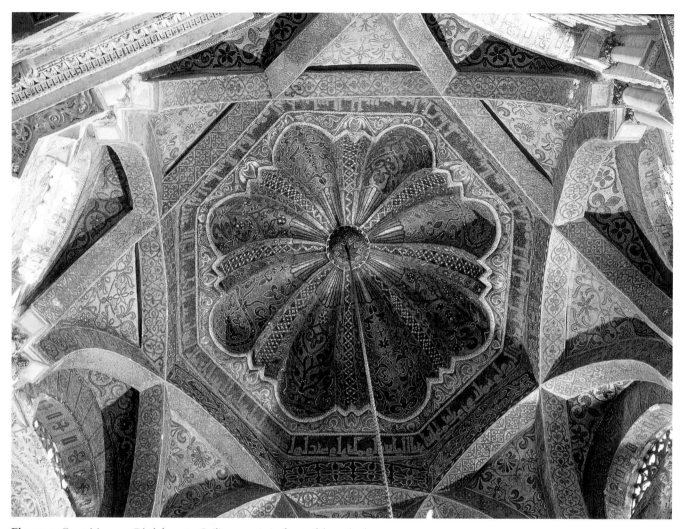

Fig. 12.4. Great Mosque, Córdoba. 965. Ceiling mosaic in front of the mihrab

The interlacing of these complex arches marks the hierarchic authority of the caliph and increases the sense of the sacred as one approaches the mihrab.

In the tenth century, the Great Mosque was remodeled a third time, between 987 and 990. Under the supervision of al-Mansur, who served as regent of the caliphate while Hisham II was too young to reign, the mosque was significantly increased in scale. Widening the prayer hall by eight aisles on the northeast side returned the mosque to its initial squared design, but it drastically affected the symmetry of the mosque, for the mihrab is no longer placed on the central axis.

The fourth renovation was of a different kind. After Córdoba fell into the hands of Christians from the north (1236), the Great Mosque was converted into the city's cathedral. During the early sixteenth century, local leaders and clergy decided to construct a walled church or *coro* in the Islamic prayer hall, effectively disrupting the extensive unity of the two-tiered horseshoe arcades. Upon visiting Córdoba, the King of Spain and the Holy Roman Emperor, Charles V,

criticized them, saying "You could have built here what you, or anyone else, might build anywhere; to do so you have destroyed what was unique to the world."[3] Ironically, the Spanish king built his own palace in the midst of the greatest of Moorish castles, the Alhambra, disrupting its established architectural harmony. Although part of Córdoba's mosque has been erased to accommodate a church, the inclusion continues to remind us of the ways in which Christianity and Islam have helped shaped the history of Spain.

During the tenth century, the caliphate of Córdoba was known as a great center of learning, noteworthy for its promotion of numerous fields of study including astronomy, physics, botany, medicine, and navigation. Córdoba also introduced Arabic numbering, algebra, and ideals of courtly love to Europe. In addition, it was a place of great wealth. A few miles outside of the city, al-Rahman III built his palace at Madinat al-Zahra. Palace workshops produced exquisitely crafted objects in ivory and metal.[4] In an ivory pyxis (**fig. 12.5**), made as a gift for the caliph's younger son,

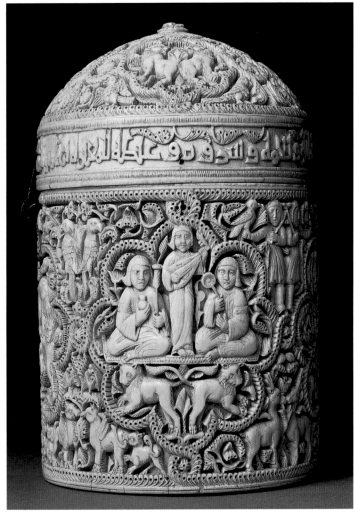

Fig. 12.5. Pyxis of al-Mughira. Ivory. Height 5⅞ × 3⅛″ diam. 968. The Louvre, Paris

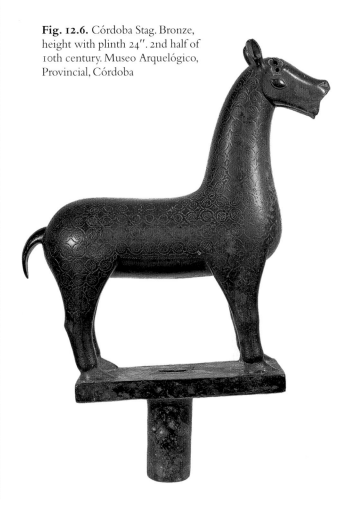

Fig. 12.6. Córdoba Stag. Bronze, height with plinth 24″. 2nd half of 10th century. Museo Arqueológico, Provincial, Córdoba

al-Mughira, no area of the exterior surface is left untouched. Vegetal and geometric motifs framing eight medallion scenes cover the vessel. The medallions make reference to regal authority and courtly pleasures. In one medallion, a lute player, a fan bearer, and a man holding a flower and a jar appear in informal conversation. This charming pyxis also includes calligraphic inscriptions marking ownership, asking for the continuation of Allah's blessings, and describing the function of the ivory, which is a receptacle for expensive aromatics. The visual charm of the pyxis and the scents derived from its contents would have delighted the senses. A bronze stag (**fig. 12.6**) reinforced the idea of the palace as a site of relaxation. Likely one of a series of figures encircling a fountain, the stag is decorated with ornamental leaf patterns and is designed for water to spray out of its open mouth. The subtle grace and elegance of the metalwork complement the abundant presence of water, evoking the sense of an oasis, a garden paradise that conceals the palace as a formidable fortress.[5]

MOZARABIC ART IN NORTHERN SPAIN

The term Mozarabic derived from the Arabic *mustarib* or "Arabized." Cloistered monks who took refuge in the Christian kingdom of the Asturias during the long Muslim occupation of the Iberian peninsula produced much of this art. While Spain was virtually cut off from the rest of European Christendom.

While Christians were tolerated under Islamic rule, it seems clear that they nonetheless felt threatened as an isolated minority, and gradually many monks migrated from Muslim territories northward to the kingdom of Alfonso III (866–911), centered in León in the Asturias, where they established monastic communities. For example, Benedictine monks cloistered near Córdoba fled north and established a new monastery, San Miguel de Escalada, on recently reclaimed land. The "frontier monasticism" of these Benedictines affirmed the triumphal return of Christianity and encouraged Christians who were still living in areas under Muslim control to move. Yet the monks continued to refer to

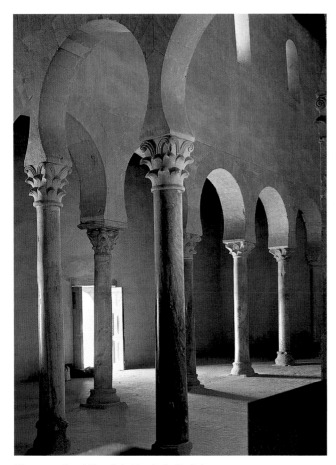

Fig. 12.7. San Miguel de Escalada (León). c. 913.
Interior

Fig. 12.8. Vimara and Johannes. *The Symbol of Saint Luke.*
Illustration in the León Bible of 920. 9¼ × 8⅝″. 920. Cathedral,
León (Cod. 6, fol. 211r)

themselves as brothers from Córdoba, an allusion to their refugee status and a call to continue the Reconquista.

San Miguel de Escalada (**fig. 12.7**) makes use of the horseshoe arch in elevation and in plan. Although this architectural characteristic is often associated with Islamic buildings, it is also a common feature in Visigothic churches. The Mozarabic liturgy performed in this monastic church forbade members of the laity to enter the altar space or even see the sacred ritual that occurred there. A curtain was placed in front of the sanctuary, preserving the mystery of the sacrament. During the Mass, clergy brought communion to the laity on the other side of the choir.

The sources of Mozarabic style have been traced in part to Visigothic and Merovingian animal styles, to Early Christian manuscript illuminations, and to some Carolingian models.[6] The stylistic or formal elements of these pictures cannot be so easily dissected. One of the earliest illustrated books in the Mozarabic style is the León Bible of 920.[7] Fortunately, Mozarabic manuscripts provide us with much information in their colophons. Abbot Maurus commissioned the León Bible for the monastery of San Martin de Albelda (Albeares) near León; it was written and illuminated by the monks Vimara and Johannes. The date in the colophon, 958, must be rectified to the year 920, since Spanish chronology diverged from the standard by thirty-eight years. The illustrations include a favorite motif, the Cross of Oviedo (a familiar sign of resistance to Muslim rule), canon tables with Evangelist symbols, and full-page frontispieces for the Gospels that feature the symbols of the Evangelists supported by angels within huge circles (**fig. 12.8**). The illumination is produced with colorful outlines and candy stripes of red, green, yellow, and blue, lending a feathery lightness and transparency to the image. No attempts at modeling can be discerned, and indications of three-dimensional space are ignored.

A later Bible of 960, signed by the monk Florentius, in San Isidoro in León, is remarkable for the vast number of narrative pictures that appear in the margins and in the text, many unframed, like column pictures (**fig. 12.9**). Again, the treatment of the figures, the suppression of gestures, and the lack of any illusion of space make these colorful illustrations difficult to read at times, but if one studies the configurations

Fig. 12.9. Florentius. *Goliath Challenges the Israelites.* Illustration in the León Bible of 960. 12⅜ × 19½″. 960. Colegiata San Isidoro, León (Cod. 2, fol. 116v)

Fig. 12.10. Magius. *The Four Angels Holding the Four Winds.* Illustration in the Morgan Beatus of Liébana, *Commentaries on the Apocalypse.* 14¾ × 11″. 922 or mid-10th century. Pierpont Morgan Library, New York (MS 644, fol. 115)

closely, as if they were flat cutouts pasted to the margins, the rudiments of the narratives become discernible.[8]

Beatus of Liébana, an eighth-century Spanish monk and mystic, wrote his commentary on the Apocalypse primarily to combat the heresy of Adoptionism—the belief that Christ was born human and only later gained his divinity through his adoption by God the Father. Adoptionism was a popular conviction in Visigothic Spain, where Bishop Elipandus of Toledo and his followers continued to promote Adoptionism well into the eighth century. Beatus's commentary encouraged readers to prepare for the *eschaton,* the end of the world, when Christ would return victoriously in Final Judgment. In anticipation of the Apocalypse, Beatus warned against false prophets and advocated fidelity to theological orthodoxy. Although his remarks were directed against Adoptionism, they could be readily interpreted as an attack on Islam.[9]

The contents of the Beatus commentaries are rich and varied, as are the illustrations. Typically, the books begin and end with large initials of the Alpha and Omega. In the more complete editions, there are genealogical tables for the descendants of Adam through Christ, a fanciful *mappa mundi,* a depiction of Noah's Ark (commemorating the Flood as the first destruction of the world), illustrations of Jerome's commentaries on the Book of Daniel and its apocalyptic visions, portraits of the Evangelists, and numerous double-page and full-page miniatures as well as column pictures of the episodes narrated in the text of Revelation.[10]

Mozarabic artists excelled at illustrating the mystical visions described by Saint John (**fig. 12.10**). For "the four

Fig. 12.11. Magius and Emeterius (?). *Scribe and Miniaturist at Work in the Tower Workshop of Tábara*. Illustration in the Beatus of Liébana, *Commentaries on the Apocalypse*. 14¼ × 10⅛″. 970. Archivo Histórico Nacional, Madrid (Cod. 1240, fol. 139r)

Fig. 12.12. Emeterius and Ende. *The Four Horsemen of the Apocalypse*. Illustration in the Gerona Beatus of Liébana, *Commentaries on the Apocalypse*. 16 × 10″. 975. Cathedral Library, Gerona (MS 7, fol. 126v)

angels holding the four winds" (Rev. 7:1–2), the earth is presented as a splendid oval with bands of bright yellow, violet, and pink, with trees and bushes scattered here and there. Framed by a border of deep blue waters with fishes, it forms the setting for the multitude of the Elect from "every tribe of the children of Israel," standing hand-in-hand like so many paper dolls. In the corners, the four angels, like giant butterflies pinned there, hold on to antennae that represent the forces of the winds, while in the upper center, the angel with the seal blossoms from a red disc labeled SOL. This colorful image of the world is just one of the many enchanting full-page miniatures in the Apocalypse in the Pierpont Morgan Library in New York, one of the earliest Beatus manuscripts known. The Morgan Beatus is signed by Magius and dedicated to the Monastery of Saint Michael, very likely San Miguel de Escalada.

Magius later settled in the Monastery of San Salvador de Tábara, north of Zamora, where he established an important atelier that produced several Beatus Apocalypse manuscripts with illustrations. We know further that the *archipictor* Magius, as he was known, died at Tábara in 968. The intriguing

representation of the bell tower at Tábara (**fig. 12.11**) features the rooms of his atelier located in a side chamber on the second level. The cross-section shows the walls lined with colorful tiles, a horseshoe-shaped doorway, and ladders giving access from one floor to the next. Magius died before the completion of the Tábara Beatus, leaving the task to his disciple Emeterius, who tells us that in this "lofty tower" he sat "for three months, bowed down and racked in every limb by copying."

Elevated to the rank of master *pictor*, Emeterius continued his mentor's work at Tábara, employing an assistant, one Ende, a *pinctrix*, a nun who lived in a convent annexed to the monastery. Together they produced the beautiful Beatus Apocalypse, today in the Cathedral of Gerona and dated 975, with additional enrichments that were copied from Carolingian models. The sequence of pictures follows closely that established in the Morgan Beatus. The page with the Four Horsemen (**fig. 12.12**) is typical of these narratives, with the mounted destroyers added one after the other against glowing bands of color (compare the Trier Apocalypse, fig. 8.28).

Fig. 12.13. The initial S in the form of a juggler. Illustration from the Psalter Commentary of 980 (fol. 270v). Real Academia de la História, Madrid

Fig. 12.14. Prior Petrus. *Christ Appearing in the Clouds*. Illustration in the Silos Beatus of Liébana, *Commentaries on the Apocalypse*. 15¼ × 10″. 1109. British Library, London (Add. MS 11695, fol. 21r)

Mozarabic illuminations can be quite playful. On one page (**fig. 12.13**) from the Psalter Commentary of 980, produced in the scriptorium of the Benedictine monastery of San Millán de la Cogolla, a juggler swings his arms in opposite directions to form the letter S. The juxtaposition of curvilinear patterns on flat fields of color effectively communicates the rhythm of his performance.

A fine example of late Mozarabic art is the famous Silos Beatus in London (**fig. 12.14**), written by Dominicus and Nunnio between 1091 and 1109, and illustrated in part by Prior Petrus, who left us the plea to treat his manuscript with care. At the end of the text, he offers a touching admonition:

A man who knows not how to write may think this no great feat. But only try to do it yourself and you shall learn how arduous is the writer's task. It dims your eyes, makes your back ache, and knits your chest and belly together—it is a terrible ordeal for the whole body. So, gentle reader, turn these pages carefully and keep your fingers far from the text. For just as hail plays havoc with the fruits of spring, so a careless reader is a bane to books and writing.[11]

Prior Petrus' scriptorium was located in Castile at the Monastery of San Sebastian (later Santo Domingo) de Silos, where some of the finest examples of monumental sculptures in the Early Romanesque style are found. Meyer Schapiro has argued that the style of the Silos manuscript leads us from Mozarabic to Romanesque, and in many ways his observations are convincing.[12] Yet such a colorful page as *Christ Appearing in the Clouds* (Rev. 1:7–8) can hardly be disassociated from the Mozarabic style of the Leónese manuscripts.

However one describes the introduction of the Romanesque style—and we have observed many anticipations of it in tenth-century art—the one famous Beatus manuscript that shows the transition from Mozarabic to Romanesque is the Saint Sever Apocalypse in Paris, a lavish production made

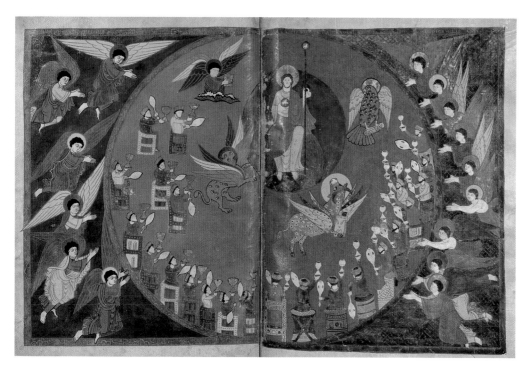

Fig. 12.15. *Maiestas Domini with Adoration of the Twenty-four Elders.* Illustration in the Saint Sever Beatus of Liébana, *Commentaries on the Apocalypse.* Each page 14⅜ × 11″. Mid-11th century. Bibliothèque Nationale, Paris (MS lat. 8878, fol. 121v–122r)

for Abbot Gregory Muntaner (1028–72) of the Gascon monastery in the western Pyrenees.[13] Here the models behind the Morgan and the Gerona Beatus cycles were followed faithfully, but the figures are normally proportioned and articulated with draperies that are more functional than patterned (**fig. 12.15**). Pockets of folds flare up at the ends in Romanesque fashion, the heads are more carefully drawn, and the gestures and movements are less conventionalized. A new style is announced here, one that portends the dynamic line of French Romanesque art. This transformation took place in the larger context of the sculptural enrichments of a new architecture in a broader international movement of style no longer bound to isolated regions and patrons but to the spread of the Church.

AFTER THE FALL
OF THE CALIPHATE

After the collapse of the caliphate of Córdoba in 1031, rival factions known as the *taifa*-kings (party rulers) competed for power. Al-Andalus became fragmented under these regional leaders. It was divided into seven major *taifas* and several smaller ones. *Taifa*-kings collected luxurious items and exhibited them to show their power and courtly prestige. Within this context, an expensive silk weaving (**fig. 12.16**), imitating valuable Persian fabrics, would have been a great treasure. On this crimson textile fantastic creatures, produced in dark green and yellow thread, are arranged in horizontal rows and follow designs popular in the Middle East. Although the representations of winged felines have been called witches, giving the work its title, the imaginary beasts closely resemble griffins. This silk weaving later fell into Christian hands and

was donated to the monastery of San Juan de la Abadesas in Catalonia, where it served as an antependium, a cloth covering the front of the church's altar.[14]

The decentering of authority and the lavish life-styles of the *taifa*-kings put Muslim territories at risk. To foster political stability against rivals, *taifa*-kings frequently offered bribes to their neighbors and regularly paid tribute to Christian kings. Throughout the eleventh century, Christian leaders in the northern kingdoms took advantage of the situation and intensified their Reconquista of the peninsula.

To defend their lands, the *taifa*-kings called upon the Almoravids, Muslims from northern Africa, for help. Upon entering Iberia, however, the Almoravids turned on the *taifa*-kings, taking control of al-Andalus for themselves. The Almoravids preferred modesty over ostentatious displays of wealth and openly criticized the *taifa*-kings for their lack of virtue and discipline. Although the Almoravids initially advocated a more austere manner of courtly life, in time they began to imitate their predecessors, producing luxurious art and architecture of their own.

In 1174, the Almoravids were overthrown by their Moroccan rivals, the Almohads. Although the city of Marrakesh served as the Almohad capital, Seville became its seat of power in Andalusia.[15] One of the early Iberian supporters of the Almohads was Ibn Rushd (more commonly known as Averroës). Noteworthy for his translations of Aristotle and Galen, Averroës helped reintroduce Classical thought into Western Europe. Christian scholastic philosophers and theologians, such as Saint Thomas Aquinas, would later revere Averroës as the greatest commentator on Aristotle.

The Almohads renewed the promotion of artistic restraint. For instance, the Giralda (**fig. 12.17**), the only

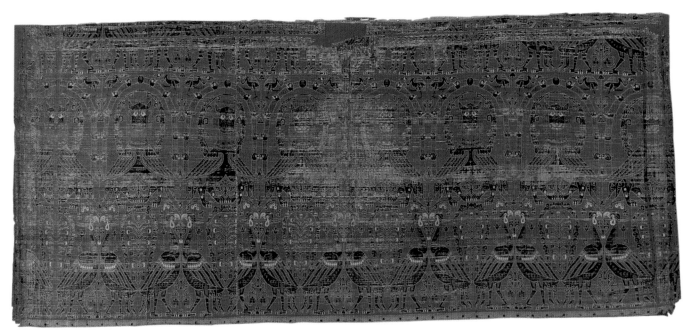

Fig. 12.16. *Witches Pallium.* Antependium. Silk. 39¾ × 91⅜″. 11th century. Museu Episcopal de Vic, Catalonia

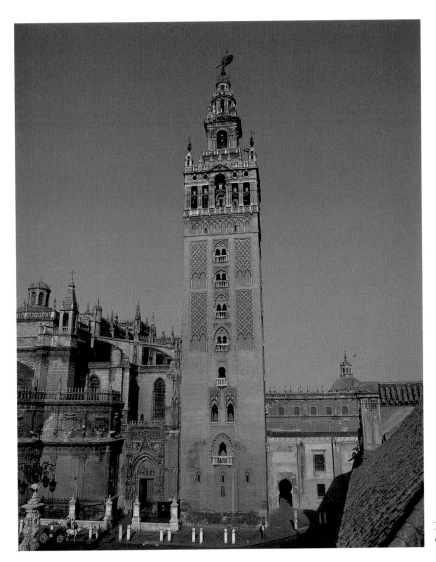

Fig. 12.17. Giralda minaret, Seville Cathedral. 1172–76. With later additions

surviving part of the Almohad mosque in Seville, is strictly controlled in the ornamental geometry of its brickwork. Based on minarets from Morocco, the tower appears austere but highly refined. Subtle variations in design keep the decoration from becoming redundant and monotonous. Today, the Giralda serves as the bell tower for the cathedral of Seville, simultaneously marking the defeat and past glory of the city's Muslim architecture.[16]

Spanish Muslims produced exquisite illuminated manuscripts and extraordinary tapestries. The calligraphy from a Qur'an now housed in the Bibliothèque Nationale in Paris (**fig. 12.18**) reinforces the sanctity of the holy writings as it conveys the rhythm of the spoken word. Diacritical marks rendered in different color facilitate pronunciation and recitation. Each *sura*, or chapter heading, is marked in reverse, in black with gold outlines, to separate it from the rest of the text. Small roundels are used to distinguish verses from one another. The style of the script, however, differs from traditional Kufic calligraphy. Angularity is replaced by a more

curvilinear technique. Graceful swinging curves join letters and words together in harmonious unity.[17] The fourteenth-century chronicler Ibn Kaldun claimed Western Muslims, unlike their counterparts in the Middle East, were trained to write entire words rather than separate letters. Whether true or not, his remarks reveal the power of cursive writing in Islamic Spain.[18]

The Almohads also highly prized silk weavings, both for their beauty and for the amount of labor it took to produce them. The Banner of Las Navas de Tolosa (**fig. 12.19**) contains nearly sixty warp threads per inch. Although decorated with numerous intricate interlocking geometric and organic motifs, an eight-pointed star in the center dominates the banner's design. On five distinct bands, calligraphy based on the Qur'an directs readers to Allah as the refuge from evil and as the merciful provider of paradise. Echoing the points of the central star, eight medallions hang from the banner's bottom, accentuating the luxurious and harmonious qualities of the weaving.

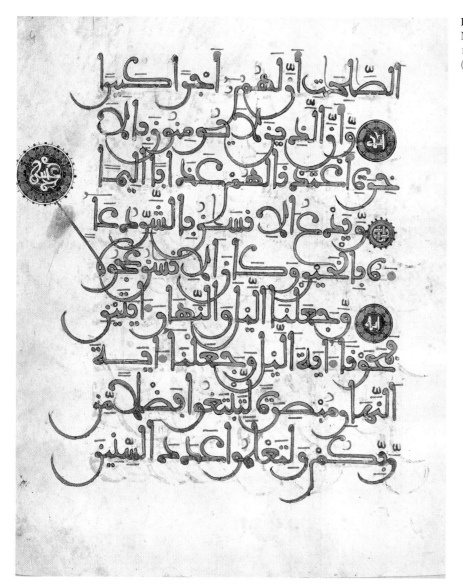

Fig. 12.18. Qur'an manuscript, Almohad or Nasrid period. 13th or 14th century. Vellum, 10⅓ × 8¾″. Bibliothèque Nationale, Paris. (Lesoeuf 217, fol. 4)

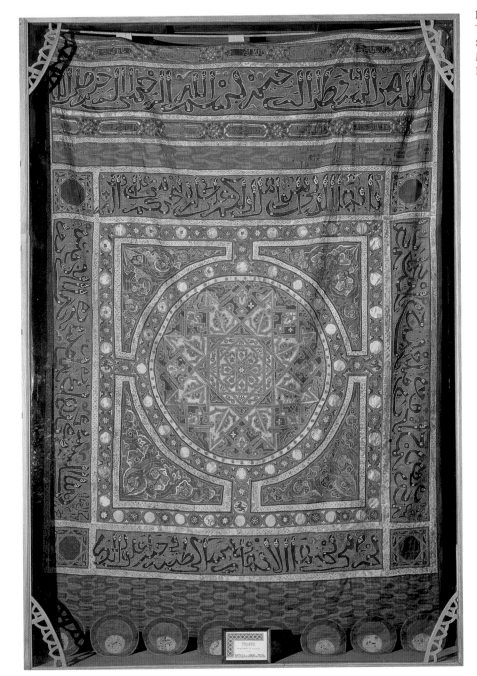

Fig. 12.19. The Banner of Las Navas de Tolosa. Silk and gilt parchment. 129⅞ × 86⅝″. 1212–50. Patrimonio Nacional, Museo de Telas Medievales, Saint María la Real de las Huelgas Monastery, Burgos

The title of the banner is a misnomer. The tapestry was thought to be a victor's trophy from the Battle of Las Navas de Tolosa, where the Christian king Alfonso VIII of Castile and his allies defeated Almohad armies in 1212. However, recent scholarship has revealed that the banner was acquired later, during the military campaigns of Fernando III. The king donated the banner to the Cisterian monastery of Santa María la Real de las Huelgas in Burgos as a sign of divine favor in the Christian crusade against Islam in Spain.[19] Throughout the thirteenth century, the Almohads continued to suffer major defeats and gradually lost power to the Christian kings.

CONVIVENCIA

Even though the Reconquista continued throughout the Middle Ages, scholars often describe the relationship between Muslims, Christians, and Jews residing in the same cities in terms of *convivencia*, living together in somewhat peaceful co-existence. Although "people of the Book" often tolerated the presence of one another in their cities, this never led to cultural homogeneity. Their contacts were sufficiently harmonious for economic gain and political stability, but the three religious groups also produced numerous rules and regulations to ensure the purity of their respective faiths. In other words, their communities may have been integrated, but

this is not to say that residents lived in a melting pot or that the assimilation was an easy or simple process. Cultural exchanges were frequently conducted with caution and suspicion and were not typically characterized by mutual equality. Admittedly, persecution and prejudices dramatically increased as Christians gained majority status. Nonetheless, despite efforts to foster uncontaminated religious identities and the marginalization of others, living together made significant differences across religious boundaries of all three faiths.[20]

In Toledo, the Ibn Shoshan synagogue (**fig. 12.20**) was divided into five aisles. This unusual organization of space may have resulted from *convivencia*, for it seems to have been appropriated from Muslim and Christian models. The dramatic horseshoe arches suggest similar imitation. The synagogue's interior walls were once covered with elaborate ornament and Hebrew calligraphy. The synagogue was later converted into a church, Santa María Blanca (Saint Mary of the Snows).

More than a century after the construction of the Ibn Shoshan synagogue, Samuel Halevi Abulafia, a treasurer and advisor to Pedro I of Castile, built a private synagogue (**fig. 2.21**) adjacent to his residence in Toledo. Known today as El Tránsito, a reference to its afterlife as a church dedicated to the Assumption of the Virgin, the synagogue is decorated with delicate multilobed arches and intricate stucco relief panels. The dazzling display of geometric and organic patterns, reminiscent of Muslim design, as well as the presence of inscriptions referring to the Temple of Solomon, heighten the sanctity of the space.[21]

GRANADA

By the middle of the thirteenth century, Christian leaders had reclaimed nearly all of the Iberian Peninsula. As Christians secured cultural dominance, the ideals of *convivencia* waned. Jews and *mudejars* (Muslims who chose to live under Christian rule) increasingly became subject to discrimination and violence. In the aftermath of Almohad control, Muhammad ibn Yusuf ibn Nasr regained his ancestral lands and established a small emirate in Granada. To guarantee the survival of his emirate, Muhammad and his descendants regularly paid large tributes to Spain's Christian kings.

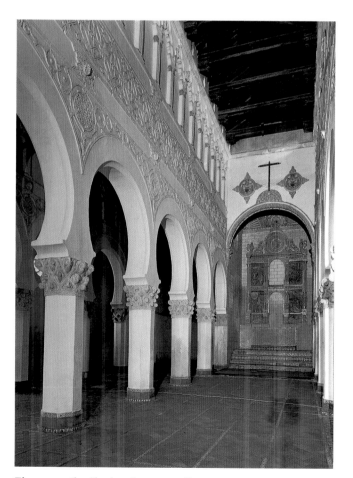

Fig. 12.20. Ibn Shoshan Synagogue (Santa María Blanca). Toledo. 13th century. Interior

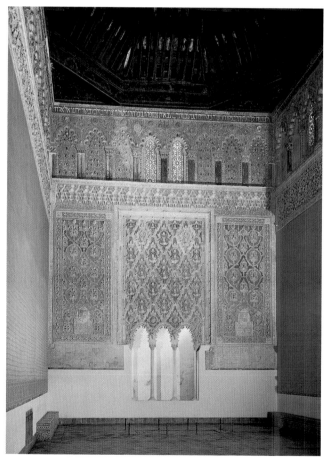

Fig. 12.21. Synagogue of Samuel Halevi Abulafia (El Tránsito). Toledo. 1355–57. Interior

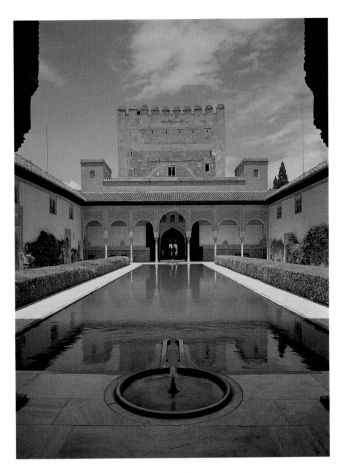

On top of a large hill overlooking the city of Granada, the Nasrid rulers built a fortified series of palaces known as the Alhambra (**fig. 12.22**), in a magnificent display of political authority. Although the Alhambra was a stronghold, it was also a glorious retreat, one designed to anticipate paradise on earth. The Alhambra contained many gardens pleasurable to the senses, and the presence of water in numerous pools and fountains reinforced its quality as an oasis. The walls of its castles are covered with delicate relief panels in stucco, enhancing the refined character of the courtly setting. Within one of its palaces, an intimate courtyard with twelve stone lions encircling a central fountain (**fig. 12.23**) offers respite fit for royalty. A *mirador* (observation chamber) on the second floor of the palace, with windows on three sides, allowed the emir to seek pleasure in viewing the inner patio within his castle as well as the valley below.

Fig. 12.22. Patio de Comares. Looking north.
c. 1320–70. Alhambra, Granada

Fig. 12.23. Courtyard of the Lions, Alhambra, Granada

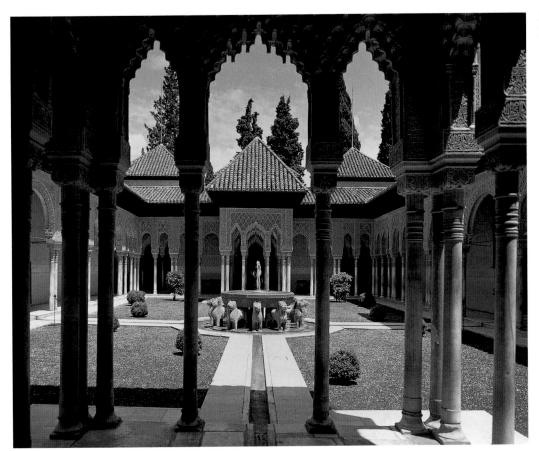

Fig. 12.24. Dome of the Hall of the Abencerrajes. c. 1370–80. Alhambra, Granada

The Courtyard of the Lions is surrounded by four pavilions. On the south side, the Hall of Abencerrajes (**fig. 12.24**), named after a noble family by nineteenth-century Romantics, provided a marvelous space for musical soirées. The substantiality of the walls seems to disappear in profusion of ornament, intricately carved in low relief. This decorative feature not only gives the room a light and airy quality, one conductive to relaxation, it also offers excellent acoustics. The dome above the room is shaped into an eight-sided star and may have symbolized the harmonious rotation of the heavens. Thousands of alternating convex and concave forms called *muqarnas* produce the elegant honeycomb or stalactite vaulting.[22]

In 1492, the year that Christopher Columbus sailed to America, Granada was defeated by the Catholic Kings, Fernando II of Aragon and Isabel I of Castile. This effectively brought the Reconquista to an end. Only weeks after taking control of the emirate, Isabel signed a decree expelling from her kingdom all Muslims and Jews who refused to accept Christianity. Fernando refused to endorse a similar policy in Aragon. In 1525, however, his successor and grandson, Charles V, approved the expulsion of unconverted Muslims and Jews across all of Spain. Islam was effectively banished from Spain and its mosques were destroyed or radically remodeled for Christian worship.

PART FIVE

THE ROMANESQUE

Fig. 13.1. Saint Martin-du-Canigou. French Pyrenees. 1001–26

13

PILGRIMAGE AND MONASTICISM

Carolingian lauds of the eighth century, "Christ is victor, Christ is king, Christ is emperor," announced the idea of Latin Christendom as a spiritual and temporal power presiding over the affairs of the world.[1] The world in medieval European eyes was quite small in our terms. They envisioned the world as a circle divided into three parts: Asia, Europe, and Africa. Pope Urban II, rallying the faithful for the First Crusade at the Council of Clermont in France (1095–96), decried the condition of the world. The enemies of Christ had seized control of Africa and Asia, and "There remains Europe, the third continent. How small a portion of it is inhabited by us Christians!"[2]

The Christian mission—beginning with that given to the apostles by Christ—to recover these lands for the *imperium christianum*, the kingdom of Christ, intensified. A mythology developed from the stories of the crusading campaigns of Constantine and his mother Helena in the fourth century, tales of the emperor Heraclius's efforts to recover the site of the Holy Cross in Jerusalem in 628, and those of Charlemagne to free the Christians from the Moors in Spain (the *Song of Roland*) in the eighth.[3] These stories revitalized the call for crusading knights of Christ in the Romanesque era.

Monasticism, founded as a mode of life in retirement or seclusion from the world, became the major organization within the Church. The Rule of Saint Benedict held the favor of the papacy, and Benedictine monastic houses spread rapidly throughout Europe.

Pilgrimages and crusades, with the pilgrimage roads forming the avenues that connected France to Spain and Italy, forged unifying links in these sprawling chains of authority.

Participating in pilgrimages to the holy sites was, of course, nothing new.[4] For centuries, Christians had performed pilgrimages, often as acts of contrition, but also as a means of gaining greater proximity to the divine through the cult of relics. European Christians, in increasing numbers, wandered from one hallowed shrine to another, usually converging on Rome and its great basilicas or, for the more ambitious, the Holy Lands in the East, especially Jerusalem. However, there were only brief interludes when Christians could safely visit the Holy Lands after they fell to Muslim hands, and consequently, during the course of the tenth and eleventh centuries, two places became the preferred pilgrimage sites: Rome and Santiago de Compostela.

The term Romanesque—meaning "in the Roman style"—is a fairly recent invention. Formerly considered a primitive phase of Gothic, the architecture of the eleventh and twelfth centuries was not given its present name or treated systematically until 1871, when Arcisse de Caumont published his "geography of styles," dividing the earlier buildings into seven regional groups.[5] Later, Caumont's schools of architecture were extended to include sculpture as well, especially the great tympana decorations.

CATALONIA (CATALUNYA)

Although scholars contest the origins of the Romanesque style,[6] most believe that it first appeared around the millennium on an east-west axis stretching from Lombardy in Italy across lower France and into Catalonia (Catalunya). The Catalonian churches are the best preserved. In 1928, an

architect and theorist from Barcelona, Josep Puig i Cadafalch, saw these structures as bridging the gap between the earlier (Visigothic, Carolingian, and Mozarabic) buildings in Spain and those of the Romanesque. Consequently, he named this phase the "first" Romanesque.[7] It was marked by the introduction of solid stone construction in the nave, with a heavy tunnel vault carried on massive piers or columns. The "will to vault" has been traced to Lombard workmen (the *comacini*), who were masters of scaffolding techniques used in vaulting crypts and side aisles with small, split stones used as bricks (*petit appareil*), a technique presumably introduced from Byzantium in the sixth century.[8]

As for decoration, the familiar Lombard corbel tables together with pilaster strips on exteriors formed a simple but effective accent to the austere surfaces of stone. In time, figurative sculptures appeared in the capitals and on the portals. Puig i Cadafalch isolated major plans, two of which interest us here. One consisted of a triple-aisled nave with tunnel vaults, without transepts, terminating in three apses opposite the entrance. The other featured the T-shaped basilical plan of Saint Peter's in Rome with a dome over the crossing of the nave and projecting transept arms.

A more picturesque setting can hardly be imagined than that of the monastery of Saint Martin-du-Canigou (French Pyrenees), nestled comfortably in the mountainous slopes above Prades (**figs. 13.1, 13.2**). The church, restored in the nineteenth century, has been dated to between 1001 and 1026. It was built on two levels and the upper church is particularly impressive. Three long tunnel vaults are carried on ten heavy supports consisting of two sets of columnar shafts separated by huge piers. The piers strengthen the middle of the nave, which is marked by a sturdy transverse arch across the vault. This sturdy arcade and the massive exterior walls resolve the problems of thrust and support. There is no clerestory, and hence the small windows at either end of the nave provide the only illumination.

The first abbot of Saint Martin-du-Canigou, the monk Scula, apparently supervised the building of the church. Its founder was Guifre, count of Cerdagne (later a monk at Canigou) and brother of the famous churchman Oliba, abbot

Fig. 13.2. Saint Martin-du-Canigou. French Pyrenees. Nave, upper church. 1001–26

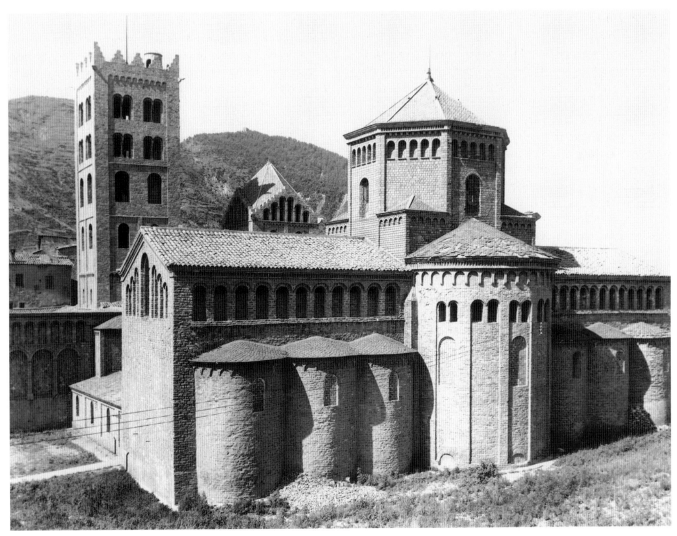

Fig. 13.3. Santa María, Ripoll, Spain. Exterior from north (restored after fire of 1835). c. 1020–32

of one of the leading cultural centers in the West, Santa María at Ripoll (**fig. 13.3**).[9] The plan of Oliba's church at Ripoll reminds us at once of the Basilica of Saint Peter in Rome, which it undoubtedly is meant to copy, with the addition of three apses on either arm of the transept. A view of the exterior (restored after a fire of 1835) dramatically changes this impression, for here we find massive walls of small stones with rhythmic pilaster strips and corbel tables applied to the elevation and a great cupola over the crossing. Even more surprising is the interior with its ponderous tunnel vaults resting on great thick piers. Windows pierce the clerestory above the nave arcade, but its austerity remains forbidding and cold. However, one must imagine the barren expanses of walls brightly decorated with frescoes, the floors glistening with marble, and lavish furnishings accenting the deep space.

In the hills some forty miles southwest of Ripoll is the elegant Church of Sant Vicenç at Cardona Castle. Begun about 1029 and consecrated in 1040, it is raised on a simpler plan with no projecting transepts. However, the building

techniques employed are so advanced that it is difficult to imagine the rapid strides in masonry that occurred in the early eleventh century. With its keen articulation of parts, the interior (**fig. 13.4**) is especially impressive. The great tunnel vault of the nave is divided into bays by transverse arches. For each vaulted bay of the nave, three groin vaults are employed in the side aisles and, over the crossing, a dome on squinches appears. Perhaps most significant feature of Sant Vicenç, however, is the use of a new architectural innovation, the articulated or compound pier. These giant supports have a complex cross section formed of trebled rectangular projections from the basic square, each of which corresponds to some element in the rising elevation of the interior. These piers form, in their cross section, a kind of working ground plan for the masons, and from their profiles the various aspects of the interior can be visualized in three dimensions.

The articulated pier is one of the major inventions in Romanesque architecture; it introduces a sophistication of building techniques and a process of thinking in architecture—

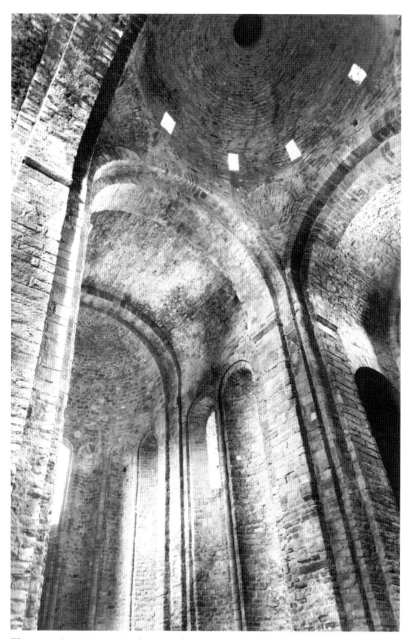

Fig. 13.4. Sant Vicenç, Cardona Castle, Spain. Interior. c. 1029–40

frequently these carvings seem to be iconic. At Saint Genis-des-Fontaines in the Pyrenees, a marble lintel (**fig. 13.5**), two feet high, spans the central doorway with a representation in relief of a squat Christ in Majesty within a figure-eight-shaped mandorla carried by angels. Aligned on either side are three doll-like figures of the apostles squeezed tightly within an arcade of horseshoe arches, resembling the childlike friezes of figures found in Beatus Apocalypse illustrations in the Mozarabic style.

The apse fresco of Sant Climent (**fig. 13.6**), in the mountain village of Tahull, depicts Christ in a mandorla. Reminiscent of a Byzantine *Pantocrator* image, he offers a gesture of blessing and holds an open book. Four angels who grasp symbols of the four Evangelists surround Christ. The elongated heads of the figures and the horizontal bands of solid color behind them recall Mozarabic painting. Latin words inscribed in Christ's book refer to him as the Light of the World (John 8:12). Suspended Greek letters, alpha and omega, located near Christ's shoulders, suggest that he is the Beginning and the End, the First and the Last (Rev. 1:8; Rev. 22:13). The iconography of the fresco reinforces the altar space as an eschatological place, where participants in the sacrament celebrate communion with the saints, represented in the lower register, in the kingdom to come. The heavy outlines of the figures and the thick folds of their drapery give the scene a flat, iconic appearance. Yet Christ seems immediately present, confronting viewers and compelling them to recognize his divine authority in the here and now as well as in the future, when he will triumphantly return. The apse fresco is no longer in Tahull; it has been detached from its original site for protection and is now reconstructed in the National Museum of Catalonian Art.

Although its initial location remains a mystery, a three-foot high wooden crucifix (**fig. 13.7**) was once displayed inside a Catalonian church. It was based on the *Volto Santo* (Holy Face), a now lost sculpture brought to Lucca (Italy) in the eighth century. According to legend, the sculpture was produced by Nicodemus, who witnessed the Crucifixion and helped to remove Christ from the cross. In the Batlló Crucifix, Christ is alive, with open eyes. He does not appear to be physically suffering. His bowed head and downcast eyes, however, suggest personal acknowledgement of the sacrifice he is making, encouraging beholders to mediate on its meaning. The Latin inscription above his head reads, "Behold

the stone mason's concept—that have revolutionary implications for later medieval buildings in the North. The articulated pier imposes a strict division of the nave into bays, which are added one to the other longitudinally and are clearly marked by transverse arches. Later Gothic architects would transform this mathematics of addition into one of division.

Some of the earliest examples of figurative sculptural decoration in architecture are found in the "first" Romanesque churches of Catalonia and the Pyrenees. Not surprisingly, these early experiments appear in marginal areas such as capitals, cloister piers, and portals. Small figures, often merely incised, appear like badges affixed to the face of a floriate capital. Sometimes a narrative is involved, but more

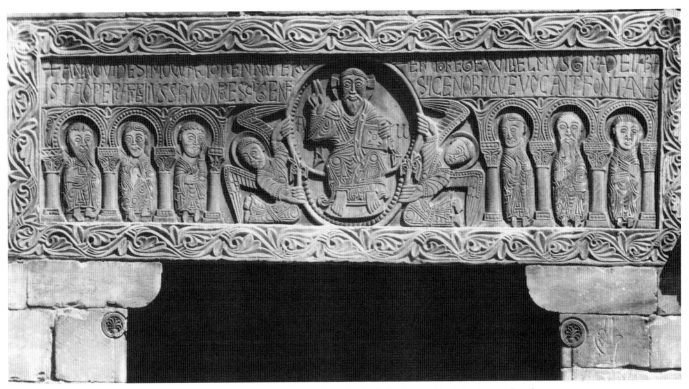

Fig. 13.5. Saint Genis-des-Fontaines, French Pyrenees. Marble lintel with relief of *Maiestas Domini*, approx. 2′ × 7′. 1020–21

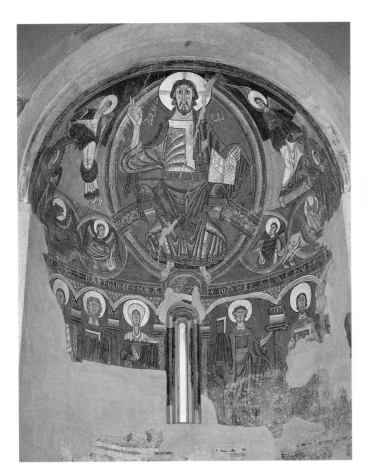

Fig. 13.6. *Christ in Majesty*. Apse fresco of Sant Climent, Tahull. Museu Nacional d'Art de Catalunya, Barcelona

Fig. 13.7. Batlló Crucifix. Olot Region (Catalonia). Wood with polychromy. 61⅜ × 47¼″. Middle of the 12th century. Museu Nacional d'Art de Catalunya, Barcelona

Fig. 13.8. Creation Tapestry. Embroidered in wool and linen on a wool background,
12′ × 15′ 8″. c. 1100. Gerona Cathedral Treasury, Spain

the King of the Jews." Surprisingly, Christ is not represented in a loincloth, but in an elaborate robe. The long-sleeved belted tunic, called a *colobium*, is decorated with Islamic motifs and appears to have been made of silk. The hem of the garment has false Arabic writing. As mentioned earlier, Iberian Christians occasionally appropriated Muslim textiles to cover the fronts of their altars and to line precious reliquaries. Consequently, Christ's ornate attire, although Islamic in appearance, was easily associated with the sacred.[10]

Catalonians also produced fine cloth of their own. In Gerona, the Creation Tapestry (**fig. 13.8**), made with linen thread against a wool background, depicts a beardless Christ as *Pantocrator* in the center of a compositional wheel, filled with scenes from Genesis, including the Days of Creation, the Creation of Eve, and Adam Naming the Animals. In the corners, symbols of the four winds turn the wheel, suggesting the movement of the days. On three sides, marginal representations of the labors of the months and emblems of the *annum* and solstices continue to convey the passage of time. Curiously, in the bottom margin, the legend of the Discovery of the True Cross is shown. Although it is not certain where or how the tapestry was originally displayed, its complex iconography reveals a belief in the enduring lordship of Christ from the beginning to the end of Creation.

THE ROAD TO SANTIAGO

Rapid developments in Romanesque architecture and sculpture in the last decade of the eleventh century appeared almost simultaneously in Spain and France. Four roads or avenues linking various religious centers in France led southward to the Pyrenees, where they joined and continued westward to the Church of Saint James in the "field of stars" in Galicia. We are fortunate that a twelfth-century handbook for pilgrims, written by the priest Aymery Picaud (preserved in an encyclopedic account of Saint James, the *Liber Sancti Jacobi*), survives as a firsthand description of these routes.[11] The southernmost road started in Arles at the column memorial to the martyr Saint Genes. It led westward through churches built over tombs, including that of Saint Gilles, on to Toulouse, where the relics of Saint Sernin were enshrined, then south into the Pyrenees, crossing into Spain, where it

initiated the major avenue across northern Iberia to Santiago de Compostela.

The second route described in the guide led from Burgundy through Notre Dame of Le Puy and Sainte Foy at Conques. The road continued to the magnificent church of Moissac and onward to Ostabat at the foot of the Pyrenees. Another, somewhat rambling route, also started in Burgundy at the Church of the Madeleine in Vézelay, led south to the tomb of Saint Front at Périgueux, and finally joined the second road near Ostabat. The fourth, beginning at Paris and Chartres, followed the Loire from Orléans to the age-old sanctuary of Saint Martin at Tours, then southward through Poitiers, Saintes, to Bordeaux, and finally converged with the other roads at Ostabat. Once across the Pyrenees, the routes formed a single road that led through the battlefield of Roncevaux, famous in the Charlemagne legends, and across

Fig. 13.9. Cathedral of Santiago de Compostela. Interior toward east. 1075–1120

Fig. 13.10. Cathedral of Santiago de Compostela. Plan (after Dehio)

the treacherous country of the Basques. This final, long leg of the journey led from Puente la Reina via Burgos and León to Compostela. The first in the group of pilgrims to sight the towers of the church of Santiago was proclaimed *roi*, or king.

The "Way of Saint James" was thus a challenging journey through the heartland of the major Romanesque churches and, like tourist centers today, the various communities vied with each other to attract the donations of the weary travelers who trudged for months from one station to the next. The towers of Santiago seen by the *roi* of the pilgrims in the twelfth century are not those that greet the modern visitor. The exterior of the famous cathedral has changed considerably over the centuries. The imposing west facade is an ornate and theatrical Baroque frontispiece masking the original two-towered entranceway, and while the flanks of the building retain something of their original massiveness, several parts have been rebuilt, restored, or added through the years.

The Romanesque cathedral, built over an earlier ninth-century church (now beneath the huge choir), was begun about 1077–78 under Bishop Diego Peláez and completed by 1124 or 1128 by his successor, Diego Gelmírez (**figs. 13.9, 13.10**). The sculptural decoration was gradually added to enhance its role as the principal monument of the pilgrimage roads.[12] The interior, entered through the Pórtico de la Gloria, with its deep, dark nave (250 feet long) and shadowy tunnel vaults, marked off regularly by the round transverse arches, is well preserved. The solemn cadence of the handsome piers of brown granite and their colonnettes rising into transverse arches mark off the nave rhythmically into square bays that lead us slowly toward the altar—the focus of pilgrims for more than a thousand years.

In the ground plan of Santiago de Compostela, we at once recognize the bold restatement of the T-shaped design of Saint Peter's in Rome, but now the complexities are multiplied, with great western foundations for the original two-towered facade. Apsidioles are attached to the transept arms and seem to sprout from the huge semicircular aisle with groin vaults that encircles the apse. This passageway, known as an ambulatory, together with the additional apses with altars, constitute what is called a pilgrimage choir, an innovation of earlier pilgrimage churches (for example, Saint Martin's at Tours) and a division of the basilical structure that will continue to grow and expand until the body of the church is nearly engulfed by it.

The additional altars were necessitated by the proliferation of relics displayed for the pilgrims—each altar housed a different relic—and the ambulatory gave the visitor access to those shrines behind the main altar. Furthermore, reforms in the church required priests in residence (canons) to perform at least one

Mass daily to accommodate the crowds. To provide even more space, the aisles of the nave were continued about the transept arms. In the twelfth century, a huge wall marked off the choir from the nave, separating the canons from the milling crowds of pilgrims.

From the ground plan one can see how the cross section of the piers led the masons in the construction of the church. A columnar shaft is attached to each face of the square pier. The inner colonnettes rise through the entire height of the nave (sixty-eight feet) to mark the spring of the transverse arch in the vault; the lateral shafts mark the arcades between the piers down the nave, while the fourth supports the transverse arch of the side aisles. Groin vaults are employed in

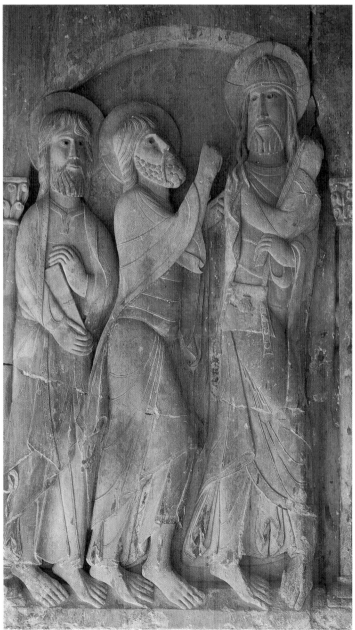

Fig. 13.11. *Road to Emmaus.* Stone relief on cloister pier. c. 1100. Santo Domingo de Silos, Spain

the bays of the side aisles, and the cross-ribs that mark them into quadrants rest on the corners of the piers. Thus the piers and their shafts both bind the divisions of the interior into a coherent whole and also articulate its elevation with the repeated round arches that rise from them. Here we can see why the term Romanesque is so appropriate. Great walls of stone masonry, simple geometric forms, define massive volumes of space and emphasize the gravity and austerity of the structure, much as in ancient Roman buildings.

The nave elevation of Santiago is also typical of many pilgrimage churches. It builds up majestically in three giant steps: the sturdy nave arcade; the solemn open gallery (each bay has another round arch divided into two smaller arches

Fig. 13.12. *Doubting Thomas.* Stone relief on cloister pier. Santo Domingo de Silos

between elegant shafts); and, finally, the broad contour of the tunnel vault spanning the nave. Surprisingly, there is no clerestory. The illumination of the interior is achieved through the fenestration at both ends of the nave—the facade and the apse—and whatever filters in from the windows in the outer walls of the side aisles. The great octagonal lantern that covered the crossing of the transepts and the nave also had windows to spotlight the beginnings of the great choir.

During the late eleventh century, the monastic church of Santo Domingo de Silos (Castile) became a pilgrimage site. Pious travelers visited Silos to venerate the sacred remains of Santo Domingo. In response, the abbot of the Benedictine monastery tried to strike a balance between monastic seclusion and public appeal by constructing a new cloister. Although the cloister was frequently closed off from the laity to foster meditational retreat among the monks, it was occasionally opened to the public. The piers of the cloister were decorated with six sculptural reliefs of biblical scenes from the Descent from the Cross to the Pentecost (two later reliefs, dedicated to the Coronation of the Virgin and the Tree of Jesse, were added in the twelfth century).

In the Road to Emmaus relief (**fig. 13.11**), three barefoot travelers, looking in different directions, appear to move left to right. Christ is depicted as the lead figure and is slightly larger in scale. His legs are oddly crisscrossed, suggesting a moment of hesitation and enabling the sculpture to maintain the contours of the pier. A satchel at Christ's waist is decorated with a pilgrimage badge, the scallop shell of Saint James, producing a pictorial analogy between the Road to Emmaus and the Road to Santiago as pathways where pilgrims can encounter Christ.

Another pier relief represents Doubting Thomas (**fig. 13.12**). In front of witnessing apostles, the resurrected Christ lifts his right arm to expose his wound to Thomas's touch. The narrative is framed by crenelated architecture and four musicians, two of whom are women. Meyer Schapiro has suggested that the musicians are secular entertainers (*jongleurs*), outside of church control. In the biblical account (John 20: 19-29), however, upon providing Thomas with sufficient visual evidence of his resurrection, Christ offers a blessing to those who have not seen but believe. Although the pier relief exposes the narrative to sight,

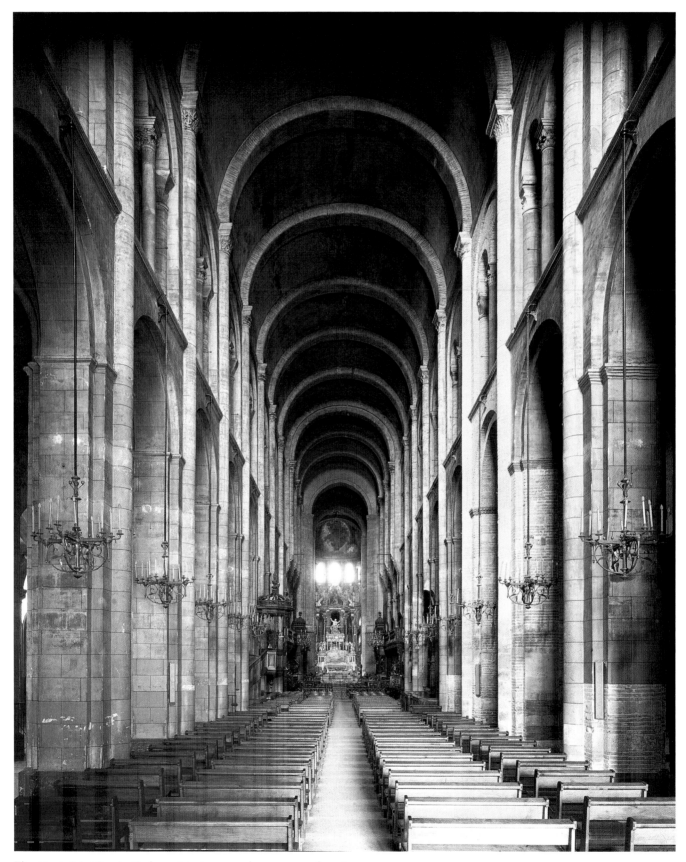

Fig. 13.13. Saint Sernin, Toulouse. Interior. 1070; altar consecrated 1096

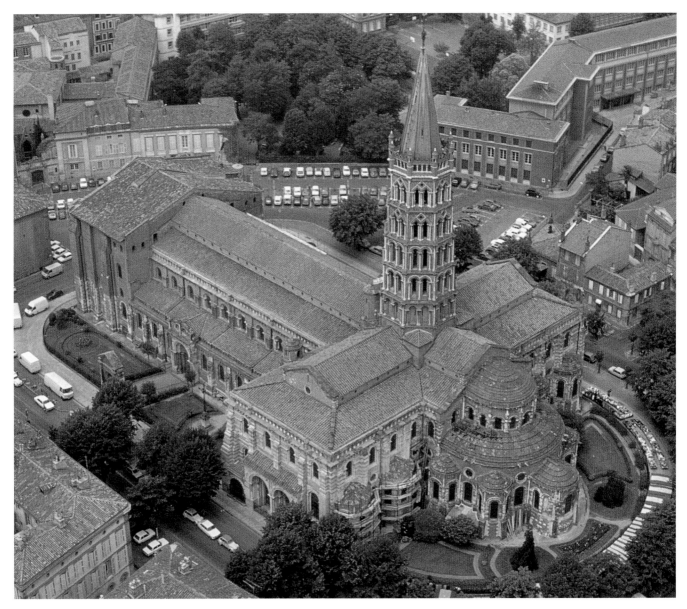

Fig. 13.14. Saint Sernin, Toulouse. Aerial view

it gives precedence to faith. By contrast, in Schapiro's view, the musicians are merely preoccupied with pleasing the senses. More recently, O.K. Werckmeister has argued for an alternative interpretation. In his view, the musicians performing above the secluded scene promote the monastic church as a place of public worship.[13]

Also located on a major pilgrimage route is the church of Saint Sernin in Toulouse (**figs. 13.13, 13.14**).[14] Here the scale is grander, and double side aisles appear. Otherwise, the interior duplicates that of Santiago (the *petit appareil* stonework has been painted to simulate larger building blocks). The exterior preserves its original twelfth-century appearance —the two towers of the facade were never completed—and offers us a view of the stately splendor of Romanesque architecture in the great massing and integration of cubic

volumes, including cylinders and cones, that is reminiscent of the simple harmonics and rhythms of a medieval plainsong. Pilaster strips on the exterior, marking the internal structure of the bays, relieve the overpowering austerity of the huge unadorned geometric forms in space; a coursing of blind corbel tables accents the roof lines; while heavy round arches carried on half-columns articulate the windows in the apsidal chapels and the upper walls. A towering octagonal spire, added in the thirteenth century, built in elegant stages, provides an emphatic focus for the pilgrimage choir.

Saint Sernin was built (the foundations date to about 1060) as a collegiate church for Augustinian canons, and in 1082–83 Cluniac monks were installed for purposes of reform. Pope Urban II consecrated the high altar in 1096, and the original marble altar table survives, with tiny angels

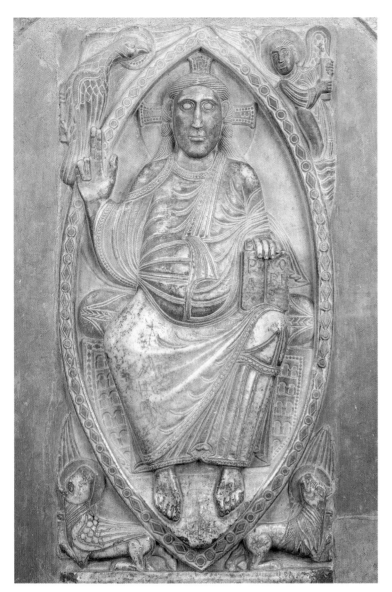

Fig. 13.15. *Maiestas Domini*. Marble relief in Saint Sernin, Toulouse. Height 50″. c. 1096

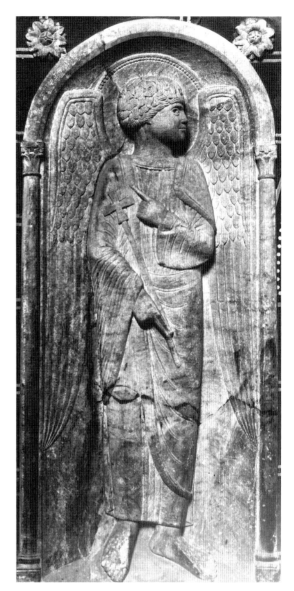

Fig. 13.16. *Angel*. Marble relief in Saint Sernin, Toulouse. Height 72″. c. 1096

carrying a medallion portrait of Christ carved along its rim. The style of these minuscule sculptures, dating to about 1096, corresponds to that of the more famous stone plaque reliefs presently set into the ambulatory wall behind the altar, with monumental representations of a *Maiestas Domini* flanked by standing apostles and angels in arched niches (**figs. 13.15, 13.16**). It is unlikely that the present location of these sculptures is original, and it has been suggested that the five stone reliefs formed part of an exterior, probably portal, decoration, or part of a shrine of Saint Sernin in the crypt of the church.[15]

The style of these imposing sculptures merits our attention. The sculptures resemble ivory plaques, and it is by virtue of the fact that the individual figures are carved independently on single stone slabs that some art historians refer to this early phase of Romanesque sculpture as the

"plaque style."[16] The sharply incised contours that describe the outlines of the drapery, the smooth facial features, and the abstract ornamental motifs about the aureole of Christ all bring to mind the metallic traits of Ottonian representations. Conventions are reduced to geometric formulae, and all forms are conceived as coplanar, with the surface as if pressed between panes of glass so that the bodies are flat, frontal, and static, with closed contours squeezed within the tight confines of the arched frame.

A similar design to that at Saint Sernin can be found in the Church of Sainte Foy in Conques (**fig. 13.17**). To accommodate pilgrims, the building includes a wide transept and an ambulatory with radiating chapels. Pilgrims traveled to Conques to venerate the relics of a local child-martyr (d. 303) who refused to offer sacrifices to a Roman god. The remains of Sainte Foy, however, were not initially translated to

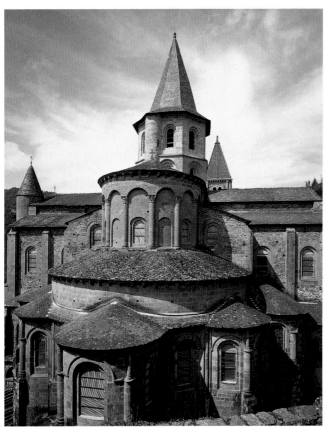

Fig. 13.17. Abbey Church of Sainte Foy, Conques. 11th–12th century with later additions

RIGHT **Fig. 13.18.** Reliquary of Sainte Foy. Gold and jewels over wood (incorporating ancient Roman helmet and cameos), height 33½″. 11–12th century with later additions. Cathedral Treasury, Conques

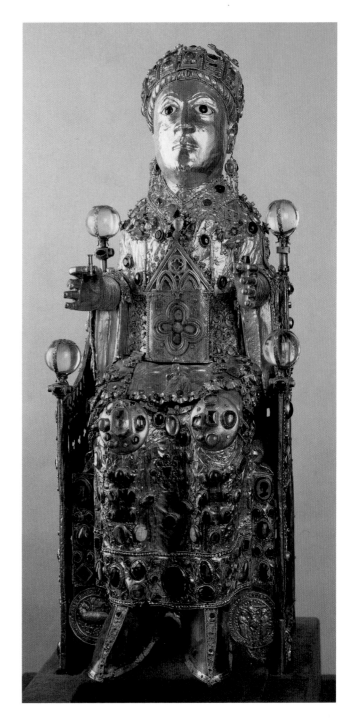

Conques, but to the nearby town of Agen. In fact, a monk stole the relics and brought them to Conques—monasteries regularly competed for popularity among pilgrims. An act of holy theft (*furta sacra*) performed for the spiritual good of the community, as opposed to material gain, legitimated the monk's actions (at least for the citizens of Conques). The gold-covered reliquary of Sainte Foy (**fig. 13.18**) is approximately three feet tall and the figure's enlarged head is made from an ancient Roman helmet. Numerous cameos and gems attached to the image were donated by venerating pilgrims.[17]

Lying some forty miles northwest of Toulouse is the church of Saint Pierre, a stopping point on the road leading from Le Puy. Legend has it that the original shrine at Moissac dated from the time of Clovis, the Merovingian ruler. It was razed by the Saracens in the eighth century, rebuilt by Louis the Pious, and destroyed by fire again in 1042. With the second rebuilding, the community was guided by the famous reformer of Cluny, Odilo, who appointed as abbot the Cluniac monk Durandus (1047–72), an illustrious churchman who also served as bishop of Toulouse. Much of the rebuilding is attributed to Durandus, but his name is not associated with the famous sculptures at Moissac. According to an early chronicle, a later abbot, Anquêtil (1085–1115), built the cloister and commissioned the tympanum sculptures for the church. The decorations were completed under Abbot Roger (1115–31). Two distinct workshops were involved, that of the cloister and that of the south portal sculptures.

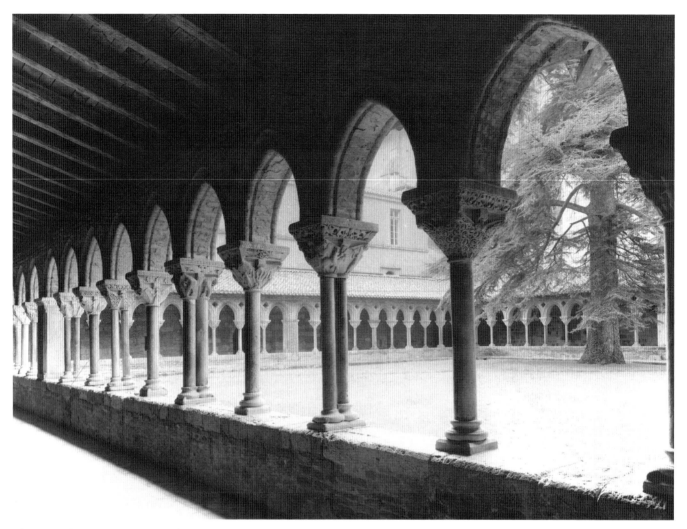

Fig. 13.19. Saint Pierre, Moissac. Cloister. c. 1100

The attribution of the cloister and its sculptures to Anquêtil seems certain (**fig. 13.19**) since the same workshop that executed the ambulatory reliefs at Toulouse was employed to execute the giant pier sculptures in the cloister. The inner sides of the corner piers have over-lifesize figures of standing apostles in shallow relief nearly identical in style to those at Toulouse. The most impressive figure, however, is the fully frontal commemorative portrait of Abbot Durandus (**fig. 13.20**) on the inside of the central pier on the east side of the cloister. The name "Durandus" is inscribed on the halo about the head, but aside from his ecclesiastical vestment, the abbot is treated in the same style as the apostles. This cannot be considered a true likeness, however; his rigid stance, his elaborate vestments and crosier serving as attributes of office, and his mask-like face all stamp this as a symbolic portrait.

The glory of Moissac is the south portal (**fig. 13.21–25**), where a new workshop, active about 1115–30, introduced a new style in sculpture. The tympanum over the doorway displays one of the most impressive *Maiestas Domini* representations ever created; the immediate door jambs and trumeau (central door post) below have extraordinary reliefs of two apostles and two prophets carved into them; the lateral walls carry complex narratives and moralizing stories. To the right, a double register and frieze of figures are devoted to the Infancy of Christ. The left illustrates the story of the Rich Man and Lazarus with personifications of *Luxuria* and *Avaritia*. Finally, the outer spandrels have portraits of Saint Benedict, the founder of their order, and Abbot Roger, under whom the church was completed.

The giant overlord—later nicknamed *Re clobis* (King Clovis) by local inhabitants in memory of the legendary benefactor—looms from the center of the tympanum with awesome majesty like an apparition (**fig. 13.22**). Relevant details described in the fourth chapter of Revelation are here. Angels and the beasts of the Apocalypse crowd about the Enthroned One; the sea of glass ripples across the tympanum below his feet; and the twenty-four elders are seated irregularly in three tiers in the margins of the field. A new style presents itself here, with an abstraction conveyed through dynamic linearism—the culmination of stylistic

Fig. 13.20. *Durandus.* Marble relief on cloister pier, Saint Pierre, Moissac. Height approx. 6'. c. 1100

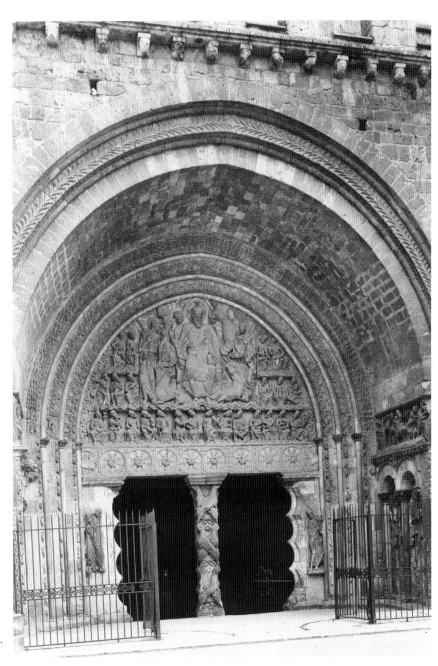

Fig. 13.21. Saint Pierre, Moissac. South portal. c. 1115–30

tendencies traceable to the exciting lines of the Utrecht Psalter. Irregular patterns of vibrating lines flicker across the surface as drapery edges dance and swell arbitrarily about the attenuated figures. Meandering ribbons along the outer border merge with the ruffled draperies of the impatient Elders seated on the perimeter, reminding us of the fusion of animal and ornament in Irish art. In contrast to the plaque style, this mode obeys no rigid frame. The design, in fact, is carved across twenty-eight blocks of stone with little regard for their junctures or structural integrity.

Within the throbbing patterns of lines there emerges a careful organization, however. Hieratic scale and centrality clearly govern here. The largest figure, the frontal Christ, is the central element, and he is the most rigid in pose, the least affected by the vibrancy of the racing lines about him. The scale decreases, the agitation increases, as we move out in concentric circles from the center. The smallest and most numerous figures, the twenty-four elders, carved nearly in the round, squirm restlessly on their benches, disturbing the symmetry of the hieratic organization as they cross and uncross their legs. An important feature of this developed Romanesque style is the subordination of the carved figures to the architecture. St. Peter and the Prophet Isaiah are represented on the door jambs. On the life, an elongated figure of the monastery's patron saint (**fig. 13.24**) appears with one knee lifted high above the other. His contorted

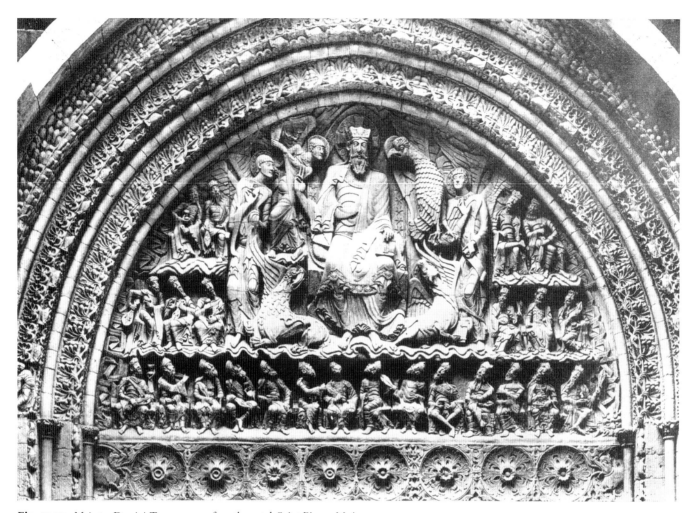

Fig. 13.22. *Maiestas Domini.* Tympanum of south portal, Saint Pierre, Moissac. c. 1115–30

pose accentuates the cusped edge of the jamb, while suggesting movement. Peter's turned head directs our attention to the church's entrance, inviting viewers to pass through its gates.

The heavy tympanum rests precariously on scalloped jambs and a writhing trumeau post (**fig. 13.23**). Three super-imposed lions and lionesses confront each other on the outer face of the trumeau; on the sides, marvelously elongated figures of Saint Paul and a prophet, their emaciated torsos twisted and crisscrossed, serve as exhausted caryatids for the *Maiestas Domini* weighing down heavily on them.

On the lateral walls to the right, scenes from Christ's infancy are shown, with the Adoration of the Magi, pre-senting gifts, located in the center (**fig. 13.25**). The sculptures on the left wall, in contrast, vividly serve as a warning for those who transgress the moral teachings of the Church. Above the twisted personifications of *Luxuria* and *Avaritia* and their satanic companions, the lesson illustrated is that of the rich man (Dives) and Lazarus, the parable (Luke 16:19–31) that teaches that sensual pleasure and earthly treasures are empty substitutes for heavenly rewards. The close nexus between lust and greed may have warned beholders of the

dangers associated with mercantile trade and moneylending, economic activites beyond ecclesiastical and guild control. Dives is claimed by demons on his deathbed, while the poor and humble Lazarus is lifted to the bosom of Abraham, the image of heaven in the parable.

Another vivid explication of the evils of avarice, the major deadly sin for the Romanesque period, appears at Souillac, just north of Moissac (**fig. 13.26**). Giant reliefs—originally part of the lateral walls of the major portal—illustrate the story of the avaricious Sicilian vicar Theophilus, a kind of medieval Faust figure, who sold his soul to the devil in return for riches and a high station in the Church. Below, Theophilus appears twice with a grotesque demon, taking an oath of fealty to Satan. After he prays for intercession, Mary mercifully saves the erring vicar in the second register. Aside from serving as an admonition against avarice and heresy, the legend of Theophilus introduces us to another aspect of the Romanesque age, namely the sudden proliferation of the popular miracles of the Virgin, which ushered in a vast new repertory of subject matter. The church at Souillac, further-more, was dedicated to the supreme intercessor for humanity, Notre Dame.[18]

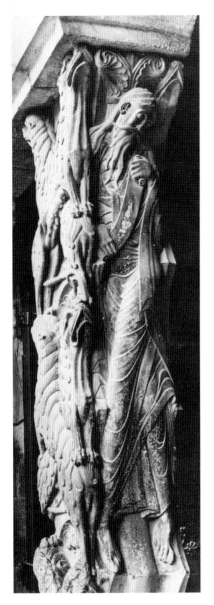

ABOVE LEFT **Fig. 13.23.** Prophet and lions. Trumeau of south portal, Saint Pierre, Moissac. c. 1115–30

ABOVE CENTER **Fig. 13.24.** Saint Peter. Jamb relief sculpture on south portal, Saint. Pierre, Moissac. c. 1115–30

ABOVE RIGHT **Fig. 13.25.** *Scenes of Christ's Infancy*. East wall of south portal, Saint Pierre, Moissac. c. 1115–30

LEFT **Fig. 13.26.** *Legend of Theophilus*. Stone relief from the former portal, Sainte Marie, Souillac. c. 1130

Fig. 13.27. *Prophet Isaiah.* Stone. Relief formerly placed on a door jamb. Sainte Marie, Souillac. 1125–30

The sculptor of the Theophilus relief offers an alternative to the conventions governing Classical composition. There is no uniform symmetry or centrality in the ordering of the actors in the tragic melodrama. In fact, the larger and more hieratic figures are those of Saints Peter and Benedict placed on the sides. Like giant bookends they frame the narrative scene. In one of the more memorable reliefs from the ensemble at Souillac, the "dancing" prophet Isaiah (**fig. 13.27**), these same dissonant contortions convey a sense of excitement and exuberance in the twisting seer who announces to the world that "a virgin shall conceive and bear a son, and his name shall be Emmanuel" (Isa. 7:14).

CLUNY

In 909, Duke William of Aquitaine presented a farmland with an old Roman station, Cluniacum, in the valley of the Grosne River, to the Benedictines. Berno of Baume, abbot of Benedictine abbeys in the area, built a modest church there (910–16). An important condition of the charter was that this new house was to be free of any local jurisdiction (the bishop or the duke) and owe allegiance only to the pope in Rome. Berno took advantage of this uniqueness and initiated an ambitious program of monastic reform with Cluny as its headquarters. Blessed with a sequence of unusually capable abbots, Cluny grew from its humble beginnings to become the largest, most powerful, and most culturally enriched monastery in all Europe.[19]

The first church, often identified as Cluny I, was a simple structure about one hundred feet long dedicated to Saints Peter and Paul. Little is known of Cluny I or Abbot Berno, but his successor, Odo (927–44), renowned for his saintly character, followed Berno's program of reform with zeal, and the prestige of Cluny spread rapidly. From the emperor Henry I, and from the pope, Odo received special privileges to oversee, as a reforming abbot, other monasteries and to append them to Cluny as "daughters," thus giving rise to the establishment of a "family" or congregation of Cluniac churches independent of other Benedictine abbeys.

Odo's fame spread to Italy, and he made a pilgrimage to Rome and south Italy in 939, reforming churches along the way, among them the original Benedictine foundation at Monte Cassino. While not recorded as a great patron of the arts, Odo was an avid musician—an important category of knowledge at Cluny—and attributed to his hand are Psalms set to music and even a treatise, *Dialogus de musica*, that provides a rudimentary system of musical notation.[20]

Within a generation, the old church at Cluny proved to be too small for the great influx of monks who came there. Under Abbots Mayeul (954–94) and Odilo (994–1049), a new basilica, Cluny II, was raised alongside the old. Relying on the scant evidence uncovered in excavations by the Medieval Academy of America at Cluny, and on the description of the ideal Benedictine monastery recorded in the "Constitutions of Farfa" (*Consuetudines Farvenses*) of 1043, Kenneth Conant has reconstructed Cluny II (**fig. 13.28**).[21]

The church that Conant reconstructs resembles a number of "first" Romanesque churches built by the Benedictines in the course of the early eleventh century, but one significant addition in Conant's plan is the Galilee porch that served as a sort of sub-nave for processions and other ceremonies. The name recalls the Mission of the Apostles given by Christ at Galilee (Matt. 28 and Acts 1), an important event for an age obsessed with the idea of crusades. The *descriptio* in the Farfa manuscript also states that two towers were built into the facade, suggesting that Odilo granted himself an imperial westwork in keeping with the new power the abbot exerted over both the ecclesiastical and the secular

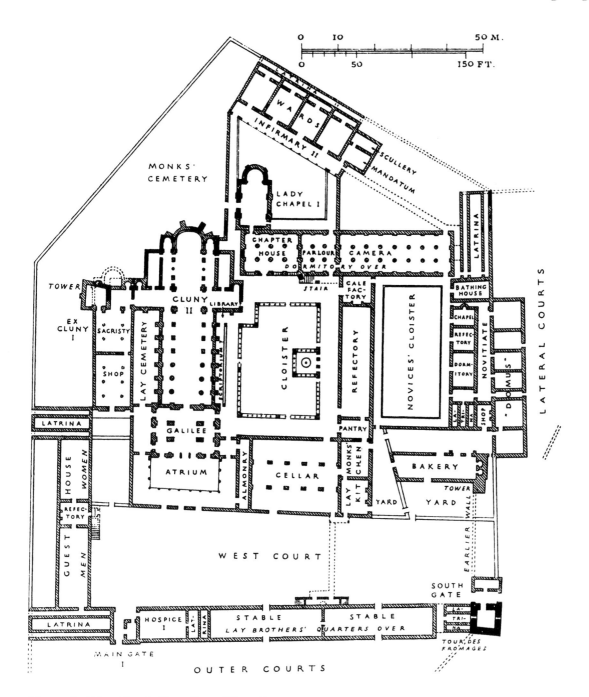

Fig. 13.28. Abbey Church, Cluny. Plan of Cluny II
(after Conant). 11th century

worlds. A monastic empire was being established under Odilo. A temporal as well as a spiritual kingdom emerged that made Cluny the capital of Christendom in the North.

If Abbot Odilo is to receive credit for establishing the empire of Cluny, then his successor, Hugh of Semur, who ruled for sixty years (1049–1109), should be acclaimed the master builder of the order. Cluny's political role in Europe was never greater. Hugh frequently settled disputes between papal and imperial opponents, including those involving Rome and Henry III, Henry IV, Philip of France, and William the Conqueror. His greatest benefactor was King Alfonso VI of Castile. The papacy was practically controlled by Cluny. Pope Gregory VII (1073–85), the great reformer, was apparently trained at Cluny; Urban II, who preached the first crusade in the North in 1095–96, was a Cluniac monk, as was his successor, Paschal II. Numerous churches along the pilgrimage roads were absorbed by Cluny, and by 1083 the number of monks residing at Cluny had grown from the initial twelve to more than two hundred. For such numbers Hugh needed a new church, Cluny III.

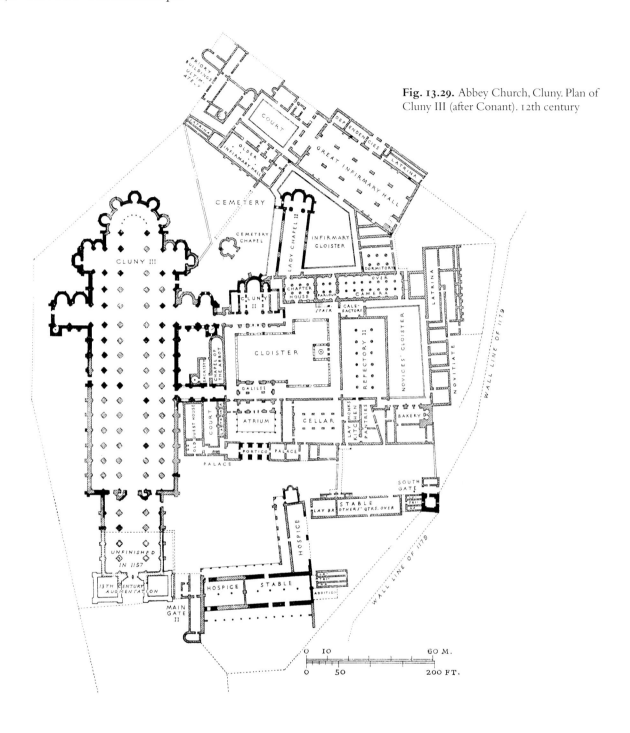

Fig. 13.29. Abbey Church, Cluny. Plan of Cluny III (after Conant). 12th century

Described as a place for angels to dwell should they come down to earth, Cluny III was the largest and most glorious church in Europe. Built entirely of stone, it stretched 616 feet in length; its vaults soared to an unprecedented 96 feet; its walls were over eight feet thick at the foundations. Sadly, this great structure, along with other churches and monasteries, was demolished after the French Revolution. In 1791 the last Mass was celebrated; in 1798 the French government sold the entire complex to three citizens; in 1810 the destruction (save for one transept) was completed; and, ironically, in 1928 costly excavations to recover and restore the great monastery were initiated.[22]

From scant remains and a number of early drawings and prints, a reliable reconstruction of Cluny III can be made. The great church displayed a complex clustering of cubic and spherical volumes, accented by six great towers, along the axis of the huge nave. The plan (**figs. 13.29, 13.30**) features double transepts, a huge ambulatory with radiating chapels, and an impressive portal (the huge covered atrium was added after Hugh's abbacy and finished in Gothic style). Construction apparently began in 1088. In 1095, Pope Urban II consecrated the high altar; transept altars were dedicated in 1104; and the nave was constructed between 1107 and 1121 (completed under Hugh's successor, Abbot Pons). Peter the Venerable

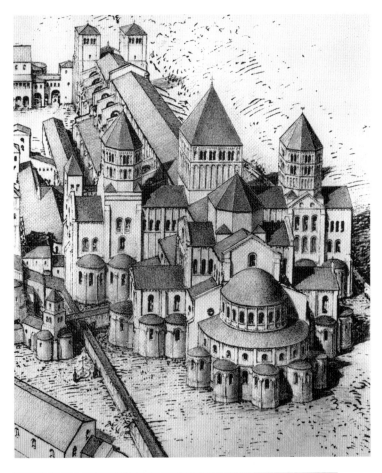

(1122–56), the last great abbot of Cluny, was largely responsible for finishing the basilical complex and its decorations. The final dedication was made by Pope Innocent II in 1130.

Conant's study has revealed that a complex harmony of parts based on the "perfect" numbers of the ancients as well as on the musical relationships of Pythagoras (as then understood) governs the measurements of the great basilica. Cluny is, in effect, solid music, a concrete embodiment on earth of the harmonies of the spheres in the heavens. Music theory was important in the education of the monk, and, in fact, one of the architects of Cluny III, Gunzo, was a learned musician. The sequence of geometric forms seems to develop one from the other like the expansion of a musical composition, with the long nave culminating in a multi-sectioned choir rising and descending in towers and chapels like crescendos.

Fortunately, ten capitals that adorned the ambulatory arcade survive. Eight have carvings on all four faces, indicating that they originally capped the freestanding columns. The Cluniac musician Guido of Arezzo (c. 1020) had given these eight tones emotional counterparts (*direct* as in storytelling, *happy* as in a turning dance, *sad* as in lamentation, and so forth). Even more surprising, however, is the fact that the personifications of the modes or tones of the plainsong—always unaccompanied in the church at this period—are figures playing musical instruments! The first mode presents a tiny figure playing a lute (**fig. 13.31**), the second taps castanets (?), the third strums a lyre of unusual shape, and the fourth is a lively dancing figure carrying a pole with bells across his shoulders. The performers are, in fact, closely related to similar figures in illustrated music manuscripts of the Romanesque period, suggesting that the inspiration for the new style may be found in book illustration.

A good idea of the style of Cluny's lost frescoes is perhaps provided in the superb paintings that survive at Berzé-la-Ville, a favorite retreat of Abbot Hugh, about seven miles from Cluny (**fig. 13.32**). What appears to be a *Maiestas Domini* in the apse of the chapel is, in fact, the Mission of the Apostles with the

ABOVE **Fig. 13.30.** Abbey Church, Cluny. Reconstruction of Cluny III, from east (after Conant). 1088–1130

LEFT **Fig. 13.31.** *First Tone of the Plainsong.* Ambulatory capital from Cluny III. c. 1088–95. Musée Ochier, Cluny

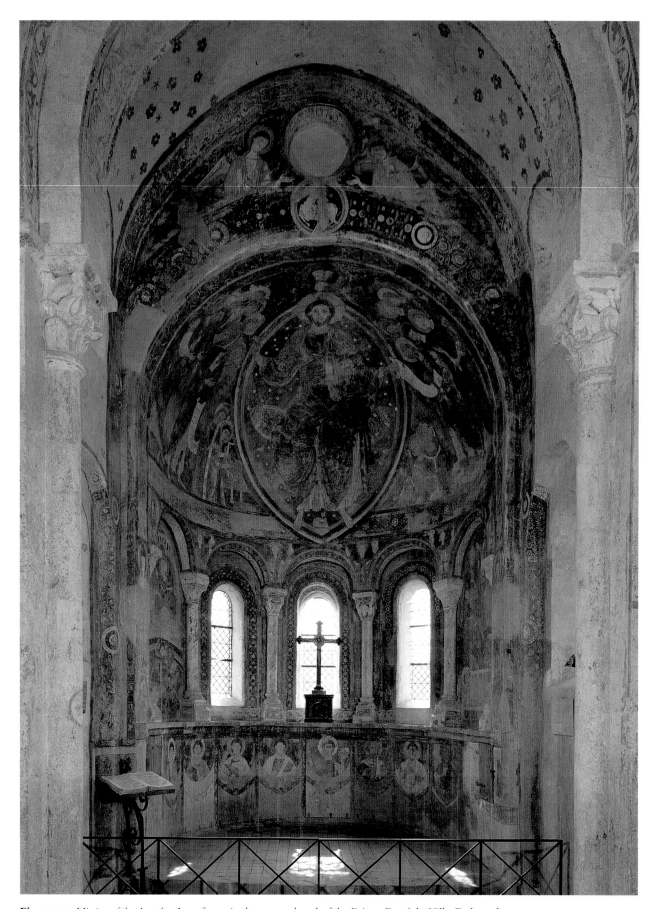

Fig. 13.32. *Mission of the Apostles*. Apse fresco in the upper chapel of the Priory, Berzé-la-Ville. Early 12th century

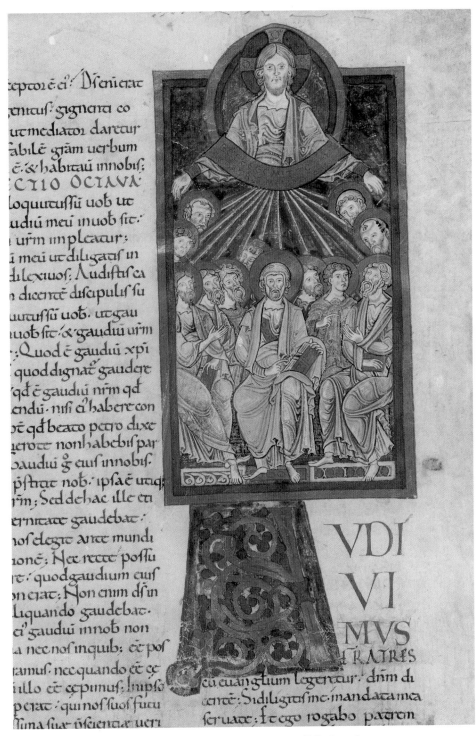

Fig. 13.33. *Pentecost.* Illustration in the Cluny Lectionary. 9 × 5″. Early 12th century. Bibliothèque Nationale, Paris (MS nouv. acq. lat. 2246, fol. 79v)

giant figure of Christ handing a scroll to Peter. What is surprising about the paintings at Berzé-la-Ville is the sophisticated style. The thin, translucent layers of paint over red ocher underdrawing impart a rich, warm tone to the whole apse, and the highlights and cross-hatching applied to the elegant draperies are derived from Byzantine conventions that are found in contemporary Benedictine paintings in Italy, which Hugh had likely seen. The library at Cluny contained manuscripts with illuminations in this same Italo-Byzantine style. Note, for example, the delicate rendering of *Pentecost* in the Cluny Lectionary (**fig. 13.33**), especially in the drapery folds that fall about the knees of the seated figures. On the whole, Cluniac painting reveals a strong dependence on Byzantine art.[23]

BURGUNDY

The careers of some of the "mason-sculptors" active at Cluny can be followed in other churches in Burgundy. One of the most gifted of these carved the great tympanum within the narthex of the Church of the Madeleine at Vézelay and a number of the capitals in the nave there (**fig. 13.34**). His work at Vézelay can be dated to after 1120, when a campaign to restore the church following a devastating fire that year was initiated by Abbot Renaud of Semur (a nephew of Hugh of Cluny). The learned prior Peter the Venerable, later the abbot of Cluny, may have been the mastermind behind the ambitious program of sculptures for the new church.[24]

A new iconography appears in the narthex sculptures (**figs. 13.34, 13.35**). The smaller doorways opening into the side aisles have tympana carved with the Infancy of Christ (south) and the Appearance of Christ to the Apostles (north), themes appropriate for a pilgrimage church. In the giant tympanum over the central portal, apostles stand in agitated postures with whipped pockets of drapery flaring out from their bent bodies on the doorjambs. The trumeau presents Saint John the Baptist, a proper doorman for the church, since Baptism was traditionally considered the "door of the sacraments."

Above, in the broad tympanum, emaciated figures swell and vibrate within the tight confines of a heavy frame. Below

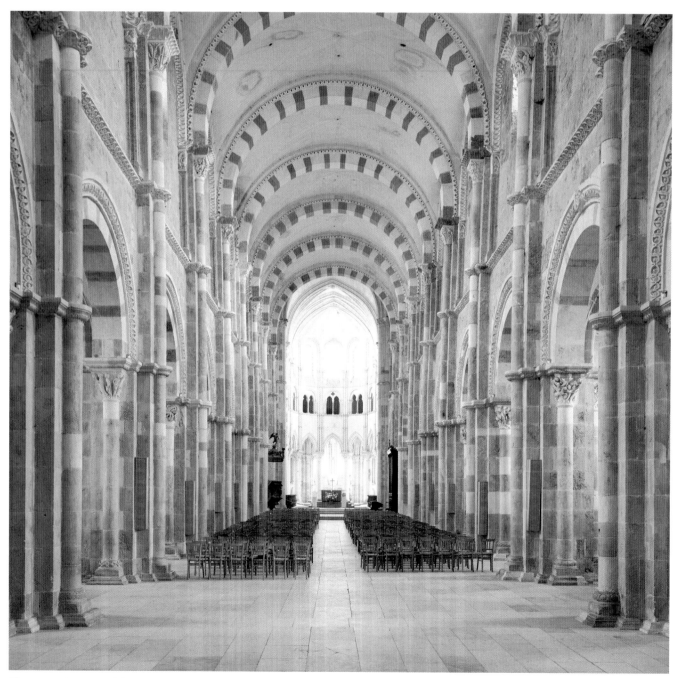

Fig. 13.34. Sainte Madeleine, Vézelay. Nave. 1120–32; choir of later date

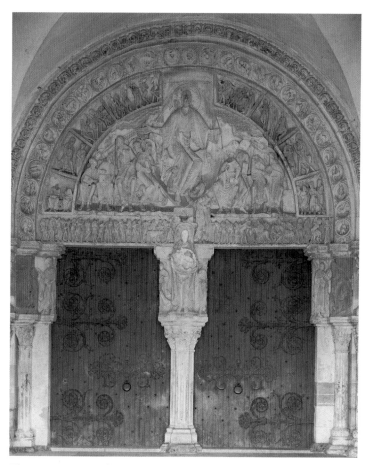

Fig. 13.35. *Mission of the Apostles.* Tympanum of Sainte Madeleine, Vézelay. 1120–32

Fig. 13.36. *Monstrous Races of the World.* Crusader's handbook. 12th century. British Library, London (MS Harley 2799, fol. 243r)

them, on the lintel, is a colorful frieze of puppet-like figures. Christ, in the center, turns sideways in a cramped position with spinning patterns of drapery at his thighs resembling coils under tension about to spring free. The apostles, descending in scale as we move out, are like marionettes bouncing on the strings formed by the rays of the Holy Spirit that issue from Christ's hands. No one is in repose at Vézelay, and the three courses of archivolts weigh heavily on them like a jack-in-the-box pressing against its lid.

The exact meaning of the central tympanum has been an issue of considerable debate. Some have argued that there is no unified program, others have identified the subject matter with traditional themes such as the Ascension and Pentecost. Regardless, the tympanum must have had special meaning for the pilgrims and crusaders who gathered there. After all, Vézelay was the starting point for one of the pilgrimage roads, and it also served as a rallying place for the Second Crusade called by Saint Bernard in 1146.

Entering the church in the company of the apostles—the original crusaders for Christ—the faithful found an encyclopedic display of the wonders and mysteries of their calling as inheritors of the original Mission of the Apostles.[25] Two closely related feasts of the church are celebrated here:

Ascension, which includes the Mission of the Apostles and an anticipation of the Second Coming of Christ (Acts 1:4–9); and Pentecost, whereby the apostles are given the powers of the Holy Spirit to heal and convert the peoples of the world (Acts 2:1–4). The secondary areas, the archivolts and the lintel, spell out in engaging details the tasks that will confront these first crusaders of Christ.

The favors bestowed by the Holy Spirit on the apostles at Pentecost included powers to convert the pagans and to heal the infirm. The heathen of the world are lined along the lintel. Recognizable on the left are tribes of Greeks and Romans, and on the right are exotic foreigners such as the pygmies of Africa, who need ladders to mount their horses, and the Panotii, who use their huge ears as umbrellas. Descriptions of such strange peoples are found in crusaders' guidebooks of the period (**fig. 13.36**), perhaps derived from the descriptions found in the seventh-century encyclopedia of the world, the *Etymologiae* of Isidore of Seville.[26]

Within the confines of the boxes in the first range of archivolts are the cramped figures of the lame, the mute, the crippled, the insane, and other afflicted peoples from the far reaches of the world. Signs of the zodiac and the labors of the months are featured in medallions in the second range of

Fig. 13.37. *Samson and the Lion.* Nave capital in Sainte Madeleine, Vézelay. 1120–32

Fig. 13.38. *The Abduction of Ganymede.* Nave capital in Sainte Madeleine, Vézelay. 1120–32

archivolts. These allude to the vast canopy of the heavens that will encompass their missions and to the anticipation of Last Judgment related in the reading for the Ascension (Acts 1:7–8). The crusaders and pilgrims who gathered at Vézelay thus had a formidable mission before them.

The capitals of Vézelay are a wonder to study. On one capital, Samson, protecting his flocks, straddles the back of a lion with a grotesque head (Judg. 14:5–9), perhaps to be interpreted analogically as the struggle of Christ against the Devil (**fig. 13.37**). On another a strange bird steals a young boy away in its beak before a satanic monster with flaming hair and a malicious grin (**fig. 13.38**). Often the wild vitality and grotesque distortions of these demonic creatures render them as nightmarish hybrids of evil spirits more than identifiable personifications. This scene has been interpreted as the Abduction of Ganymede, the mythological tale of a handsome Trojan boy who was carried away from his flocks by Jupiter in the guise of an eagle (Ovid, *Metamorphoses* 10, 152–61), an allusion to homosexual lust. Turned on his head, Ganymede appears to be in agony on the brink of damnation. Within this scenario of admonition, the terrifying eagle may symbolize perverse clerics who break their vow of celibacy and prey on vulnerable young oblates.[27]

Often the interweaving of figures reveals theological messages. One such capital (**fig. 13.39**) depicts what seems at

Fig. 13.39. *The Mystic Mill.* Nave capital in Sainte Madeleine, Vézelay. 1120–32

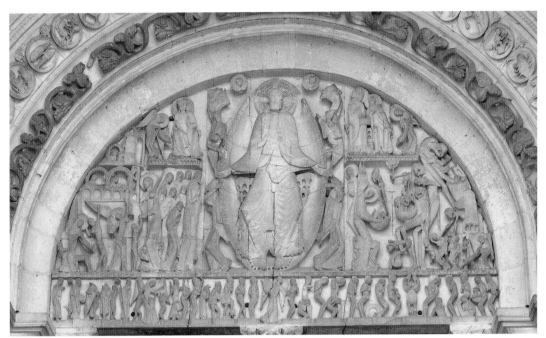

Fig. 13.40. *Last Judgment.* Tympanum and lintel on the west portal, Cathedral, Autun. c. 1120–35

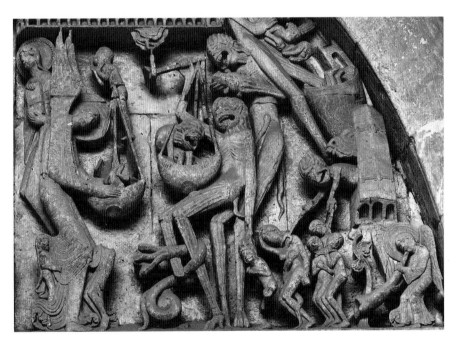

Fig. 13.41. *Saint Michael Weighing Souls.* Detail of Fig. 13.40

first glance to be a labor of the month, with two men busy grinding wheat into flour. But this literal reading conceals others as well: allegorical, tropological (moralizing), and eschatological levels of meaning that were prescribed for reading the scripture in the Middle Ages. The two laborers can be identified as the short-bearded Moses, supplying the wheat from a sack, and the long-bearded Saint Paul, collecting the flour below. Thus the allegory: the rough stock of the Old Testament is collected by Paul in the form of the sweet flour of the New to feed the pious. In instructions given to the faithful in the sixth century, Pope Gregory the Great provides us with an explanation for the "mystic mill" at Vézelay: "The letter kills as it is written, but the spirit gives life, thus the letter covers the spirit as the chaff covers the grain; to eat the chaff is to be a beast of burden; to eat the grain is to be human. He who uses human reason, therefore, will cast aside the chaff fit for the beasts and hasten to eat the grain of the spirit. For this it is useful . . . the mystery is covered in the wrappings of the letter."[28]

Another Cluniac sculptor or possible patron, Gislebertus, signed the tympanum sculptures of the nearby cathedral of Autun, Saint Lazare (**figs. 13.40, 13.41**).[29] The new church was begun under the Cluniac bishop Etienne de Bage (1112–39) and consecrated in 1132. The magnificent interior has been described as Cluniac in construction, although the classicizing details, only marginally evident in Cluny III, are

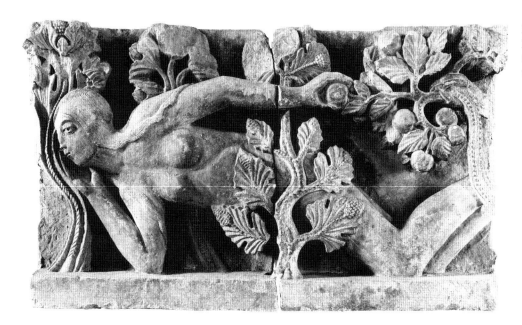

Fig. 13.42. *Eve*. Right half of lintel of north portal from the Cathedral, Autun. 27½ × 51″. c. 1120–32. Musée Rolin, Autun

here boldly displayed in the elevation of the nave, which was inspired by the old Roman Porte d'Arroux in the city.

The head master of the sculpture shop, designed and carved capitals, tympana, and other portal areas sometime between 1120 and 1135. He was a master in creating screaming monsters with spindly skeletal racks of emaciated flesh for bodies and grotesque masks with cavernous mouths and flame-like hair for heads. His blessed people, in contrast, are ethereal, disembodied specters that float weightlessly around the compositions as if buoyed by their serene holiness.

Rather than presenting the traditional *Maiestas Domini* in the tympanum, Gislebertus provides us with the Last Judgment in all its gory details. Earlier scholars found the textual source for Gislebertus in the twelfth-century *Elucidarium* (Book III) by Honorius of Autun, with its complex accounts of events on doomsday.[30] Honorius presents the end of the world as a terrifying drama in five acts beginning with the precursory signs, the onslaught of the four horsemen of the Apocalypse. Then Christ the judge appears in the heavens at midnight. The third act is announced by the blasts of trumpeting angels—the four angels in the corners of the tympanum—calling for the resurrection of the dead, here presented on the lintel. Judgment follows in the company of the apostles, the tall figures to the left, and the weighing of the souls by Saint Michael, to the right. The fifth and final act is the separation of the blessed and the damned to heaven and hell with the Inferno appearing as the mouth of the Leviathan (compare Job 41), who opens the "doors of his face" to engulf the sinners who are "drawn in by hooks." Such elaborate descriptions of the Last Judgment can be found in other contemporary compilations (compare Rupert of Deutz, *De apocalypsis*), but whatever the exact source may have been, his tympanum definitely heightened the drama associated with apocalyptic scenes.

Fragments of the north portal sculptures, destroyed in the eighteenth century, were found in the rubble of a nearby house. The most impressive of these is the large horizontal fragment from the right side of the lintel block with a representation of Eve (**fig. 13.42**) slithering on her stomach through thick foliage, apparently in search of Adam (on the missing right half?), and calling to him with her cupped hand at her cheek. With her left hand she reaches back for the apple. While a number of interpretations have been suggested for Eve's act and personality, there can be little doubt that she is the embodiment of lust and greed, and an erotic sensuousness seems to transform her body into that of the evil serpent who betrayed man.[31]

The extraordinary capitals in the nave are as varied and fantastic as those of Vézelay (**figs. 13.43, 13.44**), but the most eye-catching are those that illustrate the Infancy of Christ. In the Flight into Egypt, the journey of the charming, doll-like figures seems accelerated by the rollers beneath the hooves of the donkey. In the depiction of the Three Magi Awakened and Warned by the Angel, a finely textured blanket serves as a warm covering for the three little kings packed into one bed, their crowns still on their heads as they sleep. A quiet angel appears and lightly touches the hand of the third Magus, who suddenly opens his eyes. This charm and simplicity are important aspects of Romanesque aesthetics that are too often ignored in the quest for more profound and serious meanings.

A specialty of Burgundian and Auvergne workshops was polychromatic wooden statues of the seated Virgin and Child (**fig. 13.45**), an image of the Throne of Holy Wisdom (*sedes sapientiae*), a sculpture type we have already encountered in Ottonian art (compare fig. 9.36). These imposing statues were very popular in churches along the pilgrimage roads, where they served as objects of devotion on an altar. They were, in fact, cult images like sculptured icons (some served as

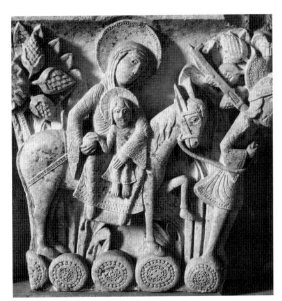

Fig. 13.43. *Flight into Egypt.* Nave capital from the Cathedral, Autun. c. 1120–32. Musée Lapidare, Autun

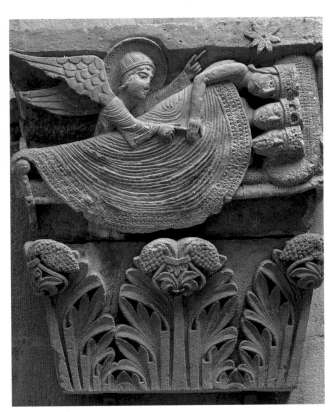

Fig. 13.44. Gislebertus. *The Magi Asleep.* Nave capital from the Cathedral, Autun. c. 1120–32. Musée Lapidare, Autun

Fig. 13.45. *Virgin and Child* (The Morgan Madonna). Wood, height 31″. 12th century. The Metropolitan Museum of Art, New York. Gift of J. Pierpont Morgan

reliquaries as well). The rigid frontality of these wood sculptures and the abstract conventions for their drapery patterns superbly convey the more transcendental or iconic function of the image. The manageable scale and lightweight character of these sculptures enabled the devout to carry them in religious processions. Occasionally, these images were used in liturgical dramas, where they played the role of Mother and Child during Epiphany.[32]

THE CISTERCIANS

In the famous *Apologia* written by Saint Bernard of Clairvaux, a polemic was directed against the "immoderate height of [Cluniac] churches . . . their immoderate length, their excessive width, sumptuous decoration and finely executed pictures, which divert the attention of those who are praying."[33] The Cistercian Order, to which Bernard belonged, was a reform movement within the Benedictine Order, as was Cluny. The founders established their first community in 1098 in marshy lands at Cîteaux, near Dijon, in Burgundy. Their aim was to purify monastic life by rejecting the worldly riches acquired by Cluny and to return to the simple precepts of communal living as originally laid down by Saint Benedict at Monte Cassino in the sixth century. The new rules and charter, drawn up under the founders—Robert of Molesme, Alberic, and Stephen Harding—were approved in 1119 by Pope Calixtus II. Bernard, the pious son of a nobleman, requested admission to the new order, but in his new calling he found life at Cîteaux too liberal and worldly, and so he set out with twelve monks to establish his own model house at Clairvaux, where he remained abbot for twenty-eight years until his death in 1153. Nonetheless, it is largely through Bernard's program for the Cistercians that we have come to understand the movement.

The Cistercian goal was to retreat from the secular world by living in poverty in some remote community, disengaged from all worldly and artistic affairs. The rules were laid down precisely, ranging from hourly routines to the physical makeup of the monastery.[34] At first they formed small communities

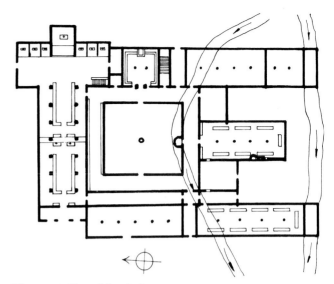

Fig. 13.46. Plan of the ideal Cistercian monastery (after Braunfels)

(twelve monks and a prior) in the wilderness. The credo of life for the monks and the *conversi* (lay brethren who served as workers) was simple: prayer and manual labor. The plan for their community was also relatively simple (**fig. 13.46**). The monastery should be located in a hidden valley near a stream. The buildings were to be humble (wooden at first) and laid out according to a rigid axial pattern. The main building, the church and its cloister, was usually on the north flank of the plan. At exact right angles all others were aligned about this core. The dormitories for the monks joined the projecting

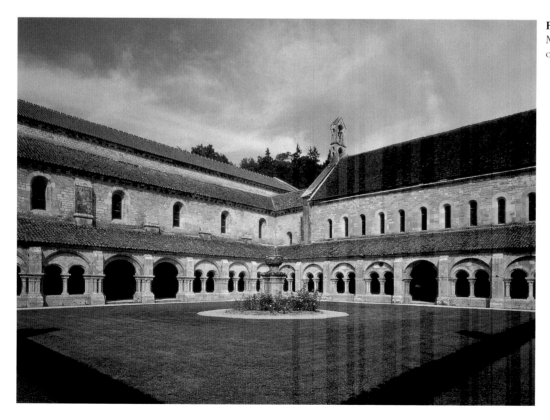

Fig. 13.47. Cistercian Monastery at Fontenay, view of the cloister. 1139–47

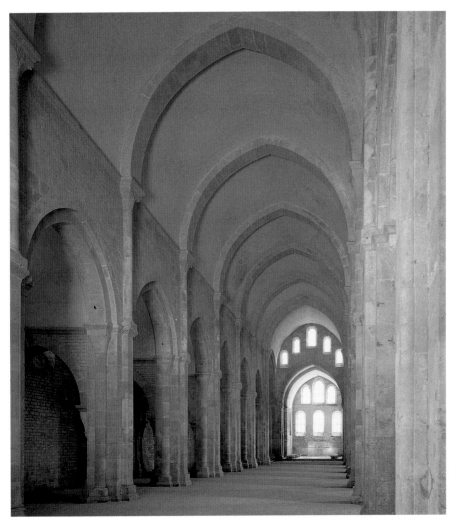

Fig. 13.48. Abbey Church, Fontenay. Interior. 1139–47

transept arm on the east, those for the *conversi* lay on the opposite side of the cloister on the west, while other buildings such as the kitchen, refectory, forge, work sheds, and calefactorium (or warming room) were located on the south side, opposite the church.

The church itself was a simple rectangular basilica. The choir was rectangular with square apse and chapels. Simple columnar supports in the nave were screened off to form two rectangular sub-choirs, one for the monks and the other (toward the narthex) for the *conversi*. The interior was unadorned.

Saint Bernard's original settlement at Clairvaux is nearly lost to us, but early descriptions of it suggest that it resembled the ideal community described above, one that we can perhaps still experience, at least in part, at Fontenay, founded on the instructions of Bernard in 1118. The church of stone was not begun until 1139, and the layout of the complex has not changed much since then (**figs. 13.47, 13.48**). In order that the church be pristine and enduring, pale stone blocks were employed, superbly dressed and fitted. The measurements of the plan and elevation imitated the numerical harmonics of the ancients.

Church interiors were pure and modest in decoration. The exterior was also plain, with no sculptured portals and no towered facade to suggest worldly power or vanity. Given the picturesque nature of their settings in wooded river valleys, the Cistercian community thus established its own quiet hermitage landscape far from the noisy congestion of the rapidly developing urban world of the twelfth century.

Saint Bernard was vehement in condemning such frivolous displays of vanities in Cluniac churches: "What profit is there in those ridiculous monsters, in that marvelous and deformed comeliness, that comely deformity? . . . So many and so marvelous are the varieties of diverse shapes on every hand that we are more tempted to read in the marble than in our books, and spend the whole day in wondering at these things than in meditating upon the law of God. For God's sake, if men are not ashamed of these follies, why at least do they not shrink from the expense?"[35]

Even though Saint Bernard warned against the dangers of idolatry and ostentation, he did not advocate iconoclasm. He believed that modest images could help viewers discover mystical insight. Bernard's absolute devotion to the Virgin, for

Fig. 13.49. *Tree of Jesse.* Illustration in the Legendarium Cisterciennse. 13 × 7″. c. 1130. Bibliothèque Municipale, Dijon (MS 641, fol. 40v)

Fig. 13.50. Initial figure in Gregory's *Moralia in Job.* Citeaux. Early 12th century. Bibliothèque Municipale, Dijon (MS 170, fol. 59)

instance, contributed to a wealth of new imagery for Mary in art. Illustrated Cistercian manuscripts offer the earliest representations of the Tree of Jesse, glorifying the royal ancestry of Mary and Christ through the kings of Judah (**fig. 13.49**).[36] Bernard's numerous sermons on the Song of Songs (*Canticum Canticorum*) provide one of the richest allegories of Mary as the Bride of Christ.

Cistercian manuscript illuminations could be quite imaginative and playful. On a page from Saint Gregory's *Moralia in Job* (**fig. 13.50**), the letter I is transformed into a tree trunk about to fall. Within this scene, a Cistercian monk and lay brother work together chopping down the tree. However, if the monk at the foot of the tree finishes first, then the lay brother will plummet to the ground. Even though Cistercians cleared forests to build and maintain their monasteries, the illumination is not merely a scene of daily life. The picture introduces the twenty-first chapter of the *Moralia*, which addresses the dangers of temptation. In Genesis, the fall of humanity is described in relationship to a tree—the Tree of Knowledge. Lured by the serpent, Adam and Eve eat its fruit

and commit the original sin. Consequently, the arbor illuminated on this page may have alluded to temptation. The monk, who lives in seclusion, cuts the tree at its roots. The layman, by contrast, chops it down branch by branch. He works dangerously within the midst of the tree, within the middle of worldly temptation, and hence, is at greater risk of falling. Besides recognizing the meaning of this scene, readers of the manuscript would have found pleasure in the inventiveness of the illumination, and humor in the folly of the precarious situation depicted.[37]

The Cistercian Order soon grew as quickly as Cluny, establishing its remote outposts widely from Scotland to Spain, from Germany to Italy. As the Cistercians spread across Europe, properties and donations increased. In addition, as a result of their hard labor, the Cistercians became proficient in agronomy, farming, stockbreeding, wool, milling, and even mining, and with their expertise in such industries even more wealth was acquired. The simple monastic community envisioned by Saint Bernard grew into a vast network of communities.

14

THE PAPACY AND THE EMPIRE

In the late eleventh century, Pope Gregory VII introduced new policies of Church reform. He called for the elimination of simony (the sale of ecclesiastical offices) and for the end of clerical marriages (which existed openly in some parts of Germany). Gregory's greatest reform, however, concerned investiture, the right of the emperor to appoint high-ranking clergy, such as abbots and bishops. He claimed that this right should not be granted to secular authorities, but to ecclesiastical rulers alone. In response, the Holy Roman Emperor, Henry IV, called for Gregory to be deposed. This led Gregory to excommunicate the emperor in 1077. In humiliation, Henry was forced to perform penance before the pope. Animosities between the emperors and popes would continue for centuries. German aristocrats chose sides in the controversy, leaving Germany divided into numerous principalities until the nineteenth century.

MONTE CASSINO AND ROME

Monte Cassino, the cradle of Western monasticism, has had a turbulent history. Only a half-century after its founding by Benedict of Nursia (c. 480–543) on the formidable peak lying between Rome and Naples in Campania, the monastery was destroyed by the Lombards, and the small band of monks fled to Rome. It was razed again in the ninth century by Muslims, and it suffered through the next two centuries of intermittent warfare in southern Italy, where three stubborn forces met head-on: the Byzantines, the Normans, and the Ottonians. Yet the Benedictine Order had acquired prestige and a mission by the eleventh century, and under the leadership of

the influential abbot Desiderius (later Pope Victor III), the abbey was gloriously rebuilt based on the architecture of the great Christian basilicas of Late Antique Rome.[1] Although smaller, the new basilica was planned to duplicate Saint Paul's Outside the Walls, which had become an important Benedictine abbey in Rome. A description of Desiderius's church survives in the *Chronica monasterii Casinensis*, written by Leo of Ostia on the occasion of the consecration in 1071. The general lines of the early Christian basilica were followed in a simple fashion with a towered atrium, narthex, nave, transept, a raised choir, and a wooden roof (**fig. 14.1**).[2] Certain modifications were necessitated by changing liturgical needs: a *schola cantorum* (a rectangular area marked off for reading and singing) was introduced in the nave; a bell tower, or campanile, was added to the facade; and three apses replaced the single projection in the model.

In order to obtain rich building materials, Desiderius imported columns and marble from Rome, and in planning the decorations for the interior, early Christian models again were followed. But times had changed, and the abbot was in need of competent craftsmen which he recruited from Constantinople. Artisans from Byzantium reintroduced in Monte Cassino techniques for making mosaics and elegant stone furniture. Desiderius ordered a bronze door from Constantinople as well as a great golden altar frontal decorated with scenes from the New Testament and the life of Saint Benedict. The splendid marble floor in the nave—a revival of the ancient type known as *opus alexandrinum*—was laid out as a giant stone intarsia work of multicolored discs and geometric shapes tied together by guilloches (ornamental lines) of white marble.[3]

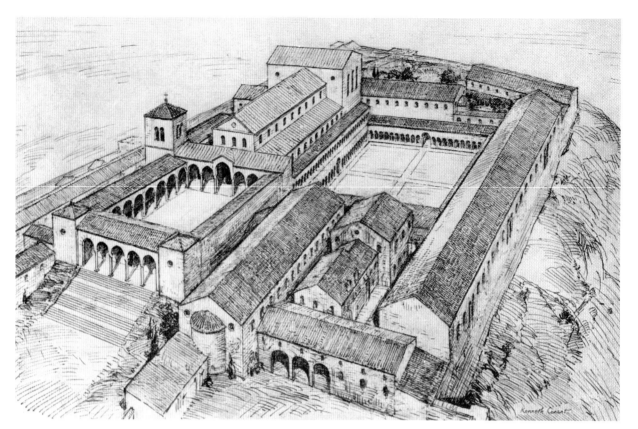

Fig. 14.1. Monastery, Monte Cassino. Reconstruction of the New Church of Abbot Desiderius (after Conant). Consecrated 1071

Little remains of Desiderius's church and its furnishings, but Monte Cassino must have been an influential example, for the revival of the Early Christian basilica was echoed throughout Europe in the late eleventh century. The extensive mural decorations in Monte Cassino are reflected in those of another church built by Desiderius in 1072, Sant' Angelo in Formis, near Capua.[4] Decorating the nave in two registers are painted stories from the Old and New Testaments. In the apse is a representation of Christ in Heaven flanked by the symbols of the Evangelists. Below, on the wall of the apse, stands Desiderius as patron, holding the church in his hands (**fig. 14.2**). All of this is painted in fresco and displays something of an eclectic mixture of Byzantine and Latin elements that, in fact, can be called "Benedictine" in style. One distinctive detail that marks the figures is a red dot added to the cheeks of nearly every face.

Fig. 14.2. *Desiderius Offering the Church to Christ.* Fresco on the lower wall of the apse in Sant'Angelo in Formis (near Capua). c. 1085

Fig. 14.3. *Scenes from the Life of Saint Benedict.* Illustration in the *Vita Benedicti.* 14¾ × 10″. 11th century. Vatican Library, Rome (MS lat. 1202, fol. 80r)

The illustrated manuscripts produced at Monte Cassino show a similar hybrid style. This is apparent in the graceful illustrations in the *Vita Benedicti* (**fig. 14.3**), an eleventh-century manuscript, and in the Exultet Rolls (**figs. 14.4, 14.5**) produced at Monte Cassino. Named after their use in the ceremonies blessing the paschal candle on Holy Saturday in Easter (*Exultet iam angelica turba callorum*), some of these large scrolls are pictures painted upside down in the text so that the clergy could follow them while singing as the deacon unwound the roll downward from the pulpit. Fascinating for their iconographies, the Exultet Rolls display a wealth of unusual illustrations, including secular subjects such as *Terra* (the Earth) and bees that produced the pure wax for the paschal candles.⁵

The elevation of Desiderius to the papacy in 1086 further testifies to the ascendancy of the Benedictines in the broader world of Christendom. In Rome, it would seem that his program for the revival of the golden era of Early

Christian culture would be quickened by the proximity of the hallowed monuments themselves, but this did not happen at once. These were troubled times in Rome. Since the days of Otto III, Rome had served as the residence of the Holy Roman emperors, and the antagonism between the papacy and the empire never slackened, culminating in the notorious struggle over investiture and the excommunication of Henry IV, nine years before Desiderius moved to Rome. In 1083, Henry besieged the papacy, and the Normans, purportedly called in to protect the pope, sacked the city instead, leaving it in ruin.

Not surprisingly, Desiderius's program of recovery was stalled for a time, but under the patronage of later Benedictines in Rome, it was fully initiated in the early years of the twelfth century. A general program of urban development was promoted to restore the grandeur of ancient Rome. The ancient statuary assembled on the grounds of the Lateran palace included the famous bronze equestrian portrait of Marcus Aurelius, long identified as Constantine. Around 1200, one Magister Gregory wrote an updated pilgrims' guide to Rome and its ancient and medieval monuments to aid visitors. Enriched with stories of images "whether produced by magic art or human labor," the *Tales of the Marvels of the City of Rome (De Mirabilibus Urbis Romae)* is a useful manual

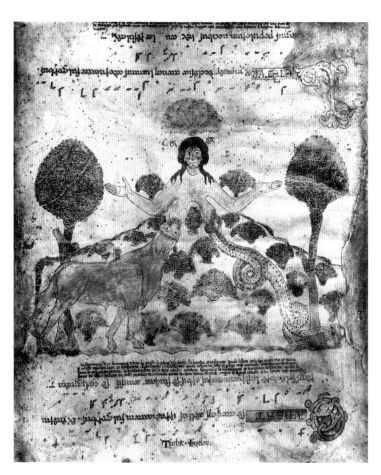

Fig. 14.4. *Terra*. Illustration in the Exultet Roll. Width 11⅜″. c. 1075. Vatican Library, Rome (Barberini lat. 592)

BELOW **Fig. 14.5.** *Gathering of Honey*. Illustration in the Exultet Roll

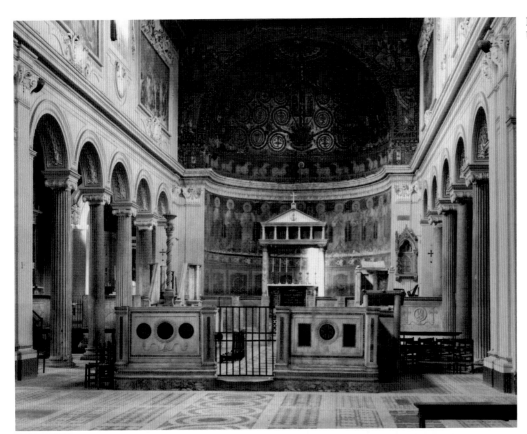

Fig. 14.6. San Clemente, Rome. Upper church. c. 1120–28

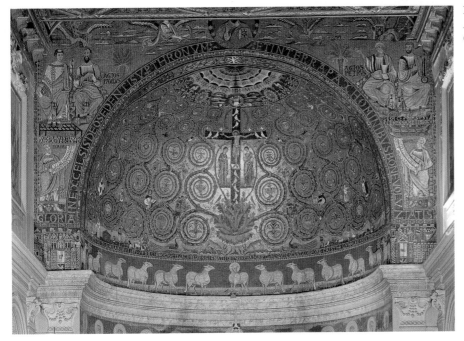

Fig. 14.7. *The Cross as the Tree of Life.* Apse mosaic in the upper church of San Clemente, Rome. Before 1128

today for studying the attractions of the eternal city as they appeared in the twelfth century.[6]

Between 1120 and 1130, the Church of San Clemente was rebuilt over the earlier fourth-century basilica, which remains, in part, as the lower church. It was lavishly decorated and outfitted with a *schola cantorum* set over an elegant floor of *opus alexandrinum*, much as at Monte Cassino (**fig. 14.6**).

A colorful mosaic filled the huge apse (**fig. 14.7**). The Early Christian canopy of the heavens appears in the summit; a predella with the mystic lambs moving from diminutive representations of Bethlehem and Jerusalem serves as the base; and the broad surface of the conch is filled with an elaborate vine scroll, reminiscent of the elegant decoration in the apse of the Lateran Baptistery but here combined with

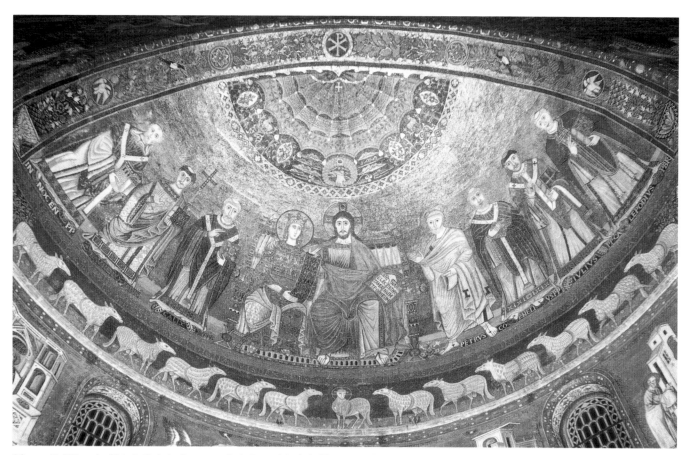

Fig. 14.8. *Triumph of Maria Ecclesia.* Apse mosaic in Santa Maria in Trastevere, Rome. 1130–43

genre motifs—a woman feeding chickens, a shepherd and slave tending flocks, and others. In the center a Crucifixion grows out of a resplendent acanthus plant, forming a giant Tree of Life.[7] The treatment of Mary and John, flanking the cross, is comparable to that of the figures in the Desiderian frescoes in Sant'Angelo in Formis.

The Church of Santa Maria in Trastevere (partly rebuilt in the nineteenth century) was raised over the remains of Early Christian and Carolingian structures about 1120–30. The impressive nave with a colonnade of Ionic columns, mostly *spolia*, terminates in a gigantic apse (**fig. 14.8**).[8] As at San Clemente, the apse is decorated with an unusual mosaic representation that at first seems to be a combination of Early Christian and later themes. Beneath the canopy of the heavens and the Hand of God, and above the familiar predella of the lambs, the Virgin and Christ appear enthroned together (he has his arm about her shoulders) between ecclesiastical saints and the benefactor, Pope Innocent II (1130–43), all standing in rigid frontal positions. Sometimes referred to as one of the earliest representations of the Coronation of the Virgin, the central group should also be considered an image of the *Triumph of Maria Ecclesia* in the context of Early Christian art, for here the Virgin appears in the guise of the *Maria Regina* found in Early Christian churches dedicated to her.

TUSCANY

Soon after Desiderius reluctantly donned the red cope in May 1086, he was deposed by the imperial "antipope," Clement III. To his rescue came Matilda of Canossa (1046–1114), countess of Tuscany, the leading aristocratic sponsor of the papacy in north Italy. From the time of the war over investiture between Pope Gregory VII and Henry IV in 1076, Matilda had been the protector of the pope, and in her will she bequeathed all of her domains to the Roman Church. Matilda had been the wife of Duke Welf of Bavaria, and from this alliance a lasting rivalry in medieval history descends. Lords of the house of Welf (Guelph in Italian) were initially supporters and sponsors of the papacy; the imperial leaders of the Holy Roman Empire were backed by the aristocratic Hohenstaufens of Swabia, their title Waiblingen (Ghibelline in Italian) coming from their ancestral castle in Franconia.

From the days of Matilda, the rival city-state powers in north Italy allied themselves with either the Guelph or the Ghibelline factions (the terms were not actually used in this context until the early thirteenth century): Florence, Guelph, versus Siena, Ghibelline; Lucca versus Pisa; Milan versus Pavia, and so on. In reality, it was the commercial rivalries between the independent city-states that set the tempo for cultural expression and exchange, and among these republics,

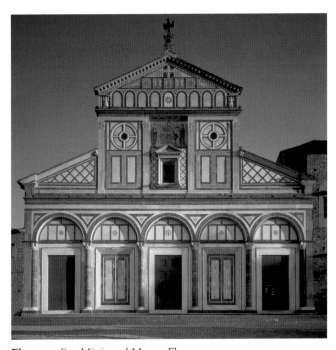

Fig. 14.9. San Miniato al Monte, Florence. Facade. 1062–1150

two emerged as leaders in Tuscany during the Romanesque period: Florence (Guelph) and Pisa (Ghibelline).

Too often the city of Florence is only associated with the artistic accomplishments of the Italian Renaissance, undermining the significance it already had in the Middle Ages. One of the richest Benedictine abbeys in Tuscany was San Miniato al Monte, situated high above the spectacular skyline of the central city (**figs. 14.9, 14.10**). Although much restored, San Miniato (begun by 1062) is captivating in its simplicity and purity of design. The Early Christian basilica provided the basic model; the building is a simple rectangular box, and the front is a gabled facade immaculately sheathed with large white marble panels divided into elegant geometric shapes by dark green bandings that roughly correspond to the divisions of the interior.[9] With its handsome facade circumscribed by a large square with triangular and rectangular subdivisions traced in orderly fashion across it, San Miniato is a study in abstract design and clarity. The interior, too, is like a study in perspective, with the pristine marble revetment articulated by the straight lines formed by the darker bandings. There is nothing complicated about its plan or structure. The tripartite elevation extends in three well-marked bays formed by two piers separated by three arches. In the tradition of Early Christian basilicas, San Miniato's roof is wooden.

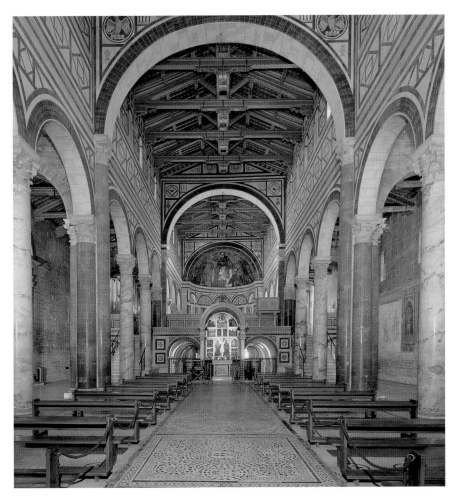

Fig. 14.10. San Miniato al Monte, Florence. Interior

The more famous Baptistery in Florence, San Giovanni (**fig. 14.11**), has foundations that go back at least to the fifth century (likely those of a Roman bath). The present structure, also much restored, was dedicated by Pope Nicholas II in 1059. The simple octagonal building features the same superb revetment of white marble panels and dark green banding as are on San Miniato. The interior has the dignity of ancient Roman sanctuaries; indeed, it has been compared to the Pantheon or, as one scholar put it, "a Roman stone aqueduct bent around eight angles."[10] The attic and Italo-Byzantine mosaics above were added in the thirteenth and early fourteenth centuries (by Venetian craftsmen). San Giovanni boasts many riches, including its three sets of bronze doors, but it is the beauty and clarity of the Romanesque octahedron rising majestically in the piazza that we first remember.

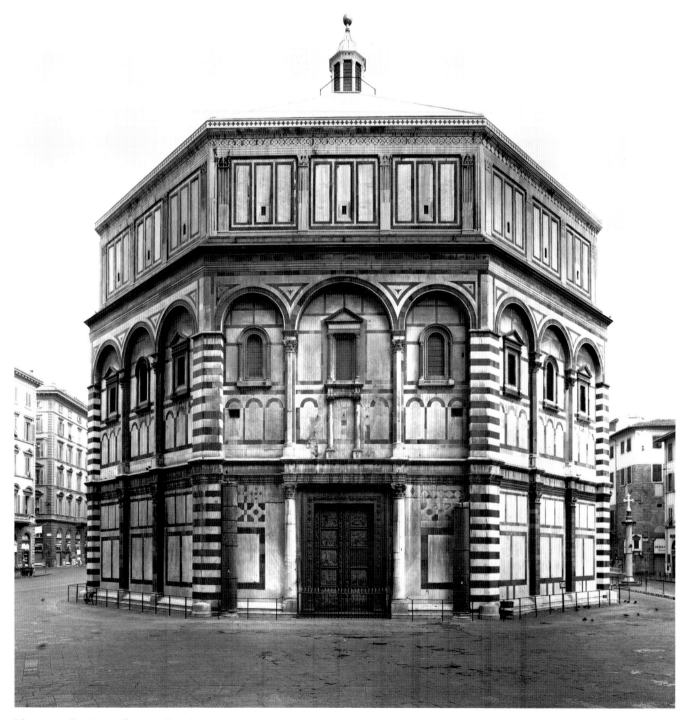

Fig. 14.11. Baptistery, Florence. Exterior. c. 1059–1150

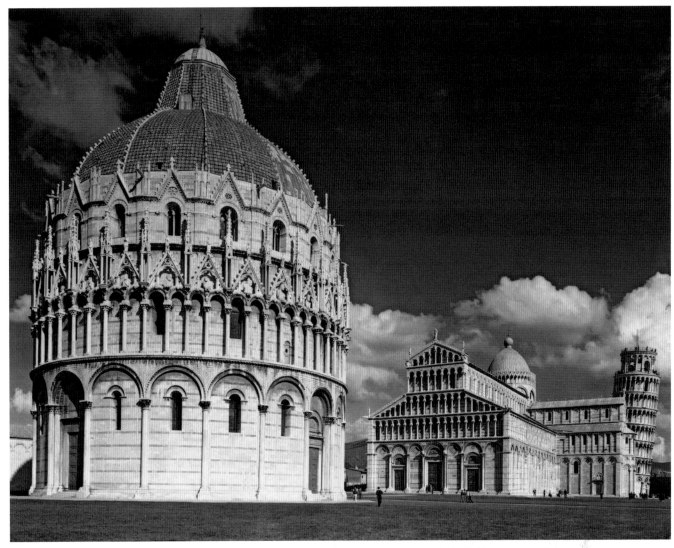

Fig. 14.12. Baptistery, Cathedral, and Campanile, Pisa. View from the west. Baptistery 1153; Cathedral begun 1063; Campanile 1174

Pisa was the major rival of Florence for leadership in Tuscany, but it was foremost a seaport, and after a decisive naval victory at Palermo in 1062, the Pisan fleets reigned as masters of the Mediterranean. With pride and prosperity came aspirations for glory, and it was in the year following the victory over the Sicilians that the Pisans began the huge complex of buildings that remains today one of the most impressive medieval sites in Italy with the huge baptistery, handsome cathedral, leaning tower or campanile, and large rectangular Campo Santo (**figs. 14.12, 14.13**).[11] The simple volumetric structures of Tuscan architecture are found here in the form of cylinders and gabled boxes, but in place of the delicately articulated bandings and geometric veneers and inlays of Florentine structures are handsome colonnaded galleries stacked in tiers. The facade of the cathedral is a wall of blind colonnades rising in five distinct stories; the Campanile "may be said to have been designed by rolling up the west front of the "cathedral"; the Baptistery, its upper stories transformed into Gothic gables by later architects, is twice the

diameter of the Campanile. How emphatically the complex of simple geometric forms—baptistery, church, campanile—is presented.

The cathedral is huge, rivaling in scale the great basilicas of Rome. Begun in 1063 by the Greek architect Busketos (Boschetto in Italian), it has a seemingly simple T-shaped ground plan that is deceptive. A great elliptical dome rises over the crossing, and the projecting transept arms are, in fact, two independent basilicas facing each other. The nave has double aisles that continue around the arms and into a rectangular choir, which is terminated by a simple apse. The interior has a continuous arcade carried on granite columns with Corinthian capitals and a handsome gallery featuring the distinctive Pisan "zebra" banded work, so familiar in later Tuscan architecture. The roof of the nave is wooden; the side aisles are groin vaulted.

The Baptistery, begun in 1153, is ninety-eight feet in diameter and is capped by a truncated cone roof (the present dome covering it was added later). The famous Campanile

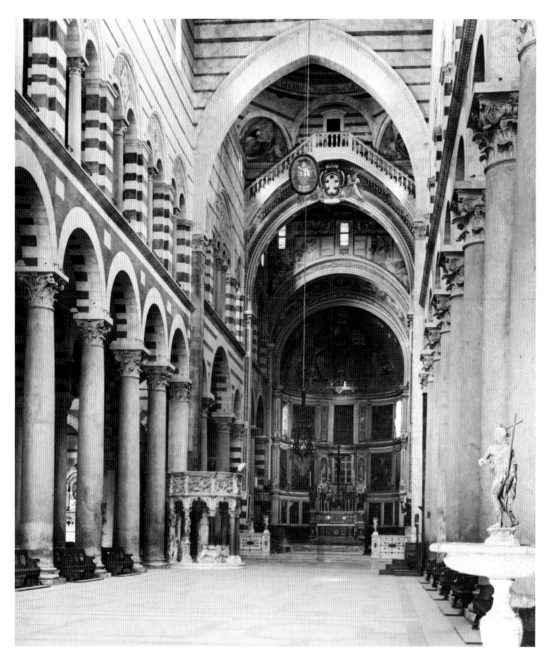

Fig. 14.13. Cathedral, Pisa. Interior

was started in 1174 by Bonanno Pisano, and it had already begun to sink on the southern side by the completion of the first stage (thirty-five feet in height). Subsequent stories were accommodated for the unusual tilt. By the time of its completion in 1350, the Campanile was nine inches off axis; today it leans some thirteen feet from its foundations.

LOMBARDY

As noted earlier, Lombard masons are credited with introducing vaulting in the "first" Romanesque churches, but the lines of development in the arts in general are obscured because of

the precarious history of the region. The basilica of Sant'Ambrogio in Milan has often been cited as the first church to be covered with ribbed vaulting, in the eleventh century, but now it is believed that the Romanesque rebuilding took place after a devastating earthquake in 1117 (**figs. 14.14, 14.15**).[12] Nonetheless, the interior of Sant'Ambrogio displays a sophisticated system of construction with heavy ribs applied to three domed-up bays resting on huge articulated piers. The side aisles, low with heavy walls, have ribbed groin vaults, and the general impression of Sant'Ambrogio is one of a heavy, earthbound structure. There is no clerestory. Although Sant'Ambrogio is wider than Cluny III, its vaults are forty feet lower.

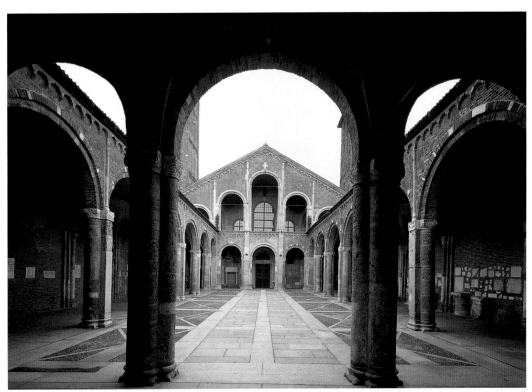

Fig. 14.14. Sant'Ambrogio, Milan. View of facade and atrium. 11th and 12th century

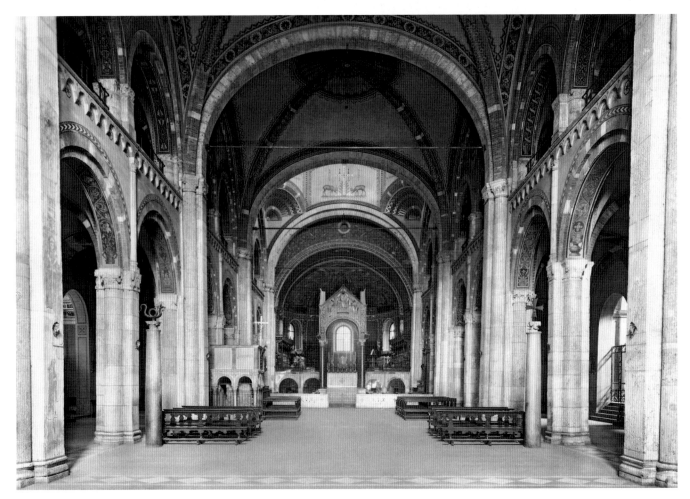

Fig. 14.15. Sant'Ambrogio, Milan. Interior. Vaulted after 1117

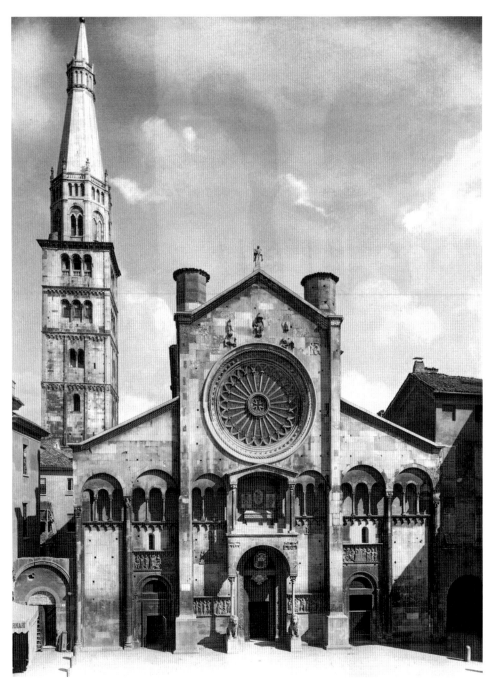

Fig. 14.16. Modena Cathedral. West facade. 1099–1120

The austere front of the narthex conceals the facade of the church, a broad gable in two stories with two flanking towers (actually campaniles) set back. Pilaster strips divide the two stories of the facade into five bands with arched openings that rise to the pitch of the gable. A spacious atrium with vaulted corridors and heavy unadorned walls dominates the exterior. Five great blind arches establish a severe rhythm across the entrance.

The sober gable facade of Sant'Ambrogio became the model for numerous churches in northern Italy, and various attempts to relieve its severity can be noted. At the Cathedral of Modena (**fig. 14.16**), further south in the province of Emilia, the stepped gable was reintroduced with marked divisions in the facade corresponding roughly to the interior disposition of the building. Blocks of sculptural friezes are here more harmoniously integrated into the divisions of the facade. A small but handsome porch with columns resting on the backs of carved lions projects from the central entrance.

The sculptor who executed the reliefs on the west facade at Modena (1106–20?) was named Wiligelmo, perhaps of German origin, who boastfully inscribed one plaque: "Among sculptors, your work shines forth, Wiligelmo."[13] Indeed, Wiligelmo has been lauded in art historical scholarship as a leader in the introduction of stone sculpture on the exteriors of Italian Romanesque churches. In moldings framing the cathedral's doors, he produced vertical relief

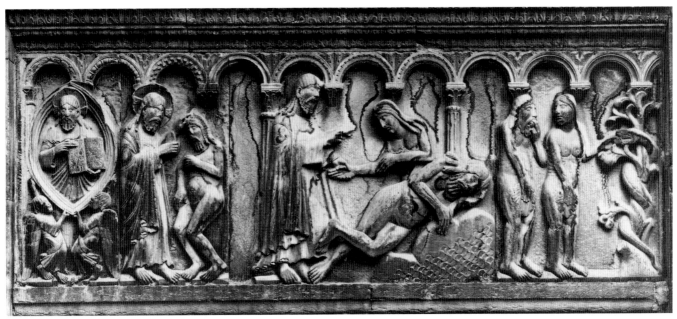

Fig. 14.17. Wiligelmo. Scenes from Genesis. Frieze on the west facade of Modena Cathedral. Stone, height approx. 36″. 1106–20

panels, with vine scrolls and prophets standing in niches. Wiligelmo also carved four high friezes above the side portals and narrative scenes from the Creation to the Flood in Genesis beneath a decorative arcade flanking the projecting porch (**fig. 14.17**). The figures of Wiligelmo remind us of the stocky forms found in later Pisan sculptures, but here they are even more ponderous in proportions and stilted in action. Often regarded as revivals of ancient Roman relief sculptures, the friezes of Wiligelmo seem more indebted to Ottonian models and the traditions of narration in medieval manuscripts than to any specific Classical sources. It is clear that the dynamic linearism of mature French Romanesque sculpture had made little impact in Italy.

GERMANIC LANDS

The artistic traditions of the Holy Roman Empire formulated in Carolingian and Ottonian times persisted under the Franconian and Hohenstaufen rulers of Germanic territories during the eleventh and twelfth centuries. The innovations in French Romanesque, namely, the elaboration of the pilgrimage choir and the ambitious sculpture programs on the exteriors of churches, are rarely encountered in western Germany, and, in general, the major influences found there seem to stem from Lombardy (which was also part of the empire).

In 1050, Herimann, the archbishop of Cologne and the grandson of Otto II, commissioned a bronze cross (**fig. 14.18**). A figure of Christ is attached to the cross, but curiously his head is blue. The head is made out of lapis lazuli (ultramarine), a precious stone found only in Afghanistan, and was appropriated from a Roman sculpted miniature from the first century A.D. In fact, it is a portrait of Livia, the wife of Caesar

Fig. 14.18. Herimann Cross. Cast bronze, filigree, gems, and lapis lazuli. 16½ × 11¼″. c. 1050. Erzbischofliches Diozesanmuseum, Cologne

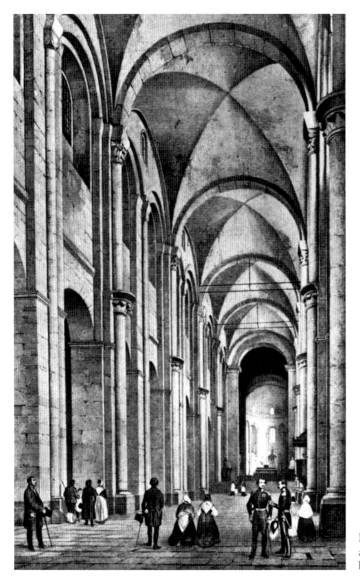

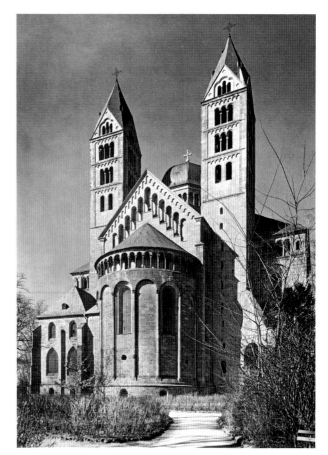

Fig. 14.20. Speyer Cathedral. Exterior. 11th century

Fig. 14.19. Speyer Cathedral. Interior after vaulting in 1106. Lithograph (made before 19th-century restorations)

Augustus. The lapis lazuli head may have been incorporated into Herimann's Cross to increase its value and to reaffirm his connection with the Holy Roman Empire.[14]

The *Kaiserdom*, or Imperial Cathedral, at Speyer (**figs. 14.9, 14.20**), the largest of the three major foundations along the Rhine River (Mainz and Worms are the others), offers a powerful statement of imperial authority.[15] The foundations of the west front, the aisles, and the vaulted crypt preserve those features of the original structure consecrated in 1061, but much of the present church was built after 1080 by Henry IV following his "victories" over Pope Gregory VII and his political rival in the North, Rudolf of Swabia. Speyer stands as a mighty symbol of Henry's supremacy.

In the second building campaign, the apse and the transept arms were refashioned, and the nave was accommodated for stone vaulting in square bays by the addition of engaged colonnettes (or responds) to every other pier, thus

creating an alternating system. The domed-up groin vaults (unribbed originally), soaring 107 feet from the floor, were added after 1106, presumably by north Italian masons (much of the nave was restored in the nineteenth century). On the exterior, "dwarf" Lombard galleries were added just below the eaves all around the church, a handsome feature that was repeated in numerous German churches. While simple in plan and conservative in structure, Speyer—435 feet long with six lofty towers dominating the exterior—is an imposing, grand monument in Latin Christendom.

Founded in 1093, the Benedictine Abbey of Maria Laach (**fig. 14.21**), beautifully situated in the woods of the Laacher See above the Rhine, serves as an attractive example of this conservative strain in monastic architecture. Here the clustered geometric volumes repeat the traditional "double-ender" features of Ottonian churches (compare Saint Michael, Hildesheim, fig. 9.19). The exterior is further

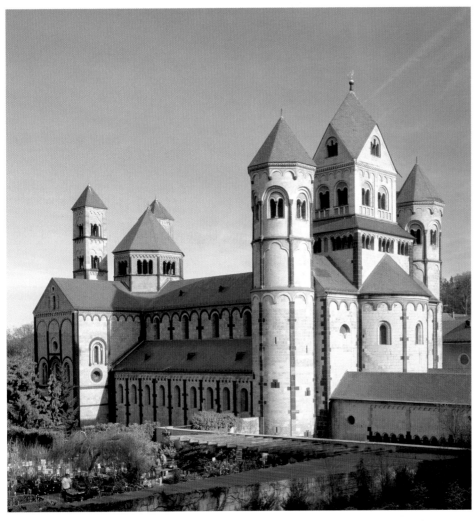

Fig. 14.21. Abbey Church, Maria Laach. Exterior from northwest. Founded 1093

enhanced by the Lombard corbel tables and pilaster strips of black stone. The rectangular groin vaults in the nave—the alternating system was not introduced here—were added in the thirteenth century, as was the impressive "Paradise" (open court) or atrium.

Whether due to conservative tastes or disinterest for elaborate figurative sculpture in general, the architectural decorations of these German churches are limited mostly to ornamental additions such as the Lombard corbel tables. Works in sculpture are found, but these take the form of individual pieces placed in the interior or apart from the actual structure.

There were, however, innovations in metalwork. The tomb effigy of the Saxon king, Rudolf of Swabia (**fig. 14.22**), who died in battle defending the papacy, is a monumental bronze casting. Nearly lifesize, the figure of Rudolf holds the traditional symbols of royalty, a scepter and an orb. His head is

Fig. 14.22. Tomb effigy of Rudolf of Swabia. Bronze with niello. 6′ 5½″ × 2′ 21½″. After 1080. Merseburg Cathedral

in higher relief than the rest of his body, making his feet appear oddly elongated. Rudolf also wears spurs, a knightly attribute, reinforcing his position as a warrior-king. The bronze casting is incised with fine lines, which are filled with *niello*, an inlay made of a black sulphur alloy, to provide greater detail.[16]

Fig. 14.23. Brunswick Lion. Bronze, length 6′. 1166. Cathedral Square, Brunswick

Fig. 14.24. Aquamanile. Gilt bronze, height 7¼″. c. 1130. Victoria and Albert Museum, London

One of the earliest freestanding sculptures on a monumental scale is the great Brunswick Lion (**fig. 14.23**), cast in bronze and gilded, that stood before the palace of Duke Henry the Lion of Saxony at Dankwarderode. The huge lion, dated 1166, is an imposing emblem of Henry's Welf (Guelph) family, but in form it resembles an enlarged lion aquamanile (an ornamental pitcher for washing hands at the altar; see **fig. 14.24**) with its stylized mane of rhythmic tufts and polished torso. For the Cathedral at Brunswick, built by Henry the Lion between 1173 and 1195, the sculptor Imervard executed a large wooden Crucifix (**fig. 14.25**) around 1173 that copies a famous type with the frontal Christ, eyes open and sheathed in a massive, long-sleeved *colobium*, the *Volto Santo* that was venerated in Lucca.[17]

German craftsmen excelled in producing magnificent small metal sculptures for liturgical objects, reliquaries, and altarpieces. The traditions of metalwork and casting were well established in Germanic lands, especially in the Rhine and Meuse river valleys. An important manual on the techniques of painting, glassworking, and metalwork, *De diversis artibus*,

Fig. 14.25. Imervard. *Volto Santo*. Wood, height approx. 7′. c. 1173. Cathedral, Brunswick

written by Theophilus about 1100, gives us a number of insights into the more practical aspects of the training of the medieval craftsmen and the organization of their shops.[18]

The author was aware of the importance of Greek (Byzantine) and Italian techniques as well as those of Northern craftsmen. The lengthy discussion of bronze-casting and goldsmith work suggests that the compiler was primarily a metalworker, and, indeed, he has been identified by some scholars as an important goldsmith, Roger of Helmarshausen (Lower Saxony), to whom is attributed the handsome portable altar from the Abbey of Abdinghof, now housed in the Franciscan Church in Paderborn (**fig. 14.26**), executed around 1100. The sides are decorated in bronze-gilt openwork with fast-paced narratives of the lives of the patron saints of Abdinghof—Felix, Blaise, and Peter—and an unidentified

martyr (Saint Paul?). The thinness and angularity of the vibrant figures are clearly Northern features, but the repeated drapery patterns, the so-called nested V-folds, are recognizable as Byzantine conventions pressed and interlocked across the costumes in a flat manner.

Another work attributed to Roger of Helmarshausen, the portable altar of Saints Kilian and Liborius (**fig. 14.27**), reveals tremendous skill in a diversity of metalsmithing techniques. On the short sides of the altar, repoussé figures of Christ and two saints are rendered in high relief. By contrast, the five saints represented on the long sides of the altar are engraved in bronze with *niello*. The altar's top includes jewelry work in precious gems and pearls. A central slab of marble is surrounded by silver incised with *niello*. In the corners, medallions of the four Evangelists are represented in

Fig. 14.26. Roger of Helmarshausen. *Martyrdom of Saint Paul(?)*. Portable altar from Abdinghof Abbey. Silver, copper, and bronze, gilded, over wood, height 4½″. c. 1100. Franciscan Church, Paderborn

Fig. 14.27. Roger of Helmarshausen. Portable altar of Saints Kilian and Liborius. Silver with niello and gemstones. 6½ × 13⅝ × 8⅜″. c. 1100. Erzbischöfliches Diözesanmuseum and Domschatzkammer, Paderborn

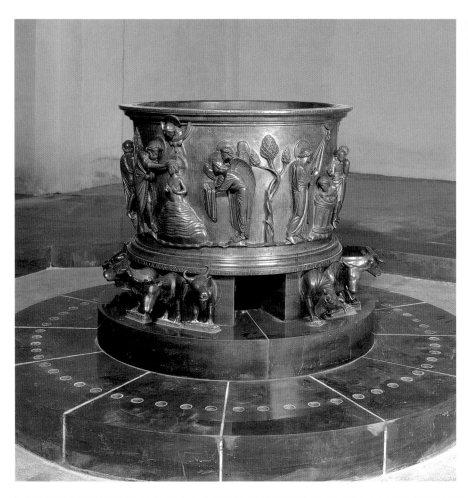

Fig. 14.28. Rainer of Huy. Baptismal font for Notre-Dame-des-Fonts, Liège. Bronze, height 23½″, diam. 31½″. 1118. Saint-Barthélemy, Liège

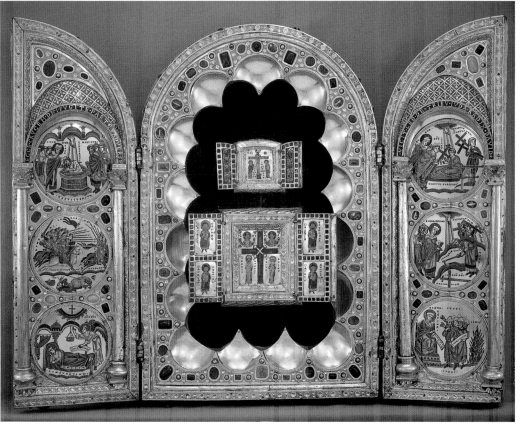

Fig. 14.29. *Scenes from the Legend of the Discovery of the True Cross* (Stavelot Portable Altar). *Champlevé* and *cloisonné* enamel on copper gilt, 19¹⁄₁₆ × 26″. After 1154. Pierpont Morgan Library, New York

meticulous detail. Between these roundels, two clerics, blessed by the hand of God, perform liturgical rituals in front of altars. On the top register, a priest elevates the chalice, while on the bottom, Bishop Heinrich de Werl, the altar's patron, swings a censer. The iconography and use of rich materials reinforce the authority of the portable table as a sacred altar, where a heavenly meal can be shared in communion with the saints.

The leading centers for such sumptuary arts were located in the valleys of the Meuse (Maas) River.[19] In addition to the excellence of craftsmanship in many of these small Mosan works, the sophistication in terms of complex subject matter is striking, particularly in the typologies of Old and New Testament narratives. Rainer of Huy, active in Liège, is one of the earliest and most impressive of these Mosan artists.[20] His baptismal font (**fig. 14.28**), originally for the Church of Notre-Dame-des-Fonts (now in Saint-Barthélemy in Liège), completed in 1118, is especially interesting for its style. Serene figures, nearly three-dimensionally conceived, are placed gracefully in a sequence of five scenes divided by symbolic trees of paradise about a heavy bronze basin.

The Baptism of Christ is the major representation. The softly modeled figures, their draperies falling in long, lyrical folds, are naturally proportioned and elegantly posed. There is something distinctly Classical in the treatment of Rainer's quiet figures placed against the plain background. The font, cast in one piece, rests atop twelve (now ten) oxen cast in half-length. The inspiration for this remarkable font was the "molten sea . . . on twelve oxen" cast in bronze for the court of the Temple of Solomon (1 Kings 7:23–25), an Old Testament type for the Baptism of Christ (the twelve oxen were likened to the apostles) found in some learned treatises of the period (compare Rupert of Deutz, *De Trinitate*, 1117).

The serene classicism of Rainer's font is not the most distinguishing feature of Mosan metalwork, however. The Stavelot triptych in the Pierpoint Morgan Library (**fig. 14.29**) glitters with gems, silver pearls, and colorful *cloisonné* and *champlevé* enamels within the copper-gilt frame that encloses two smaller Byzantine reliquary triptychs containing, among other relics, a piece of the True Cross. Probably commissioned by Abbot Wibald of Stavelot (an imperial Benedictine abbey near Liège), sometime shortly after his return from Constantinople in 1155–56, the Morgan triptych is an instructive piece to study as the meeting ground for Eastern and Western traditions in the sumptuary arts.[21] The smaller Byzantine reliquaries—gifts of the emperor Manuel I—are executed in the *cloisonné* technique in typical Middle Byzantine style.

The wings of the triptych are richly embellished with a series of *champlevé* enamel roundels, three on each side, set within elegant silver columns. These roundels depict events from the legend of the True Cross. On the left the story of Constantine's conversion appears—his dream on the eve of battle with Maxentius, the defeat of Maxentius, and

Constantine's baptism by Pope Sylvester in Rome—and on the right three episodes illustrate the miraculous recovery of the True Cross in Jerusalem by Constantine's mother, Helena. The style of the diminutive figures is dainty and bright, with the flesh parts of their bodies and the background in gilt, the costumes and settings in green, red, and blue enamel with white added for modeling effects. Unlike the iconic Byzantine enamels in *cloisonné*, those in *champlevé* resemble sparkling miniatures, and, indeed, the iconography of the six episodes conforms to Latin or Western narrative traditions.

About this time Abbot Suger of Saint Denis requested enamellers from the Mosan area to execute works for his new Gothic church on the outskirts of Paris, including a sumptuous altar crucifix which had an elaborate base decorated with no fewer than sixty-eight figured scenes in enamel with Old and New Testament events juxtaposed. Suger's Crucifix is known today only from his own description of it, but the base of a Mosan work, dating from about 1150–60, that may have been much like it, is preserved in the Museum at Saint-Omer (**fig. 14.30**).[22] The base with its typological enamels is supported by cast statuettes of the seated Evangelists in lively

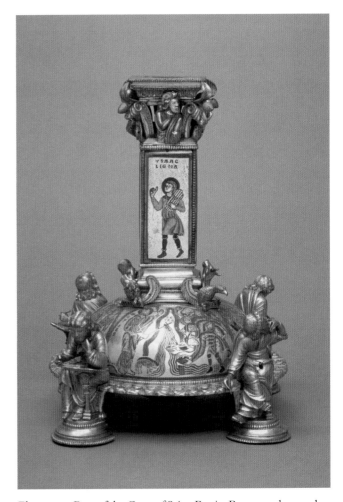

Fig. 14.30. Base of the Cross of Saint-Bertin. Bronze and enamel, height 12⅛″. c. 1150–60. Saint-Bertin Museum, Saint-Omer

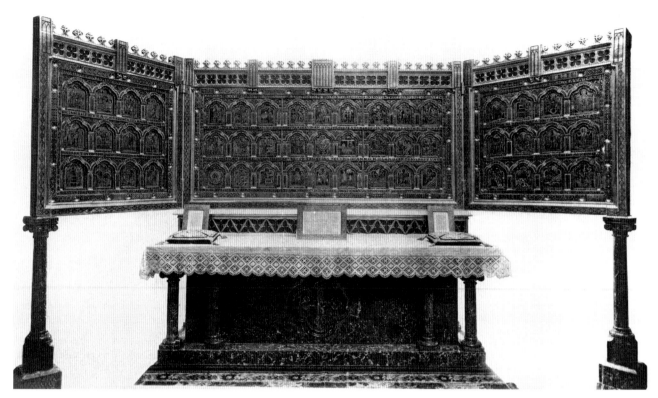

Fig. 14.31. Nicholas of Verdun. Klosterneuburg Altarpiece. Gold and enamel, height approx. *28″*. 1181. Stiftsmuseum, Klosterneuberg (originally the pulpit of the Benedictine Abbey in Klosterneuburg near Vienna)

Fig. 14.32. *Flight into Egypt.* Detail of Fig. 14.31

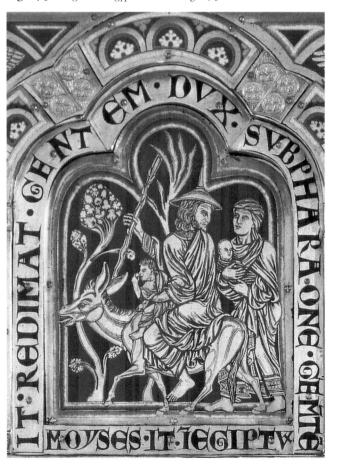

poses writing down their accounts. While the iconography of the enamels anticipates the more complex subject matter of the Gothic artists, the style of the cast figures of the Evangelists on the Saint-Omer base also announces new developments that will culminate in the Gothic sculpture in the Île-de-France in the graceful poses, natural proportions, and softly modeled draperies.

A pivotal figure in late twelfth-century metalwork is Nicholas of Verdun.[23] His work combines the elegant Classical figure style (already present in Rainer of Huy's font) with the assimilation of Byzantine drapery conventions in a new naturalism in modeling. For the provost Wernher of Klosterneuburg (near Vienna), Nicholas of Verdun executed an elaborate pulpit with tiers of *champlevé* enamels in *niello* on blue backgrounds (completed in 1181). After a fire in 1330, the pulpit was remodeled in the form of an altarpiece in triptych form (**figs. 14.31, 14.32**). Some additions were necessary. In three horizontal registers the enamels are arranged to form an ambitious Old New Testament typology (fifty-one in the final form). The middle row features New Testament scenes, labeled *subgracia*, or the world under grace, from the Annunciation to Pentecost (the final side, to the right, includes scenes from the Apocalypse). For each New Testament episode a corresponding event from Genesis, *ante legem*, or before the law of Moses, appears in the row above, while one from the period *sub lege*, or under the law of Moses (following the handing over of the Tablets of the Law on Mount Sinai), is

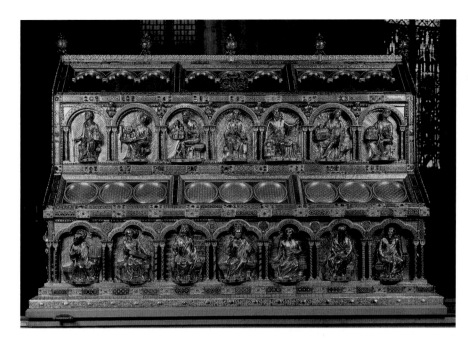

Fig. 14.33. Nicholas of Verdun and workshop. *Shrine of the Three Kings.* Silver and bronze, gilded; enamel, filigree, and precious stones, 68 × 72 × 44″. c. 1190–1230. Cathedral Treasury, Cologne

Fig. 14.34. Nicholas of Verdun and workshop. *The Prophet Joel.* Detail of Fig. 14.33

placed below. For the Last Supper, for instance, the Meeting of Abraham and Melchizedek (Gen. 14:18) appears above, the Gathering of Manna (Exo. 16:15) is placed below.

Such a complex iconographic scheme suggests that learned churchmen advised Nicholas in his project. In fact, the ambitious program of the Klosterneuburg altar presents a standard sequence of Old and New Testament parallels that we find in the more familiar typologies described in the *Biblia Pauperum* and the *Speculum Humanae Salvationis*, two important Late Medieval manuals written for preachers that were to have lasting influence in Northern art.[24]

The episodes on the individual *champlevé* plaques are squeezed under trefoil arches. Silhouetted against stunning blue enamel backgrounds, the figures are gilded with dark *niello* inlays vigorously marking out the draperies and features. Many of these present the subjects in traditional compositions, but as he worked, Nicholas became more and more dramatic, exploiting lively gestures and twisting movements in the figures with the racing *niello* lines.

The keen sense of plasticity with Classical drapery patterns is even more striking in the figures of the prophets executed by Nicholas about 1190 for the Shrine of the Three Kings in Cologne. The shrine is believed to have been made for the archbishop after the precious relics of the Magi were acquired from Emperor Frederick Barbarossa. The large shrine is an elaborate structure of silver and bronze studded with filigree, enamels, and inset gems (**figs. 14.33, 14.34**). Handsome *repoussé* figures in gold are placed along the sides and in the gables. The Shrine of the Three Kings (they appear with the Virgin and Child on the front) has been much restored, and no doubt it was a collaborative production of a large workshop, but the distinctive style of Nicholas can be discerned in some of the splendid *repoussé* apostles and prophets seated along the sides.

NUNS AND MANUSCRIPT PAINTING

During the eleventh and twelfth centuries, nuns actively participated in the production of illuminated manuscripts. They became authors, scribes, illuminators, and patrons of manuscripts. One of the most famous nuns from the Rhineland is Hildegard von Bingen (1098–1179). Already as a child, she experienced mystical visions. Well-educated and from an aristocratic family, Hildegard joined the Benedictine monastery of Disibodenberg at the age of eight, becoming a nun at fifteen. After having a vision, Hildegard left her monastic home and established a new convent at Rupertsberg (near Bingen) in 1147.

Hildegard wrote treatises on medicine and the natural world. She composed music with lyrics for numerous songs. But she is most renown for her mystical revelations, which were recorded by her confidant and friend, the monk Volmar. The opening page of the *Liber Scivias* (Knowing the Ways), shows the abbess, seated within her monastery, receiving divine revelation in earshot of Volmar (**fig. 14.35**). In the *Scivias*, Hildegard describes this moment of insight. As she puts it, "a fiery light, flashing intensely, came from the open vault of heaven and poured through my whole brain."[25]

Unfortunately, the original illuminated manuscript was lost in World War II. The illustration shown here is a reproduction of a facsimile, which was produced by twentieth-century nuns prior to the book's destruction.

Around 1175, Herrad von Landsberg, the Abbess of Hohenburg, wrote a treatise on the history of the world from the Creation story to the Apocalypse entitled *Hortus deliciarum* (The Garden of Delights). Composed for the instruction of nuns under her care, the manuscript was lavishly illuminated. Regrettably, it perished in 1870, during the Franco-Prussian War. Fortunately, the designs of most of the illuminations have been preserved in copies. In one colored drawing (**fig. 14.36**), the Woman of the Apocalypse, an allegory of the Queen of Heaven, stands on the crescent moon with the sun behind her. On the lower left, a crowned beast with the head of a lion and the feet of a bear rises from the sea to attack the saints. To the right, a floating dragon emits flooding waters from his mouth, while above an angel lifts the Christ child to safety (Rev. 12 and Rev. 13). Elegant folds of the apocalyptic woman's wings and garment are reminiscent of classical imagery associated with the metalwork of Nicholas Verdun. The subtlety and grace of the image reveals the tremendous skill of nuns as artists.[26]

Fig. 14.35. *Hildegard von Bingen Receiving Divine Illumination*. Miniature from Hildegard's *Liber Scivias* (destroyed). Facsimile (after the 12th-century original)

Fig. 14.36. *Woman of the Apocalypse*. Illustration from Herrad of Landsberg's *Hortus deliciarum* (destroyed). Bibliothèque des Museés de Strasbourg. Facsimile (after the 12th-century original)

15

NORMANDY AND WESTERN FRANCE

THE NORMANS

The saga of the Normans (Northmen) disrupted the flow of history in France and England as well as that of the Mediterranean world in the eleventh and twelfth centuries. Descendants of the Vikings, the Normans sporadically settled along the western shores of France about the valley of the Sienne, and from Carolingian times they slowly grew into a powerful dynasty of conquerors and warriors. William the Conqueror, son of Robert the Devil (who died in Asia Minor returning from a pilgrimage to Jerusalem in 1053), inherited the title of Duke of Normandy at the age of seven. Educated by shrewd and sagacious clergymen, William became a champion of the Church.

On the conditions of a papal dispensation concerning bans on marriage to a Flemish relative, Matilda, William founded two monastic communities in Caen, his favorite residence. One for the men, the Abbaye-aux-Hommes, was dedicated to Saint Étienne (**figs. 15.1, 15.2**); the nunnery, or Abbaye-aux-Dames, commemorated the Holy Trinity. Saint Étienne boasts one of the most familiar facades in Romanesque France. William the Conqueror asserted his authority resoundingly with a westwork that surpasses any comparable structure of the Carolingians or Ottonians. Two great towers dramatically command the fortress-like structure, conveyed in the massive surfaces of its blocky walls and the bold clarity of its geometric design. There are no figurative decorations to detract from its austerity. The huge facade is divided by large buttress strips and straight stringcourses into a strict tripartite division of the square.[1]

The interior echoes the clarity and stability of the facade. Finished by 1077, it rises emphatically in three stages.

The divisions are of nearly equal height with a huge continuous gallery opening on the second level, and the walls are solid stone throughout. The austerity of the bold facade is thus reflected in the interior, and sculptural decorations are kept to a minimum, appearing only in quasi-Corinthian capitals that accent the projecting colonnettes and moldings. The present vault, which dates from about 1120, features quadripartite ribbing over two bays with an extra supporting transverse arch spanning the intermediate piers across the nave, thus forming sexpartite vaults, another anticipation of vaulting experiments associated with the Gothic style.

In early September 1066, William and his fleet of four hundred ships set sail from Saint Valéry-sur-Somme, above Caen, across the narrow channel for Pevensey in England. His purpose was to claim the throne of England following the death of Edward the Confessor that same year. Edward's brother-in-law, Harold, who had formerly paid fealty to William, assumed the throne, and that riled Viking blood. In fact, King Hardraada of Norway also invaded England and, arriving before William, had somewhat sapped the strength of Harold's army. In the famous encounter between the Normans and Saxons at Hastings on 14 October, Harold was killed, his army scattered, and William marched victoriously into London to claim the crown as king of England.

Norman chroniclers have left a number of accounts of the wondrous deeds of William the Conqueror. One of these, written between 1071 and 1077 by the court chaplain William of Poitiers, the *Gesta Willelmi ducis Normannorum et regis Anglorum*, records the Battle of Hastings. The event is also recounted in the famous *Bayeux Tapestry*, believed to have

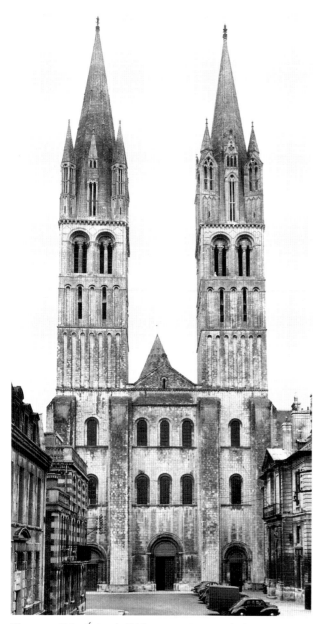

Fig. 15.1. Saint Étienne (Abbaye-aux-Hommes), Caen, France. Facade. 1064–77

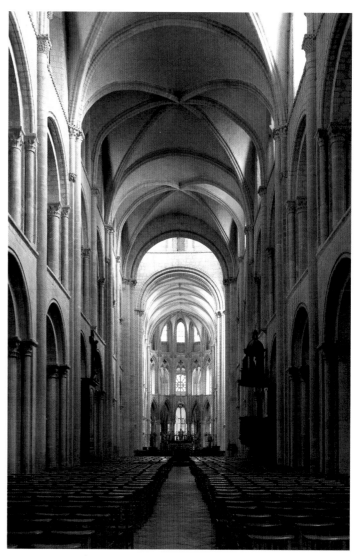

Fig. 15.2. Saint Étienne, Caen. Interior. 1064–77; vaulted c. 1120

been commissioned by William's half-brother, Odo, bishop of Bayeux, to commemorate the Norman victory and justify William's claim to the throne of England (**figs. 15.3, 15.4**).

A work of embroidery on linen stretching some seventy-seven yards, the *Bayeux Tapestry* offers a mode of pictorial narration that is analogous to the development of literary epics and *chansons de geste*, such as the *Song of Roland*.[2] The textile originally hung in a castle hall and was later placed in the nave of the city's cathedral. In continuous scroll fashion, the events unfold with lively figures engaged in boat building, sailing the channel, landing in England, and, finally, in notable episodes in the Battle of Hastings. There is even an introductory proem relating the earlier subjection of Harold

to William, thus justifying the Norman claims. The embroidery is fascinating as a document of secular interests of the time. Amid the fast-paced battles, other events of contemporary concern such as the appearance of Halley's comet and a scandalous tale involving "a clerk and Aefgyva" are inserted. In the elaborate borders along the top and bottom are strewn various subjects of marginal interest, such as exotic animals, fables, couples engaged in sexual acts, and slain soldiers with their discarded arms.

The Normanization of the Anglo-Saxon churches in England was immediate and vigorous. Lanfranc of Pavia, William's learned councilor, who had joined the important abbey at Bec and served the abbacy of Saint Étienne in Caen,

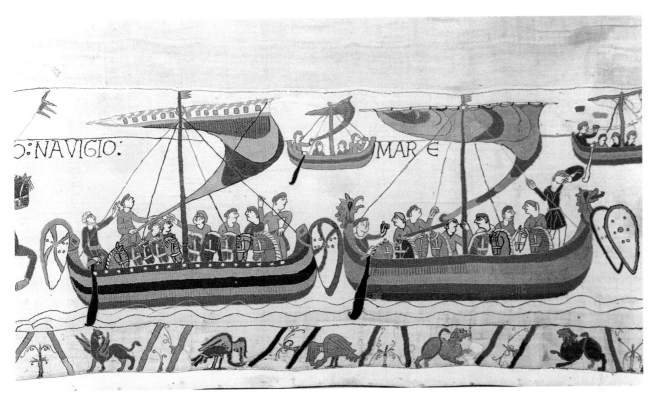

Fig. 15.3. *Normans Crossing the English Channel.* Detail from the Bayeux Tapestry. Wool embroidery on linen, height 20″ (length of entire tapestry, 229′ 8″). c. 1070–80. Centre Guillaume le Conquérant, Bayeux

Fig. 15.4. *Messengers to King Edward and Halley's Comet.* Detail from the Bayeux Tapestry.

Fig. 15.5. Durham Cathedral. Exterior. 1093–1133 and later

was a staunch supporter of the Norman acquisition of England. Acting as a vice-regent for William, he was made archbishop of the Cathedral of Canterbury and led in the reform and reorganization of the Saxon churches. Following an influx of Norman monks, building activity reached a feverish pitch. Numerous old churches were torn down and replaced with impressive Norman buildings.

A number of important churches in England today have Norman foundations. The specific Norman contribution lies in the superb stonework that gives these structures their monumental proportions and stability. Norman, too, would seem to be the introduction of the two-towered facade—the priors and bishops were, in effect, lords over both secular and

ecclesiastical affairs—but from Cluny III came the idea behind the double-transept plan that often appears (Canterbury and the priory at Lewes), while the distinctive English screen facade (for example, Ely) has been linked to churches in Aquitaine, to be discussed below.

Important experiments in vaulting with ribbed compartments or groins (instead of the usual tunnel vault) began at Durham Cathedral (**figs. 15.5–7**), one of the masterpieces of English Romanesque architecture. Set high on a cliff overlooking the picturesque river Wear, Durham served as a military headquarters as well as the seat of ecclesiastic authority. The familiar two-towered facade of Durham, however, dates variously with its Romanesque foundations,

Fig. 15.6. Durham Cathedral. Plan (after Webb)

Fig. 15.7. Durham Cathedral. Interior. (The eastern end is a later addition)

its Gothic towers, and the eighteenth-century battlements. An impressive Galilee porch, dating from about 1175, projects from the facade, but it is the interior that interests us here.[3]

The church was begun in 1087 under Bishop William de Carilef to replace an earlier Saxon church, and the vaulting in the nave (**fig. 15.7**) was completed by 1133. The nave consists of double bays (two single bays at the entrance) with huge columns alternating with complex compound piers. Great transverse arches span the nave between the piers, dividing the expanse of the nave vault into three units. Ribs spring diagonally from the piers and from corbels in the galleries above the columns, crisscrossing the ceiling so that, together with the transverse arches, the vaults display a curious seven-part division in each unit. Decorative effects seems to take precedence over clarity of structure. This is apparent in the elaborate chevrons, diaper patterns, and spiral flutings that are incised on the massive columns, diminishing their simple structural appearance. Interlaced blind arcades decorate the lower walls of the side aisles, and a variety of molding designs throughout the elevation further shows a taste for decorative touches and embellishments.

AQUITAINE

Like a giant crescent on a map, the grand duchy of Aquitaine sweeps through the western and southern counties of modern France from the borders of Normandy in the north through Poitou, Périgord, Guienne, and Auvergne to the southern domains of the Counts of Toulouse. Poitiers, the capital of Poitou, was the favored residence of the rulers of Aquitaine. Duke William IX of Aquitaine (1071–1127) is the romantic knight heralded in French history as the initiator of the colorful traditions of the chivalric romances and *chansons de geste* in the vernacular. His granddaughter, Eleanor of Aquitaine (1122–1204) was wife of two kings and mother of two kings. Her first husband was the Capetian king of France, Louis VII, whom she divorced in 1152. She then married Henry II Plantagenet, Lord of Anjou, Brittany, and Normandy, and later King of England. Richard the Lionhearted (*Coeur-de-lion*) was her son. Thus Eleanor's domain at one time covered France and England, and her reign overlapped in time the Romanesque and Gothic periods in art history.[4]

Along with her first husband, she attended the call to arms by Saint Bernard, the spiritual leader of the Romanesque,

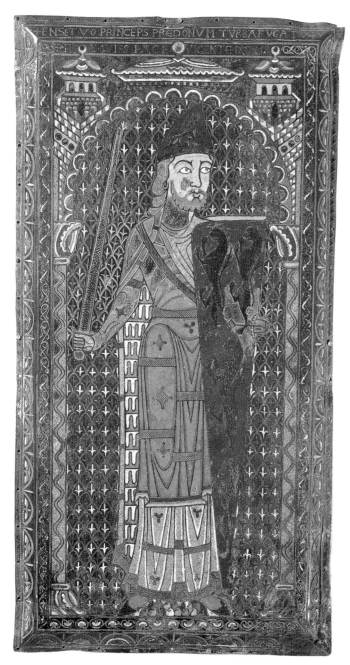

Fig. 15.8. Funeral effigy of Geoffrey Plantegenet of Anjou, Limoges *champlevé* enamel. 25 × 13″. c. 1158. Musée de Tessé, Le Mans

(**fig. 15.8**), is quite large for an enamel plaque and portrays his courtly status rather than his personal appearance. Geoffrey wears a full-length tunic and a conical hat. In his right hand, he brandishes a sword, while a long heraldic shield is held in his left. Decorated with four standing lions against a blue background, the shield reveals his family's coat of arms. The position of his sword and shield suggest that the open-eyed Geoffrey is a capable warrior, vigilant and ready to safeguard his territory.[5]

A small enamel casket depicts scenes of courtly love (**fig. 15.9**). On the left, a troubadour plays romantic music to attract the attention of a lady. With hands on her hips, she seems to rebuff his advances. The bird flying between the couple may indicate his desire, as one medieval troubadour put it, to "fly through the air and deep into her house."[6] On the right, the troubadour, in his chivalric pursuit for love, has become prisoner of his own desires and is left to the mercies of the prey of his affections. The lady has captured him, placing a leather strap around his neck. In response, with clasped hands, he surrenders to the woman in submission. By pressing his hands together, a gesture readily associated in Europe with pledges of servitude, the kneeling male offers his devotion. A domesticated falcon perches on the lady's waist, evoking notions of an aristocratic hunt and reinforcing the idea that she is in control. Even though the woman is apparently in control of the lover's destiny, it is important to recognize that the narrative gives primacy to his passions and erotic longings. Her desires remain secondary. In the center of the panel, near a keyhole, a male figure holding a sword in one hand and a key in the other guards the contents of the enameled box. He also seems to protect the lady's chastity, keeping the troubadour from entering the unattainable lady's body or penetrating the mysteries of her heart.

The Church of Notre-Dame-la-Grande (**fig. 15.10**) is typical of Poitevin Romanesque architecture.[7] The ground plan and interior are simplified pilgrimage types, but the facade is distinctive. Lacking the monumentality of the Cluniac churches, Notre-Dame-la-Grande at first strikes one as an enlarged reliquary shrine, bedecked with a profusion of sculptural gems and delicate pinnacles. The ornate facade is, in effect, a screen that is unrelated to the interior. The flanking towers are reduced to cylindrical piers of bundled shafts carrying a small drum capped by a conical roof covered with fish-scale tiles. The simple gabled face is covered with tiers of sculptural decorations. The doorways have no tympana, and the courses of archivolts (voussoirs) are carved as individual elements in a radial fashion with monotonous rows of identical figures.

at Vézelay in 1146, and, in fact, headed a band of women warriors, called "Amazons," who joined the ill-fated Second Crusade. On the other hand, her marriage to the French king had been negotiated by Abbot Suger of Saint Denis, the founder of the new Gothic style in the Île-de-France. In her later years she patronized a "court of love" for artists, poets, and literati at her residence in Poitiers.

Eleanor's second husband, Henry II, paid for daily masses to be performed at an altar in front of his father's tomb at the Cathedral of Le Mans. The two-foot high funerary effigy of Geoffrey Plantagenet, the count of Maine and Anjou

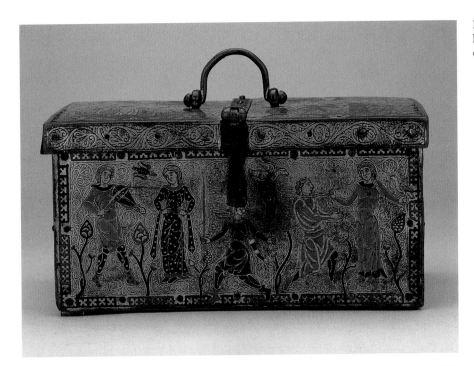

Fig. 15.9. Casket with scenes of courtly love. Limoges *champlevé* enamel. 3⅝ × 8½ × 6⅜″. c. 1180. British Museum, London

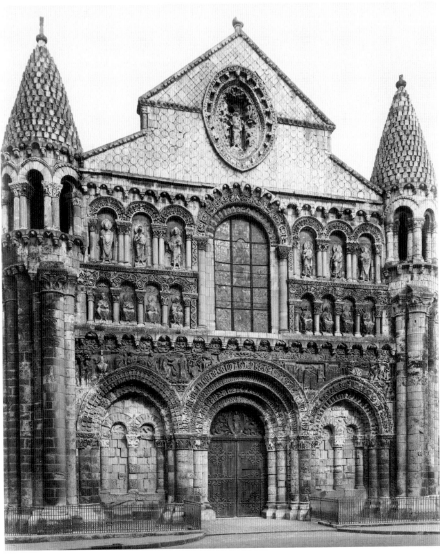

Fig. 15.10. Notre-Dame-la-Grande, Poitiers. West facade. c. 1150–70

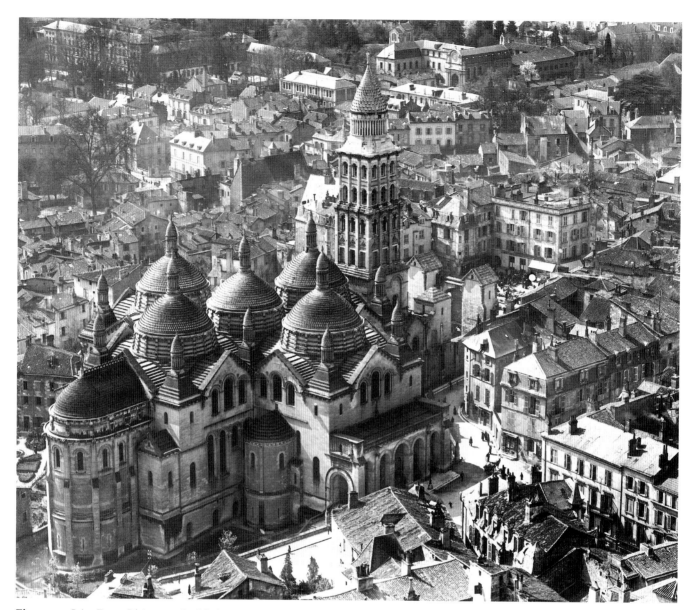

Fig. 15.11. Saint Front, Périgueux. Aerial view. c. 1120

A dog is repeated over thirty times on one range of voussoirs. In the spandrels, a frieze of relief sculptures narrates a series of biblical stories beginning with the Fall of Adam and Eve on the left, continuing with figures of prophets, the Annunciation, the Tree of Jesse, and concluding with the Nativity on the right.

The second level of the facade rises above a coursing of corbels with two arcades of ornate niches housing apostles and churchmen, all posed frontally. In the gable, a brooch-like lozenge is carved with Christ standing between angels. Thus the upper stories present a *Maiestas Domini* of sorts. Similar screen facades are found throughout Poitiers and Périgord, but surprisingly many of the churches between the Loire and the Garonne rivers depart from traditional Romanesque construction in that they are covered with a series of domes in a fashion that reminds one of Byzantine types. The most impressive of these is Saint Front at Périgueux (**figs. 15.11, 15.12**), erected about 1120, which may have been inspired directly by San Marco in Venice. Huge open piers carry massive pendentives supporting five great domes over the center and the arms of the Greek-cross plan. In some churches (such as Saint Étienne at Périgueux, Fontevrault, Angoulême, and Souillac) the domes are lined up in a row over a basilical nave. It has been suggested that domes on such a scale were introduced into western France after the First Crusade in 1100, which William IX of Aquitaine joined. The bold austerity and emptiness of these domed interiors would have been relieved by painted decorations.

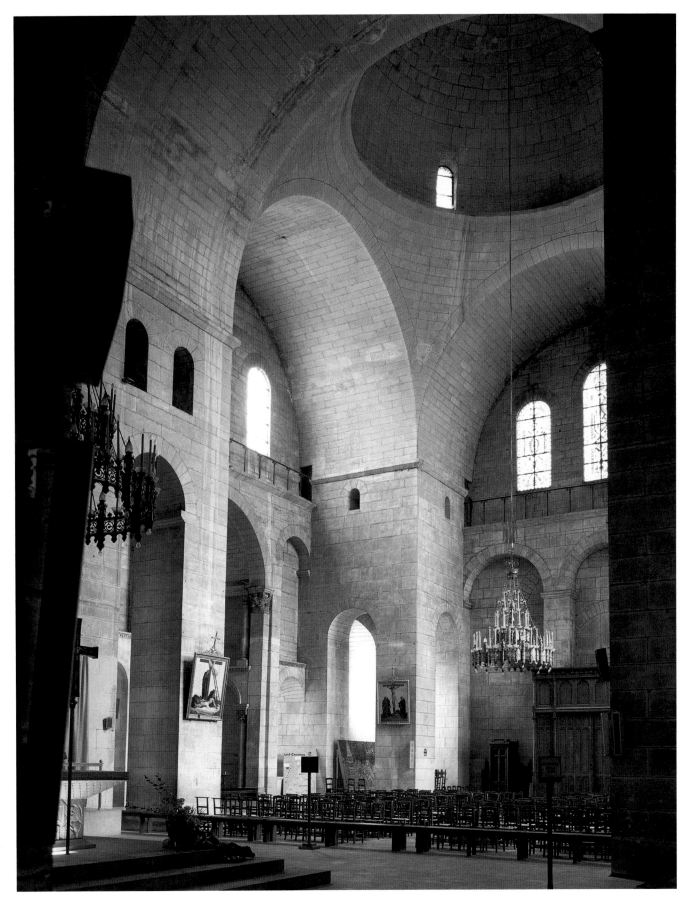

Fig. 15.12. Saint Front, Périgueux. Interior. c. 1120

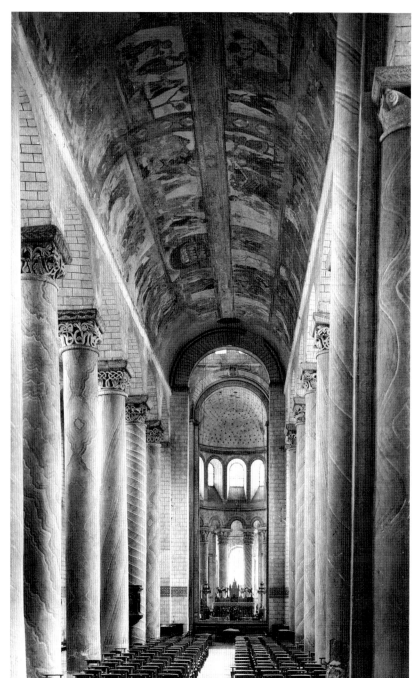

Fig. 15.14. *Plague of Locusts; Apocalyptic Woman;* and *New Jerusalem*. Frescoes in the narthex of the Abbey Church of Saint-Savin-sur-Gartempe

Fig. 15.13. Abbey Church of Saint-Savin-sur-Gartempe. Nave vaults. c. 1100

The painted ceiling of Saint-Savin-sur-Gartempe (**figs. 15.13–15.15**) miraculously survives, but here the interior is covered by a continuous tunnel vault that rests directly on the tall columns of the nave arcade, another church type in Aquitaine, the "hall church," in which the side aisles rise to the level of the nave vaults. A talented atelier executed the frescoes about 1100, probably while the scaffoldings for the erection of the vaults were still in place.

The porch or narthex is decorated with lively episodes from the Book of Revelation; the long vault of the nave has four registers of the history of ecclesia *ante legem* (before the law of Moses), with scenes from the first days of Creation to the moment when Moses received the Tablets of the Law on Mount Sinai. The charming Ark of Noah (**fig. 15.15**) resembles an enlarged miniature. The New Testament stories—only Passion pictures survive—were painted in the chapel gallery over the narthex, and frescoes in the crypt are devoted to the martyrdoms of Saint Savin and Saint Cyprian (similar remains of martyrs' histories are found in the chapels of the choir), appropriate for the function of that area as a miniature martyrium. Nothing remains of the apse painting.[8]

The frescoes in Saint-Savin are roughly contemporary with those in the chapel at Berzé-la-Ville (fig. 13.30), but they display little of the Byzantine stylizations found there. Rather,

Fig. 15.15. *Ark of Noah.* Fresco in nave vaults of the Abbey Church of Saint-Savin-sur-Gartempe. c. 1100

they seem to be distinctively Northern in style with tall, spindly figures moving in swinging, agitated postures that bring to mind the narratives in the *Bayeux Tapestry*. There is little indication of three-dimensional space or modeling.

As we have seen, there were two opposing styles of painting in France around 1100: the sophisticated Byzantine manner, especially evident in drapery conventions and head types (compare the Cluny Lectionary, fig. 13.31), and the more indigenous Northern style of dynamic linearism. Typical of the latter is *Saint Mark* in the Corbie Gospels (**fig. 15.16**), with his wild gestures and twisted pose.

Fig. 15.16. *Saint Mark.* Illustration in the Gospels of Corbie. 10¾ × 7⅞″. c. 1120. Bibliothèque Municipale, Amiens (MS 24, fol. 53r)

Fig. 15.17. *Ascension.* Illustration in the Sacramentary of the Cathedral of Saint Étienne of Limoges. 10¾ × 6⅝". c. 1100. Bibliothèque Nationale, Paris (MS lat. 9438, fol. 84v)

A daring compromise of these styles can be seen in manuscript illumination in Limoges (**fig. 15.17**). The hieratic qualities of the Ascension miniature in the Sacramentary of Saint Étienne in Limoges, dating from about 1100, have been described as creative transformations of Byzantine style. However, the flashes of hot, metallic colors held within firm but vigorous outlines, and the total suppression of space for the tall, compact figures cannot be overlooked.

Limoges is famous for its enameled reliquary shrines. The faces are decorated with *champlevé* and/or *cloisonné* enamels on copper plates affixed to a wooden core. A tabernacle with the Three Marys at the Tomb (**fig. 15.18**), dating about 1180–1200, is a fine example of such Limoges enamelwork.[9] *Champlevé* (in contrast to *cloisonné*, with its tiny partitions for the enamel) is a technique whereby the lines and shapes of the figures are actually dug out of or engraved into the metal surface with a cutting tool and then filled with enamel. Often, in late Limoges productions, separate cast heads or whole figures of bronze were applied to the enameled background. The sharp outlines and shapes of the engraved figures on the copper ground call greater attention to the surfaces of these precious shrines.

Although Limousin enamel is usually associated with intimate caskets and reliquaries, it was also applied to liturgical items such as Eucharistic doves and crosiers, adding splendor to rituals and conveying preciousness of the sacred. Occasionally, enamel doves (**fig. 15.19**) were suspended above altars to evoke the presence of the Holy Spirit. In addition, the dove served as a container of the Eucharistic host.

Fig. 15.18. Reliquary. Limoges, 14¼ × 6¼″. End of the 12th century. Metropolitan Museum of Art, New York. Gift of George Blumenthal

Fig. 15.19. *Eucharistic Dove*. French, Limoges. Copper: formed, engraved, chiseled, scraped, stippled and gilt; *champlevé* enamel; blue-black glass inset eyes (modern base and suspension plate); height 7″, width 8¹⁄₁₆″. c. 1215–35. Metropolitan Museum of Art, New York

The crosier (bishop's staff) was regularly carried in religious ceremonies. It indicates that the bishop was a shepherd of the Christian flock. A richly decorated enamel crosier (**fig. 15.20**) has a spiraling volute rendered in the shape of a snake with a flower blossom in its mouth, evoking allusions to the rod of Aaron. On two occasions in the Old Testament, Aaron's staff reveals the miraculous power of God.

In the court of the pharaoh, the rod was transformed into a serpent to encourage the king to let the children of Israel out of Egypt (Ex. 7:9–11). After the Exodus, while the Israelites were wandering through the desert, God affirmed Aaron as high priest by causing his rod to blossom (Num. 17:6–8). Like Aaron's rod, the enamel crosier elicits divine power and reinforces notions that the bishop is chosen by God.[10]

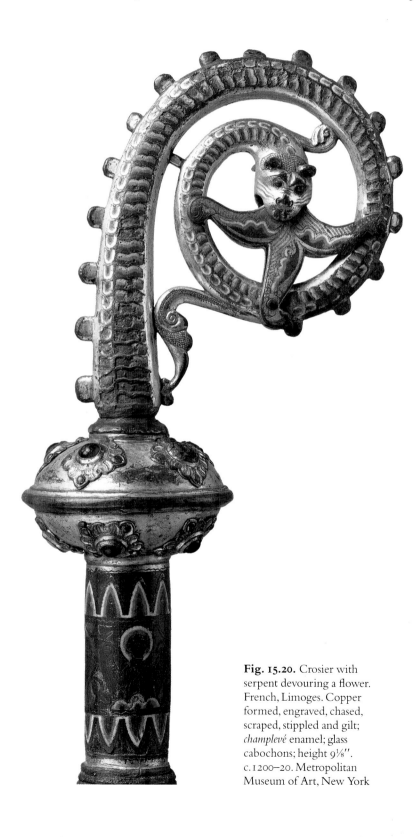

Fig. 15.20. Crosier with serpent devouring a flower. French, Limoges. Copper formed, engraved, chased, scraped, stippled and gilt; *champlevé* enamel; glass cabochons; height 9⅛″. c.1200–20. Metropolitan Museum of Art, New York

PART SIX
THE LATE MIDDLE AGES

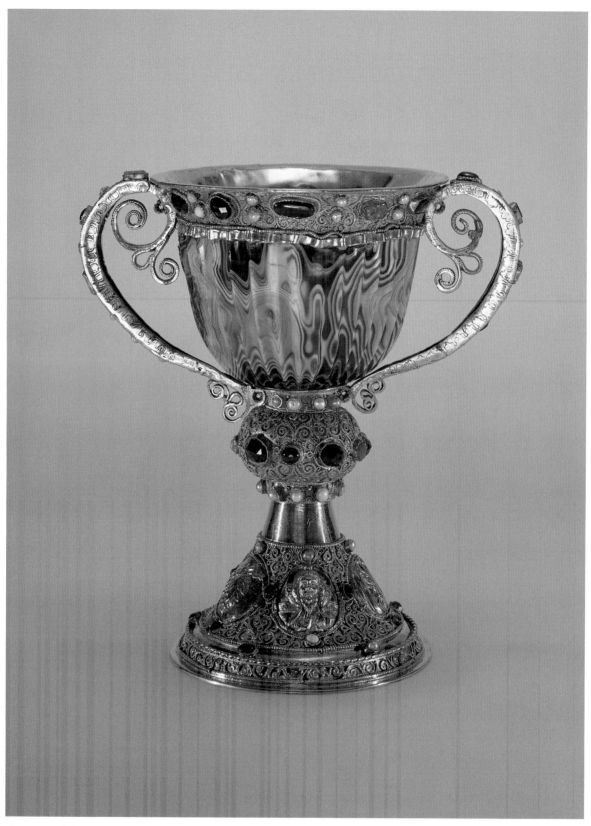

Fig. 16.1. Chalice of the Abbot Suger of Saint-Denis. Sardonyx cup with heavily gilded silver mounting, adorned with filigrees set with stones, pearls, glass insets, and opaque white glass pearls. Height 7¼″; diameter at top 4⅞″; diameter at base 4⅝″. Cup of Alexandrian origins, 2nd–1st century B.C.; mounting 1137–1140. National Gallery of Art, Washington

16
FRENCH GOTHIC ART

Many factors contributed to the emergence of Gothic art. One major aspect was the dramatic rise of urban communities. Cities replaced older monastic colonies as centers of education and the arts. Political unification also played an important role. During the late tenth century, the Count of Paris, Hugh Capet (987–96), was elected king of France. His descendents, the Capetian Dynasty, would rule France for nearly three hundred and fifty years. Through diplomacy and the brokering of noble marriages, Louis VI (1108–37) and his son Louis VII (1137–80) asserted the authority of the Capetians over numerous lords and barons. Louis VII married Eleanor, Duchess of Aquitaine, holder of the largest estates in western Europe, further increasing Capetian control. Aligning themselves with the Church, these French monarchs produced a powerful kingdom centered at Paris, and that is where our story begins. The construction of most of the French Gothic cathedrals coincides with the Capetians' ability to consolidate their power.

SAINT DENIS AND THE BEGINNINGS OF FRENCH GOTHIC

One of the major leaders of political and cultural change in early twelfth-century France was a Benedictine monk. Abbot Suger of Saint Denis (1122–51), born of humble parents, helped to initiate what is today called the Gothic style. Under his supervision, the first great monument of the Gothic, the Abbey Church of Saint Denis, was constructed. Suger was friend and councilor to both Louis VI and Louis VII; he served as regent of France during the latter's involvement in

the Second Crusade (1146), and was instrumental in keeping Louis's marriage to Eleanor of Aquitaine from disintegrating (they were divorced the year after Suger's death).

Since the sixth century, Suger's monastery-church had served as the burial site of the French kings. The church housed the *oriflamme*, a forked crimson banner, which was said to have belonged to Charlemagne, as well as the relics of Saint Denis (Dionysius of Gaul), a missionary martyr who converted the Franks to Christianity. In the ninth century, Hilduin, the monastery's abbot, confused Saint Denis with two other figures: Dionysius the Areopagite, an Athenian philosopher who became a Christian upon listening to the remarks of Saint Paul on Mars Hill (Acts 17:19–34), and Pseudo-Dionysius the Areopagite, a fifth- or sixth-century mystic and author of *The Celestial Hierarchy*. As there was a copy in the abbey's library, Suger was quite familiar with this text. For him the work tied the history of his monastery to the early Church and heightened the significance of the prized remains of the saint's body interred there. In addition, he welcomed the author's call for mystical ascent through contemplation of the sacred.

The Church of Saint Denis was situated just north of the city gates of Paris, the thriving capital of the realm (today it lies well within an industrial quarter of the city). With the assertion of political power on the part of the Capetians in Paris, Suger similarly dreamed of aggrandizing the ecclesiastical position of Saint Denis in Latin Christendom. Suger of Saint Denis was a very different cleric from Saint Bernard of Clairvaux. The pious spokesman of the austere Cistercian Order vehemently criticized Suger's actions at first. He called

Saint Denis a "synagogue of Satan," and accused Suger of ostentation and flaunting. Suger did not promote Bernard's asceticism. For Suger, art and splendor were all part of the worship of God, and these interests are announced in three treatises that he composed concerning the reform and rebuilding of Saint Denis under his abbacy.[1] His chalice (**fig. 16.1**), although altered by a series of minor restorations, reveals Suger's deep appreciation for precious sacred objects. The sardonyx cup was probably produced in Ptolemaic Egypt (200–100 B.C.). Remodeled for liturgical use at Saint Denis, the vessel was adorned with filigrees and costly gems. The

chalice is so highly decorated that there are no smooth areas on the cup's brim. Consequently, priests used liturgical straws to drink consecrated wine.

The old Carolingian church was described by Suger as being in a deplorable condition and much too small. In the treatise entitled *De Administratione*, 1144–49, Suger relates how the rebuilding progressed. First of all, the old church was so narrow that during feast days, he tells us, "the narrowness of the place forced the women to run toward the altar upon the heads of the men as upon a pavement with much anguish and noisy confusion." Suger then implores:

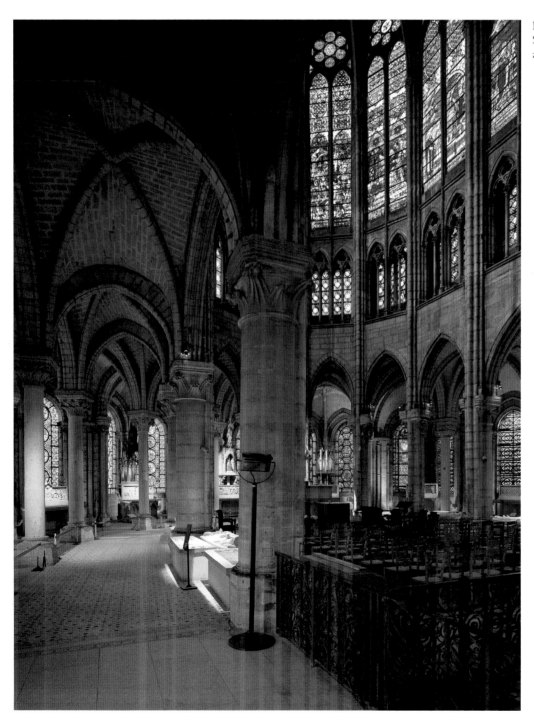

Fig. 16.2. Abbey Church of Saint Denis. Interior of the ambulatory. 1140–44

Divine mercy that He Who is the One, the beginning and the ending, Alpha and Omega, might join a good end to a good beginning by a safe middle . . . Thus we began work at the former entrance with the doors. We tore down a certain addition asserted to have been made by Charlemagne on a very honorable occasion (for his father, the Emperor Pepin, had commanded that he be buried, for the sins of his father Charles Martel, outside at the entrance with the doors, face downward and not recumbent); and we set our hand to this part . . . with the enlargement of the body of the church [the narthex?] as well as with the trebling of the entrance and the doors, and with the erection of high and noble towers.

The subsequent activity involved the rebuilding of the choir of the church. Thus, the refashioning of the imperial westwork and the holy sanctuary—evoking the presence of the monarchy and the Church—were Suger's first goals.[2]

The facade of Suger's new church was a monumental restatement of the two-towered westwork of earlier times.[3] It resembled, in fact, the great towering facade of Saint Étienne in Caen, in its high towers and massive walls, with heavy pilaster strips dividing the block into three zones corresponding to the nave and side aisles. A tripartite division also marks the vertical organization. The plain mural surface and solidity of the walls, however, were interrupted by a number of penetrations in the form of deep-set portals and ranges of trebled arcades above them in each division. Secondly, the upper part of the central division was punctured by a huge round window—the rose window—perhaps as a conscious aggrandizement of the traditional Carolingian "window of appearances" to symbolize the presence, not of the emperor, but of the "God of Light" in Suger's church. Finally, an amazing transformation of the portals has taken place. To relieve the austerity of the Normanesque entranceways, Suger added an elaborate screen of sculptures across them. Little survives of Suger's sculptures. The entire facade was crudely restored in 1839–40, following the French Revolution. Fortunately, drawings made by Antoine Benoist for Bernard de Montfaucon, a French antiquary, who published *Les Monuments de la monarchie française* in 1729, reproduce the tall, column-like figures that originally decorated the doorjambs.

Suger's new choir added in the second building campaign (1143–44) is a glorious presentation of the new principles of Gothic architecture (**fig. 16.2**). An elevated stage for exhibiting the relics was raised over the old annular crypt built in the ninth century (which Suger wished to preserve) with staircases on either side giving access to the upper choir. This in itself is not new, but the elaborate construction that encases the area around the altar is a striking departure from the Romanesque.

Two rows of slender columnar supports resting on square bases form a double-aisled ambulatory terminating radially in nine chapels that circle the apse. The chapels are no longer the isolated architectural units that we find in Romanesque pilgrimage choirs, however; they are integrated and merge with the aisles of the ambulatory along axes that radiate out from the central keystone of the apse like an intricate spider's web. The inner aisle has sections with irregularly shaped quadripartite vaults; the outer aisle with the apsidioles has five-part ribbed vaults that rest on the outer columns and the splayed piers in the wall.

Viewing the ambulatory from the side, we can see how the architect accomplished this unique solution to vaulting disparate areas. He employed pointed arches that can be easily adjusted to the desired heights (an impossibility with round arches) and added sturdy ribs along the structural lines, which were then filled in with a light webbing of stone. Unlike the more ponderous elevations of Romanesque choirs, the weight of the chevet or eastern end (apse, ambulatory, and radiating side chapels) of Suger's church is thus appreciably lessened, and the entire structure takes on the appearance of a diaphanous cage of skeletal construction. The supporting role of the outer walls is much reduced, too, so much so that they are nearly eliminated, allowing for large openings for high windows. A spaciousness and lightness result whereby the tubular delineations of ribs rising from slim columns describe a hollow volume covered with a skin of stone.

Suger's architect reintroduced one of the major features that distinguishes Gothic from Romanesque architecture: the use of pointed arches in a ribbed vault that is not only flexible but lessens the need for heavy wall supports (**fig. 16.3**). The role of the rib in Gothic vaulting has long been an issue of

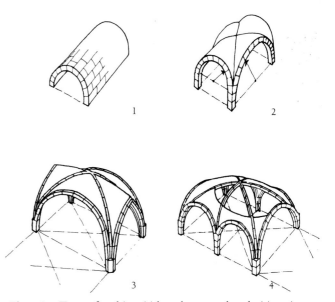

Fig. 16.3. Types of vaulting: (1) barrel or tunnel vault; (2) groin vault over a rectangular bay; (3) Gothic vault with pointed arches and ribs over a rectangular bay; (4) sexpartite vault over two rectangular bays (after Swaan)

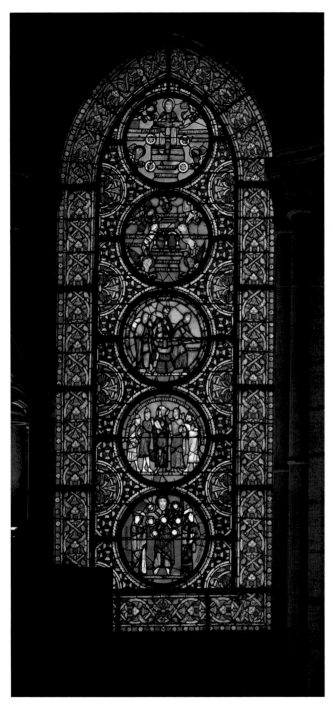

Fig. 16.4. "Anagogical" Window. Saint Denis Abbey Church. Stained glass. 1140–44

the vaults remain intact, implying that ribbing was not structurally important. Conversely, there are instances where the stone webbing has fallen and the ribs remain. The ribs are essential elements in articulating the vast spaces of Gothic vaults, dividing the space into discrete sections. At the same time, they are also necessary in forming the vault in the first place, providing the centering to shape the structure.[4]

The harmonious integration of the complex elements in Gothic architecture required someone trained in mathematics and the techniques of building, an architect. Just when the architect emerged in history as an independent designer of buildings is difficult to determine. As we have seen, trained mathematicians were summoned to Constantinople in the sixth century to oversee the building of Hagia Sophia, and a number of churchmen in the Romanesque period are recorded as designers of buildings.

The commission or rebuilding of ecclesiastical structures within the city depended on the actions of the cathedral chapter (the administrative organization of the canons of a cathedral). The chapter, in turn, would appoint a *magister operis* (*maître des ouvrages*, or master of works) to oversee the entire project, the "fabric" (*fabrica*), including the administration and maintenance of the building. The master of the masons (*maître maçon*, or *magister lathomorum*) was, in effect, the builder who had the specialized skills for planning the physical building, and his prestige grew rapidly during the thirteenth century. The epitaph of one Parisian architect suggests the elevated status of the master of the masons: "Here lies Pierre de Montreuil, a perfect flower of good manners in his life as a doctor of stones [*doctor lathomorum*]."[5]

Saint Denis was an abbey church and not a cathedral governed by a chapter, and yet it was in this monastic setting that the new principles of building were introduced on a grand scale. We know from Suger's writings that he personally sought out a quarry with proper stones and that he summoned excellent artisans from all over Europe. While Suger was no architect, he called in a master mason who was thoroughly familiar with the latest style in architecture. Ribbed vaults were common earlier; they are found in Norman churches (Durham Cathedral, Saint Étienne at Caen) and in Lombard structures that date from before Saint Denis. Pointed arches were used earlier in Burgundian churches, such as Cluny III. However, the lightness, the transparency, and the thinness of parts are new and allow the structure to open up as well as reduce its heavy walls.

Space and light are important factors. Suger vividly records the way the centering and vaults swayed precariously in a heavy storm that hit the church in January of 1143: his church must be as sturdy and stable as any other. Yet in his treatise on the consecration of the church, he tells us that he wanted the choir built with a "circular string of chapels, by virtue of which the whole [church] would shine with the wonderful and uninterrupted light [*lux continua*] of most luminous windows." In another passage, he states, "Once the

debate among art historians. Do the ribs serve a structural role once the vaulting is in place? Do they form a permanent frame that supports the weight of the stone vaults? Or are they simply decorative, serving an esthetic role in guiding the eye into the summit of the vault while, at the same time, concealing the abrupt junctures of the groins? Should they be considered structural members of engineering or expressive elements of a work of art? These issues are not easily resolved. Examples can be cited in which the ribs have collapsed and

new rear part [the choir] is joined to the part in front [the facade], the church shines with its middle part brightened. For bright is that which is brightly coupled with the bright, and bright is the noble edifice which is pervaded by the new light [*lux nova*]."[6]

The *lux nova*, or "new light," filtering in through the lofty stained-glass windows was an important feature of Suger's new chevet, and while there is some evidence for much earlier use of stained glass in windows, his concern for *lux continua*, or a continuous wall of such lights, in the chevet is new. Fragmentary remains of some of Suger's windows are preserved in the choir of Saint Denis.[7] In the chapel of the Virgin, directly behind the main altar on the central axis, were two tall windows appropriately decorated with scenes from the life of the Virgin (northern bay) and a resplendent Tree of Jesse (southern). Directly next to this chapel was that of Saint Peregrinus (now Saint Philip) with two windows, one dedicated to the story of Moses, the other, known as the "Anagogical" window (**fig. 16.4**), with typological mysteries

shown in roundels, including the "Mystic Mill," with Moses and Paul grinding grain into flour. This window does not provide a set of illustrated ideas for the illiterate. On the contrary, it offers a complex iconography, one not readily interpreted without sufficient theological education, suggesting that it was produced to stimulate mediation and study among those trained to read Scripture and the Church Fathers. The primary function of the window, for Suger, is to promote heavenly ascent, "urging us onward from the material to the spiritual."[8]

South of Paris, the Archbishop of Sens, Henri Sanglier, promoted the construction of a new cathedral. The Cathedral of Sens (**figs. 16.5, 16.6**), built between about 1145 and 1164, has a simplified ground plan with single side aisles continuing into the semicircular ambulatory of the choir without projecting apsidioles (secondary apses) as at Saint Denis. Only a single rectangular chapel extends from the east end. The nave is broad and spacious with a definite Norman appearance in the sexpartite vaults that rise from alternating pier supports.[9]

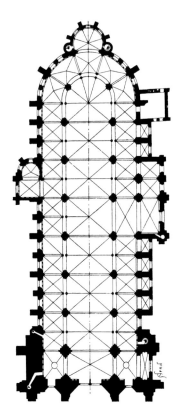

Fig. 16.5. Sens Cathedral. Plan (after Dehio)

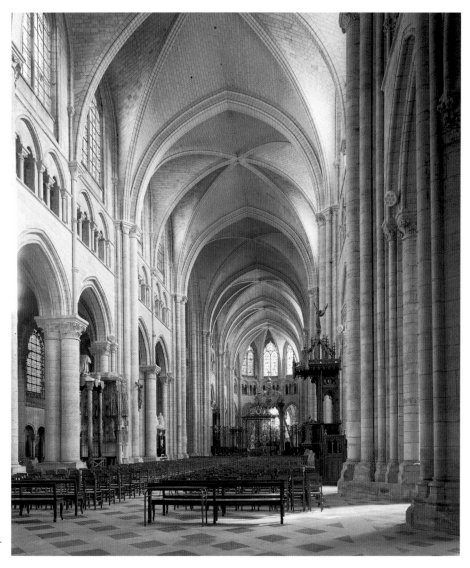

Fig. 16.6. Sens Cathedral. Interior. c. 1145–64

The elevation displays a subtle rhythm as it moves up through the three stages of nave arcade, triforium, and clerestory. Double columns alternate with huge compound piers, the latter carrying shafts that form the heavier transverse arches and diagonal ribs marking out the great hollows of the sexpartite vaults. The double columns carry shafts that form the intermediary transverse arches. In a shallow triforium, directly above the nave arcade, arches are quadrupled, while in the clerestory they are doubled. For each double bay, the tripartite division was marked with a cadence in consonance with the relative heights of each part. Although the Cathedral of Sens articulates a fine vertical thrust, it is the vast width of the nave that is striking.

North of Paris, the Cathedral of Laon (**figs. 16.7, 16.8**) presents another solution to the nave elevation.[10] Here the nave is also covered by great sexpartite vaults resting on an alternating system of columnar supports in the nave arcade.

Five, then three, clustered shafts rise from the capitals of the columns through the elevation to culminate in the transverse and diagonal ribs in the sexpartite vaults. The elevation of Laon has four stories, however, with a much more sculptural appearance in the dramatic sequence of arched members for each double bay. Directly above the nave arcade, a deep tribune gallery is introduced with vaults that serve to buttress the high nave. A triforium of blind arches runs between the open tribune and the clerestory windows above.

The facade of Laon Cathedral (**fig. 16.9**), about 1190–1205, is a daring experiment in architectural design, with its dramatic buildup of cavernous, scooped-out, arched projections with deep galleries, open niches, telescoping turrets and pinnacles. Staggered upward, these parts create a harmonious movement of architectural forms, projecting and receding as they rise in a crescendo of great towers culminating in octagonal belfries.

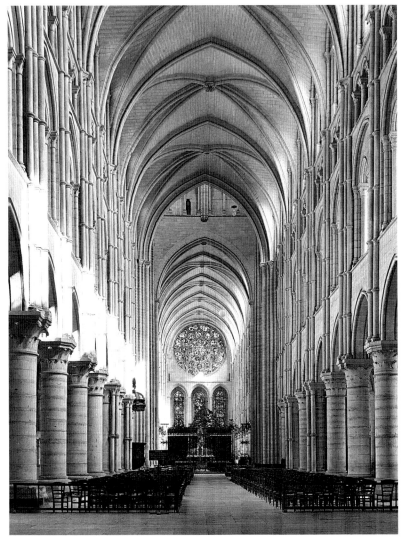

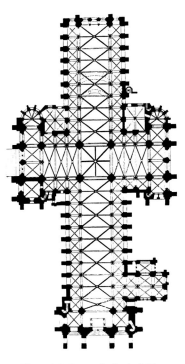

Fig. 16.8. Laon Cathedral. Plan (after Dehio)

Fig. 16.7. Laon Cathedral. Interior. 1165–1205

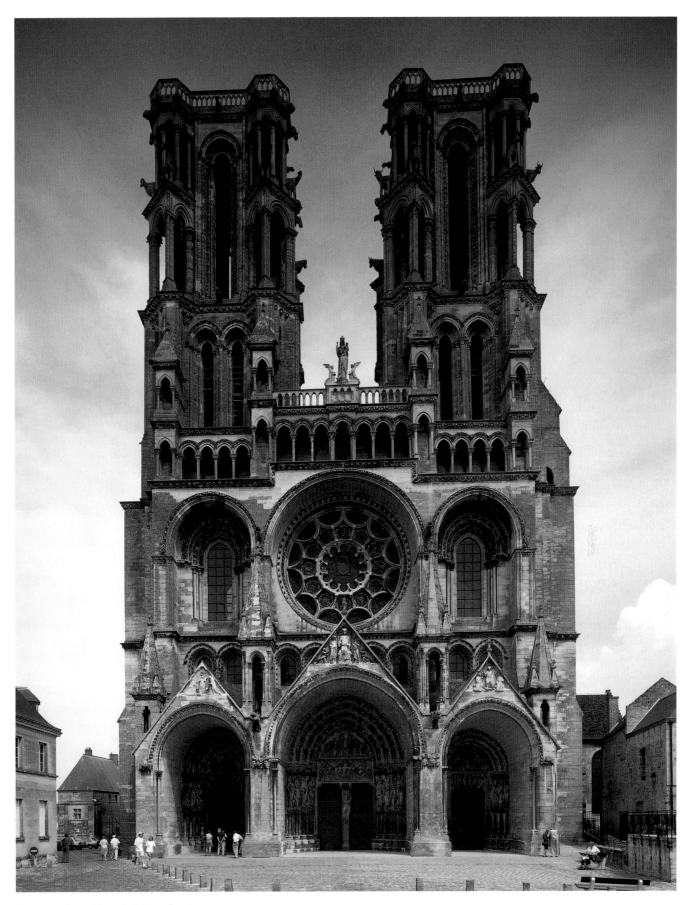

Fig. 16.9. Laon Cathedral. West facade. 1190–1205

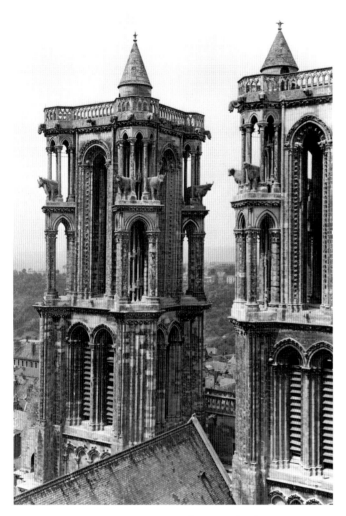

Fig. 16.10. Laon Cathedral. Towers of the west facade

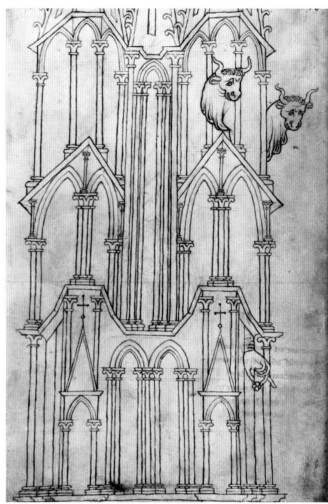

Fig. 16.11. Villard de Honnecourt. *The Tower of Laon*. Sketchbook, 9¼ × 6″. 1220–35. Bibliothèque Nationale, Paris (MS fr. 19093)

Enhancing the rich sculptural effects of the architecture, huge sculptured bulls appear in the openings of the towers, affectionate mementoes of the beasts of burden who carted the heavy stones to the site (**fig. 16.10**). The traveling draughtsman Villard de Honnecourt left a notebook of drawings, including one of the facade towers (**fig. 16.11**). Other towers were planned for the Cathedral of Laon, including paired towers for the large, aisled transept porches (they form two more facades, actually) and one over the crossing of the nave and transept. One unusual feature of Laon is the great rectangular choir that was added in the thirteenth century to replace an earlier round apse and ambulatory construction.

Although it would seem that the emphatic four-story elevation of Laon would accent the longitudinal or horizontal sense of space, the higher proportions of Laon (it is fifteen feet narrower than Sens, although both rise to approximately eighty feet) reinforce the illusion of vertical lift. As at Sens, great hollows of space are diagrammed with shafts, ribs, and rhythmic arches rising upward with a stately cadence, but at Laon space moves in many directions, especially when one approaches the lantern over the crossing of the giant projecting transepts before the choir.

Neither Sens nor Laon employ flying buttresses—usually considered hallmarks of Gothic cathedrals—although the progressive thickening of the exterior wall buttresses of the transepts and the concealment of quadrant arches under the tribune roofs on the interior at Laon anticipate this innovation. The introduction of true flying buttresses appears in the Cathedral of Notre Dame in Paris (**fig. 16.12**) around 1175–1200 (remodeled after 1225), where a series of free stone supports rise high above the triforium roof on the exterior of the nave and choir, resembling so many struts or fingers reaching up to support the thin walls of the nave carrying the high vaults (**fig. 16.13**).[11] In some respects, this innovation can be seen as a development necessitated by the new vaulting

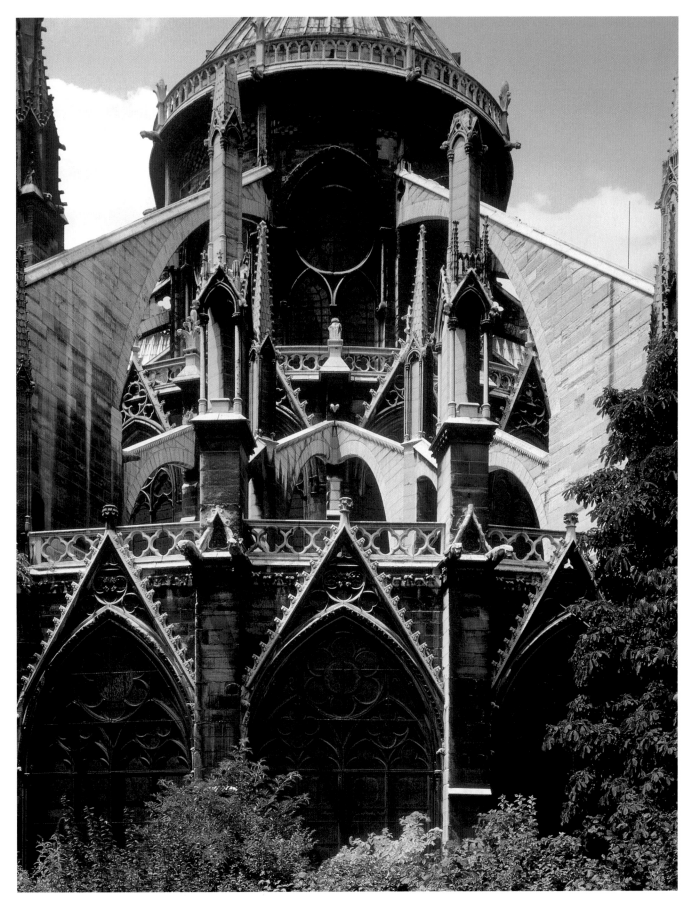

Fig. 16.12. Cathedral of Notre Dame, Paris. View of flying buttresses

schemes. The diminished wall supports of the high nave proved to be insufficient to counteract the stronger forces of the wind at the higher elevations of the galleries and clerestory.

Notre Dame, Paris, one of the largest and highest (108 feet) of the Early Gothic cathedrals, has a fascinating history. Sexpartite vaults, like those of Sens and Laon, cover the nave of Paris (**fig. 16.14**). Like Sens, Paris has a simplified, continuous

hairpin ground plan (**fig. 16.15**), but the aisles are doubled and continue in that fashion around the chevet, as they do at Saint Denis. With Laon, it shares a four-part elevation with a huge open tribune gallery directly over the nave arcade. Originally an additional wall punctured by oculi, rather than the continuous arcading of a triforium, was introduced below the clerestory with its simple lancet windows.

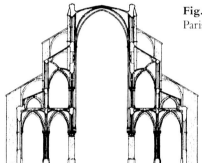

Fig. 16.13. Cathedral of Notre Dame, Paris. Cross section of the nave (after Mark)

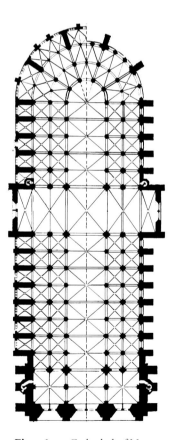

Fig. 16.14. Cathedral of Notre Dame, Paris. Plan

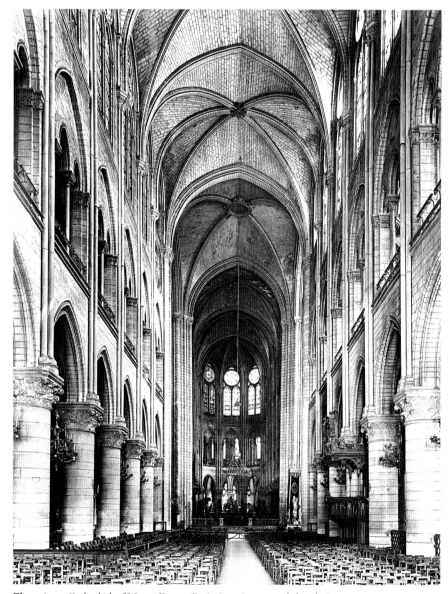

Fig. 16.15. Cathedral of Notre Dame, Paris. Interior toward the choir. Begun 1163; c. 1180–1200

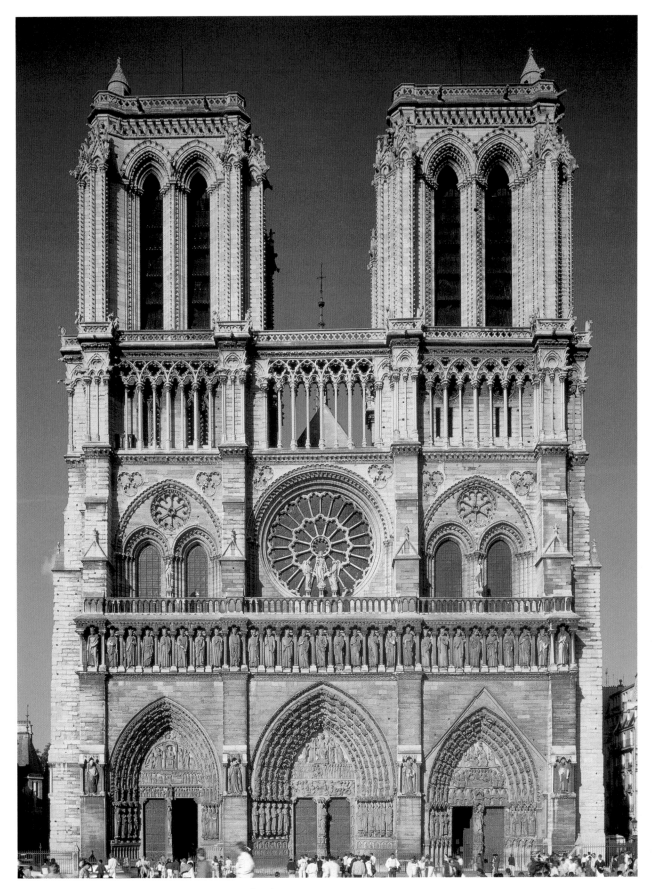

Fig. 16.16. Cathedral of Notre Dame, Paris. West facade. Begun 1163;
lower story c. 1200; window 1220; towers 1225–50

This four-part elevation was altered in the thirteenth century by eliminating the band with the oculi and absorbing it into the clerestory with taller double-lancet windows with a rose, opening the upper third of the elevation for light (Viollet-le-Duc partially restored the four-part elevation in the first two bays of the nave). Later architects added another feature to the last bays on the western extension of the nave. Here colonnettes were added to the columnar piers (not visible in the illustration), enhancing the verticality of the elevation even more. Rather than presenting a modulated elevation of sculptural parts and cavities as at Laon, the nave of Paris preserves a distinctive mural character on the interior, particularly striking in its smooth, thin walls that rise so gracefully from the nave arcade.

The immense façade of Notre Dame in Paris, about 1210–15, is also Early Gothic in the retention of the massive wall surfaces and the relatively shallow penetrations of the austere façade by the portals, galleries, rose window, and arcades, making use of simple geometric shapes—square, triangles, and circle (**fig. 16.16**). In many respects, whether considered Romanesque or Gothic, the two-towered façade represents a majestic culmination of earlier traditions in Northern architecture.

On the trumeau from the church's north transept, the Virgin Mary (**fig. 16.17**) looks like an elegant queen. She gently

Fig. 16.17. Virgin and Child (detail). Trumeau, north transept portal, Cathedral of Notre Dame, Paris c. 1250

Fig. 16.18. Two gargoyles from the balustrade of the Grande Galerie of the west façade of Notre Dame, Paris. Stone. Replica of a 12th-century original. Photograph by Eugène-Emmanuel Viollet-le-Duc

holds her garment under her left hand, producing simple folds as it affirms the dignity of her pose. The Virgin once held the Christ child in her arms. The missing figure fell victim to an iconoclastic attack during the French Revolution.

Jutting out from the cathedral's lead roof, waterspouts called gargoyles (**fig. 16.18**) provide an efficient means of drainage. Shaped as fantastic creatures, the gargoyles project rain and filth out of their orifices. In addition, chimeras, such as the grotesque griffin often associated with *The Hunchback of Notre Dame* (**fig. 16.19**), also reside on the rooftop. Strictly speaking, these works are not gargoyles, for they do not release wastewater. However, they do preserve the assumed purity of the church by encouraging demons to seek alternative sites to contaminate.[12]

Fig. 16.19. Demon gargoyle from the balustrade of the Grande Galerie of the west facade of Notre Dame, Paris. Stone. Replica of a 12th-century original. Photograph by Eugène-Emmanuel Viollet-le-Duc

CHARTRES

The Cathedral of Notre Dame at Chartres, the first of the so-called High Gothic cathedrals in the Île-de-France, is one of the most beloved monuments in Europe.[13] After a fire in 1020, the learned bishop Fulbert (1007–29) rebuilt the old Carolingian basilica with monumental proportions that included a modified westwork, a long nave with transept covered by a wooden roof, and a large pilgrimage choir with three projecting apses. Below the old church, in a huge vaulted crypt, a precious relic—the tunic of the Virgin—was displayed for pilgrims to see and venerate.

In 1134, fire devastated the city again, causing serious damage to the west front of Fulbert's cathedral. A new entranceway was immediately raised. Two great towers were set out before the western doors—apparently freestanding at first—that are still notable attractions of the great church because of the disparity of their spires (**fig. 16.20**). The north tower was begun in 1134 and raised to the base of the present spire, which was added in 1507 in a later style known as Flamboyant Gothic. The foundations of the magnificent south tower were laid in 1145; the elegant spire was completed by 1170.

Another conflagration in 1194 destroyed all of Fulbert's church except the twelfth-century facade and the crypt. The miraculous survival of the Virgin's tunic spurred the bishop and the chapter to rebuild their church again with even greater glory to Notre Dame. Work began immediately, and within a quarter of a century the new cathedral was raised, so that in 1220 the poet Guillaume le Breton could write, "Springing up anew, now finished in its entirety of cut stone beneath elegant vaults, it fears harm from no fire 'til Judgment Day."[14]

The old facade remained, but the architect designed huge projecting transepts, as at Laon, to serve as major facades on the north and south sides of the church. Nine towers were originally conceived: the two remaining of the west facade, two flanking each transept facade, one over the crossing, and two more abutting the beginnings of the semicircle of the choir. These latter towers were never finished, however.

The much-expanded choir or chevet (**fig. 16.21**) constitutes a third of the entire building and expands in width beyond the nave and side aisles with its double ambulatory and rings of apsidioles with ribbed vaults. The slightly irregular spacing of the columnar supports in the choir was due to the architect's desire to incorporate the crypt and apse foundations of Fulbert's basilica over which the new cathedral was raised. But it was the recent innovation of the flying buttress that enabled the builders of Chartres to eliminate the tiered walls in the nave (as well as in the choir) and still raise lofty vaults (fig. 16.21). The huge open walls filled with stained glass constitute nearly half of the elevation, and the vast spaces spread and rise with compelling verticality.

One's first impression of the interior of Chartres is that of a marvelous unity in the vertical flow of space from the nave floor to the vaults (**fig. 16.22**). A closer look reveals a

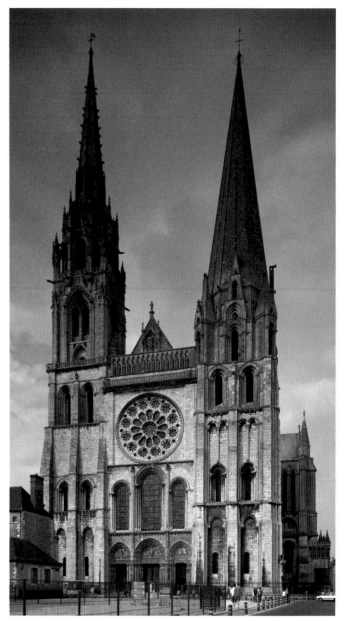

Fig. 16.20. Chartres Cathedral. West facade. 1134–1220; portals c. 1145; rose window c. 1216; north spire 1507

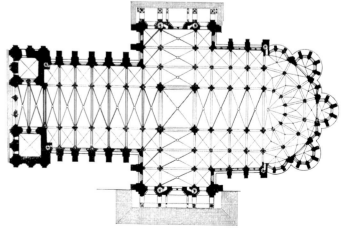

Fig. 16.21. Chartres Cathedral. Plan

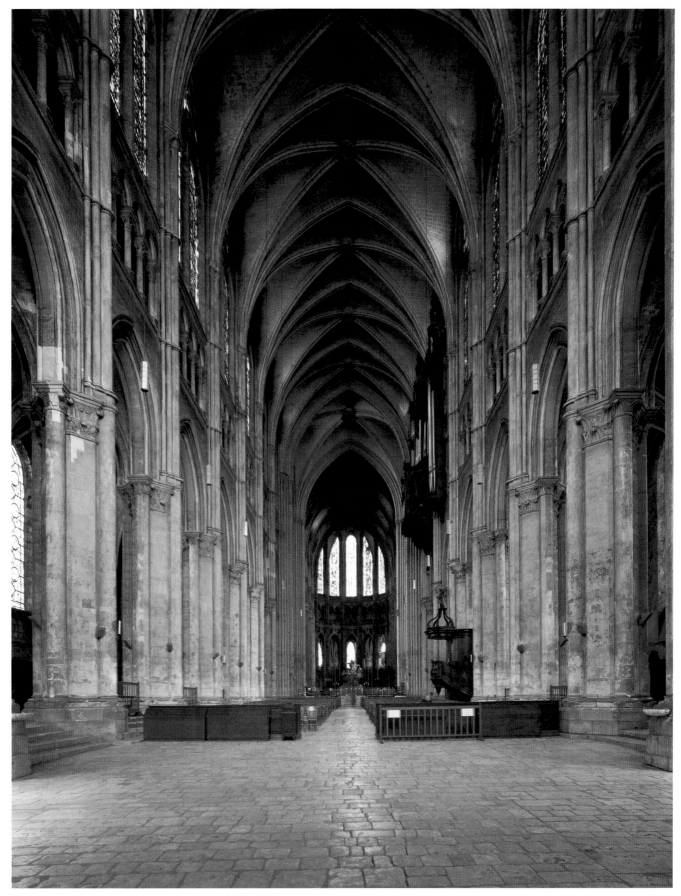

Fig. 16.22. Chartres Cathedral. Interior toward the choir. 1194–1220

number of changes and departures from the elevations in Early Gothic. The tribune galleries have been eliminated entirely (this also is true of Sens); the nave piers are not columns but colossal *colonnes cantonnées* or *piliers cantonnés* (sectioned columnar or pier supports) with alternating octagonal and circular cores from which large engaged shafts (responds) project. The clerestory is enlarged to command nearly half of the elevation, with each bay between the piers (corresponding to the flying buttresses on the exterior) filled with two tall lancet windows surmounted by a rose, all glazed with colored glass. Five clustered shafts rise uninterrupted from the capitals of the giant piers in the nave arcade through the shallow triforium to merge with the ribs of the vaults.

The alternating system has been nearly abandoned, with only vestigial forms of the system retained in the alternating circular and octagonal cores and shafts of the *piliers cantonnés*, as mentioned. Simpler quadripartite vaults that cover rectangular, not square, bay units replace the sexpartite vaults so familiar in Early Gothic churches. Hence, the integrity of the individual bay is strongly marked throughout the longitudinal axis; the side aisles with quadripartite vaults over smaller square bays repeat the scheme, and this simplicity and unity are reflected on the exterior, where the sets of clerestory windows (two lancets and a rose) are framed by double flying buttresses in each unit. The double flying buttresses, one arcing above the other, are massive, powerful struts that are tied together by round arches carried on columns like spokes between two wheel rims (the third, topmost, tier was added later), repeating a handsome architectural motif established by the great rose window added to the upper level of the western facade about 1205–10.

The transept facades are of a new design, too. A great rose window is placed over five lancets, filling the entire width of the wall between the flanking tower bases (fig. 16.33). Added about 1220–30, these windows introduce a fundamental change in the structure of the upper facade by conceiving the rose not as a punctured wall surface but as a giant circular opening in which a network of mullions or bars describe the petals of the rose outside the inner circle of columnar spokes.

The three major building campaigns presented to us at Chartres—the earlier facade, about 1135–60; the nave and choir, about 1194–1220; and the outer transept porches, added about 1235—linking the transitional or Early Gothic with the mature or High Gothic, offer us a valuable sequence for studying the development of Gothic sculpture. The early sculptures of the west facade have frequently been linked to those at Saint Denis, and, in fact, it has been argued that the sculptor-masons moved to Chartres after completing their work on Abbot Suger's church.[15] This is evident in the close relationships between the column statues of Chartres and those of Saint Denis preserved in the drawings for Montfaucon.

Twenty-two solemn figures of Old Testament precursors of Christ—kings, queens, patriarchs, and prophets, to judge by their dress—stand in regimentation across the jamb areas of the three portals (**fig. 16.23**).

The links to Romanesque style can be recognized in the linear conventions employed to describe the shallow, fluted draperies and the mask-like faces with tight ringlets of hair. Scale seems arbitrary, too. But more striking are the departures. Like the column statues at Saint Denis, those at Chartres are three-dimensional by virtue of the fact that they are carved on a round shaft and not a flat wall. While the geometric conventions delineating the abdomen, the breasts, the elbows, and so forth are reduced to simple circles, loops, and shallow fret-folds, these figures no longer appear as simple linear diagrams of energy; they are solid, static, and architectonic, and a sense of repose replaces the agitation associated with Romanesque jamb figures. They stand rigidly in a frontal posture and are described by simple, closed contours with little movement of body parts. A new articulation does appear, however, in some of the figures where the straight vertical folds of the under tunic, falling like so many plumb lines, are interrupted in the upper torso by diagonals of the

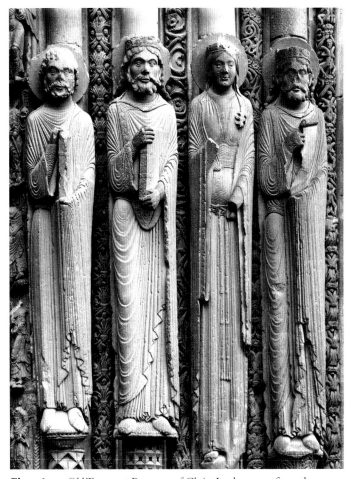

Fig. 16.23. *Old Testament Precursors of Christ.* Jamb statues from the central portal of the west facade, Chartres Cathedral. c. 1145–70

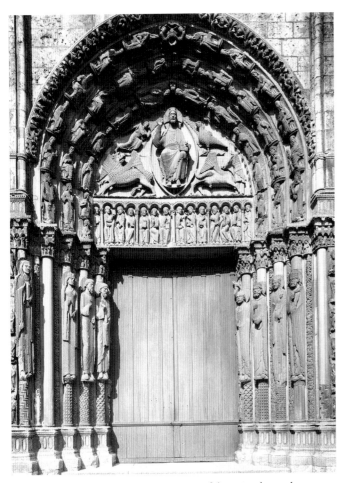

Fig. 16.24. *Maiestas Domini.* Tympanum of the central portal, west facade, Chartres Cathedral. c. 1145–55

outer mantle that lead upward and to the side. Furthermore, the higher one lifts one's eyes up the column, the more the shaft-like body is transformed into a recognizable human form. In the staring faces, the eye sockets are more deeply carved; eyelids are more naturally formed; and the mouths seem articulated with lips that open slightly.

Different hands have been discerned in these sculptures. The most talented, usually identified as the "head master," carved most of the column statues and the tympanum of the central portal with its splendid *Maiestas Domini* composition (**fig. 16.24**). One need only compare this masterful design with that of the same theme at Moissac (fig. 13.20) to see the dramatic changes that were sweeping into architectural sculpture in the Île-de-France at mid-century. The composition of the head master is balanced and controlled, with large triangular and arcing lines in the bodies of the four beasts complementing the simple ovate mandorla about the enthroned Christ. The gentle linear arcs and conventions of his ample mantle elegantly convey the serenity of his pose and noble bearing.[16]

The sculptures of the west facade present a clear and direct iconography (**fig. 16.25**). The *Maiestas Domini* appears in the central tympanum over a lintel-frieze with the twelve apostles and is framed by the twenty-four elders in the archivolts. In the right tympanum appears an iconic Virgin enthroned between angels above a double register of reliefs illustrating episodes of the Infancy of Christ, proclaiming Christ's first coming "in the flesh" with the Incarnation (**fig. 16.26**). The Virgin is portrayed as the *sedes sapientiae*, or Throne of Holy Wisdom. This is made explicit. The narratives below her assure us that the divine god was born "in the

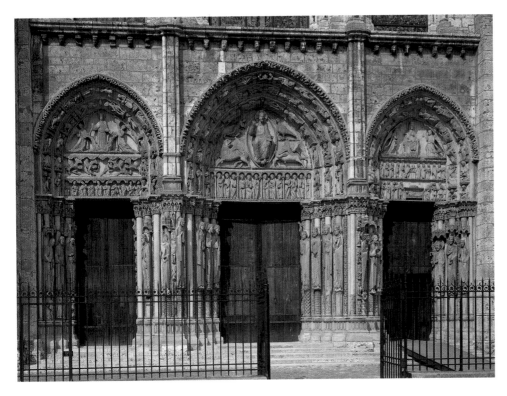

Fig. 16.25. Chartres Cathedral. West portals. c. 1145–70

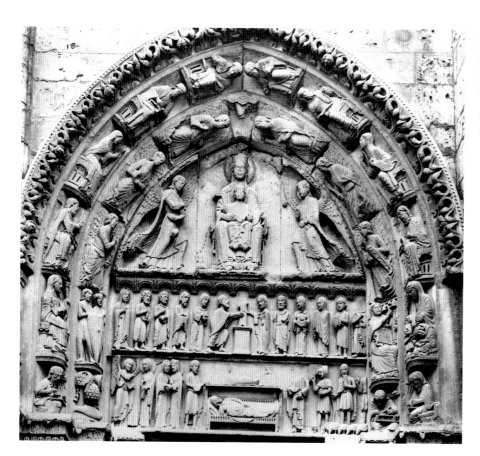

Fig. 16.26. Virgin and Child Enthroned with Scenes of the Infancy. Tympanum of the right portal, west facade, Chartres Cathedral. 1145–55

Fig. 16.27. *The Liberal Arts.* Archivolt detail of Fig. 16.26

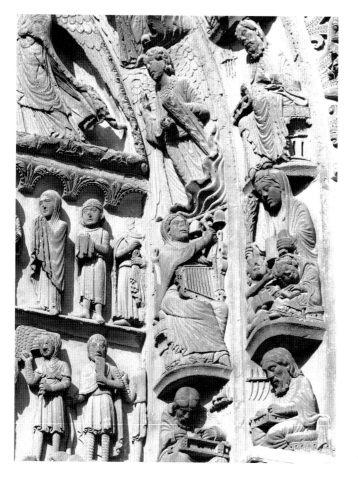

flesh" as a man. The shepherds in the lower register appear at the Nativity to recognize his humble human nature at birth, while in the Presentation scene above, his divinity is recognized by the priest Simeon and the prophetess Hannah. Along the central axis appear the frontal Madonna, the altar of the temple in the Presentation, and the mensa-crib of the Nativity with the Child placed atop it as if he were an offering at an altar, all explicit allusions to the sacramental significance of the Incarnation.

The image of Mary as the *sedes sapientiae* is augmented by the archivolt sculptures with personifications of the Liberal Arts—the trivium (grammar, rhetoric, dialectic) and the quadrivium (geometry, arithmetic, astronomy, and music) —and the authorities of these disciplines portrayed as seated scholars busy at work at their lap desks (**fig. 16.27**).[17] The moralizing polemics of Romanesque themes thus give way to statements of doctrine; dynamic composition is replaced by diagrammatic clarity; and distortion of figures is rejected for composure.

The subject matter of the left tympanum, in accord with the idea of Christ's First and Second Coming in the flesh presented in the other two, is the Ascension, a theme closely related to that of the Second Coming, but here it alludes to Christ's resurrection "in the flesh." The capitals above the column statues of the Old Testament precursors narrate details in the lives of Mary and Christ in the fashion of an unwinding scroll of sculptures.

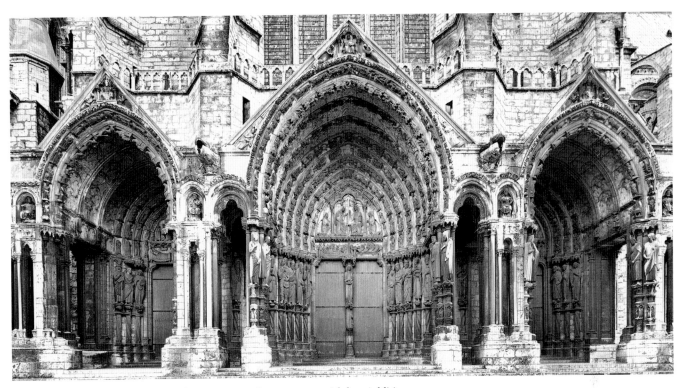

Fig. 16.28. Chartres Cathedral. North transept portals. 1194–1220 with later additions

The fire of 1194 destroyed all but the west facade, and it is to the north transept that we move for the next sequence of sculptures at Chartres (**fig. 16.28**). Two dates are important.[18] The decorations of the north transept were planned and executed after 1204, when a precious relic was acquired, the head of Saint Anne, the Virgin's mother (brought back from Constantinople after the Fourth Crusade), because the program for the central portal is dedicated to the Virgin, with Saint Anne on the trumeau carrying the infant Mary in her arms. The transept entrances were apparently finished by 1220, as we learn from the verses of Guillaume le Breton that the church was complete under stone vaults by that year, and, furthermore, documents of 1221 inform us that the canons of the church were occupying the choir stalls by then. Hence, the first sculptures should date between 1204 and 1220.[19] Work progressed rapidly, and the outer porches were

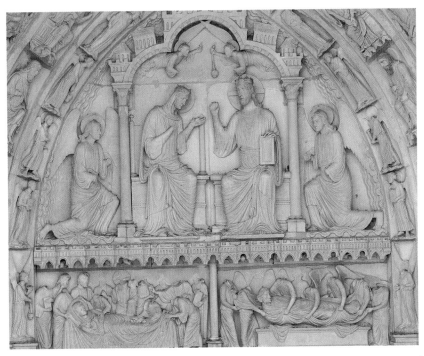

Fig. 16.29. *Coronation of the Virgin* (tympanum of the central portal, north transept); *Dormition and Assumption of the Virgin* (lintel). Chartres Cathedral. c. 1205–15

completed by about 1230. The sculptures on the three portals of the southern transept were begun shortly after those on the north, about 1210–15, with additions to the jambs as late as 1235–40. The entire campaign, therefore, was uniformly carried out over a period of some thirty years, and the iconographic scheme seems intact.

The north transept is devoted to the Virgin and her role as the link between the Old and New Testaments. This is emphatically announced in the central portal. The monumental Coronation of the Virgin as queen of heaven is presented in the tympanum, the genealogy of Mary and Christ in the Tree of Jesse appears in the four ranges of the archivolts, and, finally, important precursors of Christ from the Old Testament are lined along the jambs.

The Coronation of the Virgin was a relatively new theme, but it was destined to become one of the most

important Marian subjects in Gothic art (**fig. 16.29**).[20] In a superbly balanced composition, Mary and Christ are enthroned under a trefoil church facade and flanked by angels. Another row of angels appears in the first range of archivolts. Below, on the divided lintel block, are representations of the death and assumption of the Virgin. These three episodes—Dormition, Assumption, Coronation—were usually presented together as major events celebrated in the Feast of the Assumption of the Virgin (15 August), the principal devotion to Mary in the Church calendar.

The statues on the jambs are especially fascinating (**figs. 16.30, 16.31**). They can all be identified, as they carry specific attributes and stand atop figured consoles that allude to events in their lives. In addition, they can be differentiated as types by facial features and costumes, and can be linked iconographically across the portals. On the far left stands the

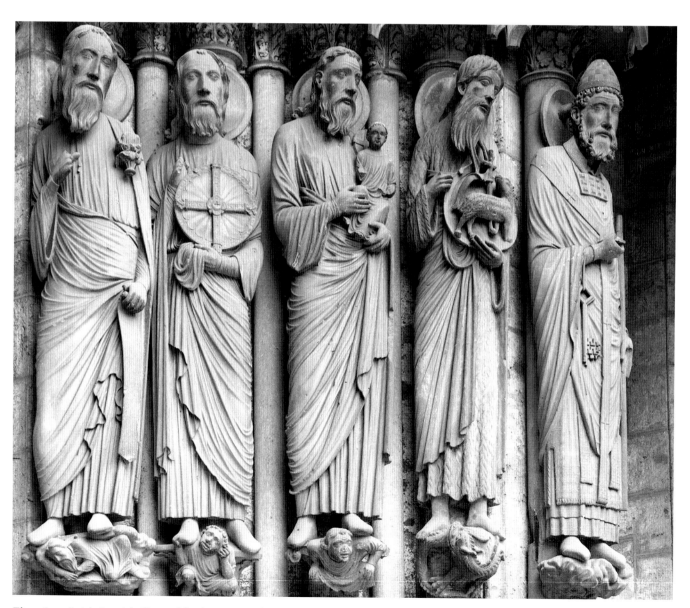

Fig. 16.30. *Isaiah, Jeremiah, Simeon, John the Baptist, and Peter.* Jamb figures from the central portal of the north transept, Chartres Cathedral. c. 1205–15

priest Melchizedek, who is the archetypal figure of Christ-priest in the Old Testament. He wears a miter and carries a censer. Directly opposite Melchizedek, on the far right, appears Saint Peter (identified by the keys and papal vestments), the first successor to Christ-priest in the New Testament. The second on the left is Abraham, about to sacrifice his son Isaac, another Old Testament figure for the sacrifice of Christ in the Mass, while opposite him stands Saint John the Baptist holding a disk with the sacrificial lamb—"Behold the Lamb of God"—another allusion to Christ's sacrificial role. These are followed on the left by Moses with the tablets of the Law, Samuel, and King David, while opposite them appear Simeon the high priest, and the prophets Jeremiah and Isaiah (from whom the Tree of Jesse, his prophecy, in the archivolts, derives). Thus the jamb figures serve as Old Testament types of Christ as priest

(Melchizedek and the others) and king (David and the royal lineage in the Tree of Jesse). It suggests that a learned theologian probably devised this comprehensive program of sculptures.

The jamb figures, dating from about 1204–10, offer us an excellent opportunity to study the development of style from the earlier statues on the west facade, which date from about 1145–55. Similarities are at once apparent. The rigid frontality of the tall figures persists, as does the shallow carving of the draperies, reminiscent of fluted columns. The statues are tightly contained within closed contours, and their feet are turned downward into the consoles to further accentuate their function as columnar supports subordinated to the architecture. But the differences are striking. There is uniformity in scale and more naturalistic proportions in the north transept figures no matter how tall and thin they may seem.

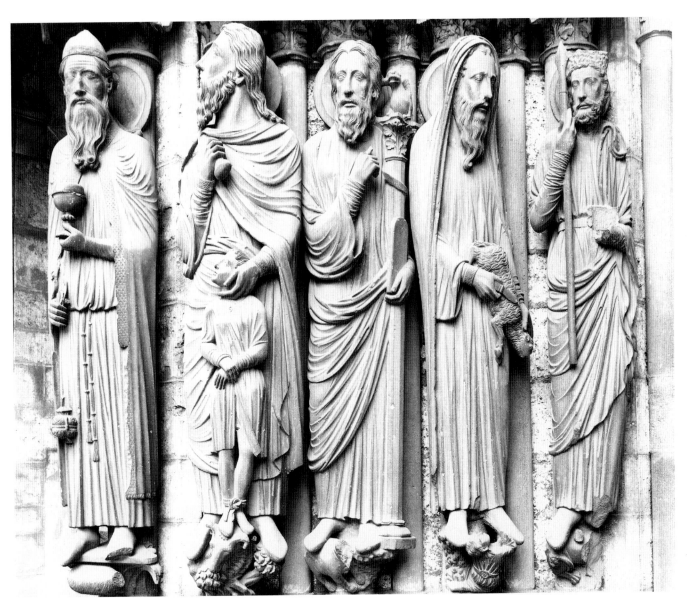

Fig. 16.31. *Melchizedek, Abraham, Moses, Samuel, and David.* Jamb figures from the central portal of the north transept, Chartres Cathedral. c. 1205–15

Their bodies can move slightly now. Abraham stops and looks up across his space into the canopy over the head of Melchizedek, where the angel appears. Samuel turns to look directly across the portal at his counterpart on the right. And the drapery falls in long sweeping arcs and softly modeled grooves that are varied in the depth of carving.

The south transept sculptures show a greater uniformity in style. The atelier responsible for the central portal sculptures on the north apparently moved to the south side, where a series of New Testament saints were carved for the three portals there about 1210–20. The four outer jamb statues on the side portals were obviously added later by another shop about 1230–35. The side porches were dedicated to the martyrs (left) and the confessor saints (right) with appropriate themes in the tympana (the martyrdom of Stephen, the stories of Saint Martin and Saint Nicholas). The central portal

presents Christ on the trumeau, the apostles on the jambs, and an impressive Last Judgment in the tympanum. The handsome warrior martyr, Saint Theodore (**fig. 16.32**), is a marvelous idealization of a knight, as he stands in a relaxed pose on the flat console. He wears the chain-mail armor of contemporary crusaders. Beside him stands Saint Stephen, a work of the earlier carvers, 1210–20.

Complementing the iconography of the sculptures are the themes presented in the stained-glass windows of the clerestory and the side aisles.[21] The three lancets of the west facade are the earliest, about 1150–60, and give us some idea of the splendor of Suger's famous windows, known only in restorations at Saint Denis. In most Gothic churches, much of the stained glass has been destroyed, and those windows that have escaped the ravages of time are usually so inaccessible that their rare stylistic qualities are difficult to study. Chartres, however, is the one cathedral where the stained glass has survived nearly in its entirety.

The nave becomes a diaphanous, shimmering, structural web wrapped in veils of intense color that seem to float in layers with a "delirium of coloured light," as Henry Adams so described the windows of Chartres. Scholars have often pondered the relationships between the metaphysics of light in Christian philosophy (compare Saint Augustine) and mysticism (Pseudo-Dionysius the Areopagite), and that of the visual sensations of stained glass.[22]

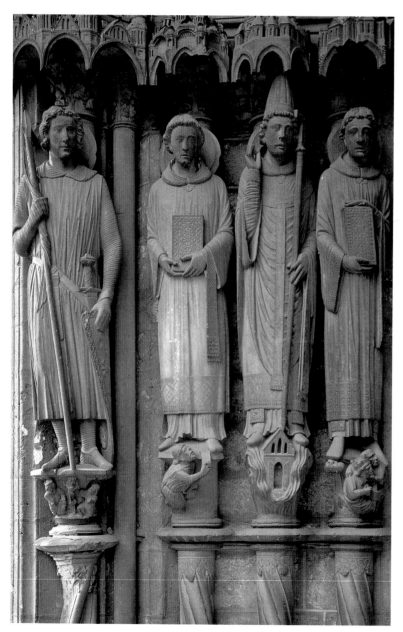

LEFT **Fig. 16.32.** *Saint Theodore* (1230–35), *Saint Stephen* (c. 1220), *Saint Clement* (c. 1220), and *Saint Lawrence* (c. 1220). Left jamb, left portal, south transept, Chartres Cathedral

OPPOSITE **Fig. 16.33.** Rose and lancet windows. North transept, Chartres Cathedral. c. 1220–30

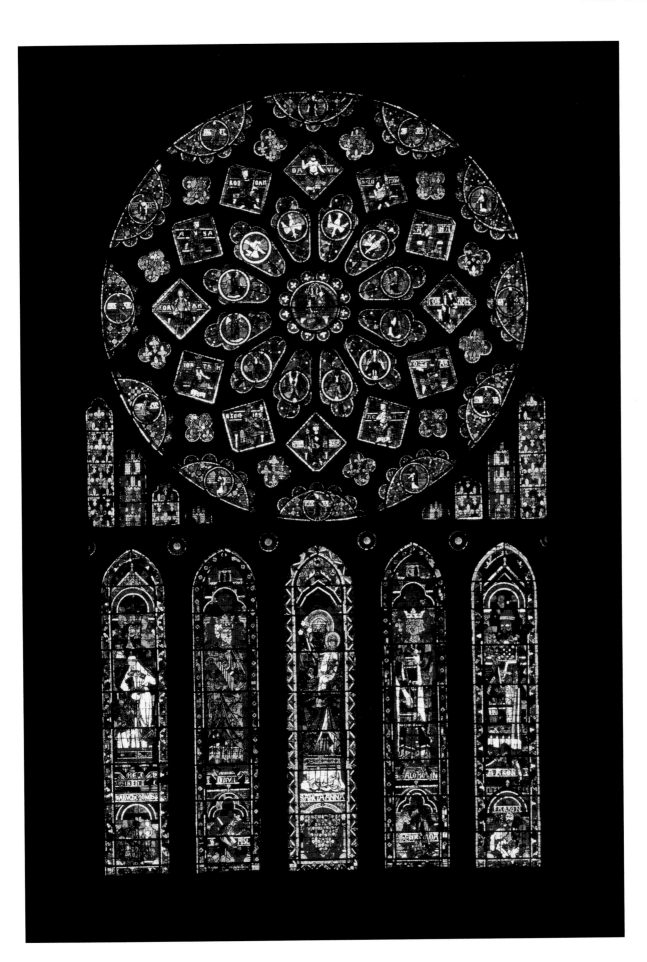

The windows in the nave were added as the building progressed, and the greater part of the interior would have been filled with stained glass by the time of its final consecration in 1260. The Chartres glass workshops were especially renowned. The later windows in the nave and choir have a marvelous reddish-violet tonality for the most part, although in a number of them, especially in the chevet, the depth of the blue forms an astonishing contrast to the brighter reds, yellows, and greens that seem to float atop it. One actually experiences color in three dimensions, with the more intense colors emerging from a sea of blue tonalities.

Of the 186 stained-glass windows in Chartres, 152 are still in place. The overall scheme for the iconographic program generally conforms to that of the sculptures on the exterior, although the Virgin receives far greater attention in the windows. The north transept rose window, over forty-two feet in diameter, has Mary and Christ surrounded by the Tree of Jesse, while the lancets carry standing figures of Saint Anne and Old Testament saints (**fig. 16.33**); the southern rose has a Last Judgment with portraits of the Evangelists carried on the shoulders of prophets in the lancets flanking the Virgin. The tall windows that fill the clerestory are glazed with single standing saints, analogous to the jamb sculptures.

The addition of minerals to molten silica in molds of round or square "tables" makes the colored glass. The individual sections are then shaped or cut from the "tables" by hot rods and are pieced together with lead into armatures of geometric forms—squares, circles, semicircles, rhomboids, quatrefoils, and so on—that, in turn, are clamped to a rigid grid of horizontal and vertical bars embedded in the walls (**figs. 16.34, 16.35**). In these earlier windows, only the heavy leaden outlines describe forms and figures. Shading and

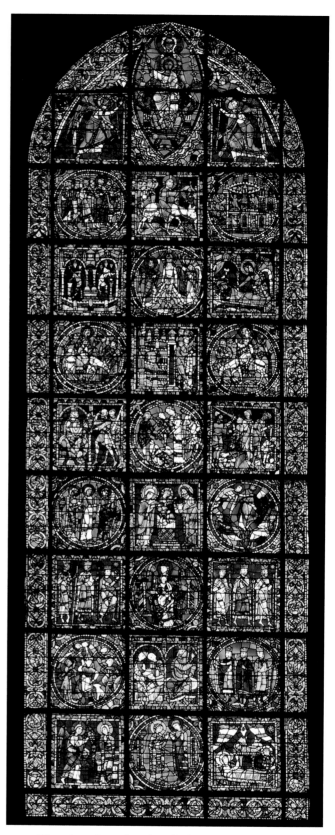

ABOVE **Fig. 16.34.** *Scenes from the Life of Christ.* Stained-glass windows from the west facade, Chartres Cathedral. c. 1150–70

LEFT **Fig. 16.35.** *The Three Magi.* Detail of Fig. 16.34

modeling are minimal. Flat shapes of color, defined by dark outlines, create a transparent world for the narratives. With some of the larger figures, such as that of the Notre Dame de la Belle Verrière (**fig. 16.36**), the stunning sensation of pure form in color resides between the spectator and the dark wall.

One window (**fig. 16.37**) combines the story of Adam and Eve's original sin and expulsion from Eden (Gen. 3:1–24) with the parable of the Good Samaritan (Luke 11:30–37). The juxtaposition of these two narratives, one above the other, openly links leaving the Garden of Eden with living in a fallen world. In addition, it reinforces the notion that Christ is the New Adam who can bring weary travelers salvation. In the bottom right corner of the window, shoemakers are represented, implicitly linking the local trade with Christian charity.

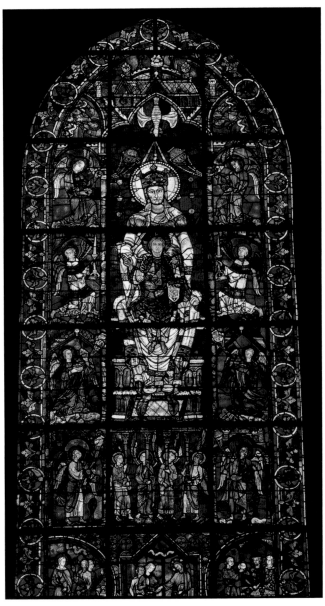

Fig. 16.36. *Notre Dame de la Belle Verrière.* Stained-glass window from the choir of Chartres Cathedral. c. 1170; side angels added in the 13th century

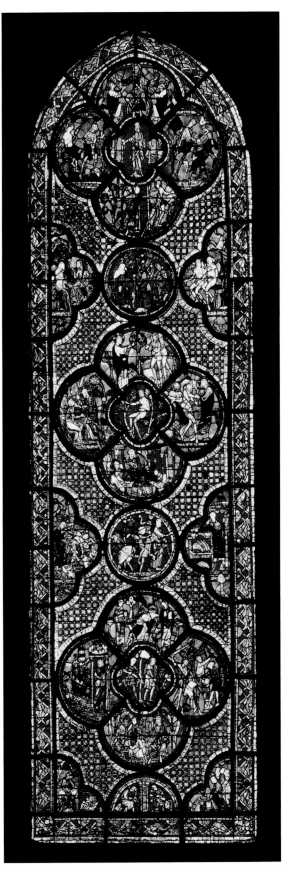

Fig. 16.37. *The Good Samaritan and Adam and Eve Window.* Stained-glass window from south aisle of the nave of Chartres Cathedral. c. 1210

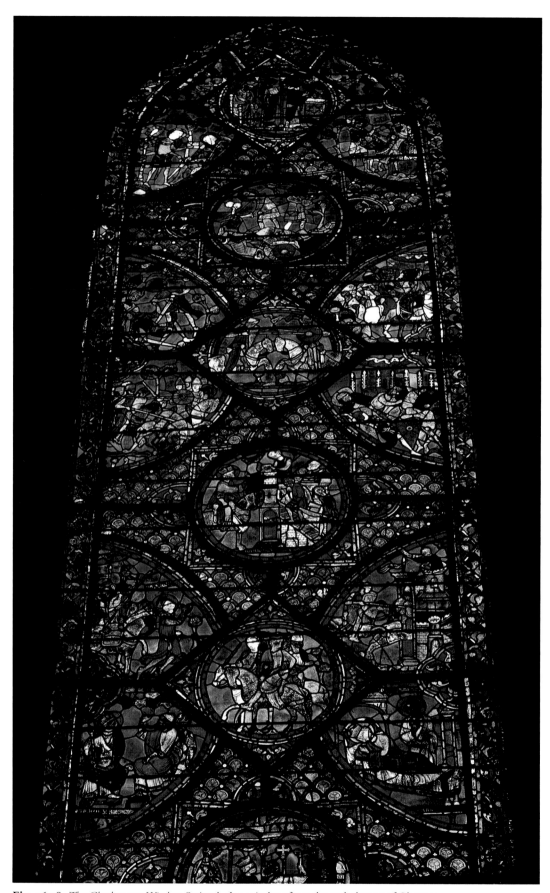

Fig. 16.38. *The Charlemagne Window.* Stained-glass window from the ambulatory of Chartres
Cathedral c. 1210–1236

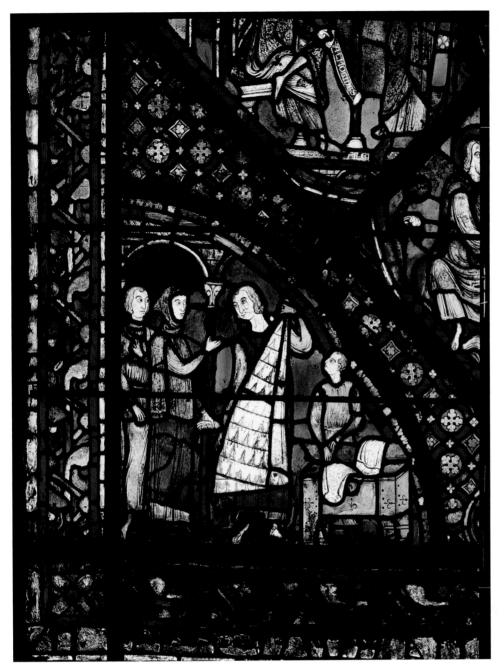

Fig. 16.39. *Furriers at Work.* Detail of stained-glass window. Nave, Chartres Cathedral. 13th century

Another window at Chartres is dedicated to Charlemagne (**fig. 16.38**). At the request of Frederick Barbarossa, the anti-pope Pascal II canonized Charlemagne in 1165 (it should be noted, however, that Rome never accepted Charlemagne as a saint). In promotion of Charlemagne's sainthood throughout Christendom, the window represents the emperor's legendary crusades to Jerusalem and Santiago de Compostela, as well as scenes from the Song of Roland. At the bottom of the window, furriers perform their craft. Their presence suggests a close affinity between the guild and the privileged nobility able to hunt.

The expense of producing stained-glass windows must have been astronomical, and it is interesting to note that royalty provided the finances for the huge rose windows; lesser nobles and members of the clergy donated funds for a number of the lancets. Although bakers, wheelwrights, weavers, furriers, goldsmiths, carpenters, and others (**fig. 16.39**) are represented performing their crafts in the margins of some of Chartres windows, there is no evidence that their guilds contributed to the church's decoration. Wealthy patrons may have commissioned the marginal depiction of craftsmen to suggest greater communal solidarity than actually existed, concealing social conflicts between the city's various guilds, between the guilds and members of the aristocracy, as well as those between the guilds and Church authorities.[23]

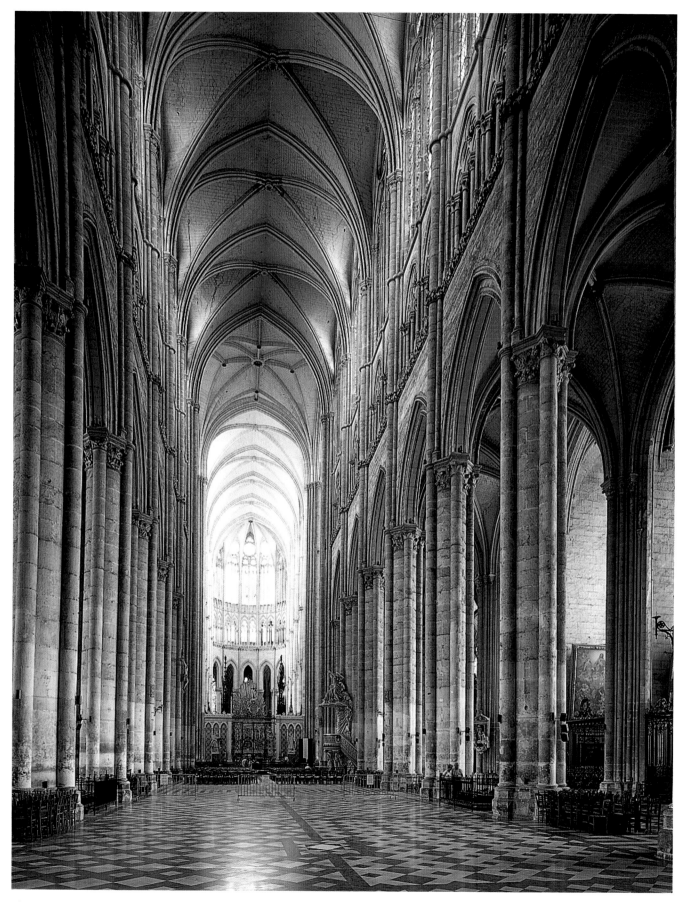

Fig. 16.40. Amiens Cathedral. Interior of the nave. 1220–88

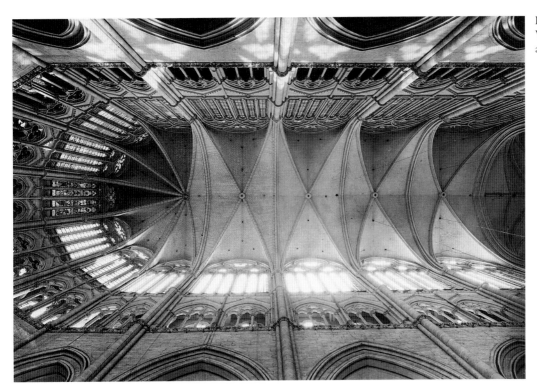

Fig. 16.41. Amiens Cathedral. View into the vaults of the nave and choir

AMIENS

The architectural developments after Chartres were consistent but subtle. The tripartite elevation of the nave (nave arcade, triforium, and clerestory), the quadripartite vaults, the elaborate chevet, the flying buttresses, and the enrichment of the portal sculptures were the basic features of High Gothic in northern France (**figs. 16.40–42**).[24] The soaring arcade of slender articulated piers rising some seventy feet creates a pronounced lightness in the interior of Amiens Cathedral. The shafts have no heavy capitals to break their rise, and the sensation of ponderous supports and weighty walls is lessened. In the clerestory a new form of window in bar tracery appears, a borrowing from the architect of Reims Cathedral. The clerestory is three-eighths of the elevation and actually merges with the narrow triforium with its stained glass.

With each step the Gothic builders reached higher (**fig. 16.43**). Paris and Laon are approximately 78 feet from the floor to the summit of the vaults; Chartres rises 118 feet; Reims reaches 123 feet; and Amiens, 139 feet. But this dramatic sense of verticality is partly illusion. The width of the nave of Amiens is 49 feet, which means that the ratio of the width to the height is about 1:3, an unprecedented narrowing of the vast space that greatly accentuates the upward thrust. At Paris the ratio is 1:2.2; at Chartres and Reims approximately 1:2.4. Thus Amiens presents the ultimate in Gothic verticality.

Fig. 16.42. Diagrammatic section of Amiens Cathedral with names of the parts in the elevation (after Viollet-le-Duc)

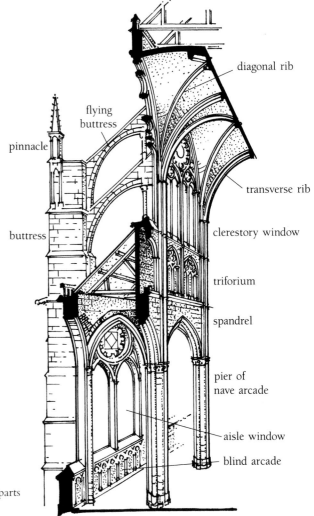

diagonal rib

flying buttress

pinnacle

transverse rib

buttress

clerestory window

triforium

spandrel

pier of nave arcade

aisle window

blind arcade

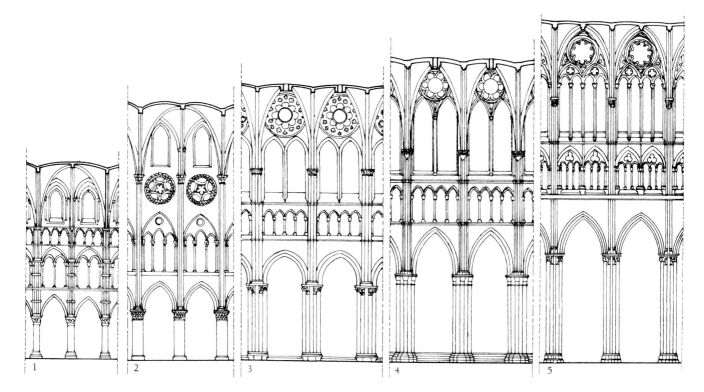

Fig. 16.43. Comparison of nave elevations in the same scale: 1. Laon; 2. Paris; 3. Chartres; 4. Reims; 5. Amiens (after Grodecki)

The earlier cathedral at Amiens had been destroyed by fire in 1218, and two years later Bishop Evrard de Fouilloy laid the foundations for the new building. Inlaid in the pavement of the nave was a giant octagonal labyrinth (destroyed in 1825), an attribute and symbol of the architect—it was derived from the plan of the legendary labyrinth at Minos designed by the mythical ancestor of all architects, Daedalus. In the center of the labyrinth was a stone inscribed with the names of the three architects who directed the building to the year 1288: Robert de Luzarches, Thomas de Cormont, and the latter's son, Renaud de Cormont (Chartres has a similar labyrinth, but unfortunately no traces of the signatures are visible). The nave was raised and vaulted by 1236; the second architect, Thomas de Cormont, completed the superb choir by 1270.[25]

Although harmoniously integrated in plan with the nave and aisles of the transept, the seven chapels of the choir display a new type of elevation with three sets of paired lancets and a rose in each that rise to the ambulatory vaults from the lower floor arcade uninterrupted by a triforium. This introduces even more transparency and lightness in the choir elevation.[26]

The facade of Amiens (**fig. 16.44**) rises over the viewer like a staggered cliff of porches, galleries, and towers. Three galleries are stacked over the huge portals. Deep arches puncture the lowest gallery with stained glass opening on the side aisles; the middle gallery is open; and the uppermost

forms a setting for sculpture. The great rose window was then lifted to the top of the center block (its tracery is later), and the two towers were added only in the fourteenth and fifteenth centuries.

The three deep porches, reminiscent of those at Laon, are filled with sculptures, and it is the stately procession of tall jamb figures that brings unity to the base of the facade at eye level. A continuous row of statue columns undulates in and out of the portals and around the projecting buttresses between them. Decorative quatrefoil reliefs stretch like a carpeted runner across the podia beneath the statues (**figs. 16.45, 16.46**), and above them the deep vaults of the porches are lined with countless archivolt sculptures.

The sculptures of Amiens display a unity of style and iconography. The iconographic program is, in many ways, a compendium of what we have seen before at Chartres. The central portal, like that of the south transept of Chartres (c. 1210–20) and the (restored) west facade of Paris (c. 1220–30), features an elaborate scheme with Christ on the trumeau, the apostles on the jambs, and a Last Judgment in the tympanum.

The most impressive assembly of sculptures at Amiens is that of Christ on the trumeau of the central portal and the apostles that flank him on the jambs. A double row of quatrefoil relief sculptures on the podia beneath the apostles illustrate the Virtues and Vices; the doorposts flanking the trumeau repeat another familiar subject that appears with the

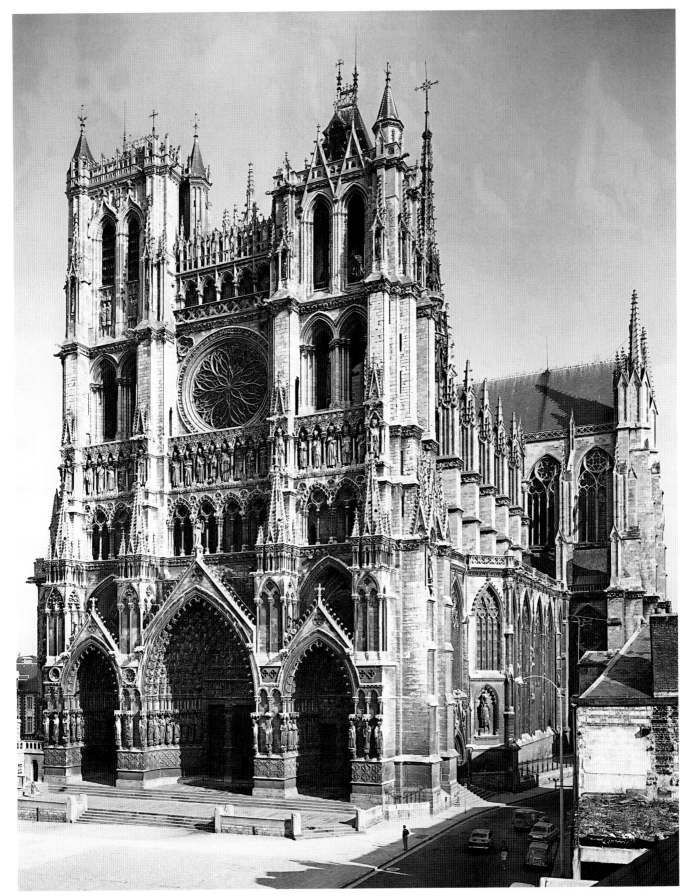

Fig. 16.44. Amiens Cathedral. West facade. c. 1220–36, with later additions

Fig. 16.45. *Zodiac and Labors of the Month* (June, July, August, September). West facade, left doorway, socle of the left jamb, Amiens Cathedral. 1225–35

Fig. 16.46. *Virtues and Vices* (Fortitude: Cowardice; Patience: Anger; Sweetness: Harshness?). West facade, central doorway, socle of the left jamb, Amiens Cathedral. 1220–35

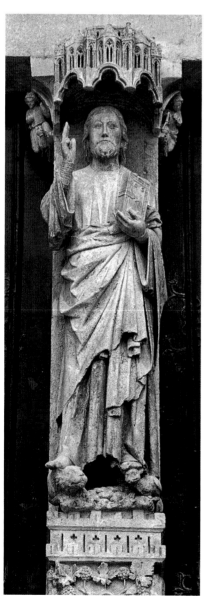

Fig. 16.47. *Le Beau Dieu.* Trumeau, central portal, west facade, Amiens Cathedral. 1220–35

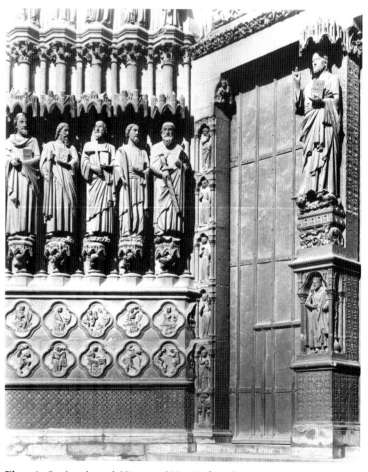

Fig. 16.48. *Apostles* and *Virtues and Vices.* Left jamb, central portal, west facade, Amiens Cathedral. 1220–35

Last Judgment, the Five Wise and Five Foolish Virgins. On the left side of the left portal, a double row of reliefs represents the zodiac signs, with the labors of the months directly below. The column statues in the outer extensions of the jambs, actually the projecting wall buttresses, are Old Testament prophets beneath whom are quatrefoil reliefs with unusual narratives pertaining to their missions and prophecies.[27]

The sculptures on the jambs and trumeau represent a concept that we first saw on the south portal of Chartres—the ideal Christian community. The handsome Christ on the trumeau (**fig. 16.47**) is known as Le Beau Dieu. The beauty of the head of Christ resides in the symmetry of his features and the smooth, broad planes in the modeling of the cheeks and forehead. His piercing eyes stare out from deeper sockets, and his lips and chin are firmly set. Le Beau Dieu of Amiens is a stern yet benevolent leader of his community. The apostles

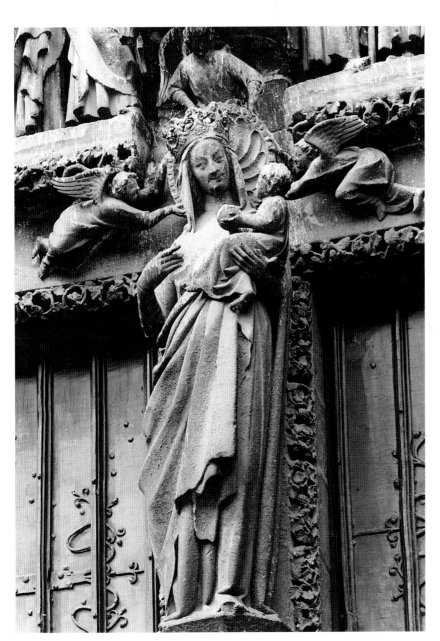

have suffered from restoration, but their integration into the portal is masterfully realized. They turn more naturally on their pedestals as individuals, and yet they all share a common goal as they attend their leader reverently (**fig. 16.48**). However, the cathedral was not always the site of communal harmony, it was also a major target at moments of civic unrest. In 1258, for instance, citizens set fire to the church in protest at the bishop's financial demands.

The charming *Vierge dorée* (**fig. 16.49**), completed around 1260–70, on the south transept portal, so named because of the gilt that originally covered the figure, sways gracefully, with the upper torso twisted off axis and her left hip raised to support the playful child. This contortion also allows the drapery to cascade in deep pockets beneath her right arm. The *Vierge dorée* is no longer conceived as a jamb or trumeau figure at all, but as an independent statue placed on the cathedral in a position that breaks across the trumeau and the lintel of the tympanum. She is characterized as a young, dimple-cheeked mother who is intimately involved with her infant, playing with him in fact, as she looks downward and smiles happily.

Throughout the thirteenth century, patrons, motivated in part by civic pride, tried to build taller churches with more spacious interiors. Their preoccupation with verticality affected the manner of devotion. Slender proportion ratios emphasizing height encouraged the pious to look upwards and internally examine their relationship with the transcendent. In 1225, Bishop Miles of Nanteuil sponsored the construction of a new cathedral at Beauvais (**fig. 16.50**). As a blatant snubbing of the French queen Blanche of Castile, the bishop dedicated the church to Saint Peter, a gesture that likely suggested his ultimate allegiance to the pope rather than the monarchy. With an elevation of 158 feet, the interior of the Beauvais Cathedral soars forty feet above than Chartres and nearly twenty more than Amiens. Beauvais is also the steepest Gothic church, with a ratio of 1:3.5. The vertical thrust of the structure, however, was not without its problems. In 1284, its choir vaults could not sustain tensions brought on by high winds and they collapsed. In the fourteenth century, large piers and sexpartite vaulting were added to support the rebuilt choir.[28]

Fig. 16.49. *Virgin and Child (Vierge dorée).* Trumeau, south transept portal, Amiens Cathedral. c. 1260–70

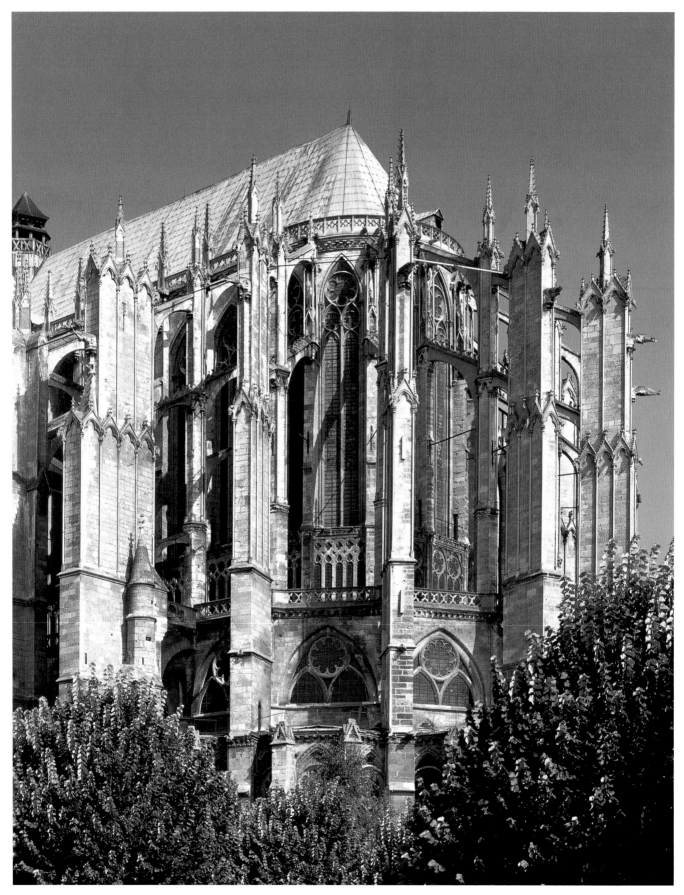

Fig. 16.50. Beauvais Cathedral. Exterior of the choir. Begun c. 1235

REIMS

Few dates can be pinpointed with regard to the construction of Reims Cathedral (**fig. 16.51**).[29] As the seat of the largest archdiocese in France, Reims was the coronation church for the French monarchy. It, like Chartres, had been the home of an important school, especially famous for the sciences, and from Carolingian times Reims had flourished as a center of the arts. The old cathedral burned down in 1211, and the foundation stone of the new church was laid in that same year by the archbishop, Aubri de Humbert. A seventeenth-century drawing preserves the labyrinth in the pavement of the nave and the names of the "masters of the works" in the thirteenth century, apparently in the chronological order of their activity: Jean d'Orbais, Jean le Loup, Gaucher de Reims,

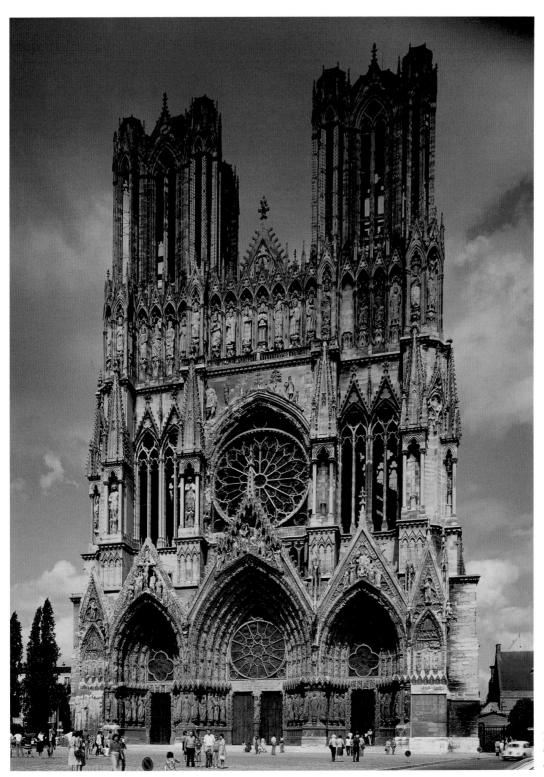

Fig. 16.51. Reims Cathedral. West facade. c. 1225–1311

and Bernard de Soissons. Between 1233 and 1236, civil strife in Reims disrupted the building activities, and this interlude perhaps marks an important shift in the planning of the sculptured portals and the designing of the transepts and choir. Major restorations were carried out in 1611–12, and considerable damage was done to parts of the cathedral during World War I.

In plan (**fig. 16.52**), Reims displays a condensation and stricter alignment of the spatial divisions found at Chartres.

The long nave with its single aisles has nine rectangular bays with quadripartite vaults. The transept now becomes part of a huge chevet by simply doubling the side aisles and continuing them into the choir, where the outer aisle is transformed into five radiating chapels in the semicircle of the apse. Porches were planned for the north and south sides. The choir and transept must have been completed by Jean d'Orbais's successor in 1241, when the canons of Reims are recorded as occupying the choir.

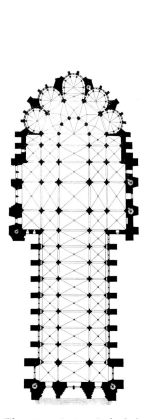

Fig. 16.52. Reims Cathedral. Plan (after Frankl)

Fig. 16.53. Reims Cathedral. Nave

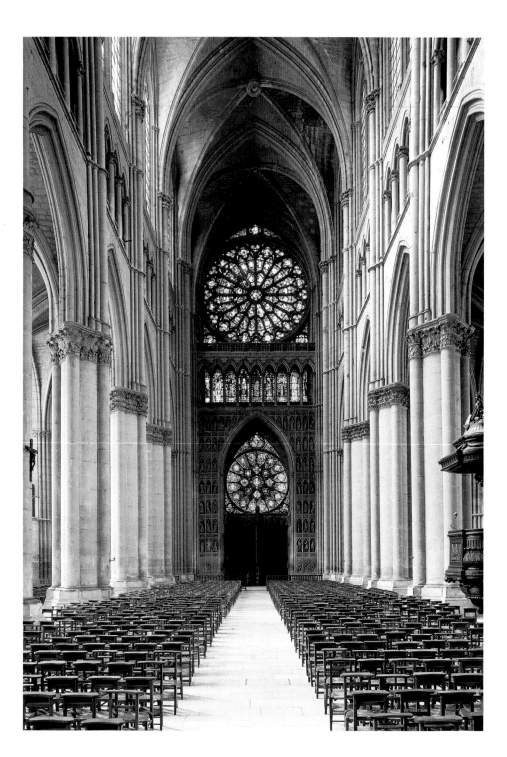

The interior (**fig. 16.53**) is a taller, narrower version of Chartres. The arches of the nave arcade are pitched higher, the divisions in the triforium are light and slender, and the clerestory is enlarged to three-eighths of the elevation. While not as lofty as Amiens or Beauvais, Reims (123 feet high) nevertheless demonstrates the development toward taller, higher, and lighter elevations. A major innovation, perhaps by the architect Jean d'Orbais, appears in the design of the clerestory window. Whereas at Chartres the window complex of two lancets surmounted by a rose is an independent unit imposed on a wall, that at Reims is designed as an open space in the bay with the divisions of the window constructed of stone mullions (bar tracery). The lancet and rose punctures of Chartres become a lattice-like construct of arches and petals filled with stained glass at Reims. The bar tracery of the Reims windows became the final solution for fenestration in Gothic architecture.

In French Gothic art and architecture, basic geometric forms seem to underlie ideal structures. The *Sketchbook* of Villard de Honnecourt reveals such a preoccupation (**fig. 16.54**). Simple geometric shapes, implicitly referring to the perfect order of God's creation, provide organizational principles for a variety of visual representations, including the depiction of buildings, animals, and human faces. An inscription at the bottom right of the page reads, "you will also find strong help in drawing figures according to the lessons taught by the art of geometry."[30] Gothic architects and masons followed analogous schemes for elevations termed *ad quadratum* and *ad triangulorum* (according to the square, according to the triangle) whereby their ideal structures could be raised according to symbolic measure and number, reflecting the geometry of the New Jerusalem and its prototype, the Temple of Solomon.[31]

The world of nature was similarly transformed. The leaves that virtually encompass the capitals of Reims Cathedral (**fig. 16.55**) are species that we can now easily identify as distinct plants when compared to the conventionalized floral motifs that adorn the moldings and capitals of Romanesque churches. The naturalistic scene of grapevines and the harvesting of its grapes is more than a decorative element. It may have evoked Eucharistic associations, elicited pride in local vinyards, and may have even conveyed notions of spiritual growth.[32]

Fig. 16.55. Floral capital in the nave of Reims Cathedral c. 1230–45

Fig. 16.54. Villard de Honnecourt. *Geometric Figures and Ornaments*. Sketchbook, 9¼ × 6″. 1220–35. Bibliothèque Nationale, Paris (MS fr. 19093, fol. 18v)

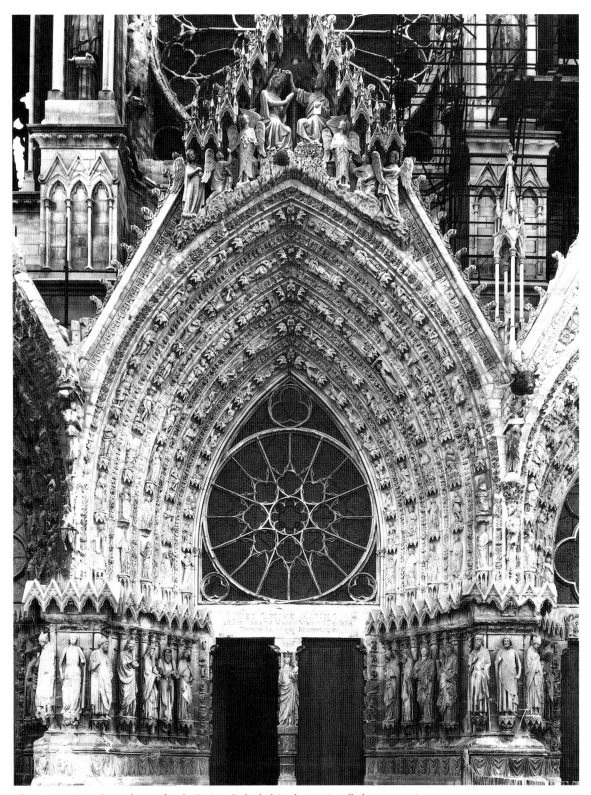

Fig. 16.56. Central portal, west facade, Reims Cathedral (sculptures installed c. 1245–55)

The facade of Reims (**fig. 16.56**) is a glorious and, in some ways, an ultimate statement of the grand tradition of regal, two-towered structures in northern Europe. Reims resembles a huge open shrine rising majestically with pointed arches repeated and multiplied at every stage. The deep porches are carved away, and diverse figures appear every-where; the tympana are now openings into which stained-glass windows are set to complement the great rose above. Sculptures that usually fill the tympana are moved to the gables above. Except for the high king's gallery at the base of

the towers, no horizontal lines are maintained, and yet the harmony of the architectural divisions between the facade and the interior elevation is beautifully shown.[33]

The diversity of sculptures at Reims is astonishing, but there are thorny problems for the art historian who wishes to study their programming and stylistic developments. It seems that a number of the jamb figures have been moved from one portal to another, indeed, from the west facade to the north transept porch. For instance, a tympanum sculpture of the Virgin and Child enthroned in the right doorway of the north transept must be a remnant from the earlier cathedral,

dating about 1180, but it is not certain whether it formerly adorned an exterior portal or, more likely, the top of a wall tomb within the church.[34]

The west facade program at an early stage in planning had focused on the veneration of the Virgin. In place of the *Maiestas Domini*, or Christ as judge, we find the Coronation of the Virgin filling the gable with the jambs devoted to the role of Mary in the Infancy cycle (as on Chartres north, left portal, and Amiens west, right portal): the Annunciation and Visitation groups to the right, the Presentation in the Temple with four figures on the left. Mary appears on the trumeau as

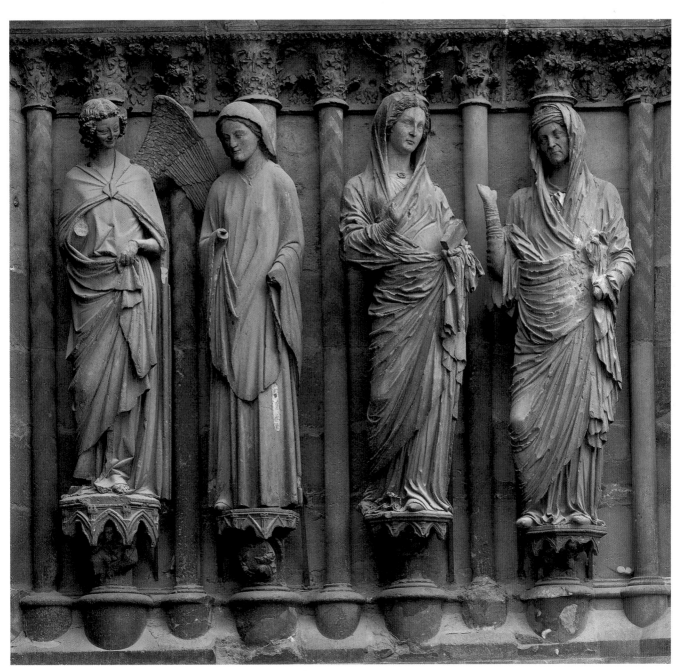

Fig. 16.57. *Annunciation and Visitation.* Right jamb, central portal, west facade, Reims Cathedral (Annunciation Angel, c. 1245–55; Virgin of Annunciation, c. 1230; Visitation group, c. 1230–33)

the "New Eve" standing atop reliefs of the story of the Fall of Adam and Eve (a frequent allusion in statues of the Virgin at this time).

The two side porches present highly original compositions and iconographies. To the left, the gable is decorated with a Crucifixion; the archivolts of the deep porch display one of the earliest known Passion narratives in architectural sculpture; and the jambs have statues of martyrs, some of whom are impossible to identify. The right porch has an abridged Last Judgment in the gable and a most unusual sequence of sculptured archivolts that narrate apocalyptic events described in the Book of Revelation.

In the Visitation (**figs. 16.57, 16.58**), two female figures recall the Greco-Roman past, so much so that some early accounts have described them as ancient statues reused. Although they display remarkable Classicism, they remain Gothic in style, as is apparent in the draperies that cascade from their wrists and elbows and in the rich folds that pile up about their feet. The complex, fussy draperies that break across their torsos in short, broken grooves and the sharp horizontal folds that wrap tightly about their bodies resemble the diaphanous drapery of the ancients, but this dramatic style had already been introduced previously in the metalwork of Nicolas of Verdun (compare figs. 14.31, 14.32).

The Annunciate Angel Gabriel is the most striking representative of the new style. According to installation marks carved on the back of this statue, it can be determined that it was moved from its original position on the left portal as one of a pair of angelic escorts (one there now is in this same style) for Saint Dionysius to its present position beside the Annunciate Virgin.

The smiling angel is posed gracefully as if swaying on the pedestal. With this pivotal stance the figure assumes a slight S-curve as if dancing, while turning the shoulders, cocking the head downward, and leaning outward from the niche. The drapery is rendered in rich, voluminous folds that

Fig. 16.58. *Virgin of the Visitation.* Detail of Fig. 16.57

fall downward in long arcs, deeply undercut, with graceful undulations and overlaps terminating in gently curling edges. The overmantle is now a fashionable cape that fits snugly about the shoulders and is fastened by a brooch at the breasts, thus enveloping the upper arms like a cocoon. The elbows move slightly within it, and on the one side deep arcing pockets descend rhythmically, breaking the closed contour of the statue, while from the left hand of the angel an end piece of the mantle unfurls downward in elegant overlaps. At the feet, the soft draperies pile up in abstract patterns anchoring the swaying figure gently to the pedestal.

The ideal for an angel has changed (and for most other figure types as well). Gabriel is a feminine type elegantly posed to reveal the splendid draperies. An enchanting sweetness pervades the face with its irresistible smile and sharply delineated features. A radiant smile is conveyed by the dimpled cheeks, the feline eyes with a slight puffing under the sockets, and the full but softly tapering chin. The naturalistic depiction of the holy figures is enchanting; they seem so lifelike and approachable. Joseph (**fig. 16.59**), in the Presentation group on the left side, is winsome with his coy, cocky expression and smile, his curly mustache and short-cropped beard.[35]

Fig. 16.59. *Joseph*. Detail of jamb figure, left jamb, central portal, Reims Cathedral. c. 1245–55

17

SAINT LOUIS AND LATE MEDIEVAL FRANCE

PARIS AND THE RAYONNANT STYLE

The reign of Louis IX (1226–70) is often considered the golden age of the French monarchy in the Middle Ages, and it was during this period that Gothic architecture reached a third stage of refinement characterized by some as the "Rayonnant style," by others, as the "Court style."[1] The Rayonnant style developed from a further sophistication of the High Gothic of Chartres, Amiens, and Reims. The mural character of the masonry walls is finally displaced by one of complete transparency with sheets of stained glass, and the sculptural qualities of the architecture, whether in undulating surfaces or punctures in stone, give way to flat surfaces wholly articulated by linear moldings and tracery.

The name, Rayonnant, derives from the "radiating" bar tracery of the rose window, which now seems to spread through the entire elevation. The heavier columnar pier with four applied colonnettes is turned into a cluster of colonnettes that rise uninterrupted into the vaults. The triforium is completely merged with the huge windows of the clerestory and is "glazed," that is, the back wall is open and filled with stained glass. But it is the sophisticated articulation of the moldings, the tracery, and the colonnettes that provides the basis of the Rayonnant style.

The invention of the Rayonnant style has frequently been credited to a Parisian builder, Pierre de Montreuil. In Paris, Notre Dame was remodeled about 1225. The zone with the oculi above the tribune gallery of the four-part nave elevation was eliminated and the clerestory was dropped down to absorb that space for larger windows. Pierre de Montreuil finished the south transept (**fig. 17.1**). Here the

mural surfaces are almost brittle, as if the tracery were incised or embossed on a sheet of light metal, enhancing the "shrine-work" appearance even more. The high-pitched gables of the doorway and buttresses rise into the glazed triforium as free-standing elements breaking through the horizontal divisions of the facade.

The model for the Rayonnant style of the French court is Sainte-Chapelle, situated near Notre Dame amid the cluster of buildings that served as royal apartments and government offices (**figs. 17.2, 17.3**). In 1239, Louis IX acquired from Constantinople valuable relics of the Passion of Christ: the Crown of Thorns, a piece of iron from the Lance, the Sponge, and a piece of wood from the True Cross itself. For these treasures, Louis commissioned a new palace chapel, adjoining the king's apartments, to serve as a monumental reliquary. Built between 1243 and 1248, Sainte-Chapelle truly does resemble a metal shrine, and in many respects it is little more than a miniature Gothic chevet in two stories with a front porch.[2]

A new intimacy and privacy are achieved in the glass chapel of the king (his apartments had direct access to the upper chapel through the projecting porch on the west), and the stained glass that entirely fills the space, although much restored, still conveys the mystical sense of the *lux nova* that transforms the environment into a resplendent world of colored lights. The lancets in the nave are filled with rows of roundels that illustrate Old Testament events from Genesis to the Book of Kings (they are not in proper order) and the prophets; and behind the altar in the apse, a window of the Tree of Jesse and one devoted to John the Baptist appropriately

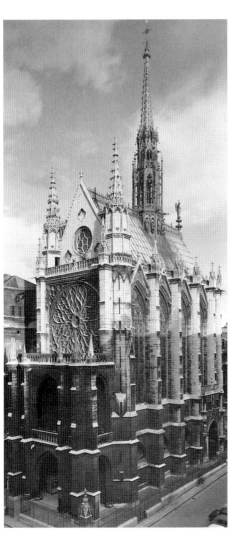

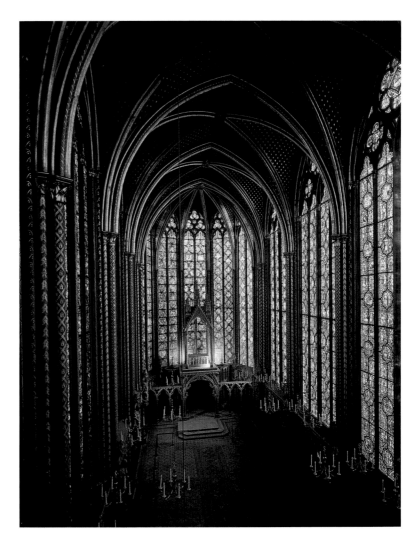

LEFT **Fig. 17.1.** Cathedral of Notre Dame, Paris. View from the south. c. 1258–65

BELOW LEFT **Fig. 17.2.** Sainte-Chapelle, Paris. Exterior. 1243–48; rose window after 1485

BELOW RIGHT **Fig. 17.3.** Sainte-Chapelle, Paris. Interior of upper chapel. 1243–48

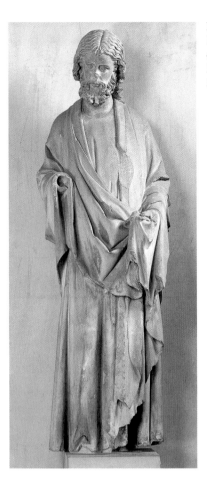

Fig. 17.4. *Apostle.* From the upper chapel of Sainte-Chapelle. Marble. 1243–48. Musée de Cluny, Paris

introduce us to two windows with episodes from the Infancy and the Passion of Christ. The cycle ends with lancets in the southwest bay that illustrate stories of the history of the relics of the Passion. The west rose window (replaced in the 1480s) originally featured events in the Book of Revelation and the Last Judgment.[3]

The wall piers of Sainte-Chapelle were decorated with statues of the twelve apostles placed on low consoles (**fig. 17.4**). Only three of these are original. The elegant treatment of the earlier sculptures of Notre Dame is here elaborated into gracefully posed figures with voluminous draperies falling in deeply cut folds of triangular pockets that cascade rhythmically. The features of the triangular faces are delicately delineated with small, pinched eyes and tiny mouths under curly mustaches, and their somewhat affected poses give them the appearance of a consortium of refined courtiers attending the king's precious relics.

Thirteenth-century reliquaries enhanced the veneration of relics. Philip, the Count of Namur, donated a relic fragment from the True Cross that he had received from his brother Baldwin I, leader of the Fourth Crusade and Latin Emperor of Constantinople, to the Norbertine abbey at Floreffe (near Namur, Belgium). The relic is enshrined in a reliquary triptych (**fig. 17.5**) that is in the shape of a Gothic chapel. In its opulent display of scenes from Christ's Passion, the gilded reliquary conceals the centrally located relic, making the distinction between relic and reliquary less apparent.[4]

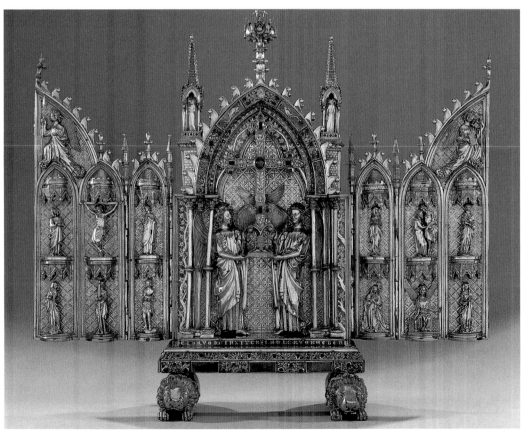

Fig. 17.5. Reliquary Cross of Floreffe. Silver and copper gilt, filigree, precious stones, and niello. Open 28⅜ × 35½″. After 1254. The Louvre, Paris

ILLUMINATED MANUSCRIPTS

In the *Divine Comedy*, Dante referred to Paris as that "city famed for the art of miniature painting."[5] Indeed, with the exception of some illuminated manuscripts dating to the early years of the thirteenth century produced in English scriptoria, the history of painting in the North is dominated by developments that took place in the capital of France. The urban cathedral replaced the rural monastic abbey as the progressive building type in architecture, and so, too, did the illuminated manuscripts produced in secular city workshops supplant the service books that were the products of monastic scriptoria. It was the urban, secular artist, not the monastic scribe, who was now called upon by wealthy patrons and members of the university circles.

The finest illuminated manuscripts were produced for kings and queens, as is to be expected, and the Capetian rulers were avid bibliophiles, especially Louis IX (Saint Louis), who accumulated vast libraries of secular as well as religious books that were passed down from generation to generation, ultimately forming the core of the Bibliothèque Nationale in Paris. For Louis's mother, Blanche of Castile, a splendid illuminated psalter was made around 1230 that serves as an excellent example of Gothic painting (**fig. 17.6**). The Psalter of Blanche of Castile has twenty-five elegant pages with miniatures, the greater part being pairs (facing verso and recto sides) forming antithetical presentations of scenes from the Old and New Testaments, independent of the verses of the Psalms.[6]

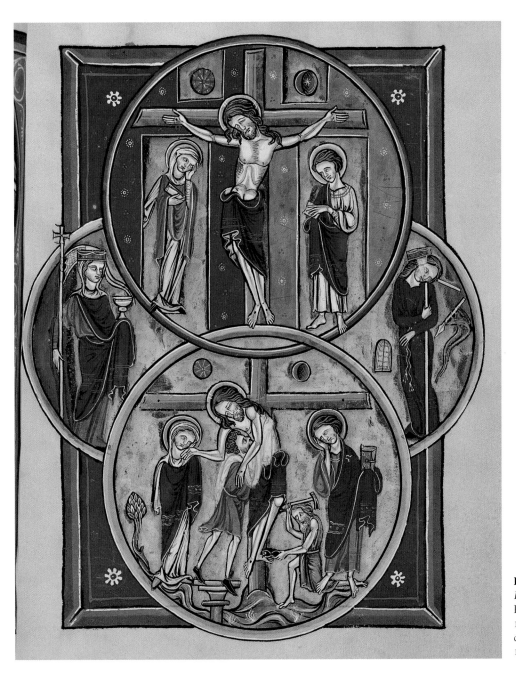

Fig. 17.6. *Crucifixion and Deposition.* Illustrations in the Psalter of Blanche of Castile. 11⅛ × 8″. c. 1230. Bibliothèque de l'Arsenal, Paris (MS franc. 1186, fol. 24r)

The brilliance of the bright colors commands our attention in these pictures. The palette consists of rich reds and deep blues with gold backgrounds, and the miniatures stand out like *cloisonné* enamels on the page. Secondary hues—fresh greens, oranges, purples—accent the blocks of saturated pure colors contained within dark outlines marking out the contours of the figures. The few lines of the drapery and the minuscule facial features resemble the leaden lines that served the compositions of stained-glass windows. Modeling in the figures and spatial projection of the settings are minimal. Often the frame of the miniature provides the ground, and when landscape is indicated, it is limited to an undulating line that serves more as an ornamental touch than a projecting stage. Further, the clarity of the organization of the compositions on each page, with intersecting circles superimposed on geometric blocks of blue with red borders, reminds one of the designs found in Gothic windows, with their clear integration of parts.

The dependence of miniature compositions on stained glass is even more apparent in the huge moralizing Bibles that

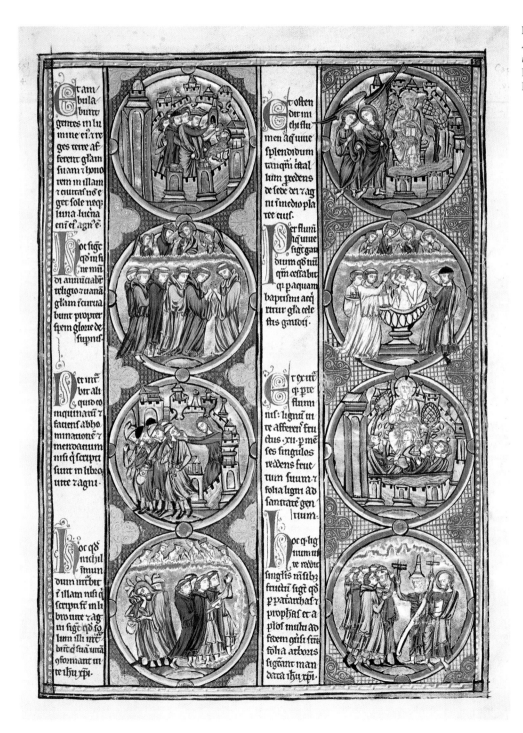

Fig. 17.7. *Scenes from the Apocalypse.* Illustration in the *Bible moralisée*. 15 × 10½″. 1226–34. Pierpont Morgan Library, New York (MS 240, fol. 6r)

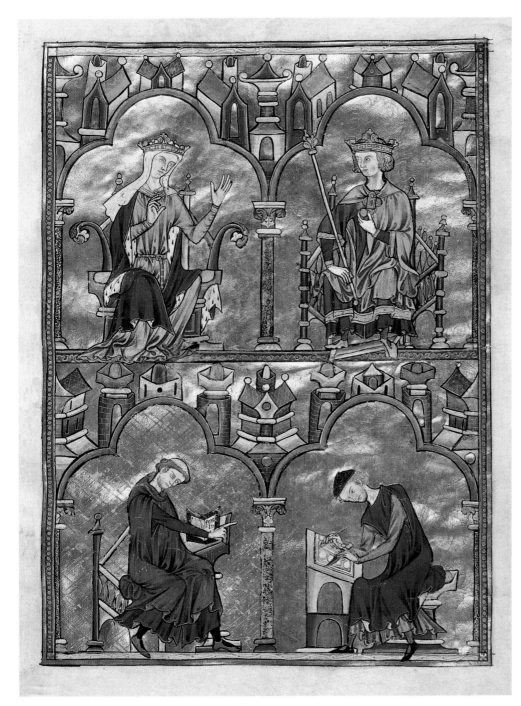

Fig. 17.8. *Blanche of Castile and Her Son, Louis IX.* Dedication page in the *Bible moralisée* (fol. 8r)

were produced in Paris (**fig. 17.7**). The *Bible moralisée* was a kind of instructional manual that formed an encyclopedic picture book of Old and New Testament typologies. The text consists of short moralizing commentaries on passages in the Bible written in the margins of the page. The most complete copies required three volumes and over five thousand illustrations. The fragment in the Pierpont Morgan Library in New York has a dedication page portraying Queen Blanche of Castile enthroned opposite her son, Louis IX, above a cleric dictating the text to a seated scribe (**fig. 17.8**). The

illustrations of the texts are organized in two columns of eight superimposed medallions, a design apparently inspired by the glass in tall lancet windows, such as those in Sainte-Chapelle.[7]

In a masterpiece of thirteenth-century painting, the Psalter of Saint Louis, dating from sometime between 1253 and 1270, Old Testament narratives are placed like stained-glass panels within elaborate frames that culminate in petite cathedrals complete with pinnacles, fretted galleries, and rose windows (**fig. 17.9**). These painted elevations copy, in fact, that of Sainte-Chapelle itself.[8] The wide border that frames

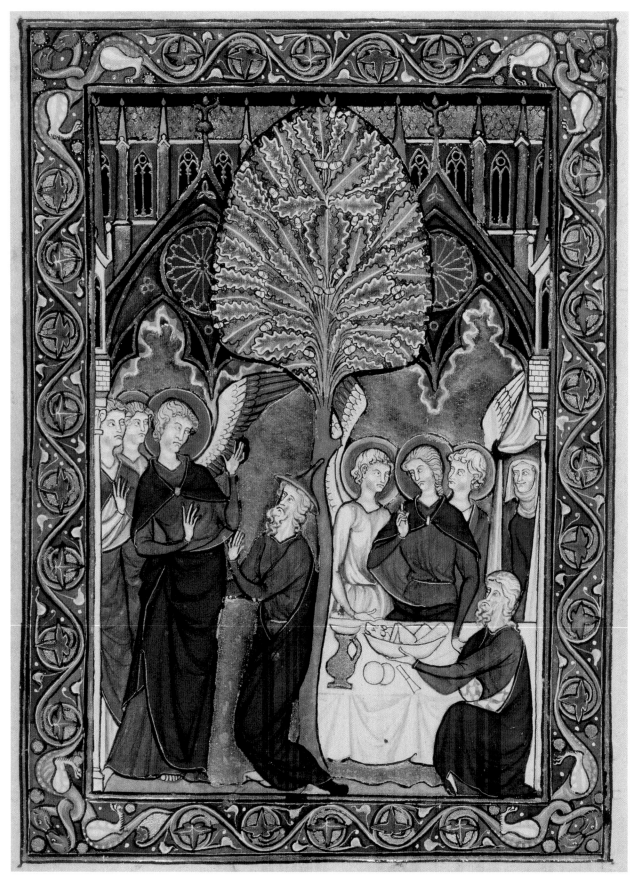

Fig. 17.9. *The Feast of Abraham.* Illustration in the Psalter of Saint Louis. 5 × 3½″. 1253–70.
Bibliothèque Nationale, Paris (MS lat. 10525, fol. 7v)

the miniature is elaborated with colorful scrolls of red and blue interspersed with conventional floral and animal motifs, a decorative touch that will gradually give way to the delicate sprays of ivy that fill the borders of later Gothic manuscripts. The tiny actors who animate the stories with their flat silhouettes are dressed in contemporary costumes.

The Psalter of Saint Louis is small, measuring only five inches by three and a half inches, but it contains over seventy-eight Old Testament illustrations (some are lost) ranging chronologically from the book of Genesis to the coronation of Saul as king of Israel in the Book of Kings. Unlike the "literal" illustrations of the Psalms in the Utrecht Psalter or the "allusive" pictures in Byzantine aristocratic psalters, those in the Psalter of Saint Louis seem to lack any immediate relationship with the text. It is, in effect, a precious picture book appended with Psalms. Because of the small size and the concentration of scenes on the feats of the militant heroes of the Old Testament, it was probably Louis's own personal devotional book and not one intended for the service of churchmen, a point of considerable interest in the changing role of art in the thirteenth century.

The miniatures in the Psalter of Saint Louis display the refined qualities of the Court style that became the primary form of painting throughout northern Europe. Indeed, Paris had become a major hub of artistic activity. Artisans from various provincial centers in northern France, the Rhineland, the Netherlands, and England poured into the capital to perfect their skills in the ateliers of Paris and to enjoy the profits of a rapidly expanding art market, particularly in book illumination. The organization of these prolific workshops is worth investigating.

The members of the atelier were enrolled in the Confraternity of Saint John, a guild that was responsible not to the provost of Paris, as were most others, but to the university. Representatives of the university regularly checked the accuracy of translations and transcriptions and virtually controlled the production of texts. Furthermore, much of the market for books was found in university circles. Students were required to have their own pocket Bibles for constant reference, and as the court and the ecclesiastical libraries grew, great demands were made on those who produced books. The various ateliers clustered in the quarters near the university (various street names still reflect this today), and for those who specialized in illustrated books, a number of trained artisans were required.

The main entrepreneur and bookseller was known as the *librarius*. Within each shop was the chef d'atelier (comparable to the master mason in architectural projects), who would lay out the book, so to speak, and organize the labor once a commission was received. The most valued member of the team was the scribe, who copied the texts in an elegant hand. The scribe was instructed to leave spaces and gaps in the text for the introduction of decorated initials and miniatures. He frequently acted as the rubricator, whose task was to fill in special entries and chapter headings in red or some other particular color.

The codex, assembled in gatherings of pages called quires, was then sent to the desks of the illuminators. These artisans often specialized in certain areas of painting, usually determined by their skills and experience, that involved the border decoration, the illuminated initials, and the painted histories, or narrative illustrations. Distinctive border motifs developed in each shop, although delicate filigree work with vine scrolls and flowers or leaves was the predominant scheme. The fancy initials required a more experienced hand because of their complex color patterns and gold inlay, and, finally, the miniatures with figures were entrusted to the most talented of the illuminators.

Frequently the chef d'atelier would indicate in the margins or in the gaps of the text left by the scribe the subject matter of the miniature to be inserted. This would be done by either a brief notation (for example, "le sacrifice Isais" for a representation of the Sacrifice of Isaac) or by a tiny sketch. Very likely those who drew and/or painted the figures had recourse to model books, much as modern commercial artists do, for elaborating standard poses, actions, face types, and costumes. After the outlines were drawn, the gold leaf (designated by "dor" in the notations of the chef d'atelier) would be carefully laid in and burnished. Then the areas of colors in the costumes and setting were added. The final touches, made in heavy ink, would trace the facial features, details of the costumes, and lines of drapery. When finished, the illuminated book was sent to the bookbinder, the final specialist in the production.[9]

The fussier drapery style of earlier miniatures gradually gives way to broader and more lyrical sweeps of folds and pockets that enhance the beauty of the bright colors. Poses are exaggerated in the affected swing and sway of the tiny figures and their costumes, and facial features acquire a studied elegance with their stereotyped expressions of joy or sorrow. Refinement, grace, and diminutiveness characterize the aristocratic style of French Gothic illumination, and while colorful details are sometimes added to indicate the setting as a throne room, a church, a city, or a woodland cove, there is no attempt to approximate a realistic setting in space. The backgrounds are filled with elegant gold leaf and bright red-and-blue diaper patterns.

Toward the end of the thirteenth century, distinguished artists emerge from the scores of painters in the workshops, and, in turn, their ateliers gained prestige among the wealthier patrons. One such atelier was headed by Master Honoré, whose name appears at the end of a volume of decrees of canon law: "In the year of our Lord twelve hundred and eighty eight I bought the present Decretals from Honoré the illuminator dwelling at Paris in the street Herenenboc de Bria [now rue Boutebrie] for the sum of forty Paris livres."[10] The Decretals of Gratian, illuminated by Honoré, are today in the Municipal Library in Tours. "Honoré the illuminator" is

Fig. 17.10. Master Honoré. *David Anointed by Samuel and the Battle of David and Goliath.* Illustration in the Breviary of Philippe IV. 7⅞ × 4⅞″. 1296. Bibliothèque Nationale, Paris (MS lat. 1023, fol. 7v)

named again in royal accounts for the year 1296 before an entry listing a costly breviary executed for King Philip IV (1285–1314). This book has been identified as the elegant Breviary of Philip IV in the Bibliothèque Nationale in Paris.

The miniature with the Anointing of David by Samuel above the Battle of David and Goliath is typical of many Parisian illuminations of the late thirteenth century (**fig. 17.10**). The facial features painted by Master Honoré, however, display a distinctive delicacy and refinement. The pincer-shaped beards and the tightly curled hair with a special lock

that falls across the middle of the forehead are mannerisms that are found in his paintings.

What is innovative about his style, however, is the new treatment of the drapery. Subtle white washes appear along the lines of the projecting knees, about the wrists and shoulders, and in the overlapping folds that model the reds and blues of the costumes as if the figures were bathed in a raking light. Rather than silhouetting the actors with elegant outlines, Master Honoré shades his figures with light and dark tones, giving them a sculptural bulk and solidity. As yet they

Fig. 17.11. *Saint Denis Preaching to the People of Paris.* Illustration in the Life of Saint Denis. 9¼ × 5¾″. c. 1317. Bibliothèque Nationale, Paris (MS fr. 2091, fol. 99)

vignettes of everyday life on the bridges of Paris (Saint Denis was the first bishop of the city).[11]

Rendered on a diminutive scale like a toy cardboard city, these charming scenes give us keen insight into the secular activities of medieval Paris. Here the noises of the city are alluded to. Below, adrift in a boat on the Seine, a group of clerics sings gleefully, but there are other sounds reverberating through the streets. To the left, in a shop built on the Grand Pont (it has four arches), a moneychanger haggles with a customer, while next door a goldsmith hammers away at an object. From the bridge gate in the center, a toll keeper shouts down to a young horseman bringing a falcon into the city. To the right, on the Petit Pont (two arches), a porter carries a heavy sack over his shoulder and a shopkeeper displays her wares—wallets and knives—to a prospective buyer. While no attempt is made to render the city in perspective or realistic scale, the delightful details of urban life indicate another developing interest in the arts of the time, namely that of everyday activities.

The concern for a more sculptural figure style, together with the interests in secular genre, can be followed more clearly in the miniatures found in a new type of devotional book that evolved during the late thirteenth century, the Book of Hours (*Horae*).[12] Essentially, the Book of Hours was a tiny breviary or missal for personal use. It included a calendar of the church year with special indications in colored inks of the major feast days and those of the saints venerated personally and in the diocese. There are many variations in the contents, but most follow a certain pattern that includes special readings from the Gospels, the "Little Office of the Virgin" (a sequence of prayers devoted to the canonical hours of each day with special veneration given to Mary), the Penitential Psalms, various litanies, the Office of the Dead, and finally a long series of prayers that served as commemorations to special saints (the Suffrages of the Saints).

The Little Office (or Hours) of the Virgin was the most important section and included eight canonical hours illustrated in a set pattern beginning with the major episodes in the Infancy cycle and concluding with the Coronation of Mary. In some manuscripts, the Hours of the Virgin were augmented with the Hours of the Passion, which included scenes from the Betrayal of Judas to those leading up to and following the Crucifixion. Bound in a leather or metal cover encrusted with gems, the Book of Hours was thus a *joyaux*, an objet d'art, a piece of jewelry for show more than for devotion, and as a status symbol it became the popular medium for painting in the North at the end of the thirteenth century.[13]

have no place to stand in the real world—note the feet of David and Goliath and those of Jesse and his sons in the anointing scene—but clearly the Parisian painter is responding to new interests that disturb the precious conventions of thirteenth-century style.

The influence of Master Honoré's more plastic modeling techniques can be seen in the charming miniatures in the Life of Saint Denis that was presented to Philip V in 1317 by Gilles de Pontoise, abbot of Saint Denis. In one of the miniatures (**fig. 17.11**), Saint Denis appears preaching from an outdoor pulpit to a crowd of townsfolk seated on the ground behind their leader, identified by an inscription as "Lisbius." In the top right corner, idols topple from their pedestals as the conversion of heathens is accomplished. Throughout the cycle, the lower half of the miniature is devoted to colorful

Fig. 17.12. Jean Pucelle. *Betrayal of Christ* and *Annunciation*. Illustrations in the Hours of Jeanne d'Evreux. Each 3½ × 2½″. 1325–28. The Cloisters Collection. Metropolitan Museum of Art, New York (fol. 11v)

One of the most exquisite examples is the tiny Hours of Jeanne d'Evreux, executed by a Parisian miniaturist, Jean Pucelle, about 1325–28. It was presumably a wedding or coronation gift given to the French queen by her husband, Charles IV.[14] She appears kneeling at her prie-dieu in the beginning initial for prayers at Matins below a representation of the Annunciation (**fig. 17.12**). In spite of the small format (3½ inches by 2½ inches), the Hours of Jeanne d'Evreux is a complex production. The pages devoted to the calendar are illustrated with diminutive genre scenes of the labors or pastimes of the month and the zodiac signs for the month. The "hours" proper have antithetical groupings of illustrations from the Infancy and the Passion facing one another. A special cycle of illustrations was dedicated to the Hours of Saint Louis, who, recently canonized, was a favorite saint especially dear to the women of the court. Of interest, too, are the numerous drolleries (*drôleries*) that animate the marginal areas of the tiny pages with fanciful figures and grotesques performing various courtly games and other secular activities. At the bottom of the page (*bas-de-page*),

children play "frog in the middle," a courtly game resembling tag. The miniatures are executed in a grisaille technique—a black and gray tonality with occasional washes of light colors—that completely breaks with the tradition of saturated pure colors and gold normally found in French miniatures.

A number of his compositions, including the Annunciation, were derived from panels of the great Maestà executed by the Sienese painter Duccio (figs. 19.21, 19.22). The tiny doll-house perspective in Pucelle's Annunciation, with its receding side walls and ceiling beams projecting diagonally to a central axis, offers an early attempt at the depiction of illusionistic space in the North. Pucelle's little space-box even includes a special trapdoor to allow the Holy Ghost (in the form of a dove) to enter Mary's chamber. Above the room appears the more traditional flattened attic, where a choir of angels has assembled to sing praises to the Virgin.

Pucelle may have experimented with the grisaille technique in order to exploit the volumetric qualities of figures so as to place three-dimensional bodies in the new projected space-boxes. By reducing the hues to black and

gray (a few tints of color are added here and there), he has been able to make the modeling of the forms more sculptural, with emphasis on the plastic qualities of the figures rather than on their color shapes. Finally, the proliferation of animal and genre motifs in the margins (this interest appears earlier in English illuminations) is a startling break with the conventional border patterns of ivy that abound in French manuscripts of the Late Middle Ages (**fig. 17.13**).[15]

Jean Le Noir, a follower of Jean Pucelle, may have painted illuminations in the Psalter of Bonne de Luxembourg, the Duchess of Normandy (months after her death, Bonne's husband would serve France as King John II). In a two-page scene reminding readers of their mortality (*memento mori*), three noblemen on horseback confront three corpses at various states of decay (**fig. 17.14**). The first of the living figures attempts to turn away from the inevitable, while the second rider covers his nose to minimize the stench. The third man, with a falcon perched on his arm, hesitantly points towards the figures of death. The illuminations reinforce the art of dying well (*ars moriendi*), helping readers prepare for the Final Judgment. The importance of this theme was made even more poignant by the spread of the Black Death (bubonic plague) in the 1340s. Bonne of Luxembourg became one of its victims in 1348.[16]

Fig. 17.13. Jean Pucelle. *November*. Miniature in the Hours of Jeanne d'Evreux (fol. 15v–16)

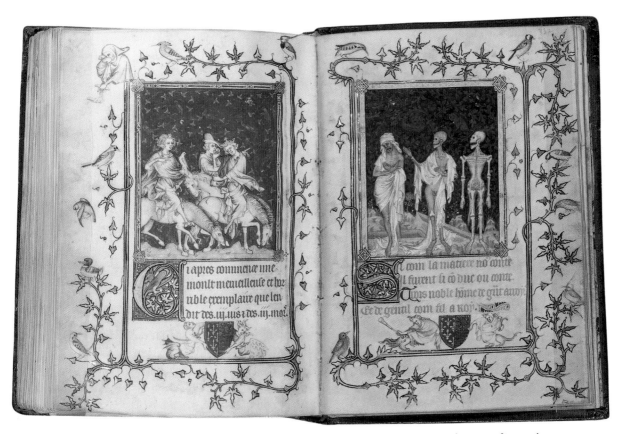

Fig. 17.14. Jean Le Noir. *The Three Living and The Three Dead*. Illustrations in the Prayer Book of Bonne of Luxembourg. 5 × 3½". c. 1345. The Cloisters Collection, Metropolitan Museum of Art, New York (fol. 321v and 322r)

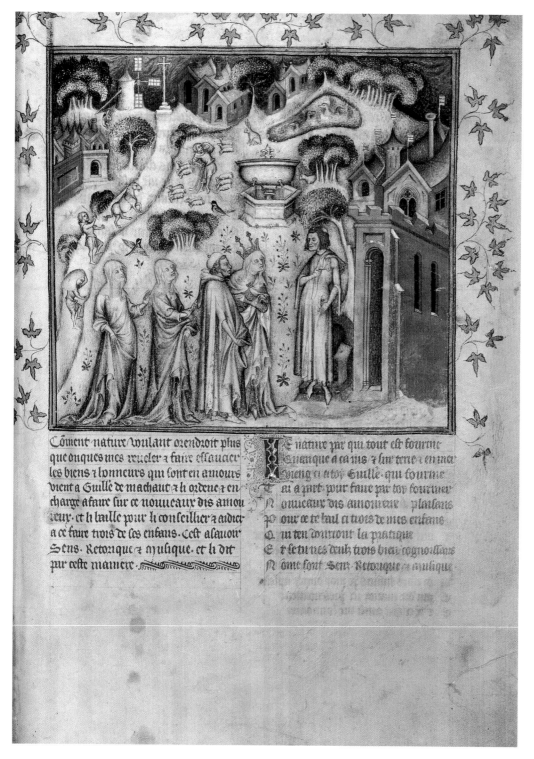

Fig. 17.15. *Nature Introduces her Children to the Poet.* Illustration in Guillaume de Machaut's *Poetic Works.* 1377. Bibliothèque Nationale, Paris (MS fr. 1584, fol. E)

One of the greatest illuminators in the court of Charles V (the eldest son and successor of John II), known as the Master of Boqueteaux (after the small clusters of trees in his pictures), painted two images introducing contemporary poetic works by Guillaume de Machaut (also a famous musical composer who served as the Canon of Reims Cathedral). In the first illumination (**fig. 17.15**), Nature, wearing a crown and enrobed in gold and white, introduces her three children (Sense, Rhetoric, and Music) to the poet dressed in his religious habit. The poet receives them in a landscape filled with numerous rustic vignettes. Nature's gesture of hospitality offers poetic inspiration, "revealing and exalting the good and the honors which exist in love." In the second illumination, Love introduces his children (Sweet Thought, Charm, and Hope) to Machaut, supplying him "with the material he needs to follow Nature's orders."[17]

IVORIES

An ivory sculpture of the Virgin and Child from the treasury of Saint Denis (**fig. 17.16**) was originally part of an ensemble that included three adoring angels. Like portal figures of the Mary at Amiens and Reims, the Saint Denis Madonna graciously turns on her pedestal. In her left arm, she holds her son, who reaches for a rose in her right hand. The two gaze lovingly into one another's eyes, suggesting the intimacy between them. Christ holds a small apple in his left hand, reinforcing the notion that the Madonna and Child are the New Adam and Eve.[18] Similar qualities can be found in a later stone sculpture of the Virgin from Notre Dame in Paris (**fig. 17.17**).

In early fourteenth-century France, depictions of Mary in ivory, stone, and illuminated manuscripts often share numerous stylistic traits. The diminutive Virgin in Pucelle's

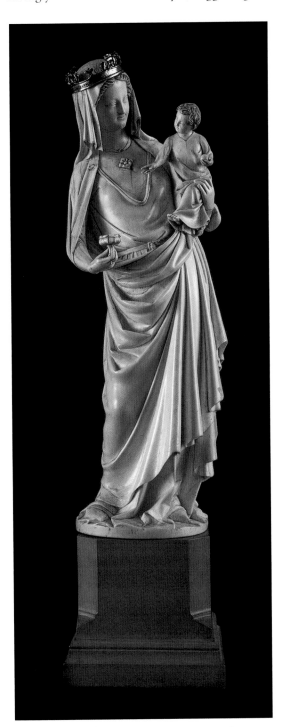

Fig. 17.16. *Virgin and Child.* Ivory, height 13¾″. c. 1260–80. Paris, Abbey Church of Saint-Denis. Taft Museum of Art, Cincinnati

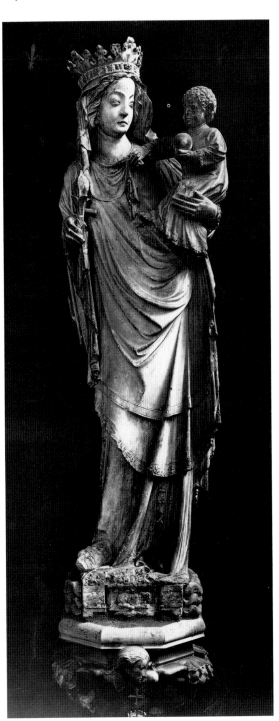

Fig. 17.17. *The Virgin of Paris.* Stone. c. 1320. Notre Dame, Paris

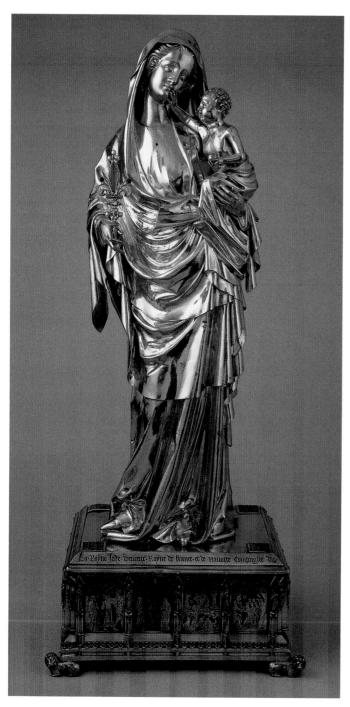

Fig. 17.18. *The Virgin of Jeanne d'Evreux.* Silver gilt, height 27½″. 1339. The Louvre, Paris

Annunciation bears an astonishing resemblance to the silver-gilt statuette of Mary presented by Queen Jeanne d'Evreux to the Abbey of Saint Denis in 1339 (**fig. 17.18**). Refined elegance and mannered grace characterize both of them. These features are also evident in the exquisite Virgin and Child, La Vierge de la Sainte-Chapelle (**fig. 17.19**), executed about 1300 in ivory with faint touches of gold added to Mary's hair, belt, and the borders of her mantle.[19] Enveloped in elegant draperies, Mary sways gently to the side. Her face is that of a coy young princess, and her smiling infant reaches for the apple she offers teasingly in her right hand. This charming portrayal of Mother and Child in immaculate ivory would be a comforting image for the worshipper in the intimacy of a family chapel.

La Vierge de la Sainte-Chapelle is only sixteen inches high. A beautiful ivory crosier head, an insignia of the bishop's office (**fig. 17.20**), presents a similar demure Virgin and Child swaying between angels. A number of secular objects—mirror backs, jewelry coffers, combs—that were valued highly by the ladies of the court were also executed in ivory, perhaps because its shining white qualities were meant to reflect the virtues esteemed by the owners.

One such object is a jewelry casket in the Walters Art Gallery (**fig. 17.21**), which has carved ivory plaques clamped to the sides and the lid.[20] A charming panorama of courtly pastimes is presented: tiny demoiselles, with their slightly puffy eyes, their sweet smiles, and their mannered gestures, flit here and there on the occasion of a courtly festival. But there is a theme to these lively diversions: the power of youthful love, embodied in the chaste young lady of the court. In the two central sections on the lid we find a tournament with two knights on horseback charging each other in an arena before a platform filled with charming young maidens. To the left is another familiar theme, the siege of the castle of love, an allegory derived in part from the *Romance of the Rose*, written by Guillaume de Lorris (finished by Jean de Meung about 1280). Knights launch roses from crossbows and a catapult, as women "defend" their fortress with the aid of Cupid. The scene on the right presents the finale to the contest with the prize, the fair lady, and the victor, the gallant knight.

The episodes on the front of the casket, as well as on the ends, serve as footnotes, with references to a variety of secular allegories that illustrate the Virtues, the Vices, and the power of women in courtly romance. On the front, the humorous story, popularized in Henri d'Andeli's *Lai d'Aristote*, of the aged Aristotle, captivated by the young princess Campase, who carries the maiden "horsy-back" on all fours, reveals the folly of the pagan philosopher when confronted with lustful desires. On the left end of the casket are episodes from the legend of

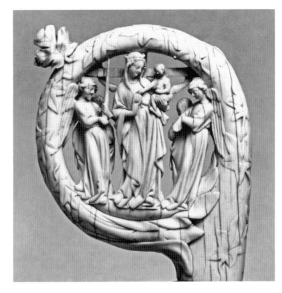

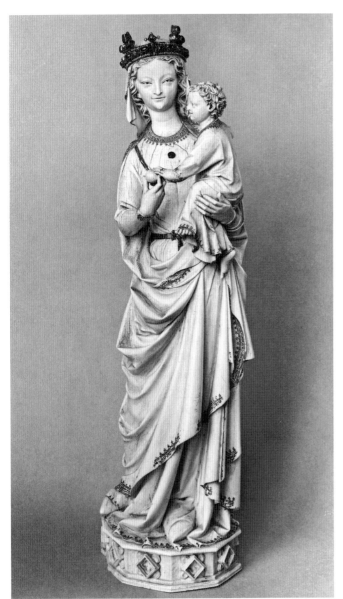

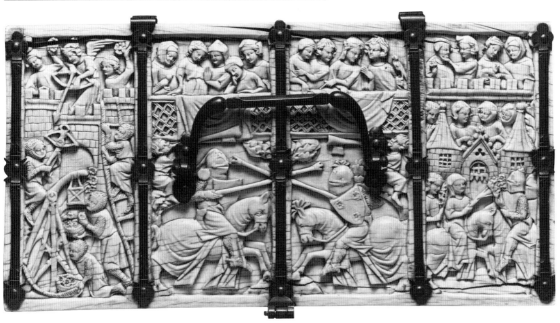

ABOVE **Fig. 17.20.** *Virgin and Child with Angels.* Head of a bishop's crosier. Ivory, height 5¼". c. 1340. Walters Art Gallery, Baltimore

LEFT **Fig. 17.19.** *Virgin and Child (La Vierge de la Sainte-Chapelle).* Ivory, height 16⅛". c. 1300. The Louvre, Paris

BELOW **Fig. 17.21.** *The Power of Love.* Jewelry casket. Ivory, 4½ × 9¾". c. 1330–50. Walters Art Gallery, Baltimore

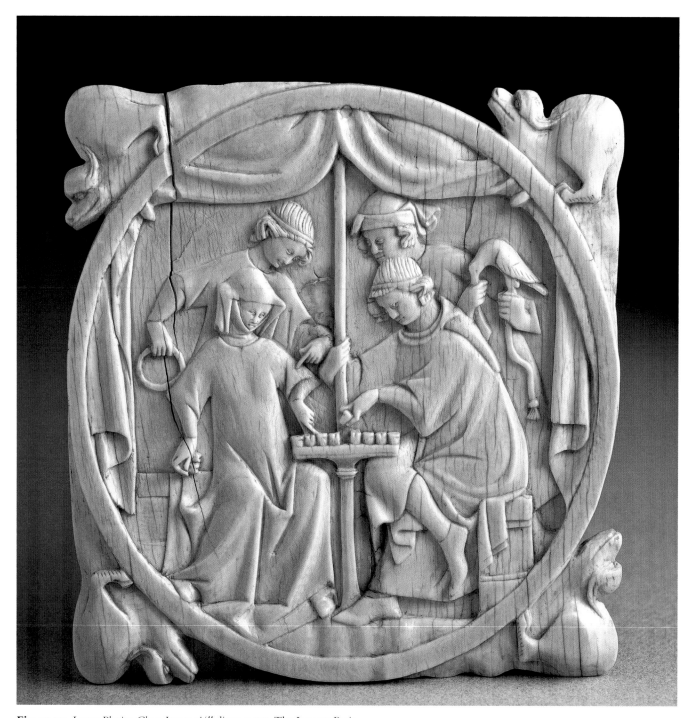

Fig. 17.22. *Lovers Playing Chess.* Ivory. 4½″ diam. c. 300. The Louvre, Paris

Tristan and Iseult, with the duped husband, King Mark, juxtaposed with an allegory of moral purity, the lady and the unicorn. Only a virgin could attract the rare white horse with the ivory horn, and, as such, she exemplified the virtue of chastity. The right end has scenes from the life of Sir Galahad, and the plaque on the rear illustrates stories from Chrétien de Troyes's *Perceval*, with Sir Gawain battling the lion and Sir Lancelot crossing the narrow bridge on his way to rescue Guinevere.

On the back of a mirror case, lovers play a game of chess, which was introduced to Europe through Islamic Spain (**fig. 17.22**). The contest of courtly love occurs within an enclosed tent. The woman wears a garment that produces a deep fold between her legs. She points suggestively to the chessboard with one hand, indicating her desire to continue play, while clutching a captured piece in the other. The man tightly grasps the central pole as he makes his next move, apparently "checking" his mate.[21]

LATE MEDIEVAL FRANCE

The Court or Rayonnant style of Paris soon became the standard mode for cathedral architecture in northern France. At Troyes, the Church of Saint Urbain (**figs. 17.23, 17.24**) provides us with an extreme version, sometimes characterized as a mannerist phase of the Rayonnant. Commissioned by Pope Urban IV (1261–64), a native of Troyes, and dedicated to his patron saint, the church has a simplified plan with three aisles, a square transept, and a polygonal apse. The triforium has been completely eliminated so that the interior rises in two stories with huge windows. The exterior displays brittleness in the sharp linear scaffolding. As at Sainte-Chapelle, the gables over the upper windows are detached and crown the walls on all sides with openwork tracery of delicate design. Thin wall buttresses rise to needlelike spires, and the whole has the crisp fragility of a metal trellis framing large openings.

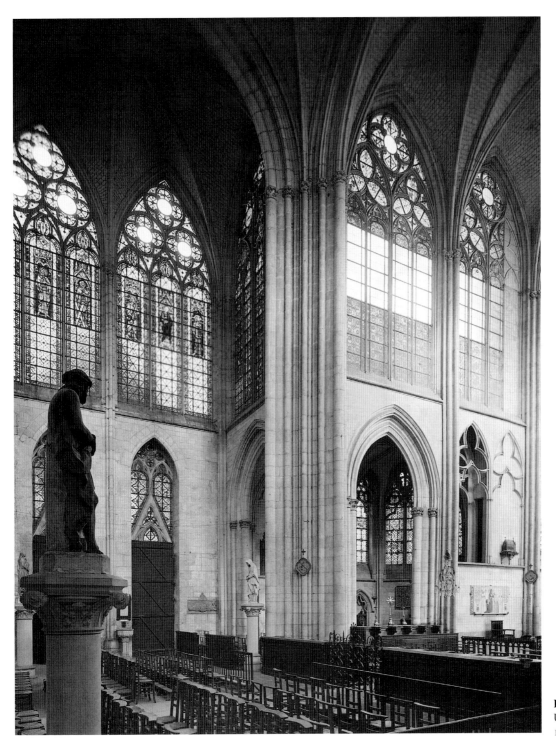

Fig. 17.23. Saint Urbain, Troyes. Interior. 1262–70

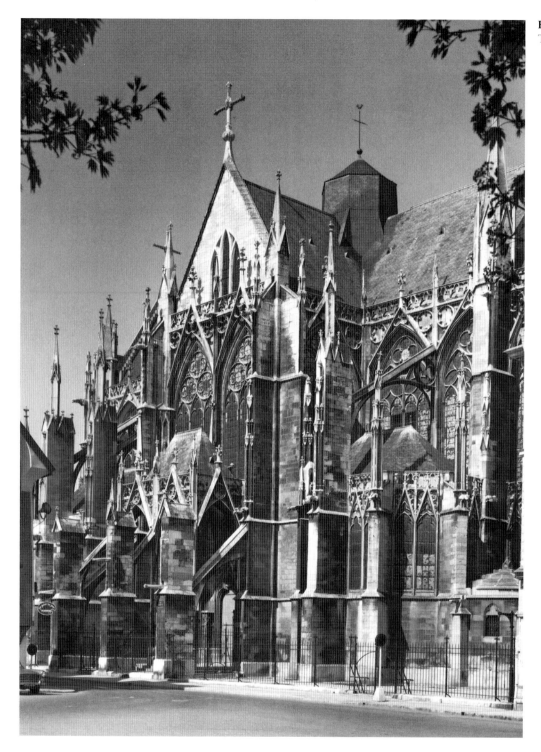

Fig. 17.24. Saint Urbain, Troyes. Exterior from the south

Throughout the late middle ages, tensions between the French monarchy and the papacy in Rome escalated. At the close of the thirteenth century, the French king Philip IV levied a tax on French clergy. In opposition to the policy, Pope Boniface VIII issues an ineffective bull, *Clericis laicos* (1296). Five years later, the pope sent a legate led by a French bishop, Bernard Saisset, demanding change. In response,

Philip arrested the bishop on charges of inciting rebellion and tried him in civil court rather than sending him back to Rome. Outraged, Boniface threatened to excommunicate the king. In retaliation, Philip seized Boniface at his papal palace in Anagni (near Rome) on 7 September, 1303. Although the humiliated pope was quickly released, he died soon after his capture.

Following the short pontificate of Benedict IX, Philip secured the election of Clement V, who promptly annulled Boniface's bulls against the French king. In 1309, Clement moved the papacy from Rome to the French city of Avignon (**fig. 17.25**), initiating the "Babylonian Captivity."

In 1377, Pope Gregory XI returned the papacy to Rome. However, this did not end hostilities between France and Rome. At Gregory's death a year later, cardinals elected an Italian, the archbishop of Bari, to serve as the next pope. However, French cardinals complained that they voted for Urban VI under coercion and distress. Consequently, the French elected an alternative pope, Clement VII, starting the Great Schism, which would last until 1417.

The papal palace at Avignon attracted numerous Italian artists, including the Sienese painter Simone Martini. Around the middle of the fourteenth century, an anonymous Italian

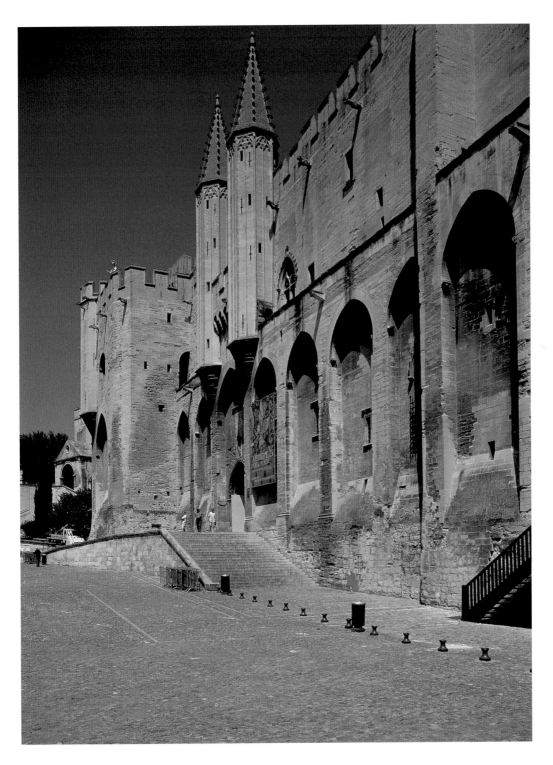

Fig. 17.25. Papal Palace, Avignon. 14th century, with later restorations

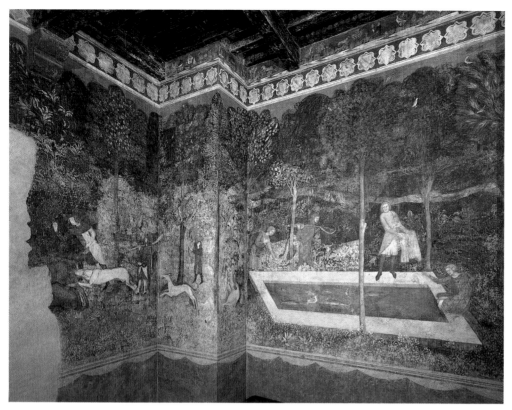

Fig. 17.26. *Fishing Scene.* Fresco in the Chambre du Cerf, Papal Palace, Avignon. 1343

Fig. 17.27. Opicino de Canistris. *Africa Whispering into the Ear of Europe.* Pen drawing on paper. 11 × 7¾".
c. 1340. Biblioteca Apostolica, Vatican, Rome

artist painted a fresco of fishing and hunting scenes for a room in one of the palace's towers, the Chambre du Cerf (**fig. 17.26**). The fresco represents recreational activities of the nobility in nature, secular themes often found in tapestries.[22]

Opicino de Canistris, a scribe from Pavia, produced a series of visually complicated allegorical maps for the papal court at Avignon. His anthropomorphic drawing of a masculine Africa whispering into the feminine ear of Europe (**fig. 17.27**) provides a highly imaginative interpretation of geography and the human body. In his eccentric map, erotic and violent fantasies intermingle. The Atlantic Ocean is transformed into an aggressive carnivore and the Mediterranean Sea takes the form of a vile demon, whose prodding fingers reach between Europe's thighs. Opicino's esoteric drawing also elicits moral and political implications, for sin and folly seem to permeate everything everywhere. Rather than evoking glorious visions of nature, his sophisticated imagery reveals the inescapable presence of the sinister and probably calls for spiritual change.[23]

18

GOTHIC STYLES
IN ENGLAND AND SPAIN

French Gothic styles affected art and architecture throughout Europe. England and Spain provide good cases in point. Artists and architects from England and Spain often appropriated French styles in their work, but did so in a manner that never forfeited local traditions. In some ways, this is not surprising. Even though both of these countries were at times politically at odds with France, they continued to maintain close ties.

Throughout the late Middle Ages, England faced problems at home and abroad. The Plantagenet dynasty, founded in the twelfth century by Henry II (1154–89) and Eleanor of Aquitaine, ruled England until the close of the fifteenth century. Even though the English monarchy was closely related to that in France, the two parties frequently feuded over the inheritance of lands. While Richard I (the Lionhearted) participated in the Third Crusade, his younger brother John (the villain of the Robin Hood legend) took over England without his brother's consent. Upon his return, Richard ended John's coup. Nonetheless, at Richard's death, John (1199–1216), nicknamed Lackland as well as Soft Sword, became king. His administration was a disaster. He lost Normandy to Philip II of France and also forfeited some of his regal authority when barons forced him to sign the Magna Carta (major charter), establishing the authority of English common law and limiting the power of the king by legal writ, in 1215. A year later, John died. His son, Henry III (1216–72) became England's monarch at the age of nine.

To subsidize his battles in Scotland, Wales, and France, as well as to pay for the construction of Westminster Abbey, Henry ignored the Magna Carta and increased taxes. Edward II (1272–1307) continued his father's foreign wars. Upon taking Wales, Edward presented his eldest son, the future Edward III, with the title of Prince of Wales, which is still given to first-born male heirs to the English crown. In response to heavy taxes, English nobles, with the intermittent support of wealthy commoners, established the Great Council, subsequently known as Parliament, further limiting the king's authority by mandating that taxes could only be levied with legislative consent.

Edward III (1327–77) defeated territories in Scotland and claimed the French throne through his mother Isabella, initiating the Hundred Years' War. Although the king won battles at Crecy (1346) and Calais (1347), the cost of these wars posed economic hardship. During his reign, Parliament divided into two representational bodies, the House of Lords and House of Commons. The reformer John Wyclif criticized Church abuse and organized a group of "poor preachers" called Lollards to spread his ideas across England. In the summer of 1348, the Black Plague devastated Edward's realm, killing nearly half its population. Richard II (1377–99) succeeded his grandfather. He also inherited economic and political difficulties from his predecessors. During his reign, Geoffrey Chaucer wrote the *Canterbury Tales*. While the king was away on a diplomatic mission in Ireland, the Lords Appellant, led by Henry Bolingbroke (son of John of Gaunt and Blanche of Lancaster) took control of England. Upon his return, Richard was arrested, and while incarcerated, was murdered. Henry of Bolingbroke was crowned Henry IV. Henry's coronation started a battle for succession known as the War of the Roses, between the Houses of Lancaster and York.[1]

ENGLISH GOTHIC ARCHITECTURE

New building techniques and concepts that developed in the Île-de-France had an immediate impact on architecture throughout Europe, and the variations that occurred in neighboring lands. Following the conquest of England in 1066, William the Conqueror's ecclesiastical administrator, Lanfranc, rebuilt the Cathedral of Canterbury (1070–89) in the Norman style. The choir was finished under succeeding priors, Ernulph (1096–1107) and Conrad (1108–26), and it was there that Thomas à Becket, archbishop of Canterbury, was murdered by knights of Henry II in 1170. Four years

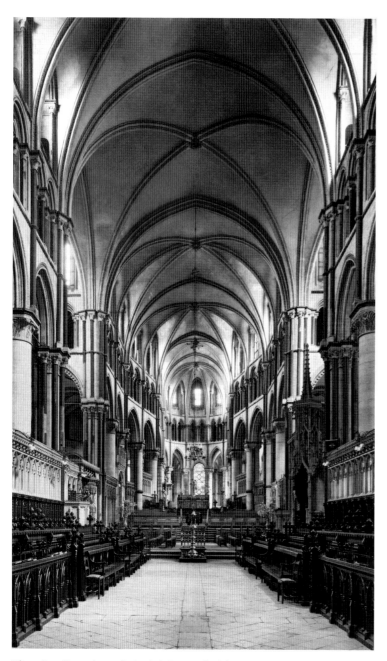

Fig. 18.1. Canterbury Cathedral. East end of the nave and choir. After 1174

later, in 1174, a fire that swept through the town destroyed the choir—Lanfranc's nave survived the conflagration—and plans were made immediately for the restoration of the hallowed area. A witness to these events was the monk Gervase of Canterbury (c. 1141–c. 1210), who leaves a remarkable description of the rebuilding.[2] Gervase tells us that an architect from France, William of Sens, was sent to England to supervise the project and that he erected the choir (**fig. 18.1**) in a new style. While overseeing the construction of the vaults, William of Sens fell from the scaffolding in 1178. His work was carried on by another William of English descent (the treatise ends in 1184). What is astonishing about the account is the clear perception that Gervase had of the differences between the earlier style, the Norman Romanesque, and the new, the French Gothic.

His descriptions of the new vaulting technique—*fornices arcuatae et clavatae* (vaults with ribs and keystones), the subtle carvings of the capitals, the tall, slender pier supports, and the fusion of elements (*convenire*) rather than the simple addition of parts—are quite revealing and indicate what the *opus francigenum* (French work) meant to the Englishman. The new choir, in fact, resembles that of the Early Gothic choir of Sens Cathedral, with a semicircular ambulatory with coupled columns in a tripartite elevation and the sexpartite vaults in the outer bays of the choir. Gervase also describes the use of dark brown-black Purbeck marble (from the island of that name) employed for the shafts and stringcourses as decorative accents to the light-hued stones of Normandy that were shipped in by William of Sens. The new vaulting techniques of French Gothic had an immediate impact on church building in England, but native tradition prevailed in the general layout of the plan and in the retention of solid mural construction.

Lincoln and Salisbury cathedrals are good examples of Early Gothic architecture in England. Their ground plans remain an emphatic cross form with double transepts. The long, narrow choir terminates in a square east end (compare Cistercian plans) and is frequently extended with a "Lady's Chapel." The fronts are broad, shallow screens, usually unrelated to the interior elevation, that mask the two towers of the facade proper. Small turrets frame the multi-tiered registers of this false front, and the comprehensive, encyclopedic programming of French cathedral sculptures is lacking.

In general, a sturdy basilical core is merely embellished with decorative Gothic details in the form of pointed arches, tracery, moldings, pinnacles, and friezes. The heavy walls eliminate the need for flying buttresses, and horizontality, not verticality, characterizes the building in general. The English

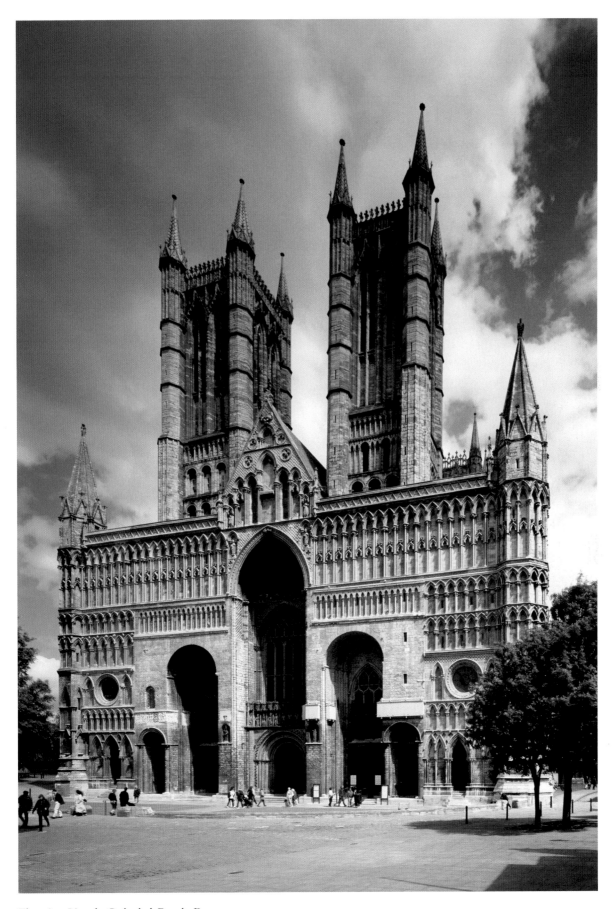

Fig. 18.2. Lincoln Cathedral. Facade. Begun 1192

House of God remains essentially a Romanesque building, earthbound and expansive.[3] Furthermore, the setting for the English Gothic church is generally that of the earlier monastic communities, on a hilltop or in a meadow apart from the city, often with a separate chapter house and an adjoining cloister enhancing its rural character.

Due to the confusing political history (and the devastations caused by the Black Death in the fourteenth century), many churches had extremely long periods of construction with successive builders, and hence few display a uniformity of style. The subdivisions of Gothic style are thus numerous. Four major phases can be noted here, and their names are derived from the nature of the decorative details and not the principles of construction, again indicative of the differences in the spirit of Gothic in England and France.[4]

The earliest phase is often called "Lancet" Gothic (c. 1200–1250), with reference to the type of windows penetrating the walls. The mature phase (c. 1250–1350) is "Decorated" Gothic, which is subdivided into (a) the "Geometric" style (1250–90), featuring elaborate decorative tracery of clearly

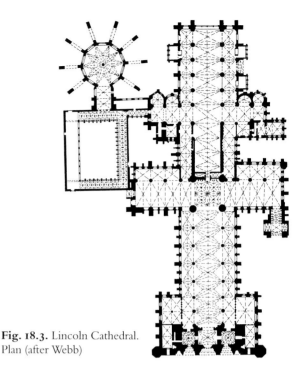

Fig. 18.3. Lincoln Cathedral. Plan (after Webb)

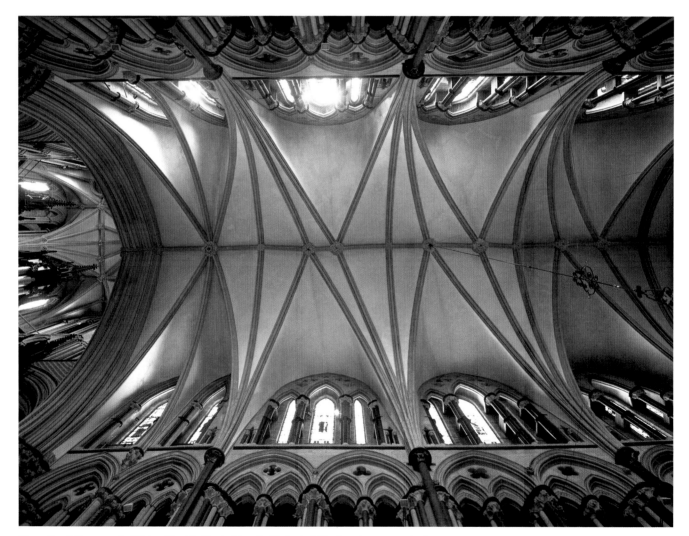

Fig. 18.4. "Crazy vaults." Saint Hugh's Choir, Lincoln Cathedral. Designed c. 1192; rebuilt 1239

delineated geometric shapes such as circles, trefoils, and quatrefoils; and (b) the "Curvilinear" (c. 1290–1350), where more flamboyant lines of intricate ogee arcs, undulating and intertwining tracery patterns, and curious new floral motifs predominate. The final phase (c. 1350–1550) is the "Perpendicular," a unique English contribution to Gothic architecture, featuring soaring walls of rectilinear design, often completely glazed, with thin vertical supports.

The English builders were masters in designing elaborate decorative ensembles in bar tracery that spread from the walls and windows into the vaults in a most colorful fashion. The Gothic style climaxes in spectacular star-and-fan vaults.

Following an earthquake and fire, the French-born archbishop Hugh of Avalon rebuilt the Romanesque Cathedral of Lincoln in 1192 (**figs. 18.2, 18.3**). The architect was Geoffrey de Noiers (Noyers?), presumably another Frenchman, and the inspiration for the sexpartite vaulting of the transepts has usually been accredited to Canterbury. However, Hugh's architect was a highly original artist, and the "crazy vaults" that he designed for the four bays between the two transepts (**fig. 18.4**) are not French in appearance or function.[5] A longitudinal rib in the summit, called a ridge rib, runs the length of the four bays, and for one of the first times the usual diagonal and transverse ribs of the sexpartite vault are replaced with what are called tiercerons. These are rib projections that extend from the side arches to some point along the ridge rib; they do not converge at a central point but split the bay into eight irregular segments of intricate shapes. The function of the rib vault is thus denied, and the result is one of pure decorative fancy. A contemporary account, the *Metrical Life of Saint Hugh* (c. 1225), compares the crazy vault to "a bird stretching out her broad wings to fly—planted on its firm columns, it soars to the clouds."[6]

Hugh's architect delighted in such unorthodox patterns in areas other than the vaults as well. He invented a new type of wall decoration in the transept arms and aisles of the choir known as syncopated arcading (**fig. 18.5**). Set flush against the wall are pointed arcades with light-colored limestone columns, and directly overlapping them is placed a series of trefoil arches carried by black Purbeck marble shafts. Thus he

Fig. 18.5. Lincoln Cathedral. Saint Hugh's Choir. Lower wall of the transept

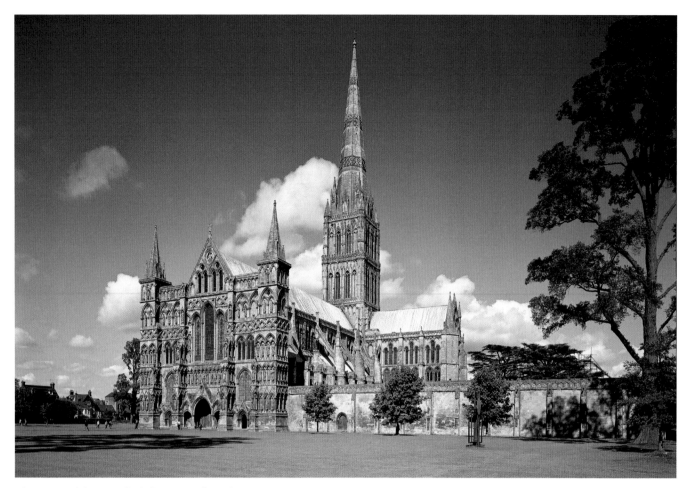

Fig. 18.6. Salisbury Cathedral. Exterior from the west. 1220–58; spire c. 1320–30

created a strange counterpoint in the lower walls analogous to the daring rhythm of the crazy vaults above. This pattern of decorative play of vaulting elements was continued in a less spectacular way by his successors in the construction of the nave and Galilee, about 1220–56, and to the old Norman towered facade was added a broad decorative screen front with tiers of arcading.

The Early Gothic Cathedral of Salisbury (**figs. 18.6, 18.7**), made famous in the nineteenth century by John Constable's romantic landscapes of its pastoral setting, displays an unusual unity. Salisbury was begun anew in 1220, having been relocated from its earlier site at Old Sarum to a valley of the Avon River a few miles south, and hence it was raised in one major campaign (1220–58) for the most part, with no earlier structures to restrict or compromise its construction. The architect of Salisbury, Master Nicholas of Ely, added uniform rectilinear parts one after the other along an axis in the simple additive fashion of a monastic church (**fig. 18.8**). There are double transepts as usual, and the long nave has a Gothic three-part elevation (a squat gallery appears in the triforium register) with a handsome nave arcade of columnar piers bounded by Purbeck marble shafts that support ribbed

Fig. 18.7. Salisbury Cathedral. Plan

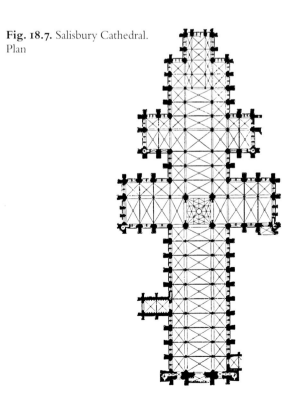

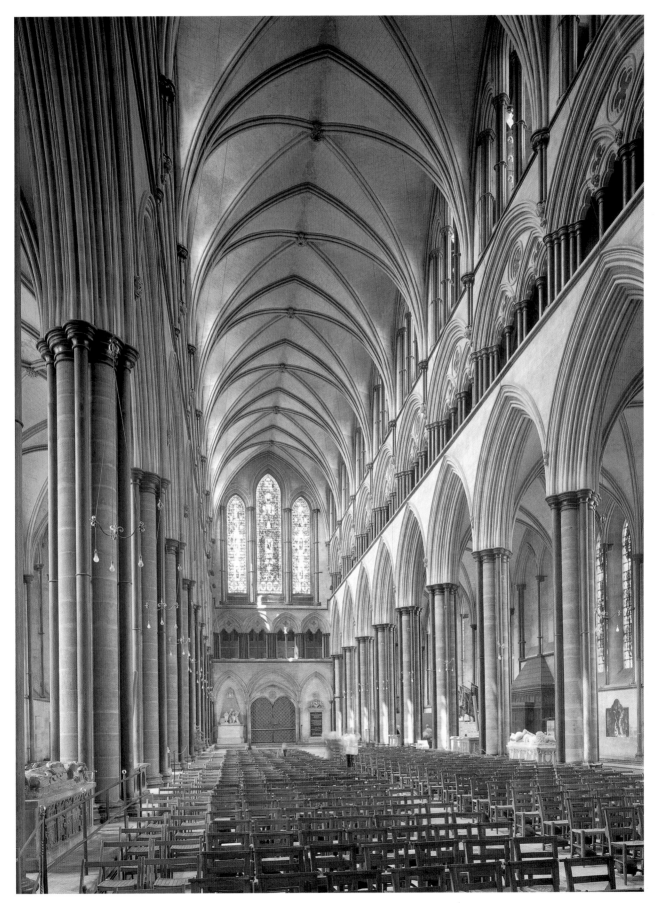

Fig. 18.8. Salisbury Cathedral. Interior of nave. 1220–58

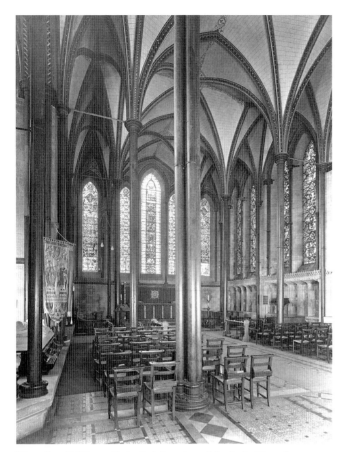

Fig. 18.9. Salisbury Cathedral. Interior of the Lady Chapel. c. 1220–25

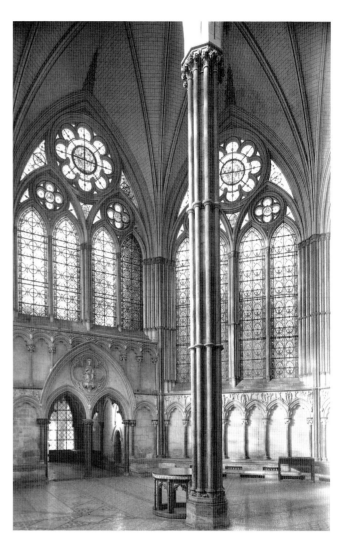

Fig. 18.10. Salisbury Cathedral. Interior of the chapter house. c. 1275–84

quadripartite vaults. The height is uniform throughout, and the decorative effects are much restrained compared to other English churches. This austerity may be due in part to later restorations and the loss of the original stained glass in many lancet windows.[7]

Master Nicholas commenced his project at the east with a typical Lady's Chapel that forms a miniature "hall church," with the side aisles reaching the same height as the nave (**fig. 18.9**). Here, however, there are no complex wall arcadings or tierceron vaults as at Lincoln. The tall lancet windows in the square box provide much light, and slender Purbeck marble shafts carry quadripartite vaults, allowing the space to flow freely from the chapel into the adjoining ambulatory. The west front is a narrow screen with tiers of arcades framed by small turrets and pierced in the center by three large lancet windows. A small porch with three doors projects from the center and gives access only to the nave. The chapter house (**fig. 18.10**), added to the eastern arm of the huge cloister, was built about 1275–84 in the later style of Gothic, the Decorated.

In 1245, Henry III sponsored an ambitious building program at Westminster Abbey in London (**figs. 18.11, 18.12**) to commemorate his favored saint, Edward the Confessor.

Henry had been impressed by the latest achievements in Paris, the Court style (Louis IX was his brother-in-law), and especially by Sainte-Chapelle. He called in a master mason, Henry de Reynes, to supervise the project.[8] The new church represents, in fact, something of a transitional monument between the earlier English Lancet Gothic and the later Decorated style.

The plan features a French chevet with polygonal apse, ambulatory, and radiating chapels. The transept and the nave retain the earlier basilical form. In elevation, Westminster Abbey looks like a French building of mid-century, although the clerestory is not as high and galleries are retained in the triforium. But the nave elevation is narrow and high (103 feet as compared to 74 feet at Lincoln) with thin walls that require flying buttresses to support the soaring vaults. The bar tracery and foliate capitals remind one of Reims Cathedral, and the huge rose windows filling the facades of the transept arms bring to mind the elegant transept portals of Paris and Saint Denis, although the double row of six lancet windows below them are still fundamentally punctures in the wall.

A combination of different kinds of vaulting appears in Westminster Abbey. Quadripartite vaults cover the central

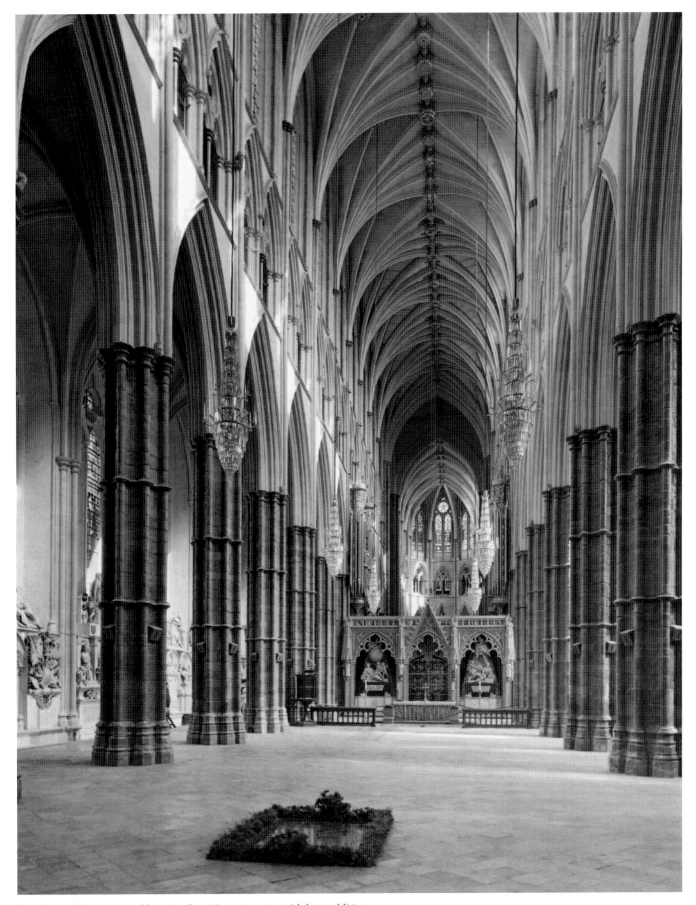

Fig. 18.11. Westminster Abbey, London. Nave. 1245–69, with later additions

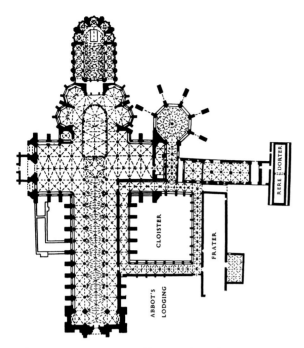

Fig. **18.12.** Westminster Abbey, London. Plan
(after Webb). Begun 1245

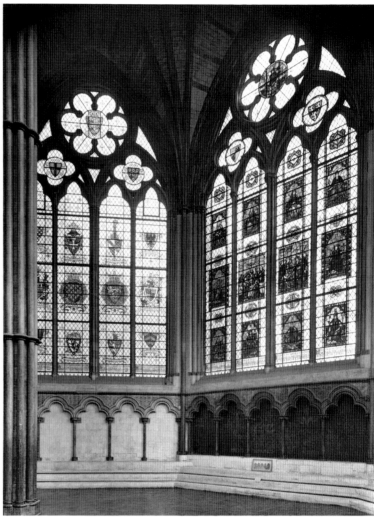

Fig. **18.13.** Westminster Abbey,
London. Chapter house. c. 1253

bays of the choir, the arms of the transept, and the side aisles
of the nave, while the nave proper, vaulted about 1260,
adapted the decorative scheme of vaulting employed in the
nave at Lincoln (tiercerons converging on a continuous ridge
rib), a concession to the English love for more linear,
ornamental surface decoration.

Abutting the south transept and the cloister is a splendid
octagonal chapter house (**fig. 18.13**), built around 1253, that
exploits the lightness of the Court style, recalling the upper
church at Sainte-Chapelle, with the opening of the walls to
windows of stained glass. As with the chapter house at
Salisbury, these later constructions at Westminster Abbey
introduce us to the beginnings of the Decorated style of
English Gothic.

An example of fully developed Decorated Gothic
appears at Exeter (**figs. 18.14, 18.15**), where the earlier Nor-
man church was rebuilt in 1275.[9] The two huge towers of the
early structure were kept and made into transepts, a nave and
facade added before them, the choir behind. The new facade
offers an ensemble of three overlapping and recessed spatial
surfaces. The broad screen with its galleries of sculptures

projects in front at the lowest level; a truncated gable with a
great window in bar tracery of the Decorated style rises
behind it; and, finally, the whole is capped by the triangular
roof line set back against the nave vaults. The stocky
westwork transepts substitute for the usual crossing tower
found in English Gothic churches.

Only sixty-nine feet high, the immense interior has a
strange, compelling horizontal pull like a vast funneled
armature projecting in space. The entire elevation is wrapped
in lines; nearly every wall surface is overwhelmed with
slender columns and ribs. The great diamond-shaped piers are
smothered under sixteen shafts that create a rippling effect
down the nave. From colorful foliate corbels in the arcade,
clusters of ribs, eleven in each bay, rise smoothly and
gracefully to the continuous ridge rib in the summit of the
vaults. So many are the ribbed lines, in fact, that one hardly
notices the webbing between them. Above an arcaded
triforium surmounted by a quatrefoil balustrade—features
that restore the horizontality of the elevation—rise huge
clerestory windows with tracery in the Decorated style. The
harmonious combination and overlay of stone—the

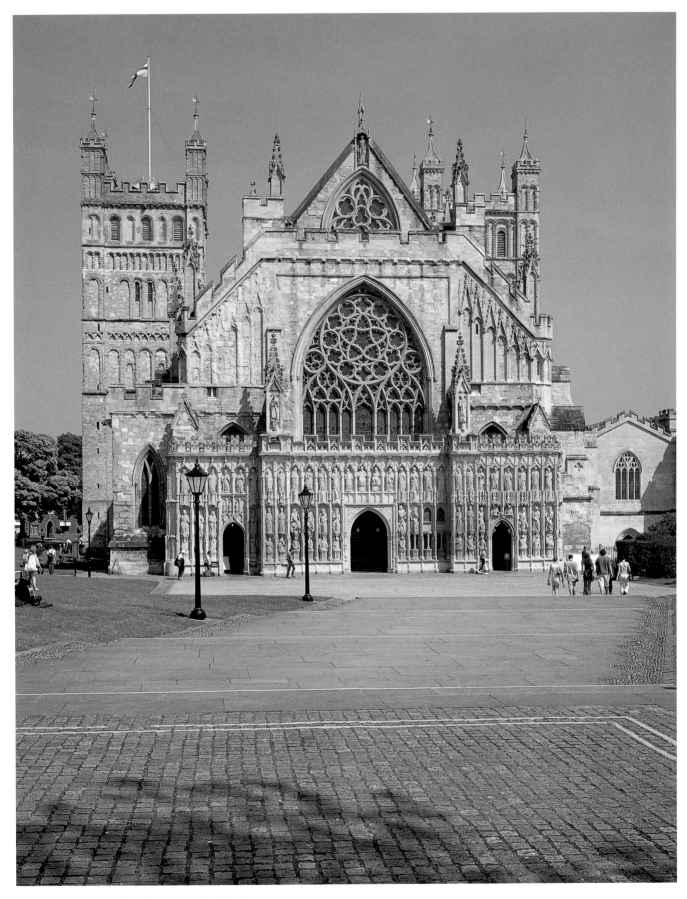

Fig. 18.14. Exeter Cathedral. West facade. Rebuilt 1275

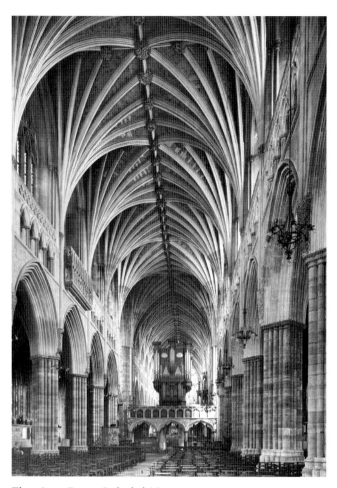

Fig. 18.15. Exeter Cathedral. Nave. c. 1275–1366

unpolished Purbeck marble shafts are gray, the arches are of yellow sandstone, and the upper walls in white stone from Caen—lend the spacious interior unusual warmth.

The Bishop's Throne (**fig. 18.16**), located in Exeter's choir, is extremely ornate. Made of carved wood, the throne contains numerous delicate pinnacles spiraling vertically. A tower serves as a canopy for the bishop's seat, but it seems to take on a life of its own. This highly decorated throne marks the authority of the bishop as it enriches the church's interior.

Wells Cathedral (otherwise known as Saint Andrew's) was built under the supervision of Bishops Reginald and Jocelin. In comparison to French Gothic churches, it has a small clerestory and thick walls. Length of nave takes precedence over height: The cathedral's nave is only sixty-four feet high. The church facade (**fig. 18.17**) functions as a screen for sculpture. Originally, 384 saintly figures standing or enthroned within solitary niches decorated the exterior. Today, only 297 of them survive. Nearly one hundred sculptures were lost in later acts of iconoclasm.

The church's interior is also decorated with figurative capitals. In one example, a tooth puller (**fig. 18.18**) emerges from foliage revealing his intense pain. His suffering is not

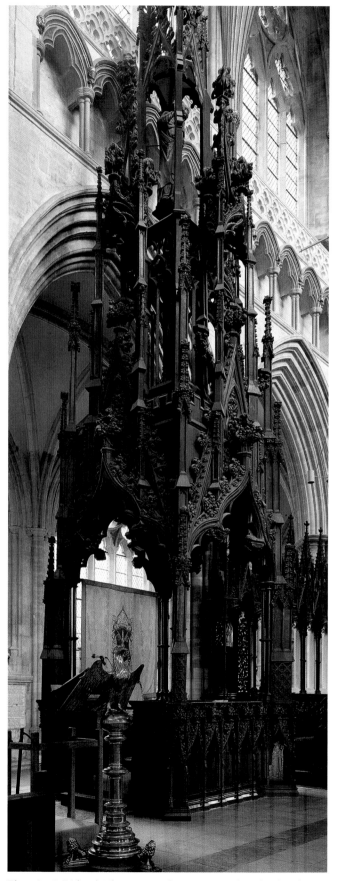

Fig. 18.16. Bishop's Throne. Wood. Approximately 60′ in height. 1312. Exeter Cathedral

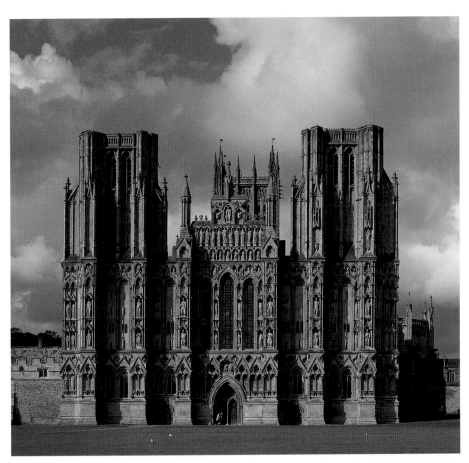

Fig. 18.17. Wells Cathedral. Facade.
c. 1220–40, with later additions

Fig. 18.18. *The Tooth Puller.* Capital from the south
transept of Wells Cathedral. c. 1220

Fig. 18.19. Wells Cathedral. Strainer or Scissor Arch,
Wells Cathedral. 1338

unique. In another capital, a figure pulls a thorn from his foot. The images may imply a justified punishment for vice. Sin and folly emitted by the mouth, for instance, may have found its reward in an aching tooth.[10]

A variety of experimentation in more monumental aspects of the interior, especially in crossing towers and vaults, mark the developments of the Decorated style. One of the most amazing innovations at Wells Cathedral is the addition of gigantic scissor or strainer arches built into the piers of the crossing tower (**fig. 18.19**). The tower, also in the Decorated style, began to show signs of failure in cracks along the foundations, and on three sides (the fourth abutted the chancel screen and was secure) massive stone arches, in the shape of scissors, were added for support. Similar inverted arch supports were added to the transept arms at Salisbury, but on a much smaller scale.

Fig. 18.20. William Hurley. Dome over the crossing, Ely Cathedral. 1328–47

Fig. 18.21. York Minster. West facade. Begun 1291; window 1338

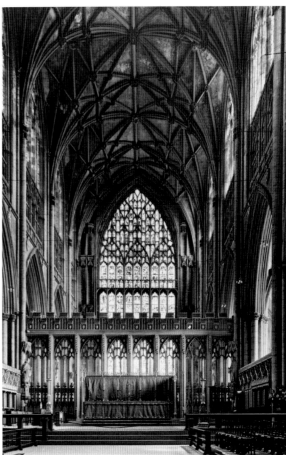

Fig. 18.22. York Minster. Nave. Begun 1291

The effect at Wells is spectacular, to say the least, creating a most surprising and dramatic spatial sensation in the very middle of the church. Even more daring is the "Gothic dome" added to the crossing of Ely Cathedral (**fig. 18.20**).[11] The earlier Norman tower fell in 1322, leaving an enormous hole in the middle of the church, and rather than vaulting the gap in stone—seventy-two feet across—it was covered with a lofty wooden lantern with a star dome. Resting on eight stone piers is an elaborate superstructure of tierceron vaults in wood that, in turn, support the octagonal drum of windows for the intricate dome above. An ingenious system of concealed cantilevers under the vaulting actually carries the drum. For this masterpiece in wood, the king's carpenter, William Hurley, was called in as consultant (1328–47). The dramatic spatial effect with light streaming through the drum windows and illuminating the star above is captivating and mysterious. The

vast hollows of space seem to float far above the nave and, much like the curious scissor arches in Wells, add to the mystery of the cathedral interior, creating at Ely a sensation of otherworldly light penetrating the darkened interior.

York Minster (**figs. 18.21, 18.22**) provides us with a sequence of styles ranging from the Romanesque to the Perpendicular.[12] The crypt is Norman; the transept arms were built in the Early Gothic style about 1220–41. The famous lancets in the north transept, known as the "Five Sisters," are some of the finest grisaille windows in England (**fig. 18.23**). The nave elevation, built around 1290, is modeled after French Gothic of the Rayonnant or Court style, with a merging of the clerestory and the triforium (the vaults are of wooden construction). The handsome two-towered facade has a huge window, the "Heart of Yorkshire," with exuberant tracery in the Curvilinear Decorated style (1338). Finally, the

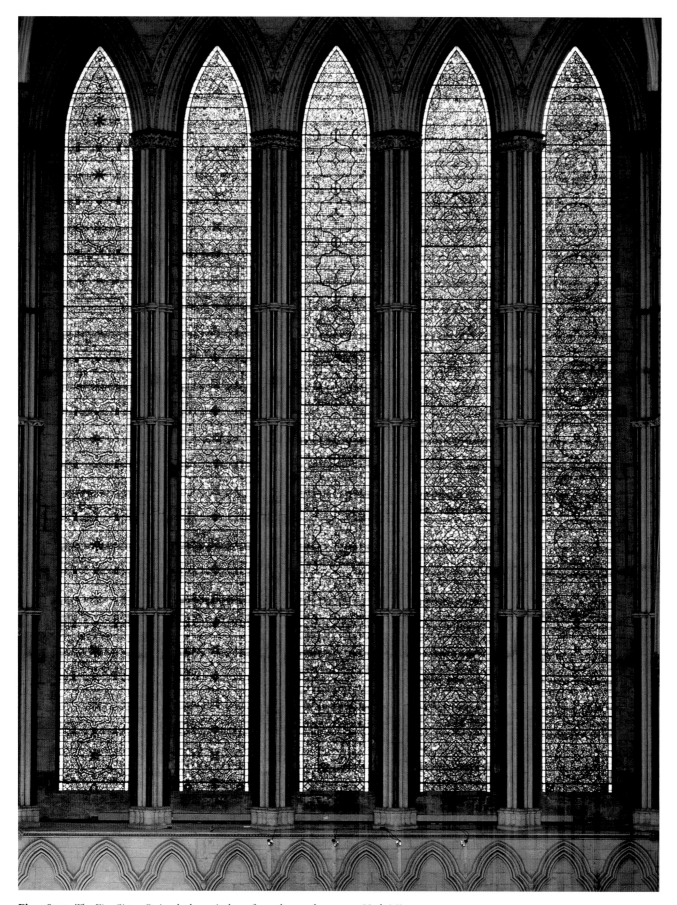

Fig. 18.23. *The Five Sisters.* Stained-glass windows from the north transept, York Minster. c. 1220–41

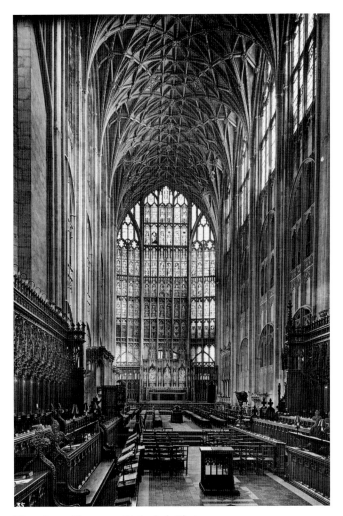

Fig. 18.24. Gloucester Cathedral. Choir. 1332–57

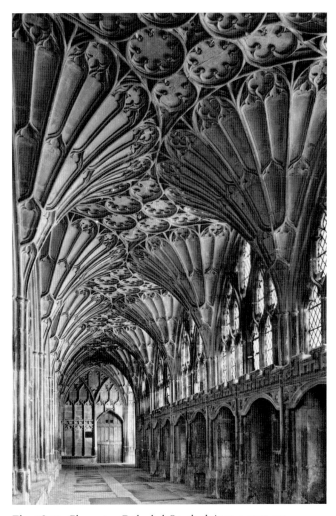

Fig. 18.25. Gloucester Cathedral. South cloister. c. 1370–77

magnificent eastern Lady's Chapel (the size of a tennis court), with its great open windows of rectilinear lines and delicate curvilinear bar tracery, dating about 1400–05, is representative of the Perpendicular style.

With the emergence of the Perpendicular style around 1350, English Gothic acquired a unique national expression. Developed directly from the Court and late Decorated style, the Perpendicular style is essentially a controlled rectilinear system of designing vast walls and windows with the repetition of cusped panels framed in huge grids of predominantly vertical lines in stone that soar from the ground to the vaults. So it appears in the huge east window of the choir at Gloucester (**fig. 18.24**).

The profuse curvilinear bar tracery in the windows grows into the vaults in two fashions. It can extend into the complex tierceron vaults of the Decorated style by multiplying the ribs in the form of countless liernes (short ribs that connect the tiercerons and ridge ribs), thus transforming the surface of the vault into an intricate spider's-web design of surface patterns. Or, it can be magically metamorphosed into "fan vaults" (see the cloister of Gloucester, c. 1370–77; **fig. 18.25**) with the multiplication of ribs rising from the walls in great open arcs, diverging in all directions, that are connected by tracery patterns and contained within a sweeping circular ridge rib that gives them the appearance of giant fans opening above us.

Basically, the fan vault is a false construction of concave semi-cones sheathing the ceiling to which bar tracery is applied with no structural role. The breathtaking intricacy of the fan vault could be more easily applied to lower, narrower passages, such as cloisters, but in the fully developed Perpendicular, such as at King's College Chapel in Cambridge, 1446–1515 (**fig. 18.26**), the builders had the daring to apply such elaborate fabrications to the vast expanse of the nave.[13]

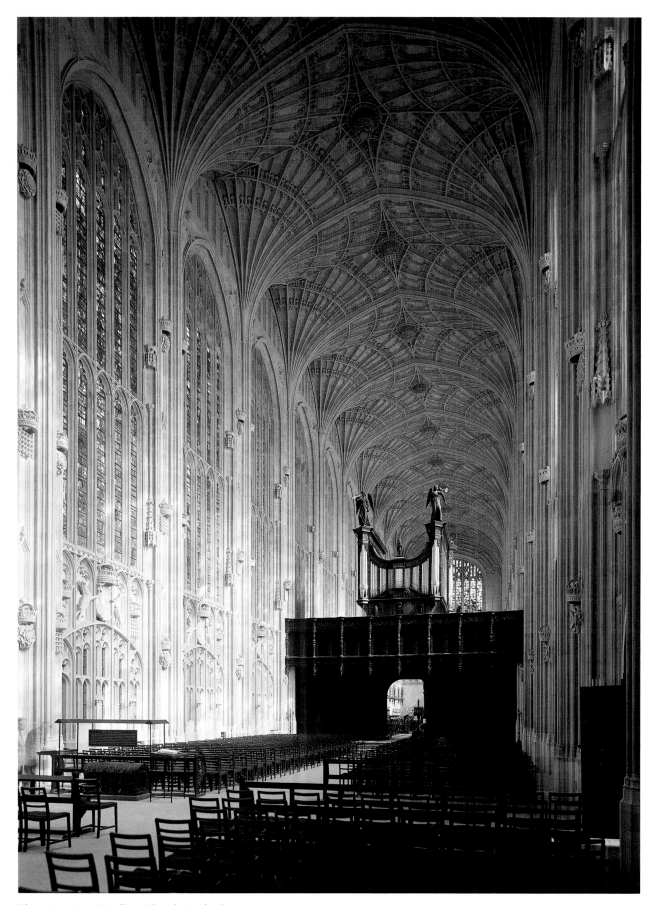

Fig. 18.26. King's College Chapel, Cambridge. Interior. 1446–1515

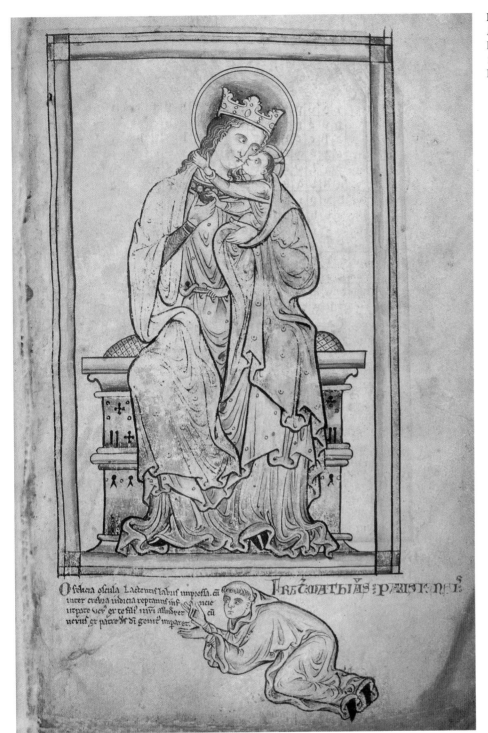

Fig. 18.27. Matthew Paris. *Self-portrait Kneeling before the Virgin and Child.* Illumination in the Historia Anglorum. 14 × 9¾″. 1250–59. British Library, London (Royal MS 14.C.VII, fol. 6r)

ENGLISH MANUSCRIPTS

Matthew Paris, a monk and chronicler from the Abbey of Saint Albans, likely produced a tinted drawing of the enthroned Virgin and Child (**fig. 18.27**) in the preface of his *Historia Anglorum*. In Matthew's portrait below, he is prostrate and rendered in smaller scale, indicating his personal piety. Although separated by a pictorial frame, he appears spiritually intimate with the Virgin and Child.[14]

One of his contemporaries, William de Brailes, an illuminator from Oxford, also represented himself within his work. He portrays himself at the Last Judgment (**fig. 18.28**) salvaged from the hell mouth by a sword-carrying angel. An inscription positioned around his neck reads, "W. de Brailes made me," suggesting perhaps that this work was performed in response to his salvation.[15]

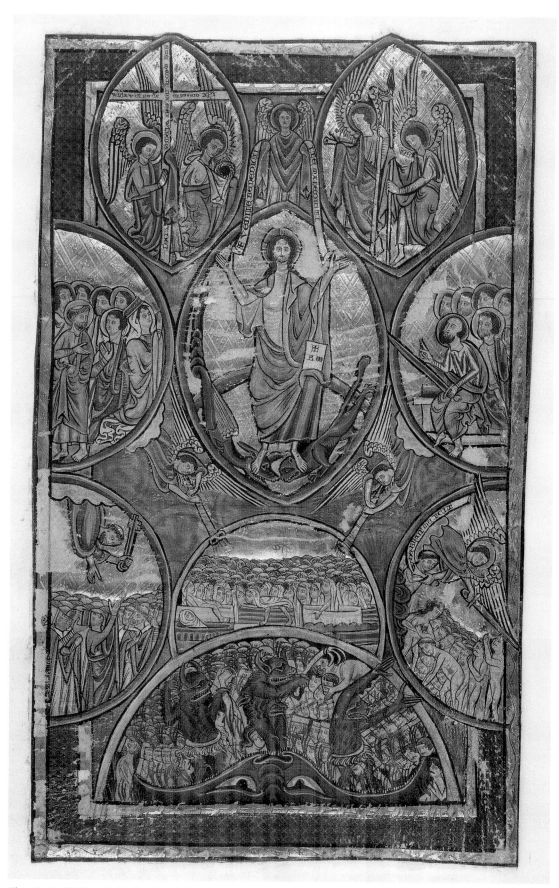

Fig. 18.28. William de Brailes. *Last Judgment.* 10½ × 6⅞″. c. 1230–40. Fitzwilliam Museum, Cambridge (Psalter MS 330, fol. 3)

Fig. 18.29. *Men Defending a Castle from Hares.* Detail from the lower border of Raynaud de Bar's *The Metz Pontifical.* 1302–16. Fitzwilliam Museum, Cambridge (MS 298, fol. 41r)

Fig. 18.30. Jeanne de Montbastón. *Nun Leading a Monk by his Penis.* Detail from the lower border of Guillaume de Lorris and Jean de Meung's *The Romance of the Rose.* 1345. Bibliothèque Nationale, Paris (MS fr. 2446 fol. 106r)

The marginalia of Late Medieval illuminated manuscripts are sometimes decorated with humorous scenes, such as men defending a castle from attacking hares (**fig. 18.29**). In these scenes the world is turned upside-down to reveal the dangers of reversing traditional roles. Humor is employed to affirm the status quo.[16]

A female illuminator, Jeanne de Montbastón, produced images for a copy of *The Romance of the Rose*. In scenes below prose describing an old woman's intercession concerning the meaning of love, a nun leads a monk by his penis and then he is shown climbing a ladder into her castle (**fig. 18.30**). The anticlerical message cannot be missed. Unable to maintain the vow of chastity, the monk is chained by the instrument of his lust. In late medieval France, male adulterers were sometimes humiliated in public by having a rope tied around their exposed genitals. The monk's ladder has five steps, indicating stages of romance, culminating in consummation. Other marginal scenes include a nun plucking "fruit" from a tree

Fig. 18.31. *Blessed be the Man.* Illustration from Windmill Psalter. 12¾ × 8¾". c. 1270–80.
Pierpont Morgan Library, New York (M.102, fol. 1v and fol. 2r)

covered with penises, and a nun and a monk engaged in sexual intercourse. Although such images may surprise twenty-first century viewers, they playfully reinforce the medieval ideals of courtly love and monastic celibacy by poking fun at failures to live up to expected standards of behavior.[17]

The Windmill Psalter offers an alternative illumination, focusing on wisdom and virtue rather than folly and vice. The first Psalm (**fig. 18.31**) is introduced by an historiated initial B decorated with interlocking branches of the Tree of

Jesse. The facing page opens with the letter e (the next letter in the word Beatus or Blessed) and includes text completing the first three verses of Psalm 1. In the upper register, Solomon administers justice in a maturity case (I Kings 4:16–28). His wisdom echoes that of the blessed man of the first Psalm, who does not walk in the consul of the ungodly but delights in God's law, upon which he meditates day and night (Ps. 1:1–2). The windmill located above the scene gives the manuscript its title and alludes to the fourth verse comparing the wicked to chaff blown by the wind.[18]

Fig. 18.32. *Scenes from the Life of the Virgin.* Back of the Chichester-Constable Chasuble. Red velvet embroidered with silk, metal thread, and seed pearls. Length 5′ 6″, width 2′ 6″. c. 1330. Metropolitan Museum of Art, New York

Fig. 18.33. The Syon Cope. Embroidered in colored silks and silver-gilt threads. Early 14th century. Victoria and Albert Museum, London

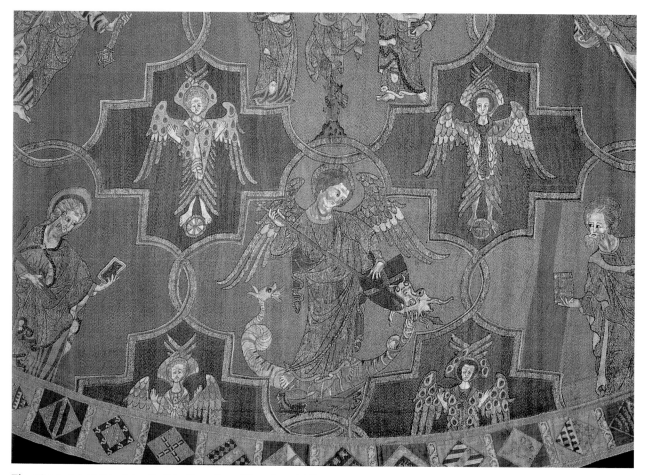

Fig. 18.34. *Saint Michael*, detail of the Syon Cope. Victoria and Albert Museum, London. Detail of Fig. 18.33

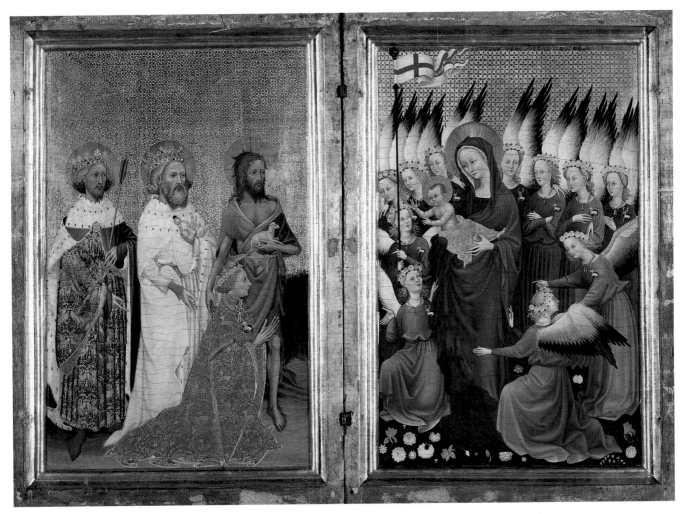

Fig. 18.35. *The Wilton Diptych.* Tempera and gold on panel. c. 1395–99. 18¾″ × 11½″.
National Gallery, London

ENGLISH LITURGICAL ART

Throughout late medieval Europe, England was renowned for its exquisite embroideries. The Chichester–Constable Chasuble (**fig. 18.32**), a sleeveless liturgical vestment worn by priests during celebration of the Mass, is over five feet long. The back of the garment represents three major events in the life of the Virgin: the Annunciation, the Adoration of the Magi, and the Coronation. Tiny pearls are sewn into the vestment, suggesting acorns tangling from oak leaves on interlocking branches, symmetrically spiraling up the garment. The Syon Cope (**figs. 18.33, 18.34**) served as a bishop's cape and is another fine example of *opus anglicanum* (English work). Produced by English workshops in gold and silk thread, the vestment is very elaborate and includes holy figures rendered in meticulous detail. Even their faces appear modeled.[19]

Richard II commissioned a two-paneled devotional painting that is today known as the Wilton Diptych (**fig. 18.35**), after a later collector. On the inner left panel, two saintly kings of England, Saint Edmund and Saint Edward the Confessor, and Saint John the Baptist introduce the kneeling Richard to the Virgin and Child depicted on the adjacent panel. The left panel shows a barren landscape. By contrast, the right panel presents the Virgin and Child surrounded by angels within a lush garden covered with flowers. Sacred and regal devotion are inseparably fused.

White harts, the king's personal badge, appear on the angel's blue garments as well as on Richard's golden robe. In addition, the angels and king wear necklaces of seedpods (*plant á genet*), emblematic of the Plantagenet dynasty.[20]

SPANISH GOTHIC ARCHITECTURE

During the Late Middle Ages, the Reconquista was still being fought. Christian kingdoms in northern Spain continued to wage war against Muslim territories. King Fernando III of Castile defeated the Moors at Las Navas de Tolosa. The Castilian monarch was also a cousin of Louis IX of France and he donated funds for a new cathedral in the Gothic style at Burgos. Fernando's successors continued the practice, sponsoring Gothic constructions in León and Toledo. To the east, Jaume I of Aragon defeated Muslim forces at Mallorca (1229) and Valencia (1238). His successors supported the building of Gothic churches in the thriving mercantile port on the Mediterranean, Barcelona.

In 1298, the architect Jaume Fabré of Mallorca started construction on the Cathedral of Barcelona (**fig. 18.36**), which is known as Santa Eulàlia after a local saint. The wide church has side aisles nearly the same height as its nave, making the triforium and clerestory quite small. The side aisles are lined with intimate compartmentalized chapels, pushing windows on the lower exterior even farther from the nave. Consequently, unlike French Gothic churches, the interior of Santa Eulàlia is quite dark. With the later addition of large *retablos* (altarpieces), illumination today is even more reduced. Thirteen geese reside in the cathedral's cloister, representing the thirteen geese who witnessed Santa Eulàlia's martyrdom.

Fig. 18.36. Santa Eulàlia, Barcelona. Begun 1298

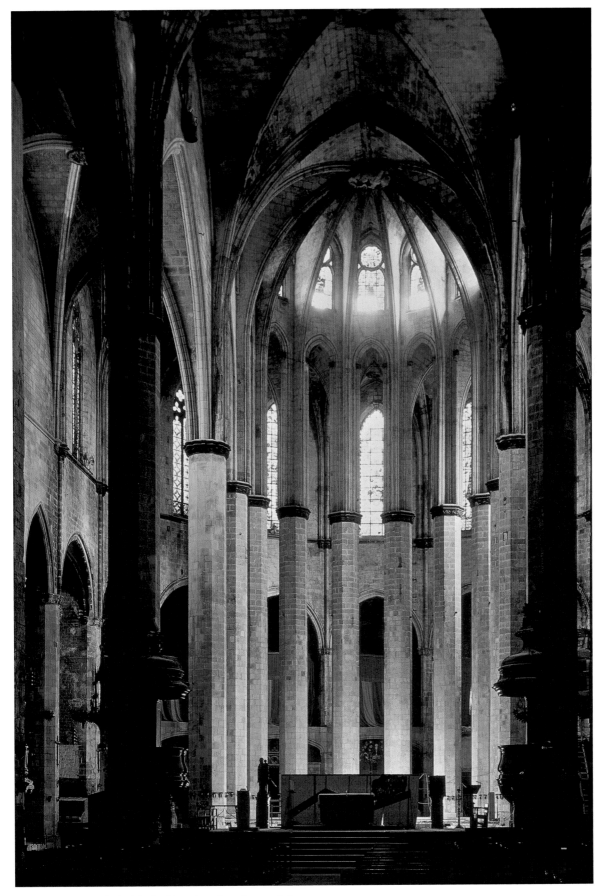

Fig. 18.37. Santa María del Mar, Barcelona. Interior. 1328–83

Another Gothic church, Santa María del Mar (**fig. 18.37**), was built within a few minutes walk of the cathedral. Stripped bare of much of its imagery by early twentieth-century anarchists, Santa María del Mar offers an excellent vision of a Gothic structure. Although the church is in many ways an imitation of Barcelona's cathedral, it departs from its model in significant ways. Santa María does not have a triforium. The elimination of the triforium allowed for a larger clerestory, bringing more light into the church. In addition, slender octagonal piers accentuate the sense of spaciousness, diminishing the division between nave and side aisles.[21]

Fig. 18.38. *Alfonso the Wise Dedicating Songs to the Virgin.* Illumination in the *Cantigas de Santa María.* 13 × 9″. c. 1250–75. El Escorial, Real Biblioteca de San Lorenzo, Madrid (Cantigas 9, fol. 4v)

SPANISH MANUSCRIPTS AND MAPS

Alfonso X of Castile and León, nicknamed the Wise for his accomplishments in music and poetry, compiled hundreds of songs dedicated to the Virgin Mary. In the frontispiece of his *Cantigas de Santa María* (**fig. 18.38**), Alfonso recites one of his songs before an appreciative courtly audience.

His songbook includes numerous illustrations showing miraculous powers associated with her life as well as her visual representations. One of the pages depicts the legend of Our Lady of Sardanay (**fig. 18.39**). In the upper left, a pious nun from Damascus asks a monk to purchase an image of the Madonna and Child for her on his journey to Jerusalem.

After completing his pilgrimage to the Holy Sepulcher, the monk obtains the requested devotional panel from a local shop. In the fourth scene, however, the monk discovers the painting's miraculous power, for he is protected against a lion and thieves on his return trip. Recognizing its value, the monk decides to keep it by donating it to his own confraternity. But his efforts are halted by a storm at sea, forcing him back to shore. Surmising that the tempest was caused by divine intervention, the monk gives the image to its rightful owner. In the final scene, the nun and monk jointly put the miraculous painting above a church altar, placing it at a site appropriate for veneration.[22]

Fig. 18.39. *Miracles of Our Lady of Sardanay.* Illumination in the *Cantigas de Santa María* (fol. 17r)

Fig. 18.40. *Map of Asia*, Atlas Catalan. c. 1375. Bibliothèque Nationale, Paris

In the late fourteenth century, Barcelona was highly regarded as a center of mapmaking. The Atlas Catalan (**fig. 18.40**), likely produced by a Jewish cartographer from Mallorca named Cresque Abraham, is a traditional *mappa mundi*, with Jerusalem in its center. The twelve-paneled map unfolds like a screen, providing information about various locations, including their geographical placement as well as their historical and mythological significance. The atlas also delineates portolan charts or sailing directions. In 1381, Pere IV of Aragon gave the work to an envoy of Charles V of France. Although the map indicates navigational directions, it was not intended for daily use. On the contrary, the atlas served as a luxurious collector's item housed in a royal library. The section of the map displayed here represents Southeast Asia and China. Although the accuracy of the map wanes as one leaves the Mediterranean basin, it is one of the first maps to indicate the international travels of Marco Polo.[23]

19
LATE MEDIEVAL ITALY AND URBAN MONASTICISM

In the Late Middle Ages, the Italian peninsula was divided into numerous city-states. Some, such as Florence and Siena, were republics governed by civic councils, whereas others were led by secular rulers (such as kings and dukes) or fell under the jurisdiction of the pope. Within this setting, urban monasticism flourished. Two new religious orders were established in the early thirteenth century: the Franciscans and the Dominicans. They are known as mendicant orders, because their members beg for alms rather than rely on funding from their own order. Instead of retreating into cloisters far removed from the hustle and bustle of city life, Franciscans and Dominicans worked within cities, preaching sermons and advocating charity. Although the two orders shared much in common, they were often rivals and frequently established monasteries on opposite sides of communities.

Due in large part to the charisma of its founder, the Franciscan order become quite prominent soon after it was established. Saint Francis (c. 1181-1226) was born in Assisi to wealthy parents. At the age of twenty-one, Francis had an intense religious experience that radically changed his life. According to his biographer, Thomas of Celano, Francis entered a small church in ruins, San Damiano near Assisi, and prayed. While contemplating a painted Crucifix on the altar, "a thing unheard-of happened:" the painted image called out to him by name and asked Francis to repair his house, and "from that moment on, compassion for the crucified Christ was fixed in his soul." Francis abandoned his opulent life-style as a rich courtier for one of extreme poverty. He dedicated himself to the imitation of the humble and charitable ways of life that Christ had advocated.

Francis gathered twelve disciples and began preaching in the countryside. His message was simple and direct. Read the Gospels and dedicate your life to fellowship and love of all of God's creatures. Saint Francis experienced astonishing visions. In 1224, while in prayer on Mount Alvera, a mountain retreat bequeathed to his newly founded order of the Friars Minor (*Frates Minore*, approved by Pope Innocent III in 1210), Francis had a vision of the crucified Christ, and shortly thereafter his body was marked by the stigmata of Christ—the wounds in his side, feet, and hands. After he had received the stigmata, some of his followers began to call Francis a second Christ (*alter Christus*). Francis died two years later and the Church quickly canonized him Saint Francis in 1228.[1]

Saint Francis was the most inspiring force in Italian art and literature during the thirteenth century.[2] Bonaventura Berlinghieri produced the earliest known representation of the saint (**fig. 19.1**), completed less than a decade after Francis's death. The painted panel served as an altarpiece in the church of San Francesco in Pescia. Similar to a Byzantine vita icon, the painting shows the saint in a frontal pose surrounded by events from his life. The elongated saint exposes his wounds, while three knots in the rope of his robe signify three vows characteristic of his order: poverty, chastity, and obedience. A narrative scene of his stigmatization can also be seen on the upper left.

Large painted crosses often hung above choir screens and altars in Late Medieval Tuscan churches.[3] A fine example of the early Crucifixion types is that known by scholars as Pisa No. 15 (**fig. 19.2**). The cross is huge (over nine feet high and over seven feet wide), and the life-size corpus of Christ, posed

Fig. 19.1. Bonaventura Berlinghieri. *Altarpiece of Saint Francis*. Tempera and gold on panel. 60 × 45¾″. 1235. Pescia, San Francesco

Fig. 19.2. School of Pisa. *Crucifix No. 15.* Tempera and gold on panel. 9′ 3″ × 7′ 9¾″. Late 12th century. Pinacoteca, Pisa

in a strictly frontal position with eyes open, fills the cross. Only a slight tilt of the head animates the flat body; anatomical details are reduced to linear arcs. At the four extremities of the cross are projecting boxes with episodes from the Life of Christ. This type of historiated cross is known as a *Christus triumphans* (Triumphant Christ) since the bold presentation of the live Savior reduces any emotional or humanizing effects. He stands before us and regards us directly, announcing that his crucifixion is a matter of doctrine, a symbol of salvation.

Numerous panels of the *Christus triumphans* are found in Lucca and Florence as well. However, a second kind of historiated cross, known as the *Christus patiens*, or "suffering Christ" (**fig. 19.3**), gained popularity in the later half of the

thirteenth century. In these works, a pronounced sway to the body is introduced. The hips swell outward and the legs taper downward and slightly overlap. The head falls to the shoulder, and the eyes are closed in death, with bold shading lines about the sockets. According to hagiographic sources, the crucifix the young Saint Francis was contemplating when he had his vision in the Church of Saint Damiano near Assisi was of this type (fig. 19.30).

The Crucifix has been attributed to Coppo di Marcovaldo, a Florentine painter active in the 1260s and 1270s. He is also sometimes credited with designing the ceiling mosaic for the interior of Florence's Baptistery. Among other works attributed to Coppo are monumental images of the Virgin

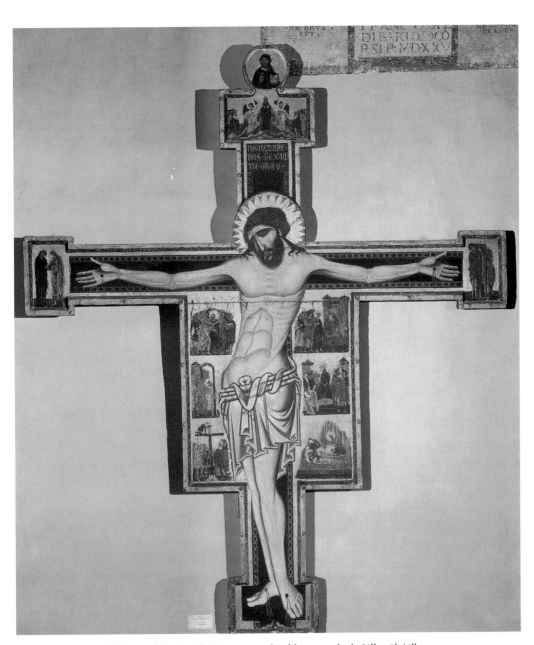

Fig. 19.3. Coppo di Marcovaldo. *Crucifix*. Tempera and gold on panel. 9′ 7⅜″ × 8′1¼″. Second half of the 13th century. Pinacoteca, San Gimignano

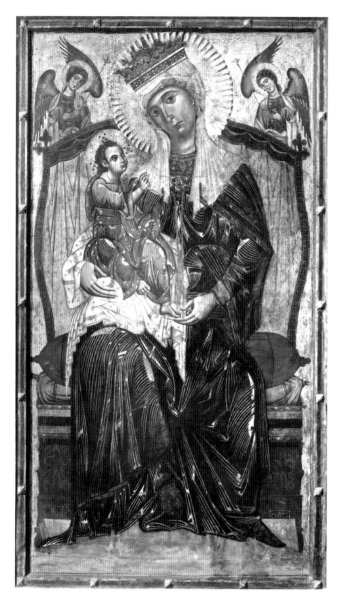

Fig. 19.4. Coppo di Marcovaldo. *Madonna and Child.* Tempera and gold on panel. 7′ 9¾″ × 4′ 5⅛″. c. 1265. San Martino ai Servi, Orvieto

and Child that served as altarpieces for churches in Siena and Orvieto. His style is easily recognized as Italo-Byzantine. The Madonna and Child in the Church of San Martino ai Servi in Orvieto (**fig. 19.4**) resembles Late Byzantine icons of the Virgin, with the Queen of Heaven seated in a frontal position on an elaborate throne holding her infant rigidly on her right knee. Behind the lyre-backed throne, against a gold background, two diminutive angels serve as the Virgin's attendants. Byzantine conventions for the facial features and the draperies are followed, but a few peculiarly Italian elements can be noted. The golden striations in the Virgin's mantle are bold and crisp; the almond eyes, elongated nose, and pinched mouth are strained and slightly modeled, adding a more impassioned expression to her countenance.[4]

PRIMI LUMI

Giotto di Bondone (c. 1277–1337) has often received special praise for being the first to abandon the conventions and stylizations of medieval traditions, paving the way for the naturalism of Renaissance painting.[5] In the eleventh canto of his *Purgatorio*, the poet Dante called attention to his celebrity:

> In painting Cimabue thought he held
> the field, and now it's Giotto they acclaim—
> the former only keeps a shadowed fame.[6]

Boccaccio, the author of the *Decameron*, also held Giotto in high regard, announcing that he was the "one who brought light back to art."[7] And the late fourteenth-century theorist Cennino Cennini even suggested that Giotto had translated the language of art from Greek into Latin.

Perhaps, the greatest praise, however, came from Michelangelo's famed pupil, Giorgio Vasari, who referred to Giotto and his teacher Cimabue as *primi lumi* (first lights), who took art out of the Dark Ages of the Middle Ages. Giotto, he claimed, was able to break free of the "crude manner of the Greeks [Byzantine artists]" and follow nature alone.[8] Yet it would be wrong to isolate Giotto from the later Middle Ages. In many respects the naturalism of his paintings echoes the sentiments expressed by Saint Francis of Assisi, who made religion a simple, everyday experience that was more emotionally appealing to common folk.

According to Vasari, Cimabue (active c. 1272–1302) taught Giotto the art of painting. Around 1280, Cimabue painted a large altarpiece of the Enthroned Madonna and Child for Santa Trinità in Florence (**fig. 19.5**). The huge panel (over eleven feet high and over seven feet wide) has a hieratic composition and follows Italo-Byzantine conventions in the depiction of draperies and head types. The elaborate throne seems to project into space and not merely float against the gold background, and the angels overlap each other and appear to be standing on a sharply inclined plane. Furthermore, they turn out and smile gently as if inviting the spectator to join them in their adoration of the Virgin and Child.

Around thirty years later, his pupil Giotto produced an astonishing *Enthroned Madonna and Child* (**fig. 19.6**) for the Florentine Church of the Ognissanti (All Saints). Rudiments of Italo-Byzantine conventions are still present, but a new sense of space has been achieved. A delicate throne with pointed arches and pinnacles replaces the earlier spooled types, and Giotto fashions the space in which the Madonna is placed as a deep box, the projecting arms, podium, and vaulted canopy forming an ample architectural setting for the weighty figures. The three-dimensional qualities of the figures are powerfully stated, so much so that the connoisseur Bernard Berenson famously characterized Giotto's style in general as being "tactile," that is, evoking the qualities of objects we wish to touch as large rounded volumes, as if they were sculptures and no longer flat patterns.[9]

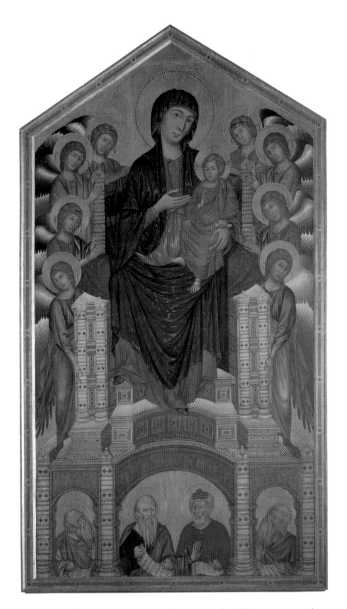

Fig. 19.5. Cimabue. *Enthroned Madonna and Child*. Tempera and gold on panel. 11′ 7″ × 7′ 4″. c. 1280. Uffizi, Florence

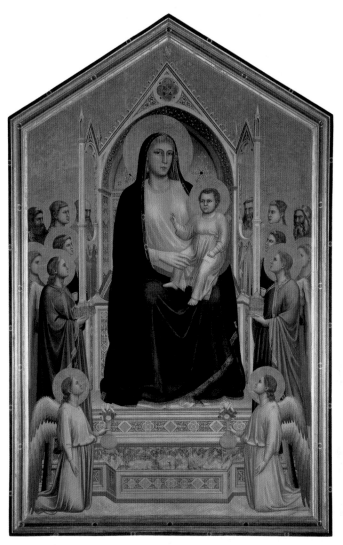

Fig. 19.6. Giotto. *Madonna and Child Enthroned*. Tempera and gold on panel. 10′ × 6′ 7″. c.1310. Uffizi, Florence

Mary is a massive figure described by a simple shape, heavily shaded on the sides and along the drapery folds to give her form rotundity and bulk. The angels gathered about the throne also have a pronounced weightiness with their heavy draperies marking out volumetric forms resembling fluted pillars placed one behind the other. Gone are the gold lines that are usually shot through the costumes and the crisp linear patterns for the draperies. Giotto has dramatically altered facial expressions, especially those of the adoring angels. They casually turn and regard the Mother and Child with a heightened intensity that conveys the sense of communal participation without losing their individuality. Religious sentiments are evoked with greater warmth and intimacy than seen in the work of Cimabue.

The most impressive cycle of frescoes to survive are those Giotto executed about 1305 for the wealthy Paduan mercantile banker, Enrico Scrovegni, who had converted an old Roman arena into grounds for a palace and chapel (**figs. 19.7–10**). The chapel is a modest rectangular box with a barrel-vaulted ceiling and windows in the eastern and southern walls. Scrovegni likely commissioned the church and its frescoes to obtain papal indulgences, reducing the time he and his deceased father (who was notorious for his usury) might spend in Purgatory. The church is appropriately dedicated to Santa Maria della Carità (charity). Soon after the building's completion, Pope Benedict XI issued a bull granting indulgences to visitors to the chapel.

Giotto covered the chapel with frescoes. On the back wall, above the church's entrance, he painted the Last Judgment. Enrico Scrovegni is painted on the right hand of Christ, donating his family chapel. On the sidewalls, he juxtaposed scenes from the lives of Christ with those of the

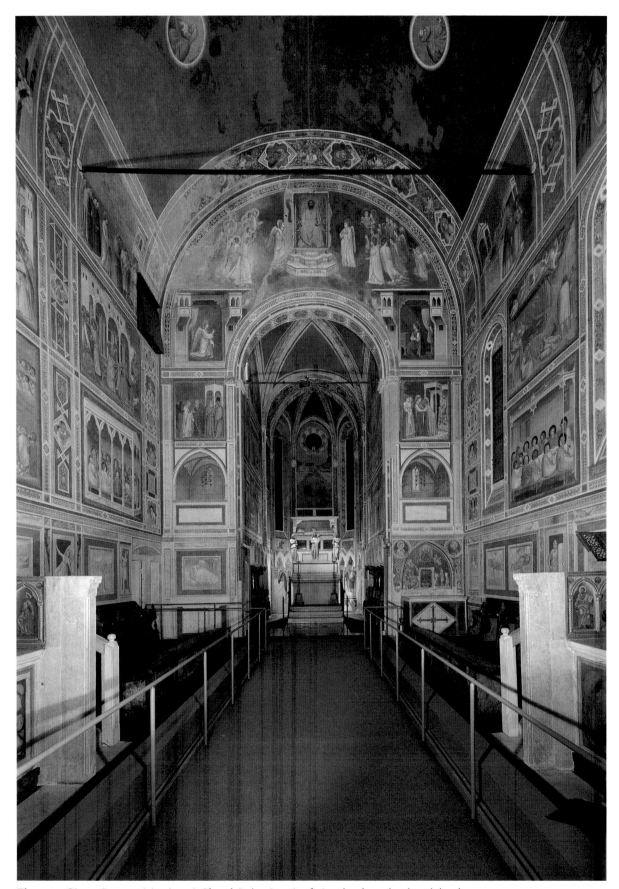

Fig. 19.7. Giotto. Scrovegni (or Arena) Chapel, Padua. Interior facing the chancel arch and the altar. c. 1305.
Post-millennium restoration

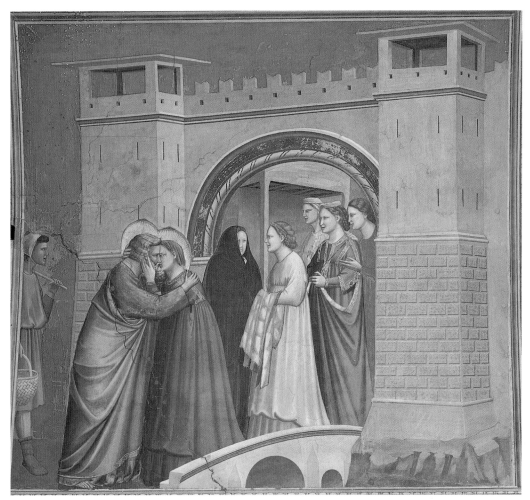

Fig. 19.8. Giotto. *Meeting of Anna and Joachim at the Golden Gate.*
Fresco in the Scrovegni (or Arena) Chapel, Padua. After 1305

Virgin. Giotto divided the sidewalls into four tiers. The lowest register forms a painted dado with imitation marble panels and simulated marble bas-reliefs depicting personifications of the Virtues and Vices. Above this area, Giotto painted the sequence of narratives in boxes, beginning in the topmost zone in the southeast. Drawing upon more contemporary apocryphal sources (the *Golden Legend* by Jacopo Voragine, c. 1270, and the *Meditations on the Life of Christ* by the Pseudo-Bonaventura, c. 1300), the cycle begins with a lengthy series illustrating the stories of Mary's parents, Anna and Joachim, and continues on the top of the north wall with episodes of her infancy. In the second register, he then placed the events from Christ's infancy (south) and ministry (north). The lowest zone of narratives was dedicated to the Passion of Christ.[10]

The *Meeting of Anna and Joachim at the Golden Gate* (**fig. 19.8**) is one of Giotto's most impressive compositions. Informed separately by angels that they would finally be blessed with a child, the elderly couple rushed to tell one another the blissful news. They met at the Golden Gate in Jerusalem, where they embraced. In sharing their kiss, the

Virgin Mary was conceived (the Immaculate Conception). For the sake of decorum, Giotto apparently avoided melodramatic aspects of the scene. Anna's garment, however, seems to billow out as the couple embrace, delicately suggesting this as the moment of impregnation.

Dominating the composition is the huge gateway, a massive, blocky form that imparts a powerful sense of monumentality to the story. Except for the shepherd, half cut off by the left margin, the main figures are contained within the giant portal. Giotto avoids such compositional devices as symmetry and centrality—they would focus too boldly on the embrace—and places Anna and Joachim alone to the left of the arched opening of the gate. But he turns our attention to them by the directional focus of the friends of Anna, gathered beneath the arch, who warmly regard the happy couple.

Giotto's figures are massive, unadorned volumes that seem like great stone blocks wrapped in pastel sheets that fall in even, shallow ridges. He also discreetly organizes the actors into groupings that are easily read as single units by the viewer. The dignity of the intimate moment is maintained by subtle nuance.

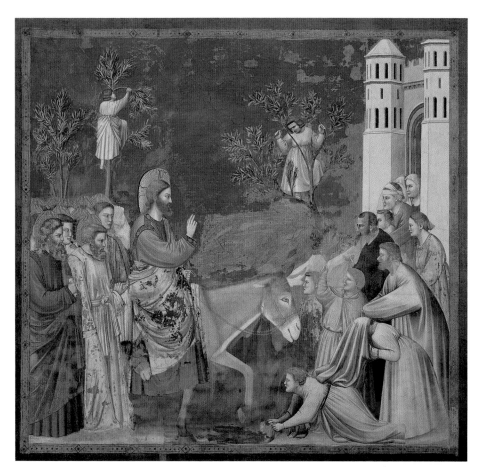

Fig. 19.9. Giotto. *Entry into Jerusalem.* Fresco in the Scrovegni (or Arena) Chapel, Padua. After 1305.

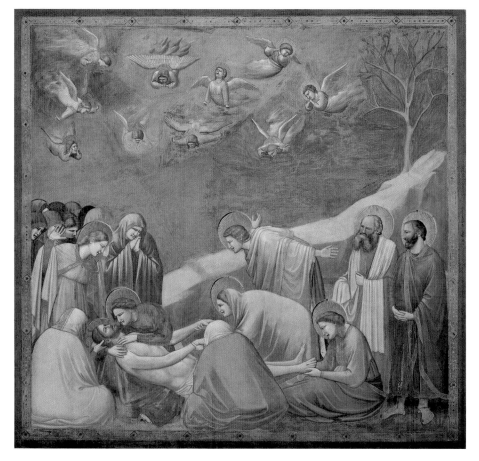

Fig. 19.10. Giotto. *Lamentation.* Fresco in the Scrovegni (or Arena) Chapel, Padua. After 1305

In the *Entry into Jerusalem* (**fig. 19.9**), Giotto simplifies the story by reducing the elements to the basic components. The apostles following Christ on the donkey form a solid rectangular block that dominates the left half of the composition. The central axis is free, and the citizens issuing from the towered gateway are presented as a compact pyramidal assembly descending to the kneeling boy, who places his shirt before the hooves of the donkey. Here, again, Giotto skillfully directs our attention towards Christ, who is slightly larger in scale.

Another narrative in the Paduan series, the *Lamentation* (**fig. 19.10**), shows the upper torso of the dead Christ resting in the arms of the Virgin, off axis, in the lower left corner. Before them are placed the ponderous figures of the seated mourners. To either side stand other grieving figures closing the compositional field like parentheses. Again Giotto employs the clever device of unfolding their postures, on the right, from an upright to a kneeling and, finally, a seated position. The great stony forms of the two women huddled to the left with their backs to us, totally weighed down by their grief, convey a sense of universal sadness. A few rhetorical gestures—hands thrust backward, hands waving above the shoulders, hands clenched to the cheek—are sufficient to communicate the range of emotions among the mourners, emotions that the tiny angels in the sky echo as they weep and wail.[11] Giotto's approach, though more naturalistic and more sensitive to human psychology than his Florentine predecessors, is not revolutionary. Similar characteristics can also be found in Byzantine paintings, such as the Lamentation fresco at Nerezi (fig. 5.30).

SCULPTURE

From 1265 through to 1268, "Nichola de Apulia" is recorded in the archives of Siena, where he was commissioned to execute the sculptured pulpit for the cathedral. He apparently had worked in Pisa five years earlier (where he was known as Nicola Pisano). In 1260, Nicola produced a pulpit for the Pisa baptistery (**figs. 19.11–13**). The idea of placing a pulpit in a baptistery is not unusual in Tuscany. Such furnishings were commonplace due to the fact that the baptistery, usually a freestanding structure in North Italy, could also function as a civic meeting place. Columns of variegated red marble and granite that alternately rest on the backs of lions support the hexagonal structure. Five sides of the pulpit have huge marble slabs, quarried in nearby Carrara, that are carved in deep relief with stories from the life of Christ. The sixth side is open for the staircase leading to the platform. An eagle, the symbol of Saint John the Evangelist, serves as a lectern. Episodes from the Infancy of Christ (Annunciation, Nativity, Adoration of the Magi, and Presentation), the Crucifixion, and the Last Judgment appear on the marble plaques. The ambitious relief that initiates the cycle (**fig. 19.12**), with the Annunciation to Mary, the Nativity, and the Annunciation to the Shepherds conflated into one cramped field, is instructive for our study.

Mary resembles a Roman matron clad in heavy garments, and the casualness of her pose brings to mind the beauty in repose of ancient deities. Her face and hair are particularly Classical in appearance; note the straight line of her nose, the fleshy modeling of her features with deep eyes sockets and her cupped chin, and the distinctive coiffure with wavy tresses issuing from a central parting. Nicola may have copied Mary and other figures from ancient Roman sarcophagi preserved in Pisa. Yet the field is packed with figures and a hieratic scale is employed (the larger Virgin commands the central axis). The iconography is Byzantine, with the grotto serving as a shelter and the Child repeated in the bathing scene. Gothic trilobed arches also support the sculpted panels. While Nicola may have looked at ancient remains, his vision did not neglect other artistic models.

Nonetheless, Nicola's work is quite striking in its classicism. The heroic male nude that stands on top of one of

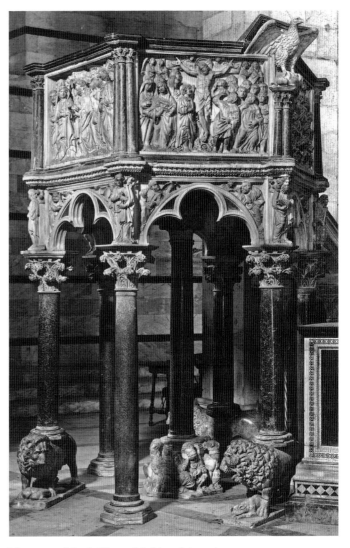

Fig. 19.11. Nicola Pisano. Marble pulpit. 1260. Baptistery, Pisa

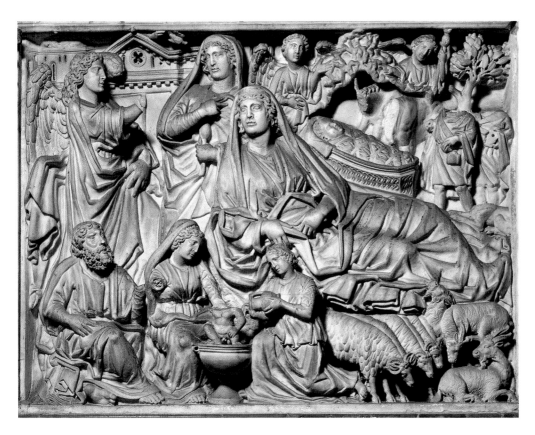

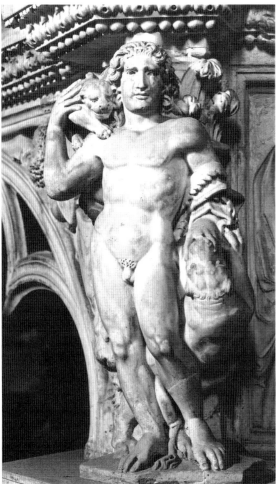

ABOVE **Fig. 19.12.** Nicola Pisano. *Annunciation, Nativity, Annunciation to the Shepherds.* Detail of the marble pulpit in Fig. 19.11

LEFT **Fig. 19.13.** Nicola Pisano. *Personification of a Virtue or the Prophet Daniel.* Detail of the marble pulpit in Fig. 19.11

the columns supporting the relief panels (**fig. 19.13**), usually identified as a personification of one of the Virtues or as the prophet Daniel, is likely modeled after an ancient statue or relief sculpture of Hercules. While the head is oversized, the finely detailed anatomy and the polished texture seem quite naturalistic.[12]

For the altar in the Arena Chapel, Enrico Scrovegni commissioned Giovanni Pisano, the son of Nicola, to execute a marble statue of the Virgin and Child (**fig. 19.14**).[13] The exaggerated sway in the upper torso and the rich cascades of drapery that fall from the Virgin's right hand bring to mind the features of ivory statuettes, and, indeed, it is very possible that Giovanni was directly indebted to such models. The intensity of the gaze between Mother and Child, on the other hand, suggests that Giovanni may have been influenced by the art of Giotto.

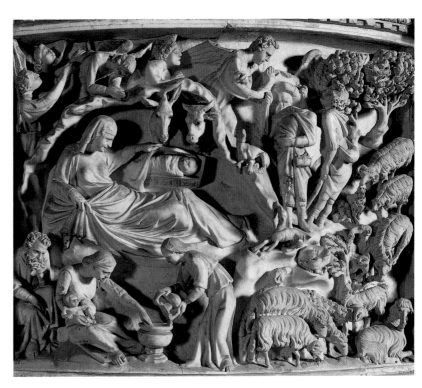

Fig. 19.15. Giovanni Pisano. *Nativity and Annunciation to the Shepherds.* Panel of a marble pulpit. 34⅜ × 43″. 1302–10. Pisa Cathedral

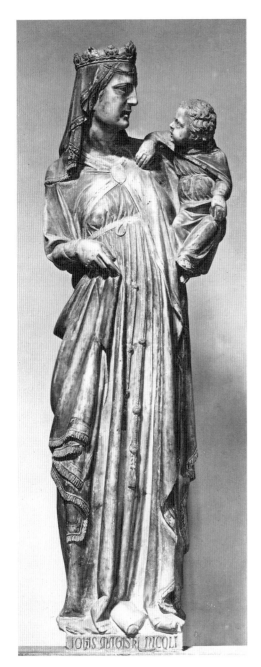

Fig. 19.14. Giovanni Pisano. *Virgin and Child.* Marble, height 4′ 3″. c. 1305. Arena Chapel, Padua

Between 1302 and 1310, Giovanni Pisano executed marble reliefs for the pulpit in the Cathedral at Pisa (**fig. 19.15**). A comparison of these reliefs with those of his father for the Pisa Baptistery pulpit demonstrates Giovanni's preference for the Gothic over the Romanized style of his father. The blocky, compact figures with their Late Antique features and the broad planes of creased drapery in Nicola's *Nativity* were rejected for a new pictorial vocabulary in Giovanni's version. The same iconographic scheme is followed, but now the figures are slender, and they sway beneath flowing draperies. The projection of the relief varies widely. Many of the heads are turned outward on long necks, arms are attenuated, and gestures curve gracefully inward so that a flickering pattern of light and dark accents sweeps across the composition like a shimmering arabesque.

Giovanni's interests in pictorial effects led him to exploit the charm of the landscape setting. Compared to the cramped surface of Nicola's relief, where all figures are squeezed into a single plane, Giovanni's work is open and interlaced like a giant vine or scroll issuing from a single source—the curved back of the maiden pouring water. Graceful tendrils of landscape tie the Virgin to the grotto, the grotto to the hills with the shepherds, and the meadows with the grazing flocks to the maiden once more.

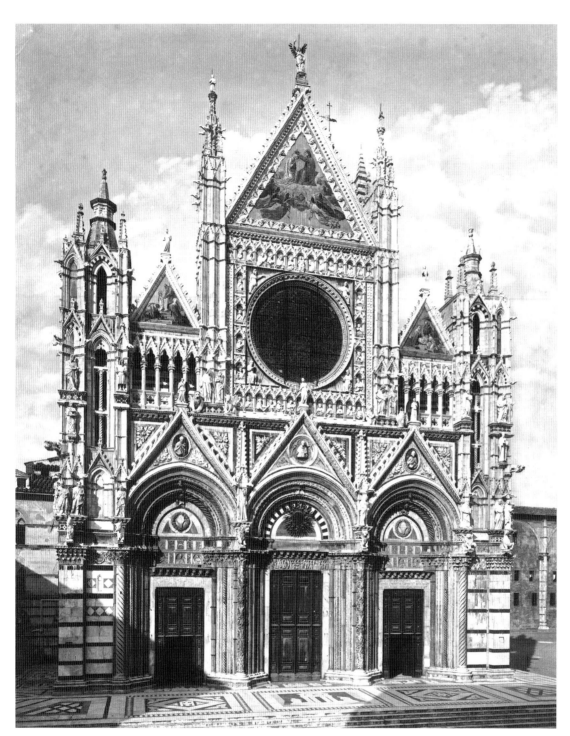

Fig. 19.16. Giovanni Pisano and others. Siena Cathedral (Duomo). Facade. 1284–99

Giovanni's talents ranged widely. He worked as an assistant to his father when the shop was called to Siena to execute the pulpit for the Duomo there between 1265 and 1268. He apparently settled in Siena and eventually worked on the facade of the Duomo (**fig. 19.16**) after the main building was completed. In a document of 1290, he is referred to as the *caput magistrorum*, or "man in charge," of the cathedral works.[14] Giovanni designed the resplendent facade with its zebra banding of dark green and white marble. His

shop completed the lower half of the front—up to the pinnacles of the side portals. The upper parts of the facade, including the rose window, were added later in the 1370s.

Some elements of French Gothic architecture are present in the bottom half of the facade, but the richly textured surface is little more than an elaborate screen. The portals do not correspond exactly to the disposition of the nave and side aisles, nor are they decorated in the French fashion. Giant marble statues stand between and atop the

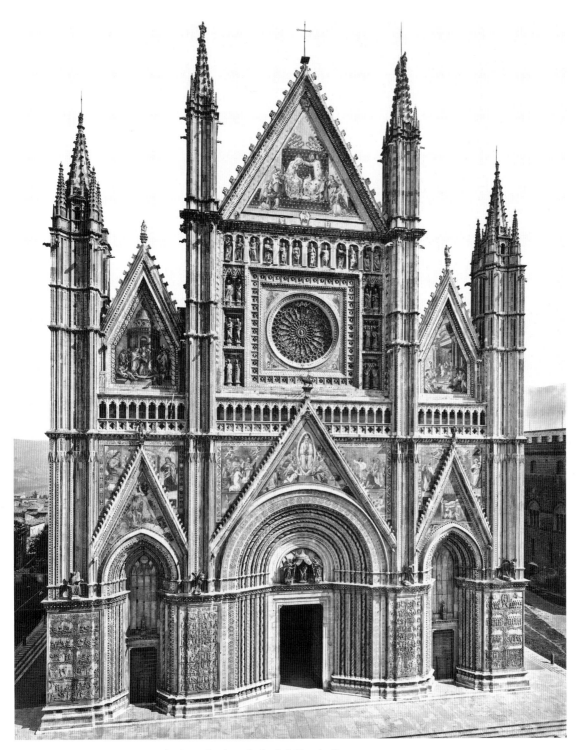

Fig. 19.17. Lorenzo Maitani and others. Orvieto Cathedral. Facade. Begun 1310

pinnacles, but they are independent creations simply laced there and not actually coordinated within the fabric of the structure. A strong cornice divides the facade into two parts. The central block is raised as a square penetrated by a huge round window with stained glass. The towers shrink to ornate turrets framing the central block.

In 1316, new additions were planned for the Duomo. These included a baptistery at the foot of the hill that provided the substructure for two bays added to the choir. Structural problems were immediately encountered, and a special commission was appointed to advise the architects concerning the additions. Among the new advisors was Lorenzo Maitani, a Sienese architect who had served since 1310 as the *capo maestro* at Orvieto, where he completed work on the interior and erected the facade of the huge church (**fig. 19.17**). The Sienese council rejected his advice.

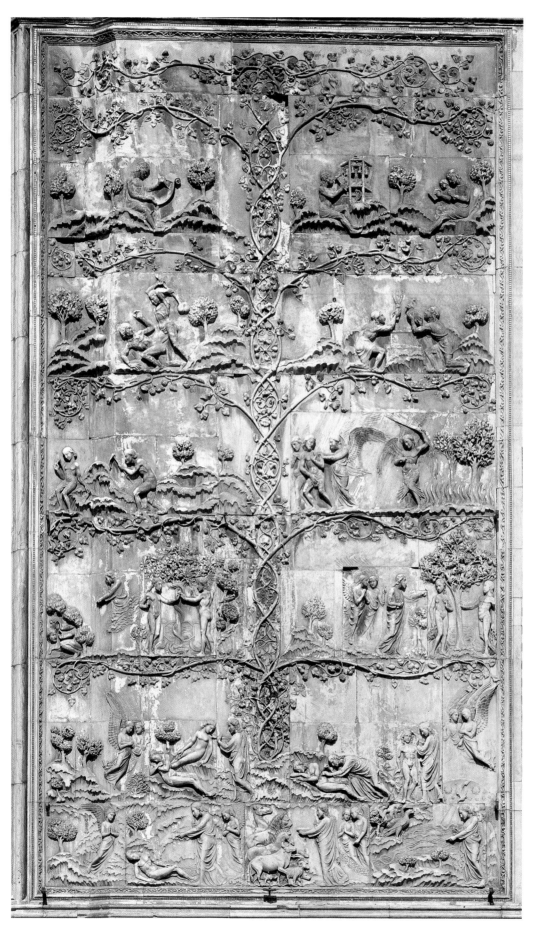

Fig. 19.18. Lorenzo Maitani. *Scenes from Genesis.* First pilaster of the facade, Orvieto Cathedral. c. 1310–15

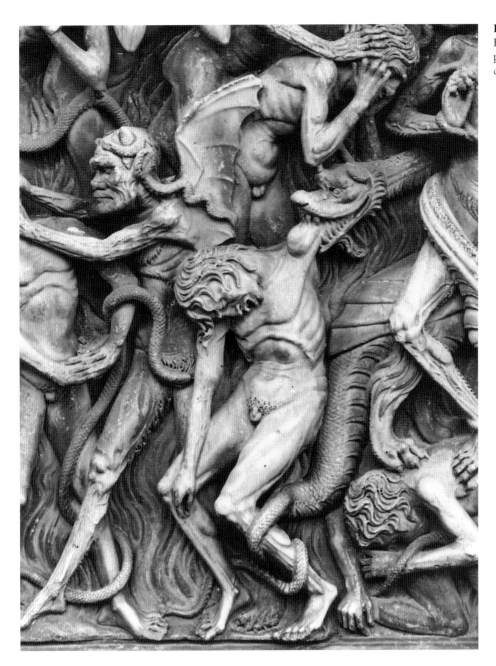

Fig. 19.19. Lorenzo Maitani. Detail of Hell from the *Last Judgment*. Fourth pilaster of the facade, Orvieto Cathedral. c. 1310–30

Maitani's design for the facade of the Duomo in Orvieto resembles that of the Duomo in Siena, but it displays more regularity and order, with the three portals clearly marked off to conform to the interior divisions. Of special interest is the sculpture decoration designed by Maitani for the facade (**fig. 19.18**). Four high marble reliefs adorn the pilasters that flank and separate the three portals. These depict, from left to right, stories from Genesis, the Tree of Jesse, the Life of Christ, and the Last Judgment.

Maitani's reliefs are delicate and refined in detail, and the tiers of figures are gracefully unified by means of meandering vines (ivy, acanthus, and grape) that grow up the central axis of each pilaster and sprout tendrils that frame the individual scenes. However poetic these sculptures may seem, certain details, especially in the Last Judgment, convey a startling pathos. The horror of a poor soul (**fig. 19.19**) in the grip of a menacing hybrid monster, placed slightly above eye level, is quite compelling and cannot be easily overlooked.[15]

DUCCIO AND SIMONE MARTINI

In September of 1260, the Florentine army surrounded the city of Siena. Concerned for the safety of his city, a man named Buonaguida disrobed and entered the cathedral, imploring the Virgin Mary for mercy. Upon hearing Buonaguida's prayers, delivered before an image of the *Virgin Hodegetria* represented on an altar front, the Sienese bishop organized clerics for a pious procession around the city. The priestly entourage carried relics and banners throughout Siena in hopes of divine intervention. The next day, the

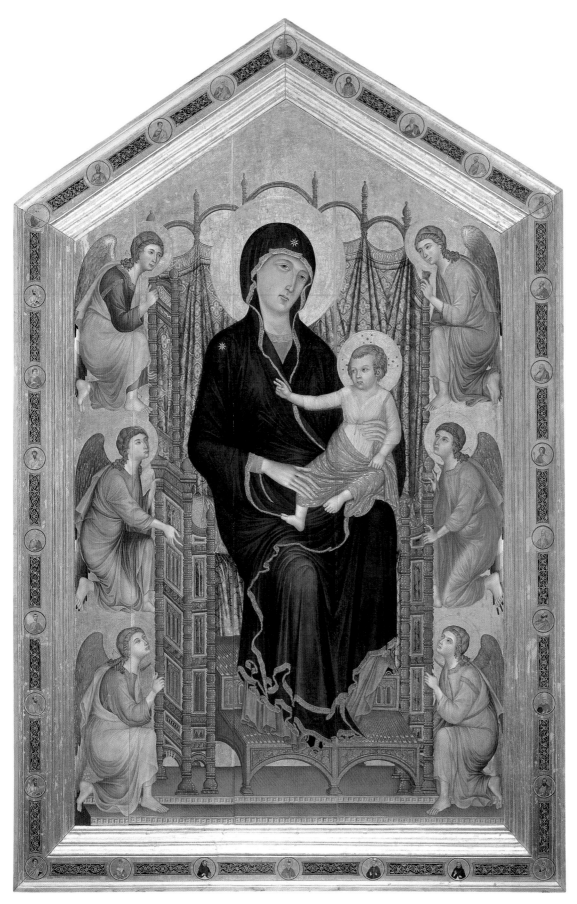

Fig. 19.20. Duccio. *Rucellai Madonna*. Panel. 14′ 9⅛″ × 9′ 6⅛″. 1285. Uffizi Gallery, Florence

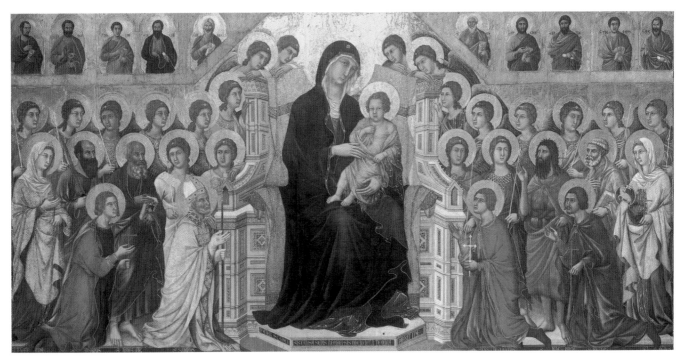

Fig. 19.21. Duccio. *Maestà*. Central panel. 7′ × 13′. 1308–11.
Museo dell'Opera del Duomo, Siena

Sienese defeated the Florentines at the Battle of Montaperti. The Virgin Mary was credited for protecting the city and made Siena's patron saint. Not surprisingly, numerous icons of the Virgin were commissioned for Sienese churches, including one by Coppo in Santa Maria dei Servi, dated 1261.[16]

In 1285, Duccio di Buoninsegna (active 1278–1318) painted an altarpiece (**fig. 19.20**) for the lay confraternity of the Laudesi, a religious organization dedicated to the Virgin Mary and associated with the Dominicans.[17] The painting was placed in the Dominican church of Santa Maria Novella. Later, it was sold to the Rucellai family, who moved it to the family chapel in the same church.

The *Rucellai Madonna*, as it is often called, is an early work by Duccio. While a hieratic formula is followed (a modification of the *Hodegetria* type), the viewer is immediately attracted to the more natural characterization of Mary and her child, achieved by subtle stylistic adjustments. Mary is not rigidly posed. She turns slightly on the throne and her right hand relaxes as she more easily carries her son on her left knee. Through subtle shading of the flesh, Duccio presents Mary as an approachable woman.

The gold striations that dominate the draperies in the Byzantine icons are abandoned for subtle highlights. A border of gold meanders gracefully along the hem of her mantle. The deep blue of the costume has darkened over the years, but the delicacy of Duccio's drapery patterns can still be discerned in the softly modeled gowns of the angels that attend her. Furthermore, the angels are no longer presented as

symbolic attributes but as full-bodied attendants placed in vertical rows about the elegant throne, a complex structure of diminutive spools and spindles that is tilted in space.

For the Duomo in Siena, Duccio produced a large polyptych (a many-paneled altarpiece) known as the *Maestà*, or Majesty of the Virgin (**figs. 19.21–24**).[18] Although Duccio employed numerous assistants in this ambitious project, the style is astonishingly uniform throughout the work. After its completion in 1311, the polyptych was carried in a grand procession through the city streets to its installation in the Duomo. In its original state, the *Maestà* formed a complex assembly of panels around a monumental centerpiece (seven feet by thirteen feet) where the Virgin appears enthroned amid rows of saints and angels. Duccio's *Maestà* was placed above the high altar under the church's crossing dome. Consequently, it is elaborately painted on both sides.

On the front, the Madonna, over twice the size of the figures around her, fills the central axis. The charming blond-headed child playfully tugs at his mantle rather than extending his fingers in benediction. The Virgin's blue mantle is modeled with graceful arcs and overlaps. From the right knee, soft highlights fall naturally along the ridges of her mantle. The familiar gold spray is limited to a few touches at the feet, where her red dress is visible. As in the *Rucellai Madonna*, an elegant line of gold traces the hem of her mantle as it delicately falls across the expanse of blue.

Angels gather comfortably around the huge stone throne. They rest on its arms as they glance lovingly at the Virgin and Child. Two lower angels on each side of the

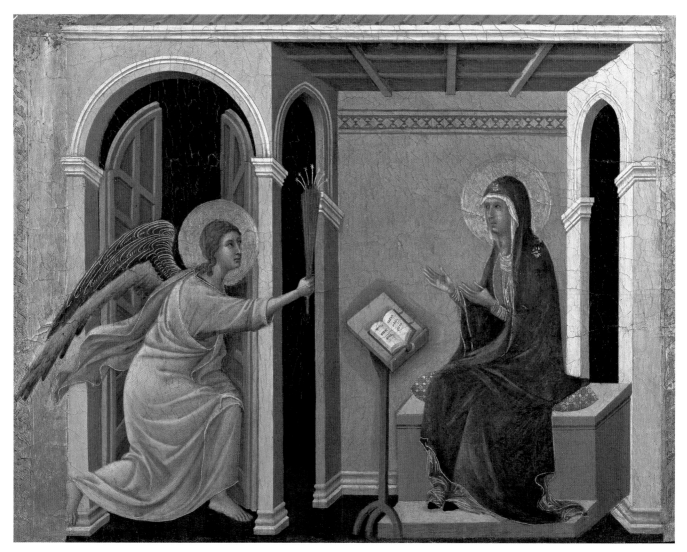

Fig. 19.22. Duccio. *Annunciation of the Death of the Virgin.* Panel from the top register of the *Maestà* front. 21¼ × 22⅞″

throne turn and regard the beholder. Three rows of figures flank the Virgin. In the lowest, two local saints (identifiable only by the inscriptions beneath them) kneel on either side. In the second row, Saints John the Baptist, Peter, and Agnes stand on the right, John the Evangelist, Paul, and Catherine on the left. The uppermost tier is filled with more angels who quietly attend the community of holy people. While some Byzantine conventions are followed, the assembly of saints and angels appears intimate and approachable.

From this central core the *Maestà* expands into a complex ensemble of pinnacles and tiered panels. The central composition rests on a low horizontal predella, or pedestal, made up of small narrative panels illustrating the story of Christ's Infancy. The altarpiece was dismantled in the sixteenth century, and there is some controversy as to the exact arrangement of the original ensemble. Scenes from the final days of the Virgin—from her death to her coronation—were lined up in the upper pinnacles. Exceptional is the episode of the *Annunciation of the Death of the Virgin* (**fig. 19.22**), a rare

event derived from apocryphal accounts of Mary's life. The palm branch in Gabriel's hand is the only clue in distinguishing the story from that of the familiar Annunciation of the Incarnation that begins the Infancy cycle.

An important feature of this engaging scene is the dollhouse treatment of the chamber, with the projection of the walls and ceiling beams that move diagonally to a vanishing axis on the back wall. Gabriel approaches from an antechamber that also projects illusionistically. Within a decade, Duccio's innovations in articulating naturalistic spatial relations had important repercussions north of the Alps.

Forty-three narrative panels arranged in six tiers that illustrate stories of Christ's Ministry, Passion, and post-Passion covered the backside of the *Maestà*. The *Entry into Jerusalem* (**fig. 19.23**), introducing the Passion sequence, is a tour de force in narrative detail. Jerusalem is envisioned as a Tuscan hilltop village. A grand Palm Sunday procession along a diagonal road leads past a walled precinct complete with gateway and orchard. Throngs of citizens gather around the city gate

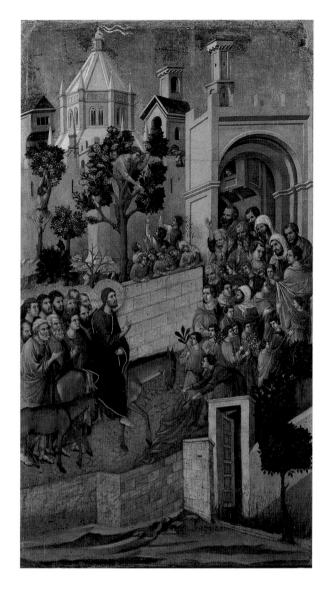

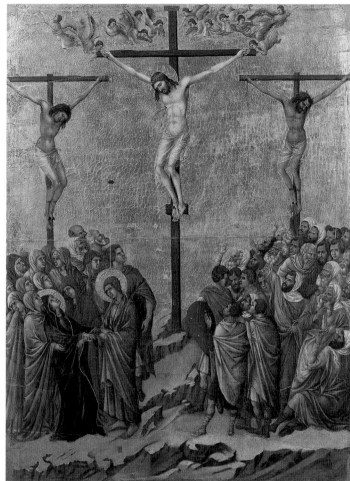

ABOVE **Fig. 19.24.** Duccio. *Crucifixion*. Panel from the back of the *Maestà*. 40⅛ × 29⅞″.

LEFT **Fig. 19.23.** Duccio. *Entry into Jerusalem*. Panel from the back of the *Maestà*. 40⅛ × 21⅛″.

to greet Christ. Some peer down from the crenellations in the wall or from balconies. Youngsters clamber up trees fetching branches to place along Christ's way into the city.

Similar pictorial devices appear in Duccio's large panel of the *Crucifixion* (**fig. 19.24**). The bent body of the dead Christ hangs high over a throng of people around the cross. The faithful have gathered on the left, the tormentors on the right. The two crucified thieves flank the central cross, while weeping angels fly in clouds above the cross arms. Notable, too, is the Virgin, who falls back into the arms of a female mourner, while John the Evangelist turns to comfort her. Duccio skillfully conveys the emotional impact of Christ's brutal death.

One of Duccio's most gifted followers, Simone Martini, executed a huge fresco (**fig. 19.25**) of the *Virgin in Majesty with Saints and Angels* (forty feet wide) for the Palazzo Pubblico (civic palace) in Siena. In many respects, it is a creative revision of the central panel of Duccio's *Maestà*. Occupying the

west wall of the council chamber, the enthroned Queen of Heaven and her court of holy figures, sheltered under a baldacchino (canopy), preside over the civic meetings conducted in the room.

Around 1330, four altars dedicated to local saints were added to the Cathedral of Siena, with altarpieces representing scenes from the life of the Virgin, designed to complement Duccio's *Maestà*. For the altar of Saint Ansanus, Simone Martini, assisted by his brother-in-law Lippo Memmi, painted a graceful scene of the Annunciation (**fig. 19.26**). The dazzling gilt frame consists of five cusped Gothic arches capped by intricate gabled pinnacles. Simone's lavish use of gold implies a heavenly setting. The delicate tooling of the haloes and the borders of the mantles reinforces the sanctity of the figures and calls attention to his fine craftsmanship.

Cascading folds with sinuous overlaps and pocketed creases mark Mary's aristocratic costume. To express the Virgin's shyness at the moment of Gabriel's appearance,

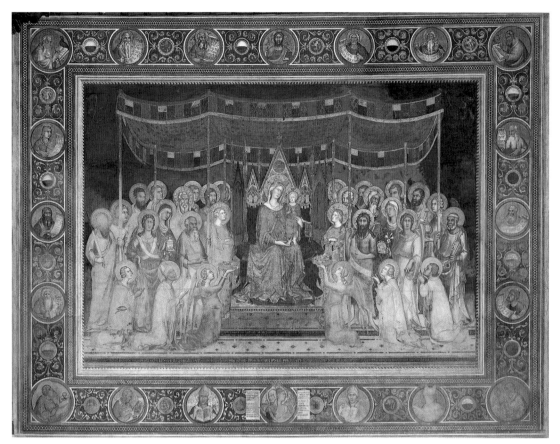

Fig. 19.25. Simone Martini. *Virgin in Majesty with Saints and Angels (Maestà)*. Fresco. 1315; partially repainted 1321. Council Chamber, Palazzo Pubblico, Siena

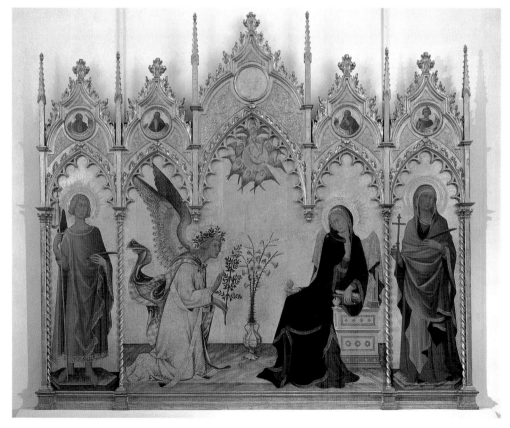

Fig. 19.26. Simone Martini. *Annunciation*. Panel. 8′ 9″ × 10′. 1333. Uffizi Gallery, Florence

Simone depicts her as shrinking back from the messenger in discrete concave arcs formed by the elegant silhouette of her mantle. Her head and arms are enveloped in ovals under the adjoining arch of the frame, further underscoring her withdrawal and introversion at this poignant moment.

The free-falling edges of Mary's blue mantle are complemented on either side by the lyrical bands of her red dress. Gabriel enters and kneels quietly before her. His body, rendered in gold, is nearly transparent, conveying an enchanting quality of his divine being. The fluttering of his colorful plaid mantle beneath the elegant peacock wings indicates his sudden appearance to the Virgin. Gabriel offers Mary a token of peace, an olive branch, and between them stands a fine golden vase containing fragile lilies, symbolizing the purity of the Virgin.[19]

ASSISI

Before he painted the *Annunciation*, Simone Martini had worked at an important ecclesiastic center in Umbria, the Church of Saint Francis of Assisi (**fig. 19.27**), where he painted frescoes of the life of Saint Martin in a chapel in the lower church. His compatriot, Pietro Lorenzetti, another follower of Duccio, executed frescoes in the lower church as well, including the impressive *Deposition* (**fig. 19.28**). The bold compositional lines and the unusual pathos expressed are striking.[20]

Rising on the slope of a hill, San Francesco at Assisi is built in the form of a double church, an upper and lower structure laid out in the form of a simple T-shaped basilica with an aisleless nave, ideal for preaching, consisting of four square bays with slightly pointed rib vaults (**fig. 19.29**).

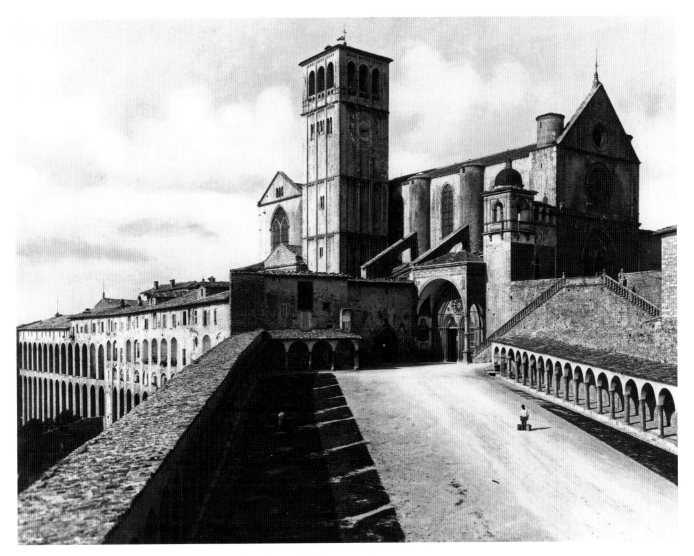

Fig. 19.27. San Francesco, Assisi. Exterior view from the south. Consecrated 1253

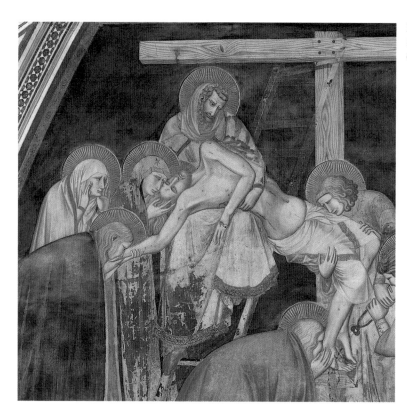

Fig. 19.28. Pietro Lorenzetti. *Deposition*. Fresco in the lower church of San Francesco, Assisi. 1320s–30s

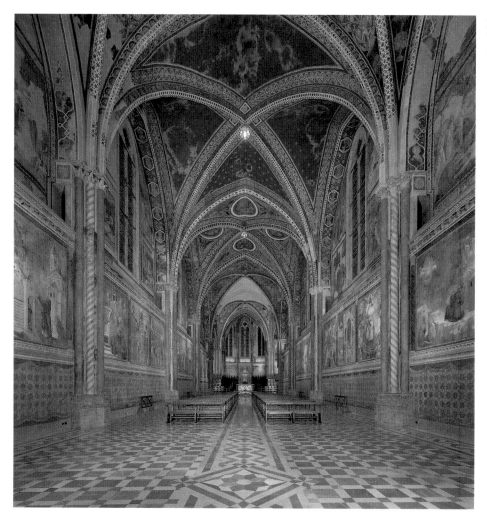

Fig. 19.29. San Francesco, Assisi. Upper church. Interior. 1228–53 (frescoes c. 1300–30)

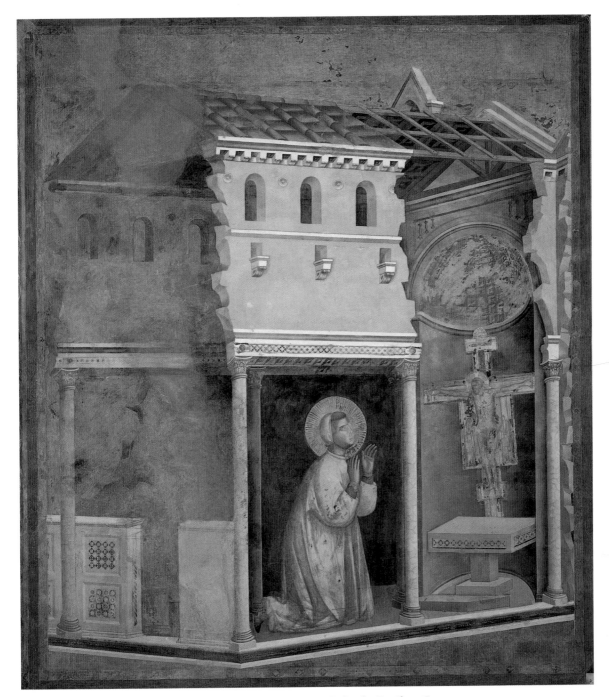

Fig. 19.30. Master of the Saint Francis Cycle. *Saint Francis Praying Before the Crucifix at San Damiano.* Fresco in the upper church of San Francesco, Assisi. Early 14th century

Consecrated in 1253 by Pope Innocent IV, the new center for Franciscan devotion was subsequently decorated with frescoes and stained-glass windows. On the lower walls of the upper church, a vast cycle of frescoes illustrates the life of Saint Francis (**fig. 19.30**). According to Vasari and other early Italian sources, Giotto executed nearly all of the twenty-eight pictures, early in his career. However, today most scholars attribute the works to anonymous followers of Giotto.

PANORAMIC SCENES

In 1338–39, Ambrogio Lorenzetti painted a series of frescoes for the Sala della Pace in Siena's Palazzo Pubblico. On the end wall (not illustrated here), Buon Commune (Good Government) is enthroned, surround by female personifications of the Virtues. Directly below this scene, the figure of Concordia, who smoothes things out between rival families, hands out ropes or "cords" to twenty-four patricians, suggesting their harmonious unity for the common good. On the wall left of

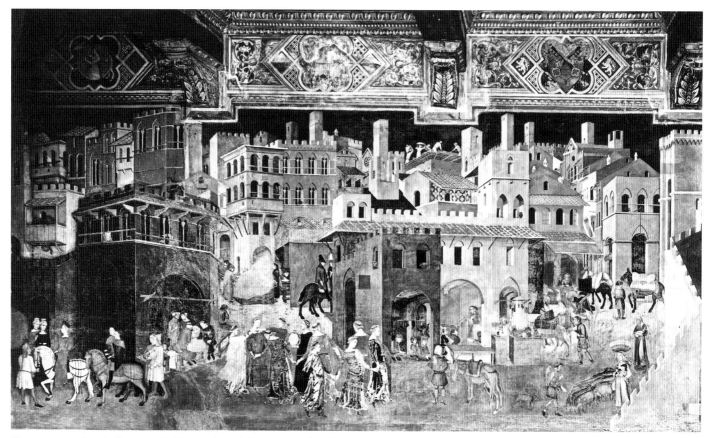

Fig. 19.31. Ambrogio Lorenzetti. *Allegory of Good Government: The Effects of Good Government in the City and the Country* (portion of the city). Fresco in the Sala della Pace, Palazzo Pubblico, Siena. 1338–39

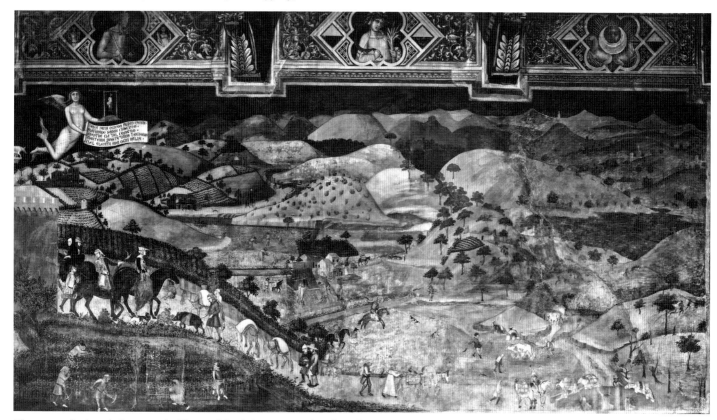

Fig. 19.32. Ambrogio Lorenzetti. *Allegory of Good Government: The Effects of Good Government in the City and the Country* (portion of the country)

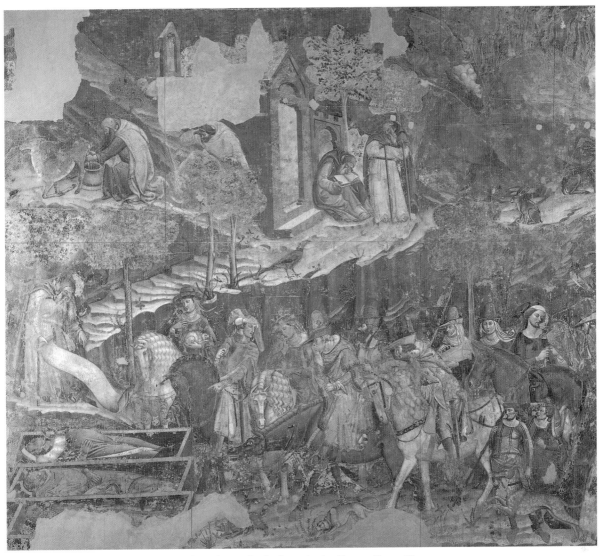

Fig. 19.33. Francesco Traini. *Triumph of Death.* Detail of a fresco in the Campo Santo, Pisa. c. 1330–40

Buon Commune (the sinister side), Tyranny and his court of Vices wreak havoc, producing a world of fear and terror, where war, violence, and crime are commonplace. On the right of Buon Commune, the effects of good government can be seen (**figs. 19.31, 19.32**). The sweeping view of the city and countryside of Siena is astonishing in its vast scope and wealth of details. Within this panoramic view, peace, prosperity, and joy abide, as citizens go about their daily activities in the security of good governance.[21] Although Lorenzetti's fresco elicits social harmony, this was not always the case. Siena, like other Late Medieval cities, had its fair share of political and economic rivalries.

Another panoramic fresco rendered in meticulous detail can be found in an enclosed cemetery called the Campo Santo (Holy Field), which was adjacent to the Cathedral of Pisa and was believed to contain sacred soil from the Holy Lands. Francesco Traini covered the cemetery walls with scenes of Christ's Passion, the Last Judgment, and the Triumph of Death (**fig. 19.33**). As a reminder of mortality, Traini depicts the meeting of the living and the dead. Like the illumination from the Psalter of Bonne of Luxembourg (fig. 17.15), the painted scene includes three courtly figures responding to various stages of human decay. To the far left, ascetic monks, unhampered by worldly ways, quietly go about their daily activities unaffected by the horrors of death, for they have humbly prepared themselves for the afterlife.[22]

At mid-century, the Black Death swept Italy and spread rapidly across Europe, decimating the population and curtailing numerous cultural projects. It took decades for Europe to recover from the devastation. Although this catastrophe may have seemed apocalyptic to those who suffered through it, the continent would once again flourish. Whether this cultural rebirth or renaissance signifies a radical break from the Middle Ages remains a matter of debate.

20

ART AND MYSTICISM
IN LATE MEDIEVAL GERMANY

The sprawling domain known as the Holy Roman Empire never recovered from the death of Frederick II in 1250. His son Conrad IV died of fever in 1254. After his sixteen-year-old grandson Conradin was defeated by Charles of Anjou at the Battle of Tagliacozzo (1268), he was murdered in Naples at Charles's command. With the death of the last Hohenstaufen, the German empire began to disintegrate into rival political states. In 1273, Rudolf of Habsburg was elected king, but that title was little more than an honorary name. The powerful princes of the duchies asserted their independence—the Luxemburgs, the Hohenzollerns, the Habsburgs—splitting the broad territory into the states we know today as Bohemia, Austria, Bavaria, Brandenburg, and so on. Two other powers emerged to further complicate the polity: (1) the wealthy Hanseatic cities in north Germany, whose mercantile league established them as "free" cities under limited royal authority; and (2) the influential archbishoprics, especially Mainz, Cologne, and Trier in the Rhine valley, who also claimed independence from the princes and frequently kept close ties with the papacy. To check the decentralization of their power, the nobility instituted the system of electors (*Kurfürsten*), made up of seven lords and three ecclesiastics from the archbishoprics, to determine the succession of rulers in Germany (a policy finalized by the Golden Bull of Charles IV of Bohemia in 1356).

RHINELAND CHURCHES

With the passing of the Hohenstaufens, whose absolute authority had been stamped on the landscape of the Rhine with huge imperial westworks (Speyer, Worms, and Mainz cathedrals), church design began emulating characteristics of French Gothic architecture. At Strasbourg (Strassburg in German) in the Upper Rhine—where German and French are still mixed in the dialect of the people—a new cathedral raised (1176) on the burned-out foundations of the earlier church marks this transition (**figs. 20.1–4**).[1] In 1225, the apse and the north transept were already completed in the Romanesque style. The architect Rudolf built the south transept and the choir in the 1240s, and his son completed the nave in 1275 in the new Gothic style. Only the wider proportions of the nave (1:2) distinguish the interior from the elegant structures in the High Gothic style of Pierre de Montreuil in Paris.

The facade was further elaborated into a Rayonnant front, based in part on Saint Urbain at Troyes, by an architect named Erwin von Steinbach in 1277. Across the solid core of the stone facade, von Steinbach constructed an intricate screen of tracery nearly two feet deep. Stone blocks are transformed into ornament resembling a huge trellis surmounted by a splendid rose window. The upper parts of the facade were added much later (c. 1365, 1384–99); the octagonal stage of the north tower and the ornate openwork spire were not completed until the fifteenth century.

The sculptural decorations for Erwin von Steinbach's recessed portals display a surprisingly uniform style and an iconographic program that is a striking variation on what we have seen in France. Although much of the sculpture was mutilated during the French Revolution, the facade sculptures have been superbly restored. Tall, thin prophets wrapped in

voluminous draperies staring down from the jambs dominate the central portal. Their bearded faces are emaciated, with pointed features and highly stylized curlicues for beards and hair. Above them appears a tympanum with four registers of reliefs illustrating the Passion of Christ (the Throne of Solomon in the sharply pointed gable and the Madonna that surmounts it are later). The left portal presents female personifications of the Virtues trampling on squirming representations of the Vices; the north portal features willowy figures of three Foolish Virgins with discarded lamps seduced by a youthful Satan, who has snakes and toads crawling up and down the sides of his garment (**fig. 20.2**). The tempter extends an apple, trying to coax the naïve into biting into the forbidden fruit. On the opposite side, three Wise Virgins hold their lamps upright before the stern figure of the Bridegroom, Christ.

The sculptural program, originally planned for the north transept, included two tympana depicting the final events in the life of the Virgin: the Dormition and Funeral (left), the Assumption and Coronation (right).

The Dormition (**fig. 20.3**) is agitated and crowded, with disembodied heads emerging from the curvature of the tympanum. The intense stares and twisted gestures of the apostles reveal the extremity of their grief. Adding to the psychological drama, a seated figure of the Magdalene, wringing her hands frantically and grimacing in her anguish, is squeezed in before the bed of the Virgin. These throbbing lines and angular movements are foreign to the French Gothic style and can be considered indigenous traits. Yet the treatment of the draperies of the reclining Virgin and the features of her face are reminiscent of the Visitation group at Reims (fig. 16.57).

Initially, the jambs and central post of the south portals were decorated with standing apostles around the enthroned King Solomon. These sculptures were destroyed, but two figures placed on the extremities of the jambs (the originals are today in the Frauenhaus in Strasbourg), personifying *Ecclesia* and *Synagoga*, are excellent examples of the blending of French and Rhenish styles in sculpture around mid-century, around 1235–40 (**fig. 20.4**). *Maria Ecclesia* is an elegant female figure, proud and dignified. She triumphantly plants the cross at her feet, while holding a chalice in her left hand. By comparison, the defeated *Synagoga*, with downcast head, twists to her left. A diaphanous blindfold covers her eyes. Yet there are significant similarities in these works. The gracefully descending draperies, the creased tucks about the belts, and the rounded abstract folds that gather about their feet are strikingly similar to those features in the later sculptures at Chartres. On the other hand, the manner in which the upper torsos are treated, with the outer mantle stretched tightly about the shoulders and fastened by a brooch in front (note especially *Ecclesia*), reminds us of the elegantly draped figures at Reims.

Further down the Rhine is one of the most impressive demonstrations of Gothic architecture: the facade of

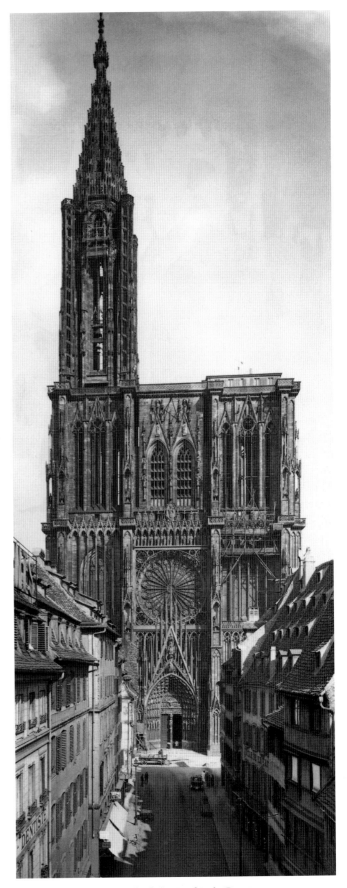

Fig. 20.1. Strasbourg Cathedral. West facade. Begun 1277; upper stories 1365, 1384–99

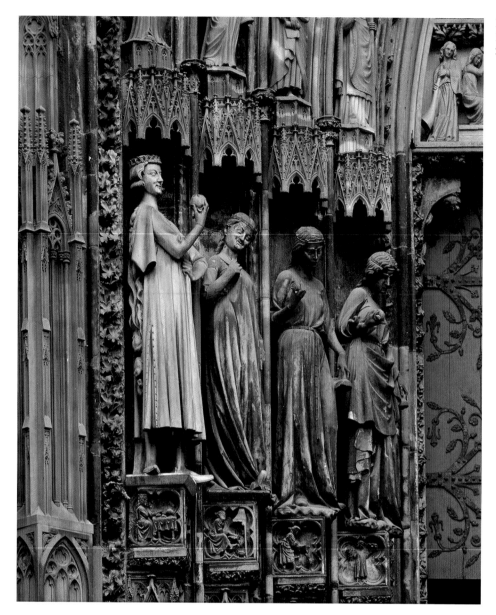

Fig. 20.2. *Satan and the Foolish Virgins.* Left jamb, north portal, facade, Strasbourg Cathedral. c. 1280

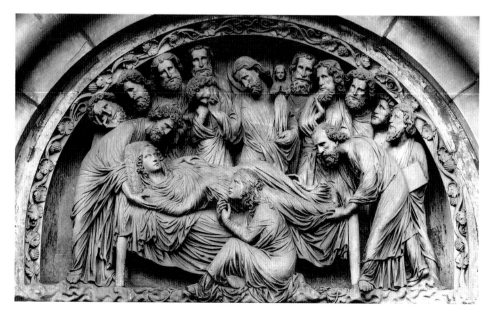

Fig. 20.3. *Dormition.* Tympanum of the south transept portal, Strasbourg Cathedral. c. 1230

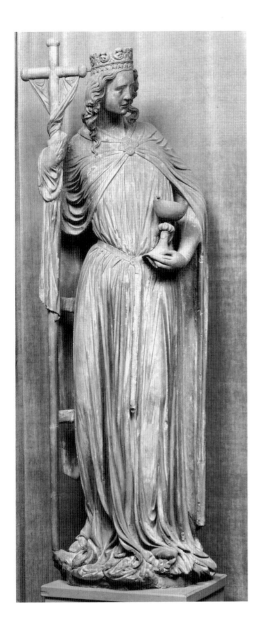

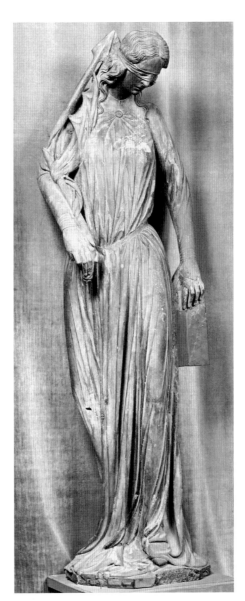

Fig. 20.4. (a) *Ecclesia* and (b) *Synagoga*. Formerly on the outer jambs of the south transept portal, Strasbourg Cathedral. Height 6′ 5″. c. 1240. Frauenhaus, Strasbourg

Cologne Cathedral (**fig. 20.5**).[2] A mammoth cliff of layered stone stories rises dramatically some five hundred feet, reducing the spectators in the view of the facade to mere ants scurrying about its foundations. This huge edifice is, however, mostly a product of nineteenth-century Gothic revival in Germany. For three centuries (1560–c. 1850) no work was carried out. The plans for the facade, designed by Master Michael around 1350, were discovered in the nineteenth century being used as a stretcher for drying beans, so the story goes, and it was then that the project was renewed and finally brought to completion by the inspired citizens of Cologne. The glory of the once-powerful archbishopric was finally restored in 1880 with the completion of the largest cathedral in northern Europe.

In 1164, Cologne Cathedral was presented with relics of the Three Magi (for which Nicholas of Verdun executed the famous shrine in 1181—fig. 14.33), and it was there that the German kings offered gifts to the Church of God following their coronation at Aachen. In 1247, the old Carolingian structure, apparently in a ruinous state, was torn down and an architect, Master Gerhard, who was certainly familiar with the buildings of Jean de Chelles and Pierre de Montreuil, began the rebuilding with the intent of creating on the site a grandiose French Gothic cathedral like Amiens (the influence of Beauvais Cathedral seems apparent, too). One wonders if this change in styles was not due, at least in part, to local opposition to the prevailing tastes of the Hohenstaufens as exemplified in the traditional Rhenish Romanesque churches.

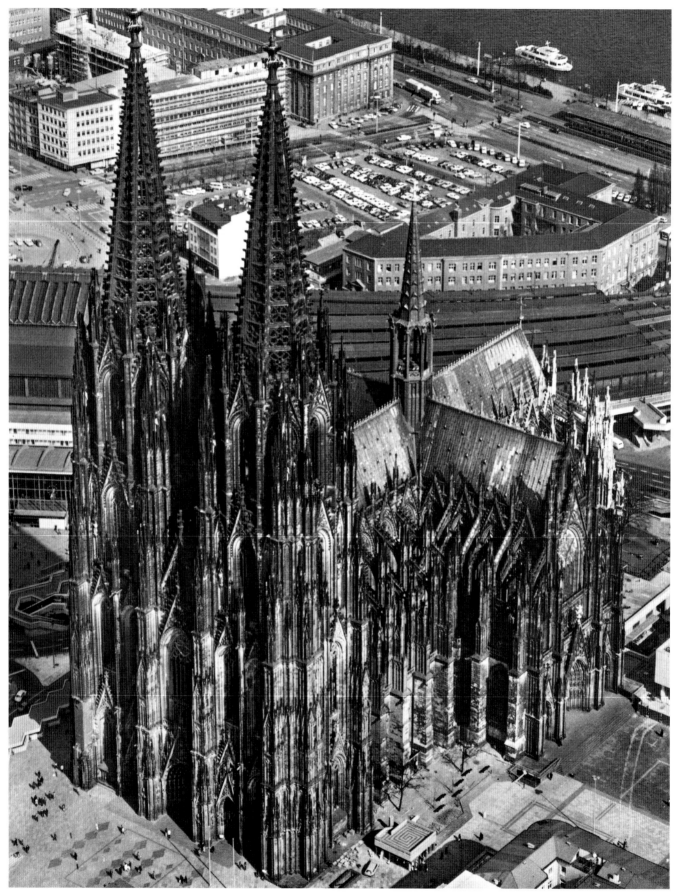

Fig. 20.5. Cologne Cathedral. Aerial view. Begun 1248; choir consecrated 1322; work stopped 1560; completed c. 1880

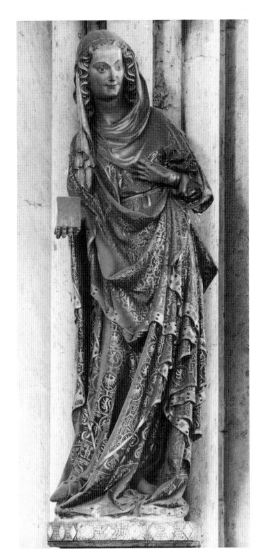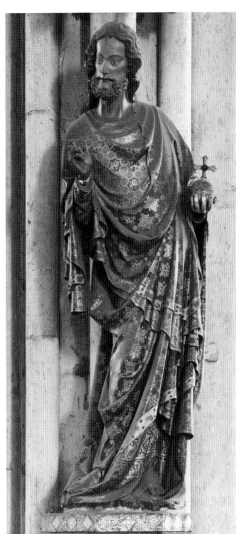

Fig. 20.6. (a) Virgin and (b) Christ. Stone statues on the piers of the choir, Cologne Cathedral. c. 1320

Master Gerhard commenced with the erection of the choir (which was consecrated in 1322, some forty years after his death) and then laid the foundations for the giant, five-aisled nave—the church is 472 feet long—but work progressed only to the height of the nave arcade (it too was completed in the nineteenth century). Its elegant proportions and soaring verticality (150 feet) bring to mind the choir of Amiens. The ground plan, with its corona of seven chapels, is also like that of Amiens. From the exterior the majestic rise of the flying buttresses creates an even more pronounced sensation of lofty verticality and transparency, resembling, in fact, the choir of Beauvais Cathedral.

The piers on the interior are grooved between the shafts so that they appear more sculptural, with concave penetrations and shadows along their contours. The exterior gables are pierced with tracery patterns of inverted Y-bars (*Dreistrahlen* in German) that accentuate the openings with rhythmic regularity. In spite of certain indifferences in the architectural execution of the huge cathedral, the final effect is overwhelming. When Petrarch visited Cologne in 1333 he noted, "In the middle of the city I saw an uncommonly beautiful temple, which, though still incomplete, can be called with good reason the most magnificent."[3]

A profusion of sculptural decoration was planned for Cologne both inside and out. With the exception of the south portal of the facade, little work was accomplished in the Middle Ages. On the interior, the fourteen piers in the choir are adorned with statues, executed about 1320. On the north and south side at the beginning of the chancel, opposite each other, stand the Virgin and Christ (**fig. 20.6**) followed by the twelve apostles, standing on foliate corbels and covered by high tabernacles.

Perhaps inspired by the similar series at Sainte-Chapelle (1248), the figures of the Cologne choir display the features of the mannered style of Late Gothic that can be seen on the west facade of Strasbourg. Their tall, lean bodies sway like

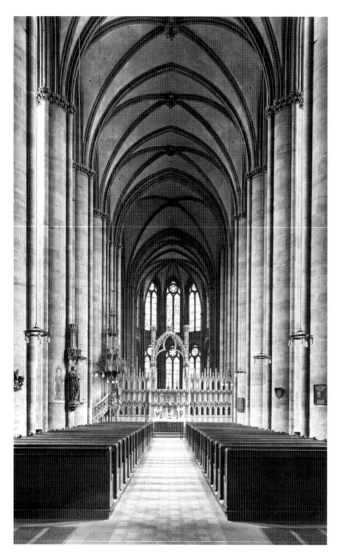

Fig. 20.7. Church of Saint Elisabeth. Marburg. Nave. 1235–83

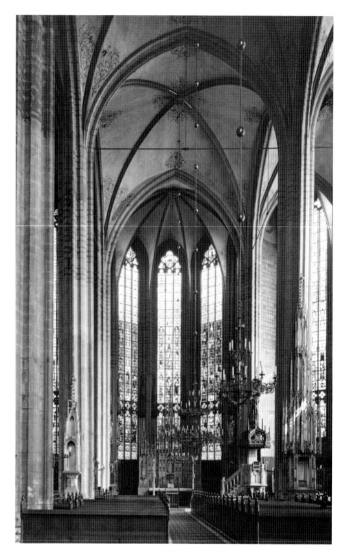

Fig. 20.8. Wiesenkirche (Santa Maria zur Wiese), Soest, Westphalia. Nave. Begun 1331

fragile coat racks upon which their heavy mantles are cast. This drapery falls in generous arcs with intricate overlaps and cascades. Not only are the postures and draperies mannered in appearance, but the heads also strike one as extreme elaborations of the charming realism initiated by the Smiling Angel Master at Reims some eighty years earlier.

East of Cologne, at Marburg on the river Lahn, the Church of Saint Elisabeth (1235–83) presents us with one of the earliest distinctive Germanic variations on French Gothic architecture (**fig. 20.7**), the so-called hall church (*Hallenkirche*). In the hall church, the side aisles are the same height as the nave and the thin piers rise uninterrupted—galleries and triforium are eliminated—creating a lofty openness with an exceptional sense of free-flowing space through the interior.[4] The side walls of the aisles and the trefoil choir are lined with two rows of tall windows, one over the other, providing the high space with a soft, diffuse illumination very unlike that of the darker interiors of French Gothic. Saint Elisabeth served

as a pilgrimage church and a mausoleum for local lords, and many of the later hall churches were built by the mendicant orders (as opposed to those built for the bishops), where the greater spatial unity enhanced their architectural character as "preaching halls."

One of the most beautiful of these churches is the Wiesenkirche (Santa Maria zur Wiese) at Soest in Westphalia (**fig. 20.8**), begun in 1331. The soaring ascension of the interior with its pear-shaped shafts and hollows in the tall piers is enhanced by the subtle proportions of height to width, which according to some scholars, are based on the principles of the golden mean. As ideal preaching halls, the *Hallenkirchen* spread rapidly throughout Germany.

Some German hall churches were constructed with remarkable ceilings decorated with intricate patterns. The vaulting of the Church of Saint Anna in Annaburg (**fig. 20.9**) is highly ornate. Delicate floral patterns, produced by the reversing of curved ribs, enhance the interior's elegance and grace.[5]

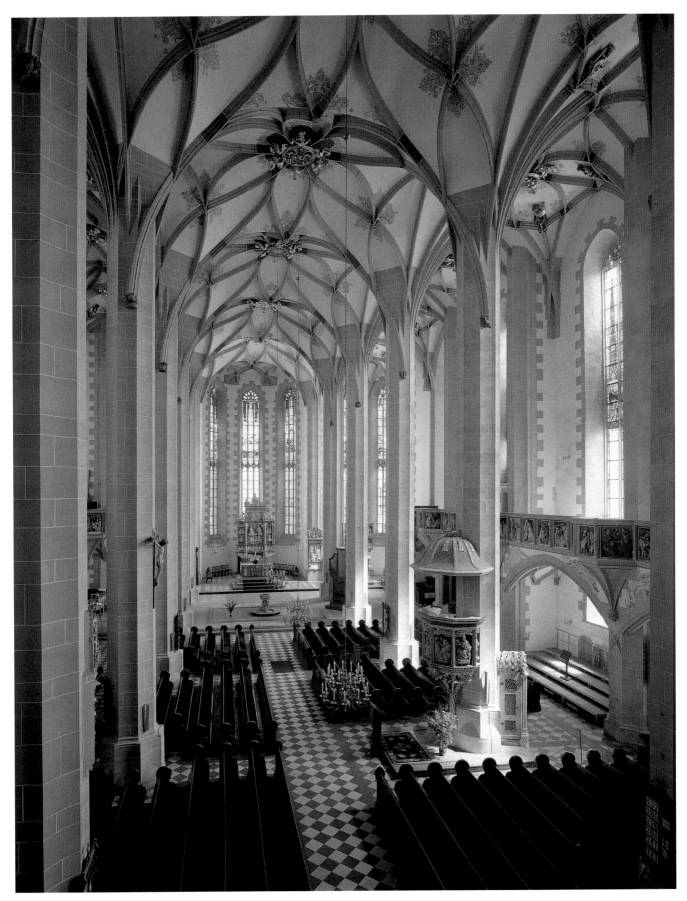

Fig. 20.9. Saint Anna, Annaburg. 1499–1522

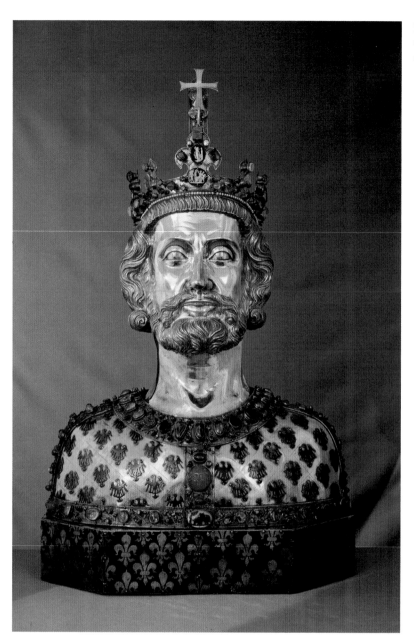

Fig. 20.10. Reliquary bust of
Charlemagne. Silver gilt, height 33⅞″.
c. 1350. Cathedral Treasury, Aachen

During the Late Middle Ages, Charlemagne's Palatine Chapel (fig. 8.2) was remodeled. A new choir was added to house the ninth-century emperor's bodily remains and served as the site for imperial coronation. Completed in 1414, the choir closely resembles Louis IX's Sainte-Chapelle, with numerous elongated windows reaching from floor to ceiling. In 1349, Charles IV of Bohemia donated a gold reliquary bust of Charlemagne (**fig. 20.10**), studded with precious gems and cameos. Charles's gift not only promoted Charlemagne's canonization, it also affirmed the legitimacy and authority of his own role as the newly crowned king of the Germans and leader of the Holy Roman Empire.

CHURCHES IN THE EASTERN TERRITORIES

The new Gothic churches in western Germany asserted their independence from the imperial foundations such as Speyer, Worms, and Mainz, much as the communities themselves, especially Cologne, broke with the authority of the Hohenstaufens after the excommunication of Frederick II. Thus it seems that emergence of the Gothic style depended not only on the proximity of France but on political circumstances as well. Matters were different further east. At Bamberg in northern Bavaria, Bishop Ekbert of Andechs (1203–37) maintained close ties to Frederick, who, in fact, was a major benefactor of the church during a rebuilding campaign following a fire in 1183.[6]

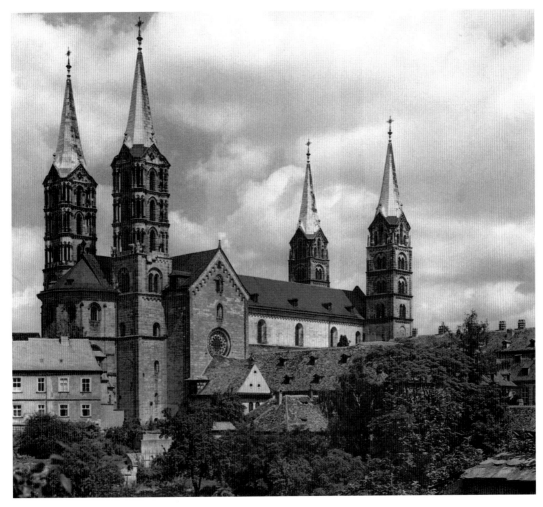

Fig. 20.11. Bamberg Cathedral. Exterior from the north. 1200–1237

The ties with the *imperium* are evident in church architecture. The new cathedral in Bamberg (**fig. 20.11**), erected between about 1200 and 1237, has a long nave terminating in double choirs, resembling the so-called double-enders found in earlier imperial foundations along the Rhine. The architect Wortvinus has been credited with much of the rebuilding as well as the sculptural decorations for the new cathedral. These include the impressive stone reliefs adorning the monumental choir screen on the east (Saint George choir) with paired figures of standing prophets, on one side (**fig. 20.12**), and apostles, on the other, in animated disputation with each other.

Originally the "Bamberger Rider" was placed on the cathedral's exterior; today, however, it is located on the side of an interior pier (**fig. 20.13**). Much has been written concerning the identity of this striking equestrian figure.[7] He has been identified as one of the three Magi, as Saint George, and as a number of historical figures, including the emperor Constantine, Henry II, Stephen of Hungary, Conrad III, and Frederick II. Such large equestrian memorials are ultimately linked to ancient Rome and often associated with the equestrian portrait of Marcus Aurelius, which was misidentified as a representation of the first Christian emperor, Constantine. But the characterization here is very different from statues of Constantine. The rider wears a crown, but he is not depicted as a conquering, militant leader. Furthermore, certain conventions employed in the characterization suggest a more contemporary figure in history.

The youthful countenance—unbearded, with bright eyes, long curls, and well-formed lips—reminds us of descriptions of the Christian knight found in German epic literature of the period, such as that of Wolfram von Eschenbach's *Parzival.* The rider appears to be a determined aristocrat, with sound body and soul, who courageously leads his people. This statue may have originally appeared in the exterior tympanum of the so-called Adam's Portal of the east choir, where it would have been placed above jamb statues of Henry II and his wife Cunigunde, the original founders of Bamberg Cathedral. However, it is also tempting to see the rider as Frederick II, Bishop Ekbert's benefactor and sponsor of the new cathedral. Nonetheless, his identity remains his secret. A similar

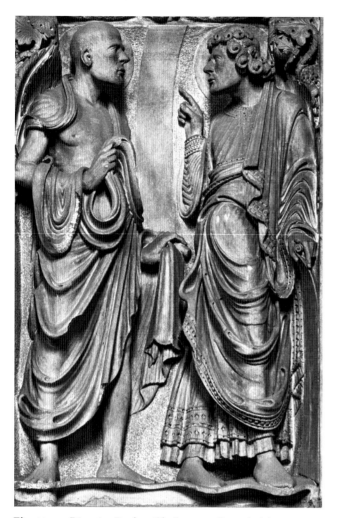

Fig. 20.12. *Disputing Prophets.* Choir screen. Stone, height approx. 4′. c. 1220–30. Bamberg Cathedral

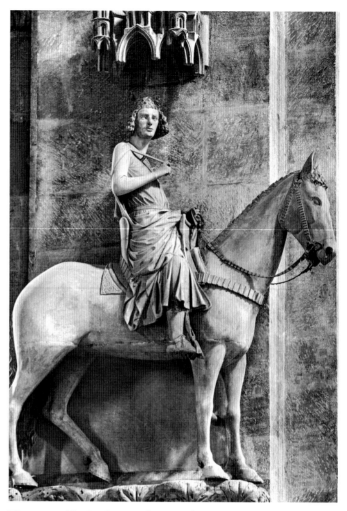

Fig. 20.13. *The Bamberger Rider.* Stone, height 7′ 9″. c. 1235–40. Bamberg Cathedral

equestrian portrait of approximately the same date was erected in the market square at Magdeburg, north of Bamberg.

In 1207, much of Madgeburg Cathedral was destroyed by fire. The church, which houses the relics of the third-century warrior-saint Maurice, was rebuilt in a Gothic style, but remained unfinished until the sixteenth century. During the renovation of the building, polychromatic sculptures were added to the church. Around 1240, a sandstone image of Saint Maurice (**fig. 20.14**) was erected. The work has been removed from its original setting on the church's exterior and is now located in the choir. According to the hagiographic sources, Saint Maurice was an Egyptian soldier in the Roman army. He was sent to Gaul, where he refused, contrary to military orders, to venerate pagan gods or kill his fellow Christians, and was subsequently martyred. The sculpture is polychromatic and is striking in its naturalism. Dressed in medieval armor, equipped with mail and a breastplate, Saint Maurice is depicted a crusading knight. His black complexion

reinforces his African identity, but it also invites comparisons to Moors depicted with similar features. Unlike infidels and mercenaries, who fight for false treasures, Maurice is an ideal Christian knight, who selflessly defends the faith. Not surprisingly, he was a very popular saint among crusaders and their supporters.[8]

During the first half of the thirteenth century, the Cathedral of Naumburg, a frontier town lying between Bamberg and Magdeburg on the Salle River, was rebuilt on the site of the castle of eleventh-century margraves. The Romanesque structure with its double choirs was completed under Bishop Dietrich II of Wettin (1244–72), who added the impressive western choir as a memorial to the members of the ruling families of Naumburg, of which he was a descendant. A very gifted sculptor headed the workshop for Dietrich's choir.[9]

The huge stone screen leading into the west choir was decorated with a broad band of reliefs along the top depicting seven scenes from the Passion of Christ, from the Last Supper

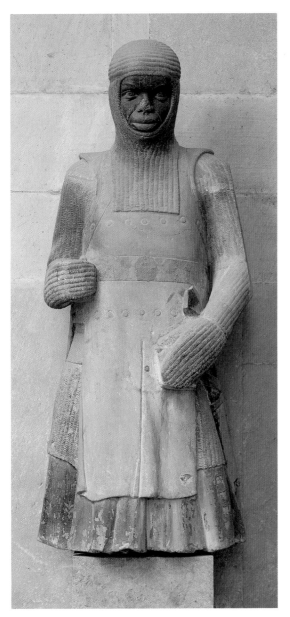

Fig. 20.14. *Saint Maurice.* Dark sandstone with traces of polychromy. c. 1240–50. Magdeburg Cathedral

Fig. 20.15. Choir screen with the Crucifixion. c. 1245–60. Naumburg Cathedral

to the Carrying of the Cross (**fig. 20.15**). The Crucifixion is presented by three monumental, freestanding sculptures placed on the jambs and the trumeau of the projecting gabled porch that serves as the entrance. Traditionally, such a Calvary group would be placed atop the screen, but here the lifesize figures are brought down to the level of the worshippers, and the exaggerated emotionalism of the two mourners, the Virgin and John the Evangelist, engages them directly. Mary, her faced lined with heartache and grief, gestures tenderly to the spectator, while, opposite her, John, sobbing openly, turns dramatically in his anguish, wringing his hands within the voluminous mantle folds as he glances tearfully downward.

Passing through this melodramatic entrance, we find ourselves in a deep, aisle-less choir lined with tall stained-glass windows. Placed within tabernacles along the wall of the choir are astonishing lifesize portraits of twelve ancestors of the houses of Billung and Wettin, who, although they counted notorious sinners among their members, were the benefactors of the original church. They stand in staid poses and look down at the altar as if perpetually attending a solemn Mass and reflecting on their fates.

Only the round-faced Regelindis, paired with her husband, the margrave Hermann (**fig. 20.16**), on the left wall, breaks the serious calm that pervades the group. She glances back toward the entrance as if to welcome the worshipper, and her warm smile, reminiscent of that of the Smiling Angel of Reims Cathedral, offers a brief moment of relief in the quiet drama that unfolds here. On the opposite side, Ekkehard

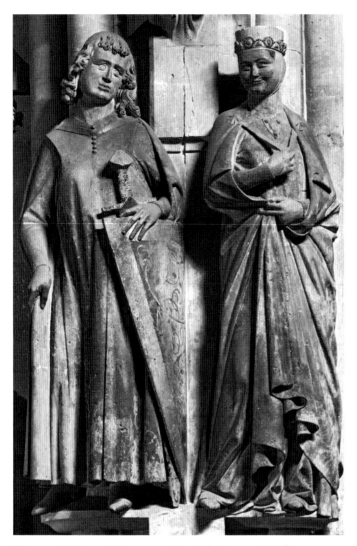

Fig. 20.16. *Margrave Hermann and Regelindis.* Stone, originally polychromed. Choir sculptures, Naumberg Cathedral. Height 6′ 2″. c. 1245–60

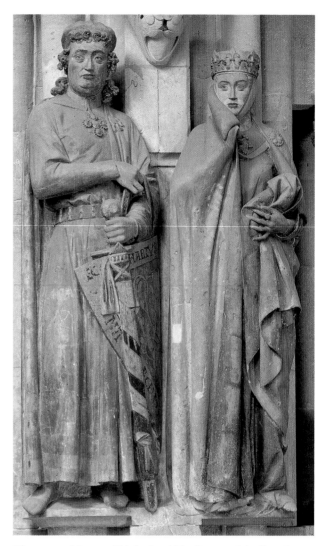

Fig. 20.17. *Margrave Ekkehard and Uta.* Stone, originally polychromed. Choir sculptures, Naumberg Cathedral. Height 6′ 2″. c. 1245–60

of Meissen is shown standing next to his wife Uta (**fig. 20.17**). Ekkehard leans on his ceremonial sword. He looks vigilant and steadfast, ever ready to protect Christendom from potential harm. Uta graciously draws the collar of her mantle across her cheek. Her elegant beauty is conveyed not only in her intense gaze and pouting lips, but in the massive straight folds of her cloak that descend from the collar. The heavy stuff, gathered and pulled upward by her left hand, sinks under the tight grasp of her fingers and breaks into a flowing cascade falling on the right. Although not actually portraits— these people lived many years before the execution of their likenesses—the sculpted figures evoke a haunting characterization of these aristocrats. Their naturalistic appearance makes them seem to be present.

ANDACHTSBILDER

Mysticism flourished in Late Medieval Germany, especially in the Rhineland. Within this religious context, a new genre of freestanding sculpture developed. Named *Andachtsbilder* in the eighteenth century, these devotional images were produced to foster religious contemplation. In *Andachtsbilder* narratives are typically abbreviated. Poignant moments and major characters of the drama are isolated to encourage empathetic responses among viewers.[10] For instance, the figures of Christ and the sleeping Saint John (**fig. 20.18**) are lifted from the familiar narrative composition of the Last Supper; alone they vividly project the comfort and warmth of Christ's words that one must love one's brother. John's sleep not only implies that he is dead to this world, but that his

Fig. 20.18. *Christ with the Sleeping Saint John the Evangelist.* Wood, height 35¼″. c. 1330. The Cleveland Museum of Art

Fig. 20.19. Crucifix *(Pestkreuz).* Wood, height 57″. 1304. Schnütgen Museum, Cologne

heart is open and awake, ready to receive mystical union with God (Song of Songs 5:2).

At the opposite extreme of psychological drama is the excruciatingly agonizing Crucifix (**fig. 20.19**), known as the *Pestkreuz*, or Plague Crucifix. The bleeding and broken body of Christ is placed directly before the worshipper at the altar in painful proximity, so that he may count every drop of blood, witness the terrible contortions of Christ's features, and shudder before the festered and emaciated limbs of the lifeless Christ, who died brutally for man's salvation. Special attention is given to Christ's suffering, inviting viewers to ponder the means of redemption. The drastic angularity of Christ's body, the attenuation of his limbs to mere skeletal contortions, with the deep, dark cavity of his stomach sucked into the bony rib cage, and the harsh features of the face, elicit empathy and compassion.

The use of optical naturalism, which is typically associated with the Renaissance and early modernity, was not foreign to the Middle Ages, nor did it pose a threat to med-

ieval piety.[11] On the contrary, naturalism was frequently employed to reveal the pertinence of the sacred in the here and now. However, it was also occasionally used to promote mystical insight.

One of the most moving *Andachtsbilder* is that of the seated Virgin holding the dead Christ across her lap (**fig. 20.20**). Extracted from the Lamentation episode, the sculpture encourages piety and pity. The traditional image of the Virgin and Child, the pretty young mother cradling her newborn baby tenderly in her arms—her joy—is transformed into a brutal portrayal of the same mother, now aged, worn, and exhausted in grief, grasping her son's broken body for the last time—her sorrow. This poignant characterization of the Mother and Child had a profound influence in Marian imagery in the next centuries, the most famous being the sublime *Pietà* by Michelangelo in Saint Peter's, where distortion and ugliness are abandoned for beauty and idealism, even in death. It is commonly called a *Vesperbild* because it evokes the heartache and grief of Mary promoted in the worshipper's

Fig. 20.20. *Pietà (Vesperbild)*. Wood, originally polychromed. Height 34½″. c. 1330. Landesmuseum, Bonn

Fig. 20.21. Master Heinrich of Constance (attributed). *The Visitation*. German. Wood, polychrome and gilt, height 23¼″ × 12″. c. 1310. Metropolitan Museum of Art, New York

contemplation during Vespers, at the end of the liturgical day. Red paint covers the deeply carved wounds of the sculpture, intensifying the horror of the scene as it encouraged viewers to meditate on the presence of his body and blood in the Eucharist.[12]

Two statuettes (**fig. 20.21**) from the Dominican convent at Katherinenthal represent the Virgin Mary and her elder cousin Elizabeth during the Visitation (Luke 1:39–56). The two pregnant women have crystals located on their chests, suggesting the purity of their wombs as virtuous places for the Son of God and John the Baptist to dwell. The sculpted figures do not merely illustrate a biblical narrative. On the contrary, they are intended to foster mystical devotion. In imitation of Mary and Elizabeth, pious viewers are expected to conform their hearts to temples or houses of God. As an image of contemplation, the scene offers opportunities to help prepare for the welcoming God into the hearts of believers.[13]

From a nunnery near Cologne, a *Madonna lactans* (**figs. 20.22, 20.23**), showing the Christ Child nursing at the Virgin's breast, promotes mystical piety and Eucharistic devotion. Christ holds a dove as he receives nourishment from his mother's anatomically dislocated breast. She is the means of

Figs. 20.22, 20.23. Shrine of Virgin and Child (*Vierge ouvrante*). Closed and open. German. Wood, covered with linen, gesso, polychrome and gilt, height 14½″. c. 1300. Metropolitan Museum of Art, New York

redemption, through her womb comes salvation. The figure is a *Vierge ouvrante*: the exterior opens up unveiling a decorated interior. When open, the interior reveals a *Gnadenstuhl* (Throne of Mercy), though the figures of Christ and the Holy Spirit are lost. In addition, the interior is painted with scenes narrating Christ's infancy. As the *Vierge ouvrante*, Mary holds the fruits of salvation within her. The sculpture may have been used to transport the consecrated host to those who were unable to attend Mass. The figure reinforces belief in the real presence of Christ in the sacrament and encourages beholders to imitate Mary by spiritual preparing themselves to receive his body and blood internally.[14]

MANUSCRIPTS

In an illuminated page from the Manesse Codex, the poet Konrad von Altstetten plays the roles of hunter and hunted in the pursuit of courtly love (**fig. 20.24**). A falcon is lured by a piece of red meat as a lady, embracing him, feeds on his heart. The woman is placed above him and her pose seems more active. Yet, it is impossible to determine which of the lovers is in control, for it simultaneously appears that he has arranged his own undoing.[15]

Images of mystical love can be as sensuous as those of courtly love. In a page from the Passionale of Cunegonde (**fig. 20.25**), the abbess of Saint George's Monastery in

Fig. 20.24. *Lady Embraces the Poet Konrad von Altstetten.* Manesse Codex. c. 1300. Universitätsbibliothek, Heidelberg (Cod. pal. Germ. 848, fol. 249v)

Fig. 20.25. *The Mystical Kiss.* Illumination in the Passionale of Abbess
Cunegonde. 1314–21. National Library of the Czech Republic, Prague
(MS xiv a 17, fol. 16v)

Fig. 20.26. *Saint Hedwig of Silesia with Duke Ludwig of Legnitz-Brieg and Duchess Agnes*. Illumination in the Hedwig-Codex. Leaf: 13⁷⁄₁₆″ × 9¾″. 1353. The Getty Museum, Los Angeles (MS Ludwig XI 7, fol. 12v)

Prague, elongated figures of the Resurrected Christ and the Virgin Mary, gazing into one another's eyes, share a warm embrace, cheek to cheek. Their loving caress seems to be a prelude to a mystical kiss. This moment of intimacy not only reveals Mary as the *Sponsa Christi* (Bride of Christ), it also calls viewers to imitate her actions, to love and embrace Christ as she does, to become Christ's devoted spouse.[16]

The frontispiece for the Hedwig-Codex (**fig. 20.26**) represents Saint Hedwig of Silesia holding devotional objects: a prayer book, prayer beads, and an ivory sculpture of the Madonna and Child. Hedwig, who was also the co-founder of the Cistercian convent at Trebnitz, is gracefully elongated

and depicted with the manuscript's patrons, Ludwig I of Liegnitz-Breig and his wife Agnes, presented in smaller scale. According to hagiographic sources, Hedwig was eternally bound to the Virgin Mary. Even after death, when most of her corpse was reduced to skeletal remains, Hedwig continued to clutch her devotional image of the Madonna and Child. Miraculously, the gripping fingers did not decay. Like her precious bones, the ivory sculpture became an object of veneration, indistinguishable from a relic.[17]

A nun from the Rhineland may have commissioned the Rothschild Canticles. Miniatures from adjoining pages allude to mystical union between Christ and the Christian

Fig. 20.27. *The Sponsa's Mystical Vision of Christ's Wounds.* Illumination in the Rothschild Canticles. c. 1340. Beinecke Library, Yale University, New Haven (MS 404, fols. 18v and 19r)

Fig. 20.28. Henry Suso. *The Mystical Way.* Illustration in *The Exemplar.* c. 1363. Bibliothèque Nationale et Universitaire, Strasbourg (MS 2929, fol. 82r)

soul (**fig. 20.27**). The illumination on the left is divided into two registers. In the upper half, the bride and bridegroom enter a garden of love, where they sweetly embrace. In the bottom register, like Longinus, the centurion who pierced Christ's side, the Sponsa holds a lance directed toward Christ on the adjacent page. On the right page, Christ is represented as the Man of Sorrows, surrounded by items associated with his Passion. Christ points to his side wound, identifying the place of penetration. As the object of devotional desire, Christ appears passive. By contrast, Sponsa seems active. Like the beloved from the Song of Songs, she ravishes his heart with one look of her eyes (4:9).[18]

The fourteenth-century mystic Henry of Suso experienced with a variety of ways to find union with God. A Dominican monk who provided pastoral care to local nuns, Henry wrote *The Exemplar*, a spiritual autobiography encouraging readers to follow a spiritual journey towards God. The earliest known copy of his book has eleven drawings illustrating the mystical way. One drawing (**fig. 20.28**) offers a diagram tracing the direction that the soul should take. It maps out spiritual progress, from its origins in the Trinity shown in the upper right to its telos in becoming one with the Godhead, which is represented on the upper left in the form of three concentric circles on the other side of a veiled tabernacle. The movement of the soul zigzags across the page in a clockwise manner. Along the way, the devout are asked to imitate Mary as the ideal model for loving God.[19]

Although mystical insight is, by definition, blind and silent to the things of this world, Late Medieval mystics and artists discovered effective ways to reveal that which transcends the possibility of communication. Their visual and verbal imagery did not merely localize the divine, but called viewers and listeners to search elsewhere, to a time and place yet to be seen or realized.

21
CODA:
INVENTING THE MIDDLE AGES

Two great principles divide the world, and contend for the mastery, antiquity and the middle ages. These are the two civilizations that have preceded us, the two elements of which ours is composed. All political as well as religious questions reduce themselves practically to this. This is the great dualism that runs through our society.

Lord Acton

Scholars of the eighteenth and nineteenth centuries created this dichotomy of the Classical and the Medieval as opposing esthetics, whereas syncretism has been a major theme of this textbook. The nostalgia for an imagined, more heroic or purer past, came in many forms. For some Catholics and some Protestants, the Gothic cathedrals embodied the beliefs of the medieval church built by the hands of master craftsmen as opposed to the increasing secularism of the Industrial Age. For others, the legends and myths of an earlier age evoked a magical time when true heroes sacrificed for king and country with little regard for their personal interests. Victorian England, Scotland, and Ireland looked to their own artistic traditions to redeem an ethnic and cultural heritage that spoke to the notion of a heroic past.

The Jesuit Marc-Antoine Laugier, an eighteenth-century proponent of Neo-Classical architecture, looked to nature for inspiration for the best architectural style. In the frontispiece for his *Essai sur l'architecture*, the personification of Architecture points toward the "primitive hut" to show Eros that it is in the forest that one must look to for true architecture (**fig. 21.1**). Architecture is seated on the rubble of Ionic columns and entablatures, while Eros contemplates the wooden columns and pediment. Written in 1753, Abbé Laugier's work offered a romantic theory that argued the origins of all good architecture could be found in the "primitive hut," a structure that relied solely on the loading bearing column, the entablature, and the pediment. While he was an advocate of Neo-Classical architecture, Laugier believed that only the Gothic, medieval style was the true expression of Catholic belief and so was the only appropriate style for churches. His

strong Catholicism overrode his intellectual pursuit of the Classical. Indeed, the religious leanings of many proponents of Gothic Revival would shape the renewed interest in all things they deemed "medieval."

This attitude is articulated most clearly by François-René Chateaubriand (1768–1848). In his *Génie du Christianisme*, he described the cathedral in these poetic words that captured the meaning of Gothic for many of his day who shared the belief that Gothic alone expressed the essence of the Catholic faith:

> Forests were the first temples of God, and in forests men grasped their first idea of architecture. This art has had to vary according to climates. The Greeks shaped the elegant Corinthian column, with its capital of leaves, on the model of the palm . . . The forests of the Gauls passed in their turn into the temples of our fathers, and our oak forests have thus preserved their sacred origin. These vaults incised with leaves, these socles that support the walls and end brusquely like broken tree trunks, the coolness of the vaults, the shadows of the Sanctuary, the dark aisles, the secret passages, the low doors, all of this evokes in a Gothic church the labyrinths of the forests; it all makes us conscious of religious awe, the mysteries, and the divinity.[1]

Chateaubriand is but one of many eighteenth-century art lovers who reacted passionately to the hostile condemnation of the Gothic that had been voiced by the humanists

Fig. 21.1. Frontispiece to *Essai sur l'architecture* by Marc-Antoine Laugier. Engraving, 6⅛ × 3⅝″. Paris. 1753

Fig. 21.2. Eugène-Emmanuel Viollet-le-Duc. Saint-Denis, project for the restoration of the west facade by François Debret, 1837

of the Renaissance. The Italian Giorgio Vasari, acclaimed the father of art history, wrote in the introduction to his *Lives of Artists* (1550) that Gothic architecture, "monstrous and barbarous," was "invented by the Goths, who filled all Italy with these damnable buildings." Those "damnable buildings" had their origins in the Île-de-France, where the interest in medieval architecture was enjoying a revival.

Eugène-Emmanuel Viollet-le-Duc (1814–79) was another strong proponent of the Gothic Revival and figured prominently in the renewed interest in Gothic cathedrals. Through his writings, his restoration work, and his designs, his name became one of the most well known in France for the advocacy of France's architectural heritage. The French Revolution had taken a heavy toll on the French Gothic cathedrals, whose Old Testament kings and queens on the western facades were mistakenly associated with the French monarchy and thus were often vandalized or even destroyed.

Viollet-le-Duc was determined to restore these cathedrals to their original style, since previous efforts at restoration had resulted in poor esthetic choices that masked the original intent. One of his primary principles was to make a series of exacting drawings from which he could then make what he deemed correct choices regarding restoration (**fig. 21.2**). Viollet-le-Duc has been vilified for some of his decisions, many of which were done out of necessity, but he should be credited for his insistence that where possible the original materials should be used and that the stability of the structure should be paramount.[2] His precise studies were part of the empirical approach to the examination of the past that marked the first renewed interest in medieval architecture. As the Gothic Revival gained momentum, a more romantic approach can be discerned.

The Gothic Revival was especially strong in England and one of its primary advocates was Horace Walpole

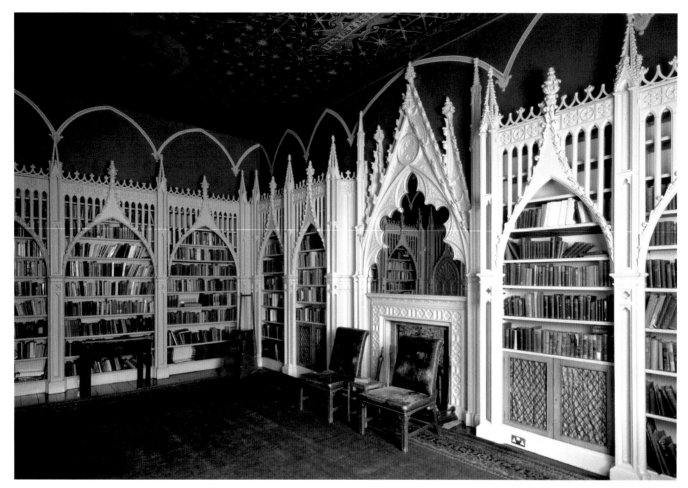

Fig. 21.3. Horace Walpole. Strawberry Hill, Twickenham. After 1754

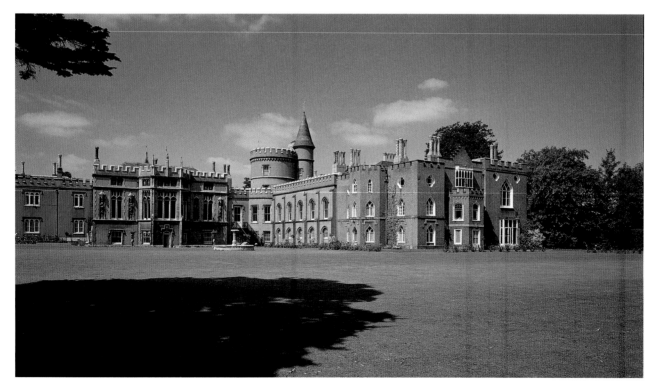

Fig. 21.4. Horace Walpole and others. Strawberry Hill seen from the gardens. 1749–76

(1717–97). Walpole advanced the notion that medieval architectural styles could not only be applied to ecclesiastical architecture but to domestic architecture as well. In the fashionable area of Twickenham, near London, Walpole purchased a small house in 1748 and immediately began plans for a complete renovation both inside and out (**figs. 21.3, 21.4**). Initially, the first designs were loose interpretations of the Gothic, but increasingly Walpole insisted on exact replication of Gothic models. Choosing an asymmetrical plan, Walpole based his designs for his gate entrance and his Chapel of the Woods on English Gothic precedents such as the tomb screens at Ely and Salisbury Cathedrals. Over the years, Walpole added a cloister, turrets, and pointed arches on the exterior to become a fantasy of Gothic Revival. Walpole's advocacy of the Gothic Revival was not limited to architecture, but extended to amassing an impressive, if erratic, collection of books, furniture, and curios, as well as promoting publications of Gothic model books.[3]

Indeed, Walpole is credited with the writing of the first Gothic horror story, *The Castle of Otranto* (1765), which was the forerunner of such books as Bram Stoker's *Dracula* of 1897. The Gothic novel is characterized by horror, violence, the supernatural, and a penchant for the medieval, since the backgrounds were often Gothic architecture, especially a gloomy, menacing, and isolated castle. The Gothic novel was wildly popular, with books such as Ann Radcliffe's *The Mysteries of Udolpho* (1794) romanticizing the tragic, dark hero.

That dark, gloomy and tragic nostalgia was brought to its apex with the paintings of the German artist Casper David Friedrich, whose medieval landscapes characterized the Romantic notions of the Middle Ages. His *Monastery Graveyard in the Snow* seems eerily parallel to the dark landscapes of the Gothic novel (**fig. 21.5**). The ruin of a Gothic choir is a repeated motif in Friedrich's work, symbolizing for him the loss of the medieval Christian Church, while the ragged trees symbolize the pagan traditions of pre-Christian Europe.[4] In Friedrich is found the curious tangle of pagan and Christian motifs that are mixed and matched to achieve a Romantic longing for a past that is both menacing and more magical.

If the Gothic novelists and Friedrich dwelt among the ruins of imaginary medieval cathedrals, Sir Charles Barry and Augustus Welby Pugin collaborated to achieve one of the most spectacular achievements of the Gothic Revival, the Houses of Parliament in London (**fig. 21.6**). A convert to

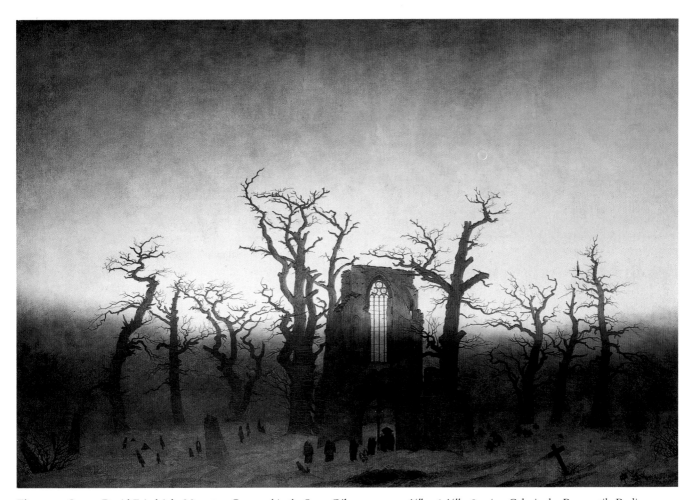

Fig. 21.5. Caspar David Friedrich. *Monastery Graveyard in the Snow.* Oil on canvas, 43½″ × 67¼″. 1809/10. Galerie der Romantik, Berlin

Fig. 21.6. Charles Barry and A. W. Pugin. Houses of Parliament, London. 1840–52

Catholicism, Pugin was taught as a young man the appreciation of medieval Gothic architecture by his father, who took him on many trips to the Continent to study its monuments. While Barry was in charge of the Houses of Parliament, it was Pugin who was relied upon for all the medieval architectural details and the interior designs.[5] With the Houses of Parliament, the Gothic had entered the political as well as the domestic and ecclesiastical arena.

In France and Britain, much of the Gothic Revival was focused on architecture of the Île-de-France, but a parallel current can also be found in Ireland, Scotland, and England. This looked to the ancient Britons and Celts for a distant past that spoke to contemporary desires. This can best be embodied by the bronze sculpture of Boudicca and her daughters that stands on Thames Embankment next to the Houses of Parliament. The 1902 sculpture by Thomas Thorneycroft portrays in an aggressively heroic manner the Iceni queen who dared to raise an army against the Roman Empire (**fig. 21.7**).[6] The Iceni king Prasutagus, hoping to curry favor with the Romans, had made the Roman Emperor Nero co-heir with

his daughters to his considerable kingdom and wealth. Suetonius Paulinus, the governor of Roman Britain at the time, did not think it suitable to co-rule with women and so he ordered the daughters raped and Boudicca publicly flogged. At this extreme insult and violence, the Iceni tribe rose up to defeat the Roman army at Camulodunum (Colchester) and moved on to sack and burn the Roman towns of Londinium (London) and Verulamium (St Albans) in A.D. 61. Eventually, Boudicca and her army were defeated and she committed suicide to escape further humiliation at the hands of the occupying Romans. Despite being a woman, she became a powerful and heroic symbol of British fortitude, a woman who dared to defy the mighty Roman Empire.

By far the most popular hero of Britain's past was the epic figure of King Arthur. Arthurian legends enjoyed a renewed popularity with Alfred, Lord Tennyson's *Idylls of the King*, a series of poems in ten books (1859–85). Tennyson drew heavily upon Sir Thomas Malory's fifteenth-century *Le morte d'Arthur*, the finest medieval prose collection of Arthurian romance. New and revised editions of Malory's work were

Fig. 21.7. Thomas Thorneycroft. *Boudicca and Her Daughters*. Bronze. 1902. Thames Embankment, London

Fig. 21.8. James Archer. *La Mort D'Arthur*. Oil on millboard. 1860. Manchester City Art Gallery

Fig. 21.9. William Morris. *Queen Guenevere*. Oil on canvas. 1858. Tate Gallery, London

issued that were intended to appeal to a broad audience, with simplified and updated language. The popularity of Arthurian legends opened up a whole new area of subject matter for nineteenth-century artists looking for historical topics and epic tales. John Archer's *La Mort d'Arthur* was one in a series of paintings that attempted to illustrate the quasi-historical King Arthur (**fig. 21.8**). Archer drew on a number of literary sources to create his series and returned to the story of Arthur's death five times. The broken and gaunt body of the king lies on the shores of Avalon, where he was taken after his final, terrible battle. Avalon is the mysterious Isle of the Blessed in the western seas from which the king intends to return to his beloved country. The death barge retreats in the distance, while the king has a vision of the Holy Grail, a symbol of his heroic sacrifice and reward. In his final battle, King Arthur faced his mortal enemy Modred (Mordred); in his confrontation with his enemy and his willingness to accept nobly his ultimate sacrifice, the figure of the Fallen Hero became a symbol of sacrifice, an adherence to ideals and duty, and to the acceptance of death with dignity.[7]

If King Arthur was the embodiment of the masculine Fallen Hero for the Victorians, the female counterpart of Queen Guenevere is more ambiguous. Guenevere's betrayal of her husband showed her to be of limited vision and personal self-interest as opposed to Arthur's vision of a united and peaceful kingdom, even at great personal cost. William Morris painted one of the more puzzling depictions of her in his 1858 *Queen Guenevere* (**fig. 21.9**). Set in a lush background of the queen's bedroom, the solitary figure of the queen is caught in a moment of contemplation while she pauses in buckling her belt. Does she regret her actions? Morris wrote a "Defence of Guenevere" in which she explains her torment at being torn between the two loves. A more sympathetic portrayal of the queen, it was not well received by the Victorian audience.

John Duncan's *Riders of the Sidhe* is an example that more than Arthurian legends were studied to find subjects of national pride and to find a higher spiritual truth (**fig. 21.10**). The Sidhe (pronounced shee) are the fairy folk whose dwelling-place is thought to be the great tumulus of New Grange on the northern bank of the Boyne in Ireland. Each year on the Eve of Saint John, the Sidhe ride forth from their dwellings to the sacred circle to initiate mortals into the mysteries of their faith. Duncan chose to paint a highly romanticized image of these otherworldly creatures, portraying them as noble lords and ladies from a romantic medieval past.

Fig. 21.10. John Duncan. *Riders of the Sidhe.* Tempera on panel, 45 × 69″. 1911. Dundee Art Gallery

Many regarded him as a mystic, and he confessed to hearing "fairy music" while he painted; nevertheless, John Duncan was a leading figure in the Celtic Revivalist movement, a movement that was simultaneously evolving throughout Europe along with the Arts and Crafts Movement, the Symbolist movement including the Pre-Raphaelites, and Art Nouveau. The Celtic Revival in Scotland started as a movement to evoke a pre-British Scotland and to stress Scotland's individual identity.[8] The Celtic Revival began around 1880 when a new wave of nationalism arose in Europe promoting the ethnic homogeneity of the states, and Scotland appears to conform to this new pattern. John Duncan's work made its

appeal on the grounds that there was once a unifying Celtic culture to which all Scots were still fundamentally related.

As one of Duncan's contemporaries stated, "he is one of les Jeunes who seek rather for the imaginative beauty of design and the loveliness of fair color, and, rejecting the tedious realism of those who merely paint what they see, try to see something worth seeing, and see it, not merely with actual and physical vision, but with that nobler vision of the soul which is far wider in spiritual scope, as it is far more splendid in artistic purpose."[9]

This notion of "seeing" more than mere physical reality but a deeper soul searching for truth is fully expressed in his

THE WEST SIDE OF THE WEST CROSS, MONASTERBOICE C^{TY} LOUTH.

Fig. 21.11. Antiquarians or Artists Inspecting the Cross at Monasterboice. *Illustrations of the Most Interesting of the Sculpted Crosses of Ancient Ireland, drawn to scale and lithographed* by Henry O'Neill. 1857

Riders of the Sidhe, which is a curious pastiche of pagan and Christian imagery. The riders carry symbols of their faith and power, each a symbol of age-long Celtic tradition. The leading rider (to the left) holds the symbol of wisdom, the tree of life, and of the knowledge of good and evil; the second holds the Grail cup of the heart of abundance and healing as the symbol of Love; the third, the sword of power, the symbol of will in action (on its active side); and the last, the crystal that reveals the past and the future, the symbol of the will in its passive form (on its passive side). Each rider by his pose and facial expression reflects the symbol he carries: the first appears wise, the second loving; the third eager and hopeful; and the fourth patient and strong. It was by filling the faces of the riders with their virtues that Duncan hoped to achieve more than allegory—a shining symbolism of the best of humankind. The inscription on the frame reads: "The Riders of the Sidhe, Lords of Life, bearing as symbols, the Tree of Experience, the Love-Cup, the Sword of Will, and the Stone of Quietness."

The painting is full of ornamentation that finds its sources in the art of the ancient past. The first two riders are wearing pennanular brooches similar to the Tara and Ardagh brooches (figs. 7.20–22), and the first and last riders are adorned with gold bracelets that resemble those found in a princely tomb in France dated around the sixth century B.C. The chalice held in the hands of the second rider appears similar to the Ardagh chalice from the ninth century A.D. The shield in Duncan's painting is decorated with two large circular discs that are connected by two back-to-back, crescent-shaped forms. This motif finds its origin in Pictish symbols. On the stone from Aberlemno, Scotland, which dates from the eighth century, a similar shield motif is visible, as well as a snake that has similarities to the gold snake on the head of the first rider (figs. 7.27, 7.28).

Interest in the past and its material remains is summed up in Henry O'Neill's lithograph of antiquarians inspecting the cross at Monasterboice, from his book entitled *Illustrations of the Most Interesting of the Sculptured Crosses of Ancient Ireland*, published in 1857 (**fig. 21.11**). Drawn to scale, his lithograph shows two well-dressed men of the intellectual class who find much to admire in the large sculpture. The cross, though admittedly one of the tallest to survive in Ireland, has grown in monumental stature and is surrounded by a wildly romantic and lonely landscape that has little to do with the reality of the setting. The wheeled Irish cross, the symbol of Catholic monasticism, has been transformed into an imposing symbol of Irish cultural heritage. Faced with the distasteful caricature of the drunken Irish "Paddy," Irish nationalists set on a determined path to retrieve and rehabilitate their image through past achievements. The Gaelic Society of Dublin, for example, founded in January 1807, published its *Transactions* in 1808. Its initial volume announced its intentions: "The Society recommends itself to every liberal, patriotic, and

enlightened Mind; an opportunity is now, at length, offered to the Learned of Ireland, to retrieve their Character among the Nations of Europe, and shew that their History and Antiquities are not fitted to be consigned to eternal oblivion." O'Neill, a passionate nationalist, was a key figure in promoting this past with his publication.

The above survey of Gothic and Celtic Revival, which can be classified under the umbrella term "Medievalism," only touches on a few themes, such as a nostalgia for a united Catholic Church, the ancient past of mythical heroes, a past golden age, and a more spiritual and magical time than the present.

The present day is not immune to the draw of the past. The sustained popularity of J. R. R. Tolkien's trilogy *The Lord of the Rings* (1954) is testament to the continued interest in an imaginary past. Peter Jackson's movie version of *The Lord of the Rings* (2001, 2002, 2003) is like a celluloid version of Acher's, Morris's and Duncan's paintings, incorporating myriad motifs from an ahistorical and highly disparate medieval cultural heritage. Perhaps Norman Cantor summarizes best the reasons for continued interest in the Middle Ages, and why this period is worthy of continued study:

> There are two ways that medieval studies can be didactically justified as of central and consistent importance in education and culture. First, we can say the medieval heritage is very rich today in a prominent set of ideas and institutions, such as the Catholic Church, the university, Anglo-American law, parliamentary government, romantic love, heroism, just war, the spiritual capacity of little as well as elite people, and the cherishing of classical literatures and languages. That this heritage ought to be consciously identified, cultivated, and refined is commonly asserted. Secondly, we can say less conventionally that medieval civilization stands toward our postmodern culture as the conjunctive other, the intriguing shadow, the marginally distinctive double, the secret sharer of our dreams and anxieties. This view means that the Middle Ages are much like our culture of today, but exhibit just enough variations to disturb us and force us to question some of our values and behavior patterns and to propose some alternatives or at least modifications. The difference is relatively small, but all the more provocative for that.[10]

The Middle Ages is not simply a period of time located between Classical Antiquity and the Renaissance (or Early Modernity), in our distant past. The Middle Ages continues to be a compelling force, shaping our understanding of the past and informing our sense of the present.

NOTES

PART ONE
LATE ANTIQUITY

Chapter 1
Art and Religion in Late Antiquity

1. J. Stevenson, *The Catacombs: Rediscovered Monuments of Early Christianity*, London, 1978; L. V. Rutgers, *Subterranean Rome: In Search of the Roots of Christianity in the Catacombs of the Eternal City*, Leuven, 2000; P. Pergola: *Le catacombe romane: storia e topografia*, Rome, 1998; A. J. Osborne, "The Roman Catacombs in the Middle Ages," *Paper of the British School in Rome*, 53, 1985, 278–328; E. S. Brettman, *Vaults of Memory: Jewish and Christian Imagery in the Catacombs of Rome: An Exhibition*, Boston, 1985. For the sarcophagi, see L. V. Rutgers, *The Jews in Late Ancient Rome: Evidence of Cultural Interaction in the Roman Diaspora*, Leiden, 2000; A. Konikoff, *Sarcophagi from the Jewish Catacombs of Ancient Rome: A Catalogue Raisonné*, Stuttgart, 1990; E. S. Malbon, *The Iconography of the Sarcophagus of Junius Bassus: neofitvs iit ad deum*, Princeton, 1990; and F. W. Deichmann, G. Bovini, and H. Brandenburg, *Repertorium der christlich-antiken Sarkophage: Rom und Ostia*, Wiesbaden, 1967.

2. *No Graven Images: Studies in Art and the Hebrew Bible*, J. Gutmann, ed., New York, 1971, reprints a number of articles related to the Jewish position on iconoclasm. In general, see P. C. Finney, *The Invisible God: The Earliest Christians on Art*, New York, 1994; M. Miles, *Image as Insight: Visual Understanding in Western Christianity and Secular Culture*, Boston, 1985; S. C. Murray, "Art and the Early Church," *Journal of Theological Studies*, 28, 1977, 304–45; *Iconoclasm: Papers Given at the Ninth Spring Symposium of Byzantine Studies*, A. Bryer and J. Herrin, eds., University of Birmingham (Eng.), Birmingham, 1977; and A. Grabar, *L'Iconoclasme byzantin*, Paris, 1957.

3. Letter to Serenus, bishop of Marseilles, *Epistula IX. 28—Monumenta Germaniae historica*, Ep. 9, 195; and *Epistula XI—Monumenta Germaniae historica*, Ep. 11, 270.

4. For the general problems of early liturgies, see G. Dix, *The Shape of the Liturgy*, London, 1945, 78ff.; J. A. Jungmann, *The Mass of the Roman Rite*, New York, 1951, 7ff.; A. von Harnack, *The Expansion of Christianity*, New York and London, 1904; B. Stewart, *The Development of Christian Worship*, London, 1953.

5. A. McGowan, "Naming the Feast: The "Agape" and the Diversity of Early Christian Meals," *Studia Patristica*, 30, 1997, 314–318.

6. D. Verkerk, "*The Font is a Kind of Grave:*" Remembrance in the Via Latina Catacombs, "in *Memory and the Medieval Tomb*, E. del Alamo and C. Pendergast, eds., Aldershot, 2000, 157–81.

7. The prayer is later in date, but it reflects Early Christian types. See E. Le Blant, *Sarcophages de la ville d'Arles*, Paris, 1878, who relates it to the Roman *Ordo commendationis animae quando infirmus est in extremis* (cited in W. Lowrie, *Art in the Early Church*, 41).

Chapter 2
Constantine and the Arts

1. E. Kitzinger, *Byzantine Art in the Making: Main Lines of Stylistic Development in Mediterranean Art, 3rd–7th Century*, Cambridge, MA, 1977, 7–21.

2. R. Krautheimer, *Early Christian and Byzantine Architecture*, 316, n. 6, reviews this literature. Cf. K. G. Holum, "Basilica," in *Late Antiquity: A Guide to the Postclassical World*, G. W. Bowersock, ed., Cambridge, MA, 1999, 337–338; L. M. White, *The Social Origins of Christian Architecture*, 2 vols., Valley Forge, PA, 1996; and N. Duval, "Les origines de la basilique chrétienne—état de la question," *L'Information de l'histoire de l'art*, 7, 1962, 1–19.

3. See B. M. Apollonj-Ghetti *et al.*, *Esplorazioni sotto la confessione di San Pietro in Vaticano1940–1949*, Vatican City, 1951; J. Toynbee and J. W. Perkins, *The Shrine of St. Peter and the Vatican Excavations*, London, 1956; S. Ferber, "The Pre-Constantinian Shrine of St. Peter: Jewish Sources and Christian Aftermath," *Gesta* 10, 1971, 1–32; and R. Krautheimer, "The Building Inscriptions and Dates of the Construction of Old St. Peter's: A Reconsideration," *Römisches Jahrbuch für Kunstgeschichte* 25, 1989, 1–24. For an excellent discussion of the influence of Saint Peter's nave program, see W. Tronzo, "The Prestige of Saint Peter's: Observations on the Function of Monumental Narrative Cycles in Italy," *Studies in the History of Art*, 16, 1985, 93–112.

4. A. Stange, *Das frühchristliche Kirchengebäude als Bild des Himmels*, Cologne, 1950, 13–16, 102–9; L. Kitscheldt, *Die frühchristliche Basilika als Darstellung des himmlischen Jerusalem*, Munich, 1938; and R. Ousterhout, "The Holy Space: Architecture and the Liturgy," in *Heaven on Earth: Art and the Church in Byzantium*, L. Safran, ed., University Park, PA, 1998, 81–120.

5. C. B. Tkacz, *The Key to the Brescia Casket: Typology and the Early Christian Imagination,* Paris, 2002. See also, J. Elsner, *Imperial Rome and Christian Triumph*, Oxford, 1998.

6. Eusebius, *Vita Constantini* in J. P. Migne, *Patrologia Graeca*,

XX, 905ff., trans. P. Schaff and H. Wace in *A Select Library of the Nicene and Post-Nicene Fathers*, 2nd ser., New York, 1890, I, 473ff. For the foundations of Constantinople in general, see D. Dagren, *Naissance d'une capitale: Constantinople*, Paris, 1974; and R. Janini, *Constantinople Byzantine*, Paris, 1964. Also see C. Mango, "Antique Statuary and the Byzantine Beholder," *Dumbarton Oaks Papers*, 17, 1963, 53ff. For an extensive discussion of the *spolia* and sculptures, see the study by S. Basset, "'*Omnium Paene Urbium Nuditate.*' The Re-use of Antiquities in Constantinople, Fourth through the Sixth Centuries," Ph.D. diss., Bryn Mawr College, 1985. Cf. S. Guberti, "The Antiquities in the Hippodrome of Constantinople," *Dumbarton Oaks Papers,* 45 (1991): 87–96; L. James, "'Pray Not to Fall into Temptation and Be on Your Guard': Pagan Statues in Christian Constantinople," *Gesta*, 35 (1996): 12–20; and H. Maguire, and R. Ousterhout, eds., "Constantinople: The Fabric of the City," *Dumbarton Oaks Papers,* 54 (2000): 157–264.

7. J. Trilling, "The Soul of the Empire: Style and Meaning in the Mosaic Pavement of the Byzantine Imperial Palace in Constantinople," *Dumbarton Oaks Papers,* 43, 1989, 27–72.

8. S. Lewis, "Function and Symbolic Form in the Basilica Apostolorum," *Journal of the Society of Architectural Historians*, 28, 1969, 83ff.; and *idem*, "The Latin Iconography of the Single-Naved Cruciform Basilica Apostolorum," *Art Bulletin*, 51, 1969, 214–18. Also see her "Problems of Architectural Style and the Ambrosian Liturgy in Late Fourth-Century Milan," in *Hortus Imaginum: Essays in Western Art*, R. Enggass and M. Stokstad, eds., Lawrence, KA, 1974, 11–19.

9. The relevant texts are discussed in L. H. Vincent and F. M. Abel, *Jérusalem nouvelle*, 2 vols., Paris, 1925; and J. W. Crowfoot, *Early Churches in Palestine*, London, 1941.

10. W. Harvey, *The Holy Sepulchre*, London, 1935; K. J. Conant and G. Downey, "The Original Buildings of the Holy Sepulchre," *Speculum*, 31, 1956, 1ff.; A. Parrot, *Golgotha and the Holy Sepulchre*, London, 1957; and G. Coüason, *The Church of the Holy Sepulchre in Jerusalem*, London, 1974.

11. R. Krautheimer, *Early Christian and Byzantine Architecture*, 4th ed., New York, 1986, 36ff.

12. See F. van der Meer and C. Mohrmann, *Atlas of the Early Christian World*, London, 1958, 105–6.

13. A. Grabar, *Les ampoules de terre sainte*, Paris, 1958.

Chapter 3
The Fifth and Sixth Centuries

1. A. Muñoz, *Il restauro della basilica di Santa Sabina*, Rome, 1938; and F. Darsy, *Santa Sabina* (Chiese di Roma illustrate, nos. 63–64), Rome, 1961.

2. J. Wiegand, *Das altchristliche Hauptportal an der Kirche der hl. Sabina*, Trier, 1900; and W. F. Volbach, *Early Christian Art*, New York, 1962, nos. 103–5.

3. See W. Green, "Augustine on the Teaching of History," *University of California Publications in Classical Philology*, 12, 1944, 320ff. For the mosaics see, C. Cecchelli, *I mosaici della basilica di S. Maria Maggiore*, Turin, 1956, 197–246. Much controversy surrounds the subject matter of the Infancy scenes on the arch. See especially B. Brenk, *Die frühchristlichen Mosaiken in Santa Maria Maggiore zu Rom*, Wiesbaden, 1975, who suggests the influence of Leo the Great and his sermons on the makeup of the unique cycle; see also, J. D. Sieger, "Visual metaphor as theology: Leo the Great's sermons on the Incarnation and the Arch Mosaics at S. Maria Maggiore," *Gesta*, 26, 1987 83–91. N. A. Brodsky, *L'iconographie oubliée de l'arc éphésien de Sainte-Marie Majeure à Rome*, Brussels, 1966, rejects any references to apocryphal sources and cites Augustine's *City of God* as the primary textual inspiration; and S. Spain, "'The Promised Blessing:' The Iconography of the Mosaics of Santa Maria Maggiore," *Art Bulletin*, 61, 1979, 518–40, also rejects apocryphal sources and stresses the uniqueness of the iconography. Spain identifies the Presentation scene as the Betrothal of Mary and Joseph, the Annunciation as the Annunciation to Abraham and Sarah, and argues that the elaborately dressed woman in the mosaics usually identified as the *Maria Regina* is not the Virgin at all (she is the one dressed in somber blue in the Adoration of the Magi and in the scene usually identified as the Presentation, according to Spain).

4. T. Birt, *Die Buchrolle in der Kunst*, Leipzig, 1907. For a further discussion see K. Weitzmann, *Illustrations in Roll and Codex*, Princeton, 1947. In the development of narrative art, Weitzmann distinguishes three basic steps: (1) simultaneous illustration in archaic Greek art where several actions occur in a single scene; (2) monoscenic, or single-scene, pictures; (3) cyclical method with a series of consecutive scenes with separate actions but the same actors. See also K. Weitzmann, *Ancient Book Illumination*, Oxford, 1959; and *idem, Late Antique and Early Christian Book Illumination*, New York, 1977. Cf. R. Kozodoy, "The Origin of Early Christian Book Illumination: The State of the Question," *Gesta*, 10, 1971, 33–40. For more recent critiques see, M-L. Dolezal, "The Elusive Quest for the 'Real Thing': The Chicago Lectionary Project Thirty Years On," *Gesta,* 35, 1996 128–141; *idem*, "Manuscript Studies in the Twentieth Century: Kurt Weitzmann Reconsidered," *Byzantine and Modern Greek Studies* 22, 1998, 216–63; L. Drewer, "Recent Approaches to Early Christian and Byzantine Iconography," *Studies in Iconography* 17, 1996, 1–65; J. Lowden, "The Beginnings of Biblical Illustration," in *Imaging the Early Medieval Bible*, John Williams, ed., University Park, PA, 9–59; and *idem, The Octateuchs: A Study in Byzantine Manuscript Illustration.* University Park, PA, 1992.

5. J. de Wit, *Die Miniaturen des Vergilius Vaticanus*, Amsterdam, 1959; D. Wright, *The Roman Vergil and the Origins of Medieval Book Design*, London, 2001; and idem, *The Vatican Vergil: A Masterpiece of Late Antique Art*, Berkeley, 1993.

6. A. M. Friend, Jr., "The Portraits of the Evangelists in Greek and Latin Manuscripts," pt. 1, *Art Studies*, 5, 1927, 115ff., and pt. 2, *Art Studies*, 7, 1929, 3ff; and *Codex Vindobonensis med. Gr. 1 der Österreichischen National-bibliothek* (facsimile), H. von Gerstinger, commentary, 2 vols., Graz, 1965–70.

7. *Wiener Genesis: Purpurpergamenthandschrift aus dem 6. Jahrhundert: vollständiges Faksimile des Codex theol. Gr. 31 der Österreichischen Nationalbibliothek in Wien* (facsimile), O. Mazal, commentary, 2 vols., Frankfurt, 1980; and J. Lowden, "Concerning the Cotton Genesis and Other Illustrated Manuscripts of Genesis," *Gesta*, 31, 1992, 40–53.

8. D. Verkerk, *Early Medieval Bible Illumination and the Ashburnham Pentateuch*, Cambridge: Cambridge University Press, 2004.

9. A. Muñoz, *Il codice purpureo di Rossano*, Rome, 1907; and A. Grabar, *Les Peintures de l'Evangéliaire de Sinope*, Paris, 1948. For an excellent analysis of the miniatures in the Rossano Gospels see W. C. Loerke, "The Monumental Miniature," in *The Place of Book Illumination in Byzantine Art*, K. Weitzmann, ed., Princeton, 1975, 68–97.

10. A. Grabar, *The Golden Age of Justinian*, New York, 1967, 208; and W. C. Loerke, "The Miniatures of the Trial in the Rossano Gospels," *Art Bulletin*, 43, 1961, 171ff.

11. C. Nordenfalk, *Die spätantiken Kanontafeln*, Göteborg, 1938; and idem, "The Apostolic Canon Tables," *Gazette des Beaux-Arts*, 62, 1963, 17ff. Also see C. Cecchelli *et al.*, *The Rabbula Gospels* (facsimile), Lausanne, 1959.

12. For a discussion of the theophanies, see especially F. van der Meer, *Maiestas Domini: Théophanies de l'Apolalypse dans l'art Chrétien*, Vatican City, 1938; and W. Neuss, *Das Buch Ezechiel in Theologie und Kunst bis zum Ende des XII. Jahrhunderts*, Münster, 1912. Cf. J. Elsner, "The Viewer and the Vision: The Case of the Sinai Apse," *Art History*, 17, 1994, 81–102; and J.-M. Spieser, "The Representation of Christ in the Apses of Early Christian Churches," *Gesta*, 38, 1998, 63–73.

13. W. Frere, *The Anaphora*, London, 1929, 69ff. For a more specific association with the Church on the Mount of Olives, see S. Euringer, "Die Anaphoren des hl. Jacobus von Serug," *Orientalis cristiana*, 33, no. 90, 1934, 79–122, esp. n. 54. Cf. K. Weitzmann, "Loca Sancta and the Representational Arts of Palestine," *Dumbarton Oaks Papers*, 28, 1974, 31ff.

14. E. Hennecke, *New Testament Apocrypha*, W. Schneemelcher, ed., Philadelphia, 1963, I, 370–88 (for the Proto-evangelion of James).

15. H. C. Butler, *Architecture and Other Arts*, Pt. II: *Architecture* (Publications of the Princeton Archaeological Expeditions to Syria in 1904–1905 and 1909, pt. 2), Leiden, 1910–23; H. C. Butler and E. B. Smith, *Early Churches in Syria*, Princeton, 1929; and J. Lassus, *Sanctuaires chrétiens de Syrie*, Paris, 1974.

PART TWO
THE BYZANTINE EMPIRE

Chapter 4
Byzantine Art Before Iconoclasm

1. J. Morehead, *Justinian*, London, 1994; G. Ostrogorsky, *History of the Byzantine State*, Oxford, 1956; W. G. Holmes, *The Age of Justinian and Theodora*, 2 vols., London, 1905–7; and C. Mango, *Byzantium: The Empire of New Rome*, New York, 1980. See especially the writings of Procopius in the Loeb Classical Library, I—VI, H. B. Dewing, ed., and VII, G. Downey, ed., London, 1959; and *Procopius' Secret History*, trans. R. Atwater, Ann Arbor, 1976.

2. R. Delbrueck, *Die Consulardiptychen und verwandte Denkmäler*, Berlin and Leipzig, 1929, 12ff.; K. Wessel, "Das Diptychon Barberini," in *Akten des XI. Internationalen Byzantinistenkongresses*, Munich, 1960, 665ff.; W. F. Volbach, *Elfenbeinarbeiten der Spätantike und des frühen Mittelalters*, 3rd ed., Mainz, 1976, 47ff., no. 48; and E. Kitzinger, *Byzantine Art in the Making: Main Lines of Stylistic Development in Mediterranean Art, 3rd-7th Century*, Cambridge, MA, 1977, 96–98.

3. Procopius, *Buildings*, trans. H. B. Dewing and G. Downey in the Loeb Classical Library, London, 1959. A. van Millingen *et al.*, *Byzantine Churches in Constantinople*, London, 1912; E. H. Swift, *Hagia Sophia*, New York, 1940; R. L. van Nice, *Saint Sophia in Istanbul: An Architectural Survey*, Washington, DC, 1965; H. Köhler, *Hagia Sophia*, trans. E. Childs, London, 1967; H. Jantzen, *Die Hagia Sophia des Kaisers Justinian in Konstantinopel*, Cologne, 1967; T. F. Mathews, *The Early Churches of Constantinople: Architecture and Liturgy*, University Park, PA, 1971; C. Mango, *Byzantine Architecture*, New York, 1976; and R. Krautheimer, *Early Christian and Byzantine Architecture* (Pelican History of Art, no. 24), 4th ed., Harmondsworth, 1986, 215–44.

4. T. F. Mathews, *The Early Churches of Constantinople*, 88–116. For the influence of liturgy in general, see K. Liesenberg, *Der Einfluss der Liturgie auf die frühchristliche Basilika*, Neustadt, 1928; L. Bouyer, *Architecture et liturgie*, Paris, 1967; C. Walter, *Art and Ritual of the Byzantine*

Church, New York, 1982; and M. M. Solovey, *The Byzantine Divine Liturgy*, Washington, DC, 1970. The tenth-century ceremonies at Hagia Sophia are recorded by Constantine VII Porphyrogenitus in the *Book of Ceremonies*. See J. Ebersolt, *Ste. Sophie de Constantinople d'après les cérémonies*, Paris, 1910.

5. R. Krautheimer, *Early Christian and Byzantine Architecture*, 233–38; T. F. Mathews, *Early Churches*, 42–76; and C. Mango, *Byzantine Architecture*, 101ff.

6. C. Mango and E. J. W. Hawkins, "The Apse Mosaics of St. Sophia at Istanbul," *Dumbarton Oaks Papers*, 19, 1965, 115–49; and R. Cormack, *Writing in Gold: Byzantine Society and its Icons*, New York, 1985, 114–58.

7. For the patriarchal palace, see R. Cormack, *Writing in Gold*, 107ff. For the mosaic in Kalenderhane Djami, see C. L. Striker and Y. D. Kuban, "Work at Kalenderhane Camii in Istanbul: Third and Fourth Preliminary Reports," *Dumbarton Oaks Papers* 25, 1971, 255ff.

8. See especially R. Delbrueck, *Consulardiptychen und verwandte Denkmäler*; and W. F. Volbach, *Elfenbeinarbeiten der Spätantike und des frühen Mittelalters*, Mainz, 1976, for numerous examples. For a general discussion, see J. Beckwith, *Early Christian and Byzantine Art* (Pelican History of Art, no. 33), Harmondsworth, 1970, 78ff.

9. H. Torp, *Mosaikkene i St Georg-Rotunden i Thessaloniki*, Oslo, 1963; A. Grabar, "A propos des mosaïques de la coupole de Saint-Georges à Salonique," *Cahiers archéologiques*, 17, 1967, 59ff.; M. G. Sotiriou, "Sur quelques problèmes de l'iconographie de la coupole de Saint-Georges de Thessalonique," in *In Memoriam Panayotis A. Michelis*, Athens, 1971, 218ff.; and W. E. Kleinbauer, "The Iconography and the Date of the Mosaics of the Rotunda of Hagios Georgios, Thessaloniki," *Viator*, 3, 1972, 27ff.

10. J. Snyder, "The Meaning of the Maiestas Domini in Hosios David," *Byzantion*, 37, 1967, 143–52; and R. Cormack, *Writing in Gold*, 132–33.

11. G. A. and M. G. Sotiriou, *He basilike tou hagiou Demetriou Thessalonikes*, Athens, 1952; and R. Krautheimer, *Early Christian and Byzantine Architecture*, 132–35. For the mosaics see R. Cormack, "The Mosaic Decoration of S. Demetrios, Thessaloniki: A Re-examination in the Light of the Drawings of W. S. George," *Annual of the British School at Athens*, 64, 1969, 17–52; *idem*, *Writing in Gold*, 50–94; E. Kitzinger, *Byzantine Art in the Making*, 105–7; and A. Grabar, "Notes sur les mosaïques de Saint-Démétrios à Salonique," *Byzantion*, 48, 1978, 64–77.

12. J. D. Jones, *Pseudo-Dionysius Areopagite: The Divine Names and Mystical Theology* (Medieval Philosophical Texts in Translation, no. 21), Milwaukee, 1980, 211–12. Cf. C. E. Rolt, *Dionysius the Areopagite on the Divine Names and Mystical Theology*, New York, 1920, 191–92 (reprinted 1957). See the discussion by P. Rorem, *Biblical and Liturgical Symbols Within the Pseudo-Dionysian*

Synthesis (Pontifical Institute of Medieval Studies; Studies and Texts, no. 71), Toronto, 1984, esp. 99–116.

13. *Plotinus, The Enneads*, trans. S. MacKenna, 3rd ed., London, 1962, esp. 56–64 for texts cited here. Cf. A. Grabar, *Plotin et les origines de l'esthétique médiévale*, Paris, 1945; P. A. Michelis, *An Aesthetic Approach to Byzantine Art*, London, 1955; G. Mathew, *Byzantine Aesthetics*, New York, 1963, 12–21; and L. James, *Light and Colour in Byzantine Art*, Oxford, 1996.

14. G. H. Forsyth and K. Weitzmann, *The Monastery of Saint Catherine at Mount Sinai: The Church and Fortress of Justinian*, Ann Arbor, 1973.

15. F. W. Deichmann, *Ravenna, Hauptstadt des spätantiken Abendlandes*, 3 vols., Wiesbaden, 1969; and E. Kitzinger, *Byzantine Art in the Making*, 53–57. For the early history of Ravenna, see Agnellus, *The Book of Pontifs of the Church of Ravenna*, trans. D. Mauskopf Deliyannis, Washington, DC, 2004.

16. F. W. Deichmann, *Ravenna*, I, 158; II, 51ff.

17. F. W. Deichmann, *Ravenna*, I, 130ff.; II, pt. 1, 15ff.; S. K. Kostof, *The Orthodox Baptistry of Ravenna*, New Haven, 1965; and A. J. Wharton, "Ritual and Reconstructed Meaning: The Neonian Baptistery in Ravenna," *Art Bulletin* 69, 1987, 358–375.

18. F. W. Deichmann, *Ravenna*, I, 171ff.; II, pt. 1, 125ff.; O. von Simson, *The Sacred Fortress: Byzantine Art and Statecraft in Ravenna*, Chicago, 1948, 40–62; G. Bovini, *Sant'Apollinare Nuovo*, Milan, 1961; and C. O. Nordström, *Ravennastudien: Ideengeschichtliche und ikonographische Untersuchungen über die Mosaiken von Ravenna*, Uppsala, 1953, 55–88.

19. Compare the interpretations of O. von Simson, *Sacred Fortress*, 78, who sees a type of *dittochaeon* in the arrangement; and A. Baumstark, "I mosaici di Sant' Apollinare Nuovo e l'antico anno liturgico ravennate," *Rassegna Gregoriana*, 9, 1919, 33ff., who relates the selection of stories to the Office of the Syrian Jacobites.

20. F. W. Deichmann, *Ravenna*, I, 226ff. Cf. C. Barber, "The Imperial Panels at San Vitale: A Reconsideration," *Byzantine and Modern Greek Studies*, 14, 1990, 19–42.

21. *Procopius' Secret History*, 41.

22. *Procopius' Secret History*, 53.

23. Quoted in Procopius, *History of the Wars*, bk. 1, chap. 24, sect. 33–37. For a discussion of Theodora's famous speech, see J. W. Barker, *Justinian and the Later Roman Empire*, Madison, 1966, 87–88. On Theodora, see: J. Herrin, *Women in Purple: Rulers of Medieval Byzantium*, Princeton, 2001.

24. Deichmann, *Ravenna*, I, 257ff.; O. Demus, "Zu den Apsismosaiken von Sant'Apollinare in Classe," *Jahrbuch der österreichischen byzantinistik Gesellschaft*, 18, 1969, 229ff.; O. von Simson, *Sacred Fortress*, 40–62; C. O. Nordström, *Ravennastudien*, 120–32; E. Kitzinger, *Byzantine Art in the Making*, 101–3; and J. Engemann, "Zu den Apsis-Tituli

des Paulinus von Nola," *Jahrbuch für Antike und Christentum*, 17, 1974, 21ff.

25. C. Cecchelli, *La cattedra di Massimiano*, Rome, 1936; G. Bovini, *La cattedra eburnea del vescovo Massimiano di Ravenna*, Faenza, 1957; and E. Kitzinger, *Byzantine Art in the Making*, 94ff.

Chapter 5
Middle and Late Byzantine Art

1. E. Kitzinger, "The Cult of Images in the Age Before Iconoclasm," *Dumbarton Oaks Papers*, 8, 1954, 83–150; and G. Mathew, *Byzantine Aesthetics*, New York, 1963, 94–107. See especially A. Grabar, *Martyrium: Recherches sur le culte des reliques et l'art chrétien antique*, Paris, 1946, II, esp. 343ff.; and H. Belting, *Likeness and Presence*, trans. E. Jephcott, Chicago, 1994.

2. A. Grabar, *La Sainte Face de Laon: Le Mandylion dans l'art orthodoxe*, Prague, 1931; and K. Weitzmann, "The Mandylion and Constantine Porphyrogenitos," *Cahiers archéologiques*, 11, 1960, 163 ff.

3. Cf. *Iconoclasm: Papers Given at the Ninth Spring Symposium of Byzantine Studies*, A. Bryer and J. Herrin, eds., Birmingham, 1977, 183, no. C. 20; A. Grabar, *L'Iconoclasme byzantin*, Paris, 1957; and C. Barber, *Figure and Likeness: On the Limits of Representation in Byzantine Iconoclasm*, Princeton, 2002. Also see St. John of Damascus, *Three Treatises on the Divine Images*, I, 17, Crestwood, NY, 2003, esp. 31–2.

4. G. Ladner, "The Concept of the Image in the Greek Fathers and the Byzantine Iconoclastic Controversy," *Dumbarton Oaks Papers*, 7, 1953, 1–34; and *Iconoclasm*, 181.

5. *Iconoclasm*, 182, no. B. 15; C. Mango, *The Art of the Byzantine Empire, 312–1453* (Sources and Documents), Englewood Cliffs, NJ, 1972, 123ff.; and *Figure and Likeness*, esp. 41–43.

6. *Iconoclasm*, 183, no. C. 19; and *The Art of the Byzantine Empire*, 165–68.

7. *Figure and Likeness*, esp. 125–26.

8. C. Mango, *The Brazen House: A Study of the Vestibule of the Imperial Palace of Constantinople*, Copenhagen, 1959, 126–28; and *Iconoclasm*, 185, no. E. 25.

9. C. Mango, *The Homilies of Photius, Patriarch of Constantinople*, Cambridge, MA, 1958, 293–94. Cf. *Iconoclasm*, 185, no. F. 27; R. Cormack, *Writing in Gold*, Oxford, 1985, 143–58; and R. Nelson, "To Say and To See: Ekphrasis and Vision in Byzantium," *Visuality before and beyond the Renaissance: Seeing as Others Saw*, R. Nelson (ed.), Cambridge, 2000, 143–68.

10. R. Cormack, *Byzantine Art*, Oxford, 2000, 28–29.

11. Ibid, 99–101; K. Corrigan, *Visual Polemics in the Ninth-Century Byzantine Psalters*, Cambridge, 1992, esp. 27–33; and J. Lowden, *Early Christian and Byzantine Art*, London, 1997, 180–83.

12. F. Dvornik, *The Photian Schism*, Cambridge, 1948; and S. Runciman, *The Eastern Schism*, Oxford, 1955. For the history of the period in general, see R. Jenkins, *Byzantium: The Imperial Centuries, A.D. 610–1071*, London, 1966; and J. J. Norwich, *A Short History of Byzantium*, New York, 1997, 109–246.

13. Constantine VII Porphyrogenitus, in A. Vogt, ed., *Le Livre des Cérémonies*, Paris, 1935.

14. N. Mesarites, *Description of the Church of the Holy Apostles*, trans. G. Downey, *Transactions of the American Philosophical Society*, n.s. 47, pt. 6, 1957, 855–925. For Rhodius, see *The Art of the Byzantine Empire*, 199–201.

15. C. Mango, *The Mosaics of St. Sophia at Istanbul* (Dumbarton Oaks Studies, no. 8), Washington, DC, 1962; and A. Grabar, *Byzantine Painting*, Geneva, 1953, 91–106.

16. A. Grabar, *Byzantine Painting*, 97; N. Oikonomides, "Leo VI and the Narthex Mosaic of Saint Sophia," *Dumbarton Oaks Papers*, 30, 1976, 151ff.; and *Early Christian and Byzantine Art*, 89ff. For more on the Virgin as intercessor, see C. Walter, "Two Notes on the Deësis," *Revue des études byzantines*, 36, 1968, 332ff.

17. "The Cult of Images in the Age Before Iconoclasm," 83–150; and A. Cameron, "The Mandylion and Byzantine Iconoclasm," *The Holy Face and the Paradox of Representation*, H. Kessler and G. Wolf, eds., Bologna, 1998, 33–54.

18. *The Glory of Byzantium: Art and Culture of the Middle Byzantine Era, A.D. 843–1261*, H. Evans and W. Wixom, eds., exh. cat., New York, 1997, 70–71.

19. For more on the use of color in Byzantine art, see L. James, *Light and Colour in Byzantine Art*, Oxford, 1996.

20. For ivories in general, see K. Weitzmann, "Ivory Sculpture of the Macedonian Renaissance," in *Kolloquium über spätantike und frühmittelalterliche Skulptur*, Mainz, 1970, II, 1ff.; A. Cuttler, *The Hand of the Master: Craftsmanship, Ivory, and Society in Byzantium*, Princeton, 1994; and C. Connor, *The Color of Ivory: Polychromy on Byzantine Ivories*, Princeton, 1998.

21. *The Hand of the Master*, 148–49; and *The Glory of Byzantium*, 133–34.

22. *The Glory of Byzantium*, 177–78.

23. *The Hand of the Master*, 22–29.

24. For this, see the articles by K. Weitzmann in *Studies in Classical and Byzantine Manuscript Illumination*, H. Kessler, ed., Chicago and London, 1971: "The Classical Heritage in the Art of Constantinople," 126–50; "The Classical in Byzantine Art as a Mode of Individual Expression," 151–75; and especially, "The Character and Intellectual Origins of the Macedonian Renaissance," 176–223.

25. K. Weitzmann, *Greek Mythology in Byzantine Art*, Studies in Manuscript Illumination, no. 4, Princeton, 1951.

26. H. Buchthal, *The Miniatures of the Paris Psalter: A Study in Middle Byzantine Painting*, London, 1938; and

K. Weitzmann, "The Macedonian Renaissance," 176–84.

27. K. Weitzmann, *The Joshua Roll: A Work of the Macedonian Renaissance*, Studies in Manuscript Illumination, no. 3, Princeton, 1948; and M. Schapiro, "The Place of the Joshua Roll in Byzantine History," *Gazette des Beaux-Arts*, 35, 1949, 161 ff.

28. K. Weitzmann, "The Character and Intellectual Origins of the Macedonian Renaissance," 199ff.

29. For Byzantine architecture in general, see R. Ousterhout, *Masters Builders of Byzantium*, Princeton, 1999. On variations on the central plan, see R. Krautheimer, *Early Christian and Byzantine Architecture*, 353–60, 405 n. 45; and C. Mango, *Byzantine Architecture*, New York, 1976, 212ff.

30. O. Demus, *Byzantine Mosaic Decoration*, Boston, 1953, 13, *passim*; and T. Mathews, *Byzantium: From Antiquity to the Renaissance*, Englewood Cliffs, 1998, esp. 97–136.

31. *Byzantine Mosaic Decoration*, 35.

32. A. J. Wharton, *Art of Empire: Painting and Architecture of the Byzantine Periphery*, University Park, 1988, esp. 53–90; and A. Weyl Carr, "Popular Imagery," *The Glory of Byzantium*, 112–18.

33. H. Maguire, *Art and Eloquence in Byzantium*, Princeton, 1981, esp. 91–108.

34. *Likeness and Presence*, 272–75; K. Corrigan, "Constantine's Problems: The Making of the Heavenly Ladder of John Climacus," *Word and Image*, 12, 1996, 61–93; and *The Glory of Byzantium*, 376–77.

35. N. Sevčenko, *The Life of St. Nicholas in Byzantine Art*, Turin, 1984; N. Sevčenko, "Vita Icons and 'Decorated' Icons of the Komnenian Period," *Four Icons in the Menil Collection*, B. Davezac, ed., Houston, 1992; and *Early Christian and Byzantine Art*, 367–68.

36. L. Jones, "The Church of the Holy Cross and the Iconography of Kingship," *Gesta*, 33, 1994, 104–11; and H. Evans, "The Armenians," *The Glory of Byzantium*, 350–55.

37. G. Hamilton, *The Art and Architecture of Russia*, New Haven, 3rd ed., 1983, 21–35, 65–73; and O. Pevny, "Kievan Rus'," *The Glory of Byzantium*, 280–87.

38. *The Art and Architecture of Russia*, 51–64.

39. *Byzantine Art*, 181–82.

40. *The Art and Architecture of Russia*, 137–39.

41. *Byzantium: Faith and Power (1261–1557)*, H. Evans, ed., exh. cat., New York, 2004, 384–85. For more on the Late Byzantine Empire, see *A Short History of Byzantium*, 247–383.

42. *The Kariye Djami*, P. Underwood, ed., 4 vols., New York, 1966–75; R. Nelson, "Taxation with Representation: Visual Narrative and the Political Field of Kariye Camii," *Art History*, 22, 1999, 56–82; and R. Nelson, "The Chora and the Great Church: Intervisuality in Fourteenth-Century Constantinople," *Byzantine and Modern Greek Studies*, 23, 1999, 67–101.

Chapter 6
Byzantine Art and Italy

1. For Byzantine art in Italy, see W. Köhler, "Byzantine Art in the West," *Dumbarton Oaks Papers*, 1, 1941, 61ff.; K. Weitzmann, "Various Aspects of Byzantine Influence on the Latin Countries from the Sixth to the Twelfth Centuries," *Dumbarton Oaks Papers*, 20, 1966, 3ff.; B. Brenk, "Early Byzantine Mural Paintings in Rome," *Palette*, 26, 1967, 13ff.; W. Oakeshott, *The Mosaics of Rome from the Third to the Fourteenth Centuries*, London, 1967; and H. Belting, "Byzantine Art Among Greeks and Latins in Southern Italy," *Dumbarton Oaks Papers*, 28, 1974, 1ff. For the frescoes in Santa Maria Antiqua, see W. de Gruneisen, *Sainte-Marie Antique*, Rome, 1911; M. Avery, "The Alexandrian Style at Santa Maria Antiqua in Rome," *Art Bulletin*, 7, 1925, 132ff.; and P. Romanelli and P. J. Nordhagen, *Santa Maria Antiqua*, Rome, 1965.

2. G. P. Bognetti et al., *Santa Maria di Castelseprio*, Milan, 1948; K. Weitzmann, *The Fresco Cycle of S. Maria di Castelseprio*, Princeton, 1951; C. R. Morey, "Castelseprio and the Byzantine 'Renaissance,'" *Art Bulletin*, 34, 1952, 173ff.; and M. Schapiro, "Notes on Castelseprio," *Art Bulletin*, 39, 1957, 292ff.

3. The major studies on San Marco have been written by Otto Demus. See his *The Church of San Marco in Venice—History, Architecture, Sculpture*, Washington, DC, 1960, and *The Mosaics of San Marco in Venice, I: The Eleventh and Twelfth Centuries*, and *II: The Thirteenth Century*, Chicago and London, 1984.

4. O. Demus, *Byzantine Mosaic Decoratio*, esp. 19–22.

5. W. F. Volbach *et al.*, *La Pala d'Oro*, Florence, 1965; J. de Luigi-Pomorisac, *Les Emaux byzantins de la Pala d'Oro de l'église de Saint-Marc à Venise*, 2 vols., Zurich, 1966; K. Wessel, *Die byzantinische Emailkunst vom fünften bisdreizehnten Jahrhundert*, Recklinghausen, 1967 (also, in English, *Byzantine Enamels*, Greenwich, CT, 1967); and O. Demus, *Byzantine Art and the West*, 209ff. For the original setting of the six "Great Feast" enamels in the Comnenian monastery, the Church of the Pantocrator in Constantinople, see C. Walter, *Studies in Byzantine Iconography*, London, 1977.

6. For the portrait, see especially E. Kitzinger, "On the Portrait of Roger II in the Martorana in Palermo," *Proporzioni*, 3, 1950, 30–35.

7. The standard reference for Sicilian architecture and mosaics is O. Demus, *The Mosaics of Norman Sicily*, New York, 1950 (with an exhaustive bibliography). Also see E. Borsook, *Messages in Mosaic: The Royal Programmes of Norman Sicily (1130–1187)*, Oxford, 1990. For an excellent discussion of the history, see J. J. Norwich, *The Kingdom in the Sun*, New York and Evanston, 1970.

8. E. Kitzinger, "The Mosaics of the Cappella Palatina in Palermo," *Art Bulletin*, 31, 1949, 269–92; and W. Tronzo,

The Cultures of his Kingdom: Roger II and the Capella Palatina in Sicily, Princeton, 1997. See also W. Krönig, "Zur Transfiguration der Cappella Palatina in Palermo," *Zeitschrift für Kunstgeschichte*, 19, 1956, 162ff. O. Demus (*The Mosaics of Norman Sicily*) attributes the "dynastic axis" of the royal box to William I (1154–66).

9. O. Demus, *The Mosaics of Norman Sicily*, 2ff.; and *Messages in Mosaic*, 6–16.

10. O. Demus, *The Mosaics of Norman Sicily*, 91ff., 271ff.,
418ff.; E. Kitzinger, *The Mosaics of Monreale*, Palermo, 1960; and *Messages in Mosaic*, 51–80.

11. See especially E. Kitzinger, "Norman Sicily as a Source of Byzantine Influence on Western Art in the Twelfth Century," in *Byzantine Art: An European Art, Ninth Exhibition Held Under the Auspices of the Council of Europe; Lectures*, Athens, 1966, 121ff. (also in *The Art of Byzantium*, 357–88), and "Byzantium and the West in the Second Half of the Twelfth Century," *Gesta*, 9, no. 2, 1970, 49ff.

PART THREE
THE EARLY MIDDLE AGES IN THE WEST

Chapter 7
Northern Traditions and Synthesis

1. *Bede's Ecclesiastical History of the English People*, B. Colgrave and R.A.B. Mynors, eds., Oxford, 1969, 183–185.

2. Gerald of Wales, *The Journey Through Wales / The Description of Wales*, trans. Lewis Thorpe, London, 1978. For Celtic art in general, see: R. and V. Megaw, *Celtic Art: From its Beginnings to the Book of Kells*, New York, 2001; M. Green, *Celtic Art: Symbols and Imagery*, New York, 1997; *The Celts*, V. Kruta *et al.*, eds, New York, 1997; and L.R. Laing, *The Art of the Celts*, London, 1992.

3. *Codex Durmachensis* (facsimile), 2 vols., T. Burckhardt, ed., Lausanne, 1960; M. Werner, "The Book of Durrow and the Question of Programme," *Anglo-Saxon England*, 26, 1997, 23–39; B. Meehan, *The Book of Durrow: A Medieval Masterpiece at Trinity College Dublin*, Boulder, CO, 1996; R. Calkins, *Illuminated Books of the Middle Ages*, Ithaca, 1983; and J. J. G. Alexander, *Insular Manuscripts: Sixth to the Ninth Century*, London, 1978.

4. M. Werner, "The Cross-carpet Page in the Book of Durrow: The Cult of the True Cross, Adomnan, and Iona," *Art Bulletin*, 72, 1990, 174–223.

5. C. Neuman de Vegvar, "The Echternach Lion: A Leap of Faith," in *The Insular Tradition*, C. E. Karkov, M. Ryan, R. T. Farrell, eds., Albany, NY, 1997, 167–188; N. Netzger, *Cultural Interplay in the Eighth Century: The Trier Gospels and the Making of a Scriptorium at Echternach*, Cambridge, 1994; G. Henderson, *From Durrow to Kells: The Insular Gospel Books, 650–800*, London, 1987, 102ff; C. Nordenfalk, *Celtic and Anglo-Saxon Painting: Book Illumination in the British Isles 600–800*, New York, 1977, 48–55; and G. Henderson, *From Durrow to Kells*, 102 ff.

6. F. Masai, *Essai sur les origines de la miniature dite irlandaise*, Brussels, 1947.

7. *Evangelia Quattor Codex Lindisfarnensis* (facsimile), T. D. Kendrick *et al.*, eds., Lausanne, 1956–1960.

8. L. Nees, "Problems of Form and Function in Early Medieval Illustrated Bibles from Northwest Europe," in
Imaging the Early Medieval Bible, J. Williams, ed., University Park, PA, 1999, 121–77.

9. C. Nordenfalk, "A Note on the Stockholm Codex Aureus," *Nordisk tidskrift för bok-och biblioteks väsen*, 38, 1951, 1–11.

10. *Evangeliorum quattuor Codex Cenannensis* (facsimile), 3 vols., E. H. Alton, ed., Lausanne, 1950–1951; and *The Book of Kells: Proceedings of a Conference at Trinity College, Dublin, 6–9 September 1992*, F. Mahony, ed., Dublin, 1994.

11. T. J. Brown, "Northumbria and the Book of Kells," *Anglo-Saxon England*, 1, 1972, 219–46; and A. M. Friend, "The Canon Tables of the Book of Kells," in *Medieval Studies in Memory of Arthur Kingsley Porter*, Cambridge, MA, 1939, II, 611–66.

12. M. Werner, "The Miniature of the Madonna in the Book of Kells," *Art Bulletin*, 54, 1972, 1–22, 129–39. Cf. E. Kitzinger, "The Coffin Reliquary," in *The Relic of St. Cuthbert*, C. F. Battiscombe, ed., Oxford, 1966, 202 ff.

13. S. Lewis, "Sacred Calligraphy: The Chi Rho Page in the Book of Kells," *Traditio*, 36, 1980, 139–59.

14. S. Mussetter, "An Animal Miniature on the Monogram Page of the Book of Kells," *Mediaevalia*, 3, 1977, 119–30.

15. F. Henry, *Irish Art During the Viking Invasions*, Ithaca, NY, 1967, 196–97.

16. J. Backhouse, *The Lindisfarne Gospels*, 27–32. For this and other riddles, see also *The Exeter Book: Part II* (Early English Text Society, no. 194), Oxford, 1934, 117; and K. Crossley-Holland, *Storm and Other Old English Riddles*, London, 1970.

17. C. Davis-Weyer, *Early Medieval Art, 300–1150 (Sources and Documents)*, Toronto, 1986, 75.

18. *Sutton Hoo: Fifty Years After*, R. Farrell and C. Neuman de Vegvar, eds., Oxford, OH, 1992; *The Age of Sutton Hoo: the Seventh Century in North-western Europe*, M.O.H. Carver, ed., Woodbridge, Suffolk, 1992; R. L. S. Bruce-Mitford, *The Sutton Hoo Ship-Burial*, London, 1978, II, 536ff.; T. D. Kendrick, *The Sutton Hoo Ship Burial: A Provisional Guide*, 9th ed., London, 1964, 53ff.

19. F. Henry, *Irish Art in the Early Christian Period, to 800 A.D.*, London, 1940, 195.

20. A. Haseloff, *Pre-Romanesque Sculpture in Italy*, New York, 1931, 46ff. See also A. Grabar, *L'Art du moyen âge en Occident*, London, 1980, 23–26.

21. F. Wormald, *Studies in Medieval Art: 6th to the 12th Centuries*, London, 1984, 13–35.

22. Gregory of Tours, *History of the Franks*, trans. O. M. Dalton, Oxford, 1927. For the "Golden Church" in Toulouse, see the translation of the description of la Daurade in the Monasticon Benedictinum (Paris, Bibliothèque Nationale, MS lat. 12680, fols. 231–35) in C. Davis-Weyer, *Early Medieval Art: 300–1150*, 59–6.

Chapter 8
Carolingian Art and Architecture

1. Indispensible for any study of Carolingian art is *Karl der Grosse, Werk und Wirkung*, W. Braunfels *et al.*, eds., exh. cat., Aachen, 1965; *Karl der Grosse, Lebenswerk und Nachleben*, 5 vols., W. Braunfels *et al.*, eds., Düsseldorf, 1965–68; and *Carolingian Culture: Emulation and Innovation*, R. McKitterick, ed., New York and Cambridge, 1994; D. Bullough, *The Age of Charlemagne*, 2nd ed., London, 1973; *The New Cambridge Medieval History*, vol. 2: *c. 700–900*, R. McKitterick, ed., Cambridge, 1991. For the biography by Einhard, see *The Life of Charlemagne by Einhard*, S. Painter, ed., Ann Arbor, 1960.

2. E. B. Smith, *Architectural Symbolism of Imperial Rome and the Middle Ages*, Princeton, 1956, 74–106, esp. 104ff.; E. Kantorowicz, *Laudes Regiae: A Study in Liturgical Acclamations and Mediaeval Ruler Worship* (University of California Publications in History, no. 33), Berkeley, 1948, 56–62. K. J. Conant, *Carolingian and Romanesque Architecture: 800–1200* (Pelican History of Art, no. 13), 2nd ed., New York, 1978.

3. W. Rave, *Corvey*. For westwork, see O. Grüber, "Das Westwerke: Symbol und Baugestaltung," *Zeitschrift des deutschen Vereins*, 3, 1936, 149–73; A. Fuchs, "Entsehung und Zweckbestimmung der Westwerke," *Westfälische Zeitschrift*, 100, 1950, 227–91; G. Bandmann, *Mittelalterliche Architektur als Bedeutungsträger*, Berlin, 1951; W. Rave, *Corvey*, Münster, 1957; and E. B. Smith, *Architectural Symbolism of Imperial Rome*. Cf. H. Shaefer, "Origin of the Two-Towered Facade in Romaneque Architecture," *Art Bulletin*, 27, 1945, 85–108.

4. The first serious study of these sculptors was W. Vöge, "Vom gotischen Schwung und der plastischen Schule des 13. Jahrhunderts," *Repertorium für Kunstwissenschaft*, 1904, 1ff. For later studies see L. Lefrançois-Pillion, *Les Sculpteurs de la cathédrale de Reims*, Paris, 1928; E. Panofsky, "Uber die Reihenfolge der vier Meister von Reims," *Jahrbuch für Kunstwissenschaft*, 1927, 55–82; R. Branner, "The North Transept and the First West Facades of

Reims," *Zeitschrift für Kunstgeschichte*, 24, 1961, 220–41 (and articles listed in n. 40, above); W. M. Hinkle, *The Portal of the Saints of Reims Cathedral*, New York, 1965; F. Salet, "Chronologie de la cathédrale [de Reims]," *Bulletin monumental*, 125, 1967, 345ff.; and W. Sauerländer, *Gothic Sculpture*, 474–88.

5. H. Reinhardt, *Der Klosterplan von St. Gallen*, St. Gall, 1952; W. Horn and E. Born, *The Plan of St. Gall: A Study of the Architecture and Economy of, and Life in a Paradigmatic Carolingian Monastery*, 3 vols., Berkeley and London, 1979; *idem*, "The Dimensional Inconsistencies of the Plan of S. Gall and the Problem of the Scale of the Plan," *Art Bulletin*, 48, 1966, 285ff. Cf. The criticism of W. Sanderson, 'The Plan of St. Gall Reconsidered,' *Speculum*, 60, 1985, 615–32; L. Nees, "The Plan of St. Gall and the Theory of the Program of Carolingian Art," *Gesta*, 25 (1986), pp. 1–8; and L. Price, *The Plan of St. Gall in Brief*, Berkeley and London, 1982 (a summary of the above). See also W. Braunfels, *Monasteries of Western Europe*, Princeton, 1972, 37–46.

6. C. Davis-Weyer, *Early Medieval Art*, 84–88.

7. A. Grabar, "Les mosaïques des Germigny-des-Prés," *Cahiers archéologiques*, 7, 1954, 171–83; and P. Bloch, "Das Apsismosaik von Germigny-des-Prés," in *Karl der Grosse, Lebenswerk und Nachleben*, III, 234ff. For a discussion of Theodulf as the author of the aniconic treatise *Libri Carolini*, see A. Freeman, "Libri Carolini ?," *Speculum*, 40, 1965, 203–89.

8. For this and other Carolingian wall paintings see also J. Hubert *et al.*, *Carolingian Renaissance*, 5–28; A. Grabar and C. Nordenfalk, *Early Medieval Painting from the Fourth to the Eleventh Century*, Lausanne, 1957; and H. Schrade, *Vor- und frühromanische Malerei*, Cologne, 1958.

9. J. Hubert *et al.*, *Carolingian Renaissance*, 344, no. 22.

10. See especially H. Kessler, *The Illustrated Bibles from Tours*, Princeton, 1977; J. Duft *et al.*, *Die Bibel von Moûtier-Grandval* (facsimile), Bern, 1971.

11. H. Kessler, *Illustrated Bibles from Tours*, 3ff.; and A. St. Clair, "A New Moses: Typological Iconography in the Moutier-Grandval Bible Illustrations of Exodus," *Gesta* 26, 1987, 19–28.

12. F. Mütherich, *Sakramentar von Metz: Fragment*, Graz, 1972; and R. Calkins, *Illuminated Books*, 162–79.

13. A. M. Friend, Jr., "Carolingian Art in the Abbey of Saint Denis," *Art Studies*, 1, 1923, 67–75.

14. R. Laufner and P. Klein, *Trierer Apokalypse, Vollständige Faksimile: Codex 31 der Stadtbibliothek, Trier*, Graz, 1972; W. Braunfels, *Die Welt der Karolinger*, 179–81; J. Snyder, "The Reconstruction of an Early Christian Cycle of Illustrations for the Book of Revelation—The Trier Apocalypse," *Vigiliae Christianae*, 18, 1964, 146–58.

15. A. Goldschmidt, *Die Elfenbeinskulpturen aus der Zeit der karolingischen und sächsischen Kaiser*, 4 vols., Berlin, 1914–26.

16. A. Goldschmidt, *Die Elfenbeinskulpturen, passim*; and

S. Ferber, "Crucifixion Iconography in a Group of Carolingian Ivory Plaques," *Art Bulletin*, 48, 1966, 323–34.

17. V. H. Elbern, *Der karolingische Goldaltar von Mailand*, Bonn, 1952.

18. R. Krautheimer, *Rome: Profile of a City*, 123ff.; C. Davis-Weyer, "Die Mosaiken Leo III," *Zeitschrift für Kunstgeschichte*, 29, 1966, 111ff.; G. Matthiae, *Mosaici medioevali Roma e suburbio*, Rome, 1934–40; P. Nordhagen, "Un problema ??a S. Prassede," in *Roma e l'età Carolingia*, 159ff.; and for the Zeno chapel, see M. Pautler-Klass, "The Chapel of Saint Zeno at S. Prassede in Rome," Ph.D. diss., Bryn Mawr College, 1971.

Chapter 9
Diffusion and Diversity

1. F. Wormald, *English Drawings of the 10th and 11th Centuries*, New York, 1952, and *Collected Writings: Studies in Medieval Art from the 6th to the 12th Century*, London, 1984, esp. 47ff.; H. Swarzenski, *Monuments of Romanesque Art*, New York, 1954, *passim*; R. Deshman, "Anglo-Saxon Art After Alfred," *Art Bulletin*, 56, 1974, 177–200; E. Temple, *Anglo-Saxon Manuscripts 900–1066* (Survey of Manuscripts in the British Isles, no. 2), London, 1976; J. Campbell, *The Anglo-Saxons*, Ithaca, 1982; D. M. Wilson, *Anglo-Saxon Art*, New York, 1984; R. Camp, *Corpus of Anglo-Saxon Stone Sculpture in England*, I–II: *County Durham and Northumbria*, London, 1984; D. H. Turner *et al.*, *The Golden Age of Anglo-Saxon Art, 966–1066*, London, 1984; and *The Making of England: Anglo-Saxon Art and Culture, AD 600–900*, L. Webster and J. Backhouse, eds., exh. cat., London, 1991.

2. F. Wormald, *Collected Writings*, I, 85–100; O. Homburger, *Die Anfänge der Malschule von Winchester im X. Jahrhundert*, Leipzig, 1912; and R. Deshman, *The Benedictional of Aethelwold*, Princeton, 1995.

3. E. Kantorowicz, "The Quinity of Winchester," *Art Bulletin*, 29, 1947, 73–85.

4. O. Pächt *et al.*, *The Saint Albans Psalter*, London, 1960. For English Romanesque manuscripts, see M. Rickert, *Painting in Britain: The Middle Ages* (Pelican History of Art, no. 5), Harmondsworth, 1954, 59–104; and C. M. Kauffmann, *Romanesque Manuscripts, 1066–1190*, London and Boston, 1975. For an excellent discussion of the sources and iconography, see O. Pächt, *The Rise of Pictorial Narrative in Twelfth-Century England*, Oxford, 1962; K. E. Haney, "The St Albans Psalter: A Reconsideration." *Journal of the Warburg and Courtauld Institutes*, 58 (1995): 1–28; *idem*, "The Saint Albans psalter and the new spiritual models of the twelfth century," *Viator*, 28 (1997) 145–173; and *idem*, *The St. Albans Psalter: An Anglo-Norman Song of Faith*, New York, 2002.

5. J. Garber, *Wirkungen der frühchristlichen Gemäldezyklen der alten Petersund Paulsbasiliken in Rom*, Berlin, 1918; see also S. Waetzoldt, *Die Kopien*, 69ff. For an excellent discussion of the influence of Saint Peter's nave program, see W. Tronzo, "The Prestige of Saint Peter's: Observations on the Function of Monumental Narrative Cycles in Italy," *Studies in the History of Art*, 16, 1985, 93–112; and R. M. Thomsen, *The Bury Bible*, Woodbridge, Suffolk, and Rochester, NY, 2001.

6. C. Cecchelli, *I mosaici della basilica di S. Maria Maggiore*, 197–246; H. Karpp, *Die frühchristlichen und mittelalterlichen Mosaiken in S. Maria Maggiore zu Rom*, Baden-Baden, 1966. Also see the discussion by E. Kitzinger, "The Role of Miniature Painting in Mural Decoration," in *The Place of Book Illumination in Byzantine Art*, Princeton, 1975, 122ff., who points out the close relationships of the mosaics to book illustration but rightly emphasizes the unique nature of the Old Testament series, suggesting that they were composed in an *ad hoc* fashion from a unique set of working drawings made up for the nave. E. C. Parker and C. T. Little, *The Cloisters Cross: Its Art and Meaning*, New York, 1994.

7. For Ottonian art in general, see H. Jantzen, *Ottonische Kunst*, 2nd ed., Hamburg, 1959; P. E. Schramm and F. Mütherich, *Denkmäler der deutschen Könige und Kaiser*, Munich, 1962; L. Grodecki et al., *Le Siècle de l'an mil*, Paris, 1973; H. Holländer, *Early Medieval Art*, London, 1974; and *Otto der Grosse: Magdeburg und Europ*, 2 vols., exh. cat., Mainz, 2001.

8. L. Grodecki, *L'Architecture ottonienne*, Paris, 1958.

9. F. J. Tschan, *Saint Bernward of Hildesheim*, 3 vols., South Bend, IN, 1942–52; E. Loaiza, "Bernward of Hildesheim (960–1022)," *Medieval Germany: An Encyclopedia*, New York, 2001, 50; A. Cohen and A. Derbes, "Bernward and Eve at Hildesheim," *Gesta* 40 (2001), 19–38; and H. Stahl, "Eve's Reach: A Note on Dramatic Elements in the Hildesheim Doors" in *Reading Medieval Images: The Art Historian and the Object*, E. Sears and T. Thomas, Ann Arbor, MI, 2002, 163–75.

10. R. Wesenberg, *Bernwardische Plastik*, Berlin, 1955.

11. For earlier discussions, see A. Boeckler, "Die Reichenauer Buchmalerei," *Die Kultur der Abtei Reichenau*, Munich, 1925, 956–98; A. Goldschmidt, *German Illumination*, II; and A. Grabar and C. Nordenfalk, *Early Medieval Painting*, 193–218. Cf. the recent arguments of C. R. Dodwell and D. H. Turner, *Reichenau Reconsidered: A Reassessment of the Place of Reichenau in Ottonian Art*, London, 1965.

12. H. Buchthal, "Byzantium and Reichenau," in *Byzantine Art: A European Art, Ninth Exhibition Held Under the Auspices of the Council of Europe; Lectures*, Athens, 1966, 58–60.

13. E. Kantorowicz, *The King's Two Bodies: A Study of Medieval Political Theology*, Princeton, 1957.

14. K. Hoffmann, "Die Evangelistenbilder des Münchener Otto-Evangeliars," *Zeitschrift für Kunstwissenschaft*, 20, 1966, 17–46.

15. A. Cohen, *The Uta Codex: Art, Philosophy, and Reform in Eleventh-Century Germany*, University Park, PA, 2000.

16. E. Panofsky, *Die deutsche Plastik des elften bis dreizehnten Jahrhunderts*, 2 vols., Munich, 1924; H. Schrade, "Zur Frühgeschichte der mittelalterlichen Monumental-plastik," *Westfalen*, 35, 1957; E. Steingräber, *Deutsche Plastik der Frühzeit*, Königstein, 1961; E. G. Grimme, *Goldschmiedekunst im Mittelalter*, Cologne, 1961; P. Lasko, *Ars Sacra: 800–1200* (Pelican History of Art, no. 36), Harmondsworth, 1972; and U. Mende, *Die Bronzetüren des Mittelalters*, Munich, 1984.

17. D. M. Wilson and O. Klindt-Jensen, *Viking Art*, rev. ed., London, 1980, 48–83.

18. S. H. Fuglesang, *Stylistic Groups in Late Viking and Early Romanesque Art, Acta Archaeologia & A. Hist. Pertinentia*, Rome, 1981, 79–125; P. Anker and A. Andersen, *The Art of Scandinavia*, vol. 1, London, 1970; E. B. Hohler, "The Capitals of Urnes Church and their Background," *Acta Archaelogia*, 46 (1975): 1–60; and E. B. Hohler, *Norwegian Stave Church Sculpture*, 2 vols., Oslo and Boston, 1999.

PART FOUR
MEDIEVAL ART AND ISLAM

Chapter 10
Islam in the Middle East

1. R. Irwin, *Islamic Art in Context: Art, Architecture, and the Literary World*, New York, 1997, 32–36.

2. S. Nuseibeh and O. Grabar, *The Dome of the Rock*, New York, 1996

3. F. B. Flood, *The Great Mosque of Damascus: Studies on the Makings of an Umayyad Visual Culture*, Leiden and Boston, 2001.

4. G. Bishei, "Qasr al-Mshatta in the Light of a Recently Found Inscription," *Studies in the Archaeology and History of Jordan*, vol. 3, A. Hadidi, ed., Amman, 1986, 193–97.

Chapter 11
Crusader Art and Architecture

1. N. J. Morgan, *Early Gothic Manuscripts (II) 1250–1285* (Survey of Manuscripts Illuminated in the British Isles), London, 1988, no. 114.

2. M. Biddle, *The Tomb of Christ*, Stroud, Gloucestershire, 1999; G. S. P. Freeman-Grenville, *The Basilica of the Holy Sepulchre of Jesus Christ in Jerusalem*, Jerusalem, 1994; and A. Borg, "Observations on the Historiated Lintel of the Holy Sepulchre, Jerusalem," *Journal of the Warburg and Courtauld Institutes*, 32 (1969): 25–40.

3. T. S. R. Boase, "Ecclesiastical Art in the Crusader States in Palestine and Syria," in *A History of the Crusades*, K. M. Setton, ed., vol. 4, *The Art and Architecture of the Crusader States*, H. W. Hazard, ed., Madison, WI, and London, 1977, 125–31, 138–9, 327; and B. Kühnel, "The Kingly Statement of the Bookcovers of Queen Melisande's Psalter," *Jahrbuch für Antike und Christentum*, 18 (1991): 340–57.

4. D. Weiss, *Art and Crusade in the Age of Saint Louis*, Cambridge, 1998.

5. J. Folda *et al.*, "Crusader Frescoes at Crac des Chevaliers and and Marqab Castle," *Dumbarton Oaks Papers*, 36 (1982): 177–210; P. Deschamps, *Le Crac des Chevaliers*, 2 vols, Paris, 1934; T. E. Lawrence, *Crusader Castles*, new ed., Oxford, 1988; R. Fedden, *Crusader Castles*, London, 1957; T. Boase, *Castles and Churches of the Crusading Kingdom*, Oxford, 1967; and H. Kennedy, *Crusader Castles*, Cambridge, 2000.

Chapter 12
Islamic Spain

1. For more on the history of Islam in Spain, see T. Glick, *Islamic and Christian Spain in the Early Middle Ages*, Princeton, 1979; R. Fletcher, *Moorish Spain*, Berkeley, 1992; and B. Reilly, *The Medieval Spains*, Cambridge, 1993.

2. J. Dodds, "The Great Mosque of Córdoba," *Al-Andalus: The Art of Islamic Spain*, exh. cat., New York, 1992, 11–25; R. Hillenbrand, *Islamic Art and Architecture*, London, 1999, 167–74; and R. Ettinghausen, O. Grabar, and M. Jenkins-Madina, *Islamic Art and Architecture 650–1250*, New Haven, 2001, 83–91.

3. Quoted in *Moorish Spain*, 3.

4. A. Vallejo Triano, "Madinat al-Zahra: The Triumph of the Islamic State," *Al-Andalus*, 27–39.

5. *Al-Andalus*, 210–11.

6. For more on Mozarabic church architecture, see, J. Dodds, *Architecture and Ideology in Early Medieval Spain*, University Park, PA, 1990. For an excellent brief survey of Mozarabic book illumination, see J. Williams, *Early Spanish Manuscript Illumination*, London, 1977; for the Beatus Apocalypse manuscripts, see especially W. Neuss, *Die Apokalypse des Hl. Johannes in der altspanischen und altchristlichen Bibelillustration*, 2 vols., Münster, 1931.

7. A. Grabar and C. Nordenfalk, *Early Medieval Painting*, 161ff.; and J. Williams, *Early Spanish Manuscript Illumination*, 44–47.

8. See the studies of J. Williams, "The Beatus Commentaries and Spanish Bible Illustration," *Actes del Simposio para el Estudio de los Codices del "Comentario al*

Apocalypsis de Beato de Liebana, 1, 1980, 203–19; *idem*, "A Castilian Tradition of Bible Illustration," *Journal of the Warburg and Courtauld Institutes*, 28, 1965, 66–85; and *idem*, "A Model for the León Bibles," *Mitteilungen des Deutschen Archäologischen Instituts*, 8, 1967, 281–86.

9. For more on Beatus of Liébana's commentary, see J. Williams, "Purpose and Imagery in the Apocalypse Commentary of Beatus of Liébana," in *The Apocalypse in the Middle Ages*, R. Emmerson and B. McGinn, eds., Ithaca, 1992, 217–33.

10. J. Williams, "Spanish Bible Illustration," 218; U. Eco and L. Vázquez de Parga Iglesias, *Beato in Liébana: Miniature del Beato de Fernando I y Sancha*, Parma, 1973; J. Camón Aznar *et al.*, *Beati in Apocalipsin Libri Duodecim: Codex Gerundensis*, Madrid, 1975; A. M. Mundó and M. Sánchez Mariana, *El Comentario de Beato al Apocalipsis: Catálogo de los códices*, Madrid, 1976; and P. Klein, *Der ältere Beatus-Kodex Vitr. 14–1 der Biblioteca Nacional zu Madrid. Studien zur Beatus-Illustration und der spanischen Buchmalerei des 10. Jahrhunderts*, Hildesheim, 1976.

11. A. Grabar and C. Nordefalk, *Early Medieval Painting*, 161ff.

12. M. Schapiro, "From Mozarabic to Romanesque in Silos," in *Romanesque Art* , New York, 1977, 28–101; and O. K. Werckmeister, "Art of the Frontier: Mozarabic Monasticism," *The Art of Medieval Spain 500 -1200*, exh. cat., New York, 1993, 121–32, esp. 128.

13. O. K. Werckmeister, "Pain and Death in the Beatus of Saint-Sever," *Studi medievali*, 14, pt. 2, 1973, 565–626; and E. Moé, *L'Apocalypse de Saint-Sever*, Paris, 1943.

14. For more on the *taifa*-kings, see D. Wasserstein, *The Rise and Fall of the Party-Kings: Politics and Society in Islamic Spain 1002–1086*, Princeton, 1985; and C. Robinson, "Arts of the Taifa Kingdoms," *Al-Andalus*, 49–61. For the Witches Antependium, see *Al-Andalus*, 230–31.

15. C. Ewert, "The Architectural Heritage of Islamic Spain in North Africa," *Al-Andalus,* 84–104.

16. M. Casamar Pérez, "The Almoravids and Almohads: An Introduction," *Al-Andalus*, 74–83.

17. *Al-Andalus*, 315.

18. Ibn Khaldun, *The Muqqadimah: An Introduction to History*, 2nd ed., trans. F. Rosenthal, Princeton, 1967, vol. 2, 378.

19. C. Partearroyo, "Almoravid and Almohad Textiles," *Al-Andalus*, 105–14, 326–27.

20. *Convivencia: Jews, Muslims, and Christians in Medieval Spain*, V. Mann, T. Glick, and J. Dodds, eds., exh. cat., New York, 1992, esp. 1–38.

21. C. Krinsky, *Synagogues of Europe*, Cambridge, 1985, 331–40; and J. Dodds, "Mudejar Tradition and the Synagogues of Medieval Spain: Cultural Identity and Cultural Hegemony," *Convivencia*, 112–31.

22. O. Grabar, *The Alhambra,* Cambridge, 1978, esp. 87–90; J. Dickie, "The Palaces of the Alhambra," *Al-Andalus*, 134–51; and D. Ruggles, "The Gardens of the Alhambra and the Concept of the Garden in Islamic Spain," *Al-Andalus*, 162–71.

PART FIVE
THE ROMANESQUE

Chapter 13
Pilgrimage and Monasticism

1. D. Hay, "The Concept of Christendom," in *The Dawn of European Civilization: The Dark Ages*, D. T. Rice, ed., New York, 1965, 328–43.

2. "The Concept of Christendom," 343.

3. For more on these legends, see J. Bédier, *Les Légendes épiques, recherches sur la formation des chansons de geste*, 4 vols., Paris, 1908–13; R. Lejeune and J. Stiennon, *La Légende de Roland dans l'art du moyen âge* , 2 vols., Brussels, 1966; and E. Mâle, *Religious Art in France, The Twelfth Century: A Study of the Origins of Medieval Iconography*, trans. M. Mathews, Princeton, 1978, 246ff.

4. For more on pilgrimage, see J. Sumpton, *Pilgrimage: An Image of Medieval Religion*, London, 1975.

5. A. de Caumont, *Abécédaire d'archéologie*, Caen, 1871. For the earliest use of the term (1818), see H. Focillon, *The Art of the West, I: The Romanesque*, 29.

6. For the traditional arguments for regional-school priorities, see especially C. Enlart, *Manuel d'archéologie française*, 2 vols., Paris, 1902–3; R. de Lasteyrie, *L'Architecture religieuse en France à l'époque romane*, 2nd ed., Paris, 1929; C. Oursel, *L'Art roman de Bourgogne*, Dijon, 1928; R. Rey, *La Sculpture romane languedocienne*, Toulouse and Paris, 1936; *idem*, *L'Art romain et ses origines*, Paris, 1945; W. Vöge, *Die Anfänge des monumentalen Stiles im Mittelalter*, Strassburg, 1894 ; and P. Lasko, "The Concept of Regionalism in French Romanesque," *Akten des XXV. Internationalen Kongresses für Kunstgeschichte*, vol. 3: *Probleme und Methoden des Klassifizierung*, J. White, ed., Vienna 1983, 17–25. For the primacy of Cluny, see E. Viollet-le-Duc, *Dictionnaire raisonné de l'architecture française du XIe au XVIe siècle*, 10 vols., Paris, 1854–68; W. Weisbach, *Religiöse Reform und mittelalterliche Kunst*, Munich, 1945; J. Evans, *Cluniac Art of the Romanesque Period*, Cambridge, 1950; and K. J. Conant, *Cluny: Les Eglises et la maison du chef d'ordre*, Cambridge, MA, 1968. For the pilgrimage roads, see E. Mâle, *Religious Art in France, The Twelfth Century*, 246–315; and A. K. Porter, *Romanesque Sculpture of the Pilgrimage Roads*, 10 vols.,

Boston, 1923. For summaries of these arguments, see
H. Focillon, *The Art of the West*, I, 118–33; and
K. J. Conant, *Carolingian and Romanesque Architecture: 800–1200* (Pelican History of Art, no. 13), Harmonds-worth, 1959.

7. J. Puig i Cadafalch, *La premier art roman* , Paris, 1928. See also W. M. Whitehill, *Spanish Romanesque Architecture of the Eleventh Century*, London, 1941; P. Klein, "The Romanesque in Catalonia," *The Art of Medieval Spain, A.D. 500–1200*, exh. cat., New York, 1983, 184–97; and C. Radding and W. Clark, *Medieval Architecture, Medieval Learning: Builders and Masters in the Age of Romanesque and Gothic*, New Haven, 1992, 11–19.

8. K. J. Conant, *Carolingian and Romanesque Architecture*, 54ff., 60; and G. T. Rivoira, *Lombardic Architecture, Its Origins and Development*, 2nd ed., Oxford, 1934, I, 71ff.

9. J. Pijoan, "Oliba de Ripoll," *Art Studies*, 6, 1928, 81–96.

10. J. Camps i Sòria, "Majestat Batlló," *Prefiguración del Museu Nacional d'Art de Catalunya*, Barcelona, 1992, 154–56.

11. For the pilgrimage to Santiago, see J. Bédier, *Les Légendes épiques*, 2nd ed., Paris, 1921, III, 75–114; G. G. King, *The Way of Saint James*, 3 vols., New York, 1920; W. M. Whitehill, *Liber Sancti Jacobi, Codex Calixtinus*, Santiago de Compostela, 1944, III, xiii–lxxv; W. F. Starkie, *The Road to Santiago*, New York, 1957; E. Mâle, *Religious Art in France, The Twelfth Century*, 282ff.; *Le Guide du pélerin de Saint-Jacques de Compostelle*, 3rd ed., J. Vielliard, ed., Mâcon, 1965; Y. Bottineau, *Les Chemins de Saint-Jacques*, Paris and Grenoble, 1964; M. Stokstad, *Santiago de Compostela in the Age of the Great Pilgrimages*, Norman, OK, 1978; S. Moralejo, "On the Road: The Camino de Santiago," *The Art of Medieval Spain*, 174–83; and A. Shaver-Crandell, P. Gerson, and A. Stones, *The Pilgrim's Guide to Santiago de Compostela*, London, 1995.

12. K. J. Conant, *The Early Architectural History of the Cathedral of Santiago de Compostela*, Cambridge, MA, 1926.

13. M. Schapiro, "From Mozarabic to Romanesque in Silos, *Romanesque Art*, New York, 1977, 28–101, esp. 46–57; and O. K. Werckmeister, "The Image of the 'Jugglers' in the Beatus of Silos," *Reading Medieval Images: The Art Historian and the Object*, E. Sears and T. Thomas, eds., Ann Arbor, MI, 2002, 128–39.

14. A. Auriol and R. Rey, *La Basilique Saint-Sernin de Toulouse*, Paris and Toulouse, 1930; and *Medieval Architecture, Medieval Learning*, 34–44.

15. W. Sauerländer, "Die Skulpturen von St.-Sernin in Toulouse," *Kunstchronik*, 24, 1971, 341–47; B. Rupprecht, *Romanische Skulpturen in Frankreich*, Munich, 1975, 78–80; M. F. Hearn, *Romanesque Sculpture: The Revival of Monumental Stone Sculpture in the Eleventh and Twelfth Centuries*, Ithaca, 1981, 76ff. Cf. J. Cabanot, "Le Décor sculpte de la basilique Saint-Sernin de Toulouse," *Bulletin monumental*, 132, 1974, 99–145.

16. H. Focillon, *The Art of the West*, I, 48ff., referred to this as

the "frieze-style." In his *L'Art des sculpteurs romans: Recherches sur l'histoire des formes*, Paris, 1931, Focillon developed the theory of the "law of the frame" in Romanesque sculpture whereby figures were purposely distorted to fill the frame or setting. J. Baltrusaitis, *La stylistique ornementale dans la sculpture romane*, Paris, 1931, extended Focillon's "law of the frame," especially in capital sculptures. Cf. M. Schapiro, "On Geometric Schematism in Romanesque Art," *Romanesque Art*, 265–84. For a summary of these arguments, see M. F. Hearn, *Romanesque Sculpture*, 14ff.

17. P. Geary, *Furta Sacra: Thefts of Relics in the Central Middle Ages*, Princeton, 1978, esp. 58–63, 138–41.

18. For a study of the Moissac sculptures, see M. Schapiro, "The Romanesque Sculptures of Moissac," *Romanesque Art*, 131–264. For more on those at Souillac, see M. Schapiro, "The Sculptures of Souillac," *Romanesque Art*, 102–30. Cf. J. Thirion, "Observations sur les fragments sculptés du portail de Souillac," *Gesta* , 15, 1976, 161ff.; and R. Labourdette, "Remarques sur la disposition originelle du portail de Souillac," *Gesta*, 18, 1979, 29–35.

19. K. J. Conant has published extensively on the excavations at Cluny. See especially his *Cluny: Les Eglises et la maison du chef d'ordre*, Mâcon, 1968. Cf. W. Braunfels, *Monasteries of Western Europe*, Princeton, 1972, 47–66; and E. Armi, *Masons and Sculptors in Romanesque Burgundy: The New Aesthetic of Cluny III*, 2 vols., University Park, PA, 1983.

20. For the role of music at Cluny in general, see K. J. Conant, *Carolingian and Romanesque Architecture*, 116ff., and "Systematic Dimensions in the Buildings of Cluny," *Speculum*, 38, 1963, 1–45. Cf. E. R. Sunderland, "Symbolic Numbers and Romanesque Church Plans," *Journal of the Society of Architectural Historians*, 18, 1959, 94–105.

21. Cf. the discussion of W. Braunfels, *Monasteries of Western Europe*, 54–58, and appendix VI for the description in the *Consuetudines Farvenses*, 23–39. C. E. Armi, *Masons and Sculptors in Romanesque Burgundy*, 151ff., refutes some of Conant's reconstruction of Cluny II.

22. K. J. Conant, *Cluny, passim*.

23. W. Köhler, "Byzantine Art in the West," in *Dumbarton Oaks Inaugural Lectures*, Cambridge, MA, 1941, 61–87.

24. F. Salet, *La Madeleine de Vézelay* , Melun, 1948.

25. E. Mâle, *Religious Art in France, The Twelfth Century* , 326ff.; M. F. Hearn, *Romanesque Sculpture*, 168ff.; A. Katzenellenbogen, "The Central Tympanum at Vézelay," *Art Bulletin*, 26, 1944, 141–51; and M. Taylor, "The Pentecost at Vézelay," *Gesta*, 19, 1980, 9–12.

26. See R. Wittkower, "Marvels of the East," *Journal of the Warburg and Courtauld Institutes*, 5, 1942, 176ff.

27. I. Forsyth, "The Gandymede Capital at Vézelay," *Gesta*, 15, 1976, 241–46.

28. From the preface of *in canticum canticorum in librum*

primum regum, attributed to Gregory the Great, *Corpus christianorum, series Latina,* 144, Turnholt, 1963, 3–5.

29. V. Terret, *La Sculpture bourguignonne aux XIIe et XIIIe siècles*, II: *Autun*, Autun, 1935; D. Grivot and G. Zarnecki, *Gislebertus, Sculptor of Autun*, New York, 1961; and W. Sauerländer, "Uber die Komposition des Weltgerichts-Tympanons in Autun," *Zeitschrift für Kunstgeschichte,* 29, 1966, 261ff. Cf. L. Siedel, *Legends in Limestone: Lazarus, Gislebertus, and the Cathedral of Autun,* Chicago, 1999.

30. V. Terret, *Autun, passim;* E. Mâle, *Religious Art in France, The Twelfth Century,* 408ff.; and Y. Christe, *Les grands portails romans,* Geneva, 1969, 127–31.

31. D. Grivot and G. Zarnecki, *Gislebertus* , 149ff.; D. Jalabert, "L'Eve de la cathédrale d'Autun," *Gazette des Beaux-Arts,* 35, 1949, 300ff.; O. K. Werckmeister, "The Lintel Fragment Representing Eve from Saint-Lazare, Autun," *Journal of the Warburg and Courtauld Institute,* 35, 1972, 1–30; and O. K. Werckmeister, "Die Auferstehung der Toten am Westportal von St. Lazare in Autun," *Frühmittelalterliche Studien,* 4, 1982, 208–36.

32. I. Forsyth, *The Throne of Wisdom: Wood Sculptures of the Madonna in Romanesque France,* Princeton, 1972.

33. Cf. E. R. Elder, *Cistercians and Cluniacs,* Kalamazoo, 1977; and C. Rudolph, *The 'Things of Greater Importance': Bernard of Clairvaux's* Apologia *and the Medieval Attitude towards Art,* Philadelphia, 1990.

34. For these, see W. Braunfels, *Monasteries of Western Europe,* 75ff.; M. Aubert, *L'Architecture cistercienne en France,* Paris, 1947; F. van der Meer, *Atlas de l'ordre cistercien,* Haarlem, 1965; and M. A. Dimier, *L'Art cistercien,* Paris, 1962.

35. *Apologia ad Guillelmum,* in J. P. Migne, *Patrologia Latina,* CLXXXII, 914–16. For a translation, see W. Braunfels, *Monasteries of Western Europe,* 241–42. Cf. M. Schapiro, "On the Aesthetic Attitude in Romanesque Art," *Romanesque Art,* 1–27.

36. C. Oursel, *Miniatures cisterciennes (1109–1134),* Mâcon, 1960.

37. C. Rudolph, *Violence and Daily Life: Reading, Art, and Polemics in the Cîteaux* Moralia in Job, Princeton, 1997, esp. 65–67.

Chapter 14
The Papacy and the Empire

1. E. Bertaux, *L'Art dans l'Italie méridionale,* Paris, 1904, 15ff.; H. Bloch, "Montecassino, Byzantium, and the West," *Dumbarton Oaks Papers,* 3, 1946, 166ff.; W. Braunfels, *Monasteries of Western Europe,* 24ff.; O. Demus, *Byzantium and the West,* New York, 1970; and K. J. Conant, *Carolingian and Romanesque Architecture,* 222–24.

2. K. J. Conant and H. M. Willard, "A Project for the Graphic Reconstruction of Monte Cassino," *Speculum,* 10, 1935, 144ff. For a translation of the text of Leo of Ostia (J. P. Migne, *Patrologia Latina,* CLXXIII, 555ff.), see W. Braunfels, *Monasteries of Western Europe,* 34–35.

3. T. R. Preston, *The Bronze Doors of the Abbey of Monte Cassino and of Saint Paul's Outside the Walls,* Princeton, 1915; G. Matthiae, *Le Porte bronzee bizantine in Italia,* Rome, 1977; M. English, "The Bronze Doors of S. Michele al Monte," Ph.D. diss., Bryn Mawr College, 1966; and U. Mende, *Die Bronzetüren des Mittelalters 800–1200,* Munich, 1983.

4. J. Wettstein, *Les Fresques de S. Angelo in Formis,* Geneva, 1960; O. Morisani, *Gli affreschi di S. Angelo in Formis,* Naples, 1962; A. Moppert-Schmidt, *Die Fresken von S. Angelo in Formis,* Zurich, 1967; and A. Grabar and C. Nordenfalk, *Romanesque Painting,* 33–39.

5. M. Avery, *The Exultet Rolls of South Italy,* Princeton, 1936; and T. F. Kelly, *Exultet Rolls of Southern Italy,* Oxford, 1996.

6. J. S. Ackerman, "Marcus Aurelius on the Capitoline Hill," *Renaissance News,* 10, 1937, 69ff.; H. Toubert, "Le renouveau paleochrétien à Roma au début du XIIe siècle," *Cahiers archéologique,* 20, 1970, 100ff. For the text of the *Marvels of Rome,* see G. M. Rushforth in the *Journal of Roman Studies,* 9, 1919. A discussion of Rome and its medieval monuments is given in R. Krautheimer, *Rome: Profile of a City, 312–1308,* Princeton, 1980 (see esp. chaps. 6 and 7, 143–202).

7. G. Matthiae, *Mosaici medioevali delle chiese di Roma,* Rome, 1967; and F. Hermanin, *L'arte in Roma dal secolo VIII al XIV,* Bologna, 1945.

8. R. Krautheimer, *Rome,* 161ff.; and D. Kinney, "Santa Maria in Trastevere from its Founding to 1215," Ph.D. diss., New York University, 1975.

9. C. Ricci, *Romanesque Architecture in Italy,* London, 1925; E. Anthony, *Early Florentine Architecture and Decoration,* Cambridge, MA, 1927, 3ff.; W. Horn, "Romanesque Churches in Florence," *Art Bulletin,* 25, 1943, 112ff.; and K. J. Conant, *Carolingian and Romanesque Architecture,* 231ff.

10. K. J. Conant, *Carolingian and Romanesque Architecture,* 231.

11. R. Krautheimer, *Early Christian and Byzantine Architecture* (Pelican History of Art, no. 24), Harmondsworth, 1965, 263; and C. Smith, "The Date and Authorship of the Pisa Duomo Facade," *Gesta,* 19, 1980, 95–108.

12. F. Reggiori, *La basilica di Sant'Ambrogio a Milano,* Florence, 1945. For the earlier dating, see A. K. Porter, *Lombard Architecture,* New Haven, 1915–17, II, 532ff.

13. G. de Francovich, "Wiligelmo da Modena e gli inizii della scultura romanica in Francia e in Spagna," *Revista del Reale Istituto di archeologia e storia dell'arte,* 7, 1940, 225–94; R. Jullian, *L'Eveil de la sculpture italienne,* Paris, 1945; R. Salvini, *Wiligelmo e le origini della scultura romanica,* Milan, 1956; E. Fernie, "Notes on the Sculpture of Modena Cathedral," *Arte Lombarda,* 14, 1969, 88–93; A. C. Quintavalle, *Da Wiligelmo a Nicolo,* Parma, 1969; and M. F. Hearn, *Romanesque Sculpture,* 85–98.

14. A. Petzold, *Romanesque Art*, New York, 1995, 140–42.

15. P. E. Schramm and F. Mütherich, *Denkmäler der deutschen Könige und Kaiser: Ein Beitrag zur Herrschergeschichte von Karl dem Grossen bis Friederich II, 768–1250*, Munich, 1962. For Romanesque architecture in Germany, see P. Frankl, *Die frühmittelalterliche und romanische Baukunst*, I, Potsdam, 1926; E. Lehmann, *Der frühe deutsche Kirchenbau*, Berlin, 1938; and H. E. Kubach, *Romanesque Architecture*, New York, 1975. For Speyer Cathedral, see P. W. Hartwein, *Der Kaiserdom zu Speyer*, Speyer, 1927; and E. Gall, *Cathedrals and Abbey Churches of the Rhine*, New York, 1963.

16. E. Panofsky, *Die deutsche Plastik des 11. bis 13. Jahrhunderts I*, Munich, 1924, 82–83; and I. Robinson, *Henry IV of Germany 1056–1106*, Cambridge, 1999, 165–205.

17. R. Haussherr, "Das Imervardkreuz und der Volto-Santo-Typ," *Zeitschrift für Kunstwissenschaft*, 16, 1962, 129–70.

18. C. R. Dodwell, *Theophilus: The Various Arts*, London, 1961 (Latin and English translation); and J. G. Hawthorne and C. S. Smith, *On Divers Arts: The Treatise of Theophilus*, Chicago, 1963.

19. For Mosan art, see S. Collon-Gevaert *et al.*, *Art roman dans la vallée de la Meuse*, Brussels, 1965; H. Swarzenski, *Monuments of Romanesque Art*, 2nd ed., London, 1967; J. J. Timmers, *De kunst van het Maasland*, Assen, 1971; P. Lasko, *Ars Sacra: 800–1200* (Pelican History of Art, no. 36), Harmondsworth, 1972, 181–211; and *Rhin-Meuse: Art et civilization 800–1400*, exh. cat., Cologne and Brussels, 1972.

20. K. H. Usener, "Reiner von Huy und seine künstlerische Nachfolge," *Marburger Jahrbuch*, 12, 1933, 77–134; and P. Lasko, *Ars Sacra*, 162–68.

21. J. Brodsky, "The Stavelot Triptych: Notes on a Mosan Work," *Gesta*, 11, 1972, 19–33; and "Le groupe du triptyque de Stavelot: Notes sur un atelier mosan et sur les rapports avec Saint-Denis," *Cahiers de la civilization médiévale*, 21, 1978, 103–20; and W. Voelkle, *The Stavelot Triptych: Mosan Art and the Legend of the True Cross*, New York, 1980.

22. M. Laurent, "Godefroid de Claire et la croix de Suger à l'abbaye de Saint-Denis," *Revue archéologique*, 19, 1924, 79ff.; P. Verdier, "La grande Croix de l'Abbé Suger à Saint-Denis," *Cahiers de la civilization médiévale*, 13, 1970, 13ff.; and P. Lasko, *Ars Sacra*, 188–91.

23. F. Röhrig, *Der Verduner Altar*, Klosterneuburg, 1955; P. Lasko, *Ars Sacra*, 240–54; and *Der Meister des Dreikönigs-schrein*, exh. cat., Cologne, 1964. For Byzantine influence, see E. Kitzinger, "The Byzantine Contribution to Western Art of the 12th and 13th Centuries," *Dumbarton Oaks Papers*, 20, 1966, 38ff. Concerning the "transitional" aspects of the art of this period, see especially W. Sauerländer, *Von Sens bis Strassburg*, Berlin, 1966.

24. For a concise table of these typologies, see J. J. M. Timmers, *Symboliek en iconographie der christelijke kunst*, Roermond-Maaseik, 1947, esp. 223–315.

25. Hildegard of Bingen, "Declaration: These are True Visions Flowing from God," *Scivias*, trans. C. Hart and J. Bishop, New York, 1990, 59.

26. R. Green, M. Evans, and C. Bischoff, *Herrad von Landsberg, Abbess of Hohenbourg*, London, 1976. For more on the work of nuns during the Late Middle Ages and Early Renaissance, see J. Hamburger, *Nuns as Artists: The Visual Culture of a Medieval Convent*, Berkeley, 1997.

Chapter 15
Normandy and Western France

1. M. Anfray, *L'Architecture normande*, Paris, 1939; E. G. Carlson, "The Abbey Church of Saint-Etienne at Caen in the Eleventh and Twelfth Centuries," Ph.D. diss., Yale University, 1968; and R. Liess, *Der frühromanische Kirchenbau des 11. Jahrhundert in der Normandie*, Munich, 1967.

2. E. Maclagan, *The Bayeux Tapestry*, London, 1949; F. Stenton *et al.*, *The Bayeux Tapestry*, London, 1957; H. Gibbs-Smith, *The Bayeux Tapestry*, London, 1973; D. Wilson, *The Bayeux Tapestry*, New York, 1985; W. Grape, *The Bayeux Tapestry: Monument to a Norman Triumph*, New York, 1994; and S. Brown, *The Bayeux Tapestry: History and Bibliography*, Woodbridge, NJ, 1998. Cf. C. R. Dodwell, "The Bayeux Tapestry and the French Secular Epic," *Burlington Magazine*, 108, 1966, 549–60.

3. J. Bilson, "Durham Cathedral and the Chronology of its Vaults," *Archaeological Journal*, 79, 1922, 101ff.; A. W. Clapham, *English Romanesque Architecture After the Conquest*, Oxford, 1934; G. Webb, *Architecture in Britain: The Middle Ages* (Pelican History of Art, no. 12), Harmondsworth, 1956; and J. P. McAleer, *The Romanesque Church Facade in Britain*, New York, 1984.

4. A. Kelly, *Eleanor of Aquitaine and the Four Kings*, New York, 1957; and A. Weir, *Eleanor of Aquitaine: A Life*, Baltimore, 2000.

5. *Enamels of Limoges 1100–1350*, exh. cat., New York, 1996, 98–101.

6. Bernart de Ventadorn, quoted in M. Camille, *The Medieval Art of Love: Objects and Subjects of Desire*, London, 1998, 11. Cf. M.-M. Gauthier, *Emaux Méridionaux. Catalogue International de l'Oeuvre de Limoges*, vol. I: *L'Époque Romane*, Paris, 1987, 160–63; and M. Müller, *Minnebilder. Französiche Minnendarstellungen des 13. und 14. Jahrhunderts*, Vienna, 1996, 59–73.

7. R. Crozet, *L'Art roman en Poitou*, Paris, 1948. For the sculptures, see B. Rupprecht, *Romanische Skulpturen*, 93ff. Cf. L. Siedel, *Songs of Glory: The Romasnesque Facades of Aquitaine*, Chicago, 1981.

8. G. Gaillard, *The Frescoes of Saint-Savin: The Nave*, New York, 1944; A. Grabar and C. Nordenfalk, *Romanesque Painting*, Geneva, 1958, 87–95; and G. Henderson, "The

Sources of the Genesis Cycle at Saint-Savin-sur-Gartempe," *Journal of the British Archaeological Society*, 26, 1963, 11–26. For Romanesque frescoes in general, see also O. Demus, *Romanesque Mural Painting*, New York, 1970; E. W. Anthony, *Romanesque Frescoes*, Princeton, 1951; and M. Kupfer, *Romanesque Wall Painting in Central France: The Politics of Narrative*, New Haven, 1993.

9. *The Year 1200: A Centennial Exhibition at The Metropolitan Museum of Art*, K. Hoffmann, ed., New York, 1970, no. 159, 153. For Limoges enamels in general, see M. S. Gauthier, *Emaux limousins: Champlevés des XIIe à XIVe siècles*, Paris, 1950; J. Maury *et al.*, *Limousin roman*, La-Pierre-qui-Vire, 1960; and *Enamels of Limoges*.

10. *Enamels of Limoges*, 272–73, 318–321.

PART SIX
THE LATE MIDDLE AGES

Chapter 16
French Gothic Art

1. *Abbot Suger and Saint-Denis: An International Symposium*, P. Gerson, ed., New York, 1986; C. Rudolph, *Artistic Change at St-Denis: Abbot Suger's Program and the Early Twelfth-Century Controversy over Art*, Princeton, 1990; and C. Radding and W. Clark, *Medieval Architecture, Medieval Learning: Builders and Masters in the Age of Romanesque and Gothic*, New Haven, 1992, 63–76.

2. E. Panofsky, *Abbot Suger on the Abbey Church of St.-Denis and Its Art Treasures*, 2nd ed., G. Panofsky-Soergel, ed., Princeton, 1979, 43–45. For a critique of Panofsky's interpretation of Suger as a follower of the Pseudo-Dionysius, see P. Kidson, "Panofsky, Suger, and St. Denis," *Journal of the Warburg and Courtauld Institutes*, 50, 1987, 1–17. For more on Suger's chalice, see *Western Decorative Arts (The Collections of the National Gallery of Art: Systematic Catalogue)*, I, Washington, DC, 1993, 4–12.

3. S. M. Crosby, *The Royal Abbey of Saint-Denis, From its Beginnings to the Death of Suger, 475–1151*, P. Z. Blum, ed., New Haven, 1987; S. M. Crosby *et al.*, *The Royal Abbey of Saint-Denis in the Time of Abbot Suger* (1122–1151), New York, 1981; J. Bony, *French Gothic Architecture*, 61–64, 90ff.; and W. Clark, "'The Recollection of the Past is the Promise of the Future.' Continuity and Contextuality: Saint-Denis, Merovingians, Capetians, and Paris," in *Artistic Integration in Gothic Buildings*, V. Chieffo Raguin, K. Brush, and P. Draper, eds., Toronto, 1995, 92–113.

4. In his *Dictionnaire raisonné de l'architecture française du XIe au XVIe siècle* (Paris, 1854–68, see esp. vol. IX), Viollet-le-Duc stressed the rationalism and functionalism of the Gothic rib as a structural member, a view that was carried to extremes by A. Choisy (*Histoire de l'architecture*, Paris, 1899, II, 239ff.), who claimed that "the history of Gothic construction will be that of the rib and the flying buttress." P. Abraham rejected Viollet's theories (*Viollet-le-Duc et le rationalisme mediéval*, Paris, 1935). He argued that the rib was merely decorative, serving an aesthetic purpose only. Scholars tend to compromise between the functionalism of Viollet and the illusionism of Abraham (cf. H. Focillon, *The Art of the West*, II: *Gothic*, 7ff.). For

further literature concerning the controversy, see G. Kubler, "A Late Gothic Computation of Rib Vault Thrusts," *Gazette des Beaux-Arts*, 6th ser., 26, 1944, 135ff., and especially P. Frankl, *The Gothic: Literary Sources and Interpretations Through Eight Centuries*, Princeton, 1960, 563ff., 805–26. Cf. R. Mark, *High Gothic Structure: A Technological Reinterpretation*, Princeton, 1985; and J. James, "The Rib Vaults of Durham Cathedral," *Gesta*, 22, 1983, 135–45.

5. N. Pevsner, "The Term 'Architect' in the Middle Ages," *Speculum*, 17, 1942, 549–62; P. Booz, *Der Baumeister der Gotik*, Munich, 1956, 25ff.; J. Gimpel, *The Cathedral Builders*, 107–46; and P. Frankl, *The Gothic*, 35ff. For the complex history of the masons' guild and lodges, see P. Frankl, *The Gothic*, 110–58.

6. *Abbot Suger on the Abbey Church of St.-Denis and Its Art Treasures*, 101, 22.

7. Ibid, 73–78. For the remains of these windows, see L. Grodecki, *Les Vitraux de Saint-Denis*, I: *Histoire et restitution* (Corpus Vitrearum Medii Aevi, France, Etudes I), Paris, 1976; and his "Les vitraux allégoriques de Saint-Denis," *Art de France*, 1, 1961, 19ff.

8. M. Camille, *Gothic Art, Glorious Visions*, New York, 1996, 74–75.

9. J. Henriet, "La cathédrale de St.-Étienne de Sens," *Bulletin Monumental*, 140, 1982, 81–174; *Medieval Architecture, Medieval Learning*, 105–9; and R. G. Calkins, *Medieval Architecture in Western Europe from A.D. 300 to 1500*, Oxford, 1998, 178–79.

10. W. Clark and R. King, *Laon Cathedral*, London, 1983.

11. J. Bony, *French Gothic Architecture*, 180–84; W. Clark and R. Mark, "The First Flying Buttresses: A New Reconstruction of the Nave of Notre-Dame de Paris," *Art Bulletin*, 66, 1984, 47–65; and C. Bruzelius, "The Construction of Notre-Dame at Paris," *Art Bulletin*, 69, 1987, 540–69.

12. M. Camille, *Image on the Edge: Margins of Medieval Art*, Cambridge, MA, 1992, 76–85.

13. See J. Bony, *French Gothic Architecture*, esp. 220ff.; H. Jantzen, *High Gothic*. The literature on Chartres is vast. Cf. E. Mâle, *Notre-Dame de Chartres*, Paris, 1948;

W. Sauerländer, *Die Kathedrale von Chartres*, Stuttgart, 1954; O. von Simson, *The Gothic Cathedral*, New York, 1956; Y. Delaporte, *Notre-Dame de Chartres*, Paris, 1957; G. Richter, *Chartres: Idee und Gestalt der Kathedrale*, Stuttgart, 1958; R. Branner, *Chartres Cathedral*, New York, 1969; L. Grodecki, *Chartres*, Paris, 1963; C. F. Barnes, "The Cathedral of Chartres and the Architect of Soissons," *Journal of the Society of Architectural Historians*, 22, 1963, 63–74; J. van der Meulen, "Recent Literature on the Chronology of Chartres Cathedral," *Art Bulletin*, 49, 1967, 152–72; J. van der Meulen, *Chartres: Biographie der Kathedrale*, Cologne, 1984; and *Medieval Architecture, Medieval Learning*, 109–22.

14. R. Branner, *Chartres*, 96–97.

15. A. Priest, "The Masters of the West Facade of Chartres," *Art Studies*, 1, 1923, 28–44; W. S. Stoddard, *The West Portals of Saint-Denis and Chartres*; P. Kidson, *Sculpture at Chartres*, New York, 1959; A. Lapeyre, *Des Façades occidentales de Saint-Denis et de Chartres aux portails de Laon*, Paris, 1960; W. Sauerländer, *Gothic Sculpture*, 383–86; M. Fassler, "Liturgy and Sacred History in the Twelfth-Century Tympana at Chartres," *Art Bulletin*, 74, 1993, 499–520; E. Armi, *The "Headmaster" of Chartres Cathedral and the Origins of "Gothic" Sculpture*, University Park, PA, 1994; and P. Williamson, *Gothic Sculpture 1140–1300*, New Haven, 1995, 14–21.

16. W. Vöge, *Die Anfänge des monumentalen Stiles im Mittelalter*, Strassburg, 1894. See translation in R. Branner, *Chartres*, 126–49.

17. A. Katzenellenbogen, *The Sculptural Programs of Chartres Cathedral*, Baltimore, 1959. Cf. E. Mâle, *Religious Art in France, The Thirteenth Century, passim*.

18. R. Branner, *Chartres*, 95–99.

19. W. Sauerländer, *Gothic Sculpture*, 430–38.

20. G. Zarnecki, "The Coronation of the Virgin on a Capital from Reading Abbey," *Journal of the Warburg and Courtauld Institutes*, 13, 1950, 1–13.

21. Y. Delaporte, *Les Vitraux de la cathédrale de Chartres*, 3 vols., Chartres, 1926; M. Aubert *et al.*, *Le Vitrail français*, Paris, 1958; L. Grodecki and C. Brisac, *Gothic Stained Glass: 1200–1300*, Ithaca, 1985; and W. Kemp, *The Narratives of Gothic Stained Glass*, trans. C. Dobson Saltzwedel, Cambridge, 1997. For a fragment of a Chartres window at the Princeton University Art Museum (Saint George, from a roundel in the choir until 1788), see F. Stohlman, "A Stained Glass Window of the Thirteenth Century," *Art and Archaeology*, 20, 1925, 135. Cf. H. B. Graham, "A Reappraisal of the Princeton Window from Chartres," *Record of the Art Museum, Princeton University*, 121, no. 2, 1962, 30–45.

22. O. von Simson, *The Gothic Cathedral*. W. Schöne, *Über das Licht in der Malerei*, Berlin, 1954, esp. 42 ff., 55, 70.

23. J. Welch Williams, *Bread, Wine, and Money: The Windows of the Trades at Chartres Cathedral*, Chicago, 1993, esp. 1–36;

and P. Kurmann and B. Kurmann-Schwarz, "Chartres Cathedral as a Work of Artistic Integration: Methodological Reflections," in *Artistic Integration in Gothic Buildings*, 131–52.

24. P. Frankl, "A French Gothic Cathedral: Amiens," *Art in America*, 35, 1947, and *Gothic Architecture*, 91ff.; and J. Bony, *French Gothic Architecture*, 275ff. Cf. L. Lefrançois-Pillion, *La Cathédrale d'Amiens*, Paris, 1937; and S. Murray, *Notre-Dame, Cathedral of Amiens: The Power of Change in Gothic*, Cambridge, 1995.

25. D. Connolly, "At the Center of the World: The Labyrinth Pavement of Chartres Cathedral," *Art and Architecture of Late Medieval Pilgrimage in Northern Europe and the British Isles*, 2 vols., S. Blick and R. Tekippe, eds., Leiden, 2004, I, 285–314, II, figs. 134–48.

26. R. Branner, *Saint Louis and the Court Style in Gothic Architecture*, London, 1965; and *idem*, "Paris and the Origins of Rayonnant Gothic Architecture down to 1240," *Art Bulletin*, 44, 1962, 39–51. Cf. J. Bony, *French Gothic Architecture*, 388–91.

27. G. Durand, *Amiens*, I, 299ff.; W. Medding, *Die Westportale der Kathedrale von Amiens und ihre Meister*, Augsburg, 1930; A. Katzenellenbogen, "The Prophets on the West Facade of the Cathedral at Amiens," *Gazette des Beaux-Arts*, 6e, 40, 1952, 241ff.; and W. Sauerländer, *Gothic Sculpture*, 460–66.

28. M. Wolfe and R. Mark, "The Collapse of the Vaults of Beauvais Cathedral in 1284," *Speculum*, 51, 1976, 462–76; and S. Murray, *Beauvais Cathedral: The Architecture of Transcendence*, Princeton, 1989.

29. P. Frankl, *The Gothic*, 55.

30. J. Gimpel, *The Cathedral Builders*, New York, 1961, 108. Villard de Honnecourt was probably an itinerant architect from Picardy. The *Sketchbook* dates from 1235 and later. See H. R. Hahnloser, *Villard de Honnecourt, Kritische Gesamtausgabe des Bauhüttenbuches ms fr 19093 der Pariser Nationalbibliothek*, Vienna, 1935. For an English translation, see T. Bowie, *The Sketchbook of Villard de Honnecourt*, Bloomington, IN, 1959. Cf. C. Barnes, *Villard de Honnecourt: The Artist and His Drawings. A Critical Bibliography*, Boston, 1982.

31. P. Frankl, *The Gothic*, 63–86; and *idem*, "The Secret of the Medieval Masons," *Art Bulletin*, 27, 1945, 46ff.

32. *Gothic Art, Glorious Visions*, 134–35.

33. L. Demaison, *La Cathédrale de Reims*, Paris, 1910; P. Vitry, *La Cathédrale de Reims*, 2 vols., Paris, 1919; J. Bony, *French Gothic Architecture*, 266–75; and P. Frankl, *Gothic Architecture*, 86ff., 112ff. Also see articles by R. Branner ("Historical Aspects of the Reconstruction of Reims Cathedral, 1210–1241," *Speculum*, 36, 1961, 23–37; "Jean d'Orbais and the Cathedral of Reims," *Art Bulletin*, 43, 1961, 131–33; "The Labyrinth of Reims Cathedral," *Journal of the Society of Architectural Historians*, 21, 1962, 18–25). Cf. B. Abou-el-Haj, "The Urban Setting for Late

Medieval Church Building: Reims and its Cathedral between 1210 and 1240," *Art History*, 11, 1988, 17–41; and idem, "Ritual, Image, and Subordination in Thirteenth-Century Reims," *World Art: Themes of Unity in Diversity (Acts of the 26th International Congress of the History of Art)*, vol. 3, I. Lavin, ed., University Park, PA, 1989, 653–64.

34. The first serious study of these sculptors was W. Vöge, "Vom gotischen Schwung und der plastischen Schule des 13. Jahrhunderts," *Repertorium für Kunstwissenschaft*, 1904, 1ff. For later studies, see L. Lefrançois-Pillion, *Les Sculpteurs de la cathédrale de Reims*, Paris, 1928; E. Panofsky, "Über die Reihenfolge der vier Meister von Reims," *Jahrbuch für Kunstwissenschaft*, 1927, 55–82; R. Branner, "The North Transept and the First West Facades of Reims," *Zeitschrift für Kunstgeschichte*, 24, 1961, 220–41 (and articles listed in n. 40, above); W. M. Hinkle, *The Portal of the Saints of Reims Cathedral*, New York, 1965; W. Sauerländer, *Gothic Sculpture*, 474–88; idem, *Gothic Sculpture*, 415–17, 481–83; and R. Branner, "The North Transept and the First West Facades of Reims," 197–203.

35. *Gothic Sculpture 1140–1300*, 156–58.

Chapter 17
Saint Louis and Late Medieval France

1. R. Branner, "Paris and the Origins of Rayonnant Gothic Architecture down to 1240," 39–51; and idem, *Saint Louis and the Court Style*, London, 1965. Cf. J. Bony, *French Gothic Architecture of the Twelfth and Thirteenth Centuries*, Berkeley, 1983, 365–81; and P. Frankl, *Gothic Architecture*, Harmondsworth, 1962, 223ff. For more on late French Gothic architecture, see L. Neagley, *The Parish Church of Saint-Maclou: A Study of Rouennais Flamboyant Architecture*, Blomington, IN, 1983; and L. Neagley, "Elegant Simplicity: The Late Gothic Plan Design of St.-Maclou in Rouen, *Art Bulletin*, 74, 1992, 394–423.

2. F. Gebelin, *La Sainte-Chapelle*, Paris, 1931; L. Grodecki, *Sainte-Chapelle*, Paris, 1962; 2nd ed., 1975; R. Branner, *Saint Louis and the Court Style*; and B. Brenk, "The Sainte-Chapelle as a Capetian Political Program," *Artistic Integration in Gothic Buildings*, V. Chieffo Raguin, K. Brush, and P. Draper, eds., Toronto, 1995, 195–213.

3. L. Grodecki, *Sainte-Chapelle*, 49–70. A complete description of the windows appears in vol. I of *Les Vitraux de Notre-Dame et de la Sainte-Chapelle de Paris* (Corpus Vitrearum Medii Aevi, France), Paris, 1959, compiled by M. Aubert *et al.*

4. M. Camille, *Gothic Art, Glorious Vision*, New York, 1996, 103–4.

5. Dante Alighieri, *Purgatorio*, Canto 11, 79–81, trans. A. Mandelbaum, New York, 1982, 98–99.

6. P. Lauer, *Les principaux manuscrits à peintures de la Bibliothèque de l'Arsenal*, Paris, 1929; G. Haseloff, *Die Psalterillustration im 13. Jahrhundert*, Kiel, 1938; V. Leroquais, *Les Psautiers manuscrits des bibliothèques publiques de France*, Paris, 1940–41; J. Dupont and C. Gnudi, *Gothic Painting*, Geneva, 1954, 27–30; *Les Manuscrits à peintures en France du XIIIe au XVIe siècle*, J. Porcher, ed., exh. cat., Paris, 1955; J. Porcher, *Medieval French Miniatures*, New York, 1959, 45ff.; R. Branner, *Manuscript Painting in Paris During the Reign of Saint Louis*, Berkeley, 1977; and J. J. G. Alexander, *Medieval Illuminators and their Methods of Work*, New Haven, 1992.

7. M. R. James, *Catalogue of the Manuscripts . . . of the Library of J. Pierpont Morgan*, 2 vols., London, 1906–7; A. de Laborde, *La Bible moralisée conservée à Oxford, Paris et Londres*, 5 vols., Paris, 1911–27; and R. Haussheer, *Bible moralisée*, Graz, 1973.

8. H. Martin, *Psautier de Saint Louis et de Blanche de Castille*, Paris, 1909; and M. Thomas, *Le Psautier de Saint Louis*, Graz, 1970.

9. For a discussion of manuscript production in Paris, see R. Branner, *Manuscript Painting in Paris*, 1–21. For model books in general, see R. W. Scheller, *A Survey of Medieval Model Books*, Haarlem, 1963.

10. E. Millar, *The Parisian Miniaturist Honoré*, London, 1959, 11–16.

11. *Les Manuscrits à peintures en France au XIIIe au XVIe siècle*, 22–24; and F. Avril, *Manuscript Painting at the Court of France- The Fourteenth Century (1310–1380)*, New York, 1978, 12, 40ff. See the lively discussion of the activities in V. W. Egbert, *On the Bridges of Mediaeval Paris*, Princeton, 1974.

12. For the Book of Hours, see V. Leroquais, *Les Livres d'heures manuscrits de la Bibliothèque Nationale*, 3 vols. and supplement, Paris and Mâcon, 1927–43; J. Harthan, *The Book of Hours*, New York, 1977; R. Calkins, *Illuminated Books of the Middle Ages*, Ithaca, 1983, 243–82; J. Backhouse, *Books of Hours*, London, 1985; and R. Wieck, *Painted Prayers: The Book of Hours in Medieval and Renaissance Art*, New York, 1997.

13. The significance of the Book of Hours in the development of Late Gothic painting is discussed at length by E. Panofsky, *Early Netherlandish Painting*, Cambridge, MA, 1953, I, *passim*.

14. J. Rorimer, *The Hours of Jeanne d'Evreux* (partial facsimile), New York, 1957. E. Panofsky, *Early Netherlandish Painting*, 29–34, 43–44. See the special issue of the *Bulletin of The Metropolitan Museum of Art*, n.s. 16, 1958, 269–92, with articles by R. H. Randall, Jr., and E. Winternitz. Also see S. Ferber, "Jean Pucelle and Giovanni Pisano," *Art Bulletin*, 66, 1984, 65–72.

15. *Manuscript Painting at the Court of France*, 14–22.

16. Ibid, 74–75.

17. Ibid, 96–98.

18. *Images in Ivory: Precious Objects of the Gothic Age*, P. Barnet, ed., exh. cat., Detroit, 1997, 124–26. For more on the

Virgin as a locus of desire, see M. Camille, *The Gothic Idol: Ideology and Image-Making in Medieval Art*, Cambridge, 1989, 220–41. Cf. M. Caviness, *Visualizing Women in the Middle Ages: Sight, Spectacle, and Scopic Economy*, Philadelphia, 2001.

19. R. Koechlin, *Les Ivoires gothique français*, Paris, 1924, I, 94; II, no. 95; L. Grodecki, *Ivoires français*, Paris, 1947, 88; J. Natanson, *Gothic Ivories of the 13th and 14th Centuries*, London, 1951, 19ff.; and *Treasures from Medieval France*, W. Wixom, ed., exh. cat., Cleveland Museum of Art, 1967, 182.

20. R. Koechlin, *Les ivoires gothiques français*, II and III, no. 1281; R. S. Loomis and L. H. Loomis, *Arthurian Legends in Medieval Art*, London and New York, 1938, 66, 70, 76; and *Treasures from Medieval France*, 208.

21. *Images in Ivory* 232–33. For more on chess and courtly love, see M. Yalom, *Birth of the Chess Queen: A History*, New York, 2004.

22. S. Gagnière, *The Palace of the Popes at Avignon*, Paris, 1965; and Y. Renouard, *Avignon Papacy, 1305–1403*, trans. D. Bethell, London, 1970.

23. *Gothic Art, Glorious Visions*, 160–61; C. Harding, "Opening to God: The Cosmological Diagrams of Opicino de Canistris," *Zeitschrift für Kunstgeschichte*, 61, 1998, 18–39; and *idem*, "Madness, Reason, Vision and the Cosmos: Evaluating the Drawings of Opicino de Canistris," in *Revaluing Renaissance Art*, G. Neher and R. Shepherd, eds., Aldershot and Brookfield, VT, 2000, 201–10.

Chapter 18
Gothic Styles in England and Spain

1. P. Binski, *Westminster Abbey and the Plantagenets: Kingship and the Representation of Power, 1200–1400*, New Haven, 1995; and *The Age of Chivalry, Art in Plantagenet England 1200–1400*, P. Binski and J. J. G. Alexander, eds, exh. cat., London, 1987.

2. *Chronica Gervasi*, translated in R. Willis, *The Architectural History of Canterbury Cathedral*, London, 1845 (rep., R. Willis, *Architectural History of Some English Cathedrals*, vol. 1, Chicheley, 1972); P. Frankl, *The Gothic: Literary Sources and Interpretations Through Eight Centuries*, Princeton, 1960, 24–33. See also F. Woodman, *The Architectural History of Canterbury Cathedral*, London, 1981; and P. Collison, N. Ramsey, and M. Sparks, *A History of Canterbury Cathedral*, Oxford, 1995.

3. The term Romanesque was actually used earlier in England, where it was applied to Norman and Early Gothic structures. See T. Bizzaro, "Romanesque Criticism: A Prehistory," Ph.D. diss., Bryn Mawr College, 1985.

4. This somewhat arbitrary nomenclature was introduced by T. Rickman, *An Attempt to Discriminate the Styles of Architecture in England from the Conquest to the Reformation*, London, 1817. For English Gothic, see F. Bond, *Gothic Architecture in England*, London, 1905; G. Webb, *Architecture in Britain—The Middle Ages* (Pelican History of Art, no. 12), Harmondsworth, 1956; H. Batsford and C. Fry, *The Cathedrals of England*, London, 1960; L. F. Salzman, *Building in England down to 1540: A Documentary History*, Oxford, 1967; J. Bony, *The English Decorated Style*; P. Johnson, *British Cathedrals*, New York, 1980; R. G. Calkins, *Medieval Architecture in Western Europe from A.D. 300 to 1500*, Oxford, 1998, 253–62; and C. Platt, *The Architecture of Medieval Britain*, New Haven, 1990.

5. P. Frankl, "The Crazy Vaults of Lincoln Cathedral," *Art Bulletin*, 35, 1953, 95ff.; G. H. Cook, *A Portrait of Lincoln*, London, 1950; P. Kidson, "St. Hugh's Choir," *Medieval Art and Architecture at Lincoln Cathedral. British Archaeological Association, Conference Transactions of 1982*, London, 1986, 29–42; and *A History of Lincoln Cathedral*, D. Owen, ed., Cambridge, 1994

6. P. Johnson, *British Cathedrals*, 74.

7. R. String, *Salisbury Cathedral*, London, 1987.

8. R. Branner, "Westminster Abbey and the French Court Style," *Journal of the Society of Architectural Historians*, 23, 1964, 3–18; W. R. Lethaby, *Westminster Abbey Re-examined*, London, 1925; and H. K. Westlake, *Westminster Abbey*, 2 vols., London, 1923.

9. For the Decorated Style, see especially J. Bony, *The English Decorated Style*; and H. Bock, *Der Decorated Style*, Heidelberg, 1962; and N. Coldstream, *The Decorated Style*, Toronto, 1994. For Exeter, see H. E. Bishop and E. K. Prideaux, *The Building of the Cathedral Church of Exeter*, Exeter, 1922; and V. Hope and J. Lloyd, *Exeter Cathedral*, Exeter, 1973.

10. *Wells Cathedral. A History*, L. S. Colchester, ed., Shepton Mallet, UK, 1982. For more on the tooth puller, see M. Camille, *Image on the Edge: The Margins of Medieval Art*, Cambridge, MA, 1992, 82–83.

11. G. Webb, *Ely Cathedral*, London, 1950.

12. G. Webb, *Architecture in Britain*, 148–50; and *A History of York Minster*, G. E. Aylmer and R. Cant, eds., Oxford, 1977. For more on stained glass painting, see R. Marks, *Stained Glass in England during the Middle Ages*, Toronto, 1993.

13. For King's College Chapel, see F. Woodman, *The Architectural History of King's College Chapel and its Place in the Development of Late Gothic Architecture in England and France*, London, 1986; J. Harvey, *The Perpendicular Style*, London, 1978; and F. Woodman, *The Architectural History of King's College Chapel*, London, 1986. English Gothic architecture had a long afterlife and periods of revival. See G. Germann, *The Gothic Revival in Europe and Britain*, London, 1972; K. Clark, *The Gothic Revival*, London, 1928; R. Wittkower, *Gothic versus Classic*; and N. Pevsner, *Ruskin and Viollet-le-Duc: Englishness and Frenchness in the Appreciation of Gothic Architecture*, London, 1969.

14. R. Vaughn, *Matthew Paris*, Cambridge, 1958; and S. Lewis, *The Art of Matthew Paris in the Chronica Majora*, Berkeley, 1987, esp. 15–33.

15. R. Marks and N. Morgan, *The Golden Age of English Manuscript Painting 1200–1500*, New York, 1981, 48–49; and M. Camille, *Gothic Art, Glorious Visions*, New York, 1996, 91.

16. Cf. L. Randall, *Images in the Margins of Gothic Manuscripts*, Berkeley, 1966.

17. M. Camille, *The Medieval Art of Love: Objects and Subjects of Desire*, London, 1998, 89–90. Cf. G. de Lorris and J. de Meung, *The Romance of the Rose,* trans. C. Dahlberg, Princeton, 1971, esp. II, 7, 216–52.

18. M. Stokstad, *Medieval Art*, 2nd ed., Boulder, CO, 2003, 316–17.

19. D. King, *Opus Anglicanum: English Medieval Embroidery*, London, 1963; K. Staniland, *Embroiderers*, Toronto, 1991; and *Medieval Art*, 317–19.

20. *The Regal Image of Richard II and the Wilton Diptych*, D. Gordon, L. Monnas, and C. Elam, eds., London, 1997.

21. E. Liaóno Martinez, *La cathedral de Barcelona*, Madrid, 1983; and *Medieval Architecture in Western Europe from A.D. 300 to 1500*, 265–69.

22. *Gothic Art, Glorious Visions*, 114–18; and J. M. Azcárate, *Arte gótico en España*, Madrid, 1996, 286–94.

23. *The Catalan Atlas of the Year 1375*, G. Grosjean, ed., Zurich, 1978. For more on medieval mapmaking, see *The History of Cartography*, J. B. Harley and D. Woodward, eds., vol. 1, Chicago, 1987; and E. Edson, *Mapping Time and Space: How Medieval Mapmakers Viewed Their World,* London, 1997.

Chapter 19
Late Medieval Italy and Urban Monasticism

1. *The Little Flowers of Saint Francis*, trans. R. Brown, New York, 1958.

2. J. R. Moorman, *Early Franciscan Art and Literature*, Manchester, 1943; G. Kaftal, *St. Francis in Italian Painting*, London, 1950; L. di Fonzo and A. Pompei, "Francesco da Assisi," in *Bibliotheca sanctorum*, Rome, 1964, cols. 1052–1150; O. Schmucki and S. Gerlach, "Franz von Assisi," *Lexikon der christlichen Ikonographie, 6*, 1974, cols. 260–315; and J. Stubblebine, *Assisi and the Rise of Vernacular Art*, New York, 1985.

3. A. Derbes, *Picturing the Passion in Late Medieval Italy: Narrative Painting, Franciscan Ideologies, and the Levant*, Cambridge, 1996, 1–11.

4. H. van Os, *Sienese Altarpieces 1215–1460*, vol. 1, Groningen, 1988, 23–25.

5. W. Ueberwasser, *Giotto: Frescoes*, New York, 1950; C. Gnudi, *Giotto*, Milan, 1959; M. Meiss, *Giotto and Assisi*; E. Borsook, *The Mural Painters of Tuscany, from Cimabue to Andrea del Sarto*, London, 1960; E. Baccheschi and A. Martindale, *The Complete Paintings of Giotto*, New York, 1966; E. Battisti, *Giotto: Biographical and Critical Study*, Cleveland, 1966; J. Stubblebine, *Giotto: The Arena Chapel Frescoes*, New York, 1969; M. Baxandall, *Giotto and the Orators*, Oxford, 1971; B. Cole, *Giotto and Florentine Painting 1280–1375*, New York, 1976; M. Barasch, *Giotto and the Language of Gesture*, Cambridge, 1987; *Giotto and the World of Early Italian Art*, A. Ladis, ed., 4 vols., New York, 1998; and *The Cambridge Companion to Giotto*, A. Derbes and M. Sandona, eds., Cambridge, 2004.

6. Dante Alighieri, *Purgatorio*, Canto 11, 94–96, trans. A. Mandelbaum, New York, 1982, 98–99.

7. Boccaccio, *The Decameron,* 6th Day, 5th Story, trans. F. Winwar, New York, 1955, 365–67.

8. Giorgio Vasari, *The Lives of the Artists*, trans. J. Conaway Bondanella and P. Bondanella, Oxford, 1991, 1–36.

9. B. Berenson, *The Florentine Painters of the Renaissance,* New York, 1896, 1–19.

10. For translations of these texts, see G. Ryan and H. Ripperger, *The Golden Legend of Jacobus de Voragine*, 2 vols., Princeton, 1993; and I. Ragusa and R. Greene, *The Pseudo-Bonaventura's Meditations on the Life of Christ*, Princeton, 1961.

11. M. Barasch, *Gestures of Despair in Medieval and Early Renaissance Art*, New York, 1976, 57ff.

12. G. Swarzenski, *Nicola Pisano*, Frankfurt, 1926; G. H. Crichton, *Nicola Pisano and the Revival of Sculpture in Italy*, Cambridge, 1938; G. N. Fasola, *Nicola Pisano*, Rome, 1941; E. M. Angiola, "Nicola Pisano, Federigo Visconti, and the Classical Style in Pisa," *Art Bulletin*, 59, 1977, 1–27; E. Carli, *Il pulpito del Battistero di Pisa*, Milan, 1971; and F. Hartt, *History of Italian Renaissance Art*, rev. D. Wilkins, 4th ed., New York, 1994, 65–69.

13. J. Pope-Hennessy, *Italian Gothic Sculpture*, London, 1955; and M. Ayrton, *Giovanni Pisano*, New York, 1969.

14. J. White, *Art and Architecture in Italy, 1250–1499*, Baltimore, 1966, 20ff., 165–69; C. Pietramellara, *Il Duomo di Siena: evoluzione dale origini alla fin del Trecento*, Florence, 1980; and K. van der Ploeg, *Architecture and Liturgy: Siena Cathedral in the Middle Ages*, Groningen, 1993.

15. *History of Italian Renaissance Art*, 129–32.

16. H. van Os, *Sienese Altarpieces 1215–1460*, vol. 1, Groningen, 1988, 11–12.

17. C. Brandi, *Duccio*, Florence, 1951; E. Carli, *Duccio*, Milan, 1952; J. White, *Duccio*, London, 1979; J. Stubblebine, *Duccio*, Princeton, 1980; and *Sienese Altarpieces 1215–1460*, 30–34.

18. *Sienese Altarpieces 1215–1460*, 39–61.

19. G. Paccagnini, *Simone Martini*, London, 1957. For Simone's activity in Avignon, see J. Rowlands, "The Date of Simone Martini's Arrival in Avignon," *Burlington Magazine*, 107, 1965, 25–32. For more on the Sienese altarpieces dedicated to civic saints located in Siena's cathedral, see *Sienese Altarpieces 1215–1460*, 76–89.

20. For more on the upper church frescoes, see A. Smart, "The St. Cecilia Master and His School at Assisi,"

Burlington Magazine, 102, 1960, 405ff., 431ff.; M. Meiss, *Giotto and Assisi*, New York, 1960; L. Tintori and M. Meiss, *The Painting of the Life of St. Francis in Assisi*, New York, 1962; and A. Smart, *The Assisi Problem and the Art of Giotto: A Study of the Legend of Saint Francis in the Upper Church of San Francesco, Assisi*, New York, 1971. For a succinct summary, see J. White, *Art and Architecture in Italy*, 115–48; and J. Poesche, *Die Kirche San Francesco in Assisi und ihre Wandmalereien*, Munich, 1985.

21. G. Rowley, *Ambrogio Lorenzetti*, 2 vols., Princeton, 1958; and R. Starn, *Ambrogio Lorenzetti: The Palazzo Pubblico, Siena*, New York, 1984.

22. M. Meiss, *Painting in Florence and Siena After the Black Death*, Princeton, 1951, 74–76. Cf. P. Binski, *Medieval Death*, Ithaca, 1996, esp. 33–47.

Chapter 20
Art and Mysticism in Late Medieval Germany

1. For Gothic architecture in Germany, see E. Gall, *Die gotische Baukunst in Frankreich und Deutschland*, Munich, 1926; G. Dehio, *Handbuch der deutschen Kunstdenkmäler*, 5 vols., Berlin, 1920; E. Hempel, *Deutsche Kunstgeschichte*, I: *Geschichte der deutschen Baukunst*, Munich, 1953; J. Baum, *German Cathedrals*, London, 1956; P. Frankl, *Gothic Architecture*; H. Busch, *Deutsche Gotik*, Vienna and Munich, 1969; W. Swaan, *The Gothic Cathedral*, New York, 1969, 225–58; E. Gall, *Cathedrals and Abbey Churches of the Rhine*, New York, 1963; W. Braunfels, *Die Kunst im Heiligen Römischen Reich Deutscher Nation*, 6 vols., Munich, 1979–89. For Gothic sculpture in Germany, see E. Panofsky, *Die deutsche Plastik des elften bis dreizehnten Jahrhunderts*, Munich, 1924; W. Pinder, *Die deutsche Plastik* (Handbuch der Kunstwissenschaft), 2 vols., Wildpark-Potsdam, 1924; H. Jantzen, *Deutsche Bildhauer des 13. Jahrhunderts*, Munich, 1939; A. Feuler and T. Muller, *Deutsche Kunstgeschichte*, II: *Geschichte der deutschen Plastik*, Munich, 1953; R. G. Calkins, *Medieval Architecture in Western Europe from A.D. 300 to 1500*, Oxford, 1998, 271–89; and N. Nussbaum, *German Gothic Church Architecture*, New Haven, 2000. For Strasbourg, see H. Weigert, *Das Strassburger Münster*, 2nd ed., Berlin, 1935 (see p. 64 for earlier bibliography); and H. Reinhardt and E. Fels, "La façade de la Cathédrale de Strasbourg," *Bulletin de la Société des Amis de la Cathédrale de Strasbourg*, Strasbourg, 1935; and H. Reinhardt, *La cathédrale de Strasbourg*, Paris, 1972.

2. H. Rosenan, *Der Kölner Dom*, Cologne, 1931; P. Clemen, *Der Dom zu Köln*, Düsseldorf, 1937; and articles in the *Festschrift des Kölner Domes*, Cologne, 1948.

3. Quoted by P. Frankl, *The Gothic: Literary Sources and Interpretations Through Eight Centuries*, Princeton, 1960, 238.

4. For a discussion of the hall churches, see P. Frankl, *Gothic*

Architecture (Pelican History of Art, no. 19), Harmondsworth, 1962, 60ff.; and J. Michler, *Die Elizabethkirche zu Marburg in ihrer ursprunglischen Farbigkeit*, Marburg, 1984.

5. *Medieval Architecture in Western Europe from A.D. 300 to 1500*, 276–77.

6. G. Dehio, *Der Bamberger Dom*, Berlin, 1924; W. Pinder, *Der Bamberger Dom und seine Bildwerke*, Berlin, 1927; W. Broeck, *Der Bamberger Meister*, Tübingen, 1960; and D. von Winterfeld, *Der Dom im Bamberg*, 2 vols., Berlin, 1979.

7. For a summary, see W. R. Valentiner, *The Bamberg Rider*, Los Angeles, 1956, esp. 116–38; *Der Zeit der Staufer: Geschicht, Kunst, Kultur*, R. Haussherr, ed., vol. 1, Stuttgart, 1977, 315–17; and P. Williamson, *Gothic Sculpture, 1140–1300*, New Haven, 1995, 95–96.

8. E. Schubert, *Der Magdeburger Dom*, Frankfurt, 1984; P. H. D. Kaplan, "Black Africans in Hohenstaufen Iconography," *Gesta*, 26, 1987, 29–36; and *Gothic Sculpture, 1140–1300*, 176–77.

9. W. Pinder, *Der Naumburger Dom und seine Bildwerke*, 5th ed., Berlin, 1935; *Der Zeit der Staufer*, vol. 1, 332–35; and *Gothic Sculpture, 1140–1300*, 180–86.

10. For a definition of *Andachtsbild*, see E. Panofsky, "Imago Pietatis," in *Festschrift für M. J. Friedländer*, Leipzig, 1927, 264–68; W. Pinder, *Die deutsche Plastik*, I, 92ff.; S. Ringbom, *Icon to Narrative: The Rise of the Dramatic Close-Up in Fifteenth-Century Devotional Painting*, Abo, Finland, 1965; H. Belting, *The Image and Its Public in the Middle Ages: Form and Function of Early Italian Paintings of the Passion*, trans. M. Bartusis and R. Meyer, New Rochelle, NY, 1990, 41–56; and J. Hamburger, *The Visual and the Visionary: Art and Female Spirituality in Late Medieval Germany*, New York, 1998, 111–48.

11. Cf. J. Marrow, *Passion Iconography in Northern European Art of the Late Middle Ages and the Early Renaissance: A Study of the Transformation from Sacred Metaphor to Descriptive Narrative*, Kortrijk, Belgium, 1979.

12. W. Pinder, *Die deutsche Plastik*, I, 92ff.; and J. Ziegler, *Sculptures of Compassion: The Pietà and the Beguines in the Southern Low Countries, c. 1300–1600*, Brussels, 1992. For the Pietà in France, see W. Forsyth, *The Pietà in French Late Gothic Sculpture: Regional Variations*, New York, 1995.

13. J. Hamburger, *The Rothschild Canticles: Art and Mysticism in Flanders and the Rhineland, circa 1300*, New Haven, 1990, 103.

14. *The Art of Devotion in the Late Middle Ages in Europe 1300–1500*, H. van Os, ed., Princeton, 1995, 50–57.

15. M. Camille, *The Medieval Art of Love: Objects and Subjects of Desire*, London, 1998, 96–97.

16. Ibid, 134–35.

17. *Der Hedwigs-Codex von 1353: Sammlung Ludwig*, W. Braunfels, ed., Berlin, 1972; and *The Visual and the Visionary*, 434–40.

18. *The Rothschild Canticles*, 72–77.

19. *The Visual and the Visionary*, 198–206. For more on Henry of Suso and late medieval mysticism, see R. Kieckhefer, *Unquiet Souls: Fourteenth-Century Saints and Their Religious Milieu*, Chicago, 1984.

Chapter 21
Coda—Inventing the Middle Ages

1. F.-R. Chateaubriand, *Génie du Christianisme*, Paris, 1801, III, chapt. 8. For a discussion and translation, see P. Frankl, *The Gothic: Literary Sources and Interpretations Through Eight Centuries*, Princeton, 1960, 482ff.
2. *Viollet-le-Duc: Architect, Artist, Master of Historic Preservation*, F. Bercé and B. Foucart, eds., exh. cat., Washington, DC, 1988; *The Architectural Theory of Viollet-le-Duc: Readings and Commentary*, M. F. Hearn, ed., Cambridge, 1990.
3. M. Aldrich, "Gothic Sensibility: The Early Years of the Gothic Revival," in *A. W. Pugin Master of Gothic Revival*, P. Atterbury, ed., New Haven, 1995, 13–29; and

M. R. Brownell, *The Prime Minister of Taste: A Portrait of Horace Walpole*, New Haven, 2001.
4. J. L. Koerner, *Caspar David Friedrich and the Subject of Landscape*, New Haven, 1990; and W. Hofmann, *Caspar David Friedrich*, New York, 2000.
5. *A. W. Pugin Master of Gothic Revival*, P. Atterbury, ed., New Haven, 1995.
6. M. J. Trow and T. Trow, *Boudicca: The Warrior Queen*, Stroud, UK, 2003.
7. D. Mancoff, *The Arthurian Revival in Victorian Art*, New York, 1990; and *idem, The Return of King Arthur: The Legend Through Victorian Eyes*, London, 1995.
8. J. Morrison, *Painting the Nation: Identity and Nationalism in Scottish Painting, 1800–1920*. Edinburgh, 2003; and J. Kemplay, *John Duncan: A Scottish Symbolist*. San Francisco, 1994.
9. "The Decorative Works of John Duncan," *The Artist: An illustrated monthly record of arts, crafts, and industries*, vol. 21, Jan-Apr. 1898, 146–152.
10. Norman Cantor, *Inventing the Middle Ages*, New York, 1991, 47.

SELECT BIBLIOGRAPHY

The following bibliography does not include articles and monographs on individual monuments or artists. Consult the text and notes for more specialized studies. Books that cover more than one category in the bibliography are listed only once under that category which seems most appropriate for their contents.

1. Early Texts and Documents

Bede. *A History of the Abbots of Wearmouth and Jarrow* (Loeb Classical Library). Trans. by J. E. King. Cambridge, MA: Harvard University Press, 1954.

——. *Bede's Ecclesiastical History of the English People.* Ed. by B. Colgrave and R. A. B. Mynors. Oxford: Oxford University Press, 1969.

Benedict the Canon. *Mirabilia urbis Romae.* Trans. by Fr. M. Nichols in *The Marvels of Rome.* London: Ellis and Elvey, 1889.

Bollandus, J. and eds. *Acta sanctorum.* 66 vols. Paris: V. Palmé, 1863—.

Bonaventura, Saint. *Meditationes vitae Christi.* See I. Ragusa and R. Green, *Meditations on the Life of Christ: An Illustrated Manuscript of the Fourteenth Century (Paris, Bibliothèque Nationale, MS. ital. 115).* Princeton: Princeton University Press, 1961.

Corpus christianorum, series Latina. 176 vols. Turnholt, Belgium: Typographi Brepols editores pontificii, 1953–65.

Dionysius of Fourna. *Painter's Handbook (Hermeneia).* French trans. in A. N. Didron, *Manuel d'iconographie chrétienne,* Paris: Imprimerie Royale, 1845; English trans. of Didron by M. Stokes, *Christian Iconography.* 2 vols. London: H. G. Bohn, 1886–91.

Durandus, W. *The Symbolism of Churches and Church Ornaments: A Translation of the First Book of the Rationale Divinorum Officiorum.* Trans. by J. N. Neale and B. Webb. London: Gibbings & Co., 1893.

Eusebius. *Vita Constantini.* Trans. by P. Schaff and H. Wace in *A Select Library of the Nicene and Post-Nicene Fathers.* 2nd ser. Vol. I. New York: The Christian Literature Co., 1890.

——. *Ecclesiastical History.* Trans. by H. J. Lawlor and J. E. Dutton. Harmondsworth: Penguin, 1965.

Fathers of the Church. 75 vols. Washington, DC: The Catholic University of America Press, 1947–86.

Gregory of Tours. *History of the Franks.* Trans. by L. Thorpe. Harmondsworth: Penguin, 1974.

Holt, E. G. *A Documentary History of Art,* I: *The Middle Ages and the Renaissance.* Garden City, NY: Doubleday, 1957.

Liber pontificalis. French ed. edited by L. Duchesne, *Le Liber Pontificalis.* 3 vols. Paris: E. Thorin, 1881–92; reprinted 1957; English ed. by L. R. Loomis, *The Book of the Popes* (Records of Civilization, no. 3). New York: Columbia University Press, 1916.

Migne, J. P. *Patrologiae cursus completus series Graeca (Patrologia Graeca).* 161 vols. Paris, J. P. Migne, 1857–1903. Usually noted as M. P. G. or P. G.

——. *Patrologiae cursus completus series Latina (Patrologia Latina).* 221 vols. Paris: Garnier fratres and J. P. Migne, 1844–79. Usually noted as M. P. L. or P. L.

Paul the Deacon. *History of the Lombards.* Trans. by W. D. Foulke. Philadelphia: University of Pennsylvania Press, 1974.

Procopius. De aedificiis. English trans. by H. B. Dewing and G. Downey, Procopius. Vol. 7. London: W. Heinemann, 1954.

Rossi, G. de. *Inscriptiones christianae urbis Romae.* 3 vols. Rome: Libraria Pontificia, 1861–88.

A Select Library of Nicene and Post-Nicene Fathers of the Christian Church. 14 vols. New York: The Christian Literature Co., 1886–90.

Theophilus. *De diversis artibus.* Trans. by C. R. Dodwell as *Theophilus: The Various Arts.* London: Nelson, 1961 (reprinted by Oxford University Press, 1994); J. G. Hawthorne and C. S. Smith. *On Divers Arts.* Chicago: University of Chicago Press, 1963.

Voragine, J. de. *The Golden Legend.* Trans. by G. Ryan and H. Ripperger. 2 vols. Princeton: Princeton University Press, 1993.

2. Historical Surveys

Abou-el-Haj, B. *The Medieval Cult of the Saints: Formations and Transformations.* Cambridge: Cambridge University Press, 1997.

Alexander, J. J. G. *The Decorated Letter.* New York: Braziller, 1978.

——. *Medieval Illuminators and Their Methods of Work.* New Haven: Yale University Press, 1992.

Baltrusaitis, J. *Le moyen âge fantastique.* Paris: A. Colin, 1955.

Belting, H. *Likeness and Presence. A History of the Image before the Era of Art,* Trans. by Edmund Jephcott. Chicago: University of Chicago Press, 1994.

Binski, Paul. *Medieval Death: Ritual and Representation.* Ithaca: Cornell University Press, 1996.

Braunfels, W. *Monasteries of Western Europe: The Architecture of the Orders.* Princeton: Princeton University Press, 1972.

Brooke, C. *The Structure of Medieval Society.* London: Thames and Hudson, 1971.

——. *The Monastic World, 1000–1300.* New York: Random House, 1974.

Brown, M. P. *Understanding Illuminated Manuscripts: A Guide to Technical Terms*. London: British Library, 1994.

Brown, P. *The Rise of Western Christendom. Triumph and Diversity AD 200–1000*. Oxford: Blackwell, 1996.

Bryer, A. and Herrin, J., eds. *Iconoclasm: Papers Given at the Ninth Spring Symposium of Byzantine Studies*, University of Birmingham, March 1975. Birmingham, UK: University of Birmingham Press, 1977.

Bynum, C. W. *Holy Feast and Holy Fast: The Religious Significance of Food to Medieval Women*. Berkeley: University of California Press, 1987.

Cabrol, F. and Leclercq, H. *Dictionnaire d'archéologie chrétienne et de liturgie*. 15 vols. Paris: Letouzey et Ané, 1907–.

Calkins, R. *Monuments of Medieval Art*. New York: Dutton, 1979.

——. *Illuminated Books of the Middle Ages*. Ithaca: Cornell University Press, 1983.

——. *Medieval Architecture in Western Europe: From A.D. 300 to1500*. New York: Oxford University Press, 1998.

——. *Programs of Medieval Illumination*. Lawrence, KS: University of Kansas Press, 1984.

Camille, M. *The Medieval Arts of Love: Objects and Subjects of Desire*. New York and London: Laurence King, 1998.

Carruthers, M. *The Craft of Thought: Meditation, Rhetoric, and the Making of Images, 400–1200*. Cambridge: Cambridge University Press, 1998.

Davidson, C. *Drama and Art*. Kalamazoo: Western Michigan University Press, 1977.

Dix, G. *The Shape of the Liturgy*. London: Dacre, 1945.

Dodwell, C. R. *Painting in Europe 800–1200* (Pelican History of Art, no. 34). Harmondsworth: Penguin, 1971.

Duchesne, L. *Christian Worship, Its Origin and Evolution: A Study of Latin Liturgy up to the Time of Charlemagne*. Trans. by M. L. McClure. London: E. and J. B. Young, 1903.

Eco, U. *Art and Beauty in the Middle Ages*. New Haven: Yale University Press, 1986.

Edson, E. *Mapping Time and Space: How Medieval Mapmakers Viewd Their World*. London: British Library, 1997.

Focillon, H. *The Life of Forms in Art*. New Haven: Yale University Press, 1942.

Fossier, R., ed. *The Cambridge Illustrated History of the Middle Ages*. 3 vols. Trans. by Janet Sondheimer and Sarah Hanbury Tenison. Cambridge: Cambridge University Press, 1986–1997.

Fulton, R. *From Judgment to Passion: Devotion to Christ and the Virgin Mary, 800–1200*. New York: Columbia University Press, 2002.

Gall, E. *Cathedrals and Abbey Churches of the Rhine*. New York: Harry Abrams, 1963.

Grabar, O. *The Mediation of Ornament*. Princeton: Princeton University Press, 1992.

Hahn, C. *Portrayed on the Heart: Narrative Effect in Pictorial Lives of Saints from the Tenth through the Thirteenth Century*. Berkeley: University of California Press, 2001.

Holmes, G., ed. *The Oxford Illustrated History of Medieval Europe*. Oxford: Oxford University Press, 1988.

Hussey, J. M. et al. *The Cambridge Medieval History*. 10 vols. Cambridge: Cambridge University Press, 1957–67. See also C. W. Previté-Orton, *The Shorter Cambridge Medieval History*. Cambridge: Cambridge University Press, 1953.

Jungmann, J. A. *The Mass: A Historical, Theological, and Pastoral Study*. Trans. by J. Fernandes and M. E. Evans. Collegeville, MN: Liturgical Press, 1976.

Kessler, H. L. *Seeing Medieval Art*. Orchard Park, NY: Broadview Press, 2004.

——. *Spiritual Seeing: Picturing God's Invisibility in Medieval Art*. Philadelphia: University of Pennsylvania Press, 2000.

Krautheimer, R. *Studies in Early Christian, Medieval and Renaissance Art*. New York: New York University Press, 1969.

——. *Rome: Profile of a City, 312–1308*. Princeton: Princeton University Press, 1980.

Lasko, P. *Ars Sacra: 800–1200* (Pelican History of Art, no. 36). Harmondsworth: Penguin, 1972.

Lindberg, D. C. *Theories of Vision from Al-Kindi to Kepler*. Chicago: University of Chicago Press, 1976.

Marle, R. van. *Iconographie de l'art profane au moyen âge et à la Renaissance*. 2 vols. The Hague: M. Nijhoff, 1932.

Martindale, A. *The Rise of the Artist in the Middle Ages and Early Renaissance*. New York: McGraw-Hill, 1972.

Matthiae, G. *Pittura romana del medioevo*. Rome: Fratelli Palombi, 1965.

——. *Mosaici medioevali delle chiese di Roma*. 2 vols. Rome: Istituto poligrafico dello stato, 1967.

Morey, C. R. *Medieval Art*. New York: W. W. Norton, 1942.

Nees, L. *From Justinian to Charlemagne, European Art, 565–787: An Annotated Bibliography*. Boston: G. K. Hall, 1985.

Nelson, R. S., ed. *Visuality before and beyond the Renaissance: Seeing as Others Saw*. Cambridge: Cambridge University Press, 2000.

Oakeshott, W. *The Mosaics of Rome from the Third to the Fourteenth Centuries*. Greenwich, Conn.: New York Graphic Society, 1967.

Ousterhout, R. and Brubaker, L., eds. *The Sacred Image East and West*. Urbana: University of Illinois Press, 1995.

Palol, P. de and Hirmer, M. *Early Medieval Art in Spain*. New York: Harry N. Abrams, Inc., 1967.

Pevsner, N. *An Outline of European Architecture*. 7th ed. Harmondsworth: Penguin, 1974.

Platt, C. *The Architecture of Medieval Britain*. New Haven: Yale University Press, 1990.

Porter, A. K. *Medieval Architecture: Its Origins and Development*. 2 vols. New Haven: Yale University Press, 1912.

——. *Lombard Architecture*. 4 vols. New Haven: Yale University Press, 1915–17.

Radding, C. M., and Clark, W. W. *Medieval Architecture, Medieval Learning: Builders and Masters in the Age of Romanesque and Gothic*. New Haven: Yale University Press, 1992.

Rhin-Meuse: Art et civilization 800–1400 (exh. cat.). Brussels: Musées royaux des Beaux-Arts, 1972.

Rickert, M. *Painting in Britain: The Middle Ages* (Pelican History of Art, no. 5). Harmondsworth: Penguin, 1954; 2nd ed., 1965.

Rubin, M. *Corpus Christi: The Eucharist in Late Medieval Culture.* Cambridge: Cambridge University Press. 1991.

Saxl, F. and Wittkower, R. *British Art and the Mediterranean.* London: Oxford University Press, 1948.

Schapiro, M. *Late Antique, Early Christian and Medieval Art.* New York: Braziller, 1979.

Scheller, R. W. *A Survey of Medieval Model Books.* Haarlem: De Erven F. Bohn, 1963.

Sears, E. and Thomas, T. K., eds. *Reading Medieval Images: The Art Historian and the Object.* Ann Arbor: University of Michigan Press, 2002.

Sed-Rajna, G. *Jewish Art.* Trans. by Sara Friedman and Mira Reich. New York: Harry Abrams, 1997.

Simson, O. von. *Das Mittelalter II* (Propyläen Kunst-geschichte, vol. 6). Berlin: Propyläen Verlag, 1972.

Smith, E. B. *The Dome.* Princeton: Princeton University Press, 1950.

——. *Architectural Symbolism of Imperial Rome and the Middle Ages.* Princeton: Princeton University Press, 1956.

Solovey, M. M. *The Byzantine Divine Liturgy.* Washington, DC: Catholic University of America Press, 1970.

Stoddard, W. S. *Art and Architecture in Medieval France.* New York: Harper and Row, 1972.

Stokstad, M. *Medieval Art.* New York: Harper and Row, 1986; 2nd ed., Boulder, CO: Westview Press, 2004.

Stone, L. *Sculpture in Britain: The Middle Ages* (Pelican History of Art, no. 9). Harmondsworth: Penguin, 1955.

Toesca, P. *Storia dell'arte italiana.* 3 vols. Turin: Unione tipografico-editrice torinese, 1927–51.

Venturi, A. *Storia dell'arte italiana.* 11 vols. Milan: C. Hoepli, 1901–40.

Weitzmann, K. *Illustrations in Roll and Codex.* Princeton: Princeton University Press, 1947; rev. ed., 1970.

Wilpert, J. *Die römischen Mosaiken und Malereien der kirchlichen Bauten vom IV. bis XIII. Jahrhundert.* 3rd ed. 4 vols. Freiburg i. B.: Herder, 1924; Condensed version edited by W. N. Schumacher, 1976.

Wixom, W. *Treasures from Medieval France* (exh. cat.). Cleveland Museum of Art, 1967.

3. Late Antique

Beckwith, J. *Coptic Sculpture,* London: A. Tiranti, 1963.

Bianchi-Bandinelli, R. *Rome, The Center of Power, 500 B.C. to A.D. 200.* New York: Braziller, 1970.

——. *Rome: The Late Empire, Roman Art A.D. 200–400.* New York: Braziller, 1971.

Butler, H. C. and Smith, E. B. *Early Churches in Syria.* Princeton: Princeton University Press, 1929.

Deichmann, F. W. *Ravenna, Hauptstadt des spätantiken Abendlandes.* 3 vols. I: *Geschichte und Monumente,* Wiesbaden: F. Steiner, 1969; II: *Kommentar,* Wiesbaden: F. Steiner, 1974; III: *Frühchristliche Bauten und Mosaiken von Ravenna,* Wiesbaden: F. Steiner, 1968–76.

Delbrueck, R. *Die Consulardiptychen und verwandte Denkmäler.* 2 vols. Berlin and Leipzig: W. de Gruyter, 1929.

Elsner, J. *Art and the Roman Viewer: The Transformation of Art from the Pagan World to Christianity.* Cambridge: Cambridge University Press, 1995.

Fine, S., ed. *Sacred Realm: The Emergence of the Synagogue in the Ancient World.* New York and Oxford: Oxford University Press, 1996.

Finney, P. C. *The Invisible God: The Earliest Christians on Art.* Oxford: Oxford University Press, 1997.

Goodenough, E. *Jewish Symbols in the Greco-Roman Period.* Volumes IX-XI: Symbolism in the Dura Synagogue. Bollingen Series. New York: Pantheon Books, 1964.

Grabar, A. *Christian Iconography: A Study of its Origins.* (The A. W. Mellon Lectures in the Fine Arts. Bollingen Series XXXV.) Princeton: Princeton University Press, 1968.

——. *Martyrium: Recherches sur le culte des reliques et l'art chrétien antique.* 2 vols. Paris: Collège de France, 1943–46.

——. *Les Ampoules de Terre Sainte (Monza, Bobbio).* Paris: C. Klincksieck, 1958.

——. *Early Christian Art, from the Rise of Christianity to the Death of Theodosius.* New York: Odyssey Press, 1969.

Hansen, M. F. *The Eloquence of Appropriation: Prolegomena to an Understanding of Spolia in Early Christian Rome.* Analecta Romana Instituti Danici, Supplementum 33. Rome: L'Erma di Bretschneider, 2003.

Ihm, C. *Die Programme der christlichen Apsismalerei vom vierten Jahrhundert bis zur Mitte des achten Jahrhunderts* (Forschungen zur Kunstgeschichte und christlichen Archäologie, no. 4). Wiesbaden: F. Steiner, 1960.

Janes, D. *God and Gold in Late Antiquity.* Cambridge: Cambridge University Press, 1998.

Jensen, R. M. *Understanding Early Christian Art.* London and New York: Routledge, 2000.

Kleinbauer, W. E. *Early Christian and Byzantine Architecture: An Annotated Bibliography and Historiography.* Boston: Reference Publications in Art History, 1992.

Krautheimer, R. *Early Christian and Byzantine Architecture* (Pelican History of Art, no. 24). Harmondsworth: Penguin, 1965; 2nd ed., 1981.

——. *Three Christian Capitals: Topography and Politics.* Berkeley: University of California Press, 1983.

—— et al. *Corpus basilicarum christianarum Romae.* 5 vols. Vatican City: Pontificio istituto di archeologia cristiana, 1937–77.

Lassus, J. *Sanctuaires chrétiens de Syrie.* Paris: P. Geuthner, 1947.

Leader-Newby, R. E. *Silver and Society in Late Antiquity:*

Functions and Meanings of Silver Plate in the Fourth to Seventh Centuries. Aldershot, UK, and Burlington, VT: Ashgate, 2004.

Levine, L. I., and Wiess, Z., eds. *From Dura to Sepphoris: Studies in Jewish Art and Society in Late Antiquity.* Portsmouth, RI: Journal of Roman Archaeology, 2000.

Mackie, G. *Early Christian Chapels in the West: Decoration, Function, and Patronage.* Toronto: University of Toronto Press, 2003.

Mathews, T. F. *The Clash of Gods. A Reinterpretation of Early Christian Art.* Rev. ed., Princeton: Princeton University Press, 1999.

Meer, R. van der. *Early Christian Art.* Chicago: University of Chicago Press, 1967.

—— and Mohrmann, C. *Atlas of the Early Christian World.* London: Nelson, 1958.

Natanson, J. *Early Christian Ivories.* London: A. Tiranti, 1953.

L'Orange, H. P. *Art Forms and Civic Life in the Late Roman Empire.* Princeton: Princeton University Press, 1965.

Rostovtzeff, M. I. *The Excavations at Dura-Europos,* Preliminary Reports I-IX. New Haven: Yale University Press, 1929–46.

——. *Dura-Europos and Its Art.* Oxford: Clarendon Press, 1938.

Sanderson, W. *Early Christian Buildings: A Graphic Introduction, 300–600.* Champlain, NY: Astrion Publishing, 1993.

Simson, O. von. *The Sacred Fortress.* Chicago: University of Chicago Press, 1948.

Verkerk, D. *Early Medieval Bible Illumination and the Ashburnham Pentateuch.* Cambridge: Cambridge University Press, 2004.

Volbach, W. F. *Elfenbeinarbeiten der Spätantike und des früühen Mittelalters.* 3rd ed. Mainz: P. von Zabern, 1976.

Waetzoldt, S. *Die Kopien des 17. Jahrhunderts nach Mosaiken und Wandmalereien in Rom.* Vienna: Schroll Verlag, 1964.

Webster, L. and Brown, M., eds. *The Transformation of the Roman World AD 400–900.* Berkeley: University of California Press, 1997.

Weitzmann, K. *Ancient Book Illumination.* Cambridge, MA: Harvard University Press, 1959.

——. *Late Antique and Early Christian Book Illumination.* New York: Braziller, 1977.

—— and H. L. Kessler. *The Frescoes of the Dura Synagogue and Christian Art.* Dumbarton Oaks Studies XXVIII. Washington, DC: Dumbarton Oaks, 1990.

Wessel, K. *Coptic Art in Early Christian Egypt.* New York: McGraw-Hill, 1975.

Wharton, A. J. *Refiguring the Post Classical City: Dura Europos, Jerash, Jerusalem, and Ravenna.* Cambridge: Cambridge University Press, 1995.

Williams, J., ed., *Imaging the Early Medieval Bible.* University Park, PA: Pennsylvania State University Press, 1999.

4. The Byzantine Empire

Barber, Charles. *Figure and Likeness: On the Limits of Representation in Byzantine Iconoclasm.* Princeton: Princeton University Press, 2002.

Beckwith, J. *The Art of Constantinople: An Introduction to Byzantine Art 300–1453.* New York: Phaidon, 1961.

Borsook, E. *Messages in Mosaic: The Royal Programmes of Norman Sicily.* Oxford: Oxford University Press, 1990.

Brubaker, L. *Vision and Meaning in Ninth-Century Byzantium: Image as Exegesis in the Homilies of Gregory of Nazianzus.* Cambridge: Cambridge University Press, 1999.

Cormack, R. *Byzantine Art.* Oxford: Oxford University Press, 2000.

——. *Writing in Gold: Byzantine Society and its Icons.* New York: Oxford University Press, 1985.

Corrigan. A. *Visual Polemics in the Ninth-Century Byzantine Psalters.* Cambridge: Cambridge University Press, 1992.

Cutler, A. *The Craft of Ivory: Sources, Techniques, and Uses in the Mediterranean Worlds: A.D. 200–1400.* (Dumbarton Oaks Byzantine Collection Publications, No. 8). Washington, DC: Dumbarton Oaks, 1985.

——. *The Hand of the Master: Craftsmanship, Ivory and Society in Byzantium (9th–11th Centuries).* Princeton: Princeton University Press, 1994.

Deichmann, F. W. *Studien zur Architektur Konstantinopels.* Baden-Baden: B. Grimm, 1956.

Demus, O. *Byzantine Mosaic Decoration: Aspects of Monumental Art in Byzantium.* London: Paul, Trench, Trubner, 1948.

——. *The Mosaics of Norman Sicily.* London: Routledge & Kegan Paul, 1950.

——. *Byzantine Art and the West.* New York: New York University Press, 1970.

——. *The Mosaics of San Marco in Venice.* 2 vols. Chicago: University of Chicago Press, 1984.

—— and Diez, E. *Byzantine Mosaics in Greece: Hosios Lucas and Daphni.* Cambridge, MA: Harvard University Press, 1931.

Evans, H., ed. *Byzantium: Faith and Power (1261–1557)* (exh. cat.). New York: Metropolitan Museum of Art, 2004.

—— and Wixom, W., eds. *The Glory of Byzantium: Art and Culture of the Middle Byzantine Era, A.D. 843–1261* (exh. cat.). New York: Metropolitan Museum of Art, 1997.

Goldschmidt, A. and Weitzmann, K. *Die byzantinischen Elfenbeinskulpturen.* 2 vols. Berlin: B. Cassirer, 1930–34.

Grabar, A. *L'Empereur dans l'art byzantin.* Paris: Belles lettres, 1936.

——. *Miniatures byzantines de la Bibliothèque Nationale.* Paris: Belles lettres, 1939; reprinted 1971.

——. *L'Iconoclasme byzantin.* Paris: Collège de France, 1957.

——. *Sculptures byzantines de Constantinople, IVe–Xe siècle.* Paris: Librarie Adrien Maissoneuve, 1963.

——. *The Art of the Byzantine Empire.* New York: Crown, 1966.

——. *The Golden Age of Justinian: From the Death of Theodosius to the Rise of Islam*. New York: Odyssey Press, 1967.

Hamilton, G. *The Art and Architecture of Russia*. 3rd ed. New Haven: Yale University Press, 1983.

Hoddinott, R. F. *Early Byzantine Churches in Macedonia and Southern Serbia*. London: Macmillan, 1963.

James, L. *Light and Colour in Byzantine Art*. Oxford: Oxford University Press, 1996.

Kartsonis, A. D. *Anastasis: The Making of an Image*. Princeton: Princeton University Press, 1986.

Kitzinger, E. *The Mosaics of Monreale*. Palermo: S. F. Flaccovio, 1960.

——. *The Art of Byzantium and the Medieval West: Selected Studies by Ernst Kitzinger*. W. E. Kleinbauer, ed. Bloomington, IN: Indiana University Press, 1976.

——. *Byzantine Art in the Making: Main Lines of Stylistic Development in Mediterranean Art, 3rd–7th Century*. Cambridge, MA: Harvard University Press, 1977.

Lowden, J. *Early Christian and Byzantine Art*. London: Phaidon, 1997.

Maguire, H. *Art and Eloquence in Byzantium*. Princeton: Princeton University Press, 1981.

——. *The Icons of Their Bodies: Saints and Their Images in Byzantium*. Princeton: Princeton University Press, 1996.

——, ed., *Byzantine Court Culture from 829 to 1204*. Washington, DC: Dumbarton Oaks, 1997.

Mango, C. *The Brazen House* (Kgl. Dansk Vidensk. Selskab., Arkaeologisk-kunsthistoriske meddelelser, no. 4). Copenhagen: I kommission hos Munksgaard, 1959.

——. *The Art of the Byzantine Empire, 312–1453* (Sources and Documents in the History of Art). Englewood Cliffs, NJ: Prentice-Hall, 1972; reprinted by University of Toronto Press, 1986.

——. *Byzantine Architecture*. New York: Harry Abrams, 1976.

——. *Byzantium: The Empire of New Rome*. London: Weidenfeld and Nicolson, 1980.

Mathew, G. *Byzantine Aesthetics*. New York: Viking Press, 1963.

Mathews, T. F. *The Byzantine Churches of Istanbul*. University Park, PA: Pennsylvania State University Press, 1976.

——. *Byzantium: From Antiquity to the Renaissance*. Englewood Cliffs, NJ: Prentice-Hall, 1998.

McClanan, A. *Representation of Early Byzantine Empresses: Image and Empire*. New York: Palgrave Macmillan, 2002.

Nelson, R. S. *Hagia Sophia, 1850–1950: Holy Wisdom, Modern Monument*. Chicago: University of Chicago Press, 2004.

Nice, R. L. van. *Saint Sophia in Istanbul: An Architectural Survey*. Washington, DC: Dumbarton Oaks, 1965.

Omont, H. *Evangiles avec peintures byzantines du XIe siècle*. 2 vols. Paris: Berthaud frères, 1908.

——. *Miniatures des plus anciens manuscrits grecs de la Bibliothèque Nationale du VIe au XIVe siècle*. Paris: H. Champion, 1929.

Ousterhout, R. *Master Builders of Byzantium*. Princeton: Princeton University Press, 1999.

Rice, D. T. *Byzantine Art*. Oxford: Clarendon Press, 1935; revised 1968.

Rodley, L. *Byzantine Art and Architecture: An Introduction*. Cambridge: Cambridge University Press, 1993.

Safran, L., ed. *Heaven on Earth: Art and the Church in Byzantium*. University Park, PA: Pennsylvania State University Press, 1998.

Sotiriou, G. A. and Sotiriou, M. *Icones du Mont Sinai*. Athens: Institut français, 1956–58.

Swift, E. H. *Hagia Sophia*. New York: Columbia University Press, 1940.

Tronzo, W. *The Cultures of His Kingdom: Roger II and the Capella Palatina in Palermo*. Princeton: Princeton University Press, 1997.

Weitzmann, K. *Studies in Classical and Byzantine Manuscript Illumination*. Chicago: University of Chicago Press, 1971.

——. *The Monastery of Saint Catherine at Mount Sinai: The Icons*. Princeton: Princeton University Press, 1976.

——. *The Icon: Holy Images, Sixth to Fourteenth Century*. New York: Braziller, 1978.

——. *The Icon*. New York: Knopf, 1982.

—— et al. *A Treasury of Icons: Sixth to Seventeenth Centuries*. New York: Harry Abrams, 1968.

——, ed. *The Age of Spirituality* (exh. cat.). New York: The Metropolitan Museum of Art, 1978–79.

——. *The Age of Spirituality: A Symposium*. New York: The Metropolitan Museum of Art, 1980.

Wessel, K. *Byzantine Enamels*. Greenwich, CT: New York Graphic Society, 1967.

Weyl Carr, A. *Byzantine Illumination, 1150–1250: The Study of a Provincial Tradition*. Chicago: University of Chicago Press, 1987.

Wharton, A. J. *Art of Empire: Painting and Architecture of the Byzantine Periphery*. University Park, PA: Pennsylvania State University Press, 1988.

Whittemore, T. *The Mosaics of St. Sophia at Istanbul. Third Preliminary Report: The Imperial Portraits of the South Gallery*. Oxford: Oxford University Press, 1942.

5. The early middle ages in the west

Alexander, J. J. G. *Insular Manuscripts: Sixth to the Ninth Century*. London: Harvey Miller, 1978.

The Art of Medieval Spain, AD 500–1200 (exh. cat.). New York: Metropolitan Museum of Art, 1993.

Arrhenius, B. *Merovingian Garnet Jewellery. Emergence and Social Implications*. Stockholm: Kungl. Vitterhets Historie Och Antikvitets Akademien, 1985.

Beckwith, J. *Early Medieval Art*. New York: Praeger, 1964; rev. ed., 1969.

Braunfels, W. *Die Welt der Karolinger und ihre Kunst*. Munich: Callwey, 1968.

—— et al., eds. *Karl der Grosse, Werk und Wirkung* (exh. cat.). Aachen: Town Hall and Cathedral, 1965.

——. *Karl der Grosse: Lebenswerk und Nachleben.* 5 vols. Düüsseldorf: L. Schwann, 1965–68.

Brown, K. R. *Migration Art, A.D. 300–800* (exh. cat.). New York: The Metropolitan Museum of Art, 1995.

Brown, M. P. *The Lindisfarne Gospels: Society, Spirituality & the Scribe.* Toronto: University of Toronto Press, 2003.

Bullough, D. *The Age of Charlemagne.* London: Elek Books, 1965.

Carver, M. O. H. *Sutton Hoo: Burial Ground of Kings.* Philadelphia: University of Pennsylvannia Press, 1998.

Chazelle, C. *The Crucified God in the Carolingian Era: Theology and Art of Christ's Passion.* New York: Cambridge University Press, 2001.

Cohen, A. S. *The Uta Codex: Art, Philosophy, and Reform in Eleventh-Century Germany.* University Park, PA: Pennsylvania State University Press, 2000.

Conant, K. J. *Carolingian and Romanesque Architecture: 800–1200* (Pelican History of Art, no. 13). Harmondsworth: Penguin, 1959.

Davids, A., ed. *The Empress Theophano: Byzantium and the West at the Turn of the First Millenium.* Cambridge: Cambridge University Press, 1995.

Davis-Weyer, C. *Early Medieval Art 300–1150* (Sources and Documents in the History of Art). Englewood Cliffs, NJ: Prentice-Hall, 1971; reprinted by University of Toronto Press, 1986.

Diebold, W. *Word and Image: An Introduction to Early Medieval Art.* Boulder, CO: Westview Press, 2000.

Dodds, J. D. *Architecture and Ideology in Early Medieval Spain.* University Park, PA: Pennsylvania State University Press, 1990.

Dodwell, C. R. *Anglo-Saxon Art: A New Perspective.* Ithaca: Cornell University Press, 1982.

Dutton, P. E. and Kessler, H. L., *The Poetry and Paintings of the First Bible of Charles the Bald.* Ann Arbor: University of Michigan Press, 1997.

Farr, C. *The Book of Kells: Its Function and Audience.* Toronto: University of Toronto Press, 1997.

Foote, P. G. and Wilson, D. M. *The Viking Achievement.* 2nd ed. London: Sidgwick & Jackson, 1980.

Gaehde, J. E. and Müütherich, F. *Carolingian Painting.* New York: Braziller, 1976.

Goldschmidt, A. *Die Elfenbeinskulpturen aus der Zeit der karolingischen und sächsischen Kaiser.* 4 vols. Berlin: B. Cassirer, 1914–26.

——. *Die deutschen Bronzetüüren des früühen Mittelalters.* 3 vols. Marburg: Verlag des Kunstgeschichlichen Seminars der Universität Marburg, 1926–32.

——. *German Illumination.* 2 vols. New York: Harcourt Brace, 1928.

Grabar, A. and Nordenfalk, C. *Early Medieval Painting from the Fourth to the Eleventh Century.* Lausanne: Skira, 1957.

Graham, J. G. *Viking Artefacts: A Select Catalogue.* London: British Museum Publications, 1980.

Harbison, P. *The High Crosses of Ireland: An Iconographic and Photographic Survey.* 3 vols. Bonn: R. Habelt, 1992.

Henderson, G. *Early Medieval.* Harmondsworth: Penguin, 1972.

——. *Vision and Image in Early Christian England.* Cambridge: Cambridge University Press, 1999.

Henry, F. *Irish Art in the Early Christian Period.* London: Methuen, 1940; rev. ed., 1965.

——. *Irish High Crosses.* Dublin: Three Candles, 1964.

——. *Irish Art During the Viking Invasions.* Ithaca: Cornell University Press, 1967.

——. *Studies in Early Christian and Medieval Irish Art.* London: Pindar Press, 1983.

Hiscock, N. *The Wise Master Builder: Platonic Geometry in Plans of Medieval Abbeys and Cathedrals.* Aldershot, UK, and Burlington, VT: Ashgate, 2000.

Hourihane, C., ed. *From Ireland Coming: Irish Art from the Early Christian Period to the Late Gothic Period and Its European Context.* Princeton: Index of Christian Art/ Princeton University Press, 2001.

Hubert, J. *The Carolingian Renaissance.* New York: Braziller, 1970.

Kendrick, T. D. *Anglo-Saxon Art to A.D. 900.* London: Methuen, 1938.

——. *Late Saxon and Viking Art.* London: Methuen, 1949.

Kitzinger, E. *Early Medieval Art, with Illustrations from the British Museum Collection.* Bloomington: Indiana University Press, 1964 (reprint of 1940 London ed.).

Kornbluth, G. *Engraved Gems of the Carolingian Empire.* University Park, PA: Pennsylvania State University Press, 1995.

Lasko, P. *The Kingdom of the Franks.* London: Thames and Hudson, 1971.

Mayr-Harting, H. *Ottonian Book Illumination: A Historical Study.* Rev. ed. 2 vols. London: Harvey Miller, 1999.

Nees, L. *Early Medieval Art.* Oxford: Oxford University Press, 2002.

——. *A Tainted Mantle: Hercules and the Classical Tradition at the Carolingian Court.* Philadelphia: University of Pennsylvania Press, 1991.

Nordenfalk, C. *Celtic and Anglo-Saxon Painting: Book Illumination in the British Isles 600–800.* New York: Braziller, 1977.

Rice, D. T., ed. *English Art, 871–1100.* Oxford: Clarendon Press, 1952.

Ryan, Michael. *Studies in Medieval Irish Metalwork.* London: The Pindar Press, 2001.

Shetelig, H., ed., *Viking Antiquities,* 6 vols, Oslo, 1940–54.

Speake, G. *Anglo-Saxon Animal Art and Its Germanic Background.* New York: Oxford University Press, 1980.

Stalley, R. *Early Medieval Architecture.* Oxford: Oxford University Press, 1999.

Stevick, R. *The Earliest Irish and English Bookarts. Visual and Poetic Forms before A.D. 1000.* Philadelphia: University of Pennsylvania Press, 1994.

Studies in Western Art: Romanesque and Gothic. Acts of the XX International Congress of the History of Art. 2 vols. Princeton: Princeton University Press, 1963.

Sullivan, R. *Aix-en-Chapelle in the Age of Charlemagne.* Norman, OK: University of Oklahoma Press, 1974.

Taylor, H. and Taylor, J. *Anglo-Saxon Architecture.* 3 vols. Cambridge: Cambridge University Press, 1965–78.

Veelenturf, K. *Dia Brátha. Eschatological Theophanies and Irish High Crosses.* Amsterdam: Stichting Amsterdamse Historische Reeks, 1997.

Verdier, P. and Ross, M. C. *Arts of the Migration Period in the Walters Art Gallery* (exh. cat.). Baltimore: Walters Art Gallery, 1961.

Verzone, P. *The Art of Europe: The Dark Ages from Theodoric to Charlemagne.* New York: Crown, 1968.

Voelkle, W. *The Stavelot Triptych: Mosan Art and the Legend of the True Cross.* New York: Pierpont Morgan Library, 1980.

Webster, L., and Backhouse, J., eds. *The Making of England: Anglo-Saxon Art and Culture AD 600–900.* Toronto: University of Toronto Press, 1991.

Wilson, D. M. *The Anglo-Saxon Art from the Seventh Century to the Norman Conquest.* New York: Overlook Press, 1984.

——— and Klindt-Jensen, O. *Viking Art.* 2nd ed. Minneapolis: University of Minnesota Press, 1980.

Wormald, F. *English Drawings of the Tenth and Eleventh Centuries.* London: Faber and Faber, 1952.

Zimmermann, E. H. *Vorkarolingische Miniaturen.* 5 vols. Berlin: Deutscher Verein für Kunstwissenschaft, 1916.

6. Medieval Art and Islam

Barasch, M. *Crusader Figural Sculpture in the Holy Land.* New Brunswick, NJ: Rutgers University Press, 1971.

Blair, S. and Bloom, J. *The Art and Architecture of Islam, 1250–1800.* New Haven: Yale University Press, 1994.

Brend, B. *Islamic Art.* Cambridge, MA: Harvard University Press, 1991.

Buchthal, H. *Miniature Painting in the Kingdom of Jerusalem: A Corpus.* Oxford: Clarendon Press, 1957.

Cresswell, K. A. C., *Early Muslim Architecture.* 2nd ed. New York: Hacker Art Books, 1979.

Dodds, J., ed. *Al-Andalus: The Art of Islamic Spain* (exh. cat.). New York: Metropolitan Museum of Art, 1992.

Ettinghausen, R., Grabar, O., and Jenkins-Madina, M. *The Art and Architecture of Islam.* 2nd ed. New Haven: Yale University Press, 2001.

Flood, F. B. *The Great Mosque of Damascus: Studies on the Makings of an Umayyad Visual Culture.* Leiden: Brill, 2001.

Folda, J. *The Art of the Crusaders in the Holy Land 1098–1187.* Cambridge: Cambridge University Press, 1995.

———. *Crusader Art in the Holy Lands, 1187–1291: From the Third Crusade to the Fall of Acre.* Cambridge: Cambridge University Press, forthcoming in 2005.

———. *Crusader Manuscript Illumination at Saint-Jean d'Acre,*
1275–1291. Princeton: Princeton University Press, 1976.

———. *The Nazareth Capitals and the Crusader Shrine of the Annunciation.* University Park, PA: Pennsylvania State University Press, 1986.

Gómez-Moreno, M. *Iglesias mozárabes.* 2 vols. Madrid: Centro de estudios históricos, 1919.

———. *El arte árabe español hasta los Almohades, Arte Mozárabe* (Ars Hispaniae, vol. 3). Madrid: Plus-Ultra, 1951.

Grabar, O. *The Alhambra.* Cambridge, MA: Harvard University Press, 1978.

———. *The Formation of Islamic Art.* Rev. ed., New Haven: Yale University Press, 1987.

———. *The Shape of the Holy: Early Islamic Jerusalem.* Princeton: Princeton University Press, 1996.

Hillenbrand, R. *Islamic Art and Architecture.* London: Thames and Hudson, 1999.

Irwin, R. *Islamic Art in Context: Art, Architecture, and the Literary World.* New York: Prentice-Hall, 1997.

Khatibi, A. and Sijelmassi, M. *The Splendour of Islamic Calligraphy.* Rev. and exp. ed. London: Thames and Hudson, 2001.

Kühnel, G. *Wall Painting in the Latin Kingdom of Jerusalem.* Berlin: Mann, 1988.

Mann, V., Glick, T., and Dodds, J., eds. *Convivencia: Jews, Muslims, and Christians* (exh. cat.). New York: The Jewish Museum, 1992.

Pringle, D. *The Churches of the Crusader Kingdom of Jerusalem: A Corpus.* Cambridge: Cambridge University Press, 1992.

Ruggles, D. F. *Gardens, Landscape, and Visions in the Palaces of Islamic Spain.* University Park, PA: Pennsylvania State University Press, 2000.

Talgam, R. *The Stylistic Origins of Umayyad Sculpture and Architectural Decoration.* Wiesbaden: Harrassowitz, 2004.

Williams, J. *Early Spanish Manuscript Illumination.* New York: Braziller, 1977.

———. *The Illustrated Beatus.* London: Harvey Miller, 1994.

7. Romanesque

Armi, C. E. *Masons and Sculptors in Romanesque Burgundy: The New Aesthetic of Cluny III.* University Park, PA: Pennsylvania State University Press, 1983.

El arte románico (exh. cat.). Barcelona: Palacio de bellas artes, and Santiago de Compostela, 1961.

Bernstein, D. J. *The Mystery of the Bayeux Tapestry.* Chicago: University of Chicago Press, 1986.

Brooke, C. et al. *English Romanesque Art, 1066–1200.* London: Abner Schram, 1984.

Brown, S. A. *The Bayeux Tapestry: History and Bibliography.* Woodbridge, NJ: Boydell Press, 1998.

Cahn, W. *Romanesque Bible Illumination.* Ithaca: Cornell University Press, 1982.

——— and Seidel, L. *Romanesque Sculpture in American Collections.* New York: B. Franklin, 1979.

Conant, K. J. *Cluny: Les Eglises et la maison du chef d'ordre.* Mâcon: Protat frères, 1968.

Cook, W. and Gudiol i Ricart, J. *Pintura románica: Imaginería románica* (Ars Hispaniae, vol. 6). Rev. ed. Madrid: Plus-Ultra, 1979.

Dale, T. E. A. *Relics, Prayer, and Politics in Medieval Venetia: Romanesque Painting in the Crypt of Aquileia Cathedral,* Princeton: Princeton University Press, 1994.

Demus, O. *Romanesque Mural Painting.* New York: Harry Abrams, 1970.

Evans, J. *Monastic Life at Cluny, 910–1157.* London: Oxford University Press, 1931.

——. *The Romanesque Architecture of the Order of Cluny.* Cambridge: Cambridge University Press, 1938.

——. *Cluniac Art of the Romanesque Period.* Cambridge: Cambridge University Press, 1950.

Fergusson, P. *Architecture of Solitude: Cistercian Abbeys in Twelfth-Century Europe.* Princeton: Princeton University Press, 1984.

Focillon, H. *The Art of the West in the Middle Ages,* I: *Romanesque Art.* New York: Phaidon, 1963; reprinted 1980.

Forsyth, I. H. *The Throne of Wisdom: Wood Sculptures of the Madonna in Romanesque France.* Princeton: Princeton University Press, 1972.

Garrison, E. B. *Italian Romanesque Panel Painting.* Florence: L. S. Olschki, 1949.

——. *Studies in the History of Medieval Italian Painting.* 4 vols. Florence: L'Impronta, 1952–62.

Gómez-Moreno, M. *El arte románico español.* Madrid: Blass, 1934.

Grabar, A. and Nordenfalk, C. *Romanesque Painting from the Eleventh to the Thirteenth Century.* Geneva: Skira, 1958.

Grape, W. *The Bayeux Tapestry: Monument to a Norman Triumph.* New York: Prestel, 1994.

Hearn, M. F. *Romanesque Sculpture.* Ithaca: Cornell University Press, 1981.

Kubach, H. E. *Romanesque Architecture.* New York: Harry Abrams, 1975.

Kupfer, M. *The Art of Healing: Painting for the Sick and the Sinner in a Medieval Town.* University Park, PA, 2003.

——. *Romanesque Wall Painting in Central France: The Politics of Narrative.* New Haven: Yale University Press, 1993.

Mâle, E. *L'Art religieux du XIIe siècle en France.* Paris: A. Colin, 1922; English ed., H. Bober, ed., *Religious Art in France, The Twelfth Century.* Princeton: Princeton University Press, 1978.

Michel, P. H. *Romanesque Wall Paintings in France.* London: Thames and Hudson, 1950.

Oakeshott, W. *The Artists of the Winchester Bible.* London: Faber and Faber, 1945.

O'Neill J. P. *Enamels of Limoges 1100–1350* (exh. cat.). New York: Metropolitan Museum of Art, 1996.

Pächt, O. *The Rise of Pictorial Narrative in Twelfth-Century England.* Oxford: Clarendon Press, 1962.

Panofsky, E. *Die deutsche Plastik des elften bis dreizehnten Jahrhunderts.* 2 vols. Munich: K. Wolff, 1924.

Petzold, A. *Romanesque Art.* New York: Prentice-Hall, 1985.

Porter, A. K. *Romanesque Sculpture of the Pilgrimage Roads.* 10 vols. Boston: Marshall Jones, 1923.

——. *Spanish Romanesque Sculpture.* 2 vols. Florence: Pantheon, 1928.

Puig i Cadafalch, J. *Le premier art roman.* Paris: H. Laurens, 1928.

Rudolph, C. *The "Things of Greater Importance": Bernard of Clairvaux's Apologia and the Medieval Attitude Toward Art.* Philadelphia: University of Pennsylvania, 1990.

——. *Violence and Daily Life: Reading, Art and Polemics in the Citeaux Moralia in Job.* Princeton: Princeton University Press, 1997.

Saxl, F. and Swarzenski, H. *English Sculptures of the Twelfth Century.* London: Faber and Faber, 1954.

Schapiro, M. *Romanesque Art: Selected Papers.* New York: Braziller, 1977.

Seidel, L. *Songs of Glory: The Romanesque Facades of Aquitaine.* Chicago: University of Chicago Press, 1981.

Stones, A., Krochalis, J., Gerson, P., and Shaver-Crandell, A., eds. *The Pilgrim's Guide: A Critical Edition.* London: Harvey Miller, 1998.

Turner, D. H. *Romanesque Illuminated Manuscripts in the British Museum.* London: British Museum, 1966.

Wilson, D. M. *The Bayeux Tapestry: The Complete Tapestry in Color.* New York: Knopf, 1985.

Zarnecki, G., Holt, J. et al., eds. *English Romanesque Art 1066–1200* (exh. cat.). London: Hayward Gallery/Weidenfeld and Nicolson, 1984.

8. The Late Middle Ages

Alexander, J. J. G. and Binski, P., eds. *Age of Chivalry: Art in Plantagenet England, 1200–1400* (exh. cat.). London: Royal Academy of the Arts, 1987.

Avril, F. *Manuscript Painting at the Court of France—The Fourteenth Century (1310–1380).* New York: Braziller, 1978.

Barnet, P., ed. *Images in Ivory: Precious Objects of the Gothic Age* (exh. cat.). Detroit: Detroit Institute of the Arts, 1997.

Belting, H. *The Image and Its Public in the Middle Ages: Form and Function in the Early Paintings of the Passion.* New Rochelle, NY: A. D. Caratzas, 1990.

Binski, P. *Westminster Abbey and the Plantagenets: Kingship and the Representation of Power, 1200–1400.* New Haven: Yale University Press, 1995.

Bony, J. *The English Decorated Style.* Ithaca: Cornell University Press, 1979.

——. *French Gothic Architecture of the Twelfth and Thirteenth Centuries.* Berkeley: University of California Press, 1983.

Borsook, E. *The Mural Painters of Tuscany.* London: Phaidon, 1960.

Branner, R. *Burgundian Gothic Architecture.* London: A. Zwemmer, 1960.

——. *Gothic Architecture.* New York: Braziller, 1961.

——. *Manuscript Painting in Paris During the Reign of Saint Louis.* Berkeley: University of California Press, 1977.

——. *Saint Louis and the Court Style in Gothic Architecture.* London: A. Zwemmer, 1965.

Bruzelius, C. *The Thirteenth-Century Church at Saint-Denis.* New Haven: Yale University Press, 1986.

Camille, M. *Gothic Art: Glorious Visions.* New York: Prentice-Hall, 1996.

——. *The Gothic Idol: Ideology and Image-Making in Medieval Art.* Cambridge: Cambridge University Press, 1999.

——. *Image on the Edge: The Margins of Medieval Art.* Cambridge, MA: Harvard University Press, 1992.

Christie, A. G. I. *English Medieval Embroidery.* Oxford: Clarendon Press, 1938.

Clanchy, M. T. *From Memory to Written Record: England 1066–1307.* 2nd ed. Oxford: Blackwell, 1993.

Clarke, G. and Crossley, P., eds. *Architecture and Language: Constructing Identity in European Architecture, ca. 100–1650.* Cambridge: Cambridge University Press, 2000.

Crosby, S. M. *L'Abbaye royale de Saint-Denis.* Paris: Paul Hartmann, 1953.

——. *The Royal Abbey of Saint-Denis from Its Beginnings to the Death of Suger, 475–1151.* New Haven: Yale University Press, 1987.

—— et al. *The Royal Abbey of Saint-Denis in the Time of Abbot Suger (1122–1151).* New York: The Metropolitan Museum of Art, 1981.

Derbes, A. *Picturing the Passion in Late Medieval Italy: Narrative Painting, Franciscan Ideologies, and the Levant.* Cambridge: Cambridge University Press, 1996.

Evans, J. *English Art, 1307–1461.* Oxford: Clarendon Press, 1949.

Favier, J. *The World of Chartres.* Trans. by Francisca Garvie. New York: Harry Abrams, 1990.

Focillon, H. *The Art of the West in the Middle Ages*, II: *Gothic Art.* New York: Phaidon, 1963; reprinted 1980.

Frankl, P. *The Gothic: Literary Sources and Interpretations Through Eight Centuries.* Princeton: Princeton University Press, 1960.

——. *Gothic Architecture* (Pelican History of Art, no. 19). Harmondsworth: Penguin, 1962.

Frisch, T. G. *Gothic Art, 1140–1450* (Sources and Documents in the History of Art). Englewood Cliffs, NJ: Prentice-Hall, 1971; reprinted by University of Toronto Press, 1987.

Frugoni, C. *A Distant City: Images of Urban Experience in the Medieval World.* Princeton: Princeton University Press, 1994.

Gerson, P., ed. *Abbot Suger and Saint-Denis.* New York: Metropolitan Museum of Art, 1986.

Gimpel, J. *The Cathedral Builders.* New York: Grove Press, 1961.

Gordon, D., Monnas, L., and Elam, E., eds. *The Regal Image of Richard II and the Wilton Diptych.* London: Harvey Miller, 1998.

Grant, L. *Abbot Suger of St.-Denis: Church and State in Twelfth-Century France.* London and New York: Longmans, 1998.

Green, R., Evans, M., and Bischoff, C. *Herrad von Landsberg, Abbess of Hohenbourg.* London: Warburg Institute, 1979.

Grodecki, L. *Gothic Architecture.* New York: Harry Abrams, 1977.

—— and Brisac, C. *Gothic Stained Glass: 1200–1300.* Ithaca: Cornell University Press, 1985.

Hamburger, J. F. *Nuns as Artists: The Visual Culture of a Medieval Convent.* Berkeley: University of California Press, 2001.

——. *The Rothschild Canticles: Art and Mysticism in Flanders and the Rhineland circa 1300.* New Haven: Yale University Press, 1990.

——. *The Visual and the Visionary: Art and Female Spirituality in Late Medieval Germany.* New York: Zone, 1998.

Harvey, J. *The Gothic World, 1100–1600: A Survey of Architecture and Art.* London: B. T. Batsford, 1950.

——. *English Medieval Architects: A Biographical Dictionary down to 1550.* London: B. T. Batsford, 1954.

Hoffmann, K., ed. *The Year 1200* (exh. cat.). 2 vols. New York, The Metropolitan Museum of Art, 1970.

Huizinga, J. *The Autumn of the Middle Ages.* Trans. by R. Payton and U. Mammitzsch. Chicago: University of Chicago, 1996.

Jantzen, H. *High Gothic: The Classic Cathedrals of Chartres, Reims, Amiens.* New York: Pantheon Books, 1962; reprinted 1984.

Johnson, J. R. *The Radiance of Chartres: Studies in the Early Stained Glass of the Cathedral.* London: Phaidon, 1964.

Johnson, P. *British Cathedrals.* New York: W. Morrow, 1980.

Kaftal, G. *The Saints in Italian Art.* 2 vols. Florence: Sansoni, 1952–56.

Katzenellenbogen, A. *Allegories of the Virtues and Vices in Medieval Art.* London: Warburg Institute, 1939; reprinted by University of Toronto Press, 1989.

——. *The Sculptural Programs of Charters Cathedral.* Baltimore: Johns Hopkins Press, 1959.

Kemp, W. *The Narratives of Gothic Stained Glass.* Trans. by C. D. Saltzwedel. Cambridge: Cambridge University Press, 1997.

Kidson, P. *Sculpture at Chartres.* London: A. Tiranti, 1958.

King, D., ed. *Opus Anglicanum: English Medieval Embroidery* (exh. cat.). London, Victoria and Albert Museum, 1963.

Lord, C. *Royal French Patronage of Art in the Fourteenth Century: An Annotated Bibliography.* Boston: G. K. Hall, 1985.

Lowden, J. *The Making of the Bibles Moralisées.* University Park, PA: Pennsylvania State University Press, 2000.

Mâle, E. *L'Art religieux du XIIIe siècle en France.* Paris: E. Leroux, 1898. First English ed. published as *The Gothic Image.* New York: Harper and Row, 1958; new English

ed., H. Bober, ed. *Religious Art in France, The Thirteenth Century*. Princeton: Princeton University Press, 1984.

———. *L'Art religieux de la fin du moyen âge en France*. Paris: A. Colin, 1908.

Mark, R. *High Gothic Structure: A Technological Reinterpretation*. Princeton: Princeton University Press, 1985.

Martindale, A. *Gothic Art from the Twelfth to the Fifteenth Century*. London: Thames and Hudson, 1967.

Meiss, M. *Painting in Florence and Siena After the Black Death*. Princeton: Princeton University Press, 1951.

Nussbaum, N. *German Gothic Architecture*. New Haven: Yale University Press, 2000.

Os, H. van. *Sienese Altarpieces 1215–1460*. 2 vols. Groningen: Egbert Forsten, 1988.

———, ed. *The Art of Devotion in the Late Middle Ages in Europe 1300–1500*. Princeton: Princeton University Press, 1994.

Panofsky, E. *Gothic Architecture and Scholasticism*. Latrobe, PA: Saint Vincent Archabbey Press, 1951; reprinted by New American Library, 1976.

Pinder, W. *Die deutsche Plastik* (Handbuch der Kunstwissenschaft). 2 vols. Munich: K. Wolff, 1924.

Pope-Hennessy, J. *Italian Gothic Sculpture*. 2nd ed. London: Phaidon, 1972.

Porcher, J. *Medieval French Miniatures*. New York: Harry Abrams, 1959.

Raguin, V. C. *Stained Glass in Thirteenth-Century Burgundy*. Princeton: Princeton University Press, 1982.

Raguin, V., Brush, K., and Draper, P., eds. *Artistic Integration in Gothic Buildings*. Toronto, Buffalo, and London: University of Toronto Press, 1995.

Randall, L. *Images in the Margins of Gothic Manuscripts*. Berkeley: University of California Press, 1966.

Rudolph, C. *Artistic Change at St.-Denis: Abbot Suger's Program and the Early Twelfth-Century Controversy over Art*. Princeton: Princeton University Press, 1990.

Sauerländer, W. *Gothic Sculpture in France: 1140–1270*. London: Thames and Hudson, 1972.

Simson, O. von. *The Gothic Cathedral: Origins of Gothic Architecture and the Medieval Concept of Order*. New York: Pantheon Books, 1956; reprinted 1967.

Staniland, K. *Embroiderers*. Toronto: University of Toronto Press, 1991.

Stoddard, W. S. *The West Portals of Saint-Denis and Chartres*. Cambridge, MA: Harvard University Press, 1952.

Stubblebine, J. *Dugento Painting: An Annotated Bibliography*. Boston: G. K. Hall, 1983.

———. *Assisi and the Rise of Vernacular Art*. New York: Harper and Row, 1985.

Wieck, R. S. *Painted Prayers: The Book of Hours in Medieval and Renaissance Art*. New York: George Braziller, 1997.

White, J. *Art and Architecture in Italy, 1250–1400* (Pelican History of Art, no. 28). Harmondsworth: Penguin, 1966.

Williams, J. W. *Bread, Wine, and Money: The Windows of the Trades at Chartres Cathedral*. Chicago: University of Chicago Press, 1993.

Williamson, P. *Gothic Sculpture 1140–1300*. New Haven: Yale University Press, 1995.

9. Medievalism

Cantor, N. F. *Inventing the Middle Ages: The Lives, Works, and Ideas of the Great Medievalists of the Twentieth Century*. New York: Quill, 1993.

Driver, M. W. and Ray, S., eds. *The Medieval Hero on Screen: Representations from Beowulf to Buffy*. Jefferson, NC: McFarland, 2004.

Edelstein, T. J., ed. *Imagining an Irish Past: The Celtic Revival, 1840–1940* (exh. cat.). Chicago: David and Alfred Smart Museum of Art, 1992.

Emery, E. and Morowitz, E. *Consuming the Past: The Medieval Revival in fin-de-siècle France*. Aldershot, UK, and Burlington, VT: Ashgate, 2003.

Netzer, N. and Reinburg, V., eds. *Memory and the Middle Ages*. Chestnut Hill, MA: Boston College Museum of Art, 1995.

Pevsner, N. *Ruskin and Viollet-le-Duc: Englishness and Frenchness in the Appreciation of Gothic Architecture*. London: Thames and Hudson, 1969.

TIMETABLES OF
MEDIEVAL HISTORY AND ART

ROME AND THE LATIN WORLD	BYZANTIUM AND THE EAST
300	
Last persecutions of the Christians (303–11)	
Constantine the Great defeats Maxentius (312)	
Diocletian (d. 313)	
Edict of Milan (313)	Council of Nicaea (325)
Pope Sylvester (314–35)	Constantinople founded as the new Rome (330)
	Death of Eusebius, Bishop of Caesarea, author of the *Historia ecclesiastica* and *Vita Constantini* (340)
Julian the Apostate restores paganism (361)	
Ambrose, Bishop of Milan (374–97)	
Theodosius I the Great, Emperor (379–95)	Gregory of Nazianzus, *Homilies* (c. 370)
Jerome translates the Bible, the Vulgate (382)	
Honorius, Emperor of the West (395–423)	
Augustine, Bishop of Hippo (395–430)	Arcadius, Emperor of the East (395–408)
400	
Alaric invades Italy (400); sacks Rome (410)	
Honorius moves capital to Ravenna (402)	Theodosius II, Emperor of the East (408–50)
Galla Placidia, regent (424–50)	
Pope Sixtus III (432–40)	Council of Ephesus (431)
Pope Leo the Great (440–61)	
	Council of Chalcedon (451)
Venice founded by refugees from the Huns (457)	
Odoacer, Heruli chieftain, conquers empire of the West (474–93)	
Theodoric the Great, King of Ostrogoths (488–526) at Ravenna	
500	
	Neoplatonic writings of Pseudo-Dionysius the Areopagite (c. 500)
Priscian, Latin grammarian, writes *Institutiones grammaticae* (520)	
Boethius writes *De Consolatione philosophiae* in prison in Pavia before his execution (524)	Justinian I, Byzantine Emperor (527–65)
	Nika riots in Constantinople (532)
Monte Cassino founded by Saint Benedict (c. 529)	
Totila, the Ostrogoth, enters Rome (546)	Byzantine army recaptures Ravenna (540)
Lombards capture North Italy (568); Pavia made capital (c. 575)	Justin II, Emperor (565–78)
Lombards capture Monte Cassino (581)	
Pope Gregory the Great (590–604)	
600	
Isidore, Bishop of Seville (600–636), writes *Etymologiae* by 635	
	Heraclius I, Byzantine Emperor (610–41)
	Mohammed flees to Medina (622)
	Caliph Omar captures Jerusalem (637)
Recceswinth, King of Visigoths (649–72)	
	Justinian II, Emperor (685–95)
	Quinisext Council (692)
	Muslims destroy Carthage (697)
700	
Muslim conquest of Visigothic Spain (711)	Leo III the Isaurian, Byzantine Emperor (717–41)
	Iconoclasm (726–843)
Desiderius, King of the Lombards (756–74)	Nicephorus, Patriarch of Constantinople (758–829)
	Irene, Byzantine Empress (780–90)
	Council of Nicaea, temporary rejection of iconoclasm (787)
Pope Leo III (795–816)	

NORTHERN EUROPE

THE ARTS

300

Arch of Constantine, Rome (312)
Lateran Baptistery, Rome (founded c. 320)
Saint Peter's, Rome (founded c. 324)
Church of the Holy Sepulcher, Jerusalem (c. 335)

San Lorenzo Maggiore, Milan (c. 355–75)
Huns invade Europe (c. 360)
Sarcophagus of Junius Bassus (359)

Saint Martin, Bishop of Tours (371–97)
San Paolo fuori le mura (385)

Roman legions gradually evacuate Britain; Angles, Saxons, and
Jutes move in (383–436)

400

Santa Sabina, Rome (422–32)
Saint Patrick's mission to Ireland (432)
Mausoleum of Galla Placidia, Ravenna (425–50)
Attila, King of the Huns (433–53)
Santa Maria Maggiore, Rome (432–40)

Anglo-Saxon raids on England (450–650)
Orthodox Baptistery, Ravenna (c. 450)

Huns withdraw from Europe (470)
Pilgrimage Church, Qal'at Si'man (c. 470)

Clovis, King of the Franks (481–511)

500

Sant'Apollinare Nuovo, Ravenna (c. 500)

Hagia Sophia, Constantinople (532–37)

Saint Columbanus (c. 540–615)
San Vitale, Ravenna, mosaics (c. 548)
Sant' Apollinare in Classe (c. 549)
Saint Catherine, Mount Sinai, mosaic (c. 550)

Saint Gregory, Bishop of Tours (573–93); *History of the Franks* (c. 575)

Rabbula Gospels (c. 586)
Saint Augustine of Canterbury sent to England (597)

600

Hagios Demetrios, Thessaloniki (c. 610–40)
Cyprus silver plates (c. 610–41)
Dagobert I, Merovingian King (628–39)
Sutton Hoo ship burial (c. 625–33)

Votive crown of Recceswinth (649–72)
Synod of Whitby, England accepts Roman liturgy (663)
Book of Durrow (c. 660–80)
The Venerable Bede (673–735)

700

Charles Martel, Mayor of the Franks (714–41)

Boniface (d. 755) appointed Bishop of Germany (722)
Altar of Duke Ratchis, Cividale (731–44)
Battle of Poitiers, defeat of Muslims (732)

Pepin III, crowned King of Franks at Saint Denis (754)
Saint Denis rebuilt (754)

Charlemagne defeats Desiderius (774)
Defeat of Roland at Roncesvalles (778)
Vikings destroy Lindisfarne (793)
Godescalc Gospels (781–83)
Frankfurt Synod, *Libri Carolini* (794)
Beatus of Liébana, *Commentary on the Apocalypse* (786)

ROME AND THE LATIN WORLD	BYZANTIUM AND THE EAST

800

Pope Paschal I (817–24)
Saracens invade Sicily (827)

Theophilus, Byzantine Emperor (829–42)

Michael III, first Emperor of Macedonian dynasty (842–67)
Theodora, Byzantine Empress (843–56)
Council of Constantinople, end of iconoclasm (843)
Photius, Patriarch of Constantinople (858–67; 877–86)
Basil I, Byzantine Emperor (867–86); Macedonian dynasty begins

900

Constantine VII Porphyrogenitus, Byzantine Emperor (913–59)

Romanus II, Byzantine Emperor (959–63)

Basil II, Byzantine Emperor (976–1025)

Gerbert, scholar and churchman, elected Pope Sylvester II (999)

1000

Turks take Asia Minor from Byzantines (1007)

Norman conquest of Sicily begins (1043)
Desiderius, Abbot of Monte Cassino (1058–86)
Lateran Council (1059)
Normans sack Rome (1064)
Alfonso VI, King of León and Castile (1072–1109)
Hildebrand becomes Pope Gregory VII (1073)
Henry IV submits to Pope Gregory VII at Canossa (1077)
Pope Urban II (1088–99)
First Crusade to Holy Land (1095–99)
Latin kingdom of Jerusalem founded (1099)

Armenia annexed by Byzantines (1046)
Papacy in Rome excommunicates Byzantine patriarch (1054)

Comneni dynasty (1081–1185); consolidation of the Byzantine state under Alexius I Comnenus (1081–1118)
Latin kingdom of Jerusalem founded (1099)

1100

Roger II, King of Sicily (1130–54)
Pope Innocent II (1130–43)

Frederick I (Barbarossa), Holy Roman Emperor (1152–90)

William II, King of Sicily (1166–89)
Lombard League established (1167)
Frederick Barbarossa defeated at Legnano (1176)

Third Crusade (1189)

Manuel I Comnenus, Emperor (1143–80)

Saladin captures Jerusalem (1187)

1200

Fourth Crusade and the sack of Constantinople (1202–4)
Franciscan Order founded, Assisi (1209)
Frederick II Hohenstaufen, Holy Roman Emperor (1220–50)

Sack of Constantinople by Venetians during Fourth Crusade (1204); Latin dynasty rules (1204–61)
Nikolaos Mesarites writes description of the Church of the Holy Apostles in Constantinople (c. 1220)

End of the Hohenstaufen reign with death of Conrad IV (1254)

Byzantines retake Constantinople from Latins (1261); beginning of the Palaeologus dynasty (1261–1453)

Marco Polo returns from China (1285)

Turks take Acre (1291)

1300

Papacy moves to Avignon, the "Babylonian captivity" (1309–78)

Dante Alighieri (d. 1321)

Black Death (1347–49)

Boccaccio (d. 1375)

NORTHERN EUROPE

THE ARTS

800

Charlemagne crowned Emperor of the West (800)
Louis the Pious, Carolingian Emperor (814–40)

Utrecht Psalter (816–35)
Santa Prassede, Rome, mosaics (817–24)

Viking raids on England (835)
Charles the Bald, Carolingian Emperor (840–77)
Treaty of Verdun; the beginnings of modern Europe (France, Germany, Italy) (843)
Viking raids in France (853; 885)

Moûtier-Grandval Bible (c. 840)

Hagia Sophia, Constantinople: apse mosaic (before 867)

Alfred the Great, King of England (871–99)

Homilies of Gregory of Nazianzus (880–83)

900

Cluniac Order founded (910)
Conrad, the Frank, turns the crown over to Henry I, the Saxon (918)

First church at Cluny (c. 910)

Otto I the Great crowned Holy Roman Emperor (962)
Otto II Holy Roman Emperor (973–83); marries Theophano, Byzantine Empress (972)
Otto III, Holy Roman Emperor (983–1002)
Hugh Capet, King of France (987–96)
Bruno, cousin of Otto III, appointed Pope Gregory V (996)

Benedictional of Ethelwold (971–84)
Golden Virgin of Essen (973–82)
Codex Egberti (977–93)

1000

Henry II, Holy Roman Emperor (1002–24)

Saint Michael's, Hildesheim (1010–33)
Katholikon, Hosios Loukas (c. 1020)

William the Conqueror, Duke of Normandy (1035–87)
Henry III, Holy Roman Emperor (1039–56)
Edward the Confessor, King of England (1042–66)
Hugh, Abbot of Cluny (1049–1109)
Battle of Hastings (1066)

Saint Genis-des-Fontaines, lintel (1020–21)
Santa María, Ripoll (c. 1020–32)
Cathedral, Speyer (1030–61)

San Marco, Venice (after 1063)
Saint Etienne, Caen (1064–77)
Bayeux Tapestry (1070–80)

Carthusian Order founded (1084)

Cathedral, Santiago de Compostela (1075–1120)
Cluny III (1088–1130)

Cistercian Order founded (1098)

1100

Henry V, Holy Roman Emperor (1106–25)
Saint Bernard, Abbot of Clairvaux (1115–53)
Concordat of Worms (1122)
Suger, Abbot of Saint Denis (1122–51)
Death of Henry V initiates conflicts between the Guelphs and Ghibellines (1125)
Eleanor of Aquitaine, Queen of France (1137–52)
Henry the Lion, Duke of Saxony (1139–95)
Saint Bernard preaches the Second Crusade at Vézelay (1146)
Second Crusade to Acre and Damascus (1147)
Henry II Plantagenet, King of England (1154–89)
Philip II Augustus, King of France (1180–1223)
Richard I *Coeur-de-lion*, King of England (1189–99)

Rainer of Huy, baptismal font, Liège (1107–18)
Saint Pierre, Moissac, south portal sculptures (c. 1115–30)
Sainte Madeleine, Vézelay (1120–32)
Cathedral, Chartres, west facade (begun 1134)
Saint Denis, west facade (1135–40)
Abbey Church, Fontenay (1139–47)

Guglielmo, pulpit for Cagliari Cathedral (1159–62)
Notre Dame, Paris (begun 1163)
Cathedral, Monreale (1174–83)
Benedetto Antelami, *Deposition* sculpture, Parma (1178)
Nicholas of Verdun, Klosterneuburg altar (1181)
Cathedral, Chartres, transepts (1194–1240)

1200

Albigensian Crusade (1208)
Battle of Bouvines (1214)
Magna Carta (1215)
Saint Thomas Aquinas (1225–74)
Saint Louis IX, King of France (1226–70)

Cathedral, Reims (begun 1211)
San Francesco, Assisi (1228–53)
Cathedral, Bamberg: choir sculptures (c. 1230–40)

Sainte-Chapelle, Paris (1243–48)

Nicola Pisano, pulpit, Pisa Baptistery (1260)

Philip III the Bold, King of France (1270–85)
Edward I, King of England (1272–1307)
Philip IV the Fair, King of France (1285–1314)

Pietro Cavallini, mosaics in Santa Maria in Trastevere, Rome (1290s)
Jacopo Torriti, apse mosaic, Santa Maria Maggiore, Rome (c. 1294)

1300

Giovanni Pisano, pulpit, Pisa Cathedral (1302–10)
Giotto, frescoes in the Arena Chapel, Padua (1305–)
Duccio, *Maestà*, Duomo, Siena (1308–11)

Jeanne d'Evreux, Queen of France (1325–28)
Hundred Years War begins (1337–1453)

Jean Pucelle, *Hours of Jeanne d'Evreux* (1325–28)
Ambrogio Lorenzetti, frescoes in the Palazzo Pubblico, Siena (1338–39)

John II the Good, King of France (1350–64)

INDEX

Note: Page numbers in *italics* are for illustrations.

The index entries are arranged in a letter-by-letter sequence which means that the spaces between words are ignored for filing purposes, for example, "Christianity" will follow "Christ Enthroned", but come before "Christ in Majesty". This does not apply to the entries beginning with "Saint", "Sainte", "Saints", or "St" which are inter-filed in a single sequence, or to entries beginning with "San", "Sant", or "Santa", which are also in a single sequence.

F

G

H

M

Q

R

S

PICTURE CREDITS

Laurence King Publishing and Pearson Prentice Hall wish to thank the institutions and individuals who have kindly provided photographic materials for use in this book. Additional source and copyright information is given below. Every effort has been made to contact the copyright holders, but should there be any errors or omissions the publishers would be pleased to insert the appropriate acknowledgment in any subsequent edition of this book.

Roubier, Paris. **13.6** Oronoz Archivo Fotográfico. **13.7** Oronoz Archivo Fotográfico. **13.8** © Paul M.R.D.C. Maeyaert. **13.9** A.F.D.C. Kersting, London. **13.10** G. Dehio and G. von Bezold, *Die Kirchliche Baukunst des Abendlandes*, 1887-1901. **13.11** Bridgeman Art Library/ Giraudon/ Lauros. **13.12** Leonard von Matt, Buochs. **13.13** © 1990, Photo Scala, Florence. **13.14** Jean Dieuzaide. **13.15** © Paul M.R.D.C. Maeyaert. **13.16** Archives Photographiques, Paris. **13.17** The Art Archive/Dagli Orti. **13.18** © Paul M.R.D.C. Maeyaert. **13.19** Wim Swaan, New York. **13.20** Archives Photographiques, Paris. **13.21** Archives Photographiques, Paris. **13.22** Conway Library, Courtauld Institute of Art, London. **13.23** Archives Photographiques, Paris. **13.24** Wim Swaan, New York. **13.25** Archives Photographiques, Paris. **13.26** © Paul M.R.D.C. Maeyaert. **13.27** © 1995, Photo Scala, Florence. **13.28** K.J.D.C. Conant, *Carolingian and Romanesque Architecture*, 1959. **13.29** K.J.D.C. Conant, *Carolingian and Romanesque Architecture*, 1959. **13.30** © Paul M.R.D.C. Maeyaert. **13.31** Bridgeman Art Library/Giraudon. **13.32** © Paul M.R.D.C. Maeyaert. **13.33** AKG Images. **13.34** © Paul M.R.D.C. Maeyaert. **13.35** © Paul M.R.D.C. Maeyaert. **13.36** British Library, London. **13.37** Wim Swaan, New York. **13.38** Wim Swaan, New York. **13.39** Archives Photographiques, Paris. **13.40** © Paul M.R.D.C. Maeyaert. **13.41** Bildarchiv Foto Marburg. **13.42** Jean Roubier, Paris. **13.43** Jean Roubier, Paris. **13.44** Bridgeman Art Library/Board of Trinity College Dublin. **13.45** Metropolitan Museum of Art, Gift of J.Pierpont Morgan, 1916. (16.32.194) Photograph © 1999 The Metropolitan Museum of Art. **13.46** W. Braunfels, *Monasteries of Western Europe*, 1972. **13.47** Bridgeman Art Library. **13.48** AKG Images/Paul Maeyaert. **13.49** Bibliothèque Municipale de Dijon. **13.50** Bibliothèque Municipale de Dijon

14.1 K.J.D.C. Conant, *Carolingian and Romanesque Architecture*, 1959. **14.2** Art Archive/Dagli Orti. **14.3** © Biblioteca Apostolica Vaticana. **14.4** © Biblioteca Apostolica Vaticana. **14.5** © Biblioteca Apostolica Vaticana. **14.6** G.E.D.C. Kidder Smith, New York. **14.7** © Photo Vasari, Rome. **14.8** © 1990, Photo Scala, Florence. **14.9** © Studio Fotografico Quattrone, Florence. **14.10** © Studio Fotografico Quattrone, Florence. **14.11** © Ralph Lieberman/Calmann & King Archives. **14.12** Wim Swaan, New York. **14.13** G.E.D.C. Kidder Smith, New York. **14.14** © 2001, Photo Scala, Florence. **14.15** Archivi Alinari, Florence. **14.16** Archivi Alinari, Florence. **14.18** Kolumba, Köln. **14.19** Philip Evola, New York. **14.20** © Paul M.R.D.C. Maeyaert. **14.21** Achim Beednoraz/Monheim/Artur. **14.22** Artothek/Constantin Beyer. **14.23** Deutscher Kunstverlag, Munich. **14.24** Victoria and Albert Museum, London. **14.25** © Jutta Brüdern, Braunschweig, Germany. **14.26** Bildarchiv Foto Marburg. **14.27** Erzbischöfliches Diözesanmuseum and Domschatzkammer, Paderborn. **14.28** © IRPA-KIK, Brussels. **14.29** Pierpont Morgan Library, New York. **14.30** Musée Sandelin. **14.31** Stiftsmuseum, Klosterneuburg. **14.32** Stiftsmuseum, Klosterneuburg. **14.33** Rheinisches Bildarchiv, Cologne. **14.34** © Dombauarchiv Köln, Matz und Schenk. **14.35** AKG Images/Erich Lessing. **14.36** Bibliothèque des Museés de Strasbourg. Photo by M. Bertola

15.1 Jean Roubier, Paris. **15.2** © Paul M.R.D.C. Maeyaert. **15.3** Detail from the Bayeux Tapestry. By special permission of the City of Bayeux . **15.4** Detail from the Bayeux Tapestry. By special permission of the City of Bayeux. **15.5** © Angelo Hornak. **15.6** G. Webb, *Architecture in Britain: The Middle Ages*, 1956. **15.7** A.F.Kersting. **15.8** Bridgeman Art Library/Musee Tesse, le Mans, France. **15.9** © The Trustees of The British Museum, London. **15.10** Archives Photographiques, Paris. **15.11** Archives Photographiques, Paris. **15.12** © Paul M.R.D.C. Maeyaert. **15.13** Jean Roubier, Paris. **15.14** Archives Photographiques, Paris. **15.15** Art Archive/Dagli Orti. **15.16** Archives Photographiques, Paris. **15.17** Bibliothèque Nationale de France. **15.18** The Metropolitan Museum of Art, Gift of George Blumenthal, 1941 (41.100.184). **15.19** Metropolitan Museum of Art, Gift of J.Pierpont Morgan, 1917. (17.190.125) Photograph © 1994 The Metropolitan Museum of Art. **15.20** Metropolitan Museum of Art, Gift of J.Pierpont Morgan, 1917. (17.90.833) Photograph © 1995 The Metropolitan Museum of Art

16.1 Widener Collection. Image © 2004 Board of Trustees, National Gallery of Art, Washington. **16.2** © Paul M.R.D.C. Maeyaert. **16.3** W. Swaan, *The Gothic Cathedral*, 1969. **16.4** © Angelo Hornak. **16.5** G. Dehio and G. von Bezold, *Die Kirchliche Baukunst des Abendlandes*, 1887-1901. **16.6** © Paul M.R.D.C. Maeyaert. **16.7** Samuel Chamberlain. **16.8** G. Dehio and G. von Bezold, *Die Kirchliche Baukunst des Abendlandes*, 1887-1901. **16.9** © Angelo Hornak. **16.10** Wim Swaan, New York. **16.11** Bibliothèque Nationale de France. **16.12** © 1990, Photo Scala, Florence. **16.15** Bildarchiv Foto Marburg. **16.16** AKG Images/Erich Lessing. **16.17** Wim Swaan, New York. **16.18** Bridgeman Art Library/Alinari. **16.19** Bridgeman Art Library/Alinari. **16.20** © Angelo Hornak. **16.22** © Paul M.R.D.C. Maeyaert. **16.23** Bildarchiv Foto Marburg. **16.24** Clarence Ward, Oberlin. **16.25** © Angelo Hornak. **16.26** Archives Photographiques, Paris. **16.27** Wim Swaan, New York. **16.28** Hirmer Verlag, Munich. **16.29** Sonia Halliday. **16.30** Conway Library, Courtauld Institute of Art, London. **16.31** Wim Swaan, New York. **16.32** Bridgeman Art Library/Peter Willi. **16.33** © Angelo Hornak. **16.34** Sonia Halliday. **16.35** Archives Photographiques, Paris. **16.36** Art Archive/Dagli Orti. **16.37** Bridgeman Art Library/Giraudon. **16.38** Bridgeman Art Library/Giraudon . **16.39** Bridgeman Art Library/ Chartres Cathedral. **16.40** © Angelo Hornak. **16.41** Clarence Ward, Oberlin. **16.43** AKG Images/Gilles Mermet. **16.44** Bridgeman Art Library/Giraudon. **16.45** © Angelo Hornak. **16.46** Archives Photographiques, Paris. **16.47** Patrick Muller © CMN, Paris. **16.48** Archives Photographiques, Paris. **16.49** Wim Swaan, New York. **16.50** Bridgeman Art Library. **16.51** © 1996, Photo Scala, Florence. **16.52** P. Frankl, *Gothic Architecture*, 1962. **16.53** Bridgeman Art Library/Peter Willi. **16.54** Bibliothèque Nationale, Paris. **16.55** Bildarchiv Foto Marburg. **16.56** Hirmer Verlag, Munich. **16.57** © Angelo Hornak. **16.58** Jean Roubier, Paris. **16.59** © Museo di Storia della Fotografia Fratelli Alinari, Florence

17.1 © 1990, Photo Scala, Florence. **17.2** A.F.D.C. Kersting, London. **17.3** Art Archive/Dagli Orti. **17.4** © Photo RMN/Michèle Bellot/René-Gabriel Ojéda. **17.5** © Photo RMN/Daniel Arnaudet. **17.6** Bibliothèque Nationale de France. **17.7** The Pierpont Morgan Library © 2004, Photo Pierpont Morgan Library/Art Resource/Scala Florence. **17.8** The Pierpont Morgan Library © 2004, Photo Pierpont Morgan Library/Art Resource/Scala Florence. **17.9** Bibliothèque Nationale de France. **17.10** Bibliothèque Nationale de France. **17.11** Bibliothèque Nationale de France. **17.12** Metropolitan Museum of Art, The Cloisters Collection, 1954. (54.1.2) Photograph © 1991 The Metropolitan Museum of Art. **17.13** The Metropolitan Museum of Art, The Cloisters Collection, 1954. (54.1.2). **17.14** Metropolitan Museum of Art, The Cloisters Collection, 1969. (69.86) Photograph © 1991 The Metropolitan Museum of Art. **17.15** Bibliothèque Nationale de France. **17.16** Bequest of Charles Phelps and Anna Sinton Taft, Taft Museum of Art, Cincinnati, Ohio. **17.17** Bildarchiv Foto Marburg. **17.18** © Photo RMN/Martine Beck-Coppola. **17.19** Service Photographique, Paris. **17.20** The Walters Art Museum, Baltimore. **17.21** The Walters Art Museum, Baltimore. **17.22** © Photo RMN/Daniel Arnaudet. **17.23** Bildarchiv Foto Marburg. **17.24** Archives Photographiques, Paris. **17.25** AKG Images/Schütze/ Rodemann. **17.26** Art Archive/Papal Palace Avignon/Dagli Orti . **17.27** © Biblioteca Apostolica Vaticana

18.1 A.F.Kersting. **18.2** © Florian Monheim/Bildarchiv Monheim. **18.3** G. Webb, *Architecture in Britain: The Middle Ages*, 1956. **18.4** © Angelo Hornak. **18.5** © Florian Monheim/Bildarchiv Monheim. **18.6** A.F.D.C. Kersting. **18.8** © Angelo Hornak. **18.9** A.F.D.C. Kersting. **18.10** A.F.D.C. Kersting. **18.11** A.F.Kersting. **18.12** G. Webb, *Architecture in Britain: The Middle Ages*, 1956. **18.13** A.F.D.C. Kersting. **18.14** © Angelo Hornak. **18.15** A.F.Kersting. **18.16** A.F.D.C. Kersting. **18.17** © Angelo Hornak. **18.18** © Angelo Hornak. **18.19** Wim Swaan, New York. **18.20** © Angelo Hornak. **18.21** Bildarchiv Foto Marburg. **18.22** Wim Swaan, New York. **18.23** © Sonia Halliday and Laura Lushington. **18.25** Wim Swaan, New York. **18.26** A.F.D.C. Kersting. **18.27** British Library, London.

18.28 Reproduction by permission of the Syndics of the Fitzwilliam Museum, Cambridge. **18.29** Reproduction by permission of the Syndics of the Fitzwilliam Museum, Cambridge . **18.30** Bibliothèque Nationale, Paris. **18.31** The Pierpont Morgan Library © 2004, Photo Pierpont Morgan Library/Art Resource/Scala Florence. **18.32** Metropolitan Museum of Art, Fletcher Fund, 1927. (27.162.1) Photograph © 1981 The Metropolitan Museum of Art. **18.33** © V Picture Library. **18.34** © V Picture Library. **18.35** © The National Gallery, London. **18.36** Oronoz Archivo Fotográfico. **18.37** Oronoz Archivo Fotográfico. **18.38** Oronoz Archivo Fotográfico. **18.39** Oronoz Archivo Fotográfico. **18.40** Bibliotheque Nationale de France

19.1 © 1990, Photo Scala, Florence. Courtesy of the Ministero Beni e Att. Culturali. **19.2** © 1990, Photo Scala, Florence. Courtesy of the Ministero Beni e Att. Culturali. **19.3** © 1990, Photo Scala, Florence. **19.4** Archivi Alinari, Florence. **19.5** © Studio Fotografico Quattrone, Florence. **19.6** © Studio Fotografico Quattrone, Florence. **19.7** © Studio Fotografico Quattrone, Florence. **19.8** © Quattrone, Florence. **19.9** © Studio Fotografico Quattrone, Florence. **19.10** © Studio Fotografico Quattrone, Florence. **19.11** Archivi Alinari, Florence. **19.12** © 1990, Photo Scala, Florence. **19.13** Archivi Alinari, Florence. **19.14** Archivi Alinari, Florence. **19.15** © 1990, Photo Scala, Florence. **19.16** © 1990, Photo Scala, Florence. **19.17** © 1990, Photo Scala, Florence. **19.18** © 1990, Photo Scala, Florence. **19.19** Archivi Alinari, Florence. **19.20** © Studio Fotografico Quattrone, Florence. **19.21** © Studio Fotografico Quattrone, Florence. **19.22** © 1990, Photo Opera Metropolitana Siena/Scala, Florence. **19.23** © Studio Fotografico Quattrone, Florence. **19.24** © 1990, Photo Opera Metropolitana Siena/Scala, Florence . **19.25** © Studio Fotografico Quattrone, Florence. **19.26** © Studio Fotografico Quattrone, Florence. **19.27** Archivi Alinari, Florence. **19.28** © Studio Fotografico Quattrone, Florence. **19.29** © Studio Fotografico Quattrone, Florence. **19.30** © 1990, Photo Scala, Florence . **19.31** © Studio Fotografico Quattrone, Florence. **19.32** Ludovico Canali, Rome. **19.33** © 1990, Photo Scala, Florence

20.1 Bildarchiv Foto Marburg. **20.2** AKG Images. **20.3** Bildarchiv Foto Marburg. **20.4** a Hirmer Verlag, Munich. **20.5** German Information Center, New York. **20.6** Helga Schmidt-Glassner, Stuttgart.

20.7 Bildarchiv Foto Marburg. **20.8** Bildarchiv Foto Marburg. **20.9** Artothek/Constantin Beyer. **20.10** © Domkapitel Aachen. Photo: Ann Münchow. **20.11** German Information Center, New York. **20.12** Hirmer Verlag, Munich. **20.14** Artothek/Constantin Beyer. **20.15** Artothek/Constantin Beyer. **20.17** Artothek/Constantin Beyer. **20.18** © The Cleveland Museum of Art, Purchase from the J.H.D.C. Wade Fund, 1928.753. **20.20** Rheinisches Landesmuseum, Bonn. **20.21** Metropolitan Museum of Art, Gift of J. Pierpont Morgan, 1917. (17.190.724) Photograph © 1982 The Metropolitan Museum of Art. **20.22** Metropolitan Museum of Art, Gift of J. Pierpont Morgan, 1917. (17.190.185) Photograph © 1987 The Metropolitan Museum of Art. **20.23** Metropolitan Museum of Art, Gift of J. Pierpont Morgan, 1917. (17.190.185) Photograph © 1987 The Metropolitan Museum of Art. **20.24** Universitätsbibliothek, Heidelberg. **20.25** National Library of the Czech Republic. **20.26** © The J. Paul Getty Museum, Los Angeles. **20.27** Beinecke Rare Book and Manuscript Library, Yale University. **20.28** Collection & Photo B.N.U.D.C. Strasbourg

21.1 New York Public Library. **21.2** © Photo RMN/Arnaudet. **21.3** © Florian Monheim/Bildarchiv Monheim. **21.4** A.F.D.C. Kersting. **21.5** AKG Images. **21.6** © Peter Ashworth, London. **21.7** Alamy/Jack Sullivan. **21.8** Bridgeman Art Library/Manchester City Art Gallery. **21.9** © Tate, London 2005. **21.10** McManus Galleries, Dundee City Council Leisure & Arts © Estate of John Duncan 2004. All rights reserved, DACS. **21.11** British Library, London

LITERARY CREDITS

Dumbarton Oaks: from *The Homilies of Photius, Patriarch of Constantinople*, by C. Mango (Cambridge, Mass., 1958)

Hodder & Stoughton Ltd: from *Holy Bible, New International Version* (London, 1979), © 1973, 1978, 1984 by International Bible Society

Oxford University Press: from *Bede's Ecclesiastical History of the English People*, edited by B. Colgrave and R. A. B. Mynors (Oxford, 1969)

Random House Inc.: from *Purgatorio*, by Dante Alighiere, translated by Allen Mandelbaum (New York, 1982)